MAKING VALUE, MAKING MEANING: TECHNÉ IN THE PRE-COLUMBIAN WORLD

DUMBARTON OAKS PRE-COLUMBIAN SYMPOSIA AND COLLOQUIA

Series Editor
Colin McEwan

Editorial Board
Elizabeth Hill Boone
Tom Cummins
Barbara Arroyo

MAKING VALUE, MAKING MEANING: TECHNÉ IN THE PRE-COLUMBIAN WORLD

CATHY LYNNE COSTIN

Editor

DUMBARTON OAKS RESEARCH LIBRARY AND COLLECTION
WASHINGTON, D.C.

LIBRARY OF CONGRESS CATALOGING-IN-PUBLICATION DATA

NAMES: Costin, Cathy Lynne, editor of compilation. | Dumbarton Oaks. | Pre-Columbian Studies Symposium
"Making Value, Making Meaning : Techné in the Pre-Columbian World" (2013 : Washington, D.C.)

TITLE: Making value, making meaning : techné in the pre-Columbian world / Cathy Lynne Costin, editor.

DESCRIPTION: Washington, D.C. : Dumbarton Oaks Research Library and Collection, [2016] | Series:
Dumbarton Oaks pre-Columbian symposia and colloquia | "Volume based on papers presented at the Pre-
Columbian Studies Symposium 'Making Value, Making Meaning : Techné in the Pre-Columbian World,'
held at the Dumbarton Oaks Research Library and Collection, Washington, D.C., on October 11-12,
2013"—Title page verso. | Includes bibliographical references and index.

IDENTIFIERS: LCCN 2015045619 | ISBN 9780884024156 (hardcover : alkaline paper)

SUBJECTS: LCSH: Indians of Central America—Antiquities—Congresses. | Indians of South America—
Antiquities—Congresses. | Indian artisans—Central America—History—Congresses. | Indian artisans—
South America—History—Congresses. | Handicraft—Central America—History—Congresses. |
Handicraft—South America—History—Congresses. | Indian arts—Central America—History—
Congresses. | Indian arts—South America—History—Congresses. | Social archaeology—Central
America—Congresses. | Social archaeology—South America—Congresses.

CLASSIFICATION: LCC F1434.2.A7 M35 2016 | DDC 972.8/01—dc23

LC record available at https://lccn.loc.gov/2015045619

GENERAL EDITOR: Colin McEwan

ART DIRECTOR: Kathleen Sparkes

DESIGN AND COMPOSITION: Melissa Tandysh

MANAGING EDITOR: Sara Taylor

Volume based on papers presented at the Pre-Columbian Studies symposium "Making Value, Making
Meaning: Techné in the Pre-Columbian World," held at the Dumbarton Oaks Research Library and
Collection, Washington, D.C., on October 11–12, 2013.

www.doaks.org/publications

CONTENTS

FOREWORD

IN 2010, ON THE OCCASION OF THE 100TH Annual Conference of the College Art Association in Los Angeles, Cecilia Klein convened a special session to address "Theory, Method, and the Future of Pre-Columbian Art History." She invited a representative roster of senior colleagues who, in the course of long teaching careers, have "carried the torch" for the field and helped train the current generation of practitioners. In her opening remarks, Klein explained her motives for organizing the session and shared her underlying misgivings about the way in which "Pre-Columbian art historians are increasingly specializing in a single geographic area, or so-called 'culture,' and sometimes a single, often very short, time period within that culture's history." This, she declared, "occurs to the near or total exclusion of the myriad other places, peoples, and historical moments covered by the field . . . many younger scholars do not seem to be trying to make their work relevant even to Pre-Columbianists specializing in other areas and periods, and evidence less interest in engaging the broader issues and theoretical debates within their own discipline." She noted that this is "part of a much larger problem vexing the humanities as a whole" and that it is "tied to the growing disinterest in deep history."*

While referencing such art historical concerns may appear tangential to the aspirations of this volume, I would suggest otherwise for two main reasons. First, an understanding of the practical knowledge and materiality of craft production is no longer optional for the younger generation of art historians; it is, in truth, indispensable. The diverse media and approaches embraced by the essays featured here will ensure that the volume becomes required reading for a wide interdisciplinary audience that, perforce, includes art historians. Second, it is to be hoped that the converse will prove equally true—namely, that the application of new analytical techniques and methodologies to a wide range of Pre-Columbian materials, objects, and settings will stimulate a renewed interest from further afield in the sites, cultures, and material production of the prehispanic Americas. Several chapters in this volume are the result of collaborative efforts between archaeologists, art historians, and materials scientists; many give new literal force to attempts to see and understand what lies behind the appearances. Across materials ranging from ceramics to metals, shell, textiles, and polychrome pigments, insights into preparing and presenting surface textures and colors that were not possible just a generation ago are now rendered accessible to study. Powerful imaging techniques are making visible previously invisible aspects of extraction, processing, and production. As the hidden alchemy of techné in the Pre-Columbian world is revealed, it brings the world of its makers to life in new and unexpected ways. The field is the richer for it and

better placed to attract the talents of the archaeologists, materials scientists, and art historians who can decipher the next set of challenges.

Volume editor Cathy Costin has labored heroically to produce a groundbreaking compilation whose whole is greater than the sum of its parts; she liaised seamlessly with Pre-Columbian Studies administrator Kelly McKenna to prepare the volume for transmittal. Successive Dumbarton Oaks volumes seem to set a new benchmark in terms of the quality of editing and visual presentation; for this, we are, as ever, hugely indebted to our publications department and its director, Kathy Sparkes; editor, Sara Taylor; and copyeditor Sarah Soliz.

Colin McEwan
Director, Pre-Columbian Studies
Dumbarton Oaks

* Electronic document, "Theory, Method, and the Future of Pre-Columbian Art History," http://arthistoriography.files. wordpress.com/2012/12/Klein.pdf.

Introduction

Making Value, Making Meaning: Techné in the Pre-Columbian World

CATHY LYNNE COSTIN

Techné: Ancient and Contemporary Views of Skilled Crafting

IN THIS VOLUME, WE ADOPT THE CONCEPT OF techné as an analytic tool useful for understanding how the production process created value and meaning for social valuables and public monuments in the complex societies of Pre-Columbian Mesoamerica and the Andes. The contributors to this volume add to the study of ancient artisans and craftsmanship through the exploration of how technology, the organization of production, artisan identity, and the deployment of esoteric knowledge factor into the creation of symbolically and politically charged material culture.

Techné was the ancient Greek goddess of skilled crafting and artisanship. For the ancient Greek poets and philosophers, the word "techné" also referred to "a thorough, masterful knowledge of a specific field" that entailed crafting with skill and intent to produce something with social utility

(Roochnik 1996:2–3; see also Pollitt 1974). In the classical world, this form of practical knowledge included not only the ability to make ceramic vessels, tunics, or jewelry but also the knowledge of how to build houses and ships, manage an estate, create government, maintain social relationships, and produce other essential elements of civic life. Indeed, political *arete* (adeptness or excellence) was just as much the product of techné as was a suit of armor. Thus, the concept of techné is a powerful one for understanding the political economy of craft production and the role of objects in social life—as well as how their creation and use helps to generate their social, political, and spiritual power.

Although the contributors to this volume are archaeologists and art historians working in the ancient Americas, we built our understanding of techné from the ancient Greek concept.[1] We do not argue that there was necessarily an indigenous concept analogous to techné in either Mesoamerica or the Andean world. Rather, we suggest that, as a

heuristic framework, the characteristics of techné can help us to understand how crafted goods came to have social meaning and value—that is, the concept of techné focuses our attention on the full suite of knowledge, materials, processes, tools, and technical gestures that Pre-Columbian artisans employed to produce valued, socially meaningful, and ritually efficacious things.

The criteria that defined an activity as techné evolved over time, but, as generally discussed by the ancient Greek poets and philosophers, it had the following basic attributes:[2]

1. Techné is a transformative and generative human action; it produces something outside of or beyond natural processes.
2. Techné consisted of knowledge—both theoretical and procedural—of a specific field with a determinate range of tasks, subject matter, or objectives.
3. The goal of techné was to produce something socially useful and beneficial.[3]
4. Techné encompassed mastery of general rational principles that could be communicated, explained, and taught (as opposed to unique experiences gained through trial and error).
5. Techné was reliable; the processes were sound and the practitioner was skillful.
6. Techné and its products were recognized, evaluated, and rewarded by other members of the community.

While some Greek writers were primarily interested in determining whether a particular activity constituted techné, others focused on the ends to which skilled crafters—*technités*—deployed their knowledge and skill, and therefore on how techné contributed to the successful functioning of society. It is this latter mode of inquiry that concerns the contributors to this volume, who consider how we can translate the attributes of an ancient concept into a more general framework that is useful to archaeologists and art historians interested in understanding the value and meaning of material culture in Pre-Columbian societies.

Transformation and Generation

There are strong parallels between ancient Greek and modern anthropological views on the role of skilled crafting in human social life. Techné involves conscious human intervention to transform matter from its "natural" state into something wholly different from what natural processes might bring about (Meagher 1988).[4] At its heart, the concept of techné points to a distinctly human ability to make things, just as anthropologists and archaeologists recognize that crafting—the transformation of raw materials into finished goods of social, economic, political, and ritual usefulness and significance—is essential to human existence. As Stephen Houston (2014:59) has noted, "the urge to work clay, hide, wood, stone, and fibers to transform things by use of multiple media is, in the main, a distinguishing feature of humanity."[5] Indeed, one of the earliest representatives of our own genus was named *Homo habilis*, or "handy man," because they were believed to be the first hominids to make stone tools. The ancient Greek concept is particularly useful because it pays no heed to many of the conceptual boundaries—between persons and things, tangible and intangible, objects and institutions, comestible and noncomestible—that recent scholarship is also trying to bridge (see also Clark 2007; Clark and Houston 1998). For the ancient Greeks, all of human culture was the product of techné (Pollitt 1974:33). As V. Gordon Childe proclaimed, "man makes himself," positing that changes in productive regimes were at the heart of social and political development (Childe 1950; Wailes 1996).

The ancients were most interested in the prosaic objectives of crafting, both tangible (buildings and armament) and intangible (good government). Acknowledging that the human world is "pervasively artefactual" (Preston 2000:41), we are equally interested in the ways in which material culture shapes behavior, mediates social relations, defines and expresses social roles and distinctions, and materializes beliefs. Production isn't just about making things; it is about imbuing them with all their necessary qualities so that they will achieve their fullest social utility.

Knowledge and Skill, Principles and Procedures, Process and Product

Today, the term "techné" is most often translated as "craft" or "art," and set in opposition to *episteme* (translated simply as "knowledge"), thus leaving us with an apparent dichotomy between knowing and doing, theory and practice (Parry 2008). But for the Greeks, techné encompassed both productive processes and the knowledge that allowed and accounted for those processes; it was the "intellectual principles upon which practical artistic procedure was based" (Pollitt 1974:27). Because techné involves crafting with the explicit intention of creating something socially useful, it fundamentally entails an understanding of the relationship between the productive process and its product or outcome. To function properly at the various levels of social utility, a thing must have a range of properties and characteristics, and the artisans involved in its production must have commanded the practical and esoteric knowledge necessary to materialize them. Therefore, techné encompassed far more than mere technique or manual dexterity; it was not the "relatively unintelligent praxis of the button-pusher" (Caws 1979:236).

Useful Social Ends

One of the most significant attributes of the ancient Greek conceptualization of techné for modern scholarship is the emphasis on social utility as an intended outcome of production. As Larry Shiner (2001:xvi) has pointed out, throughout the premodern world, things were "made for a purpose" rather than solely for decontextualized, aesthetic admiration. For the ancient Greeks, such beneficial purposes were largely pragmatic: *technitai* built houses that could shelter, practiced medicine that could heal, and created laws that could keep the peace. One of the key developments in contemporary scholarship is that we explicitly investigate how objects were used to produce social life, recognizing that many things have multiple functions: utilitarian (e.g., serve food), social (e.g., manifest social identity), and ideological (e.g., symbolize abstract beliefs or values) (cf. Preston 2000; Schiffer 1992).

The products of skilled crafting play a central role in social reproduction, serving such diverse functions as bridewealth, insignia of office, and symbols of group membership and identity. They make social boundaries tangible and can be used to mediate tensions between antagonistic groups. In complex societies, the creation, distribution, and use of elaborate, high-value objects is key to political centralization and the creation and perpetuation of socioeconomic inequality; these objects legitimize power, inform statecraft, and contribute to the acquisition and consolidation of social and political capital among those in positions of power and authority. In most societies, such objects convey information and materialize beliefs. As particularly apt symbols of deeply held morals and values, they can explicitly or unconsciously arouse sentiments and actions in users and viewers. These items have value far beyond the ostensible worth of the raw materials and labor invested in their production, and meaning far beyond any utilitarian functions they might serve. They are social valuables, and the production process itself is a key factor in creating meaning and imbuing these things with their social, political, and symbolic worth.

A Teachable Body of Knowledge

For the ancient Greeks, techné was teachable. It was not the result of empirical trial and error, but rather a set of skills and principles that an experienced master could articulate and explain to a novice, who would then practice them until he mastered them. The transmission of knowledge and technical skills has not been well studied by archaeologists (but see Minar and Crown 2001; Stark et al. 2008; Wendrich, ed. 2012); generally, scholarship has focused on identifying communities of practice and technological styles, which imply the conveyance and sharing of knowledge formally or informally. There are rare examples of figurative representations of masters and students (Wendrich 2012:fig. 1.1); possible evidence for artisan's practice (Cooney 2012) and samplers (Sawyer 1997); and instances where multiple hands of varying skill are recognized in a single piece, which

suggests the work of a master and possible apprentices (Paul and Niles 1985; Houston, this volume; Trever, this volume).

Reliability

Techné was a form of knowledge necessary for human survival; its products were central to human life. Society depended on the products of the artisan, and therefore on the artisan him- or herself. Neither the individual nor society could afford a shipbuilder who failed to make a seaworthy craft or a smith who delivered faulty armor. Objects that bore inappropriate or unintelligible messages would fail in their communicative function. Similarly, the population could suffer if ritual objects failed to appropriately embody or direct supernatural power, or if such items failed to appease the deities or spirits whose aid and good will were necessary for life's continuity. Thus, both technical skill and appropriate esoteric knowledge were fundamental qualities of master craftspeople. Reliability is an outcome of the proficiency an artisan develops through training and practice.

The reliability of technical processes is hard to assess archaeologically, although (1) we can assume that the technological practices that were maintained over generations were those that were proven dependable; and (2) experimental archaeology could shed light on the success and failure rates of alternative procedures. More experimental work has been done to assess the performance characteristics of particular materials and finished products (see, for example, Bronitsky and Hamer 1986; Neupert 1994; Pierce 2005; Skibo 2013; Tite et al. 2001), which can provide a way to assess the reliability of finished products. Here, however, we need to be careful not to impose our own expectations for the performance characteristics on ancient artisans, as, for example, durability might not have been a critical attribute (see DeLeonardis, this volume).

Recognition and Reward, Value and Evaluation

In theory, techné was valued, evaluated, socially recognized, and rewarded. In the ancient Greek world, all sorts of practitioners strove to be called technitai. The philosophers recognized that some

rulers were wiser and did a better job of ruling the city; metalsmiths and woodworkers alike were celebrated by poets and playwrights. Language and terminology suggest that artisans' skills and knowledge were recognized in other societies as well. For example, Houston (this volume) translates the Maya title *itz'aat*—often part of the signature of painters and sculptors—as either "wise person" or "skilled person." Similarly, the suffix used to denote a skilled practitioner in Quechua (*-kamayoq* or *–camayoq*) labeled him as just that, a "skilled man" (Zori, this volume; see also Costin 1998). We also see that, in many societies, artisans held privileged status. What is difficult to know is whether they were elite because they were artisans or artisans because they were elite. Likely, to some degree, one status informed the other. Moreover, in ancient times, as many of these chapters discuss, artisans were rarely explicitly acknowledged as individuals or depicted in figural representations. Some scholars (e.g., Durland 1991; Joyce 2000; Looper 2006) have suggested that artisans are more obliquely referenced in the objects they created or in depictions thereof. This question of why artisans were so rarely acknowledged is in itself an interesting one, taken up by Houston and Trever in their chapters.

Why Production Now?

This volume emerges out of a changing emphasis in studies of material culture generally and of production in particular. As Schortman and Urban noted, the end of the twentieth century

> witnessed an increasing concern with the emic quality of artifacts, i.e., what these items meant to those who made and used them. . . . Specifically, there [was] a growing sense that the material world has more than economic significance. Artifacts, through their patterned forms, arrangements, and uses, materialize values and beliefs distinctive of specific cultures or segments thereof. By making the abstract tangible, artifacts are essential to inculcating basic cultural premises across the generations and to creating

those meaningful contexts that impart significance to, guide, and motivate patterned human action (Schortman and Urban 2004:199).

The focus on techné—skilled crafting to produce something with social utility—draws our attention to what "goes in" to something to make it useful, meaningful, and valuable. As Marx (1973 [1939–1941]) pointed out a long time ago, we cannot have consumption (or exchange) until something has been produced. Moreover, consumption is mediated by the symbolic and technical elements of production such that they are inextricably linked: "the conditions of production . . . affect conditions of consumption [just as] consumers . . . drive processes of production" (Heath and Meneley 2007:593). If things are (always) produced with an eye toward where, how, and by whom they will be used, it follows that the production process will imbue things with at least some of the qualities needed in the next stage of their life histories: consumption. Thus, contra Clark (2007), we see the conditions of production as having a central role in determining the value and meaning of goods—that is, we argue cultural values are transferred to or instantiated in material things in the process of their creation, and both the means and the social relations of production will affect how those values are embodied and materialized.

The techné framework reorients studies of craft production in significant ways. An earlier generation of archaeological studies of craft production flourished in the 1990s, spurred in large measure by materialist emphases on the role of economic power in the development of complex societies. Important headway was made in understanding technological processes and organizational structures in a wide variety of geographic and temporal contexts (for formative works and key overviews, see Bey and Pool 1992; Brumfiel and Earle 1987; Clark and Parry 1990; Costin 1991, 2001; Costin and Wright 1998; Mills and Crown 1995; Rice 1981; Sinopoli 1988; Wailes, ed. 1996). There was a strong focus on identifying and explaining the organization of production and its role in sociopolitical evolution. But interest in craft production waned in the first

decade of the twenty-first century, as many scholars focused attention on consumption and such themes as identity, agency, personhood, practice, and performance. Interest in material culture generally and crafts in particular remained among those scholars interested in how ancient peoples materialized their ideologies of status and power (e.g., Bayman 2002; DeMarrais et al. 1996; Earle 2004; Walker and Schiffer 2006), and there were some attempts to refresh the discussion of production by reexamining the basic concepts and strategies that had guided earlier studies of crafting in light of the vast amount of material that had been collected under that program and the aforementioned themes of agency, practice, and identity (e.g., Costin 2005; Hirth 2009; Hruby and Flad 2007; Schortman and Urban 2004; Shimada 2007). At the same time, a whole field has developed that investigates the role of technology—as the knowledge and processes of making things—in culture and society, and how it creates meaning and informs identity (e.g., Arnold and Dransart 2014; Dobres 2000, 2001, 2010; Ingold 2001; Lechtman 1984, 1993; Schiffer 2001).

Techné, as defined here, situates production as an activity deeply embedded in social life. Informed by agent- and object-centered approaches, analytic concepts such as materialization and inalienability, and advances in technical analyses, studies of production such as those collected in this volume are poised to make a significant contribution to our understanding of Pre-Columbian societies. This new generation of research on ancient crafting moves far beyond the programmatic, typological approaches developed in the 1990s to consider more fully the role material culture plays in social life; the symbolic and ideological elements of production; the processes of creation; and the roles of artisans, patrons, and consumers in the creation of value, power, and meaning.

Purpose, Value, Meaning

The emphasis on the social utility of crafting and its products links function, value, and meaning. People respond to material things consciously or

unconsciously, and, in doing so, behave in certain ways. Objects have power both because cultural values give them intrinsic power and because they affect their users and audiences in particular ways.

In exploring techné as socially purposeful, skilled crafting, the contributors to this volume strive for a contextual, emic approach to meaning and value; we make three fundamental assumptions. First, we presume that the items of material culture analyzed herein have both meaning and value because they were displayed, exchanged, gifted, and/ or deposited in socially, politically, or ritually significant contexts. Although assuming rather than demonstrating the presence of value and meaning has risks, it frees the authors to consider fully what goes into making meaning and value; it also frees them from the tyranny of Western systems of valuation and the strictures of modern connoisseurship. We see this particularly in the fascinating cases that, in some ways, defy our suppositions about what makes things "valuable" or "prestigious"—for example, in the "sloppy" wall paintings studied by Lisa Trever and the seemingly less labor intensive translucent cloth analyzed by Christina Halperin.

A second fundamental assumption is that both meaning and value are grounded in function and, in many ways, inseparable from it. While those functions are often intended to meet a utilitarian need, other key functions include conveying significant social or political information, representing cultural "values," or storing economic worth. Stores of meaning and value are often key proper functions (*sensu stricto* Preston 2000). The various functions of material culture are interconnected; for example, we can't understand how material culture expresses ideas without looking at (prosaic) function.

Third, we treat meaning and value as closely interconnected: things have meaning because they have—or represent—value(s), and things are valuable because they are meaningful in some way. Indeed, it is hard to imagine that something without "value" can be meaningful, or that something without meaning can be valuable.[6] We do not see economic or utilitarian worth and symbolic or cultural meaning as wholly independent qualities; rather, we treat value and meaning as mutually reinforcing.

Value

Generally, the term "value" is used herein in its vernacular sense—to connote relative worth, status, and esteem—recognizing that, as a quality of material objects, it lies at the intersection of the social and the economic (Graeber 2001:1–2). But it is not our intent to develop a broadly applicable definition or theory of value in this volume.[7] We are not interested in abstract ways of thinking about value or in measuring the relative value of things; rather, we want to consider more particularly what makes them valuable. For the things analyzed in this volume, one cannot understand economic worth without understanding social utility, and vice versa. While it is clear that many of the materials discussed by the contributors to this volume were valuable—costly—in a real economic sense (cf. DeLeonardis, this volume), rarely were they fungible—freely exchangeable, interchangeable, or replaceable. They were more often inalienable objects than commodities. They were *social valuables*, finely made, usually labor-intensive items whose "worth" exceeded their production costs because they held larger social, political, and/ or religious significance (Appadurai 1988; Helms 1988, 1993; Spielmann 2002). It is a central tenet of both classical and Marxian economics that the amount of labor often, albeit not always, informs the material worth of things, and archaeologists have looked at labor investment in order to measure value (Clark and Parry 1990; Costin and Hagstrum 1995; Feinman et al. 1981). In many ways, these chapters implicitly turn the labor theory of value on its head. Rather than trying to identify things as valuable by quantifying the amount of labor invested in their production, contributors to this volume assume that people invested labor in the items' creation because such items were meaningful and worthy.

The contributors here present a series of empirical cases that demonstrate how value is created, focusing on the processes of transforming raw materials into finished, usable things. The emphasis is less on the "cost" of the raw materials (often measured by scarcity, difficulty of procurement,

exoticness, or sanctioned access) and the amount of labor required to produce them, and much more on such qualities as the degree of technical skill or esoteric knowledge required in production; the identity of the producers or the patrons of their production; the identities of their previous owners or users; their association with potent political, social, or ritual events; and their aesthetic qualities. In taking up these various factors, these chapters show that there is no universal or unvarying way to create value. Nothing is intrinsically valuable; value, like meaning, is socially constructed.

Several of the chapters in this volume consider the qualities that are valued in particular contexts. For example, DeLeonardis emphasizes the importance of form, color, design, paint quality, and weight in elaborate Paracas ritual ceramic objects, while noting that durability—a criterion often perceived as conferring value—might have, in fact, not been as desirable as these other attributes. Callaghan discusses the difficulty of recognizing "valuable" objects in the Maya Preclassic period if using criteria applied to Late Classic-period Maya pottery. Trever—in her discussion of the surprisingly sloppy, somewhat expedient craftsmanship manifest in the Pañamarca murals—and Halperin—in her analysis of labor investment in Maya translucent cloth—demonstrate the significance of looking at the broader context to identify attributes of importance. And as Colleen Zori points out in her chapter, while some materials were widely valued across the Andean region, there were also local systems of value that privileged other materials within a much more spatially restricted cultural value system. In the case she describes, the Inka were able to successfully exploit these variations in cultural preferences to successfully extract silver and copper from southern Andean groups without excessive coercion, not only through the empire-wide practice of massive feasting but especially by increasing access to locally valued, ground, blue minerals, such as turquoise, azurite, and chrysocolla—known collectively as *challa*. Archaeological evidence indicates that challa had been used in a variety of ritual contexts for nearly two millennia before the Inka arrived in northern Chile and Argentina. Evidence from the regions where the various blue minerals were sourced indicates that extraction intensified significantly during the Late Horizon. Interestingly, the organization of metal production in the Tarapacá Valley also suggests gradations of value in the empire. Both copper and silver were extracted and refined in the region during the Inka occupation; however, the data show that only copper objects were produced and distributed locally. There is no evidence that silver objects were produced or distributed. Rather, Zori argues, the refined silver was likely conveyed to imperial centers, where highly skilled artisans worked it into sumptuary items destined only for the highest-status individuals (see also Costin and Earle 1989; Earle 1987).

Meaning

All of the objects and monuments discussed in this volume are elaborated or embellished in ways that go beyond the utilitarian or "practical." Why? Because part of their social utility lay in their use as conveyors of culturally significant messages (Hodder 1982; Panofsky 1970; Schiffer and Miller 1999; Wobst 1977). Material culture is a particularly effective medium for communicating crucial information not easily transmitted or expressed as a statement. It can enhance our perception and understanding of the natural, social, and political world; it can serve as a conduit of communication with the supernatural. The physical properties of social valuables and monuments draw and hold attention. The use of particularly apt imagery and specific symbolic content of social valuables is highly impactful (Clark 1996; Geertz 1974; Hayden 1998). These symbols often convey underlying, intangible ideas beyond the immediate visual image; ambiguity can often play an important role.

It is a fundamental premise of this volume that the skilled artisan creates meaning through the intentional selection and utilization of particular materials, processes, forms, and iconography. Meaning can be created by association with materials' intrinsic properties, their reference to natural

phenomena or social groups, or their embodiment of esoteric ideas. Skilled artisans must know how to properly create things and how to properly represent things via motifs, design conventions, etc. In the studies that follow, we see how important the mastery of both technical and esoteric knowledge is throughout the production process. Techné includes not just virtuosity of technique but also mastery of content. Although material culture gains symbolic, political, and social meaning and value over its full life history, the chapters here deal largely with the first part of an object's life history—its production—and how skilled crafting plays its particular role in the creation of meaning and value. In identifying these processes, we define a semiotics of production.

Manifestations of Techné in the Pre-Columbian World

The chapters that follow explore how techné was deployed to create and control the value and meaning of politically, socially, and ritually significant material culture in the ancient Americas. Portable objects and monuments instantiated potent messages and values in their structures, forms, physical properties, motifs, and subject matters. Skilled artisans must have known what the essential attributes were; they were able to coax them from the raw materials or to introduce them during the stages of production. Using techné as an analytic tool, we can ask the following questions about a particular object or class of material culture: Why was it made (that is, what was its social utility)? What attributes made it useful, valuable, or meaningful? How was it made (that is, what technology and organization of production)? Why was it made in this particular way (that is, how did making this thing in this way enhance its meaning, value, and efficacy vis-à-vis its various purposes)?

Material Properties: Raw and Transformed

The materials from which things are fabricated are often a primary locus of meaning and value. We know that in the ancient Americas, jade, shell,

gold, silver, stone, and other materials were closely bound up with ideas about value—be they about efficacy, kinship, and other social relations, or moral beliefs. Materials might come from distant or spiritually powerful places, or be differentially associated with those who hold power and authority in society. Different materials were often ranked in terms of their value (Bray 2012; Flad 2012; Zori, this volume); likewise, varieties of a single material might be internally ranked in terms of value or prestige (Callaghan, this volume; Filloy Nadal, this volume). Such hierarchies might be based on physical properties, relative abundance, or attributed spiritual/supernatural powers. In the case of the Postclassic Nahua valuation of greenstones, these properties included luster, chromatic intensity, purity, and water retention. As Filloy Nadal (this volume) points out, some materials were so precious that objects made from them were recycled, with their vital essence inhering even in fragments (see also Callaghan, this volume). Many times, specific attributes appear to be more highly "valued" than others. For example, the Paracas seemed to value color above durability (DeLeonardis, this volume). Social valuables often have physical properties with special significance (Burger 2012; Flad 2012; Gaydarska and Chapman 2008; Renfrew 1986; Saunders 2001, 2002, 2003). These properties—such as reflectivity, iridescence, translucence, color, shimmer, shine, and sound—contribute to the aesthetic qualities of valuable objects and often drive their power to evoke emotional and intellectual responses and to engender behavior. Indeed, it is this aesthetic response that amplifies the ability of material objects to communicate wider social principles and to prompt social action (Gell 1998).

The raw materials from which symbolically charged objects are made might have spiritual or supernatural connotations, as they were viewed as gifts from deities or divine beings (DeLeonardis, this volume; Kalavrezou 2013). In the late Pre-Columbian Andean region, *Spondylus* shells were considered the daughters of the sea, the mother of all waters, and were strongly associated with water rituals (Moore and Vílchez, this volume). The physical qualities of raw materials might themselves be

associated with the spiritual or the divine, or they might reference such cultural values as purity, fertility, or invulnerability. Filloy Nadal (this volume) emphasizes the polysemic values and meanings of Mesoamerican greenstones, which cross-referenced ideas about authority, wealth, fertility, abundance, and sacrality, among others. As Maldonado (this volume) notes, many Pre-Columbian societies valued spiritual brilliance, a character that manifested as bright colors and shiny surfaces in natural materials such as feathers, shells, and various metals and minerals. This spiritual brilliance infused objects fabricated from these materials, enhancing their value and meaning and marking them as reflections of supernatural and immanent forces in the universe. Metals were strongly associated with celestial bodies—and their spiritual powers—in both Mesoamerica and Andean South America (Maldonado, this volume; Zori, this volume). Gold was associated with the sun and often gendered masculine, while silver was associated with the moon and gendered feminine. Gold, which does not tarnish or oxidize, was associated with immortality, while silver and copper, both of which are subject to corrosion, were often associated with transformation, regeneration, or rebirth, and therefore with the cycle of human life. Maldonado suggests that these cosmologically derived meanings also help to explain why alloying was so important in Pre-Columbian metallurgical traditions. In the Inka empire, gold and silver were tightly bound up in the origin myths of the royal dynasties; for thousands of years before Inka dominion, gold and silver were integral to the regalia that legitimized power and authority. Sumptuary laws in both the Chimú and Inka empires regulated access to and use of gold and silver; we can infer from the limited distribution of these metals in earlier periods that access then was similarly restricted.

In their chapter, Janusek and Williams describe the sacred character of the places where Tiwanaku's builders quarried the stone from which they fashioned monumental structures and stelae. Evidence suggests that these quarries were powerful ritual places in prehispanic times, as they continue to be for contemporary communities; even today,

thousands undertake pilgrimages to these locales to make offerings. Moreover, the authors suggest that the stelae fashioned from these different sources embodied the ancestors, who themselves animated the mountains from which the stone derived.

Crafting can bring out or amplify the intrinsic qualities of materials, increasing their value or enhancing their meaning (Hruby 2007; Saunders 2001). The skilled artisan can also bring out properties that are "hidden" in the natural state; indeed, the Aristotelian conceptualization of techné suggests that it is the bringing forth or revealing of these concealed qualities that lies at the heart of techné (Heidegger 2010 [1954]). As Filloy Nadal (this volume) points out, this ability to enhance was greatly valued in Mexican lapidary specialists, who, according to the Spanish chronicler Sahagún, were celebrated for taking "rough stones that [had] no notable appearance or beauty" and transforming them into "beautiful, polished, or gleaming" objects. Similarly, ancient Chilean metallurgists transformed "dull gray silver-bearing ores to gleaming silver metal...[and] green copper-bearing ores into shiny copper" (Zori, this volume).

Laura Filloy Nadal (this volume) analyzed three assemblages containing objects manufactured from greenstone, or social jade, to demonstrate how material choice creates value and meaning. Although not all of the specific sources of the raw materials could be identified conclusively, Filloy Nadal's technical analyses in each case revealed that raw materials were drawn from multiple sources, often quite distant from the final location of deposition. In the case of the elaborate greenstone effigy recovered from the Pyramid of the Moon at Teotihuacan, different components were not only made from different materials but also likely manufactured in different places—some in a lapidary workshop at Teotihuacan and others in the Maya area. The second assemblage consisted of the greenstone regalia recovered from the burial of Palenque ruler K'inich Janaab' Pakal. The most striking element of the assemblage, Pakal's death mask, is composed of hundreds of individually distinctive greenstone tesserae made from a variety of greenstone minerals likely originally

acquired from several different non-local sources. The artisans who created Pakal's burial assemblage chose specific shades for the diverse elements of the assemblage and materials from different sources for different artifacts. The overall choice of greenstone equated Pakal directly with the maize god, the deity associated with fertility and creation.[8] The third assemblage consisted of the well-known La Venta Offering 4. Analyses revealed that five types of stone were used, but the technical sequence used to produce them was the same for all of the objects. Filloy Nadal's further analysis of the placement of the figurines and their biometric features suggests that material type and color differences among the figurines indicated the rank or role of the anthropomorphic figures in the ritual scene represented in the offering.

Often materials of considerable value are rare, or are acquired from great distances or with difficulty. As DeLeonardis points out in her chapter, some of the mineral colorants used to create the Paracas post-fire paints likely came from Tacna and Huancavelica, making them costly and creating value for these objects in a real economic sense. The relative economic cost of various colorants was reflected in the contexts in which the raw materials were recovered: easily obtained pigments were generally found in domestic contexts, while the more difficult to acquire pigments were more likely to be recovered as offerings and burial goods in tomb contexts. She argues that the latter group, obtained through long-distance exchange, likely functioned as a social currency of sorts, conferring prestige on those who possessed them, in death if not in life. Filloy Nadal (this volume) demonstrates that artisans in Central Mexico carefully selected materials based on their geological origins, reserving materials from more distant locations and/or distinctive shades of green for objects or parts of objects that held particular importance, such as kingly regalia or central figures in complex scenes. They also chose materials that could be burnished to higher degrees of luster and sheen to reinforce the high status of rulers and the divinity of deities. As Filloy Nadal makes clear, while we recognize the physical properties of these materials, the social, religious,

political, and economic meanings and value they held were socially constructed, attributed to them by the societies in which they were made and used.

Brittenham and Magaloni also discuss the symbolic significance of material source location. The Maya blue pigment that colors valuable items—such as the jade, maize plants, and quetzal feathers depicted in the Red Temple murals at Cacaxtla—was itself a precious substance, imported from hundreds of kilometers away. The Cacaxtla artisans had the technical knowledge to formulate pigments from locally available raw materials that more closely resembled the actual colors of those precious items, but chose instead to use an economically costly and symbolically potent pigment to depict other valuable materials. In this case, the preciousness of the colorant would have been quite recognizable to viewers, particularly in light of the fact that the Red Temple artisans eschewed more mimetic shades of green in order to represent the symbolic equivalency among these items and to underscore their preciosity overall.

Raw materials can derive value as signs or symbols of the high-valued, often sacred, places in the landscape from which they are sourced (Bennett 2007). Zori (this volume) deals extensively with the ways in which the conceptualization of the sources of raw materials contributed to their value. In different parts of the Andes, mines and veins of ores were variously viewed as agricultural fields or the flesh and veins of animate beings—strong associations between the living and life-giving forces. Ethnohistoric sources indicate that the silver mines of Huantajaya in Chile were considered to be the property of the sun. The Andean worldview infused elements of nature with an animating life force—*camaquen* or *kamaquen*—giving these places the power to benefit or harm people. Even a small piece of material extracted from such a sacred place carried with it the full essence and identity of its source. Rituals and offerings of coca and *chicha* (maize beer), and even human sacrifices, were often required to assuage the powers that suffused these places and to ensure safe removal of raw materials. Properly extracting raw materials and harnessing their inherent power required both technical

skill and esoteric knowledge. The same Quechua word—*camay* or *kamay*, meaning to animate or fill with being—is the root for both camaquen and -kamayoq, the suffix used to denote someone skilled in creating or manipulating materials and objects.[9]

In a similar vein, Janusek and Williams (this volume) explore how Andean worldviews conceptualized stone as animate and the mountains from which it was quarried as embodying community ancestors. The various lithic materials used to create public structures and stelae at altiplano centers were visually distinctive; audiences would have easily recognized that these stones came from different sources. Janusek and Williams suggest the materials used at Tiwanaku had indexical qualities as well. For example, red, sandy-textured sandstone indexed the local landscape, while bluish-gray andesite indexed Lake Titicaca, across which the material had to be transported from source to final installation. Moreover, they argue, Tiwanaku's builders strategically incorporated different materials. Less easily procured volcanic stone was purposefully placed where it would have the greatest sensory impact on audiences and ritual participants. In particular, builders used volcanic stone for staircases, portals, and hallways (presumed to be processional pathways). These features aligned views and ritual movements with particularly sacred places in the landscape or key celestial events. In contrast, less visible profane or prosaic structures and spaces were constructed of more accessible, local sandstone.

Sometimes material attributes are not visible to the naked eye; however, modern analytic techniques reveal patterns and choices that were almost certainly not random or happenstance. Brittenham and Magaloni (this volume) illustrate clearly how material choices can augment the efficacy and meaning of an image—what the authors call "material rhetoric." Their analysis of the chemical composition and deployment of colorants used in public murals at the Mexican citadel of Cacaxtla reveals how variably formulated pigments and diverse painting techniques were used to represent equivalencies among some things in the Red Temple mural—quetzal feathers, jade, and maize and cacao plants—and to differentiate, starkly, others—victorious warriors from one

another and from their defeated foes—in the Battle Mural. Although there are visible iconographic contrasts in, for example, the Battle Mural—winners and losers are differentiated by their physical characteristics, costume, and details of their body paint—there was clearly something in the very essence of their separateness that could be expressed only through differences in the materials with which they were represented. But because these material similarities and differences were invisible to the naked eye, the symbolism of color formulas would have been known only to the artisans and, likely, their patrons. What is interesting is that, at some point after painting had begun but before its completion, additional markers of identity were added to the victors, perhaps to make their individual identities known to an audience not privy to the techné of the creation process. Other examples abound in the Cacaxtla murals: the similarity in the pigments used to paint the defeated warriors of the Battle Mural and the earth beneath them, and the differences in the pigments used to paint the ground band in the Battle Mural and the low bands of similar color—but different chemical composition—found on other interior walls at the site. In sum, similarities in material denoted similarities in meaning, while differences in material denoted differences in meaning.

In another interesting example of visually concealed material meaning, Trever (this volume) notes that some Moche artisans used the juice of the hallucinogenic San Pedro cactus as a binder in preparing the paints used to color wall murals at many Moche sites. She wonders whether the use of this mescaline-containing liquid was a utilitarian decision or one with symbolic meaning, especially given the subject matter of the murals: sacrificial rituals that involved the use of intoxicants and pharmacological agents. DeLeonardis (this volume) similarly notes that the minerals used to produce Paracas paint colors and the plants likely used to produce colorant binders have medicinal properties, a characteristic that might have given added meaning or value to ritual ceramics.

Other attributes of the materials were likely meaningful as well. For example, DeLeonardis (this volume) argues that the fragile and impermanent

nature of Paracas post-fire paints themselves was meaningful and intentional—the result of a high degree of knowledge, rather than an ignorance, of the technical properties of the raw materials used to make them. Trever, too, notes the meaningfulness of impermanence in her chapter.

But esoteric or "hidden" means of embodying meaning and value are fraught as well. Brittenham and Magaloni demonstrate the difficulty of perpetuating information encoded in visual images when it is difficult, if not impossible, to discern with the naked eye. Maintaining this knowledge might require performance of some sort—telling and retelling so that it can be passed on. And the fragility of the Paracas post-fire paints analyzed by DeLeonardis means that, at some point, meaning encoded in color—arguably so important to the Paracas—would be lost.

Technology: Knowledge and Technique

To craft is to transform, and technology is, of course, the bridge between raw and transformed material properties, between a substance that might have primal qualities but limited social utility and an entity ready to function in the human social realm (i.e., Heidegger's [1971] domains of "earth" and "world"). As with materials, technological processes contribute to the creation of value and meaning in myriad ways. Often the intrinsic properties of the raw materials necessitated labor-intensive or complex refining and manufacturing processes, all but assuring that the finished goods would have great value. Technological knowledge can be limited to just a few practitioners, which also imbues items with greater consequence. Technological style is often a marker of social identity (Degoy 2008; Gosselain 2000; Lemonnier 1993; Stark 1998; Stark et al. 2000). Methods of processing and construction might symbolize core societal principles (Lechtman 1984, 1993) or reflect cultural values. For example, in her chapter, DeLeonardis argues that the choice of post-fire paint reflects the Paracas' aesthetic value for brilliant colors, which cannot be achieved to the same degree via conventional slips and paints applied before firing. Ritualized or esoteric production techniques might bestow

special properties on otherwise mundane materials or might be needed to ensure successful crafting (Childs 1998); the power of objects often derives from the technological processes they embody (Gell 1992). Technology can also have a performative aspect, particularly when items are made and used in a ritual context (Carter 2007; Spielmann 2002). Extraordinary artisanry in and of itself can bestow value.

The techné framework emphasizes that artisans need manual and cognitive skills to craft successfully. For the most part, the fabrication of social valuables and prestige goods required expertise that was often hard to learn, required considerable practice to develop, and/or entailed regular practice in order to maintain.[10] Indeed, special skill is often seen as a criterion for identifying objects as valuable. Many of the processes used to fabricate the items discussed in this volume placed high technical and intellectual demands on the artisans who made them. DeLeonardis states that the knowledge of colorants and binders possessed by Paracas ceramic artisans "bordered on alchemy." Although much remains unknown about the specific processes used to create Paracas post-fire ceramics, DeLeonardis effectively demonstrates that a tremendous body of specialized knowledge would have been required. Filloy Nadal's experimental work and careful observations made on elaborate Mesoamerican greenstone objects reveal the technical mastery of their Olmec, Maya, and Teotihuacan artisans. Although they used a similar technical sequence, they carefully matched their specific tools—especially those used for polishing—to the particular physical properties of the different stones they were working. Callaghan demonstrates that successfully achieving qualities, such as polished slipped surfaces on ceramics—characteristics often ignored by modern scholars—can require training and skill in myriad tasks, including sorting, mixing, and refining slip mixtures; application to the surface; burnishing; and controlled firing. Callaghan also notes the high degree of skill (and labor investment) required to produce the elaborate forms characteristic of Late Preclassic Maya prestige ceramics, just as DeLeonardis emphasizes the technical virtuosity

reflected in the vessel forms interred with high-status Paracas individuals. Ancient Andean shell-workers were also highly skilled, able to judge the qualities of individual *Spondylus* shells and their suitability for the production of different classes of objects (Moore and Vílchez, this volume).

The chapters here also demonstrate that the knowledge possessed by these artisans was often rather broad, as indicated by shared technology, shared styles of representation, shared imagery or iconography, or other cross-media references. DeLeonardis, for example, discusses the degree to which design motifs, compositional qualities, technical knowledge, and specific methods were shared among media, and she raises the question as to whether artisans might have been active in several media or at least in close communication with one another. For example, tools used in several different crafts might be found together in the same Paracas burial. Colonial dictionaries from Peru suggest a strong conceptual linkage among a number of crafting processes, using the same term to refer to writing, drawing, carving, embroidering, and dyeing—all actions that decorate surfaces. The hybrid ceramic vessels analyzed by Costin made clear reference to ethnically specific textile designs and structures, carrying the function of textiles as markers of identity to a new medium. Trever notes that some Moche murals and painted reliefs emulate sumptuous textiles in their patterns and composition, while others adopt the narrative iconography of Moche fineline ceramics, suggesting interrelationships among designers as well as executors. Houston also notes that titles associated with Maya artisans suggest that some had cross-media skills; in some cases, master artisans in different media were called "head quill."

Perhaps nowhere is the importance of both technical skill and esoteric knowledge to successful crafting more apparent than in metal production, as the chapters by Zori and Maldonado attest. Zori's detailed explication of the processes used to refine copper and silver in the Tarapacá Valley in the late prehispanic southern Andes demonstrates the degree of technical sophistication that underlay Andean metalworking. The multistage process necessary to produce relatively pure metals both revealed and contributed to the value of these metals in the Andean world. Zori cites ethnographic studies that highlight the importance of ritual in ensuring a successful smelt. Maldonado similarly argues that esoteric, ritual knowledge was essential for successful crafting and was often as highly guarded or restricted as technical knowledge. Maldonado suggests that only master artisans commanded full knowledge of all the steps and processes required, in order to increase the awe that surrounded production stages, such as smelting, as well as value and meaning overall. In her comparative overview of copper metallurgy in Mesoamerica and the southern Andes, Maldonado analyzes the technological choices made by Pre-Columbian metallurgists within their environmental, cultural, and social contexts. She enumerates the many elements of specialized technical knowledge required at each stage in the production process, considering how economic, political, ritual, and symbolic factors contributed to the decisions made by artisans at each step. It is particularly illuminating that at times ritual and symbolic factors seem to trump economic and logistical ones. Skill itself was believed to be supernaturally derived. She also makes the intriguing point that what we often consider "esoteric" knowledge was also pragmatic, suggesting that rituals and taboos associated with metal production might have facilitated the recognition of appropriate raw materials and, perhaps more importantly, guided the sequencing of complex tasks and timing in a process that had a very narrow permissible margin of error. Thus, there might, in fact, not be a hard line between "technical" and "esoteric" knowledge.

Many of these chapters call attention to the beginning and intermediate stages in the production process, emphasizing that meaning is not created only in the terminal stages responsible for surface finish and decoration. Halperin (this volume) draws attention to the effort and skill required to produce fine threads, a part of textile production often overlooked in the literature, even though spinning the thread usually took significantly more time than did weaving it into cloth. As Maldonado

does for metallurgy, Moore and Vílchez reconstruct the *chaîne opératoire* to document how value and meaning were constructed through the successive steps of the process used to create shell objects in the Late Horizon Andes. Based on their analyses of tools associated with shell production and of shell "debitage" recovered from an Inka *Spondylus* workshop in Tumbes, Moore and Vílchez identified five distinct, albeit partially overlapping, production sequences, each one associated with a different kind of artifact. The authors suggest that artisans carefully assessed the physical characteristics of each individual shell—thickness (including the relative thickness of the colored layers), porosity, and color—and determined for which form it was most suited, given the production steps necessary to manufacture the various object types. Moore and Vílchez demonstrate that this was not rote production, but rather required careful assessment of the highly variable raw material and tremendous skill in working it.

Technological choices, innovations, and change are often closely associated with broader social or political processes (e.g., Burger 1988, 1993). Callaghan suggests that the Late Preclassic Maya practice of tempering ceramics with crushed sherd inclusions served to symbolically link past and present ritual activities by literally incorporating older vessels into the pastes of newer ones. He further argues that the cessation of this technique in the subsequent Classic period reflected a radical change in political strategies and ideology, as community-wide rituals gave way to public ceremonies that emphasized and legitimized the power and authority of select elite lineages. Callaghan's suggestion is particularly interesting in light of Filloy Nadal's work (this volume), which demonstrates that the reuse of greenstone—arguably a more precious or valuable material than ceramic—continued to be significant in the creation of ritually and politically charged items.

In contrast with the technological change discussed by Callaghan, Costin and Zori describe two examples in which technological stability was meaningful during a period of political upheaval. Both studies show that the Inka largely continued local technologies for the production of Inka-related goods in the regions they conquered. In both instances—production of ceramics on the North Coast (Costin) and metal processing in the south (Zori)—the decision was partially pragmatic. Local artisans were recruited to work in state-sponsored workshops; the continuation of local technologies meant that the state did not have to teach local artisans new techniques. In the case of silver production, metallurgists working for the Inka applied the same techniques they had long used for copper smelting to newly in-demand silver smelting. The Inka did introduce techniques for refining silver, which had not been developed prior to the conquest, but processing this new material used many of the technical skills local artisans had previously employed to refine copper. In the case of the Peruvian North Coast ceramics, it was also likely more efficient to allow local artisans to use their regionally specific, ceramic mold-based technology to produce Inka forms than to introduce the hand-building methods used in other parts of the empire. But Costin suggests that this technological choice was also politically meaningful. She argues that the choice to use local technology in state-run workshops was made deliberately to create multivalent messages about status and identity in conquered regions. Drawing on the Andean notion that materials continue to carry a relationship with the places and people with which they were formerly associated, she argues that the use of local artisans and technology to manufacture state vessel forms served to symbolically incorporate the local into the imperial.

Of course, not all artisans were "highly skilled"; there often exists a range of technical expertise within a corpus of materials. Variation in skill might be seen among different objects of similar type or even within a single piece where multiple, differently trained or skilled hands contributed to the work. In other cases, what we today judge to be high levels of proficiency or "quality" was not an essential element of techné, contra the Greek association of techné with excellence or perfection. The notion of quality, then, may itself be a cultural value. DeLeonardis demonstrates that the painters of the exquisite Paracas ritual ceramics did not

always paint within the lines, and that even the lines used to define color blocks were often "imperfect"—shallow or unevenly incised. As DeLeonardis also points out, precision might have been differently valued in different artifact attributes; in the case of Paracas ceramics, shapes appear more carefully formed. While overall color sense was essential, there might have been less need for precise incising or painting to achieve visual and ritual efficacy.

In a challenge to conventional treatments of technical skill, Trever considers the Moche painted murals at the site of Pañamarca, which exhibit poorly formed details and drips of paint, among other indicators of seeming laxity in their production; however, Trever does not think that expediency is a sufficient explanation for the apparently hasty execution of these late murals. Rather, she suggests, the apparent "failure" to invest time and expertise reflects an emphasis on visual effect and ritual performance. She argues that a shift away from technical mastery appears to coincide with a change in the iconography of Moche murals—from a formal, fixed, and repetitive format to more complex, narrative scenes. Thus, the nature of Moche mural painters' techné changed from mastery of technique to mastery of esoteric knowledge and ritual content. At Pañamarca, some of the murals were splashed with a liquid, possibly *chicha* mixed with ground seeds that contain a potent hallucinogen, an action that could destabilize the somewhat fragile surfaces. In addition, the adobe structures upon which these murals and reliefs appear were vulnerable to a wide array of environmental factors; thus, she argues, the Moche themselves might have recognized the structures, in part, as transient and perishable. They were painted and repainted—at Pañamarca, more than eight layers of paint have been identified[11]—and sometimes rebuilt. The repainting and rebuilding so evident in the archaeological record were likely important social and political events, pragmatically repairing fragile surfaces but also renewing a more enduring life force in sentient buildings. Trever also notes that the use of adobe to construct these buildings was a technological choice; stone was available. Thus, the choice of a material that would degrade and

disintegrate might have been central to the meaning of these monumental structures and their wall murals, and their use in performative, renewal rituals. In the end, knowing how much "perfection" was required to achieve efficacy might have been an essential element of the artisans' techné, again, reflecting a profound understanding of the intended use of their creations.

Form, Surface Decoration, and Iconography

Form, surface decoration, and iconography are the attributes of material culture most often analyzed when art historians and archaeologists examine meaning in material culture. Mastery in the content area and the successful execution of forms and motifs clearly are part of an artisan's technical skill and command of esoteric knowledge. The skilled artisan must know how to appropriately deploy apt images in the creation of socially, politically, and ritually meaningful objects. Form, motif, and iconography occupy an important place in the discussions of techné in this volume but are not treated in isolation; rather, these chapters reveal the interplay among these attributes and the technical and material ones, which amplifies value and meaning (cf. Flad 2012). Material, technique, form, and esoteric iconography might cross-reference one another, adding complexity to meaning. Redundancy might have been necessary or desirable when a highly varied audience was involved, but all meaning might not have been available to all comers—the use of multiple strategies could either conceal some information or allow some viewers to be more "in the know." In other cases, the combination of different modes of creating value and meaning might have increased the value of a particular object, what Callaghan has dubbed "value-additive techné."

Brittenham and Magaloni (this volume) demonstrate the multiple ways in which victors and vanquished were represented in Cacaxtla murals. The authors describe an "iconography of difference," strong visual comparisons made between the winners and losers in the Battle Mural. The victors are armed, unhurt, clothed in jaguar pelts; they have long black hair and their bodies are painted gray or black. In contrast, the losers are represented

disarmed, wounded, naked except for their bird helmets, and they have red hair and bodies painted blue or yellow. As discussed above, the Cacaxtla muralists also used different formulas and different substances to make the paints used to represent the warriors: the victors were individually painted with different pigments, while the losers were all painted with the same basic paint. As the authors note, material choices underscore and complement visual representations of difference. But while some of this information would have been available to most viewers, only those familiar with the process of creation would know about the underlying material similarities and differences.

Costin (this volume) looks at how elements of ceramic form, technology, and iconography from two distinct polities were deliberately selected and systematically combined to instantiate social identities in areas conquered by the Inka. Her chapter focuses on a particular vessel form, the *aríbalo*, which she argues served as icon, index, and symbol of the Inka state (this volume; see also Costin 2011). When decorated with standard Inka-style motifs that reference textile designs, these vessels are sometimes interpreted as "imperial" dressed bodies. But in the case analyzed by Costin, these vessels "wear" motifs that have deep antiquity not in the Inka heartland, but rather in a region conquered by and incorporated into the Inka empire. By uniting local iconography, imperial vessel forms, and local technology, artisans who crafted these vessels—likely at the behest of the state—were able to adroitly combine local and imperial symbols to instantiate and communicate new forms of social identity for local leaders coopted into the imperial bureaucracy. As with the Cacaxtla murals, the use of multiple, complementary modes to construct meaning created a complex rhetoric about power, identity, victors, and vanquished.

As Michael Callaghan reveals in his chapter, early Maya ceramics in their form and surface treatment embodied important messages about sociopolitical organization. The use of ceramic vessels was important in feasting events that were part of the political process. In the Middle Preclassic period, the emphasis was on community-based events, and artisans crafted vessels appropriate to these types of events: large jars that could contain beverages to be consumed by many people and wide-open plates that could hold large amounts of food to be served to an assembled crowd. The emphasis would have been on solidarity, sharing, and cooperation. The Late Preclassic period witnessed a shift toward greater social differentiation, with elites coopting traditional community rituals to affirm the power and authority of elite lineages. Callaghan argues that the smaller, elaborate effigy and composite silhouette vessel shapes characteristic of Late Preclassic elite ceramics would have been highly recognizable in the still public context of large-scale feasting events, serving to differentiate the elites who used them while at the same time transmitting a message of community through similarities in traditional surface treatment. The introduction of figurative painting at the end of the Late Preclassic period suggests a change in the context in which messages about value, prestige, and social identity were communicated, as this medium is best suited to smaller, more intimate groups. The ability to fabricate these new types of vessels required the development of an entirely new techné, one with different forming and finishing skills, as well as new areas of content knowledge.

Artisans: Social Identity, Organization, and Characteristics

Schortman and Urban (2004:186) note that "artisans are increasingly envisioned as having actively participated in fashioning the social and cultural worlds they inhabited." This idea, of course, is at the center of the conceptualization of techné as used in this volume and is explicitly discussed in the chapters by Costin and Rengifo. Artisans are integral to all production processes, producing value and meaning at each stage of manufacture through their direct actions. In addition, the very nature of the labor used to transform raw materials into finished goods confers value and meaning in many ways. Aspects of artisans' social identity, such as social status (Halperin and Foias 2010; Inomata 2001, 2007) or gender (Brumfiel 2006; Costin 2013), can confer social and political meaning. The

organization of production itself might be meaningful, reflecting key social principles or the nature of patronage or control in hierarchical societies.

As much as the identity of specific creators factors heavily in the value of "art" works in the post-Enlightenment West, we rarely have evidence for individual artisans in the premodern world. And as much as we might celebrate the aesthetic and technical mastery of the artisans who created the objects we study, those individuals were rarely explicitly recognized in visual images or texts in their own times.[12] For example, as Trever points out, we have barely half a dozen representations of Moche artisans, and the few we do have are limited to weavers and probably metal workers.

In a rare case where artisans' identities were recorded, Houston (this volume) compiles and analyzes the evidence for signed works in the Maya region. Most of the signed painted ceramic vessels come from a relatively small area and chronologically span little more than forty years. The practice of including signatures on monumental stone carvings endured for several centuries, but it was concentrated in a fifty-year period and in a similarly restricted geographic region. Unlike paintings, some carved monuments have multiple signatures, indicating that sculptors did not work alone. In few cases, one individual bears the title "head," while the relative positioning of the signatures in other cases may signal ranking or ordering among them.

As Houston analyzes them, the signatures are fascinating in that they convey much about the social identities of these artisans. It is telling that many sculptors had theonyms, which tied them not only to deities but also to royal lineages—a link that speaks to the high status of (some) carvers. Some also held the title of *ajaw*, translated as "lord." Others were marked as courtly subordinates, relatively young adults, "heads" (probably masters) of one sort or another, or with titles and terms that still defy definitive translation. Some signatures included a phrase (*cheheen*) that suggested artisans had agency in the creation of their works; others were accompanied by a different phrase (*anab*), interpreted by some to indicate that artisans were little more than instruments in the materialization of the desires and

aspirations of their royal patrons. Importantly, some sculptors were identified by their place of origin/residence, which allowed Houston to reconstruct the wider social networks in which sculptors worked, yielding provocative information not only on the organization of production but also on attendant political relations and patterns of patronage.

Houston's chapter demonstrates that signatures, albeit rare, reflect diverse and complex social and political processes. For example, he notes that the contexts in which signatures of painters and sculptors appear are different. Although sculptors' signatures are displayed publicly, they are often relatively obscure, carved lightly in out-of-the-way places. In contrast, painters' signatures—found on exquisite polychrome ceramics—would only be seen in more private contexts but were in many ways easier to read, as participants in these events could view them at close range. Houston, while focusing on an exceptional case where we do have individual artisans identified, also asks the question: Why don't we have more evidence for this behavior, even among the literate Maya? He suggests that permission to sign works was likely at the discretion of royal patrons, and at most times, in most places, such practice was unnecessary, unwelcome, or inappropriate. He also reminds us that signatures were rare in European art until the Enlightenment, when radical cultural shifts simultaneously began to emphasize markets and sales, the individual, and realignment in the noble and elite classes. It may very well be that, in general, we have little evidence for individual, named artisans because in most places, throughout time, making things was a collaborative and cooperative effort rather than the work of a single individual (cf. Shiner 2001).

In contrast with our difficulty in identifying individual artisans, archaeologists can often detect aspects of artisans' collective or categorical identities: gender, social status, geographic origin, or place of work. Callaghan, for example, suggests that women had an important role in ceramic production, relying primarily on ethnographic analogy and the correlations between the techniques used in many steps in ceramic production—grinding, kneading, mixing, shaping, and firing—and those

needed in other activities more firmly identified with women: grinding maize, preparing masa, shaping tortillas and tamales, and cooking. As Callaghan points out, for the Classic-period Maya, successful production required both male and female components—which might have been achieved by including female and male labor in production—or production by "third gender" individuals who combined aspects of female and male. Halperin (this volume) notes that among the Late Classic Maya, textile production was associated with both femininity and eliteness, ideologically if not in actual practice.[13]

The inclusion of mineral pigments in a number of tombs of high-status Paracas individuals suggests that elites were likely involved in crafting activities that used colorants—if not ceramic painting, then painting or dyeing textiles (DeLeonardis, this volume). Although DeLeonardis cautions that these individuals might have been patrons rather than artisans, the broader literature usually accepts that elite individuals buried with crafting paraphernalia did, in fact, participate in those activities (e.g., Hendon 1999; Uceda and Armas 1998), particularly now that we recognize the significant role elites played in the actual crafting of goods (Houston, this volume; Inomata 2001; Inomata and Triadan 2000; Rengifo, this volume; Widmer 2009). Indeed, DeLeonardis's careful analysis of the contents of a number of Paracas tombs indicates strongly that high-status ritual specialists were also artisans (cf. Spielmann 2002). Based on the physical location of craft workshops, inventories of funerary goods, and tomb locations, Rengifo (this volume) similarly argues that at least some Moche artisans had elevated social status, although in contrast with the Paracas case, roles were more segmented: artisans do not appear to have been drawn from the highest echelons of Moche societies, and artisans did not appear—based on their funerary goods—to have roles in the most potent ritual activities.

The organization of production itself can either inform us about meaning and value or lend meaning and value to objects. Moore, Vílchez, and Zori discuss how the Inka established long-distance supply chains for *Spondylus* from Tumbes and for refined silver from Tarapaca—both materials destined to be used by artisans many kilometers away. Thus, techné included the extraction, preparation, and distribution of the components needed to make meaningful objects. The locus of production was also often significant. Several chapters deal with objects manufactured in imperial Inka workshops. Moore and Vílchez argue that state production of *Spondylus* shell figures critical to water rituals reflected state cooption of responsibility (and credit) for agricultural fertility and productivity. Costin argues that the infrastructure of state workshops was tied more generally to the system of state largesse, in which symbolically potent and valuable goods flowed from the state. She also argues that the structure of patronized labor—imperial overseers and local workers—symbolized the more general political and social hierarchy that consistently placed the Inka and their consigliores in positions of power and authority over conquered local populations.

Value, Meaning, and Post-Production Processes

Key to the concept of techné is the notion that artisans create objects and monuments with their eventual use in mind—indeed, intended use is key in determining not just what will be made but how it will be made. Textiles were meant to be worn or displayed; ceramic vessels to contain or transport meaningful foods and beverages; and stone monuments and buildings to instruct, awe, enchant, commemorate, intimidate, or even terrify. Thus, production cannot be wholly separated from distribution and consumption (cf. also Bayman 1999; Schortman and Urban 2004), and it is well to remember that goods often continue to accrue value and meaning after their initial transformations are complete. Finished goods can gain meaning or value as they travel along long-distance exchange networks (Helms 1988, 1993; Smith 2013) or are used in rituals or in elite-sponsored gifting activities (Reents-Budet 1998; Voutsaki 1997). Similarly, they can gain value over time as they accumulate history, eventually becoming heirlooms (Cummins 2013; Lillios 1999; Smith 2013). Chapters here demonstrate that association with a particular ritual activity, such as serving and consuming liquid cacao (Callaghan), maize

beer (Costin), or other libations (DeLeonardis and Trever), could confer value as well.

Costin, Moore and Vílchez, and Zori illustrate that goods produced and distributed under the auspices of the Inka empire gained inalienable value and meaning because, as Zori says, once they were bestowed on someone by the state or its representatives, they "bore the indelible imprint of the Inka and the ongoing relationship between the royal source and the recipient" (see also Morris 1986).

As Halperin (this volume) demonstrates in her analysis of Maya translucent cloth, post-production processes are particularly salient when "valuable" objects lack the other criteria we most often associate with value: rare or otherwise "costly" materials, complex technology or high degree of esoteric knowledge, high labor investment, or other special skill. Such cases remind us most forcefully that production alone does not necessarily impart value, and they underscore the idea that the social construction of value and meaning is fundamentally located in social utility. Although the production of translucent textiles in the Maya region required great practice and proficiency in order to spin the extremely fine, consistently even threads from which they were made, in general, this type of cloth lacked many of the features we normally expect in "valuable" objects: in relative terms, their material (cotton) was commonplace, they used far less raw material than did more tightly spaced weaves, they were much less labor intensive than other sumptuous cloth types, they were technologically simple to produce, and they bore little design elaboration. And the one area where greater skill and effort were required—spinning—might not have been as recognized as other production tasks. As Halperin notes, in general in the Maya sphere, the final stages of the production process appear to have been more highly valued—or at least more publicly acknowledged—than the beginning or intermediate steps. Above all, the translucent textiles seem to violate the valuation system for Mesoamerican textiles recorded at the time of the Spanish conquest, which praised tightly woven cloth as the standard against which weaving work should be judged. We appreciate the techné of producing translucent cloth best when we take into account the contexts in which this cloth was worn. Indeed, as Halperin notes, the value and meaning of this cloth is best discerned when worn—usually depicted on a moving body in Maya representations—rather than when folded into tribute bundles (also depicted on Maya painted vases) or hung static on the wall of a modern museum. Here, we clearly see how artisans matched technical processes with intended uses. The contexts in which these garments were worn also suggest Late Classic Maya value systems associated with femininity, beauty, and agency. Importantly, women wearing translucent *huipiles* in painted scenes are actively engaged in the pictured activities in a way that suggests a more egalitarian relationship with the males than is the case in other depictions of women not so dressed.

Social Utility, Prestige Goods, and Social Valuables: The Role of Crafting Material Culture in the Creation and Maintenance of Social Life

With its emphasis on the relationship between means and ends, the concept of techné is particularly well suited for understanding the production of specific values and meanings in the social valuables and prestige goods that create, legitimize, and maintain differential access to power and wealth in sociopolitically complex societies.

In his chapter, Rengifo uses the organization of production to reflect on the sociopolitical processes associated with the adoption of Moche material culture in an area at the southern edge of its distribution. In rebutting claims that the introduction of Moche ceramics signaled the military conquest of the region, Rengifo relies on the organization of production of local- and Moche-style objects to argue instead for the peaceful adoption of Moche ideology and worldview. As both Rengifo and Trever (this volume) demonstrate, Moche artisans in the Nepeña Valley understood the meaning and use of Moche iconography. These artisans were capable of expressing complex ideas in material form, indicating that the elites of Cerro Castillo entered into the cosmopolitan Moche world. But Moche material culture did not replace local high-status goods; as Rengifo notes, the two modes of techné continued

to be used in Nepeña. Interestingly, Moche material culture appeared in Nepeña just before the vast Moche center at the Huacas de Moche was largely abandoned. Rengifo adapts Luis Jaime Castillo and colleagues' (2008) argument that artisans from the center moved northward and revitalized the crafting traditions of Jequetepeque and Lambayeque, suggesting that some artisans moved southward, settling in the Santa and Nepeña Valleys, where they strongly influenced elite crafting and worldview as well.

Janusek and Williams trace significant changes in techné that coincide with the rise of Tiwanaku as the preeminent center in the Titicaca Basin, arguing that the ability to harness the animate forces inhabiting mountain peaks through the material transformation of "raw" stone into public monuments was a physical manifestation of leaders' power to dramatically reorder the world. In the Late Formative period, Tiwanaku and other altiplano centers shared a "tectonic techné" based on sandstone quarried from local mountains. Moreover, the stelae and structures fashioned from this sandstone were similar to one another. A key material and technological change occurred, however, as Tiwanaku consolidated its political and economic hegemony at the beginning of the Middle Horizon. Increasingly, key public monuments at the center incorporated volcanic stones quarried from a number of more distant sources; there was little use of volcanic stone at other contemporaneous sites. A whole new techné appeared, as not only is the material itself different but also innovative methods of transport and carving were utilized. These changes were accompanied by a major change in the iconography of stelae—an indication that artisans and their elite patrons were employing new forms of content as well as technical knowledge.

Of particular interest in many chapters here is the role objects play in creating, reflecting, defining, or embodying social identity, especially the ways in which materials and technology—not just iconographic content—were used to negotiate social inclusion and exclusion, and to distinguish among social entities of all sorts. As discussed already, Costin argues that Inka forms and North Coast technology and design motifs were intentionally hybridized to materialize and communicate the social identities of local elites coopted into the Inka bureaucracy. Rengifo takes up the "new wave" in Moche studies, arguing that the Moche phenomenon was not a political one as much as an ideological one that bound elites into an ideological and social sphere. Thus, the process of adopting Moche material culture and its underlying techné was part of broader sociopolitical processes in which "local" elites adopted new practices and elements of material culture in order to associate themselves with a more cosmopolitan, pan-regional identity. In his case study, Rengifo addresses the question of who might have made the Moche-style pottery used at Cerro Castillo, a site far to the south of the Moche heartland, which, he argues, was already culturally and economically rich when the inhabitants first began to use distinctive Moche pottery. Rengifo argues that the Cerro Castillo consumers who adopted Moche-style ceramics were fully aware of the ideological "agenda" encoded in its themes and motifs. Evidence suggests that both local-style and Moche ceramics were manufactured in the same location. He argues that artisans might have been of relatively high status; importantly, he suggests that production was under the control of local, not foreign, elites. Similarly, Rengifo reasons that Moche artisans, working within a restricted ideological framework to produce works that communicated acceptance of an institutionalized belief system, were limited to a narrow range of subject matter with specific themes and motifs. The artisans creating objects in the "Moche" style had to be familiar with the code or canon. Margaret Jackson (2008) has suggested that Moche art encompassed more than a visual narrative; it was structured around a grammar of sorts, requiring a high degree of knowledge on the part of at least master artisans.

Other chapters demonstrate that when objects are valued for their role in political and social control, their techné may be supervised or dictated by relevant authorities. In the case of *Spondulus* production at Taller Conchales, Moore and Vílchez argue that Inka control of shell items—key to

water rituals—was part of a much broader imperial strategy to control water resources and ensure agricultural yields. Much has been written about such "attached specialization," but rarely are the artisans afforded much agency unless they themselves are considered to be of elite social status. Using techné as a framework for analysis suggests that artisans should be treated as active, agentive participants in the production process (recall Caws's comment that techné is not mindless button-pushing). Nevertheless, artisans were never wholly free to "create" whatever they so desired, certainly not on a widespread basis. There was always an element of control, whether implicit in community "demand" or explicit in the patronage of political elites. For example, Costin (this volume) argues that Andean North Coast artisans fabricating the full range of vessel styles and forms associated with the state "type" worked under the auspices of the Inka empire or its consigliores. In the particular case of the hybrids on which her analysis herein focuses, hybridization did not occur willy-nilly but in a patterned—that is, controlled—manner so as to emphasize the very specific ways in which social and political identities were constructed.

In sum, the contributors to this volume aim to demonstrate that the concept of techné—socially purposeful skilled crafting—provides a fruitful framework for understanding the production of social valuables, prestige goods, and public monuments in Pre-Columbian societies. More broadly, it offers an analytic tool for explicating the interrelationships among people (as patrons, users, enactors, and audiences), production processes, and the life cycle of things. Indeed, it can enrich and expand our understanding of both production and the role of things in the social world.

Acknowledgments

My deepest thanks go to Joanne Pillsbury, Colin McEwan, the Dumbarton Oaks Pre-Columbian Studies staff members—including Emily Jacobs, Katie Caruso, Kelly McKenna, and Sara Taylor—and the Pre-Columbian Studies senior fellows for their help and support during the long process that brought this volume to fruition. Many thanks also go to Julia Guernsey, Bill Sillar, and the anonymous reviewers. The participants in the 2013 symposium and the contributors to this volume were instrumental in helping me to develop the ideas presented in this introduction. I would also like to thank Dean Stella Theodoulou of the California State University, Northridge (CSUN), the College of Social and Behavioral Sciences, and the Center for the Study of Mexico and Latin America at CSUN for their generous support.

NOTES

1 One of the anonymous reviewers of this volume brought to our attention a volume, published in fall 2014, on Andean textile technology; in it, several contributors made reference to techné (Arnold 2014). Since that work was not available before the reviews of the chapters in this volume were returned to the contributors, we have not made extensive reference to it. I note that the contributors to the Arnold volume used a conceptualization of techné that was at once narrower and more generalized than the one used here. Their discussions largely defined techné as a form of knowledge related to techniques of production: "knowledgeable practice and practical knowledge" (Splitstoser 2014:47), "a materialisation of knowledge" (Peters 2014:109), and "productive knowledge" (Dransart 2014:216). The other fundamental characteristics of the conceptualization of techné adopted in this volume—social utility, the importance of esoteric and content knowledge, the role of material inputs as well as processes—are largely missing from their discussion of techné.

2 See also Angier 2014; Hofmann 2003; Parry 2008; Pollitt 1974; Roochnik 1996; and Tiles 1984.

3 But Plato and others note that *technai* (skills) could be used for contrary ends (Tiles 1984:51).

4 This does not mean that things in their natural state have no meaning; indeed, objects in their natural states were often valued or revered in both Mesoamerica (e.g., Canto and Castro Mendoza 2010) and the Andes (e.g., Dean 2010).

5 Of course, we recognize that other species make things: not only do our closest relatives among the great apes make and use tools, but birds build nests, beavers build dams, and so on. Nevertheless, the degree to which we (humans) rely on transforming naturally occurring materials in order to survive; the amount of abstract thinking, planning, problem solving, and symbolic thinking associated with human crafting; and the extent to which we embellish objects and structures beyond minimal utilitarian requirements in order to imbue them with social and cultural meaning does seem to be something more or less uniquely "human."

6 Take care not to confuse relative ubiquity with the degree of meaningfulness or value. As Bayman (2002) points out, sometimes the widespread distribution of a particular class of things is evidence of high social value and meaning.

7 For a recent discussion of how archaeologists, anthropologists, and art historians have dealt with "value" on a more theoretical level, see Papadopolous and Urton (2012).

8 It was also the patron deity of scribes and painters.

9 For example, a *qompikamayoc* was an individual skilled in weaving fine cloth; a *qhipukamayoc* was an individual skilled in manipulating a *qhipu*, or accounting device. See Costin (1998) for the gender implications of this term.

10 Of course, the same can be said of many utilitarian objects as well.

11 And at Huacas de Moche, conservators have identified more than twelve layers on the Huaca de la Luna (Lisa Trever, personal communication, August 2014).

12 Scholars of Moche (Donnan and McClelland 1999), Maya (Reents-Budet et al. 1994), and Greek (Oakley 2009; Smith 2012) art, among others, have made headway in identifying "hands" or "workshops" in large corpuses of otherwise unsigned works (see also Brittenham and Magaloni, this volume, note 4). However, this is quite different from having works that are signed by the artisans. The former represents an etic approach to studying the organization of production; the latter reflects an emic value and interest in recording the individual ascreator.

13 A point that Costin (1998, 2013) makes clear for Andean South America and many other parts of the world.

REFERENCES CITED

Angier, Tom

2014 *Techne in Aristotle's Ethics: Crafting the Moral Life*. Bloomsbury Academic, London.

Appadurai, Arjun

1988 *The Social Life of Things: Commodities in Cultural Perspective*. Cambridge University Press, Cambridge.

Arnold, Denise Y., and Penelope Dransart (editors)

2014 *Textiles, Technical Practice, and Power in the Andes*. Archetype, London.

Bayman, James M.

1999 Craft Economies in the North American Southwest. *Journal of Archaeological Research* 7(3):249–299.

2002 Hohokam Craft Economies and the Materialization of Power. *Journal of Archaeological Method and Theory* 9(1):69–95.

Bennett, Gwen P.

2007 Context and Meaning in Late Neolithic Lithic Production in China: The Longshan Period in Southeastern Shandong Province. In *Rethinking Craft Specialization in Complex Societies:*

Archaeological Analyses of the Social Meaning of Production, edited by Zachary X. Hruby and Rowan K. Flad, pp. 52–67. Archeological Papers of the American Anthropological Association 17. American Anthropological Association, Washington, D.C.

Bey, George J., and Christopher A. Pool (editors)

1992 *Ceramic Production and Distribution: An Integrated Approach*. Westview Press, Boulder, Colo.

Bray, Tamara

2012 From Rational to Relational: Reconfiguring Value in the Inca Empire. In *The Construction of Value in the Ancient World*, edited by John K. Papadopolous and Gary Urton, pp. 392–405. Cotsen Institute of Archaeology, Los Angeles.

Bronitsky, Gordon, and Robert Hamer

1986 Experiments in Ceramic Technology: The Effects of Various Tempering Materials on Impact and Thermal-shock Resistance. *American Antiquity* 51(1):89–101.

Brumfiel, Elizabeth M.

2006 Cloth, Gender, Continuity, and Change: Fabricating Unity in Anthropology. *American Anthropologist* 108(4):862–877.

Brumfiel, Elizabeth M., and Timothy K. Earle (editors)

1987 *Specialization, Exchange, and Complex Societies*. Cambridge University Press, Cambridge.

Burger, Richard L.

1988 Unity and Heterogeneity within the Chavín Horizon. In *Peruvian Prehistory*, edited by Richard Keatinge, pp. 99–144. Cambridge University Press, New York.

1993 The Chavin Horizon: Stylistic Chimera or Socioeconomic Metamorphosis? In *Latin American Horizons: A Symposium at Dumbarton Oaks*, edited by Don S. Rice, pp. 41–82. Dumbarton Oaks Research Library and Collection, Washington, D.C.

2012 The Construction of Values during the Peruvian Formative. In *The Construction of Value in the Ancient World*, edited by John K. Papadopoulous and Gary Urton, pp. 288–304. Cotsen Institute of Archaeology, Los Angeles.

Canto Aguilar, Giselle, and Victor Castro Mendoza

2010 Zaxacatla in the Framework of Olmec Mesoamerica. In *The Place of Stone Monuments: Context, Use, and Meaning in Mesoamerica's Preclassic Tradition*, edited by Julia Guernsey, John E. Clark, and Barbara Arroyo, pp. 77–96. Dumbarton Oaks Research Library and Collection, Washington, D.C.

Carter, Tristan

2007 The Theatrics of Technology: Consuming Obsidian in the Early Cycladic Burial Arena. In *Rethinking Craft Specialization in Complex Societies: Archaeological Analyses of the Social Meaning of Production*, edited by Zachary X. Hruby and Rowan K. Flad, pp. 88–107. Archeological Papers of the American Anthropological Association 17. American Anthropological Association, Washington, D.C.

Castillo, Luis Jaime, Julio Rucabado Y., Martín del Carpio P., Katiush Bernuy Q., Karim Ruiz R., Carlos Rengifo, Gabriel Prieto B., and Carole Fraresso

2008 Ideología y poder en la consolidación, colapso y reconstitución del estado mochica del Jequetepeque: El Proyecto Arqueológico San José de Moro (1991–2006). *Ñawpa Pacha* 29(1–86).

Caws, Peter

1979 Praxis and Techne. In *The History and Philosophy of Technology*, edited by George Bugliarello and Dean B. Doner, pp. 227–237. University of Illinois Press, Urbana.

Childe, V. Gordon

1950 The Urban Revolution. *Town Planning Review* 21(1):3.

Childs, S. Terry

1998 Social Identity and Craft Specialization among Toro Iron Workers in Western Uganda. In *Craft and Social Identity*, edited by Cathy Lynne Costin and Rita P. Wright, pp. 109–121. Archeological Papers of the American Anthropological Association 8. American Anthropological Association, Washington, D.C.

Clark, John E.

1996　Craft Specialization and Olmec Civilization. In *Craft Specialization and Social Evolution: In Memory of V. Gordon Childe*, edited by B. Wailes, pp. 187–199. University of Pennsylvania Museum of Archaeology and Anthropology, Philadelphia.

2007　In Craft Specialization's Penumbra: Things, Persons, Action, Value, and Surplus. In *Rethinking Craft Specialization in Complex Societies: Archaeological Analyses of the Social Meaning of Production*, edited by Zachary X. Hruby and Rowan K. Flad, pp. 20–36. Archeological Papers of the American Anthropological Association 17. American Anthropological Association, Washington, D.C.

Clark, John E., and Stephen D. Houston

1998　Craft Specialization, Gender, and Personhood among the Postconquest Maya of Yucatan, Mexico. In *Craft and Social Identity*, edited by Cathy Lynne Costin and Rita P. Wright, pp. 31–46. Archeological Papers of the American Anthropological Association 8. American Anthropological Association, Washington, D.C.

Clark, John E., and William J. Parry

1990　Craft Specialization and Cultural Complexity. In *Research in Economic Anthropology*, vol. 12, edited by B. L. Isaacs, pp. 289–346. JAI Press, Greenwich, Conn.

Cooney, Kathlyn M.

2012　Apprenticeship and Figured Ostraca from the Ancient Egyptian Village of Deir el-Medina. In *Archaeology and Apprenticeship: Body Knowledge, Identity, and Communities of Practice*, edited by Willeke Wendrich, pp. 145–170. University of Arizona Press, Tucson.

Costin, Cathy Lynne

1991　Craft Specialization: Issues in Defining, Documenting, and Explaining the Organization of Production. In *Advances in Archaeological Method and Theory*, vol. 3, edited by M. B. Schiffer, pp. 1–56. University of Arizona Press, Tucson.

1998　Housewives, Chosen Women, Skilled Men: Cloth Production and Social Identity in the Late Prehispanic Andes. In *Craft and Social Identity*, edited by Cathy Lynne Costin and Rita P. Wright, pp. 123–141. Archeological Papers of the American Anthropological Association 8. American Anthropological Association, Washington, D.C.

2001　Craft Production Systems. In *Archaeology at the Millenium: A Sourcebook*, edited by Gary M. Feinman and T. D. Price, pp. 273–327. Kluwer Academic/Plenum, New York.

2005　Craft Production. In *Handbook of Archaeological Methods*, edited by Herbert D. G. Maschner, pp. 1034–1107. AltaMira Press, Lanham, Md.

2011　Hybrid Objects, Hybrid Social Identities: Style and Social Structure in the Late Horizon Andes. In *Identity Crisis: Archaeology and Problems of Social Identity*, edited by L. Amundsen-Meyer, N. Engel, and S. Pickering, pp. 211–225. University of Calgary, Canada.

2013　Gender and Textile Production in Prehistory. In *Companion to Gender Prehistory*, edited by Diane Bolger, pp. 180–202. Wiley-Blackwell, New York.

Costin, Cathy Lynne, and Timothy K. Earle

1989　Status Distinction and Legitimation of Power as Reflected in Changing Patterns of Consumption in Late Prehispanic Peru. *American Antiquity* 54(4):691–714.

Costin, Cathy Lynne, and Melissa B. Hagstrum

1995　Standardization, Labor Investment, Skill, and the Organization of Ceramic Production in Late Prehispanic Highland Peru. *American Antiquity* 60(4):619–639.

Costin, Cathy Lynne, and Rita P. Wright (editors)

1998　*Craft and Social Identity*. Archeological Papers of the American Anthropological Association 8. American Anthropological Association, Washington, D.C.

Cummins, Tom

2013　Competing and Commensurate Values in Colonial Conditions: How They Are Expressed and Registered in the Sixteenth-Century Andes. In *The Construction of Value in the Ancient*

World, edited by John K. Papadopoulous and Gary Urton, pp. 406–426. Cotsen Institute of Archaeology, Los Angeles.

Dean, Carolyn

2010 *A Culture of Stone: Inka Perspectives on Rock*. Duke University Press, Durham, N.C.

Degoy, Laura

2008 Technical Traditions and Cultural Identity: An Ethnoarchaeological Study of Andhra Pradesh Potters. In *Cultural Transmission and Material Culture: Breaking Down Boundaries*, edited by Miriam T. Stark, Brenda J. Bowser, and Lee Horne, pp. 199–222. University of Arizona Press, Tucson.

DeMarrais, Elizabeth, Luis Jaime Castillo, and Timothy Earle

1996 Ideology, Materialization, and Power Strategies. *Current Anthropology* 37(1):15–31.

Dobres, Marcia-Anne

2000 *Technology and Social Agency: Outlining a Practice Framework for Archaeology*. Blackwell, Oxford.

2001 Meaning in the Making: Agency and Social Embodiment of Technology and Art. In *Anthropological Perspectives on Technology*, edited by Michael Brian Schiffer, pp. 47–76. University of New Mexico Press, Albuquerque.

2010 Archaeologies of Technology. *Cambridge Journal of Economics* 34(1):103–114.

Donnan, Christopher B., and Donna McClelland

1999 *Moche Fineline Painting: Its Evolution and Its Artists*. Fowler Museum of Cultural History, Los Angeles.

Dransart, Penelope

2014 Thoughts on Productive Knowledge in Andean Weaving with Discontinuous Warp and Weft. In *Textiles, Technical Practice, and Power in the Andes*, edited by Denise Y. Arnold and Penelope Dransart, pp. 216–232. Archetype, London.

Durland, Kaye

1991 Signs of Power: An Analysis of the Structure and Content of Inca Textile Tocapus. Master's thesis, Department of Art History, University of California, Los Angeles.

Earle, Timothy K.

1987 Specialization and the Production of Wealth: Hawaiian Chiefdoms and the Inka Empire. In *Specialization, Exchange, and Complex Societies*, edited by Elizabeth M. Brumfiel and Timothy K. Earle, pp. 64–75. Cambridge University Press, Cambridge.

2004 Culture Matters in the Neolithic Transition and Emergence of Hierarchy in Thy, Denmark: Distinguished Lecture. *American Anthropologist* 106(1):111–125.

Feinman, Gary M., Steadman Upham, and Kent G. Lightfoot

1981 The Production Step Measure: An Ordinal Index of Labor Input in Ceramic Manufacture. *American Antiquity* 46(4):871–884.

Flad, Rowan

2012 Bronze, Jade, Gold, and Ivory: Valuable Objects in Ancient Sichuan. In *The Construction of Value in the Ancient World*, edited by John K. Papadopolous and Gary Urton, pp. 306–335. Cotsen Institute of Archaeology, Los Angeles.

Gaydarska, Bisserka, and John Chapman

2008 The Aesthetics of Colour and Brilliance—Or, Why Were Prehistoric Persons Interested in Rocks, Minerals, Clays, and Pigments? *Geoarchaeology and Archaeomineralogy: Proceedings of the International Conference, 2008*, edited by R. I. Kostov, B. Gaydarska, M. Gurova, pp. 63–66. St. Ivan Rilski, Sofia, Bulgaria.

Geertz, Clifford

1974 Art as a Cultural System. *MLN (Modern Language Notes)* 91(6):1473–1499.

Gell, Alfred

1992 The Technology of Enchantment and the Enchantment of Technology. In *Anthropology, Art, and Aesthetics*, edited by Jeremy Coote and Anthony Shelton, pp. 40–63. Oxford University Press, New York.

1998 *Art and Agency: An Anthropological Theory*. Oxford University Press, New York.

Gosselain, Oliver

2000 Materializing Identities: An African Perspective. *Journal of Archaeological Method and Theory* 7(3):187–217.

Graeber, David

2001 *Toward an Anthropological Theory of Value: The False Coin of Our Dreams.* Palgrave, New York.

Halperin, Christina T., and Antonia E. Foias

2010 Pottery Politics: Late Classic Maya Palace Production at Motul de San José, Petén, Guatemala. *Journal of Anthropological Archaeology* 29(3):392–411.

Hayden, Brian

1998 Practical and Prestige Technologies: The Evolution of Material Systems. *Journal of Archaeological Method and Theory* 5(1):1–55.

Heath, Deborah, and Anne Meneley

2007 Techne, Technoscience, and the Circulation of Comestible Commodities: An Introduction. *American Anthropologist* 109(4):593–602.

Heidegger, Martin

2010 [1954] The Question Concerning Technology. In *Technology and Values: Essential Readings*, edited by Craig Hanks, pp. 99–113. Wiley-Blackwell, Malden, Mass.

1971 The Origin of the Work of Art. In *Poetry, Language, Thought*, translated by Albert Hofstadter, pp. 15–86. Harper and Row, New York.

Helms, Mary W.

1988 *Ulysses' Sail: An Ethnographic Odyssey of Power, Knowledge, and Geographical Distance.* Princeton University Press, Princeton, N.J.

1993 *Craft and the Kingly Ideal.* University of Texas Press, Austin.

Hendon, Julia A.

1999 Spinning and Weaving in Pre-Hispanic Mesoamerica: The Technology and Social Relations of Textile Production. In *Mayan Clothing and Weaving through the Ages*, edited by Barbara Knoke de Arathoon, Nancie L. Solien Gonzalez, and John M. Willemsen Devlin, pp. 7–16. Museo Ixchel del Traje Indígena de Guatemala, Guatemala City.

Hirth, Kenneth G. (editor)

2009 *Housework: Craft Production and Domestic Economy in Ancient Meso-america.* Archeological Papers of the American Anthropological Association 19. American Anthropological Association, Washington, D.C.

Hodder, Ian

1982 *Symbols in Action: Ethnoarchaeological Studies of Material Culture.* Cambridge University Press, Cambridge.

Hofmann, Bjørn

2003 Medicine as Techné—A Perspective from Antiquity. *Journal of Medicine and Philosophy* 28(4):403–425.

Houston, Stephen

2014 *The Life Within: Classic Maya and the Matter of Permanence.* Yale University Press, New Haven, Conn.

Hruby, Zachary X.

2007 Ritualized Chipped-Stone Production at Piedras Negras, Guatemala. In *Rethinking Craft Specialization in Complex Societies: Archaeological Analyses of the Social Meaning of Production*, edited by Zachary X. Hruby and Rowan K. Flad, pp. 68–87. Archeological Papers of the American Anthropological Association 17. American Anthropological Association, Washington, D.C.

Hruby, Zachary X., and Rowan K. Flad (editors)

2007 *Rethinking Craft Specialization in Complex Societies: Archeological Analyses of the Social Meaning of Production.* Archeological Papers of the American Anthropological Association 17. American Anthropological Association, Washington D.C.

Ingold, Tim

2001 Beyond Art and Technology: The Anthropology of Skill. In *Anthropological Perspectives on Technology*, edited by Michael Brian Schiffer, pp. 17–31. University of New Mexico Press, Albuquerque.

Inomata, Takeshi

2001 The Power and Ideology of Artistic Creation. *Current Anthropology* 42(3):321–349.

2007 Knowledge and Belief in Artistic Production by Classic Maya Elites. In *Rethinking Craft Specialization in Complex Societies: Archaeological Analyses of the Social Meaning of Production*, edited by Zachary X. Hruby and Rowan K. Flad, pp. 129–141. Archeological Papers of the American Anthropological Association 17. American Anthropological Association, Washington, D.C.

Inomata, Takeshi, and Daniela Triadan
2000 Craft Production by Classic Maya Elites in Domestic Settings: Data from Rapidly Abandoned Structures at Aguateca, Guatemala. *Mayab* 13:57–66.

Jackson, Margaret Ann
2008 *Moche Art and Visual Culture in Ancient Peru*. University of New Mexico Press, Albuquerque.

Joyce, Rosemary A.
2000 *Gender and Power in Prehispanic Meso-america*. University of Texas Press, Austin.

Kalavrezou, Ioli
2013 Light and the Precious Object, or Value in the Eyes of the Byzantines. In *The Construction of Value in the Ancient World*, edited by John K. Papadopolous and Gary Urton, pp. 354–369. Cotsen Institute of Archaeology, Los Angeles.

Lechtman, Heather
1984 Andean Value Systems and the Development of Prehistoric Metallurgy. *Technology and Culture* 25(1):1–36.

1993 Technologies of Power: The Andean Case. In *Configurations of Power: Holistic Anthropology in Theory and Practice*, edited by John S. Henderson and Patricia Netherly, pp. 244–280. Cornell University Press, Ithaca, N.Y.

Lemonnier, Pierre (editor)
1993 *Technological Choices: Transformation in Material Cultures Since the Neolithic*. Routledge, New York.

Lillios, Katina T.
1999 Objects of Memory: The Ethnography and Archaeology of Heirlooms. *Journal of Archaeological Method and Theory* 6(3):235–262.

Looper, Matthew G.
2006 Fabric Structures in Classic Maya Art and Ritual. In *Sacred Bundles: Ritual Acts of Wrapping and Binding in Mesoamerica*. Ancient America Special Publication, no. 1, edited by Julia Guernsey and Kent F. Reilly, pp. 80–104. Boundary End Archaeology Research Center, Barnardsville, N.C.

Marx, Karl
1973 *Grundrisse der Kritik der Politischen*
[1939–1941] *Okonomie (Outlines of the Critique of Political Economy). Economic Works of Karl Marx 1857–1861*. Electronic document, http://www.marxists.org/archive/marx/works/1857/grundrisse/, accessed March 28, 2014.

Meagher, Robert
1988 Techné. *Perspecta* 24:159–164.

Mills, Barbara J., and Patricia L. Crown (editors)
1995 *Ceramic Production in the American Southwest*. University of Arizona Press, Tucson.

Minar, Jill, and Patricia Crown (editors)
2001 Learning and Craft Production. Special issue, *Journal of Anthropological Research* 57(4).

Morris, Craig
1986 Storage, Supply, and Redistribution in the Economy of the Inka State. In *Anthropological History of Andean Polities*, edited by John V. Murra, Nathan Wachtel, and Jacques Revel, pp. 59–68. Cambridge University Press, Cambridge.

Neupert, Mark A.
1994 Strength Testing Archaeological Ceramics: A New Perspective. *American Antiquity* 59(4):709–723.

Oakley, John H.
2009 Greek Vase Painting. *American Journal of Archaeology* 113(4):599–627.

Panofsky, Erwin
1970 *Meaning in the Visual Arts*. Penguin, Harmondsworth.

Papadopoulos, John K., and Gary Urton (editors)
2012 *The Construction of Value in the Ancient World*. Cotsen Institute of Archaeology, Los Angeles.

Parry, Richard

2008 Episteme and Techne. In *Stanford Encyclopedia of Philosophy (Fall 2008 Edition)*. Electronic document, http://plato.stanford.edu/archives/fall2008/entries/episteme-techne/, accessed January 6, 2016.

Paul, Anne, and Susan Niles

1985 Identifying Hands at Work on a Paracas Mantle. *Textile Museum Journal* 25:5–15.

Peters, Ann H.

2014 Paracas Necropolis: Communities of Textile Production, Exchange Networks, and Social Boundaries in the Central Andes, 150 BC to AD 250. In *Textiles, Technical Practice, and Power in the Andes,* edited by Denise Y. Arnold and Penelope Dransart, pp. 109–139. Archetype, London.

Pierce, Christopher

2005 Reverse Engineering the Ceramic Cooking Pot: Cost and Performance Properties of Plain and Textured Vessels. *Journal of Archaeological Method and Theory* 12(2):117–157.

Pollitt, J. J.

1974 *The Ancient View of Greek Art: Criticism, History, and Terminology.* Yale University Press, New Haven, Conn.

Preston, Beth

2000 A Philosophical Perspective on Material Culture. In *Matter, Materiality, and Modern Culture*, edited by P. Graves-Brown, pp. 22–49. Routledge, London.

Reents-Budet, Dorie

1998 Elite Maya Pottery and Artisans as Social Indicators. In *Craft and Social Identity*, edited by Cathy Lynne Costin and Rita P. Wright, pp. 71–92. Archeological Papers of the American Anthropological Association 8. American Anthropological Association, Washington, D.C.

Reents-Budet, Dorie, Joseph W. Ball, and Justin Kerr

1994 *Painting the Maya Universe: Royal Ceramics of the Classic Period.* Duke University Press, Durham, N.C.

Renfrew, Colin

1986 Varna and the Emergence of Wealth in Prehistoric Europe. In *The Social Life of Things: Commodities in Cultural Perspective,* edited by Arjun Appadurai, pp. 141–168. Cambridge University Press, Cambridge.

Rice, Prudence M.

1981 Evolution of Specialized Pottery Production: A Trial Model. *Current Anthropology* 22(3):219–240.

Roochnik, David

1996 *Of Art and Wisdom: Plato's Understanding of Techne.* Pennsylvania State University Press, University Park.

Saunders, Nicholas J.

2001 A Dark Light: Reflections on Obsidian in Mesoamerica. *World Archaeology* 33(2):220–236.

2002 The Colours of Light: Materiality and Chromatic Cultures of the Americas. *Colouring the Past: the Significance of Colour in Archaeological Research*, edited by Andrew Jones and Gavin MacGregor, pp. 209–226. Bloomsbury, London.

2003 "Catching the Light": Technologies of Power and Enchantment in Pre-Columbian Goldworking. In *Gold and Power in Ancient Costa Rica, Panama, and Colombia*, edited by Jeffrey Quilter and John W. Hoopes, pp. 15–47. Dumbarton Oaks Research Library and Collection, Washington, D.C.

Sawyer, Alan Reed

1997 *Early Nasca Needlework.* Laurence King Publishing, London.

Schiffer, Michael Brian

1992 *Technological Perspectives on Behavioral Change.* University of Arizona Press, Tucson.

2001 *Anthropological Perspectives on Technology.* University of New Mexico Press, Albuquerque.

Schiffer, Michael Brian, and Andrea R. Miller

1999 A Behavioral Theory of Meaning. In *Pottery and People: A Dynamic Interaction*, edited by James M. Skibo and Gary M. Feinman, pp. 199–217. University of Utah Press, Salt Lake City.

Schortman, Edward M., and Patricia A. Urban

2004 Modeling the Roles of Craft Production in Ancient Political Economies. *Journal of Archaeological Research* 12:185–226.

Shimada, Izumi (editor)

2007 *Craft Production in Complex Societies: Multicraft and Producer Perspectives.* University of Utah Press, Salt Lake City.

Shiner, Larry

2001 *The Invention of Art: A Cultural History.* University of Chicago Press, Chicago.

Sinopoli, Carla M.

1988 The Organization of Craft Production at Vijayanagara, South India. *American Anthropologist* 90(3):580–597.

Skibo, James M.

2013 *Understanding Pottery Function.* Springer, New York.

Smith, Monica L.

2013 The Substance and Symbolism of Long-Distance Exchange: Textiles as Desired Trade Goods in the Bronze Age Middle Asian Interaction Sphere. In *Connections and Complexity: New Approaches to the Archaeology of South Asia,* edited by Shinu Abraham, Praveen Gullipalli, Teresa P. Raczek, and Uzma Z. Rizvi, pp. 143–160. Left Coast Press, Walnut Creek, Calif.

Smith, Tyler Jo

2012 Greek Vases: From Artistic Personalities to Archaeological Contexts. *American Journal of Archaeology* 116(3):549–554.

Spielmann, Katherine A.

2002 Feasting, Craft Specialization, and the Ritual Mode of Production in Small-Scale Societies. *American Anthropologist* 104(1):195–207.

Splitstoser, Jeffrey C.

2014 Practice and Meaning in Spiral-Wrapped Batons and Cords from Cerrillos, a Late Paracas Site in the Ica Valley, Peru. In *Textiles, Technical Practice, and Power in the Andes,* edited by Denise Y. Arnold and Penelope Dransart, pp. 46–82. Archetype, London.

Stark, Miriam T. (editor)

1998 *The Archaeology of Social Boundaries.* Smithsonian Institution Press, Washington, D.C.

Stark, Miriam T., Ronald L. Bishop, and Elizabeth Miksa

2000 Ceramic Technology and Social Boundaries: Cultural Practices in Kalinga Clay Selection and Use. *Journal of Archaeological Method and Theory* 7(4):295–331.

Stark, Miriam T., Brenda Bowser, and Lee Horne (editors)

2008 *Cultural Transmission and Material Culture: Breaking Down Boundaries.* University of Arizona Press, Tucson.

Tiles, J. E.

1984 "Techné" and Moral Expertise. *Philosophy* 59(227):49–66.

Tite, Michael S., Vassilis Kilikoglou, and Giorgos Vekinis

2001 Strength, Toughness, and Thermal Shock Resistance of Ancient Ceramics, and Their Influence on Technological Choice. *Archaeometry* 43(3):301–324.

Uceda, Santiago, and Jose Armas

1998 An Urban Pottery Workshop at the Site of Moche, North Coast of Peru. In *Andean Ceramics: Technology, Organization, and Approaches,* edited by Izumi Shimada, pp. 91–110. Vol. 15 of *MASCA Research Papers in Science and Archaeology.* Museum Applied Science Center for Archaeology and the University of Pennsylvania Museum of Archaeology and Anthropology, Philadelphia.

Voutsaki, Sofia

1997 The Creation of Value and Prestige in the Aegean Late Bronze Age. *Journal of European Archaeology* 5(2):34–52.

Wailes, Bernard

1996 V. Gordon Childe and the Relations of Production. In *Craft Specialization and Social Evolution: In Memory of V. Gordon Childe,* edited by Bernard Wailes, pp. 3–16. University of Pennsylvania Museum of Archaeology and Anthropology, Philadelphia.

Wailes, Bernard (editor)

1996 *Craft Specialization and Social Evolution: In Memory of V. Gordon Childe.* University of Pennsylvania Museum of Archaeology and Anthropology, Philadelphia.

Walker, William H., and Michael Brian Schiffer

2006 The Materiality of Social Power: The Artifact-Acquisition Perspective. *Journal of Archaeological Method and Theory* 13(2):67–88.

Wendrich, Willeke

2012 Archaeology and Apprenticeship. In *Archaeology and Apprenticeship: Body Knowledge, Identity, and Communities of Practice*, edited by Willeke Wendrich, pp. 1–19. University of Arizona Press, Tucson.

Wendrich, Willeke (editor)

2012 *Archaeology and Apprenticeship: Body Knowledge, Identity, and Communities of Practice*. University of Arizona Press, Tucson.

Widmer, Randolph J.

2009 Elite Household Multicrafting Specialization at 9N8, Patio H, Copan. In *Housework: Craft Production and Domestic Economy in Ancient Mesoamerica*, edited by Kenneth G. Hirth, pp. 174–205. Archeological Papers of the American Anthropological Association 19. American Anthropological Association, Washington, D.C.

Wobst, H. Martin

1977 Stylistic Behavior and Information Exchange. In *For the Director: Research Essays in Honor of James B. Griffin*, edited by Charles E. Cleland, pp. 317–342. Anthropological Papers 61. University of Michigan Museum of Anthropology, Ann Arbor.

2

Lustrous Surfaces and Shades of Green

Value and Meaning in Three Mesoamerican Lapidary Ensembles from Teotihuacan, Palenque, and La Venta

LAURA FILLOY NADAL

ACROSS MESOAMERICA, A GREAT RANGE OF hard rocks—including quartz, carnelian, opal, jasper, travertine, flint, obsidian, marble, and jadeite, to name just a few—were exploited during prehispanic times for the purpose of transforming them into finely worked objects. Notwithstanding this enormously diverse mineral universe, indigenous peoples over the centuries clearly had a predilection for green-colored stone (Figure 2.1). In fact, taking into account all of the polished stone objects found in public and private collections, along with the increasing number recovered in archaeological excavations, it is readily apparent that there is a great preponderance of hard rocks that are colored various shades of green, including serpentinite, jadeite, chrysoprase, quartz, chloromelanite, schist, hornblende, and metandesite, among others (Curtis 1959). Together, they are commonly subsumed under the terms "cultural" or "social" jade (Bishop et al. 1991:318; Lange 1993:1). And although these varieties of greenstone obviously differ physically and chemically, all of them acquire greater

chromatic intensity, as well as an exceptional luster and sheen, after undergoing a long process of grinding, polishing, and burnishing.

Evidently, Mesoamerican peoples made extensive use of many types of greenstone, which they valued and esteemed more than any other material. Greenstone was used to craft jewelry and insignia that served as markers of social status, and to fashion religious symbols and instruments that were often interred in ritual deposits. Among the offerings found at the Templo Mayor of Tenochtitlan, for example, greenstone was the second most widely used raw material after conch and other marine shells (López Luján 2005) (Figure 2.2). In thirty-five years of excavations, archaeologists from the Templo Mayor Project have recovered around ten thousand greenstone artifacts, compared to only about three hundred in gold (López Luján 2015:12–13). According to sixteenth-century sources, as well as modern studies such as those of Marc Thouvenot (1982), Karl Taube (1998:454–463, 2005), and Virginia Fields (1991), Mesoamericans

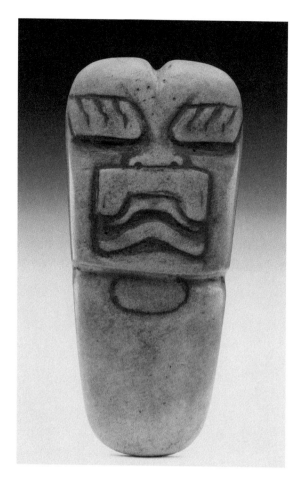

figure 2.1
Olmec metamorphic greenstone ceremonial celt
(13-435) from La Venta, Middle Formative period.
Museo Nacional de Antropología, Mexico City.
(Photograph from the Archivo Digital de las
Colecciones del Museo Nacional de Antropología,
sponsored by the Instituto Nacional de Antropología
e Historia, and the Canon Corporation; courtesy of
the Museo Nacional de Antropología.)

nearly always imbued such greenstone objects with
polysemic values related to notions of wealth, pre-
ciosity, perfection, governmental authority, sacral-
ity, centrality, abundance, and eternality. They also
associated them with water and, thus, the fertility
of maize and agricultural vegetation, and some-
times considered them to be a material manifesta-
tion of certain animistic entities and the essence of
life itself.

It is important to note, however, that not all
varieties of greenstone enjoyed the same prestige;
consequently, they had different uses and mean-
ings. At least this is what the alphabetic historical
sources, which provide a glimpse of the old tax-
onomies that classified various kinds of greenstone
according to certain real or imagined attributes, say.
In the *Florentine Codex* (Book 11, Chapter 8), which
was compiled under the auspices of the sixteenth-
century Franciscan friar Bernardino de Sahagún
(1950–1982, 1979, 2000), we find that Nahuas dur-
ing the Postclassic period differentiated at least nine
types of greenstone, or *chalchihuitl*,[1] based on lus-
ter, chromatic intensity and homogeneity, transpar-
ency, purity, and alleged magical, therapeutic, or
water-retentive properties. With regard to this last
property, we are told that all types of chalchihuitl
emitted a fresh, moist vapor and caused the vegeta-
tion above them to grow greener than any of the
surrounding herbage: "yoan inic quiximati inin tla-
çotetl, uncan ca: muchipa tlacelia, tlacecelia, quil-
mach inin chalchiutl ihiio; auh in ihiio cenca cecec"
(they know that this precious stone is there: [the
herbs] always grow fresh; they grow green. They
say that this is the breath of the green stone, and its
breath is very fresh) (Sahagún 1950–1982:11:222). In
a complementary manner, the mestizo chronicler
Juan Bautista Pomar (1941 [1582]:38) informs us that
the value of these precious stones actually derived
from "la fineza de su color y por haber pocas de
ellas" (their fine color and because there were few of
them [i.e., their relative scarcity]).

The *Florentine Codex* (Book 9, Chapter 17)
also mentions the existence of lapidary specialists
who had an intimate knowledge of the properties
of each kind of stone and possessed great technical
skill in cutting, grinding, and, especially, polishing
and burnishing. Elsewhere (Book 11, Chapter 8),
in the Spanish column of the bilingual codex,
Sahagún (2000:3:1118) notes that "piedras preciosas
no se hallan así como están agora en poder de los
que las tienen o que las venden. No se halla ansí
hermosas y polidas y resplandecientes; mas antes
se crían en unas piedras toscas, que no tienen nin-
guna apariencia ni hermosura" (precious stones are
not found in the condition that they are now, in the

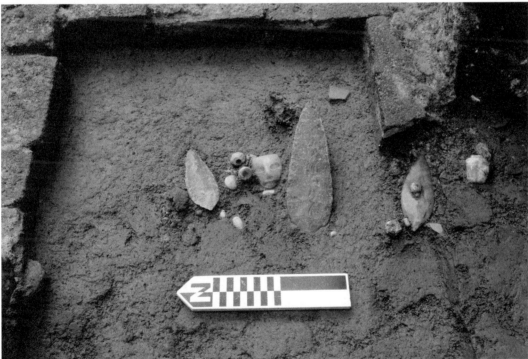

figure 2.2

Offering 144, interred under the plaza floor immediately in front of the Templo Mayor of Tenochtitlan, Mexico City. In this cache alone, Mexica priests deposited 338 small worked pieces of metamorphic greenstone around the turn of the fifteenth or sixteenth century (a), above which they placed large sacrificial flint knives and some additional greenstone objects (b). (Photographs courtesy of Leonardo López Luján, Proyecto Templo Mayor, Instituto Nacional de Antropología e Historia.)

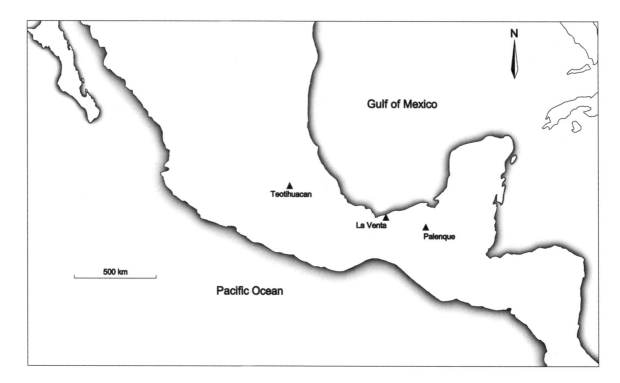

figure 2.3
Geographical provenance of the three ensembles of archaeological artifacts in this study: Teotihuacan, Estado de México; Palenque, Chiapas; and La Venta, Tabasco, Mexico. (Map by Michelle De Anda Rogel.)

possession of those who have or sell them. They are not so beautiful, polished, or gleaming; rather, they are created from rough stones that have no notable appearance or beauty). Unfortunately, these sources do not specify which tools the lapidaries favored for each task, nor the techniques, solutions, and technical sequences they employed in producing specific kinds of objects.[2]

While the written sources provide details about some aspects of lapidary work, they are silent about others—hence, the need to complement these descriptions of Postclassic societies with the study of their material culture using modern scientific instruments and techniques. We must interrogate both archaeological objects and their contexts, especially those of earlier prehispanic Mesoamerican societies for which no historical data exist. This is precisely where materials science, technological analysis, morphofunctional testing, and careful observation of the contexts of use and meaning of the artifacts become indispensable. As Lorraine Daston (2008:20) has pointed out: "Things communicate

by what they are as well as by how they mean. A particular cultural setting may accentuate this or that property, but a thing without any properties is silent." In this regard, a *chaîne opératoire* analysis (Leroi-Gourhan 1964–1965, 1993) can be especially useful, for it involves detailing all of the steps in the production process—including the acquisition of the raw materials, the manufacturing sequence, and the strategies followed to transform them into culturally meaningful and functional objects (and thus uniting the tangible and intangible dimensions of praxis) until their final deposition—as well as delving into the "life-history" of the artifacts (Dobres 1999; Kopytoff 1986).

This essay, then, will examine three Mesoamerican lapidary ensembles of great historical and aesthetic importance in order to learn much more about the uses and meanings that their respective societies attributed to certain lustrous varieties of metamorphic greenstone. These varieties are geologically rare; thus, in all three cases, their acquisition and transport involved a large investment of

time and effort, and certain intrinsic characteristics of these raw materials also required a long and laborious manufacturing process that could only be performed by the expert hands of lapidary specialists. All of these objects, currently conserved at the Instituto Nacional de Antropología e Historia in Mexico, were recovered in scientifically controlled excavations and, according to field registers, were found in votive or funerary contexts in ceremonial precincts of primary importance in their respective urban centers. These three sets of artifacts, however, differ greatly in terms of provenance, age, and culture; they include: 1) an Early Classic anthropomorphic sculpture (10-615743) from the Pyramid of the Moon at Teotihuacan; 2) the extraordinary funerary mask (10-1300) and accessories of the Late Classic Maya ruler K'inich Janaab' Pakal (603–683 CE) of Palenque; and 3) the figurines and celts of Offering 4 (10-9650) from the much older Middle Formative Olmec site of La Venta (Figure 2.3). Focusing on the materiality of these objects, this study will combine a *technological* approach to identify the origin and characteristics of the raw materials, the technical sequences of production, the essential skills of the lapidaries (Leroi-Gourhan 1964–1965, 1993; Mauss 1935, 1973) and the qualities of the finished products, with a *contextual* approach to address their symbolic and utilitarian aspects. This study, therefore, embraces techné in its broadest sense, as discussed in the introduction to this volume.

A Bejeweled Sculpture from the Pyramid of the Moon at Teotihuacan

The first group of artifacts to be examined here was uncovered by Professor Saburo Sugiyama in Burial 6, inside the Pyramid of the Moon, in the city of Teotihuacan (Figure 2.4). The objects were among several precious offerings deposited around

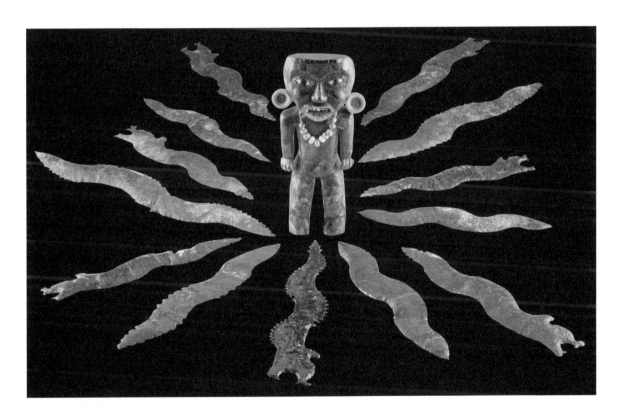

figure 2.4
Serpentinite mosaic anthropomorphic sculpture (10-615743) with obsidian eccentrics, from Burial 6, Pyramid of the Moon, Teotihuacan. Instituto Nacional de Antropología e Historia, Mexico City. (Photograph by Michel Zabé; courtesy of Estudio Zabé.)

figure 2.5

Serpentinite deposits in Mesoamerica. (Map by Yuriria Pantoja Millán, based on data from Robles Camacho et al. 2008; Ricardo Sánchez Hernández, personal communication, 2012.)

300 CE in a receptacle measuring 5 meters (north–south) by 4.5 meters (east–west) by 2 meters (high), during the ritual consecration of the fourth phase of the pyramid's construction (Sugiyama and Cabrera Castro 2007). Following a well-established liturgical pattern, nine pairs of obsidian eccentrics, a slate and pyrite mirror, and a full-bodied anthropomorphic

sculpture, carved in wood and covered with a mosaic of polished greenstone tesserae, were placed in the center of the offering (Sugiyama and López Luján 2007:139–141). The sculpture was also adorned with a delicate diadem made of obsidian platelets, a pair of undecorated greenstone earspools, and a necklace of ten spherical pale greenstone beads

figure 2.6
Jade pyroxene deposits in the central Motagua region of Guatemala. (Map by Yuriria Pantoja Millán, with data based on Harlow et al. 2011; Ricardo Sánchez Hernández, personal communication, 2012.)

(Filloy Nadal et al. 2006:63, 67). After restoration, the maximum dimensions of the sculpture measure 31 by 15.6 by 7.6 centimeters.

Once the excavation of the sculpture was complete, it was moved to Mexico City for restoration. Before reassembling the mosaic, we took the opportunity to study the tesserae. The analysis of the raw materials of the sculpture, conducted with polarized light microscopy (PLM) and X-ray diffraction (XRD), revealed that the stones selected for the mosaic belong to the serpentinite group (Sánchez Hernández and Robles Camacho 2005). The nearest sources of this type of rock are located between 250 and 300 kilometers south of the Teotihuacan Valley,

in the Tehuitzingo-Tecomatlán area of the state of Puebla and in the foothills of the Sierra Madre del Sur (Sánchez Hernández and Robles Camacho 2005); both regions were under Teotihuacan control at the time (Figure 2.5).

The beads of the necklace were fashioned from several kinds of metamorphic rock, such as jadeite, metadiorite, and quartz (Sánchez Hernández and Robles Camacho 2005), whose common origin could very well be the Motagua River fault zone in Guatemala (Figure 2.6). The earspools were carved out of fuchsite, a chromium-rich, green variety of muscovite (Sánchez Hernández and Robles Camacho 2005), whose source was probably in the adjacent Baja Verapaz region. Whereas the raw material of the anthropomorphic sculpture came from sites located within the area of Teotihuacan control, perhaps as tribute, the stones selected for these accessories originated from outside the hegemonic area and thus would have come to the city through commercial channels.

During the process of restoring the anthropomorphic sculpture, we undertook a meticulous analysis of various parts of the mosaic, especially the serpentinite tesserae. No two of the more than three hundred pieces were alike in size, shape, and thickness, although all of them had carefully beveled edges to help assure precise assembly. The

exposed surface of the tesserae was smooth and lustrous, while the back had a rough finish to maximize adhesion to the support.[3] The relatively low hardness of serpentinite (Mohs 2–3.5) facilitated cutting the tesserae as well as obtaining their final luster. In order to identify the tools used to produce them, we turned to experimental archaeology (Ascher 1961; Binford 1977; Velázquez Castro 2007). With the aid of scanning electron microscopy (SEM),[4] we observed manufacturing marks left by prehispanic tools on the artifacts and compared them to those made on an experimental corpus developed specifically for our research (Melgar Tísoc 2003, 2004, 2006; see Table 2.1).[5] As a result, we discovered that various stone tools were used, including flint chips for cutting and incising, and andesite slabs for grinding to refine the shape. The lustrous, smooth surface was obtained first by polishing with flint nodules and then by burnishing, probably with leather (Filloy Nadal and Melgar Tísoc 2009; see Figure 2.7). This technical sequence suggests that the sculpture is of local origin, as manufacturing marks from the same tools have been detected on other pieces of known Teotihuacan origin found in various parts of the city (López Juárez 2007; Melgar Tísoc 2006). Moreover, standardized tool use in each step of the technical sequence of the serpentinite tesserae suggests that the entire

table 2.1

Experimental corpus for replicating the technical sequence employed in the production of jadeite objects

MODIFICATIONS	TOOLS USED
Cutting	Sand, water, leather, or vegetal fibers. Flint and obsidian lithic tools.
Grinding	Basalt, andesite, rhyolite, sandstone, limestone, or granite slabs, adding water and occasionally sand.
Drilling	Abrasives (sand, volcanic ash, obsidian powder, flint powder, or quartz powder), applying reed or bone in motion, adding water. Flint and obsidian lithic tools.
Boring/Openwork	Abrasives (sand, volcanic ash, obsidian powder, flint powder, or quartz powder), applying reed or bone in motion, adding water.
Incising	Flint and obsidian lithic tools.
Finishing	Polishing with abrasives, wet leather. Burnishing with dry leather. Application of both.

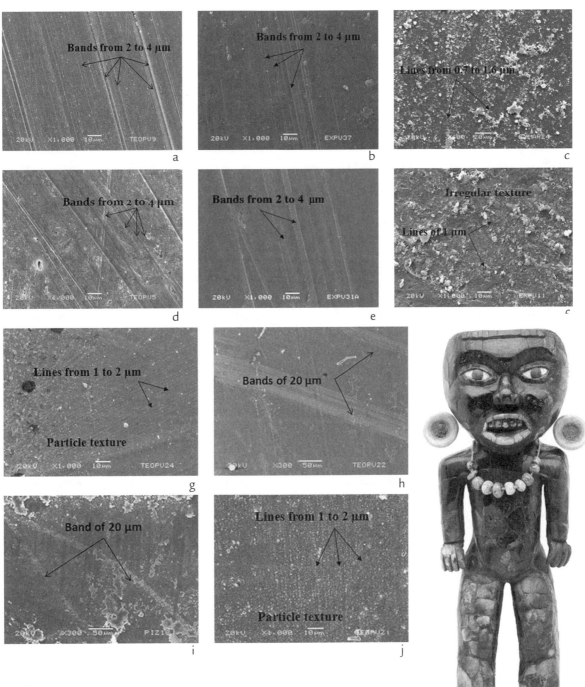

figure 2.7

Manufacturing marks related to the study of the anthropomorphic sculpture and necklace
from Burial 6, Pyramid of the Moon, Teotihuacan: a) edge of a serpentinite tessera from the sculpture;
experimental cutting with b) a flint chip and c) an obsidian chip; d) polished surface of a serpentinite tessera from
the sculpture; experimental polishing with e) a flint nodule and f) sand; g–h) surface of a metamorphic stone
bead; and experimental polishing with i) a flint nodule and j) a jadeite nodule. (SEM images by José Antonio Alva
and Emiliano Melgar Tísoc for the Proyecto Estilo y Tecnología de los Objetos Lapidarios en el México Antiguo,
Museo del Templo Mayor; courtesy of the Laboratorio de Conservación, Museo Nacional de Antropología, and the
Instituto Nacional de Antropología e Historia. Photograph by Michel Zabé, courtesy de Estudio Zabé.)

mosaic was made in the same lapidary workshop in Teotihuacan (Filloy Nadal and Melgar Tísoc 2009).

The technical sequence for fashioning the earspools and beaded necklace, however, was considerably different. In these cases, the archaeological manufacturing marks matched our experimental corpus of grinding with limestone, cutting with flint, and polishing with jadeite to obtain such a luster (Filloy Nadal and Melgar Tísoc 2009). As we shall see below, grinding with limestone and polishing with jadeite are characteristic of technical sequences that have been identified at Maya sites (Kovacevich 2006). Therefore, we believe that the beads and earspools had already been finished in the Maya area before they were imported to Teotihuacan.

With respect to style, the mosaic sculpture fits perfectly within the corpus of Teotihuacan anthropomorphic green or pale metamorphic stone sculptures dating from the early centuries of the common era (López Luján et al. 2006:19). The lack of specific attributes, however, makes the iconographic identification of the sculpture difficult, although other data are suggestive. For example, the greenstone necklace and earspool accessories are clearly symbols related to the status of the sculpture, which was interred in the Pyramid of the Moon during a consecration ritual. Moreover, the placement of the sculpture, at the center of Burial 6, standing upright on a pyrite mirror, is significant in terms of its symbolism and function. Karl Taube (1993), Guilhem Olivier (2003), and Miguel Rivera Dorado (2004) have proposed that mirrors in Mesoamerica served as portals for traveling the universe and connected the heavens above with the underworld below. Based on the position of the sculpture in the deposit, Leonardo López Luján (2012:20) has suggested that it may represent a deity or dignitary, occupying the center of the universe, with the ability to travel through the mirror to different levels of the cosmos.

Accoutrements for Eternity from the Temple of the Inscriptions in Palenque

The second group of artifacts consists of the funerary items of the Maya ruler K'inich Janaab' Pakal, who died in 683 CE and was interred in a monolithic sarcophagus inside the Temple of the Inscriptions at Palenque. The crypt, discovered in 1952 by the Mexican archaeologist Alberto Ruz, is 7 meters long (north–south) by 3.75 meters wide (east–west), while its corbel-vaulted ceiling begins 3 meters above the level of the floor and reaches a maximum height of 6.5 meters (Ruz Lhuillier 1973:83). As part of his funerary rites, Pakal was carefully adorned with a rich array of accoutrements made primarily from metamorphic greenstone—including a diadem, a pair of earspools, a necklace, a tubular-beaded pectoral, ten rings, and a mask—and was placed inside the sarcophagus, whose interior walls were painted bright red. This portion of the present study will focus primarily on the mask, which consists of a greenstone tesserae mosaic with two round obsidian appliqués in between four others made of mother-of-pearl, which formed the eyes (Figure 2.8). After restoration, in 2002, the maximum dimensions of the mask measure 26.6 by 18.8 by 10.6 centimeters.

Most likely, all of these pieces were produced well in advance, as their manufacture involved a long series of technical processes that required a considerable amount of time and effort. The Palenque craftsmen first had to be provided with a large quantity of greenstone, as the combined weight of all the items exceeds 3.5 kilograms (Filloy Nadal 2014). Of course, sculpting any stone object involves a certain amount of waste, which must be accounted for at the beginning of the process by acquiring a much larger quantity of raw material.

In order to make the mask, the craftsmen selected various types and shades of greenstone. Using XRD,[6] we were able to identify the raw materials as kosmochlor (ureyite), jadeite, and albite (Robles Camacho et al. 2010)—all pyroxene minerals primarily composed of sodium aluminum silicates and commonly included under the term "jade" (Walker 1991:23). Although the precise location where the greenstone was obtained is not yet known, it is clear that there are no jade deposits in the immediate vicinity of Palenque. The formation of jade requires extremely complex geological processes in which several factors come together,

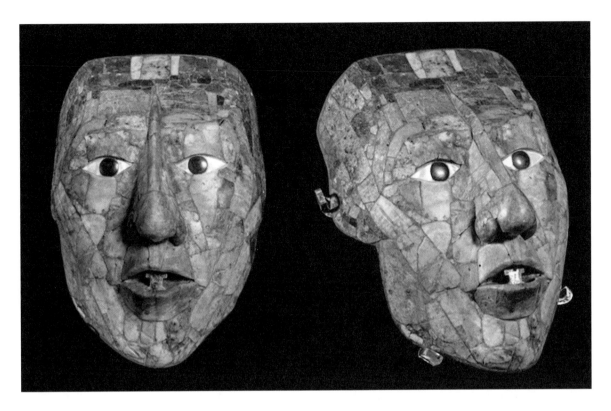

figure 2.8

K'inich Janaab' Pakal's funerary mask (10-1300), from the Temple of the Inscriptions, Palenque. Museo Nacional de Antropología, Mexico City. (Photograph from the Archivo Digital de las Colecciones del Museo Nacional de Antropología, sponsored by the Instituto Nacional de Antropología e Historia, and the Canon Corporation; courtesy of the Museo Nacional de Antropología.)

including great depth, enormous pressure, and extremely low temperatures of metamorphism (Harlow 1993:13). In Mesoamerica, such conditions only occur in Guatemala (Bishop et al. 1991:329–332; Harlow 1993:13), and the only pyroxene deposits presently known are found along the Motagua River and in adjacent regions (Figure 2.9).[7] With the aid of laser ablation inductively coupled plasma mass spectrometry (LA-ICP-MS),[8] we detected clear similarities between some of the mask's tesserae and jades originating from sites in the central Motagua Valley, which were commonly exploited by the Maya (Kovacevich 2006:144; Neff et al. 2010:134). Thanks to X-ray florescence (XRF) spectrometry,[9] we know that these Palenque craftsmen also used a jade whose composition resembled specimens from the Alta Verapaz region, also in Guatemala (Ruvalcaba Sil 2011).

Once again, the restoration process offered the ideal occasion for studying manufacturing techniques (Filloy Nadal 2010), as one of the first tasks we undertook was the complete disassembly of the mosaic. The funerary mask is composed of more than 350 jade fragments (Figure 2.10e), among which no two pieces are exactly alike (Filloy Nadal and Martínez del Campo Lanz 2010). Our analysis of the tesserae revealed that the pieces were worked by means of cutting and grinding before being polished. Using SEM, we observed manufacturing marks on the tesserae left by prehispanic tools, which allowed us to summarize the technical sequence followed by the Maya craftsmen in this manner: the pieces were cut and incised with obsidian chips or blades, ground on limestone slabs, perforated with flint chisels or chips, polished with jadeite nodules, and perhaps burnished with

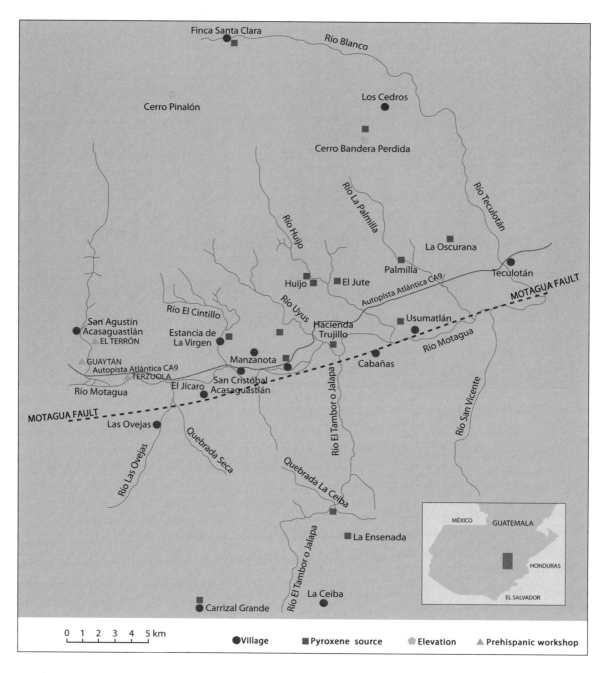

figure 2.9
Pyroxene deposits in the Motagua and Verapaz regions of Guatemala. (Map by Yuriria Pantoja Millán, with data based on Gendron et al. 2002; Hammond et al. 1977; Harlow et al. 2011; Ricardo Sánchez Hernández, personal communication, 2012; Seitz et al. 2001; Weyl 1980.)

leather to achieve a fine luster (Melgar Tísoc et al. 2013; Figure 2.10a–d). This technical sequence is not unknown in the Motagua and Passion River areas. For example, archaeologists who excavated a lapidary workshop at Cancuen found limestone slabs with the silhouettes of beads that had been shaped on them, as well as the obsidian blades and jadeite polishers that the craftsmen had used (Kovacevich 2006, 2015). It is interesting to note that some of the tesserae of the funerary mask were made from old greenstone earspools, beads, and pendants, and included recycled pieces depicting human faces,

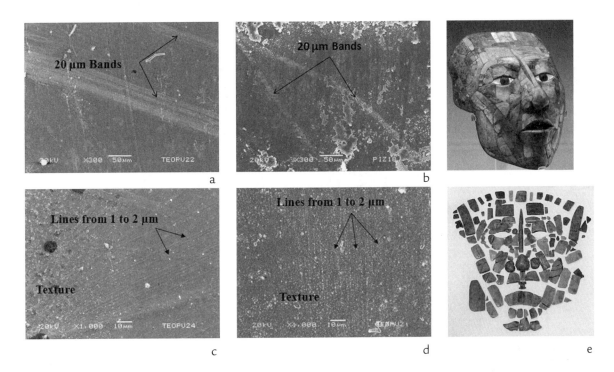

figure 2.10

Manufacturing marks related to the study of K'inich Janaab' Pakal's mask (pictured on top right): a–b) two jade tesserae from the mask; c) experimental grinding of jadeite with sandstone; d) experimental polishing of jadeite with a jadeite nodule; and e) the disassembled mask. (SEM images by José Antonio Alva and Emiliano Melgar Tísoc for the Proyecto Estilo y Tecnología de los Objetos Lapidarios en el México Antiguo, Museo del Templo Mayor; courtesy of the Laboratorio de Conservación, Museo Nacional de Antropología, and the Instituto Nacional de Antropología e Historia. Photographs courtesy of the Laboratorio de Conservación, Museo Nacional de Antropología.)

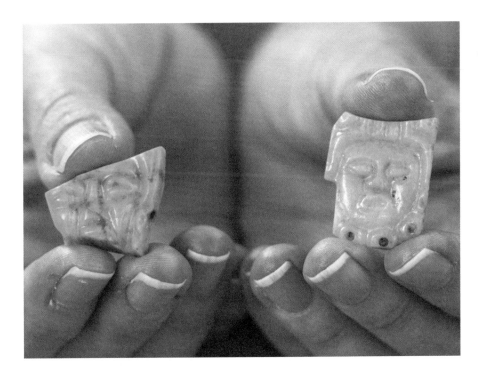

figure 2.11

Glyphs on the back sides of two tesserae from K'inich Janaab' Pakal's mask. Museo Nacional de Antropología, Mexico City. (Photograph courtesy of the Laboratorio de Conservación, Museo Nacional de Antropología.)

figure 2.12

Comparative colorimetric values of four artifacts among the funerary accoutrements of K'inich Janaab' Pakal. (Illustration by Laura Filloy Nadal, after Ruvalcaba Archivo Digital et al. 2011; photographs from the Archivo Digital de las Colecciones del Museo Nacional de Antropología, sponsored by the Instituto Nacional de Antropología e Historia, and the Canon Corporation; courtesy of the Museo Nacional de Antropología.)

geometric motifs, or carved glyphs (Figure 2.11). We will return below to discuss the significance of these reused elements. Moreover, the mosaic mask contained six different shades of greenstone, each of which was employed on specific areas of the face either to define an anatomical element or adornment or to draw the viewer's attention toward the central portion (Filloy Nadal 2012).[10] For example, the craftsmen used three luminous, pale green tesserae to represent the central jewel of a schematic diadem on the mask and various emerald green platelets for the ends of the depicted diadem (see Figures 2.8 and 2.10e). The central part of the face contained the brightest green, also known as "imperial jade," while the hair was represented with a darker, mottled shade.

Spectrophotometric measurements enabled us to chromatically differentiate the jade objects in the funerary assemblage.[11] In Figure 2.12, the chromatic groupings are clear: Pakal's mask (10-1300) and actual diadem (10-1291), for example, possess the brightest shade, corresponding to the imperial jade from the central Motagua area (Manrique Ortega 2012). The beads of the pectoral (10-1288) and necklace (10-1286), on the other hand, have a darker hue, characteristic of jade originating from Alta Verapaz, west of the Motagua River (Manrique Ortega 2012; Ruvalcaba Sil et al. 2012). These data would suggest that the Maya craftsmen selected specific shades of jade for each artifact of the assemblage from different sources, though all still within the Motagua River fault zone.

In terms of the original process used to assemble the mask during the Late Classic period, beveled edges on all of the tesserae and the use of a wooden support and a lime paste adhesive enabled precise adjustment of the pieces. During the restoration, we identified a logical assembly sequence: the craftsmen must have begun in the center with nose, eyes, and mouth, then continued on to the cheeks and chin, followed by the forehead and diadem, and finally the ears and the sides of the mask.

This concerted, collective effort to produce the Palenque ruler's funerary accoutrements ensured that Lord K'inich Janaab' Pakal was suitably adorned to journey into the world of death and to achieve his final apotheosis. Iconographically, the characteristic features of the funerary mask from the Temple of the Inscriptions are also those of the maize god. The mask and the jade accessories are the locus of the deity they embody; thus, their bearer is inseparable from the entity that he represents (Freedberg 1991:31). Therefore, interring the ruler with this jade assemblage equates him with the maize god, who is perpetually revitalized inside the sacred mountain (Filloy Nadal 2014; see also Brittenham and Magaloni, this volume). Just like the maize god, Maya sovereigns were able, in turn, to overcome the trials of the underworld and thus death itself, to emerge from the depths transformed into divine beings (Houston and Stuart 1996) and powerful ancestors (Filloy Nadal 2014). Accordingly, the scene carved on the lid of Pakal's sarcophagus depicts the transformation of the deified ruler who, like maize, returns from the underworld by way of the cosmic tree to arrive in the celestial realm as K'inich Ahau.

A Dramatic Scene at the Center of the Cosmos: Offering 4 from La Venta

The third and final set of artifacts is the famous Offering 4 from La Venta, discovered in 1955 in Complex A, a ritual area of restricted access located north of the ceremonial precinct. The offering has been dated at around 700 BCE, and it was situated in the construction fill covering Massive Offering 3,

an installation of hundreds of carved blocks of dark green serpentinite (González Lauck 2004; González Lauck and Courtès 2013; Pool 2007:160–164). Offering 4 is a homogenous, compact group of sixteen anthropomorphic male figurines standing in solemn assembly, framed by six celts that resemble stelae (Figure 2.13).

Three figurines taken from the offering had resided in the Smithsonian Institution since the 1970s. They were returned to Mexico in May 2012 (Magaloni Kerpel and Filloy Nadal, eds. 2013), whereupon we had an opportunity to closely examine the varieties of stone employed by the Olmecs (Magaloni Kerpel and Filloy Nadal, eds. 2013). With a combination of noninvasive studies and XRD, we were able to determine that five types of stone were used.[12] One of the celts was crafted from a bright green pyroxenite, while the other five were made of albitic jadeite, a pale rock with green veins. Of the sixteen figurines, one (7/22) was made of plagiogranite, an igneous rock, while three types of metamorphic rock were employed for the rest, including one (9/22) made of albitic jadeite; another (22/22) composed of zoisite, chlorite, cordierite, and chromite,[13] characterized by its bright emerald green color with dark spots; and thirteen crafted from mylonitic serpentinite (Filloy Nadal et al. 2013; Sánchez Hernández 2012; Figures 2.14 and 2.15).

The Olmecs of La Venta must have obtained these raw materials from distant regions before working them into figurines and celts for the offering. Using Fourier Transform Infrared (FTIR) spectroscopy, we identified two distinct groups of jadeites whose spectra corresponded with Motagua and Alta Verapaz sources, respectively (see Figures 2.6 and 2.9). Moreover, the composite emerald-colored stone with dark spots used for one of the figurines and the pyroxenite used for one of the celts also may have come from the Motagua River fault zone (Ruvalcaba Sil et al. 2012).[14] At this time, the specific sources where the Olmecs exploited plagiogranite are not known. As previously mentioned, the most common type of stone in Offering 4 is the mylonitic serpentinite used for thirteen of the figurines, which came from sites

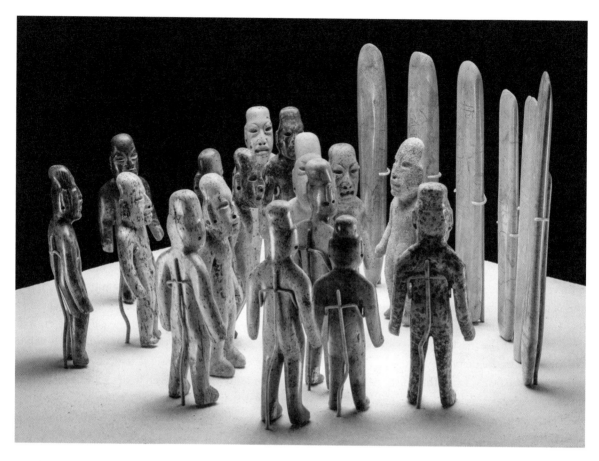

figure 2.13

La Venta Offering 4 (10-9650), now exhibited in the Hall of Gulf Coast Cultures, Museo Nacional de Antropología, Mexico City. (Photograph from the Archivo Digital de las Colecciones del Museo Nacional de Antropología, sponsored by the Instituto Nacional de Antropología e Historia, and the Canon Corporation; courtesy of the Museo Nacional de Antropología.)

located in the Sierra de Juárez of Oaxaca (Sánchez Hernández 2012; see Figure 2.5).

The production of both the celts and the figurines followed the same technical sequence. First, preforms were obtained by means of percussion, and then their shapes were refined by grinding on sandstone slabs (Drucker 1952:146; Jaime-Riverón 2013). The cuts, incisions, and perforations were likely made with obsidian or flint, while the finish must have been obtained with a stone of considerable hardness and probably burnished with leather (Walsh 2013).[15]

In terms of form, the figurines are fairly homogenous.[16] Only the albitic jadeite figurine (9/22) exhibits significant differences.[17] At the time of its placement, this figurine was already missing the lower portion of its left arm, thus it may have been a relic. Three of the celts also appear to be recycled pieces that may have previously formed part of a pectoral (Jaime-Riverón 2013:69, 73, 77; Figure 2.16). At the time of their interment, all of the figurines were carefully coated with cinnabar and hematite,[18] and their feet and the bases of the celts were planted in reddish-brown sand and clay so that they would stand upright. Subsequently, white sand was added until the heads of the figurines were completely covered. Finally, the entire complex was sealed with a layer of brown sand and clay, then a thin succession of pink, rose, white, and tan-colored floors, and lastly a thick red clay cap that formed the platform floor above the offering (Drucker et al. 1959:154–155).

figure 2.14

Texture and characteristics of four types of rocks utilized in La Venta Offering 4 (10-9650): a) plagiogranite; b) albitic jadeite; c) the metamorphic zoisite, chlorite, cordierite, and chromite composite; and d) mylonitic serpentinite. (Microphotography courtesy of the Laboratorio de Conservación, Museo Nacional de Antropología.)

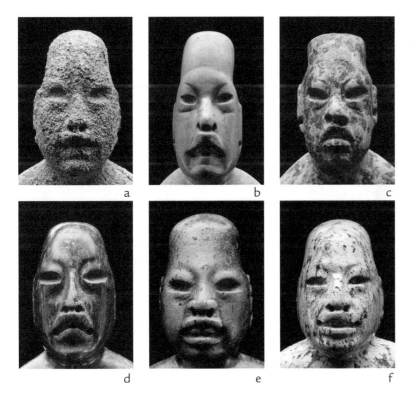

figure 2.15

Detail of the faces of six figurines from La Venta Offering 4 (10-9650): a) 7/22; b) 9/22; c) 22/22; d) 13/22; e) 15/22; and f) 20/22. (Photographs from the Archivo Digital de las Colecciones del Museo Nacional de Antropología, sponsored by the Instituto Nacional de Antropología e Historia, and the Canon Corporation; courtesy of the Museo Nacional de Antropología.)

In spite of the figurines' relative formal homogeneity, biometric variations suggest that each figurine depicted a particular individual who played a specific role in the scene represented in Offering 4 (Bautista Martínez 2013). No iconographic symbols offer clues to the individuals' identity or social status, although dental mutilation or cranial deformation may be indicative of the latter. Nevertheless, our analysis (Magaloni Kerpel and Filloy Nadal 2013) leads us to believe that the selected color and type of stone indicated the rank or the preferential role played by some of the figurines placed in strategic locations (Figure 2.17). The scene unfolds within a space bordered on the east side by six celts that seem to simulate stelae; only the plagiogranite figurine (7/22) faces west with his back toward the stelae. On the south end of the scene, slightly removed, we see the mottled, emerald-colored figurine (22/22) who observes, from a privileged position, a group of individuals who seem to walk toward him. The albitic jadeite figurine (9/22) stands slightly to the east of this group and the file of personages he heads. The other figurines, all made of serpentinite, appear to be spectators of the action occurring near the stelae.

In this context, we think that the plagiogranite figurine (7/22) may be a captive or a notable personage who is distinguished from the rest by his yellowish hue and isolated position, standing with his back toward the row of stelae. Undoubtedly, the mottled individual (22/22) is the most important member of the group and the one presiding over the ritual, for his emerald green color with black inclusions (similar to jaguar skin) gives him a striking and singular appearance; his unique biometric

figure 2.16
Celt (4/22) from La Venta Offering 4 (10-9650), Museo Nacional de Antropología, Mexico City. (Photograph from the Archivo Digital de las Colecciones del Museo Nacional de Antropología, sponsored by the Instituto Nacional de Antropología e Historia, and the Canon Corporation; courtesy of the Museo Nacional de Antropología.)

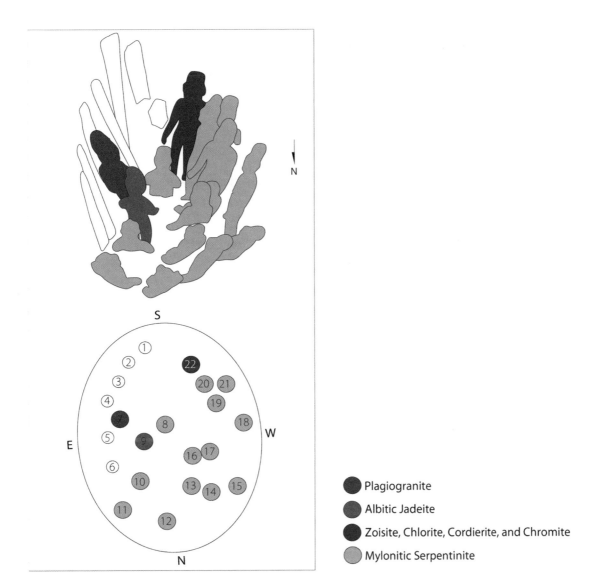

figure 2.17

Distribution of the La Venta Offering 4 figurines based on their type of raw material. (Drawing by Mariana López Filloy and Yuriria Pantoja Millán, based on Drucker et al. 1959:fig. 38.)

features (advanced age, rectangular face, erect annular cephalic deformation) further distinguish him (see Bautista Martínez 2013). In this arrangement, a line of individuals, headed by the albitic jadeite figurine (9/22), seem to file by the captive (7/22) toward this high-ranking figure (22/22) (Magaloni Kerpel and Filloy Nadal 2013).

Joyce Marcus (2009) has proposed that Offering 4 may have been deposited during a dedication ritual for the Northeast Platform of Complex A at La Venta. Noting that the alignment of the celts in the

offering resembles the position of the columns that border the ceremonial court just above the deposit, she believes that the figurines mimic the same positions that the royal individuals would have assumed in the court during a particular ceremony. In fact, the superficial buildings of Complex A—as well as the interred offerings beneath them—seem to follow a pattern associated with the representation of the universe and the position of the ruler as axis mundi (Marcus 2009:28–31; for more information, see also Reilly 2002).

The Raw Materials and the Contexts of Their Use

Based on the foregoing examination of these three sets of artifacts, the following reflections on value and meaning may be made in terms of the use of greenstone in the production of offerings in different areas of Mesoamerica.

Origin and Sources

These three cases demonstrate that craft producers had access to raw materials from various sources that yielded several shades of greenstone with different characteristics. The Olmecs and Teotihuacanos obtained a dark green serpentinite from deposits relatively close to their cities in territories under their control. Moreover, both cultures had access—albeit more limited—to greenstone that originated in the Maya area. Based on indirect evidence presented above, we know that during the Middle Formative period, Olmecs were importing a pale jade from central Motagua and Alta Verapaz sources, later to be worked in shops within the nuclear area of the Gulf of Mexico.[19] Teotihuacanos, on the other hand, would import prefinished objects from the Maya area. In the case of the Maya of Palenque, K'inich Janaab' Pakal had managed to expand the borders of his kingdom and forge the necessary relations to gain access to the jadeite of the central Motagua and Verapaz regions. There, the Maya obtained the imperial jade whose intense hue was highly valued during the Late Classic period and is absent in the Palenque tombs from earlier times (Filloy Nadal 2014).

The Technical Sequences

In all three of these cases, craftsmen clearly mastered the lapidary arts to produce complex artifacts of high aesthetic quality. All three cultures followed the same technical sequence (when percussion was not used) of cutting, grinding, polishing, and burnishing, but the tools they employed often differed (Table 2.2). For example, obsidian or flint blades were used for cutting, depending on the case. The abrasive stones used for grinding were easily accessible in the area near the workshops: Teotihuacan craftsmen preferred slabs of volcanic rock, such as andesite, whereas the Maya employed limestone and the Olmecs sandstone. The selection of raw materials for polishing, on the other hand, depended on the hardness of the stone that had to be smoothed: flint for serpentinite (Mohs 2–3.5), which is softer, and jadeite for green quartz (Mohs 7) or jade (Mohs 6–7.5). In all cases, however,

table 2.2

Technical sequence and raw materials employed in the production of the three sets of objects, based on the results obtained through archaeometric techniques and experimental archaeology

OBJECT	PROVENANCE	RAW MATERIALS
anthropomorphic sculpture	Burial 6, Pyramid of the Moon, Teotihuacan	serpentinite
beads of necklace	Burial 6, Pyramid of the Moon, Teotihuacan	jadeite, metadiorite, and quartz
earspool	Burial 6, Pyramid of the Moon, Teotihuacan	fuchsite
mask	Temple of the Inscriptions, Palenque	jadeite
figurines and celts	Offering 4, La Venta	jadeite, serpentinite, and composite metamorphic stone

n/a: not applicable
n/d: no data

polishing and burnishing combined to transform the rough and dull character of the stone's natural state into smooth and lustrous surfaces. Obviously, bringing out these physical and optical qualities in the stone required a technical mastery that was the hallmark of specialized, full-time craftsmen.

The Qualities and Values of the Raw Materials

Everything seems to indicate that greenstone varieties from the central Motagua area were scarcer and most valued (especially the imperial green). Their rarity was an incentive for them to be passed down from generation to generation, and even reused (Renfrew 2004). At Teotihuacan, up until now, only Burials 5 and 6 at the Pyramid of the Moon have yielded objects crafted in greenstone from the Maya area, which are associated with sculptures and individuals of high rank in their respective deposits (Sugiyama and López Luján 2006, 2007). Some of the artifacts in Offering 4 at La Venta were recycled from older pieces and may have been considered relics. We observed a similar phenomenon in the funerary mask from the Temple of the Inscriptions at Palenque, where old pieces of imperial jade were modified and transformed into small tesserae and placed in the areas of utmost importance: under the eyes and next to the mouth. Particularly noteworthy is the presence of the *ik* (wind/breath) symbol on the back of one of the tessera found next to

the mouth. Such placement perhaps reinforces the association with breath, spirit, or vital essence, and may also have had the same significance as placing a greenstone bead in the mouth of the deceased. Because relics were thought to have been crafted by extraordinary beings, they were viewed as possessing a supernatural quality. This feature made them valuable (Coggins 1998; Wagner 2000:68), as they contained a portion of the vital essence of an exceptional ancestor. Apparently, this essence resided not only in complete pieces but also in their fragments (Joyce 2000; Weiner 1992).

Over the course of many centuries of working these obdurate materials, master craftsmen won a hard-earned and profound knowledge of the physical qualities and symbolic values associated with each type of rock. This wisdom is clearly evident in their careful selection of raw materials based on various criteria, such as geological origin. The anthropomorphic sculpture from the Pyramid of the Moon and eighty percent of the figurines in Offering 4 are of serpentinite, which, significantly, was the most widely used raw material in the lapidary of Teotihuacan and La Venta. In contrast, the jadeites originating in the central Motagua and Verapaz regions were specifically used for the celts and the most important figurines of the Olmec offering, the accessories adorning the Moon Pyramid sculpture, and the funerary

TECHNICAL PROCESSES

CUTTING	GRINDING	INCISING OR DRILLING	POLISHING	BURNISHING
flint chips or blades	andesite	flint chips or blades (incising)	flint nodules	leather
flint chips or blades	limestone	obsidian dust and reed (drilling)	jadeite nodules	leather
flint chips or blades	limestone	n/a	jadeite nodules	leather
obsidian chips or blades	limestone	flint chips or blades (incising)	jadeite nodules	leather
n/d	probably sandstone (Drucker 1952:146)	n/d	n/d	n/d

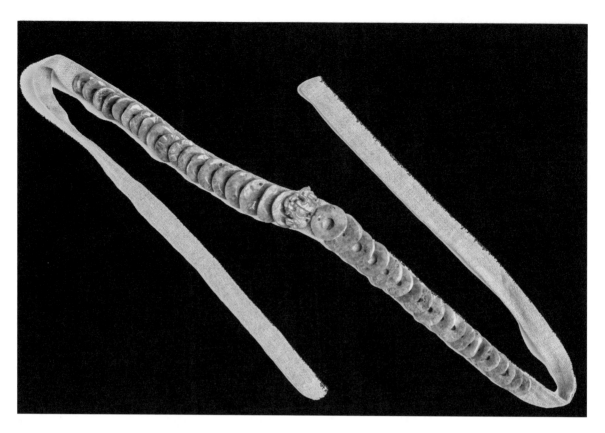

figure 2.18

K'inich Janaab' Pakal's diadem (10-1291), from the Temple of the Inscriptions, Palenque. Museo Nacional de Antropología, Mexico City. (Photograph from the Archivo Digital de las Colecciones del Museo Nacional de Antropología, sponsored by the Instituto Nacional de Antropología e Historia, and the Canon Corporation; courtesy of the Museo Nacional de Antropología.)

accoutrements of K'inich Janaab' Pakal. In all of these Mesoamerican cultures, the use of jadeite was limited to elites, who conveyed their power by wearing insignia and jewelry crafted from this material. The physical qualities of each rock and the potential final product also were a factor in valorization and selection. For example, thanks to burnishing, jadeite achieves an exceptional luster and sheen, much greater than serpentinite allows. Moreover, metamorphic rocks are extremely resistant to intemperism, or weathering, and they retain their optical qualities even after being buried for long periods of time.

On the other hand, color was an attribute that underscored the value and utility of each object. In the case of the Teotihuacan sculpture, the lustrous pale green accessories from the central Motagua area reinforced the high status, whether ruler or deity, of the personage represented. The bright green color holds an even greater value when we consider artifacts found in Burial 5 at the Pyramid of the Moon, where the principal personage wears a large pendent, also made of Motagua jadeite, in the shape of a bar that represented time (Sugiyama and López Luján 2007:135–136, fig. 8). In the case of Pakal, his funerary mask schematically depicts a diadem with pieces, especially the central one, of exceptionally brilliant imperial jade. Similarly, Pakal's actual diadem (Figure 2.18) bears in the center an image of the piscine version of the Jester God, a motif that alludes to water in different forms—both as rain and as streams, rivers, and lakes (Taube and Ishihara-Brito 2012:148–149)—as well as to maize and to royal power (Fields 1991; Filloy Nadal 2014).

Polysemic and Symbolic Characteristics

As we have seen, the value and use of greenstone embraced concepts related to wealth, preciosity, perfection, abundance, eternity, the breath spirit or vital essence, and centrality. In these three lapidary ensembles ranging across time and space in Mesoamerica, the locations where such greenstone offerings were placed marked the axis mundi, or sacred mountain, which was linked to vegetation, maize, regeneration, governmental authority, and royal succession.

Concluding Remarks

This comparative analysis has revealed that the three sets of lapidary items discovered by archaeologists at Teotihuacan, Palenque, and La Venta are the result of technical processes that are both complex and multidimensional. We have seen how Mesoamerican craft specialists in different times, places, and cultures made a long series of individual and collective decisions throughout the production process, or chaîne opératoire (Leroi-Gourhan 1964–1965, 1993). Although rooted in the artisans' own traditions, material production was marked by a desire to combine stylistic and technological innovation and excellence (Sackett 1982). These full-time specialists carefully selected types of greenstone according to their physical qualities and origin, but they also based their decisions on the economic, social, political, and religious values attributed to the stones by the societies to which they belonged. In order to transform these raw materials, artisans employed a diverse tool set, made from materials that were accessible and suitable for creating objects of great technical perfection and beauty. This is how they produced precious goods that conveyed the status of those who possessed them and that often facilitated communication with deities when the items constituted parts of tombs and offerings.

This analysis has also confirmed the enormous transcendence of greenstone—especially the metamorphic varieties—in the lapidary work performed over the course of nearly one and a half millennia. But we have seen that not all varieties of greenstone enjoyed the same level of prestige. The historical sources tell us that the Postclassic societies of Central Mexico attributed varied values and meanings to different types of greenstone, depending on their real or imagined properties. We have pointed to the ways in which a similar taxonomy and hierarchy can be seen to be at work in these three groups of artifacts, created at different times and places in Central Mexico, in the Maya area, and on the Gulf Coast. In all cases, the selection of raw materials was based on well-established criteria. The value of each artifact increased proportionally based on the origin, rarity, purity, transparency, luster, and chromatic intensity of the raw materials involved. The varieties most valued for their qualities, such as imperial jade, were precisely those that were utilized to elevate the splendor of an artifact or a specific portion thereof. And without doubt, this significantly contributed to the ways in which the exceptional lapidary objects examined here, each in their respective ritual contexts, contributed to the equilibrium and renewal of the universe.

Acknowledgments

This essay has greatly benefited from discussions I had with my friend and colleague Diana Magaloni Kerpel while we worked together on the text commemorating the return of La Venta Offering 4 to the Museo Nacional de Antropología in Mexico City. I also wish to express my gratitude and appreciation to Joanne Pillsbury and Colin McEwan for encouraging me to present this work in the "Making Value, Making Meaning: Techné in the Pre-Columbian World" symposium at Dumbarton Oaks; to organizer Cathy Costin for offering many valuable comments during the preparation of the essay; and to Scott Sessions for translating my Spanish text into English.

1 The informants of Sahagún (1950–1982:11:222–226, 2000:3:1118–1123; Thouvenot 1982:138–142) identified the following varieties of greenstone: 1) *quetzalitztli* (emerald green, transparent, dense, the color of the tail feathers of the quetzal bird); 2) *quetzalchalchihuitl* (very green, without mottling, transparent, easy to work); 3) *chalchihuitl* (green, opaque, mixed with white); 4) *tlilayotic chalchihuitl* (green and black, opaque); 5) *iztac chalchihuitl* (very pale, green mottling, some with green or bright blue veins); 6) *mixtecatetl* (green, mottled like a jaguar with white or black spots, of lesser value); 7) *xiuhtomotetl* (green, mottled with white); 8) *xoxouqui tecpatl* (similar to *chalchihuitl*, lapidaries called it *tecelic* because it was easy to carve); and 9) *toltecaitztli* (bright green, highly esteemed).

2 Chapter 17 in Book 9 of the *Florentine Codex*, however, is devoted to the working of precious stones. It lists and depicts the characteristic activities of a lapidary: cutting the stone, then grinding, polishing, and burnishing the surface (Sahagún 1950–1982:9:79–82, figs. 66–69, 1979:3:54r, 55v, 56r). Interestingly, among the words chosen to describe working with greenstone, percussion (*teuia*) is not mentioned; rather, the shape of the object is obtained by cutting (*tequi*) and grinding (*canaua*). For a comprehensive account of the terms used for lapidary production in the *Florentine Codex*, see Thouvenot 1982:193–194.

3 In order to produce the sculpture, a support was carved out of wood from a local conifer of the Pinaceae family, probably from the genus *Pinus* (Quintanar Isaías 2006). Subsequently, only the front of the wooden support was covered with greenstone tesserae, with an extremely sticky gray clay used as an adhesive.

4 The pieces were studied with SEM at amplifications of 100×, 300×, 600×, and 1,000×, using a Joel JSM-6460LV operated by José Antonio Alva at the Laboratorio de Microscopía Electrónica, Subdirección de Laboratorios y Apoyo Académico Instituto Nacional de Antropología e Historia.

5 The comparative study was carried out by members of the Proyecto de Lapidaria del Templo Mayor: Estilos y Tradiciones Tecnológicas (Templo Mayor Lapidary Styles and Technological Traditions Project), directed by archaeologist Emiliano Melgar Tísoc, who has been replicating modifications observed on many archaeological objects—including percussion fracturing, cutting, grinding, drilling, incising, smoothing, and finishing—using tools and processes that: 1) are mentioned in the sixteenth-century historical sources (Sahagún 1950–1982:9:79–82); 2) have been observed on archaeological objects and on tools recovered in controlled excavations (Domínguez Carrasco and Folan 1999:643; Kovacevich 2006:74–86; Rochette 2009:209–216); and 3) may have been used in prehispanic Mexico, according to specialized studies (Digby 1972:15–16, 20; Kidder 1947:122–123; Mirambell 1968; Smith and Kidder 1951:33–36). At the end of the experimental phase, silicone rubber molds were made, and the manufacturing marks on the experimentally produced objects were obtained and analyzed with SEM. The same procedure was carried out on the archaeological objects. Finally, the experimental marks were compared with those detected on the archaeological pieces.

6 The identification of the minerals with XRD was done by Jasinto Robles Camacho and Ricardo Sánchez Hernández of the Instituto Nacional de Antropología e Historia, and Margarita Reyes Salas of the Instituto de Geología, Universidad Nacional Autónoma de México.

7 The jadeite pyroxene sources reported for the Motagua River fault zone are located in Guatemala near Kaminaljuyú (Bishop et al. 1998:259), El Manzanal (Foshag and Leslie 1955:81) or Manzanotal, and San Cristóbal Acasagustlán (Barbour 1957; Becquelin and Bosc 1973:67). More recently, however, additional deposits have been located in the Tambor and Jalapa River basins (Seitz et al. 2001), the Sierra de las Minas region (Jaime-Riverón 2003, 2010; Seitz et al. 2001), and the Salamá Valley of Baja Verapaz (Andrieu et al. 2012).

8 The LA-ICP-MS was performed by Hector Neff, Brigitte Kovacevich, and Ronald L. Bishop (2010) in the Archaeometry Laboratory, Institute for Integrative Research in Materials, Environments, and Societies, California State University, Long Beach.

9 The XRF studies were conducted by José Luis Ruvalcaba Sil of the Instituto de Física, Universidad Nacional Autónoma de México, with a SANDRA (Non-Destructive X-Ray Analysis System) team

using a molybdenum (Mo) X-ray tube, 1.5 mm diameter 30 kV beam spot, 0.2–0.4 mA, and a 120–180s Si-PIN detector (Ruvalcaba Sil et al. 2012). For a detailed discussion of this technology, see Ruvalcaba Sil et al. (2010).

10 This characteristic is not limited to Classic-period Maya masks. In the British Museum's collection, fine examples from Postclassic Mesoamerica include various objects with turquoise appliqués, in which some attributes were highlighted with brighter shades of blue (McEwan et al. 2004:43–44).

11 These measurements were conducted by José Luis Ruvalcaba Sil of the Instituto de Física, Universidad Nacional Autónoma de México, with an Ocean Optics USB 2000 spectrometer, 10 mm slit, 300–1000 nm range, 600 mm optic fibers, deuterium-halogen (DH) lamp, and 0.1 nm resolution.

12 The mineralogical identification was made by Ricardo Sánchez Hernández (2012) of the Subdirección de Laboratorios y Apoyo Académico, Instituto Nacional de Antropología e Historia. Fourier Transform Infrared (FTIR) and FRX analyses were conducted by José Luis Ruvalcaba Sil of the Instituto de Física, Universidad Nacional Autónoma de México (Ruvalcaba Sil et al. 2012).

13 The mineralogical identification of this figurine (22/22) required XRD analysis, which was conducted by Jasinto Robles Camacho of the Laboratorio de Arqueometría del Occidente, Instituto Nacional de Antropología e Historia.

14 With regard to this figurine (22/22), I have not found any bibliographical references concerning the location of zoisite deposits in Mesoamerica, but it is interesting to note that it has been found as a secondary mineral in jadeite chips in the lapidary workshops of Guaytán, Guatemala (Garza Valdés 1993).

15 The technological study of the three figurines that formerly resided at the Smithsonian Institution was performed by Jane Walsh, but her results have not yet been fully published. A technological analysis of all twenty-two objects of La Venta Offering 4, following the methodology described above, is still pending at the Museo Nacional de Antropología.

16 The sixteen personages are standing upright, facing forward, with their arms at their sides. Their heights are similar, averaging 17.9 cm and ranging from 17 to 20.5 cm (Magaloni Kerpel and Filloy Nadal 2013:134).

17 This figurine (9/22) is distinguished from the rest of the group by its morphological characteristics as well as its color and type of stone (see Figures 2.14b and 2.15b): a very pale green (Munsell 5Y 7/2) albitic jadeite (Magaloni Kerpel and Filloy Nadal 2013:147).

18 Even the incomplete arm of the albitic jadeite figurine (9/22) was coated with cinnabar, which indicates that it was already broken when it was placed in the offering.

19 The interregional exchange of jadeite during the Formative period has been described for various sites in the area of Olmec influence. There is evidence of occupation and the exploitation of jadeite in the Motagua area from the Middle Formative to the Postclassic periods (Taube et al. 2004), whose distribution reached various Olmec sites in the Central Highlands, including the lapidary workshop found at Nativitas in Tlaxcala (Hirth et al. 2009:169). LA-ICP-MS analysis of samples from the Nativitas workshop yielded results consistent with jadeite originating in the Motagua and Alta Verapaz regions, respectively (Hirth et al. 2009:169).

REFERENCES CITED

Andrieu, Chloé, Mélanie Forné, and Arthur Demarest
2012 El valor del jade: Producción y distribución del jade en el sitio de Cancuén, Guatemala. In *El jade y otras piedras verdes: Perspectivas interdisciplinarias e interculturales*, edited by Walburga Wiesheu and Gabriela Guzzy, pp. 145–180. Instituto Nacional de Antropología e Historia, Mexico City.

Ascher, Robert
1961 Experimental Archaeology. *American Anthropologist* 63(4):793–816.

Barbour, George B.

1957 A Note on Jadeite from Manzanal, Guatemala. *American Antiquity* 22(4):411–412.

Bautista Martínez, Josefina

2013 Descripción antropométrica de las figurillas de la Ofrenda 4 de La Venta. In *La Ofrenda 4 de La Venta: Un tesoro olmeca reunido en el Museo Nacional de Antropología; Estudios y catálogo razonado*, edited by Diana Magaloni Kerpel and Laura Filloy Nadal, pp. 89–102. Instituto Nacional de Antropología e Historia, Mexico City.

Becquelin, Pierre, and Eric A. Bosc

1973 Notas sobre los yacimientos de albita y jadeíta de San Cristóbal Acasaguastlán, Guatemala. *Estudios de cultura maya* 9:67–73.

Binford, Lewis R.

1977 General Introduction. In *For Theory Building in Archaeology: Essays on Faunal Remains, Aquatic Resources, Spatial Analysis, and Systemic Modeling*, edited by Lewis R. Binford, pp. 1–10. Academic Press, New York.

Bishop, Ronald L., Frederick W. Lange, and Elizabeth Kennedy Easby

1991 Jade in Meso-America. In *Jade*, edited by Roger Keverne, pp. 316–341. Anness Publications, London, and Van Nostrand Reinhold, New York.

Bishop, Ronald L., Dorie Reents-Budet, Virginia M. Fields, and David Mora Marín

1998 El jade de Costa Rica y la región maya en la época precolombina: Sus aplicaciones en la interacción internacional. *Los investigadores de la cultura maya* 6(2):258–271.

Coggins, Clemency Chase

1998 Objetos portátiles de arte. In *Los mayas*, edited by Peter Schmidt, Mercedes de la Garza, and Enrique Nalda, pp. 249–269. Consejo Nacional para la Cultura y las Artes and Instituto Nacional de Antropología e Historia, Mexico City.

Curtis, Garniss H.

1959 Appendix 4: The Petrology of Artifacts and Architectural Stone at La Venta. In *Excavations at La Venta, Tabasco, 1955*, edited by Philip Drucker, Robert F. Heizer, and Robert. J. Squier, pp. 284–289. Bulletin 170, Bureau of American Ethnology, Smithsonian Institution, Washington, D.C.

Daston, Lorraine

2008 Introduction: Speechless. In *Things That Talk: Object Lessons from Art and Science*, edited by Lorraine Daston, pp. 9–26. Zone Books, New York.

Digby, Adrian

1972 *Maya Jades*. British Museum, London.

Dobres, Marcia-Anne

1999 Technology's Links and *Chaînes*: The Processual Unfolding of Technique and Technician. In *The Social Dynamics of Technology: Practice, Politics, and World Views*, edited by Marcia-Anne Dobres and Christopher R. Hoffman, pp. 124–146. Smithsonian Institution Press, Washington, D.C.

Domínguez Carrasco, María del Rosario, and William J. Folan

1999 Hilado, confección y lapidación: Los que haceres cotidianos de los artesanos de Calakmul, Campeche, México. In *XII Simposio de Investigaciones Arqueológicas en Guatemala, 1998*, edited by Juan Pedro Laporte, Héctor L. Escobedo, and Ana Claudia Monzón de Suasnávar, pp. 628–646. Museo Nacional de Arqueología y Etnología, Guatemala City.

Drucker, Philip

1952 *La Venta, Tabasco: A Study of Olmec Ceramics and Art*. Bulletin 153, Bureau of American Ethnology, Smithsonian Institution, Washington, D.C.

Drucker, Philip, Robert F. Heizer, and Robert J. Squier

1959 *Excavations at La Venta, Tabasco, 1955*. Bulletin 170, Bureau of American Ethnology, Smithsonian Institution, Washington, D.C.

Fields, Virginia

1991 The Iconographic Heritage of the Maya Jester God. In *Sixth Palenque Round Table, 1986*, edited by Merle Greene Robertson and Virginia Fields, pp. 167–174. University of Oklahoma Press, Norman.

Filloy Nadal, Laura

2012 Mineralogy and Manufacturing
Technique in a Group of Archaeological
Greenstone Mosaics from Classic Period
Mesoamerican Sites. In *Turquoise in
Mexico and North America: Science,
Conservation, Culture, and Collections,*
edited by Jonathan C. H. King, Max
Carocci, Caroline Cartwright, Colin
McEwan, and Rebecca Stacey, pp. 13–26.
British Museum and Archetype, London.

2014 *Costume et insignes d'un gouver-
nant maya: K'inich Janaab' Pakal
de Palenque.* Paris Monographs in
American Archaeology 34. British
Archaeological Reports Series 2590.
Archaeopress, Oxford.

Filloy Nadal, Laura (editor)

2010 *Misterios de un rostro maya: La más-
cara funeraria de K'inich Janaab' Pakal
de Palenque.* Instituto Nacional de
Antropología e Historia, Mexico City.

Filloy Nadal, Laura, María Eugenia Gumí, and
Yuki Watanabe

2006 La restauración de una figura antropo-
morfa teotihuacana de mosaico de ser-
pentina. In *Sacrificios de consagración
en la Pirámide de la Luna,* edited by
Saburo Sugiyama and Leonardo López
Luján, pp. 61–79. Consejo Nacional para
la Cultura y las Artes, Instituto Nacional
de Antropología e Historia, and Museo
del Templo Mayor, Mexico City, and
Arizona State University, Tempe.

Filloy Nadal, Laura, Diana Magaloni Kerpel, José Luis
Ruvalcaba Sil, and Ricardo Sánchez Hernández

2013 Las materias primas utilizadas para
la manufactura de las figurillas y
hachas de la Ofrenda 4 de La Venta:
Caracterización y fuentes de origen. In
*La Ofrenda 4 de La Venta: Un tesoro
olmeca reunido en el Museo Nacional de
Antropología; Estudios y catálogo razo-
nado,* edited by Diana Magaloni Kerpel
and Laura Filloy Nadal, pp. 103–127.
Instituto Nacional de Antropología e
Historia, Mexico City.

Filloy Nadal, Laura, and Sofía Martínez del
Campo Lanz

2010 El rostro eterno de K'inich Janaab'
Pakal: La máscara funeraria. In

*Misterios de un rostro maya: La máscara
de funeraria de K'inich Janaab' Pakal
de Palenque,* edited by Laura Filloy
Nadal, pp. 109–130. Instituto Nacional
de Antropología e Historia, Mexico City.

Filloy Nadal, Laura, and Emiliano Melgar Tísoc

2009 Manufacture Technique of a Figurine
Made of a Greenstone Mosaic from the
Pyramid of the Moon, Teotihuacan,
Mexico. Paper presented at the 18th
International Materials Research
Congress, Cancun, Mexico.

Foshag, William F., and Robert Leslie

1955 Jadeite from Manzanal, Guatemala.
American Antiquity 21(1):81–83.

Freedberg, David

1991 *The Power of Images: Studies in the
History and Theory of Response.* Uni-
versity of Chicago Press, Chicago.

Garza Valdés, Leoncio A.

1993 Mesoamerican Jade: Surface Changes
Caused by Natural Weathering. In
*Precolumbian Jade: New Geological
and Cultural Interpretations,* edited
by Frederick W. Lange, pp. 104–124.
University of Utah Press, Salt Lake City.

Gendron, François, David C. Smith, and Aïcha
Gendron-Badou

2002 Discovery of Jadeite-Jade in Guatemala
Confirmed by Non-Destructive Raman
Microscopy. *Journal of Archaeological
Science* 29:837–851.

González Lauck, Rebecca B.

2004 Observaciones en torno a los contextos
de la escultura olmeca en La Venta. In
*Acercarse y mirar: Homenaje a Beatriz de
la Fuente,* edited by María Teresa Uriarte
and Leticia Staines Cicero, pp. 75–106.
Instituto de Investigaciones Estéticas,
Universidad Nacional Autónoma de
México, Mexico City.

González Lauck, Rebecca B., and Valérie Courtès

2013 La Ofrenda 4 de La Venta: Sus contex-
tos e interpretaciones. In *La Ofrenda 4
de La Venta: Un tesoro olmeca reunido
en el Museo Nacional de Antropología;
Estudios y catálogo razonado,* edited by
Diana Magaloni Kerpel and Laura Filloy
Nadal, pp. 103–127. Instituto Nacional
Antropología e Historia, Mexico City.

Hammond, Norman, Arnold Aspinall, Stuart Feather, John Hazelden, Trevor Gazard, and Stuart Agrell

1977 Maya Jade: Source Location and Analysis. In *Exchange Systems in Prehistory*, edited by Timothy K. Earle and Jonathon E. Ericson, pp. 35–67. Academic Press, New York.

Harlow, George E.

1993 Middle American Jade: Geologic and Petrologic Perspectives on Variability and Source. In *Precolumbian Jade: New Geological and Cultural Interpretations*, edited by Frederick W. Lange, pp. 9–29. University of Utah Press, Salt Lake City.

Harlow, George E., Virginia B. Sisson, and Sorena Sorensen

2011 Jadeite from Guatemala: New Observations and Distinctions among Multiple Occurrences. *Geologica acta* 9(3–4):363–387. Facultat de Geologia, Universitat de Barcelona, Spain.

Hirth, Kenneth G., Mari Carmen Serra Puche, Jesús Carlos Lazcano Arce, and Jason P. De León

2009 Intermittent Domestic Lapidary Production during the Late Formative Period at Nativitas, Tlaxcala, Mexico. In *Housework: Craft Production and Domestic Economy in Ancient Mesoamerica*, edited by Kenneth G. Hirth, pp. 157–173. Archeological Papers of the American Anthropological Association 19. Wiley, Hoboken, N.J.

Houston, Stephen, and David Stuart

1996 Of Gods, Glyphs and Kings: Divinity and Rulership among the Classic Maya. *Antiquity* 70(268):289–313.

Jaime-Riverón, Olaf

2003 El hacha olmeca: Biografía y paisaje. MA thesis, Instituto de Investigaciones Antropológicas, Facultad de Filosofía y Letras, Universidad Nacional Autónoma de México, Mexico City.

2010 Olmec Greenstone in Early Formative Mesoamerica: Exchange and Process of Production. *Ancient Mesoamerica* 21(1):123–133.

2013 Las hachas de jadeíta de la Ofrenda 4 de La Venta. In *La Ofrenda 4 de La Venta: Un tesoro olmeca reunido en el Museo Nacional de Antropología; Estudios y catálogo razonado*, edited by Diana Magaloni Kerpel and Laura Filloy Nadal, pp. 55–88. Instituto Nacional de Antropología e Historia, Mexico City.

Joyce, Rosemary A.

2000 Heirlooms and Houses: Materiality and Social Memory. In *Beyond Kingship: Social and Material Reproduction in House Societies*, edited by Rosemary A. Joyce and Susan D. Gillespie, pp. 189–212. University of Pennsylvania Press, Philadelphia.

Kidder, Alfred Vincent

1947 *The Artifacts of Uaxactun, Guatemala.* Publication 576. Carnegie Institution of Washington, Washington, D.C.

Kopytoff, Igor

1986 The Cultural Biography of Things: Commoditization as a Process. In *The Social Life of Things: Commodities in Cultural Perspective*, edited by Arjun Appadurai, pp. 64–94. Cambridge University Press, New York.

Kovacevich, Brigitte

2006 Reconstructing Classic Maya Economic Systems: Production and Exchange at Cancuén, Guatemala. PhD dissertation, Department of Anthropology, Vanderbilt University, Nashville, Tenn.

2015 La technología del jade: Explotación, técnicas de manufactura, talleres especializados. *Arqueología mexicana* 23(133):42–47.

Lange, Frederick W.

1993 Introduction. In *Precolumbian Jade: New Geological and Cultural Interpretations*, edited by Frederick W. Lange, pp. 1–8. University of Utah Press, Salt Lake City.

Leroi-Gourhan, André

1964–1965 *Le geste et la parole.* 2 vols. Albin Michel, Paris.

1993 *Gesture and Speech.* Translated by Anna Bostock Berger. Massachusetts Institute of Technology Press, Cambridge, Mass.

López Juárez, Julieta

2007 Los objetos de pizarra de Teotihuacan. Paper presented at the Sexto ciclo de conferencias del Templo Mayor y Tlatelolco en voz de sus investigadores,

Museo del Templo Mayor. Manuscript on file, Archivo del Museo del Templo Mayor, Mexico City.

López Luján, Leonardo

2005 *The Offerings of the Templo Mayor of Tenochtitlan.* Rev. ed. University of New Mexico Press, Albuquerque.

2012 Les dépôts rituels et les cérémonies de reconstitution de l'univers à Teotihuacan, Mexique. *Annuaire: Résumés des conférences et travaux* 119:9–23. École Pratique des Hautes Études, Section de Sciences Religieuses, Paris.

2015 Tenochtitlan's Gold: The Archaeological Collection of the Great Temple Project. *Estudios de cultura nahuatl* 49:7–57

López Luján, Leonardo, Laura Filloy Nadal, Barbara Fash, William L. Fash, and Pilar Hernández

2006 The Destruction of Images in Teotihuacan: Anthropomorphic Sculpture, Elite Cults, and the End of a Civilization. *Res: Anthropology and Aesthetics* 49–50:13–39.

Magaloni Kerpel, Diana, and Laura Filloy Nadal

2013 Retrato de los ancestros: La Ofrenda 4 de La Venta y sus 16 figurillas en piedra verde. In *La Ofrenda 4 de La Venta: Un tesoro olmeca reunido en el Museo Nacional de Antropología; Estudios y catálogo razonado,* edited by Diana Magaloni Kerpel and Laura Filloy Nadal, pp. 130–223. Instituto Nacional de Antropología e Historia, Mexico City.

Magaloni Kerpel, Diana, and Laura Filloy Nadal (editors)

2013 *La Ofrenda 4 de La Venta: Un tesoro olmeca reunido en el Museo Nacional de Antropología; Estudios y catálogo razonado.* Instituto Nacional de Antropología e Historia, Mexico City.

Manrique Ortega, Mayra Dafne

2012 Análisis no destructivo por técnicas espectroscópicas de las piedras verdes del ajuar funerario del rey maya Pakal. MA thesis, Facultad de Ciencias, Universidad Nacional Autónoma de México, Mexico City.

Marcus, Joyce

2009 Rethinking Figurines. In *Mesoamerican Figurines: Small-Scale Indices of Large-Scale Phenomena,* edited by Christina T. Halperin, Katherine A. Faust, Rhonda Taube, and Aurore Giguet, pp. 25–50. University Press of Florida, Gainesville.

Mauss, Marcel

1935 Les techniques du corps. *Journal de psychologie normal et pathologique* 32:271–293.

1973 Techniques of the Body. *Economy and Sociology* 2(1):70–88.

McEwan, Colin, Andrew Middleton, Caroline Cartwright, and Rebecca Stacey

2004 *Turquoise Mosaics from Mexico.* The British Museum, London.

Melgar Tísoc, Emiliano R.

2003 La lapidaria del Templo Mayor: Estilos y tradiciones tecnológicas. Manuscript on file, Archivo del Museo del Templo Mayor, Mexico City.

2004 Primer informe del proyecto "La lapidaria del Templo Mayor: Estilos y tradiciones tecnológicas." Manuscript on file, Archivo del Museo del Templo Mayor, Mexico City.

2006 Análisis de huellas de manufactura de la lapidaria de Teopancazco y Xalla, Teotihuacán, México: Informe. Museo del Templo Mayor, Mexico City. Manuscript on file, Archivo del Proyecto Teotihuacan, Élite y Gobierno, Instituto de Investigaciones Antropológicas, Universidad Nacional Autónoma de México, Mexico City.

Melgar Tísoc, Emiliano R., Reyna Solís Ciriaco, and Laura Filloy Nadal

2013 Análisis tecnológico de las piezas de jadeíta y pedernal del cinturón de poder y de la banda frontal de K'inich Janaab' Pakal de Palenque. In *Técnicas analíticas aplicadas a la caracterización y producción de materiales arqueológicos en el área maya,* edited by Adrián Velázquez Castro and Lynneth S. Lowe, pp. 135–162. Centro de Estudios Mayas, Instituto de Investigaciones Filológicas, Universidad Nacional Autónoma de México, Mexico City.

Mirambell, Lorena

 1968 *Técnicas lapidarias prehispánicas.* Instituto Nacional de Antropología e Historia, Mexico City.

Neff, Hector, Brigitte Kovacevich, and Ronald L. Bishop

 2010 Caracterización de los compuestos de la jadeíta mesoamericana: Breve revisión a partir de los resultados obtenidos durante el estudio de la máscara de K'inich Janaab' Pakal. In *Misterios de un rostro maya: La máscara funeraria de K'inich Janaab' Pakal,* edited by Laura Filloy Nadal, pp. 131–137. Instituto Nacional de Antropología e Historia, Mexico City.

Olivier, Guilhem

 2003 *Mockeries and Metamorphoses of an Aztec God: Tezcatlipoca, "Lord of the Smoking Mirror."* University Press of Colorado, Boulder.

Pomar, Juan Bautista

 1941 [1582] Relación de Texcoco. In *Relaciones de Texcoco y de la Nueva España,* edited by Joaquín García Icazbalceta, pp. 1–64. Nueva colección de documentos para la historia de México 3. Salvador Chávez Hayhoe, Mexico City.

Pool, Christopher H.

 2007 *Olmec Archaeology and Early Mesoamerica.* Cambridge University Press, New York.

Quintanar Isaías, Alejandra

 2006 Identificación preliminar de una muestra de madera proveniente del Entierro 6 de la Pirámide de la Luna, Teotihuacan, México. Departamento de Biología, Universidad Autónoma Metropolitana–Iztapalapa. Manuscript on file, Archivo del Laboratorio de Conservación, Museo Nacional de Antropología, Mexico City.

Reilly, F. Kent, III

 2002 The Landscape of Creation: Architecture, Tomb, and Monument Placement at the Olmec Site of La Venta. In *Heart of Creation: The Mesoamerican World and the Legacy of Linda Schele,* edited by Andrea Stone, pp. 34–65. University of Alabama Press, Tuscaloosa.

Renfrew, Colin

 2004 Towards a Theory of Material Engagement. In *Rethinking Materiality: The Engagement of Mind with the Material World,* edited by Elizabeth DeMarrais, Chris Gosden, and Colin Renfrew, pp. 23–31. McDonald Institute for Archaeological Research, Cambridge.

Rivera Dorado, Miguel

 2004 *Espejos de poder: Un aspecto de la civilización maya.* Miraguano, Madrid.

Robles Camacho, Jasinto, Hermann Köhler, Peter Schaaf, and Ricardo Sánchez Hernández

 2008 Serpentinitas olmecas: Petrología aplicada a la arqueometría. *Monografías del Instituto de Geofísica* 13:1–64. Universidad Nacional Autónoma de México, Mexico City.

Robles Camacho, Jasinto, Ricardo Sánchez Hernández, and Margarita Reyes Salas

 2010 La mineralogía de la piedra verde. In *Misterios de un rostro maya: La máscara funeraria de K'inich Janaab' Pakal de Palenque,* edited by Laura Filloy Nadal, pp. 138–143. Instituto Nacional de Antropología e Historia, Mexico City.

Rochette, Eric T.

 2009 Jade in Full: Prehispanic Domestic Production of Wealth Goods in the Middle Motagua Valley, Guatemala. In *Housework: Craft Production and Domestic Economy in Ancient Mesoamerica,* edited by Kenneth G. Hirth, pp. 205–224. Archeological Papers of the American Anthropological Association 19. Wiley, Hoboken, N.J.

Ruvalcaba Sil, José Luis

 2011 Informe preliminar de los materiales constitutivos de las hachuelas del ajuar funerario de K'inich Janaab' Pakal (10-8649, 10-8699) y del Templo Olvidado (10-620825), Palenque, Chiapas. Instituto de Física, Universidad Nacional Autónoma de México. Manuscript on file, Archivo del Laboratorio de Conservación, Museo Nacional de Antropología, Mexico City.

Ruvalcaba Sil, José Luis, Mayra Manrique Ortega, María Angélica García Bucio, V. Aguilar Melo, E. Casanova, and Laura Filloy

2011 Non-Destructive In Situ Characterization of the Mask of Pakal and the Green Stone Burial Dress. Paper presented in the 20th International Materials Research Congress, Quintana Roo, Mexico. Manuscript on file, Archivo del Laboratorio de Conservación, Museo Nacional de Antropología, Mexico City.

Ruvalcaba Sil, José Luis, Héctor Daniel Ramírez Miranda, V. Aguilar Melo, F. Picazo

2010 SANDRA: A Portable XRF System for the Study of Mexican Cultural Heritage. *X-Ray Spectrometry* 39(5):338–345.

Ruvalcaba Sil, José Luis, Malinalli Wong Rueda, María Angélica García Bucio, and Pieterjan Claes

2012 Estudio no destructivo *in situ* de la Ofrenda 4 de La Venta, Tabasco: Informe preliminar. Instituto de Física, Universidad Nacional Autónoma de México. Manuscript on file, Archivo del Laboratorio de Conservación, Museo Nacional de Antropología, Mexico City.

Ruz Lhuillier, Alberto

1973 *El Templo de las Inscripciones, Palenque.* Instituto Nacional de Antropología e Historia, Mexico City.

Sackett, James R.

1982 Approaches to Style in Lithic Archaeology. *Journal of Anthropological Archaeology* 1:59–112.

Sahagún, Bernardino de

1950–1982 *Florentine Codex: General History of the Things of New Spain.* Edited and translated by Arthur J. O. Anderson and Charles E. Dibble. 13 vols. School of American Research, Santa Fe, N.Mex.

1979 *Códice Florentino: El Manuscrito 218–220 de la Colección Palatina de la Biblioteca Medicea Laurenziana.* Facsimile edition. 3 vols. Archivo de la Nación, Secretaría de Gobernación, Mexico City, and Giunti Barbera, Florence.

2000 *Historia general de las cosas de Nueva España.* Edited by Alfredo López Austin and Josefina García Quintana. 3 vols. Consejo Nacional para la Cultura y las Artes, Mexico City.

Sánchez Hernández, Ricardo

2012 Características texturales y mineralógicas de los artefactos de la Ofrenda 4 de La Venta, Tabasco: Informe preliminar. Subdirección de Laboratorios y Apoyo Académico, Instituto Nacional de Antropología e Historia. Manuscript on file, Archivo del Laboratorio de Conservación, Museo Nacional de Antropología, Mexico City.

Sánchez Hernández, Ricardo, and Jasinto Robles Camacho

2005 Petrografía y mineralogía de los componentes líticos de una figura antropomorfa de mosaico procedente de la Pirámide de la Luna, Zona Arqueológica de Teotihuacan: Informe preliminar. Subdirección de Laboratorios y Apoyo Académico, Instituto Nacional de Antropología e Historia. Manuscript on file, Archivo del Laboratorio de Conservación, Museo Nacional de Antropología, Mexico City.

Seitz, Russell, George E. Harlow, Virginia B. Sisson, and Karl A. Taube

2001 "Olmec Blue" and Formative Jade Sources: New Discoveries in Guatemala. *Antiquity* 75(290):687–688.

Smith, Augustus Ledyard, and Alfred Vincent Kidder

1951 *Excavations at Nebaj, Guatemala.* Publication 594. Carnegie Institution of Washington, Washington, D.C.

Sugiyama, Saburo, and Leonardo López Luján

2006 Simbolismo y función de los entierros dedicatorios de la Pirámide de la Luna en Teotihuacan. In *Arqueología e historia del centro de México: Homenaje a Eduardo Matos Moctezuma*, edited by Leonardo López Luján, Davíd Carrasco, and Lourdes Cué, pp. 131–151. Instituto Nacional de Antropología e Historia, Mexico City.

2007 Dedicatory Burial/Offering Complexes at the Moon Pyramid, Teotihuacan: A Preliminary Report of 1998–2004 Explorations. *Ancient Mesoamerica* 18(1):127–146.

Sugiyama, Saburo, and Rubén Cabrera Castro

2007 The Moon Pyramid Project and the Teotihuacan State Polity. *Ancient Mesoamerica* 18(1):109–125.

Taube, Karl A.

1993 The Iconography of Mirrors at Teotihuacan. In *Art, Ideology, and the City of Teotihuacan*, edited by Janet C. Berlo, pp. 169–204. Dumbarton Oaks Research Library and Collection, Washington, D.C.

1998 The Jade Hearth: Centrality, Rulership, and the Classic Maya Temple. In *Function and Meaning in Classic Maya Architecture*, edited by Stephen Houston, pp. 427–478. Dumbarton Oaks Research Library and Collection, Washington, D.C.

2005 The Symbolism of Jade in Classic Maya Religion. *Ancient Mesoamerica* 16(1):23–50.

Taube, Karl A., and Reiko Ishihara-Brito

2012 From Stone to Jewel: Jade in Ancient Maya Religion and Rulership. In *Ancient Maya Art at Dumbarton Oaks*, edited by Joanne Pillsbury, Miriam Doutriaux, Reiko Ishihira-Brito, and Alexandre Tokovinine, pp. 135–272. Dumbarton Oaks Research Library and Collection, Washington, D.C.

Taube, Karl A., Virginia B. Sisson, Russell Seitz, and George Harlow

2004 The Sourcing of Mesoamerican Jade: Expanded Geological Reconnaissance in the Motagua Region, Guatemala. In *Olmec Art at Dumbarton Oaks*, edited by Karl A. Taube, pp. 203–220. Dumbarton Oaks Research Library and Collection, Washington, D.C.

Thouvenot, Marc

1982 *Chalchihuitl: Le jade chez les aztèques.* Institut d'Ethnologie, Musée de l'Homme, Paris.

Velázquez Castro, Adrián

2007 *La producción especializada de los objetos de concha del Templo Mayor.* Instituto Nacional de Antropología e Historia, Mexico City.

Wagner, Elizabeth

2000 El jade: El oro verde de los mayas. In *Los mayas: Una civilización milenaria*, edited by Nikolai Grube, pp. 66–69. Könemann, Cologne.

Walker, Jill

1991 Jade: A Special Gemstone. In *Jade*, edited by Roger Keverne, pp. 18–40. Anness Publications, London, and Van Nostrand Reinhold, New York.

Walsh, Jane

2013 El papel del Instituto Smithsoniano en el descubrimiento y estudio de la Ofrenda 4 de La Venta. In *La Ofrenda 4 de La Venta: Un tesoro olmeca reunido en el Museo Nacional de Antropología; Estudios y catálogo razonado*, edited by Diana Magaloni Kerpel and Laura Filloy Nadal, pp. 31–40. Instituto Nacional de Antropología e Historia, Mexico City.

Weiner, Annette B.

1992 *Inalienable Possessions: The Paradox of Keeping-While-Giving.* University of California Press, Berkeley.

Weyl, Richard

1980 *Geology of Central America.* 2nd rev. ed. Gebrüder Borntraeger, Berlin.

The Eloquence of Color

Material and Meaning in the Cacaxtla Murals

CLAUDIA BRITTENHAM AND DIANA MAGALONI KERPEL

IN A WORLD BEFORE COLOR WAS AVAILABLE IN tubes, paint chips, or pixels on a screen, ancient Mesoamericans were attentive to the ways in which color came into being. Color was fiercely material, inextricable from the substrate and methods that produced it. Color was not neutral; rather, it was richly endowed with value and symbolic associations. This was true not only of objects that bear color within them, such as jade, pearls, *Spondylus* shell, or feathers—examples of what we might term "prime colorants"—but also of manufactured colorants, such as pigments and dyes, whose origins, materials, and modes of processing could affect their symbolic meanings as well as their optical qualities (for studies about the symbolic and material properties of color in Mesoamerica and colonial Mexico, see Dehouve 2003; Dupey 2010, 2014/2015; Houston et al. 2009; Magaloni 2010, 2014; and the articles in Tokovinine and McNeil 2012 and Wolf and Connors 2011, especially Magaloni 2011 and Zetina et al. 2011). For a mural painter, techné involved knowledge not only of how to represent

figures in a given space but also of how to procure, prepare, and apply color to an appropriately prepared surface. Indeed, in a mural painting, the meanings of color were richly layered. Choices of materials could augment the iconographic messages of the painting and perhaps even make the painting more efficacious.

This essay considers several examples of the materiality of color in the murals of Cacaxtla, a small hilltop citadel located approximately 120 kilometers east of Mexico City (Figure 3.1). During the tumultuous Epiclassic period after the fall of the great city of Teotihuacan, between 600 and 950 CE, the inhabitants of this embattled city-state turned to mural painting as the predominant form of public art (for general introductions to the site and its murals, see Brittenham 2015; Foncerrada 1993; Lombardo et al. 1986; Santana 2011; Uriarte and Salazar 2013). Murals defined critically important spaces on the acropolis; there are likely other murals buried in the portions of the acropolis that have not yet been excavated (Figure 3.2).

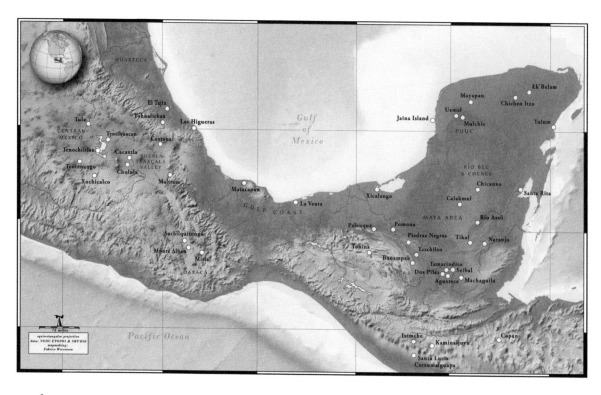

figure 3.1
Map of Mesoamerica. (Map by Fabrice Weexsteen, http://aworldofmaps.free.fr.)

The principal problem the paintings pose is one of style. In their naturalism and emphasis on the human form as a real, corporeal entity, these murals strongly resemble Maya painting from southern Mexico and Guatemala, more than 700 kilometers to the southeast (Abascal et al. 1976:23–49; Robertson 1985:297–299). They are more like the paintings of the Maya cities of Bonampak or Calakmul than they are like any other artwork known from Mesoamerica. But equally importantly, in terms of style, the Cacaxtla murals are a far cry from the hieratic murals of Teotihuacan, 70 kilometers to the northwest, the dominant painting tradition in Central Mexico in the centuries before Cacaxtla's rise; they have even less in common with the murals of Cholula, a rival city-state a mere 15 kilometers away. They also exhibit glimmers of knowledge of other far-flung Mesoamerican traditions, especially those from the Gulf Coast and Oaxaca (Foncerrada 1980:184; Kubler 1980:171–172).

Yet the Cacaxtla murals are a firmly local product. They were painted at different moments and are the work of numerous artists, attesting to an extended painting tradition—a cohesive and unified body of work created by generations of artists who shared similar training, background, and artistic goals (Brittenham 2008:127–224, 2015; Lucet 2013:27–85).[1] The Cacaxtla paintings may look strikingly Maya at first glance, but closer examination reveals substantive originality in style, technique, and iconography. In spite of the human scale and proportions of the painted figures and their naturalistic colors, the Cacaxtla paintings privilege uniformity of line and color deployed in a shallow pictorial space, just like many artworks of Central Mexico that came before and after them. Their materials and techniques, as much as their style, are a synthesis of different Mesoamerican painting traditions perfectly adapted to local conditions.

The Cacaxtla murals demonstrate an understanding of the symbolic properties of color in unexpected contexts. Historically, it has been easiest to identify symbolic choices of color when the colors of a painting depart widely from the colors of

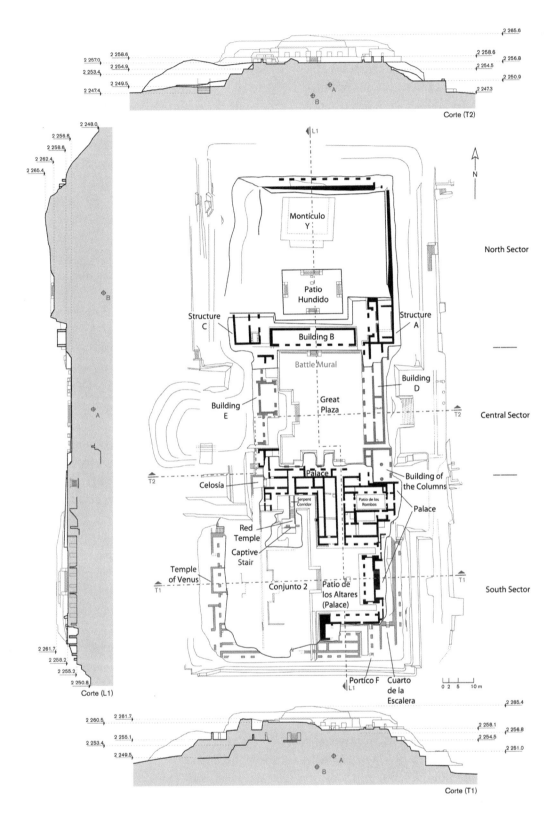

figure 3.2

Plan of Cacaxtla, showing in red the locations of the murals discussed in the text. (Courtesy of Geneviève Lucet and the archive of the Proyecto La Pintura Mural Prehispánica en México, Instituto de Investigaciones Estéticas, Universidad Nacional Autónoma de México.)

its referents—for example, in the red-on-red murals of Teotihuacan, which Diana Magaloni has argued represent nocturnal sight and otherworldly spaces (Magaloni 2003:188–201, 2010:57–58), or in the blue-and-black style of Late Postclassic Maya painting, where the restricted color palette seems to evoke the world of the gods (Houston et al. 2009:91–97). What the Cacaxtla murals reveal is that color choices that appear to have been made for mimetic reasons could simultaneously have been made for deeply symbolic ones, and the same could be said for the ways that paint was applied to the wall.

Yet material meaning could inhere in a variety of ways at Cacaxtla. At the Battle Mural, differences in pigment and the mode of paint application underlie an iconography of difference in the mural; at the Red Temple, the use of a uniform pigment for disparate materials creates rhetorical similarities among them. Pigment choices at Structure A highlight both similarities and differences between figures. But subsequent interventions to the Structure A murals suggest that these material choices were later misunderstood or forgotten. In all three cases, these deeply significant material choices, sometimes invisible to the naked eye, offer important perspectives for understanding the making, patronage, and reception of Mesoamerican art.

Cacaxtla Painting Technique

Like the murals' style and iconography, the painting technique at Cacaxtla has points of commonality with Maya, Zapotec, and Gulf Coast painting traditions but is well adapted to local materials and conditions (Magaloni 1994; Magaloni et al. 2013). It is a profoundly Mesoamerican technique, involving the alkaline chemistry and manipulations of plant gums that characterize so many Mesoamerican technologies, from papermaking to tortilla preparation (for Mesoamerican painting methods, see Magaloni 1994, 1995, 1998, 2001, 2003, 2004a, 2004b, 2010; Magaloni et al. 2013; Magaloni and Falcón 2008; Vázquez 2010; for cooking and papermaking, see S. Coe 1994:14 and passim; Coe and Kerr 1997:143–144; Hagen 1944:57; Magaloni 1998:68). At Cacaxtla, nopal cactus gum was mixed with the pigments, along with lime water, to create the paints; nopal cactus mucilage (the slimy exudate of the paddles) was also mixed into the plaster to ensure that it would dry slowly and evenly (Magaloni 1994:57–73; Magaloni et al. 2013:150–156). Artists began to paint while the plaster was still slightly damp but continued, using the same materials, to layer yet more pigments even after the wall had dried.

Cacaxtla painting technique, like many other Meosamerican painting techniques, thus sits uneasily between the categories of "fresco" and "secco" that define most mural painting traditions in other parts of the world. In fresco techniques, pigments are applied to the plaster while it is still wet. The pigments become integrated into the plaster as calcium hydroxide from the drying plaster migrates to the surface and reacts with the air, forming a crystalline layer of calcium carbonate covering the surface of the painting (Mora et al. 1984:11–12). By contrast, secco painting techniques apply pigments to an already dry wall, using a binder (such as egg yolk, oil, or, in Mesoamerica, plant gums) to make the paint adhere; capillary absorption binds the paints to the wall (Magaloni 1994:20–21; Mora et al. 1984:12–13). Mesoamerican painting techniques challenge this dichotomy: plant gums and resins added to both the plaster and the pigments slowed drying of both elements, and painting spanned the drying of the plaster (Magaloni 2001:159–161, 168–171, 188–196, 2004a:437, 2004b:251–252; Magaloni and Falcón 2008:195, 204–205; Magaloni et al. 2013:150–156; Vázquez 2010:124–136). From an analytical standpoint, this means that some pigments are embedded in the plaster, as in a fresco technique, and others are held in place by the nopal gum binder, as in secco technique (there is no binder in pure fresco technique).

Cacaxtla painting technique is markedly unlike the burnished fresco technique popular at Teotihuacan (Magaloni 1995, 2003). It is similar, but not identical, to Maya painting technique, where tropical plant gums and resins were mixed with the plaster and the pigments to slow the drying of both elements, and painting began on a very wet surface (Magaloni 1998, 2001, 2004b; Vázquez

2010). Cacaxtla painting technique is most like that of tomb paintings in Oaxaca, where nopal gums were also used to apply paint to relatively dry and textured walls. But the composition of those walls and the plaster adhering to them is quite different: in Zapotec painting technique, fine plaster, or *enlucido*, is layered directly over the wall without the intermediate layer of coarser mortar, or *mortero*, that is used in Cacaxtla and Maya painting technique (Magaloni and Falcón 2008:191).

The pigments at Cacaxtla are most comparable to those used in the Maya area, although almost all could be derived from locally available materials (Magaloni 1994:53, 2001:172–187; Magaloni et al. 2013:169–183). The black is charcoal; the white, calcite (calcium carbonate) that was obtained by processing local limestones. Red, yellow, and brown pigments are derived from iron-rich clays abundant in the region (Magaloni 1994:53). Only one color is clearly the product of trade and exchange: the blue ubiquitous in the Cacaxtla paintings is Maya blue, a white palygorskite clay dyed with indigo (Magaloni 1994:48, 53; Magaloni et al. 2013:169–174). The technology to create this stable blue pigment was developed in the Maya area in the fifth or sixth century CE (Houston et al. 2009:78–82), and the palygorskite clay, the pigment's base, is most readily available from particular locations on the Yucatan Peninsula (Arnold 2005:53–59; Arnold et al. 2008; Arnold et al. 2007:47–50, 54–56; Folan 1969; José-Yacamán et al. 1996:223, 225; Littmann 1982:404; see also Reyes-Valerio 1993). The invention of Maya blue opened a new world of color for Mesoamerican painters: the technique could produce a whole range of blue-green tones, depending on the control of heating, acidity, and other factors during preparation (Ovarlez 2003a, 2003b), and the extension of this technology using other vegetal dyes could produce greens, yellows, and brilliant reds (Magaloni 1998:68–76, 2001:178–180; for organic colorants at Cacaxtla, see Magaloni et al. 2013:173–174, 176–178). But as the following examples will show, in the Cacaxtla murals, pigments did more than merely color the wall; they also created a kind of reality in the painting, marking similarities and drawing distinctions that went deeper than the visible surface.

The Battle Mural: Material Difference

In the Battle Mural at Cacaxtla, the gulf between victors and vanquished is unbridgeable (Figures 3.3 and 3.4). In this 20-meter-long mural bordering the Great Plaza of the Cacaxtla acropolis, life-sized struggling figures formed a violent backdrop for all actions that took place in this central gathering space (for interpretations of the iconography of the Battle Mural, see Brittenham 2011, 2015:111–144; Escalante 2002:75–77; Graulich 1990:107–112; Lombardo 1986:220–230; McCafferty and McCafferty 1994; Piña Chan 1998:63–87; Uriarte 2012; Uriarte and Velásquez 2013). Contrasts structure nearly every element of the painting. The winners are armed and ferocious; the losers are almost universally disarmed and dying, bleeding from copious wounds while their opponents have not a scratch among them. The winners are clothed; the losers naked—a sure sign of humiliation in Mesoamerican art. Some of these differences stem from a powerful rhetoric of the inevitability of victory and defeat, a visual strategy of conflating time to introduce the outcome of the battle into even its earliest stages, something that Mary Miller and Stephen Houston have termed "resonance" in the context of Maya art (see Brittenham 2011; Miller and Houston 1987), but at Cacaxtla it is also a prelude to even deeper disparity. The victors wear jaguar pelts; the vanquished, bird helmets. The victors' bodies are painted gray or black;[2] the vanquished may be painted brilliant blue or yellow, and they may color their faces as well as their bodies. The winners have black hair, partly shaved to expose rounded skulls; the defeated warriors have long red hair and elongated heads, cranial deformation exaggerated almost to the point of caricature. Not just details of clothing and body paint but also physical characteristics separate the winners from the losers, as if the differences between these bodies moved beyond the surface to the flesh, blood, and bone underneath.

The differences go even deeper: victors and vanquished literally do not share the same substance. They are painted using different pigments, and those pigments are used to form their bodies

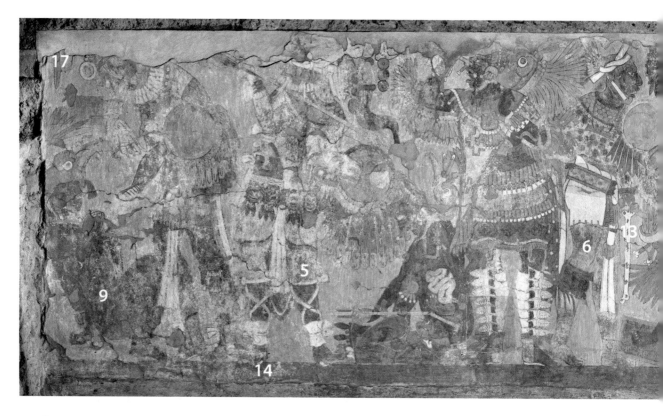

figure 3.3

Battle Mural, east talud, Individuals E1 to E12. Numbered marks indicate places where samples were taken from the mural, and correspond to the figure numbers where microphotographs of these samples are reproduced in this article. (Photograph by Ricardo Alvarado Tapia, courtesy of the archive of the Proyecto la Pintura Mural Prehispánica en México, Instituto de Investigaciones Estéticas, Universidad Nacional Autónoma de México.)

figure 3.4

Battle Mural, west talud, Individuals W7–W5. The numbered mark indicates where the sample reproduced in Figure 3.8 was taken. (Photograph by Ricardo Alvarado Tapia, courtesy of the archive of the Proyecto la Pintura Mural Prehispánica en México, Instituto de Investigaciones Estéticas, Universidad Nacional Autónoma de México.)

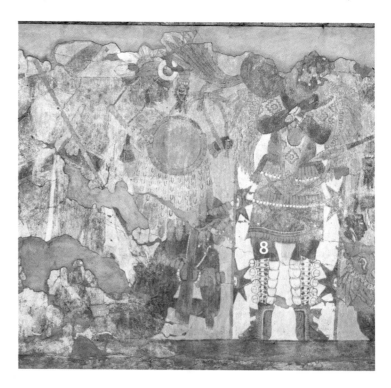

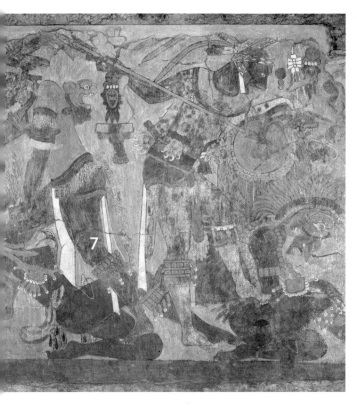

fig. 3.5

fig. 3.6

fig. 3.7

figure 3.5
Battle Mural, Individual E2. Detail of jaguar warrior's painted skin, which is a mixture of hematite and carbon pigments. Magnified 50×. (Microphotograph by Diana Magaloni and Andrés Paz.)

figure 3.6
Battle Mural, Individual E7. Detail of jaguar warrior's painted skin, which is a mixture of hematite and carbon pigments. Magnified 100×. (Microphotograph by Diana Magaloni and Andrés Paz.)

figure 3.7
Battle Mural, Individual E9. Detail of jaguar warrior's painted skin, which is a mixture of hematite and carbon pigments. Magnified 100×. (Microphotograph by Diana Magaloni and Andrés Paz.)

fig. 3.8

fig. 3.9

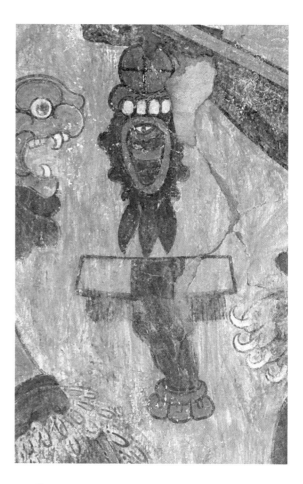

fig. 3.10

figure 3.8
Battle Mural, Individual W5. Detail of bird warrior's painted skin, which is a red iron-oxide pigment dyed with an organic red dye. Magnified 20×. (Microphotograph by Diana Magaloni and Andrés Paz.)

figure 3.9
Battle Mural, Individual E1. Detail of bird warrior's painted skin, which is a red iron-oxide pigment dyed with an organic red dye. Magnified 50×. (Microphotograph by Diana Magaloni and Andrés Paz.)

figure 3.10
Battle Mural, east talud, disk–teeth–bleeding-heart glyph between Individuals E8 and E9. Although the text appears to hang from Individual E9's hand, it may name Individual E8, whose back is to the left. This is one of many examples of an awkward glyphic placement within the mural. (Photograph by Ricardo Alvarado Tapia, courtesy of the archive of the Proyecto la Pintura Mural Prehispánica en México, Instituto de Investigaciones Estéticas, Universidad Nacional Autónoma de México.)

in distinct ways. In skin tone and clothing, no two victorious warriors are exactly alike. Different concentrations of hematite reds and carbon black are mixed together to form the flesh tones for these warriors, yielding a constellation of sober skin hues ranging from dark red to black (Figures 3.5–3.7). In some cases, gray pigment is even layered over fleshy red, as if body paint were being applied to painted skin (see Figure 3.5). By contrast, the rich red-brown bodies of the defeated warriors are all painted using a single, uniform pigment: a red iron oxide (Fe_2O_3) mixed with white clays and perhaps dyed with an organic colorant as well (Figures 3.8 and 3.9; Magaloni et al. 2013:176–182, 186–188).[3]

This real, material difference is scarcely visible to the naked eye, and it is not immediately obvious

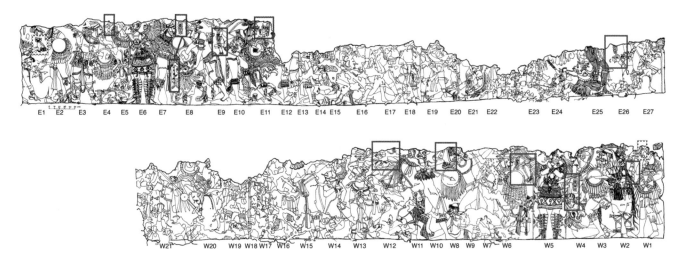

figure 3.11

Diagram showing locations of texts in the Battle Mural. Figures in the Battle Mural are numbered from the center outward on the east and west taludes flanking the central staircase. (Line drawing by Debra Nagao; diagram by Claudia Brittenham.)

why different pigments were necessary to achieve this effect. It is clear from the bodies of the victors that combinations of hematite and carbon could produce a wide range of red-brown hues, so why not adopt one of those tones for the losers' skin? Why go to the trouble of obtaining yet another mineral and then coloring it with an organic colorant? There is little information available about the sources of iron oxides around Cacaxtla, though we might speculate that this particular pigment came from an unusual geological formation or other source that imbued it with significance. Whatever the case, its use in the painting reinforces—or, more properly, underlies—a whole series of distinctions between victors and vanquished. By painting these figures with different pigments, the muralists seem to suggest that such difference is insurmountable. It is real, material, and fundamental.

Furthermore, the use of a range of hematite-carbon combinations for the winners' bodies and a common dyed iron-oxide pigment for the losers' establishes a profound distinction between the individualized victors and the undifferentiated mass of losers. Once again, iconographic cues reinforce this material distinction. A glyphic compound consisting of a turquoise disk, a row of teeth, and a bloody heart symbol repeats eight times throughout the mural, each time paired with a different variable element, such as a bird, a bloody bone, a panache of feathers, or a more complex compound (Figure 3.10). This is most likely a title, perhaps a military rank; the pattern of deployment resembles that of texts presumed to be titles at Teotihuacan (Brittenham 2011:77; Helmke and Nielsen 2011:22–28; Millon 1973; Paulinyi 1991:63; Taube 2000:10–12, 15–18). Each surviving text can be associated with a standing jaguar warrior and nearly every well-preserved jaguar warrior can be associated with a text (Figure 3.11). Before the upper part of the painting suffered extensive root damage, it is likely that each of the winning jaguar warriors was named with one of these heart compound titles, while their defeated opponents remained anonymous. Material and textual rhetorics are mutually reinforcing.

However, all of the texts are late additions to the mural. They were painted over the blue background of the scene rather than placed directly on the white plaster, as were other elements of the painting. The texts squeeze awkwardly into spaces in the preplanned composition. For example, in the case of the text naming Individual E7, the heart compound glyph floats directly in front of his face, but the bloody bone that constitutes its variable element hangs in front of his legs, so far

separated from its textual complement that it is tempting to read it as part of his outfit rather than his title (Figure 3.12). Yet close examination shows that it is nowhere attached to his body, as it would be if it were a physical trophy. And in microscopic section, it is clear that the bone is created by layering thick white pigment over the blue ground (Figure 3.13), rather than reserving the white of the unpainted plaster support, as is the case with most white elements in the painting, including this figure's white hipcloth and hanging loincloth. Furthermore, the bone covers several feathers of the adjoining bird headdress, again evidence that it was painted after these elements. Similarly, the confusion of feathers between Individuals W7 and W5 results from the late addition of a text naming Individual W7 on the left, which consists of the heart compound title and a hand clutching an arching plume; this plume cuts across the one long, drooping feather from Individual W5's headdress, which had previously occupied the entire space (see Figure 3.4).

These texts made the subject of the painting more concrete, directly identifying its aggressive actors and thus possibly specifying the approximate time of the events depicted. The late changes clarified the interpretation of the painting, perhaps responding to a risk that the painting might be read in unintended ways. But while the titles of victorious warriors were only added later—after painting was already well under way[4]—difference between individualized victors and undifferentiated losers was built into the structure of the painting from the outset through the choice of pigments. The later changes only made subtle material rhetorics more explicit.

Likewise, pigment choices create a rhetoric of equivalence between the defeated warriors and the earth beneath them, echoed in the iconography of the painting. The long red hair and elongated skulls of the defeated warriors find their closest parallel at Cacaxtla on the anthropomorphic maize plants growing at the Red Temple, which in turn resemble depictions of the Maya maize god and other maize deities throughout Mesoamerica (see Figures 3.16 and 3.23; for the Battle Mural, see Brittenham 2009, 2015:138–139; Uriarte 2012; Uriarte and Velásquez

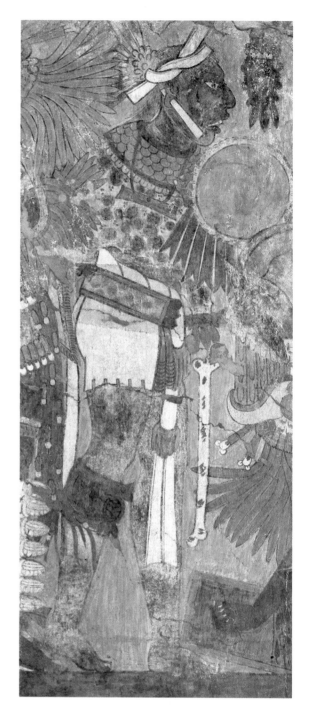

figure 3.12
Battle Mural, bloody-bone text in front of Individual E7. This variable element of the text is far separated from the disk–teeth–bleeding-heart glyph above, and it overlaps feathers of the adjoining figure's headdress. (Photograph by Ricardo Alvarado Tapia, courtesy of the archive of the Proyecto la Pintura Mural Prehispánica en México, Instituto de Investigaciones Estéticas, Universidad Nacional Autónoma de México.)

fig. 3.13

fig. 3.14

fig. 3.15

2013:693–722; for the Red Temple, see Brittenham 2015:145–182; Domínguez and Urcid 2013:576–577; Taube 1992:46; see also Carlson 1991:42; Santana et al. 1990:332). Representing the defeated in this way adds overtones of agriculture and harvest to the gory scene of combat. Thus, the choice of these features suggests that the defeated warriors' ends are inevitable, like the sacrifice of the maize god or

figure 3.13
Battle Mural, detail of bloody-bone glyph in front of Individual E7. Note that the white of this bone is a white pigment layered over the blue color of the background scene, rather than using the reserved white of the plaster support, as is the usual practice in the Cacaxtla murals. This difference suggests that the bone glyph, like all of the texts in the painting, was a late addition to the scene. Magnified 20×. (Microphotograph by Diana Magaloni and Andrés Paz.)

figure 3.14
Battle Mural, east talud, detail of red band beneath the figures. The pigment here is a red iron-oxide dyed with an organic colorant, just as in the bodies of the defeated. Magnified 10×. (Microphotograph by Diana Magaloni and Andrés Paz.)

figure 3.15
Building B, guardapolvo. The pigment is hematite, heated to achieve a dark red hue and burnished until the surface is smooth and shiny. Magnified 20×. (Microphotograph by Diana Magaloni and Andrés Paz.)

the harvest of maize—a death that eventually nourishes the earth to enable other cycles of generation.

Once again, this iconographic argument of the painting is already present in the materials chosen to represent it. The dyed iron-oxide pigment of the vanquished bodies occurs in only one other place within the murals of Cacaxtla: the ground band beneath the Battle Mural (Figure 3.14). This dark red ground band looks remarkably like the *guardapolvos* at Cacaxtla, low bands of solid red or burnished white running along the bottom of interior walls— for example, at Building B, Building E, Portico F, or the Red Temple (see Figure 3.16; for guardapolvos at Cacaxtla, see Lucet 2013:85–90). Yet technical analysis reveals that these are, in fact, distinct pigments (Figure 3.15). The guardapolvos are painted with a hematite pigment that was heated to achieve a particular dark red hue and then burnished until the surfaces were flat and shiny; the combination

of this particular iron oxide and an organic colorant is unique to bodies and the ground band at the Battle Mural. The smooth, burnished surface of the guardapolvos also differs significantly from the rough and uneven texture of the wall of the Battle Mural, which is typical of the mural paintings at Cacaxtla (Magaloni et al. 2013:149–150). Because the Battle Mural is materially different, it seems likely that its meaning is different as well: the ground band at the Battle Mural does not mark an interior space like all the other guardapolvos elsewhere at Cacaxtla. If the band instead represents the earth, then this material rhetoric may argue that the defeated warriors are already becoming part of the earth, the ultimate degradation and the eventual fate of captives (Houston et al. 2006:223–226). Perhaps the unusual pigment even came from the land of the defeated warriors, so that its presence here references not just the bodies but also the soil of these utterly foreign foes (we are indebted to Barbara Arroyo for this suggestion; personal communication, 2013).[5]

Blood also has its particular material rhetoric in the Battle Mural. It is not represented with the same pigments used to color the flesh of either the victorious or the defeated warriors; instead, it appears with yet another very particular iron oxide, called maghemite (Magaloni et al. 2013:179–181).[6] Even though their colors differ, both the bright red blood flowing from wounds and the dark red blood of the bleeding heart glyphs seem to be made out of this same pigment, perhaps darkened by heating to produce the dried-blood hue of the heart glyphs. Thus, both fresh and dried blood are represented via the same pigment, signifying an underlying sameness in spite of superficial color changes. This same pigment in its unheated state limns the lips of the victorious warriors, further underlining their ferocity.

The material rhetorics outlined here are subtle, hard to see with the untrained eye, but fundamental to the meaning of this painting. They underpin every distinction that even the novice viewer can discern in this mural. They suggest that choices of materials in a mural painting can be deeply significant—that they have the capacity not only to represent but also to embody the subjects painted on the walls.[7] These material distinctions were not accessible to every viewer; on the contrary, they created additional layers of meaning accessible only to those with specialized knowledge—to craftspeople, and perhaps also to the patrons who designed and dictated the iconographic programs.

The Red Temple: Material Equivalences

At the Battle Mural, the contrastive deployment of pigments within a single painting enables arguments about color symbolism. But in addition to creating rhetorics of similarity and difference within a single painting, choices about color and its application can simultaneously gesture out toward the wider world. It is especially appropriate that this occurs at the Red Temple, where a complex allegory of wealth and trade lines a staircase in the center of the acropolis (Figure 3.16). Ascending this stair simultaneously replicated the merchant's journey from the hot lowlands to the Central Highlands as well as the ascent from the underworld, where cacao and maize grew in captivity before the creation of the present era (Brittenham 2015:145–182; Domínguez and Urcid 2013; Martin 2013; Santana 1990).

Standing out against the warm red background, which gives the mural its name, one color dominates the painting: a bright blue hue used to paint the maize and cacao plants, the old merchant god's heavy jade jewelry, the quetzal feathers found in a bundle on his backpack, the plumes of the bird above the cacao tree, and the feathered serpent bordering the scene. In short, most of the precious things in this mural about luxury and preciousness are painted in a single blue hue. This blue pigment is the famous Maya blue, white palygorskite clay dyed with indigo (Figure 3.17; Magaloni 1994:48, 53).

Thus, although all of the other pigments at Cacaxtla could have been made of locally available materials, the Maya blue in the Cacaxtla paintings is an index of cosmopolitanism, concrete evidence of contact between Cacaxtla and the Maya area.[8] Whether it was palygorskite clay, found principally on the Yucatan Peninsula, that was imported and then dyed at Cacaxtla or already

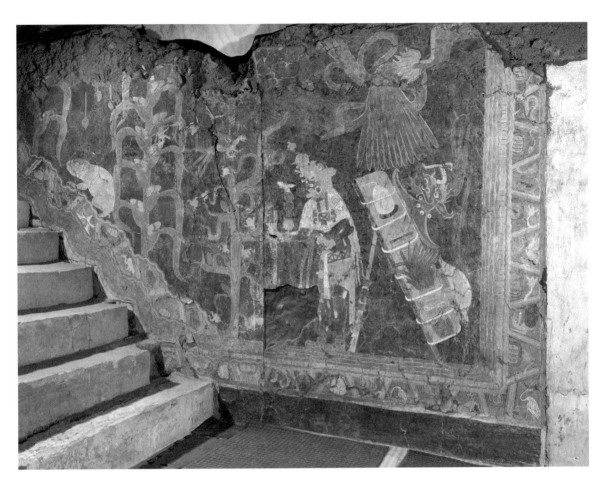

figure 3.16

Red Temple, east wall. (Photograph by Ricardo Alvarado Tapia, courtesy of the archive of the Proyecto la Pintura Mural Prehispánica en México, Instituto de Investigaciones Estéticas, Universidad Nacional Autónoma de México.)

prepared Maya blue pigment, which made its way to the city, transport costs may have made obtaining the color quite expensive.[9] Maya blue technology can produce a wide range of blue-green hues (Ovarlez 2003a, 2003b), but the color chosen for the maize, jade, and feathers at the Red Temple is one of the most characteristic and recognizable shades of Maya blue. Its lavish use on the Cacaxtla walls may be a public—and immediately legible—display of wealth, like the copious use of gold leaf or lapis lazuli in medieval European painting.

It is important to emphasize that painters at Cacaxtla had the technical knowledge to create green pigments that would more closely approximate the hues of maize plants or feathers, had they so desired—though, of course, most Mesoamericans described blue and green as part of a single visual and conceptual spectrum (Dehouve 2003; Houston et al. 2009:40–41; Izeki 2008). In fact, two different "Maya greens"—that is, clay compounds dyed with indigo and other organic colorants—are contrasted in the murals of Structure A, where they color critically important objects held by the figures on the inner jambs, their unusual hues drawing attention to these precious vessels while simultaneously insisting on their material differences (see Figures 3.28 and 3.29). The Maya green of the Tlaloc jar held by the figure on the north jamb is mixed with lime to give it a light, opaque color (Figure 3.18), while iron-oxide ochres make the hue of the conch shell on the south jamb more yellow than its counterpart (Figure 3.19; Magaloni et al. 2013:173–174). Elsewhere in the murals, greens are confined to the aquatic borders of Structure A and the Temple of

fig. 3.17

fig. 3.18

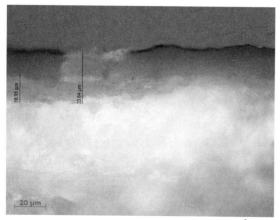

fig. 3.19

figure 3.17
Maya blue pigment, detail of medium-blue feathers from the Battle Mural, Individual E2. This pigment made of palygorskite clay dyed with indigo is used throughout the Cacaxtla murals. Magnified 100×. (Microphotograph by Diana Magaloni and Andrés Paz.)

figure 3.18
Structure A, north jamb, detail of green pigment of the Tlaloc jar. The pigment is a Maya green (palygorskite clay dyed with an organic colorant) mixed with lime to achieve a light, opaque color. Magnified 50×. (Microphotograph by Diana Magaloni and Andrés Paz.)

figure 3.19
Structure A, south jamb, detail of green pigment on the conch shell. The Maya green pigment here is mixed with ochre to yield a more yellowish tone. Magnified 50×. (Microphotograph by Diana Magaloni and Andrés Paz.)

Venus—though a whole range of hues are present there, as if the space of the border allowed a kind of chromatic experimentation that was more constrained in the central portion of each scene.

Although the technology to make a more mimetic green was undoubtedly available, Cacaxtla painters did not strive for mimetic color at the Red Temple. Instead, they painted jade, feathers, and maize foliage the same middle blue hue, creating a set of symbolic equivalences between the three materials while simultaneously emphasizing their preciousness through the use of a recognizably precious and exotic pigment. Although this uniformity of color might at first seem like a poverty of pigment, skill, or imagination, it instead heralds rhetorical riches. This choice of color and material suggests a local inflection of long-standing and deeply held Mesoamerican beliefs about the relationships between jade, feathers, and maize, which had long been bound into a circuit of value and meaning by their blue-green color as well by other material qualities. Indeed, a sixteenth-century mythological narrative written in alphabetic Nahuatl speaks of the possibility of confusing these three precious blue-green things. In the *Leyenda de los soles*, Huemac, the ruler of the legendary city of Tollan, played the ballgame against the Tlalocs, or rain gods (Bierhorst 1992:156; Tena 2011:195). They wagered "their jades, their quetzal plumes" on the outcome of the game. Huemac won.

But instead of giving him jades and feathers, the rain gods offered Huemac an ear of green corn in the place of the jade, and the shuck in which it grows in place of the quetzal feathers. Huemac protested that he had been deceived. "Take away this maize," he cried, "and give me my jade and feathers." The rain gods did exactly as Huemac asked: he got his jade and feathers, but for four years, the Tlalocs hid their real riches by withdrawing their benevolent control over the weather. It snowed in July, and the crops were destroyed; for four years, maize did not grow, and there was famine in Tollan. This is one of the episodes that led to the fall of the city.

This story is an allegory of good government. It is also a cautionary tale about the seductive power of riches, with the moral that maize is the real precious blue-green thing for which jades and quetzal feathers are merely substitutes (see also gzuernsey 2006:150–151 for a Late Preclassic example of the same rhetoric; for equivalences of jade, maize, and feathers, see Taube 1996:71). Huemac's failing is not just that he prizes jade and feathers over sustenance, the real treasure, but also that he fails to recognize elevated, rhetorical speech: he takes "the jades, the quetzal feathers" literally, rather than understanding the phrase as a poetic metaphor for riches.[10]

figure 3.20
Bonampak, detail of painted jade, showing superposition of yellow-green and blue layers of pigment. Magnified 100×. (Microphotograph by Diana Magaloni, courtesy of the archive of the Proyecto La Pintura Mural Prehispánica en México, Instituto de Investigaciones Estéticas, Universidad Nacional Autónoma de México.)

figure 3.21
Bonampak, detail of painted quetzal feather, showing layers of green and blue pigments over red background. Magnified 100×. (Microphotograph by Diana Magaloni, courtesy of the archive of the Proyecto La Pintura Mural Prehispánica en México, Instituto de Investigaciones Estéticas, Universidad Nacional Autónoma de México.)

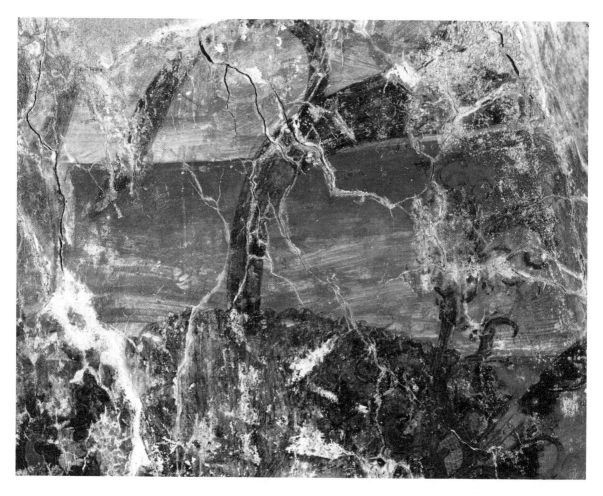

figure 3.22
Bonampak, Room 3, south wall, detail of dancer's headdress. Note the contrast between the texture of the red steps in the background, where the brushstrokes are clearly evident and layers of translucent pigment build solid forms, and the quetzal feathers and other headdress details, which were painted in secco, superimposing paint on paint. (Photograph by Hans Ritter, 1963, courtesy of the Bonampak Documentation Project.)

Significantly, the story emphasizes the potential interrelationships between precious jade, quetzal feathers, and maize before insisting on their fundamental incommensurability, just as pigment and color equate jade, maize, and quetzal feathers at the Red Temple. The Red Temple murals may also emphasize the primacy of maize: maize plants outnumber everything else in the painting and are located in a privileged position higher on the stairway.

To appreciate the power of this rhetorical gesture, it may be helpful to compare it to the markedly different use of color in the work of contemporary Maya painters. In the murals of Structure 1 at Bonampak, for example, artists used three distinct pigment combinations to capture the different tones of jade, quetzal feathers, and maize. The artists of Bonampak layered a yellow-green pigment over a dark Maya blue, mixed with carbon, to mimic the density of jade (Figure 3.20); and they layered a nearly indigo blue over a dark Maya green pigment to capture the iridescence that made quetzal feathers so precious, a combination especially powerful when painted over the red ground of an architectural scene (Figure 3.21; Magaloni 1998:72–73, 2001:175). In a photograph by Hans Ritter, it is possible to appreciate how the complexity of this layered pigment begins to evoke the structural iridescence of a quetzal plume

(Figure 3.22). A recent conservation intervention at Bonampak has discovered yet other layerings of two and even three pigments to create additional blue-green tones (Orea et al. 2011:63); the rich green hue of the ear of maize in Room 1 was not analyzed, but appears likely to be yet another pigment combination (see Miller and Brittenham 2013:fig. 226). At Bonampak, each precious material is rendered with a distinct set of pigments, combined into layers, to achieve a hue that approximates the optical experience of a specific material at a particular moment in time (Houston et al. 2009:86). Not just hue but also the process of paint application may be at stake here, especially in the realm of the quetzal feathers, where the successive layers of pigment seem to evoke the colors contained within the quetzal feather's structural iridescence. This approach fundamentally differs from the holism at Cacaxtla, which renders all precious blue-green things in a single pigment. What both approaches reveal, however, is a deep attentiveness to the material and symbolic properties of color.

At the Red Temple, this material attention is recruited to tell a story about preciousness. All of the sources of wealth for Cacaxtla—agricultural and mercantile alike—are brought together in this painting. What is equally significant is that these precious things are painted in an especially luxurious way, layering different pigments in a manner rarely equaled elsewhere at Cacaxtla. The edges of the lamina of the maize plants are highlighted with a thick border of opaque light blue, which creates a sense of light and volume, echoed on the old god's jade belt and pectoral (Figures 3.23 and 3.24). Simultaneously, the yellow and red lines defining the central vein in the middle of each lamina of the maize plants equate their leaves with the precious quetzal feathers of the plumed serpent bordering the scene, which receive the same treatment (see Figure 3.23). Notably, no other feathers in the murals have this double central line—not the feathers on the backpack, nor the feathers on headdresses, nor the feathers of the birds at the Red Temple and Structure A. Some have a single central line in black or yellow, but the paired red and yellow lines are restricted to maize and the plumed serpent

(the plumed serpent at Structure A receives similar treatment). Perhaps they indicate light reflecting off these surfaces or their potential iridescence; they mark the two as especially potent. The other materials that receive this kind of attention in the Cacaxtla murals are precious luxuries: expensive textiles in the Battle Mural (see Figure 3.4), eagle feathers at Structure A (see Figure 3.27), the pattern of rosettes on jaguar pelts, and, most especially, the goods on the old merchant god's backpack at the Red Temple (see Figure 3.24). These effects are more intense at the Red Temple than in any other painting.

Both the uniform medium-blue pigment and this sumptuous mode of painting link jade, maize, and feathers at the Red Temple, marking them as similar to one another and distinct from the other things represented in the mural. Other elements of the painting share one of these characteristics but not both—the cacao plant is the same medium blue;[11] the dark panels of the aquatic border are painted in a luxurious way (see Figure 3.23)— yet this similarity is not sufficient to bring them into the same tight circuit of color and meaning. Multiple lines of evidence are necessary to avoid falling into the fallacy that blue signifies preciousness each and every time it is deployed.[12]

This opulent application of paint and the choices of color recall the painting of the tropical Maya and Gulf Coast Lowlands. Maya painters layered veils of color to create the iridescent hues of precious substances, like jade and quetzal feathers (Magaloni 1998:72–73; 2001:175). They were masters of both the transparent wash of paint on the wet wall and the later addition of detail in secco, from a delicate tracing of white to an almost sculptural impasto (see Figure 3.22; Magaloni 1998:57–60, 2001:196, 2004c:250; Miller and Brittenham 2013:50–51). At the same time, the treatment of the blues at the Red Temple recalls the mural painting of El Tajín and Las Higueras on the Gulf Coast, which favors an opaque light Maya blue mixed with lime—the same kind of hue used to highlight the jades and maize plants at the Red Temple (Magaloni et al. 2013:194). Painters at El Tajín also juxtaposed this light blue with brilliant opaque greens and a dark blue created by covering a layer of medium Maya blue with

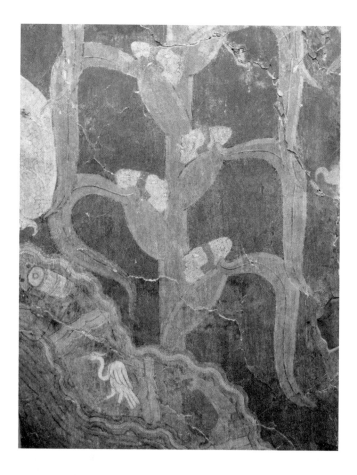

figure 3.23
Red Temple, east wall, maize plant with human ears of maize on elongated heads with long red hair. Note the red and yellow lines in the center of each lamina of the maize plant and in the feathers of the plumed serpent beneath the aquatic border. (Photograph by Claudia Brittenham.)

figure 3.24
Red Temple, east wall, view of old god and his backpack. Both are luxuriously painted. (Photograph by Claudia Brittenham.)

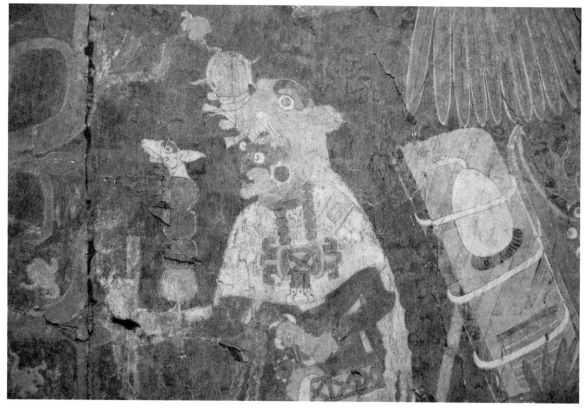

figure 3.25
El Tajín, Building I. Note the use of an opaque Maya green and a dark Maya blue, created by layering dark color over a layer of opaque medium blue. (Photograph by Rafael Doniz.)

a thin veil of carbon or indigo (Figure 3.25), like the dark blue of the aquatic border at the Red Temple (see Figure 3.23; Magaloni et al. 2013:171). Perhaps not only the choice of pigments but also the ways of applying paint augmented the tale of cosmopolitan riches told at the Red Temple.

Structure A: Material Rhetoric Forgotten?

Some of the material rhetorics at Cacaxtla were hard to see. Their interpretation required not just close observation of the mural—something that could be difficult to achieve in the dark and ritually charged spaces of the Red Temple or Structure A, for example—but also knowledge of the sources and ways of processing particular pigments. The

meaning, and even the sheer presence, of many of these material choices must have been transmitted as much through verbal communication as through visual observation, and over time much about the creation of the painting would have to be remembered for its material significance to be understood (for performative elements of techné, see also the essays by Halperin and Trever in this volume). In the murals of Structure A, one of the most important and enduring ritual spaces on the Cacaxtla acropolis, it may be possible to see that chain of communication and memory failing, and the meaning of a material rhetoric becoming lost.

At Structure A, paintings shaped one of the most sacred experiences on the Cacaxtla acropolis; repeated interventions and modifications to the painting program kept the structure vital for

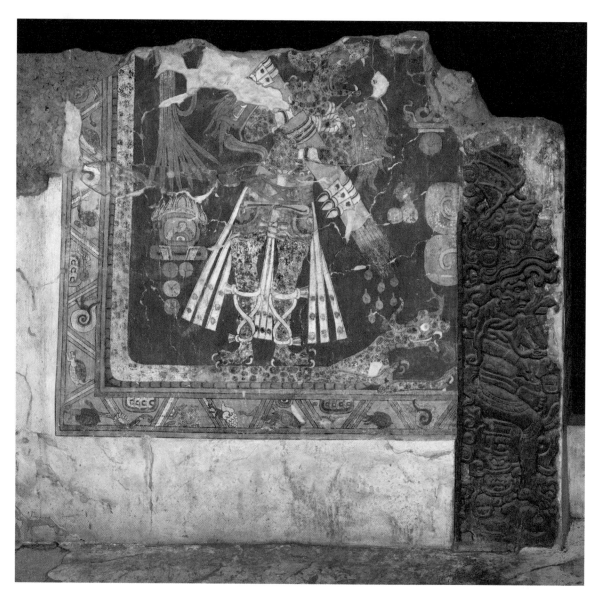

figure 3.26

Structure A, north portico mural. (Photograph by Ricardo Alvarado Tapia and Patricia Peña González, courtesy of the archive of the Proyecto la Pintura Mural Prehispánica en México, Instituto de Investigaciones Estéticas, Universidad Nacional Autónoma de México.)

generations (Brittenham 2015:183–215; López and Molina 1986: 41–42; Lucet 1998:118–121, 2013:77–85; Magaloni et al. 2013:162–167; Urcid and Domínguez 2013:610–611, 650–659). Two black-skinned figures flank the doorway into the inner room of this two-room temple, as if guarding the inner sanctum (Figures 3.26 and 3.27). Passing through the doorway, the observer confronts two smaller figures painted on the wide jambs of the door (Figures 3.28 and 3.29). The portico and jamb murals of Structure A draw on a rich rhetoric of seasonal opposition, signifying both alternation and completion, to demonstrate the centrality of the city-state to natural cycles of growth and sustenance (Brittenham 2015:185–189, 197–201; Foncerrada 1976; Graulich 1990:98–107; Lombardo 1986:230–238; Piña Chan 1998:87–100; Townsend 1997:97–98; Urcid and Domínguez 2013; Uriarte 1999:75–78).

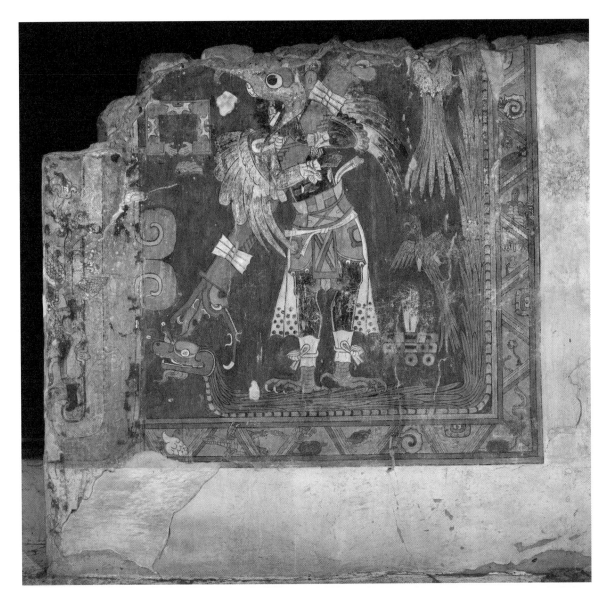

figure 3.27
Structure A, south portico mural. (Photograph by Ricardo Alvarado Tapia and Patricia Peña González, courtesy of the archive of the Proyecto la Pintura Mural Prehispánica en México, Instituto de Investigaciones Estéticas, Universidad Nacional Autónoma de México.)

All four of the figures guarding the inner doorway originally had black-painted skin; this is still apparent on both portico figures, and on the south jamb figure, but the face of the figure on the north jamb is now painted a light pinkish-orange hue (see Figure 3.28). However, in microscopic section, it is clear that this warm color covers an earlier layer of black skin tone, which consists of carbon black mixed with particles of hematite (Figure 3.30). This

was the original skin tone of the north jamb figure; the layer of pink-orange pigment—a mixture of yellow ochre, red hematite, and white limestone—is so thick, in part, because it must cover the earlier and darker pigment. It corresponds to a later campaign of repainting that also added a bright (and often runny) red pigment to many details of the portico and jamb murals, as if to revitalize them (Magaloni et al. 2013:162–167, 196).

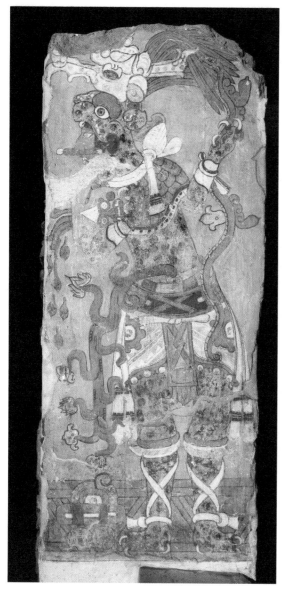

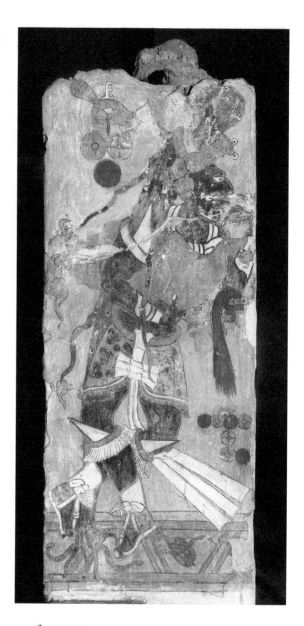

figure 3.28
Structure A, north jamb mural. (Photograph
by Ricardo Alvarado Tapia and Patricia Peña
González, courtesy of the archive of the Proyecto
la Pintura Mural Prehispánica en México, Instituto
de Investigaciones Estéticas, Universidad Nacional
Autónoma de México.)

figure 3.29
Structure A, south jamb mural. (Photograph
by Ricardo Alvarado Tapia and Patricia Peña
González, courtesy of the archive of the Proyecto
la Pintura Mural Prehispánica en México, Instituto
de Investigaciones Estéticas, Universidad Nacional
Autónoma de México.)

Crucially, the black skin pigment on the north
jamb is distinct from the black skin pigment on the
south figures. Although the north portico figure's
face was not sampled, visual inspection suggests
that it was likely painted with this same mixture
of black and red pigment. By contrast, the skin of
both of the southern figures is composed of a very
thin layer of pure black pigment (Figures 3.31 and
3.32). Thus, at Structure A, color simultaneously
establishes similarity and difference. The choice of
black skin tones for all four figures implies relation
ships among them, as color did at the Red Temple,

fig. 3.30

fig. 3.31

fig. 3.32

figure 3.30
Structure A, north jamb, detail of standing figure's face. The first layer of dark paint is the original color of the figure's face: the pigment is carbon black mixed with hematite red. The thick upper layer is a later modification to the painting, which changed the color of the figure's skin to pink-orange: the pigment here is a mixture of yellow ochre, red hematite, and white lime. Magnified 20×. (Microphotograph by Diana Magaloni and Andrés Paz.)

figure 3.31
Structure A, south portico, detail of principal figure's leg. This is an unusually thin layer of pure black pigment. Magnified 50×. (Microphotograph by Diana Magaloni and Andrés Paz.)

figure 3.32
Structure A, south jamb, detail of principal figure's arm. The thin layer of black is the original color of the figure's skin and the same pigment seen on the south portico figure; the thick layer of hematite red above is the runny red pigment added to many details of the painting during the later campaign of repainting that also changed the color of the north jamb figure's face (see Figure 3.30). The thick opaque layer on top is the sulfates and polymer resin covering the painting. Magnified 50×. (Microphotograph by Diana Magaloni and Andrés Paz.)

but as at the Battle Mural, the choices of those pigments create contrasts between the north and the south figures. Once again, these material distinctions anticipate the iconographic program of the painting, which contrasts the nocturnal and telluric imagery of jaguars on the north with the solar, aerial imagery of birds on the south—a juxtaposition of

the rainy season on the north with the dry season on the south (Escalante 2002:76–77; Graulich 1990:98–106; McVicker 1985:45; Piña Chan 1998:98–100).

The use of different materials for these two pairs of painted bodies not only structures differences between them but also may refer to distinct body-painting practices. In a study of Aztec color, some six hundred years after Cacaxtla, Elodie Dupey García has demonstrated that the materiality of pigment also mattered deeply for Aztec god-impersonators. Sixteenth-century texts refer to various kinds of black pigments, called *olli* and *tlilpopotzalli*, which seem to have been made out of different materials and associated with different deities—although these distinctions in the texts do not correspond perfectly with what is found in the

material record (Dupey 2010:425–458, 2014/2015; see also Carreón 2006).[13] The historical gap is too great to map these substances and practices directly onto the Cacaxtla figures, but it raises the possibility that this material difference in the murals might refer to different kinds of body-painting practices, perhaps keying associations with particular deity impersonations or other religious rituals.

Whatever the meaning, the Cacaxtla painters provided subtle visual cues to these material contrasts. The bodies of the figures on the south portico and jamb are outlined with a thick white line, while the black skin of the figure on the north jamb has no outline, as if the artists sought to indicate that these two apparently identical black skins are not as similar as they seem. A lighter outline also surrounds the obsidian points of the atlatl projectiles held in a bundle by the figure on the north portico, as if to suggest that the southern bodies have a brilliant shine like that of obsidian (the pigment of the projectiles was not analyzed; Magaloni et al. 2013:195–196). Yet even these visual cues may have been insufficient to preserve the material meaning.

Decades later, a repainting campaign changed the color of the north jamb figure's face, disrupting the equivalences between the four portico and jamb figures. Instead, it placed emphasis on a relationship within the jamb murals, associating the principal figure on the north jamb with the yellow-skinned figure emerging from the conch shell on the south (see Figures 3.28 and 3.29). This latter figure also appears to have a complex material history. The colors of the face and body are not identical: the face is far more yellow in hue than the body, which appears pinkish but also seems to have a brown overlay that has largely flaked off. It seems likely that this figure's face was also retouched in the repainting campaign. Yet neither face nor body color is identical to that of the repainted face on the north jamb; it is likely that different materials were used here as well, although no samples were taken. Despite such dissimilarities, these figures are united by their pale, yellowish skin, so unlike familiar Mesoamerican skin tones. This skin color, combined with their red hair, which was also reemphasized in this late episode of repainting, likens

both figures to the anthropomorphic ears of maize at the Red Temple; the Structure A mural also seems to tell a story of maize generating inside the body of the earth, which is re-created in this inner room of Structure A (Brittenham 2015:201–206; Graulich 1990:99, 103; Townsend 1997:97–98). But the figures tell this story obliquely, with none of the explicitness of the Red Temple maize plants, and perhaps the color change on the north jamb was necessary to clarify the relationship between the sprouting plant emerging from the north jamb figure's navel and the figure emerging from the conch shell. Both of these elements received a great deal of emphasis in the repainting, with many details painted or repainted using a runny red pigment (Magaloni et al. 2013:165–167, 196).

The repainting of this figure signals the emergence of a new rhetoric—one of color, but not, significantly, of material. Yet it also marks the occlusion of an old one, of a material rhetoric difficult for the naked eye to discern, even with the subtle visual cues left by the original painters. Could this change indicate that the original rhetoric was forgotten—that the chains of speech and memory that must have made the material choices at Cacaxtla meaningful had broken down? Without sampling and microscopic analysis, these rhetorics were only as good as the communication networks that sustained them, and in these late years of the Cacaxtla polity, perhaps many things were already being forgotten.

Closing Reflections

Color does not signify in exactly the same way at Structure A that it does at the Red Temple or the Battle Mural, and perhaps we should not expect it to: the murals were made at different historical moments and addressed radically different audiences. Not everyone would have had the right to enter the inner sanctum of Structure A or descend into the sacred space of the Red Temple, and the artists may have been able to presume a certain kind of knowledge on the part of the viewers, at least at the moment of the painting's creation—a knowledge of the wider Mesoamerican world, perhaps, and a keen

awareness of the price and source of expensive pigments. At the public Battle Mural, by contrast, the audience was vast and varied, and here choices about the materiality of color seem to be almost deliberately concealed from the uninitiated eye, a way of creating added significance for those in the know. Yet what all three examples reveal is how materials make value and meaning in a painting. In each case, the most vital iconographic arguments are already present in the choice of materials—or at least in the choice of certain materials, for not every color or pigment at Cacaxtla seems to have had equal rhetorical power in every context. Makers' deep knowledge of the sources of color and of the ways to make pigments—that is, techné—shaped the points of diacritic emphasis on color in the Cacaxtla murals and enabled pigments to tell a story that enriched the meaning of the murals. Yet the example of Structure A is also a cautionary tale—that such meaning may have proved fragile and vulnerable, more ephemeral than the painting itself.

Acknowledgments

We thank the Instituto Nacional de Antropología e Historia, Mexico, for authorizing this research project and the Proyecto la Pintura Mural Prehispánica en México, Instituto de Investigaciones Estéticas of the Universidad Nacional Autónoma de México, under whose auspices this research was carried out. Special thanks to its director, María Teresa Uriarte Castañeda, and to all of our colleagues who offered valuable commentaries on our work. We are grateful to Piero Baglioni, Rodorico Giorgi, and Lorenza Bernini of the Centro degli Studi, Università di Firenze, for performing many of the technical analyses cited here, and to Andrés Paz at the UNAM for helping to prepare the slides for the microphotographs. We also thank Barbara Arroyo, Elizabeth Boone, and Elodie Dupey García for their insightful questions at the symposium, as well as Cathy Costin and two anonymous reviewers for their helpful comments.

NOTES

1 Most of the visible murals were painted in the eighth and ninth centuries CE, though the tradition may have started at least a century earlier. It is impossible to propose precise dates for any of the murals: conservation interventions have rendered AMS radiocarbon dating of the carbon pigments in the murals largely unreliable, and other radiocarbon measures more loosely associated with the murals must be carefully interpreted. For further discussion, see Brittenham 2015:221–224.

2 Bodies that now appear white on the Battle Mural—such as those of 3 Deer Antler on both taludes (Individuals W2 and E3) as well as Individuals E17, E22, E26, W18, and W21—were originally painted with a black or gray pigment that has eroded substantially (see Magaloni et al. 2013:183, fig. 3.51).

3 This practice of dyeing clays with an organic colorant is similar to the manufacture of Maya blue. Red pigments made with this technique are found in the Maya murals of Bonampak and Calakmul (Magaloni et al. 2013:178; Vázquez 2010:102–106), as well as in Zapotec tombs in Oaxaca (Magaloni 2010:60, 68–71; Magaloni and Falcón 2008: 203, 205, 215–216). For the data suggesting the presence of an organic colorant in the red pigment in the Cacaxtla Battle Mural, see Magaloni et al. 2013:fig. 3.40).

4 The texts may have been painted by the same artists who created the rest of the mural, with each person responsible for the texts in his own area of the painting. Although the sample of glyphs is too small to permit a conclusive analysis, similarities exist between the forms of image and text in certain passages of the painting—such as the curved beaks of bird headdresses and glyphs on the far end of the east talud or the crisp lines of the glyphs at its center. Furthermore, when the artists differ, as in the case of the two figures named 3 Deer Antler on the east and west taludes, so does the form of the glyphs (Brittenham 2008:158; 2013:293, 340–343).

The probable continuity of painters' hands suggests that the decision to add the texts cannot have come after too long of a lapse—perhaps even while work on the mural was being completed.

5 Indeed, Magaloni and Falcón have discovered precisely such a pattern in the tombs of Oaxaca, where mineral green pigments vary widely from tomb to tomb, as if they were brought from the territories of different lineages (Magaloni 2010:66–67; Magaloni and Falcón 2008:196–197, 209, 216, 223).

6 Hematite, maghemite, and the red pigment used to paint the bodies of the defeated are all iron oxides with the chemical structure Fe_2O_3; they have different crystalline structures, visible through x-ray diffraction. For more detail, see Magaloni et al. 2013:174–182.

7 For more on the capacity of Mesoamerican images to act as subjects and not only as objects, following Viveiros de Castro's (2003) theories of indigenous subjectivity, see Magaloni 2014. For a recent reassessment of Viveiros de Castro, see Turner 2009.

8 Surprisingly little other material evidence of contact between Cacaxtla and the Maya area has been found during excavations. Foreign ceramics make up less than one percent of all ceramics collected, and most are from the Gulf Coast and Oaxaca; ceramics of clear Maya origin are exceedingly rare (Rosalba Delgadillo Torres and Beatriz Palavicini Beltrán, personal communications, 2006; Delgadillo 2005:107, 113, n.d.; López 1980:298–299; López and Molina 1986:70; Serra et al. 2004:151–157). Greenstone plaques at the site have more in common with Monte Albán than with the Maya region (Nagao 2007:421–425). A single pot incised with Maya glyphs, recovered at Xochitécatl and currently on display in the Museo Regional de Tlaxcala, is one of the few clear indices, beyond the murals themselves, of contact with the Maya area (Cherra Wyllie, personal communication, 2007; Wyllie 2002:262; note that this object is not published in Serra et al. 2004, the official catalogue of Xochitécatl ceramics). If extensive trade between Cacaxtla and the Maya region took place, much of it could have consisted of ephemeral goods, such as cloth and feathers. On the other hand,

Cacaxtla may never have been as rich or as cosmopolitan as the paintings claim. See Nagao 1989 and Brittenham 2015 for further discussion.

9 Leonardo López Luján et al. (2005:22–27) suggest that in Aztec times, Maya merchants may have controlled the technology for producing the pigment as well as the clay needed to produce it. However, trade patterns may have differed earlier in Mesoamerican history: the idiosyncratic greens at Structure A and the Temple of Venus suggest that Cacaxtlans were making their own lake pigments by dyeing clays with organic colorants, not just importing prepared pigments from the Maya area. "Maya" blues, again likely of local manufacture, are also found in Oaxaca (Magaloni and Falcón 2008:196–197, 203–204). Teotihuacan blue pigments come out of another tradition entirely; their composition is still not well understood, but it is clear that they are not Maya blue, even though an organic colorant may be involved in their manufacture (Magaloni 1995:210–212).

10 For *difrasismo,* or "diphrastic kennings," paired couplets that together represent abstract concepts, and their centrality to Mesoamerican rhetorical tradition, see Garibay 1940:112–113; Knowlton 2002; Montes de Oca 2000; Sahagún 1950–1982:bk. 6, chs. 41 and 43, 219–253, 241–260; Stuart 2003.

11 While the cacao plant is painted a simple medium blue, its precious fruits are colored a magenta hue, created by layering a pink pigment (composed of a mixture of red hematite and white lime) over a layer of Maya blue (Magaloni 1994:50).

12 By this same measure, the use of a medium-blue hue for feathers and jade at the Battle Mural, in the absence of any special attention to the mode of painting, is insufficient to argue for a similar rhetoric there.

13 In spite of the clear distinctions in textual sources, different kinds of body paint often ended up represented with a single charcoal-based pigment in Postclassic Central Mexican codices (Laurencich-Minelli et al. 1993:204, cited in Dupey 2014/2015), and kinds of paints identified as *olli* in textual sources are made out of different materials on sculpture (Carreón 2006:166–183).

Abascal, Rafael, Patricio Dávila, Peter Schmidt, and
Diana Z. de Dávila

1976 La arqueología del sur-oeste de Tlaxcala
(primera parte). *Communicaciones del
Proyecto Puebla-Tlaxcala* Suplemento II.

Arnold, Dean E.

2005 Maya Blue and Palygorskite: A Second
Pre-Columbian Source. *Ancient
Mesoamerica* 16(1):51–62.

Arnold, Dean E., Jason R. Branden, Patrick Ryan
Williams, Gary Feinman, and J. P. Brown

2008 The First Direct Evidence for the
Production of Maya Blue: Rediscovery
of a Technology. *Antiquity* 82:151–164.

Arnold, Dean E., Hector Neff, Michael D. Glascock,
and Robert J. Speakman

2007 Sourcing the Palygorskite Used in Maya
Blue: A Pilot Study Comparing the
Results of INAA and LA-ICP-MS. *Latin
American Antiquity* 18(1):44–58.

Bierhorst, John

1992 *History and Mythology of the Aztecs:
The Codex Chimalpopoca.* University
of Arizona Press, Tucson.

Brittenham, Claudia

2008 The Cacaxtla Painting Tradition: Art
and Identity in Epiclassic Mexico. PhD
dissertation, Department of the History
of Art, Yale University, New Haven.

2009 Portraiture, Emotion, and the Represen-
tation of Ethnicity at Cacaxtla. Paper
presented at the College Art Association
Annual Conference, Los Angeles.

2011 About Time: Problems of Narrative
in the Battle Mural at Cacaxtla.
Res: Anthropology and Aesthetics
59/60:74–92.

2013 Los pintores de Cacaxtla. In *La pin-
tura mural prehispánica en México V:
Cacaxtla—Tomo II; Estudios,* edited
by María Teresa Uriarte and Fernanda
Salazar Gil, pp. 267–361. Universidad
Nacional Autónoma de México,
Instituto de Investigaciones Esteticas,
Mexico City.

2015 *The Murals of Cacaxtla: The Power of
Painting in Ancient Central Mexico.*
University of Texas Press, Austin.

Carlson, John B.

1991 *Venus-Regulated Warfare and Ritual
Sacrifice in Mesoamerica: Teotihuacan
and the Cacaxtla Star Wars Connection.*
University of Maryland Center for
Archaeoastronomy, College Park.

Carreón Blaine, Emilie

2006 *El olli en la plástica mexica: El uso
del hule en el siglo XVI.* Universidad
Nacional Autónoma de México,
Instituto de Investigaciones Estéticas,
Mexico City.

Coe, Michael D., and Justin Kerr

1997 *Art of the Maya Scribe.* Harry N.
Abrams, New York.

Coe, Sophie D.

1994 *America's First Cuisines.* University of
Texas Press, Austin.

Dehouve, Danièle

2003 Nombrar los colores en náhuatl
(siglos XVI–XX). In *El color en el arte
mexicano,* edited by Georges Roque,
pp. 51–95. Universidad Nacional
Autónoma de México, Instituto de
Investigaciones Estéticas, Mexico City.

Delgadillo Torres, Rosalba

2005 La cerámica del epiclásico de Tlaxcala.
In *La producción alfarera en el México
antiguo,* edited by Beatriz Leonor
Merino Carrión and Angel García
Cook, pp. 105–124. Instituto Nacional de
Antropología e Historia, Mexico City.

n.d. Informe final: Proyecto ceramoteca
realizado en el gran basamento de
Cacaxtla, Tlaxcala. Report presented to
the Instituto Nacional de Antropología e
Historia (Archivo Técnico 28–81).

Domínguez Covarrubias, Elba, and Javier Urcid
Serrano

2013 El ascenso al poder del señor 4 Perro:
Las pinturas murales del Conjunto 2–
sub en Cacaxtla. In *La pintura mural
prehispánica en México V: Cacaxtla—
Tomo III; Estudios,* edited by María
Teresa Uriarte and Fernanda Salazar
Gil, pp. 547–607. Universidad Nacional
Autónoma de México, Instituto de
Investigaciones Esteticas, Mexico City.

Dupey García, Elodie

2010 Les couleurs dans les practiques et les répresentations des Nahuas du Méxique central (XIVe-XVIe siècles). PhD dissertation, École Pratique des Hautes Études, Paris.

2014/2015 The Materiality of Color in the Body Ornamentation of Aztec Gods. *Res: Anthropology and Aesthetics* 65/66:72–88.

Escalante Gonzalbo, Pablo

2002 Allegory in the Cacaxtla Murals. *Voices of Mexico* 61:73–77.

Folan, William J.

1969 Sacalum, Yucatan: A Pre-Hispanic and Contemporary Source of Attapulgite. *American Antiquity* 34(2):182–183.

Foncerrada de Molina, Marta

1976 La pintura mural de Cacaxtla, Tlaxcala. *Anales del Instituto de Investigaciones Estéticas* 46:5–20.

1980 Mural Painting in Cacaxtla and Teotihuacan Cosmopolitanism. In *Tercera Mesa Redonda de Palenque, 1978, Part 2*, edited by Merle Greene Robertson and Donnan C. Jeffers, pp. 183–203. Pre-Columbian Art Research Center, Monterey, Calif.

1993 *Cacaxtla: La iconografía de los olmeca-xicalanca.* Universidad Nacional Autónoma de México, Instituto de Investigaciones Estéticas, Mexico City.

Garibay Kintana, Angel

1940 *Llave del náhuatl, colección de trozos clásicos, con gramática y vocabulario, para utilidad de los principiantes.* Mayli, Otumba.

Graulich, Michel

1990 Dualities in Cacaxtla. In *Mesoamerican Dualism/Dualismo mesoamericano: Symposium of the 46th International Congress of Americanists, Amsterdam, 1988*, edited by Rudolf van Zantwijk, Rob de Ridder, and Edwin Braakhuis, pp. 94–118. RUU-ISOR, Utrecht.

Guernsey, Julia

2006 *Ritual and Power in Stone: The Performance of Rulership in Mesoamerican Izapan Style Art.* University of Texas Press, Austin.

Hagen, Victor Wolfgang von

1944 *The Aztec and Maya Papermakers.* J. J. Augustin, New York.

Helmke, Christopher, and Jesper Nielsen

2011 *The Writing System of Cacaxtla, Tlaxcala, Mexico.* Ancient America Special Publication 2. Boundary End Archaeology Research Center, Barnardsville, N.C.

Houston, Stephen D., Claudia Brittenham, Cassandra Mesick, Alexandre Tokovinine, and Christina Warinner

2009 *Veiled Brightness: A History of Ancient Maya Color.* University of Texas Press, Austin.

Houston, Stephen D., David Stuart, and Karl A. Taube

2006 *The Memory of Bones: Body, Being, and Experience among the Classic Maya.* University of Texas Press, Austin.

Izeki, Mutsumi

2008 *Conceptualization of 'Xihuitl': History, Environment and Cultural Dynamics in Postclassic Mexica Cognition.* BAR International Series 1863. Archaeopress, Oxford.

José-Yacamán, Miguel, Luis Rendón, J. Arenas, and Mari Carmen Serra Puche

1996 Maya Blue Paint: An Ancient Nanostructured Material. *Science* 273(5272):223–225.

Knowlton, Timothy

2002 Diphrastic Kennings in Mayan Hieroglyphic Literature. *Mexicon* 21(1):9–12.

Kubler, George A.

1980 Eclecticism at Cacaxtla. In *Tercera Mesa Redonda de Palenque, 1978, Part 2*, edited by Merle Greene Robertson and Donnan C. Jeffers, pp. 163–172. Pre-Columbian Art Research Center, Monterey, Calif.

Laurencich-Minelli, Laura, Giorgio Gasparotto, and Giovanni Valdrè

1993 Notes about the Painting Techniques and the Morphological, Chemical and Structural Characterization of the Writing Surface of the Prehispanic Mexican Codex Cospi. *Journal de la Societé des Américanistes* 79(1):203–207.

Littmann, Edwin R.

1982 Maya Blue—Further Perspectives and the Possible Use of Indigo as the Colorant. *American Antiquity* 47(2):404–408.

Lombardo de Ruiz, Sonia

1986 La pintura. In *Cacaxtla: El lugar donde muere la lluvia en la tierra*, pp. 209–499. Gobierno del Estado de Tlaxacala and Instituto Nacional de Antropología e Historia, Mexico City.

Lombardo de Ruiz, Sonia, Diana López de Molina, Daniel Molina Feal, Carolyn Baus de Czitrom, and Oscar J. Polaco

1986 *Cacaxtla: El lugar donde muere la lluvia en la tierra.* Gobierno del Estado de Tlaxcala and Instituto Nacional de Antropología e Historia, Mexico City.

López de Molina, Diana

1980 Relación entre Cacaxtla y el Golfo de México. In *Rutas de intercambio en Mesoamérica y el norte de México: XVI Reunión de Mesa Redonda de la Sociedad Mexicana de Antropología, Saltillo, Coahuila, del 9 al 14 de septiembre de 1979*, pp. 295–304. Sociedad Mexicana de Antropología, Saltillo.

López de Molina, Diana, and Daniel Molina Feal

1986 Arqueología. In *Cacaxtla: El lugar donde muere la lluvia en la tierra*, pp. 11–208. Gobierno del Estado de Tlaxacala and Instituto Nacional de Antropología e Historia, Mexico City.

López Luján, Leonardo, Giacomo Chiari, Alfredo López Austin, and Fernando Carrizosa

2005 Línea y color en Tenochtitlan: Escultura policromada y pintura mural en el recinto sagrado de la capital mexica. *Estudios de cultura náhuatl* 36:15–45.

Lucet Lagriffoul, Geneviève

1998 La computación visual aplicada a la documentación y estudio de monumentos: El sitio arqueológico de Cacaxtla y el mural O'Gorman; Dos estudios de caso. PhD dissertation, Facultad de Arquitectura, Universidad Nacional Autónoma de México, Mexico City.

2013 Arquitectura de Cacaxtla, lectura del espacio. In *La pintura mural prehispánica en México V: Cacaxtla—Tomo II; Estudios*, edited by María Teresa Uriarte and Fernanda Salazar Gil, pp. 19–109. Universidad Nacional Autónoma de México, Instituto de Investigaciones Esteticas, Mexico City.

Magaloni Kerpel, Diana Isabel

1994 *Metodología para el análisis de la técnica pictórica mural prehispánica: El Templo Rojo de Cacaxtla.* Colección científica. Instituto Nacional de Antropología e Historia, Mexico City.

1995 El espacio pictórico teotihuacano: Tradición y técnica. In *La pintura mural prehispánica en México I: Teotihuacán—Tomo II; Estudios*, edited by Beatriz de la Fuente, pp. 187–225. Universidad Nacional Autónoma de México, Instituto de Investigaciones Estéticas, Mexico City.

1998 El arte en el hacer: Técnica pictórica y color en las pinturas de Bonampak. In *La pintura mural prehispánica en México II: Área maya—Bonampak—Tomo II; Estudios*, edited by Beatriz de la Fuente and Leticia Staines Cicero, pp. 49–80. Universidad Nacional Autónoma de México, Instituto de Investigaciones Estéticas, Mexico City.

2001 Materiales y técnicas de la pintura mural maya. In *La pintura mural prehispánica en México II: Área maya—Tomo III; Estudios*, edited by Beatriz de la Fuente and Leticia Staines Cicero, pp. 155–198. Universidad Nacional Autónoma de México, Instituto de Investigaciones Estéticas, Mexico City.

2003 Teotihuacán: El lenguaje del color. In *El color en el arte mexicano*, edited by Georges Roque, pp. 163–203. Universidad Nacional Autónoma de México, Instituto de Investigaciones Estéticas, Mexico City.

2004a Los pintores de El Tajín y su relación con la pintura mural teotihuacana. In *La costa del Golfo en tiempos teotihuacanos: Propuestas y perspectivas; Memoria de la Segunda Mesa Redonda de Teotihuacan*, edited by María Elena Ruiz Gallut and Arturo Pascual Soto, pp. 427–439. Instituto Nacional de Antropología e Historia, Mexico City.

2004b Technique, Color, and Art at Bonampak. In *Courtly Art of the Ancient Maya*, edited by Mary Ellen Miller and Simon Martin, pp. 250–252. Fine Arts Museums of San Francisco, San Francisco, and Thames and Hudson, New York.

2010 The Hidden Aesthetic of Red in the Painted Tombs of Oaxaca. *Res: Anthropology and Aesthetics* 57/58:55–74.

2011 Painters of the New World: The Process of Making the *Florentine Codex*. In *Colors Between Two Worlds: The Florentine Codex of Bernardino de Sahagún*, edited by Gerhard Wolf and Joseph Connors, pp. 47–76. Kunsthistorisches Institut in Florenz, Max-Planck-Institut, and Villa I Tatti, the Harvard University Center for Italian Renaissance Studies, Florence.

2014 *The Colors of the New World: Artists, Materials, and the Creation of the Florentine Codex*. Getty Research Institute, Los Angeles, and Universidad Nacional Autónoma de México, Instituto de Investigaciones Esteticas, Mexico City.

Magaloni Kerpel, Diana Isabel, Claudia Brittenham, Piero Baglioni, Rodorico Giorgi, and Lorenza Bernini

2013 Cacaxtla, la elocuencia de los colores. In *La pintura mural prehispánica en México V: Cacaxtla—Tomo II; Estudios*, edited by María Teresa Uriarte and Fernanda Salazar Gil, pp. 147–197. Universidad Nacional Autónoma de México, Instituto de Investigaciones Esteticas, Mexico City.

Magaloni Kerpel, Diana Isabel, and Tatiana Falcón Álvarez

2008 Pintando otro mundo: Técnicas de pintura mural en las tumbas zapotecas. In *La pintura mural prehispánica en México III: Oaxaca—Tomo III; Estudios*, edited by Beatriz de la Fuente, pp. 177–225. Universidad Nacional Autónoma de México, Instituto de Investigaciones Estéticas, Mexico City.

Martin, Simon

2013 El Templo Rojo y los mayas: arte, mitología y contactos culturales en las pinturas de Cacaxtla. In *La pintura mural prehispánica en México V: Cacaxtla—Tomo III: Estudios*, edited by María Teresa Uriarte and Fernanda Salazar Gil, pp. 529–545. Universidad Nacional Autónoma de México, Instituto de Investigaciones Esteticas, Mexico City.

McCafferty, Sharisse D., and Geoffrey G. McCafferty

1994 The Conquered Women of Cacaxtla: Gender Identity or Gender Ideology? *Ancient Mesoamerica* 5(2):159–172.

McVicker, Donald

1985 The "Mayanized Mexicans." *American Antiquity* 50(1):82–101.

Miller, Mary Ellen, and Claudia Brittenham

2013 *The Spectacle of the Late Maya Court: Reflections on the Murals of Bonampak*. University of Texas Press, Austin.

Miller, Mary Ellen, and Stephen D. Houston

1987 The Classic Maya Ballgame and Its Architectural Setting. *Res: Anthropology and Aesthetics* 14:46–65.

Millon, Clara

1973 Painting, Writing, and Polity in Teotihuacan, Mexico. *American Antiquity* 38(3):294–314.

Montes de Oca, Mercedes

2000 *Los difrasismos en náhuatl del siglo XVI*. Universidad Nacional Autónoma de México, Mexico City.

Mora, Paolo, Laura Mora, and Paul Philippot

1984 *Conservation of Wall Paintings*. Butterworths, London.

Nagao, Debra

1989 Public Proclamation in the Art of Cacaxtla and Xochicalco. In *Mesoamerica After the Decline of Teotihuacan, A.D. 700–900*, edited by Richard Diehl and Janet Catherine Berlo, pp. 83–104. Dumbarton Oaks Research Library and Collection, Washington, D.C.

2007 Piezas lapidarias de Cacaxtla, Tlaxcala en el contexto del epiclásico. In *Memorias del Primer Coloquio Internacional Cacaxtla a sus Treinta Años de Investigación*, pp. 417–440. Centro Regional INAH Tlaxcala, Tlaxcala.

Orea Magaña, Haydée, Gilberto Buitrago Sandoval, and Olga Lucía González Correa

2011 Recientes intervenciones en Bonampak: Hacia una nueva lectura de los murales en el Templo de la Pinturas. *Intervención* 2(3):58–65.

Ovarlez, Sonia

2003a Aportación de la colorimetría al estudio de las recetas antiguas de fabricación de los azules mayas. *Boletín informativo la pintura mural prehispánica en México* 9(19):35–42.

2003b Yax: Fabrications et utilisations des bleu-vert mayas. MA thesis, Ecole d'Art d'Avignon, Département Conservation-Restauration d'Oeuvres Peintes, Avignon.

Paulinyi, Zoltán

1991 Una imagen del dios de la lluvia en Cacaxtla y la iconografía teotihuacana. *Boletín del Museo Chileno de Arte Precolombino* 5:53–66.

Piña Chan, Román

1998 *Cacaxtla: Fuentes históricas y pinturas.* Fondo de Cultura Económica, Mexico City.

Reyes-Valerio, Constantino

1993 *De Bonampak al Templo Mayor: El azul maya en Mesoamérica.* Siglo XXI Editores, Mexico City.

Robertson, Donald

1985 The Cacaxtla Murals. In *Fourth Palenque Round Table, 1980,* edited by Elizabeth P. Benson, pp. 291–302. Pre-Columbian Art Research Institute, San Francisco.

Sahagún, Fray Bernadino de

1950–1982 *Florentine Codex: General History of the Things of New Spain.* Translated by Arthur J. O. Anderson and Charles E. Dibble. 13 vols. School of American Research, Santa Fe.

Santana Sandoval, Andrés

1990 El simbolismo de las pinturas murales del Templo de Venus y el Templo Rojo. In *Cacaxtla: Proyecto de investigación y conservación,* pp. 67–75. Instituto Nacional de Antropología e Historia, Tlaxcala.

2011 *El santuario de Cacaxtla.* Editorial Trillas, Mexico City.

Santana Sandoval, Andrés, Sergio Vergara Berdejo, and Rosalba Delgadillo Torres

1990 Cacaxtla, su arquitectura y pintura mural: Nuevos elementos para su analisis. In *La época clásica: Nuevos hallazgos, nuevas ideas,* edited by Amalia Cardos de Méndez, pp. 329–350. Instituto Nacional de Antropología e Historia, Mexico City.

Serra Puche, Mari Carmen, Jesús Carlos Lazcano Arce, and Manuel de la Torre Mendoza

2004 *Cerámica de Xochitécatl.* Universidad Nacional Autónoma de México, Instituto de Investigaciones Antropológicas, Mexico City.

Stuart, David

2003 On the Paired Variants of TZ'AK. Electronic document, www.mesoweb.com/stuart/notes/tzak.pdf, accessed December 1, 2013.

Taube, Karl A.

1992 *The Major Gods of Ancient Yucatan.* Studies in Pre-Columbian Art and Archaeology 32. Dumbarton Oaks Research Library and Collection, Washington, D.C.

1996 The Olmec Maize God: The Face of Corn in Formative Mesoamerica. *Res: Anthropology and Aesthetics* 29/30:39–81.

2000 *The Writing System of Ancient Teotihuacan.* Center for Ancient American Studies, Washington, D.C.

Tena, Rafael

2011 *Mitos e historias de los antiguos nahuas.* 2nd ed. Paleography and translations by Rafael Tena. Cien de México, Mexico City.

Tokovinine, Alexandre and Cameron McNeil (editors)

2012 Color in American Prehistory. *Res: Anthropology and Aesthetics* 61/62:279–376.

Townsend, Richard F.

1997 Cacaxtla and Xochicalco: The Archetype of Nature's Renewal. In *Ideología, cosmovisión y etnicidad a través del pensamiento indigena en las Américas: 48 Congreso Internacional de Americanistas, Suecia, 1994,* edited by Yosuke Kuramochi and Anna-Britta Hellbom, pp. 75–103. Abya-Yala, Quito.

Turner, Terry S.

2009 The Crisis of Late Structuralism: Perspectivism and Animism; Rethinking Culture, Nature, Spirit, and Bodiliness. *Tipití: Journal of the Society for the Anthropology of Lowland South America* 7(1):1–40.

Urcid Serrano, Javier, and Elba Domínguez Covarrubias

2013 La casa de la tierra, la casa del cielo: Los murales en el Edificio A de Cacaxtla. In *La pintura mural prehispánica en México V: Cacaxtla—Tomo III; Estudios*, edited by María Teresa Uriarte and Fernanda Salazar Gil, pp. 609–675. Universidad Nacional Autónoma de México, Instituto de Investigaciones Esteticas, Mexico City.

Uriarte, María Teresa

2012 El mural del edificio B de Cacaxtla: ¿una batalla? *Arqueología mexicana* 19(117):46–51.

Uriarte, María Teresa, and Fernanda Salazar Gil (editors)

2013 *La pintura mural prehispánica en México V: Cacaxtla.* 2 vols. Universidad Nacional Autónoma de México, Instituto de Investigaciones Estéticas, Mexico City.

Uriarte, María Teresa, and Erik Velásquez García

2013 El mural de La Batalla de Cacaxtla: Nuevas aproximaciones. In *La pintura mural prehispánica en México V: Cacaxtla—Tomo III; Estudios*, edited by María Teresa Uriarte and Fernanda Salazar Gil, pp. 677–739. Universidad Nacional Autónoma de México, Instituto de Investigaciones Esteticas, Mexico City.

Vázquez de Ágredos Pascual, María Luisa

2010 *La pintura mural maya: Materiales y técnicas artísticas.* Centro Peninsular en Humanidades y Ciencias Sociales, Universidad Nacional Autónoma de México, Merida.

Viveiros de Castro, Eduardo

2003 Perspectivismo y multinaturalismo en la América indígena. In *Racionalidad y discurso mítico*, edited by Adolfo Chaparro Amaya and Cristina Shumacher, pp. 37–80. Centro Editorial Universidad del Rosario, Bogota.

Wolf, Gerhard, and Joseph Connors (editors)

2011 *Colors Between Two Worlds: The Florentine Codex of Bernardino de Sahagún.* Kunsthistorisches Institut in Florenz, Max-Planck-Institut, and Villa I Tatti, the Harvard University Center for Italian Renaissance Studies, Florence.

Wyllie, Cherra

2002 Signs, Symbols, and Hieroglyphs of Ancient Veracruz: Classic to Postclassic Transition. PhD dissertation, Department of Anthropology, Yale University, New Haven.

Zetina, Sandra, Tatiana Falcón, Elsa Arroyo, and José Luis Ruvalcaba

2011 The Encoded Language of Herbs: Material Insights into the *De la Cruz-Badiano Codex.* In *Colors Between Two Worlds: The Florentine Codex of Bernardino de Sahagún*, edited by Gerhard Wolf and Joseph Connors, pp. 221–255. Kunsthistorisches Institut in Florenz, Max-Planck-Institut, and Villa I Tatti, the Harvard University Center for Italian Renaissance Studies, Florence.

Telluric Techné and the Lithic Production of Tiwanaku

JOHN W. JANUSEK AND PATRICK RYAN WILLIAMS

CREATING PRE-COLUMBIAN URBAN CENTERS demanded dramatic tectonic movements. It required chains of material practices—quarrying, transporting, transforming, and recombining earthly materials—that converted vast landscapes into human-wrought worlds ordered according to specific cultural logics. The material transformation of urban production was a sustained, profoundly political process. Yet archaeologists tend to seek the political exclusively *behind* rather than *in* material practices of production, enacting a contemporary Western experience of monumentality similar to the one gorgeously dramatized in the slave-driven pyramid-building scenes in Cecil B. DeMille's 1956 film *The Ten Commandments*. From this perspective, Wizard of Oz–like operatives and imperatives simply *direct* the production of monumental structures and urban centers, while political practice remains tangential to the intricate operations that produce them. The ongoing production of past cities reflected but did not embody or enact past realpolitik.

Power to dramatically reorder the world was central to authority globally. Yet tectonic practices in the Pre-Columbian Andes—the physical movement of earthen materials to build centers and monuments, and the skilled practices that facilitated that movement—were grounded in *telluric techné*. By this, we mean an ongoing appropriation and reassembly of the animate forces that prominent earthly and celestial features, objects, and materials were considered to embody. Tiwanaku authority was situated in novel material practices of monumental production that mediated relations between human communities and nonhuman living forces inherent in landscape. Reciprocally, it required actions and allegiances on the part of the multiplex human communities that constituted Tiwanaku and facilitated its telluric production and fame. They included specialized communities of practice that quarried, transported, carved, and carefully assembled stone to construct monuments. More broadly, it called for an emergent political community consisting of the ritually obligated subjects

beholden to the telluric assemblies that Tiwanaku monumental production created. Producing and reproducing this macrocommunity—what archeologists call the Tiwanaku state—required hard, sustained work.

We investigate the shifting tectonic authority of Tiwanaku before and after 500 CE, a transformative series of generations that ended the South Central Andean Late Formative and initiated the Middle Horizon. Critical for understanding Tiwanaku's emergent centrality is the monumental site of Khonkho Wankane, located across the Corocoro Mountains and approximately 25 kilometers—a six- to eight-hour walk—to the north. During the Late Formative (100 BCE–500 CE), Khonkho Wankane and Tiwanaku constituted a pair of interlinked and transacting centers on either side of Corocoro. In the latter part of this period, they comprised the most influential centers in the southern Lake Titicaca basin. After 500 CE, the initiation of the Middle Horizon—known locally as the Tiwanaku period (500–1000 CE)—Tiwanaku emerged as the principal center in the region and perhaps the most influential in the south central Andes.

In the south central Andes, monumentality was not a passive consequence of abstracted, Kafkaesque bureaucrats lurking in dimly lit rooms and dictating production from afar; monumental production itself enacted Tiwanaku political process. By comparing changes in monumental materiality at Khonkho Wankane and Tiwanaku, we present evidence for a major shift in monumental production at the beginning of the Middle Horizon, a shift from sandstone to volcanic stone that we suggest was critical for the hegemonic consolidation and emergent fame of Tiwanaku. We argue that monumental production was a sustained process that was critical for the recurring ritual-political events that periodically drew persons who identified with Tiwanaku—whether as pilgrims or otherwise—toward the center, through its labyrinthine corridors, and into inner sancta that housed its most powerful lithic objects. Further, innovations in the telluric materiality and technological

practices of monumental production were central elements in Tiwanaku's emergent political ecology and expansive geopolitical designs.

Telluric Monumentality as Technology of Essence

Foregrounding monumental production invokes a perspective on political ecology that emphasizes, as Eric Wolf put it, "how power relations mediate human–environmental relations" (Wolf 1972, cited in Biersack 2006:3). Applying this perspective to the Pre-Columbian Andes requires attention to a specific range of *nature regimes*—institutionalized articulations of humans and their environments (Escobar 1999:5)—that differ from those predominant in contemporary Western societies. Western regimes construct "nature" as a world ontologically distinct from and subordinate to people and human productions (Descola 1996). Andean communities produced an alternative mesh of animistic regimes (Janusek 2012, 2015). Authority in the Pre-Colombian Andes focused on ritual-political centers that animated and empowered specific worldly places, objects, and landscapes. Carefully built environments fostered vivid corporeal engagements and ontological transactions with a host of earthly materials, landscape features, and celestial observations. Particularly potent transactions occurred at auspicious moments that corresponded with conjunctive celestial events and rituals of communal gathering.

Tiwanaku monumental construction showcased the sculpted stones that comprised Tiwanaku's foundations, revetments, orthostats, and anthropomorphic stelae. Vranich (2001, 2006) notes that Tiwanaku monuments were always under construction. Their ongoing production rendered technological chains of lithic production an eminently visible element of social and ritual experience at Khonkho Wankane and Tiwanaku. He notes further that Tiwanaku monuments manifest a "facade-like" character in that their best sides faced places of frequent communal viewing

and ritual gathering. Monumental facades showcased the most complete sections of a structure but also the most valued lithic materials incorporated into it.

A likely original name for Tiwanaku is *taypikala*, "central stone" in Aymara (Cobo 1990 [1653]:100). The term communicates the significance of lithic construction for Tiwanaku's monumental image as well as the centrality of stone for practices of human identification and ritual reproduction in the pre- and postconquest Andes. In the highlands, mountains embody generative community ancestors, and montane stones constitute the most essential form of that embodiment and the most intimate forms of human identification with the telluric power of those ancestors (Abercrombie 1998; Astvaldsson 1997, 1998). Stone was animate because humans identified with stone. We suggest that stone in this co-constitutive sense drove Tiwanaku's fame.[1]

Ritual events focused the attention of participants on the materiality—the arresting *presence* (Gumbrecht 2004)—of monuments and their crafted relations to landscape and skyscape. Lithic components of monuments indexed significant landscape features and celestial events; indexical qualities included color, texture, mineralogy, and spatial references to landscape features and celestial movements. The lithic production of Khonkho Wankane and Tiwanaku manifested multiple monumental *technologies of essence* (Lechtman 1977). Stone appropriated from dramatic mountain outcrops embodied the animate essences of those locales as constructed monumental facades and strategically placed stelae, and monumental production incorporated this telluric power into Khonkho Wankane's and Tiwanaku's built landscapes. A critical shift in monumental production after 500 CE—from locally quarried sandstone to the incorporation of distantly quarried volcanic stone—marked a decisive geopolitical coup that engendered a new political ecology and technology of essence that, perceptually, trumpeted Tiwanaku's rise as the singular primary center of an emergent pan-Andean polity.

The Lithic Production of Khonkho Wankane and Tiwanaku

Situated at an altitude of 3,800 meters above sea level in the South Central Andean altiplano, Tiwanaku occupies an inland portion of the south Lake Titicaca basin. Tiwanaku was the center of an influential panregional Andean polity during the Andean Middle Horizon (500–1000 CE). Numerous semiautonomous ritual-political centers occupied the region during the preceding Late Formative period (200 BCE–500 CE). They were characterized by platforms and sunken court complexes that framed carved stone monoliths depicting anthropomorphic personages. Khonkho Wankane and Tiwanaku were two of the most influential ritual-political centers in the region (Figure 4.1). Constructed on opposite sides of the Corocoro range on the same north–south axis (Benitez 2013:102–103), and dependent on the montane springs that originated on opposite sides of that range, the two centers formed a pair (Janusek 2012). Their Formative sunken temples and anthropomorphic monoliths mirror one another. At both locales, monumental and monolithic construction consisted entirely of sandstone. What practices rendered Tiwanaku *the* preeminent center during the Middle Horizon? We argue that transformations in monumental production and lithic materiality were central.

During the Late Formative, Khonkho Wankane and Tiwanaku were complementary centers of monumental production in the southern Lake Titicaca basin. Earliest construction at both places began early in the Late Formative period, around the turn of the first millennium. Early monumentality at each site included a plaza attached to a trapezoidal sunken court (Figure 4.2). The internal facades of both courts were faced with sculpted rectangular blocks. To maximize stability against the pressure of the earthen platforms that these blocks framed, builders adopted a construction technique that alternated wide sections of coursed, stratigraphically bonded rectangular blocks with vertically positioned, large pilasters sunk deep in the earth.

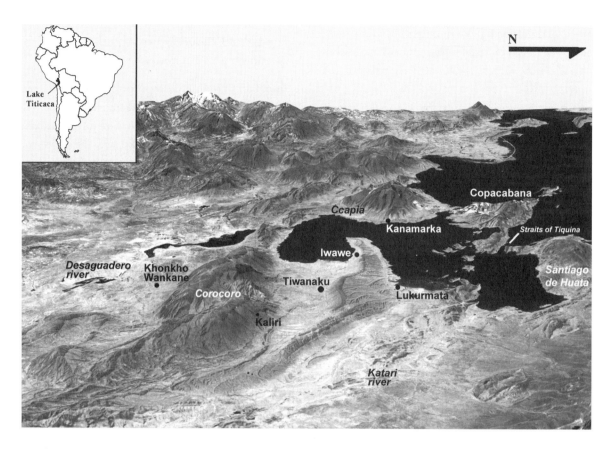

figure 4.1

The southern Lake Titicaca basin. (Image by John W. Janusek.)

The two sunken courts mirrored one another in multiple respects. Remarkably, they formed a precise north–south axis across Corocoro. Further, both courts incorporated a primary south entrance formed by pilaster jambs that framed a stone staircase. Each entrance was slightly offset from the precise center point of its south wall: the Khonkho entrance 1.3 meters west of center, the Tiwanaku entrance 0.85 meters east of center (Benitez 2013:94, 96). The peculiar off-centeredness of the two courts served to coordinate dramatic visual engagements with key terrestrial features and celestial phenomena. Facing south from the center of the back (north) wall of each court—which at Khonkho consisted of a corridor leading from the site's main plaza—allowed for a dramatic view of a mountain peak in the distance. At Khonkho, this was Sajama, a snow-capped peak in the distant Cordillera Negra; at Tiwanaku, it was Kimsachata, the nearest peak in the Corocoro range. Both courts simultaneously facilitated views of the rise of important celestial phenomena. At Khonkho, an offset entrance in the western facade of its court offered a view of the rise of Alpha and Beta Centauri through the court's south entrance (Benitez 2013:94–95). In later mythology, these two stars formed the eyes of the dark-cloud constellation *yacana*, which depicts a mother llama and her calf. At Tiwanaku, a sculpted pilaster near the middle of the west wall of its court provided a similar view through its own south entrance.

During Late Formative 2 (ca. 250–300 CE), the aesthetics of monumental production shifted at Khonkho and Tiwanaku. Monuments still consisted chiefly of sandstone quarried from outcrops on either side of the Corocoro range, but new monumental structures differed in form and orientation, and, at Tiwanaku, they were much larger than before. At Khonkho Wankane, the west portion of the Wankane Platform was fitted with an extensive Dual Court Complex. This complex filtered people

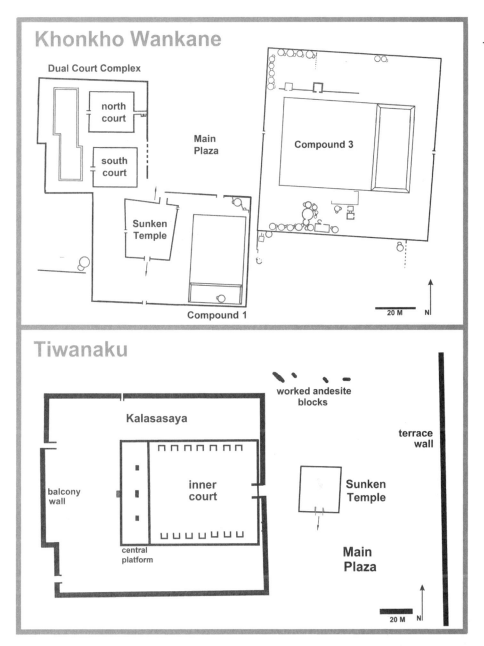

figure 4.2
The sunken temples of Khonkho Wankane and Tiwanaku in relation to other Late Formative structures, notably Khonkho's Dual Court Complex and Tiwanaku's Kalasasaya. (Image by John W. Janusek.)

from the site's main plaza through narrow corridors and into a pair of sunken courts, each of which framed a towering sculpted monolith (Janusek and Ohnstad n.d.; Ohnstad 2013). Notably, the corridors linking the plaza with the two courts aligned east to west. At Tiwanaku, early residential compounds on the west side of the sunken court were covered by the Kalasasaya Platform. Like Khonkho's Dual Court Complex, Kalasasaya manifested an oblique east-to-west orientation.

Monumental Sandstone Production for Khonkho Wankane

Sandstone for Late Formative monuments at Khonkho Wankane and Tiwanaku derived from the Corocoro range that separated the centers. We located several small quarries near the south summit of the range, approximately 12 kilometers from Khonkho Wankane, in a locale known as Lawakollu (Janusek 2012; Ohnstad 2013). The outcrops were associated with several partially carved

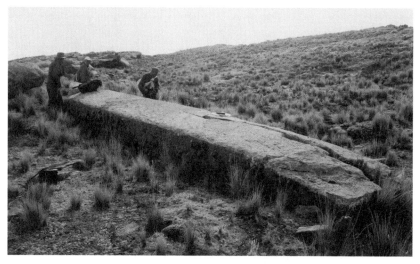

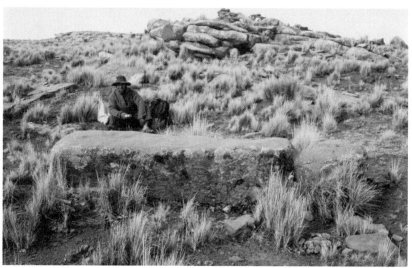

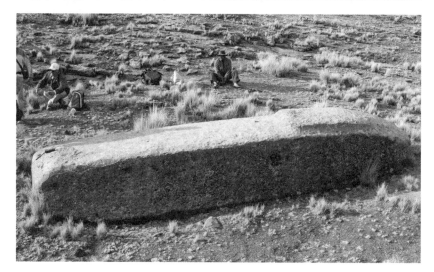

figure 4.3
Monolith "pre forms" in the Lawakollu quarries on the south slopes of Corocoro.
(Photographs by John W. Janusek.)

anthropomorphic stelae and architectural pilasters (Figure 4.3). The stelae are roughly carved in the form of personages and lack finely sculpted features. On one, the head portion is coarsely shaped in an ovoid form; on another, it is carved to form an elegantly curved, convex face panel. A third monolith, which lacks a preform head element, is 8.85 meters in length and appears to have cracked in the process of its sculpting (Ohnstad 2013:61).

The presence of several large, unfinished sandstone slabs near Khonkho helped us to map a broad path of movement from these montane outcrops down toward the site. We located twelve unfinished sandstone blocks on the outskirts of Khonkho—five just northwest of the site, a group that constitutes a mythicized locus known as Pusikala, and seven on its north edge (Ohnstad n.d.). Both groups of blocks were left alongside spurs of an ancient

road that maintains a highly visible trace scar on the ground. This mark allowed us to reconstruct the path by which unfinished sandstone blocks were carted southward from montane quarries down a steep valley to the flat pampa, and then hauled southeast along a well-worn trail toward Khonkho Wankane.

Monumental Sandstone Production for Tiwanaku

Sandstone quarrying on the north side of Corocoro has a long history of study. In the 1970s, the Bolivian archaeologist Carlos Ponce Sanginés and colleagues initiated surveys in the northern valleys of Corocoro to determine the sources of Tiwanaku sandstone. In 2010, Janusek initiated a project to complete that study and to better understand the technology of Tiwanaku sandstone production (Janusek et al. 2013) in complement to the

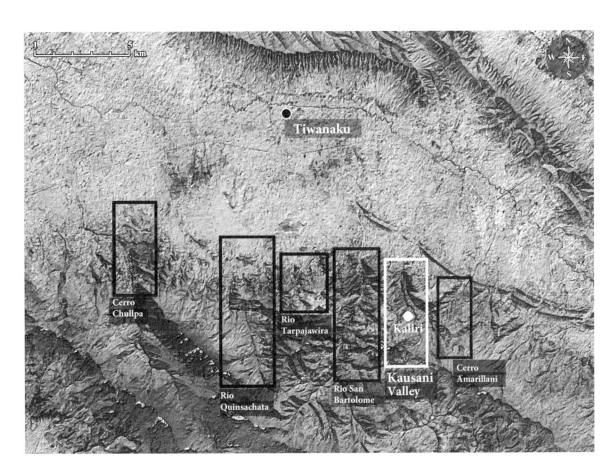

figure 4.4
Surveyed valleys on the north slopes of Corocoro, highlighting the primary quarry of Kaliri in the Kausani Valley. Other valleys were ancillary sources of sandstone for Tiwanaku. (Image by Patrick Ryan Williams and John W. Janusek.)

figure 4.5

Sandstone production in
Kaliri. The lower image
shows a block that had
been roughly carved
and pecked with a
hammerstone and then
split. (Photographs by
John W. Janusek.)

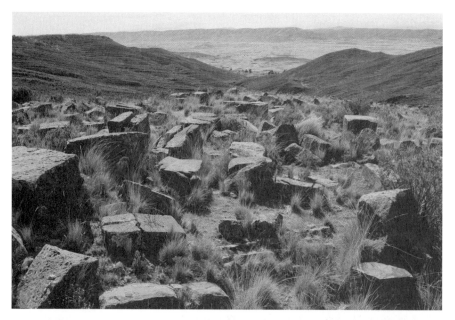

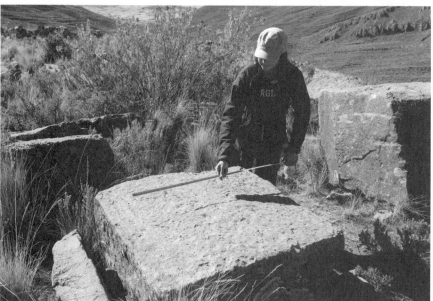

pioneering analyses of Protzen and Nair (2013) on
the architectural praxis of Tiwanaku monumental-
ity. Building on Ponce's early surveys, we investi-
gated six river valleys and likely sandstone sources
on the north side of the Corocoro range facing
Tiwanaku from 2010 to 2014 (Figure 4.4). Based on
combined chemical analysis, petrographic analy-
sis, and archaeological survey, we conclude that
sandstone outcrops in several of these valleys likely
contributed to Tiwanaku construction. Yet it was
the Kaliri quarry in the upper Kausani River valley,

southeast of the center, that served as Tiwanaku's
primary sandstone quarry (Janusek et al. 2013;
Protzen and Nair 2013:175–180).

The Kaliri quarry occupies an altitude of
4,150–4,250 meters and covers approximately
12 hectares. Scaling the Kausani Valley from the
Tiwanaku Valley pampa, Kaliri is the first sedi-
mentary exposure that exhibits relatively large,
minimally foliated sandstone outcrops. The out-
crops are geologically fractured such that each
horizontal stratum is divided perpendicularly into

figure 4.6

Quarried and roughly worked sandstone block on the path between Kaliri and Tiwanaku, showing rope holds. (Photograph by John W. Janusek.)

rough blocks that can be pried apart relatively easily. Tiwanaku stonemasons took advantage of this geological condition to maximize the production of large sandstone blocks. Several geologically fractured areas were being mined when the quarry was abandoned. Rough blocks were pried out of their geological beds and hauled to nearby areas for finer work. Worked blocks left behind demonstrate evidence for having been split, hammered, pecked, and smoothed (Figure 4.5) (Janusek et al. 2013). Stoneworking tools consisted of durable stones not readily available at the quarry, notably quartzite and porphyry cobbles (Protzen and Nair 2013:177). Roughly carved stones were then hauled to an area of fine working near the center of the quarry, a place still littered with sandstone flakes (Janusek et al. 2013:fig. 4.18).

Coarsely carved blocks were then hauled down one of two paths through the Kausani Valley. An upper road drew stones down from the west, or upper, portion of the quarry and a lower road drew stones down from the east, or lower, portion of the quarry. Markings on the stones indicate that most were carted using thick ropes (Protzen and Nair 2013:176). Some 10 percent of blocks near the area of fine work had been notched on at least two—and in some cases, four—opposing edges. The lower portion of the conjoined road revealed several clusters of blocks that had been abandoned in transit. Ninety percent of these blocks incorporated notched edges (Figure 4.6). The notches clearly served as "rope holds" or grips that allowed groups of persons to carry the blocks (Janusek et al. 2013:85). Several abandoned blocks on the Kausani

road presented linear scrape marks, indicating that some stones had been dragged on the ground rather than carted by rope.

Sandstone blocks were hauled to a place just above where the Kausani Valley meets the pampa; Chusicani, a site with monumental platforms, occupies this locale. Nearby are clusters of quarried blocks that had been left in transit. It was here that roughly formed blocks were prepared for the long haul over the valley floor toward Tiwanaku. Older members of the local community recall having seen abandoned worked stones—known commonly as "tired stones"—on pampas just north and west of this site, and en route to Tiwanaku. These stones have since been appropriated to build houses and other recent structures. We propose that the site housed the masons and carvers who worked the Kaliri quarry. Further, it may have been a key locale for ritual activities associated with sandstone production.

Volcanic Stone Production in Ccapia and Copacabana

Tiwanaku masons worked volcanic stone on a significant scale just after Khonkho Wankane and several other major Late Formative centers in the region waned in influence. From this point forward and through the early Middle Horizon, Tiwanaku established a monopoly on monumental production in volcanic stone. The sources of volcanic stone—in particular, the origin of andesite for Tiwanaku construction—has been a politically

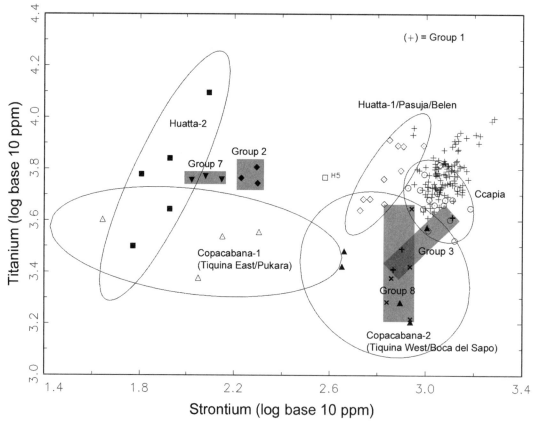

figure 4.7
Bivariate plot of logged (base 10 ppm) concentrations in geological samples and archaeological samples (Groups 1–3, 7–8), comparing geological chemical profiles to identified archaeological chemical profiles. Ninety-percent confidence ellipses are drawn around raw material chemical profiles. Geological samples: Ccapia (O), Huatta-1/Pasuja-Belen (◇), Huatta-2 (■), Copacabana-1 (△), and Copacabana-2 (▲). Geological sample H5 is a chemical outlier sample collected near Huatta. (Image by Patrick Ryan Williams and John W. Janusek.)

figure 4.8
Roughly carved
andesite blocks at the
site of Kanamarka,
including a detail (lower
photo) of a block that
was abandoned in
the process of being
hammered down on one
side. (Photographs by
John W. Janusek.)

fraught question. Though numerous early travelers and scholars pinpointed the ancient volcano Cerro Ccapia (Forbes 1870; Posnansky 1904; Squier 1877:313; Stübel and Uhle 1892), located just across the small portion of Lake Titicaca from Tiwanaku, the Bolivian archaeologist Carlos Ponce Sanginés (1968, 1970), who spearheaded the nationalization of Bolivian archaeology in the 1950s, concluded that Tiwanaku's volcanic stone derived from the Copacabana Peninsula. Ccapia is in Peru; Copacabana is within the Bolivian nation state.

Our chemical sourcing indicates that Ccapia was the primary source of volcanic andesite for Tiwanaku monumental production (Figure 4.7). Many of Tiwanaku's iconic volcanic stone works—the Solar Portal, the Ponce Monolith, and the massive orthostats in Kalasasaya's west balcony—were hewn from Ccapia andesite. We have not yet located primary andesite quarries on the order of Kaliri. Protzen and Nair (2013:179–180) suggest, based on Alphons Stübel's observation (Stübel and Uhle 1892:pt. 1, pl. 31), that Tiwanaku quarry masons

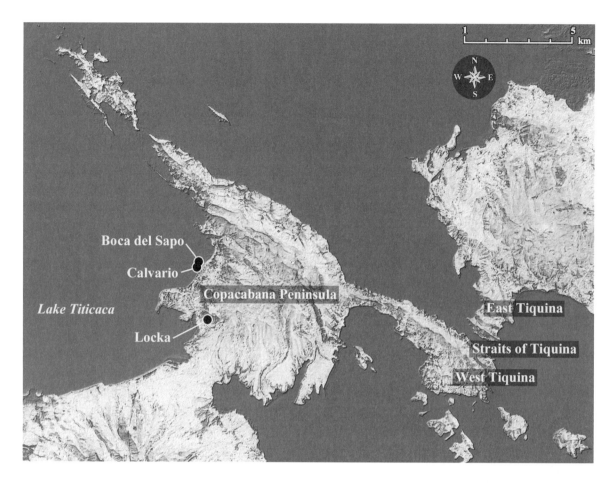

figure 4.9

 Map of the Copacabana region showing the location of key volcanic stone sources, including East Tiquina, West Tiquina, and Boca del Sapo. (Image by Patrick Ryan Williams and Jill Seagard, Field Museum.)

took advantage of large andesitic boulder outcrops below Ccapia foothills and near lakeshores. Such opportunistic quarrying is in keeping with Tiwanaku quarrying practices in Kaliri and foreshadows later Inka quarrying in Ollantaytambo, Peru (Protzen 1983). Since the late nineteenth century, travelers and researchers have noticed clusters of the so-called tired stones along the east shores of the Ccapia Peninsula (Forbes 1870; Squier 1877:313). The wide dispersion of these locales indicates that multiple sources served as quarries for Tiwanaku. Our survey confirmed Stanish and colleagues' observation (1997:92–94; also Protzen and Nair 2013:179) that the monumental lakeshore site of Kanamarka was a key locale for gathering, sculpting, and then disembarking large andesite blocks across the southern part of Lake Titicaca toward Tiwanaku (Figure 4.8). Here, clusters of large andesite blocks cover a series of platforms overlooking the east shore. Many of the blocks demonstrate evidence for rough and fine carving, and the soil around the clusters is thick with dense quantities of coarse volcanic grains.

Volcanic outcrops on and near the Copacabana Peninsula served as sources for certain strategically placed stones in Tiwanaku (Figure 4.9). Our Copacabana East (1) group (our Source Groups 2 and 7), quarried from mountainous outcrops east of the straits of Tiquina, provided mafic, iron-rich basalt for crafting small sculptures and architectural elements, such as feline sculptures known as *chachapuma* and the lintel portions of stone

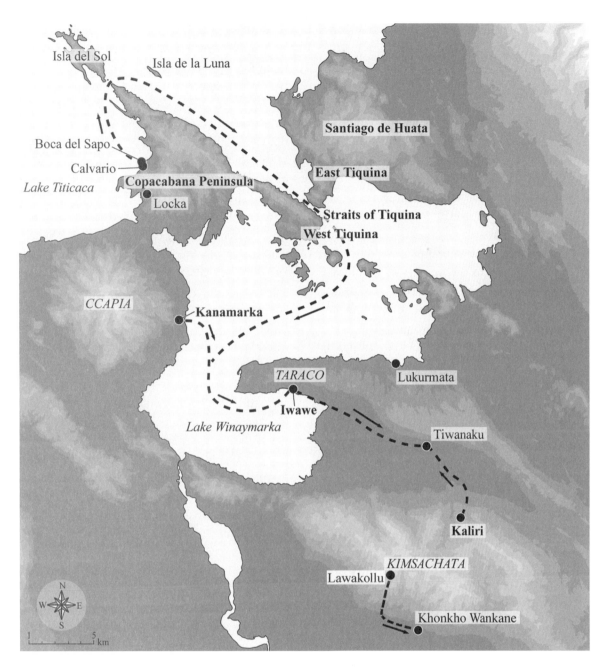

figure 4.10
Map showing the movement of sandstone to Khonkho Wankane and Tiwanaku on either side of the Corocoro range, and the movement of volcanic stone to Tiwanaku from Ccapia and Copacabana. (Image by Patrick Ryan Williams and Jill Seagard, Field Museum.)

portals from the west side of the Pumapunku. Our Copacabana West (2) group (our Source Groups 3 and 8), quarried on the Copacabana Peninsula itself, provided felsic, high-silica diorite and andesite that is more texturally akin to yet subtly distinct from Ccapia volcanic stone. Stones from Copacabana West were strategically incorporated into Tiwanaku monuments, such as Kalasasaya and Kantatayita. Complementary origins and material qualities of volcanic stone helped determine their monumental emplacement and telluric resonance in Tiwanaku.

From Ccapia and Copacabana, volcanic stones were floated across the southern portion of Lake Titicaca and around the Taraco Peninsula toward landings near Iwawe (Figure 4.10). This portion of travel required boats and rafts constructed of the versatile *totora* reed that is abundantly cultivated along the shores of Lake Titicaca, its tributaries, and its outlets (Orlove 2002). Carting weighty volcanic blocks across Lake Wiñaymarka required well-engineered totora-reed watercraft. Alexei Vranich and colleagues (Vranich et al. 2005) proved this was possible when they commissioned a 24,000-pound reed boat to carry an 18,000-pound stone block from Copacabana to the west tip of the Taraco Peninsula. Specially made rafts could have transported even weightier stones, including the orthostats in Kalasasaya's west balcony wall.

The southeast shore of Taraco, including beaches near the local ritual-political center of Iwawe, provided many points for collecting andesite blocks from Ccapia and Copacabana. Gregorio Cordero Miranda and Carlos Ponce Sanginés interpreted Iwawe as a port dedicated to the fine-working of volcanic blocks carted from various locales from across Lake Titicaca (Ponce Sanginés 1970:146). They reasoned that stones roughly carved near Iwawe were then hauled overland for the 11-kilometer journey to Tiwanaku, but just how those blocks were transported to Tiwanaku is not entirely clear. Partially carved andesite blocks near Kanamarka and Iwawe have no rope holds. As Protzen and Nair point out (2013:180), many andesite blocks at Tiwanaku manifest drag marks on at least one face. They suspect that andesite blocks were transported to Tiwanaku by dragging them on roadbeds constructed for this purpose, just as the Inka moved rhyolite blocks from riverside quarries to Ollantaytambo (Protzen 1993). In this scenario, not just the quarries, production circuits, and lithic matter of sandstone and volcanic stone but also the technologies of transport differed markedly between them.

Fine Stone Carving in Tiwanaku

Rough and fine stone sculpting occurred at key places along the respective routes of movement for sandstone and andesite. For sandstone, it occurred at various places in the Kaliri quarry and possibly in the foothills of Corocoro at the site of Chusicani. For volcanic stone, it occurred at outcrop sources, at such lakeshore sites as Kanamarka, and on the south Taraco shore near Iwawe (see Figure 4.10). Yet the fine working of monumental stone also occurred at Tiwanaku. Two key areas were dedicated to andesite production and carving (Figure 4.11). One area is located approximately 200 meters southwest of the Akapana. Here, two massive andesite blocks were left behind while being carved into smaller blocks. One was left in the process of being cut in half along its horizontal axis (Protzen and Nair 2013:fig. 5.1), and the other was being carved down in parallel troughs perpendicular to its vertical length. Production scars indicate that multiple persons worked each stone at once (Protzen 1993:171–172). One thick trough on the second stone had been ground to what appears to have been a target level, suggesting that one or two master craftsmen mentored and directed teams of stone sculptors.

If there were a sector dedicated to andesite fine carving, it was located on the north edge of Tiwanaku's monumental complex, near the northeast corner of the Kalasasaya. Several large stones with production scars litter this area of the site. They include an andesite block that was left in the process of being carved into four separate monumental blocks (Figure 4.12). They also include a massive andesite block gridded with parallel troughs much like those of the second stone from the south portion of the site. Like that stone, the central portion of this one had been ground toward a target level, surrounded by shallower troughs. This sector of Tiwanaku is located near a "ramp" that leads up to the monumental core from the river to the north (see Posnansky 1945). It seems likely that volcanic stones carted overland from Taraco's south shore were dragged up the ramp and deposited here for final carving.

Strategic Volcanic Monumentality in Tiwanaku

After 500 CE, volcanic stone was strategically incorporated into Tiwanaku monumental constructions. It was built into spaces that became

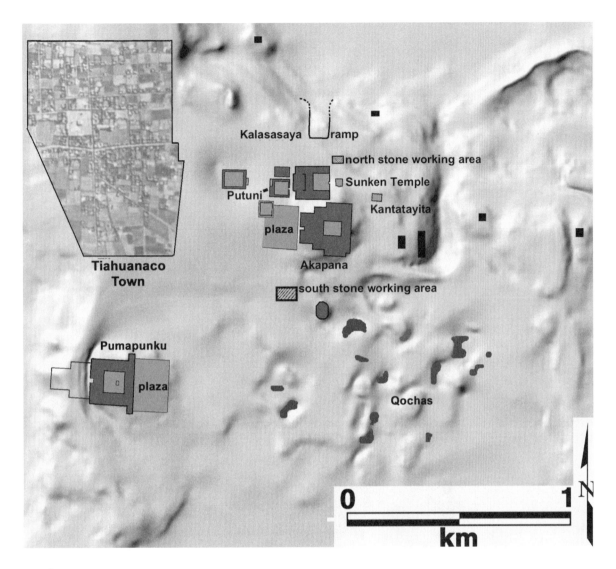

figure 4.11

Map of Tiwanaku, showing key monumental complexes and stoneworking areas. (Image by John W. Janusek.)

prominent during major ritual events and that facilitated dramatic sensory engagements with key terrestrial features and celestial movements. Andesite was integrated into particularly evocative spaces of Pumapunku and Akapana, the visually imposing stepped platforms of Tiwanaku's Middle Horizon dual monumental campuses (see Figure 4.11). Both structures consisted primarily of sandstone facades over thick earthen fill. In both locales, terraces were intermittently fitted with facades of carved andesite blocks. Pumapunku's massive east sandstone platform supported several elaborately carved andesite portals. Its central sunken court incorporated a large andesite portal. Further, covering Pumapunku's primary west staircase were lintels of Ccapia andesite that had been carved to index the totora-reed thatch roofs that protected Tiwanaku dwellings (Janusek 2008:121; Ponce Sanginés 1971:59–61).

Akapana's cyclopean basal west terrace facade incorporated regularly placed andesite orthostats (Janusek et al. 2013:71–73). This terrace included Akapana's primary entrance. Volcanic stone appears less commonly in other sectors of the structure—those less central to Tiwanaku's sensory impact. The primary staircase entrances of

figure 4.12

Massive andesite blocks left in the process of being carved into orthostats or monoliths in the north (upper photo) and south (lower photo) stoneworking areas of Tiwanaku. (Photographs by John W. Janusek.)

Pumapunku and Akapana were strategically fitted with volcanic stone. Each funneled persons up toward a dramatic view of Illimani, a glaciated peak in the eastern cordillera. Yet each demanded passage through volcanic stone portals; in Pumapunku, through bluish-gray Ccapia andesite portals capped with totora lintels, and in Akapana, up an andesite staircase and toward a massive trilithic, charcoal-colored portal of Ccapia andesite that occupied its summit. Volcanic staircases and portals facilitated corporeal transactions with a visually striking peak in the eastern cordillera.

Important Late Formative monuments were fixed with andesite details that adapted them to the emergent political aesthetic. For example, a vertically aligned, narrow basalt slab was placed near the center of the north wall of the sunken temple (Benitez 2013:97). It is the only volcanic stone object in the structure. Facing it on the opposite side is the south stairway. During the Late Formative, the two pilasters that defined the south staircase framed a view of the peak of Kimsachata in the Corocoro range to the south; the construction of Akapana after 500 CE blocked this view (Benitez

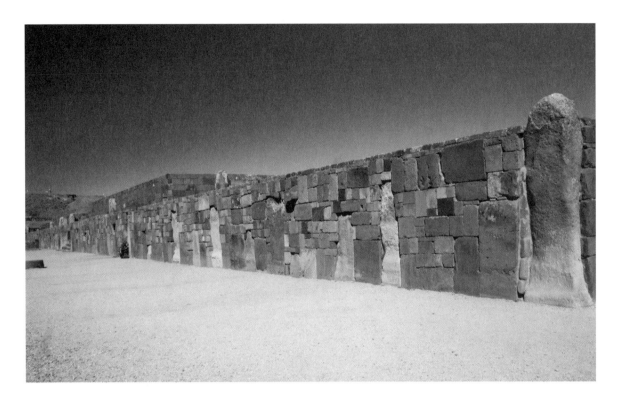

figure 4.13
The early east wall of Kalasasaya, with the diorite pilasters of its north half. (Photograph by John W. Janusek.)

2009). Nevertheless, viewed from the basalt slab, ritual participants gained a privileged view of the south sky. The visual path due south defines a precise celestial meridian such that an observer would have seen the Milky Way and other stars rotate around a celestial axis over the Akapana (Benitez 2013:98–100).

Constructed just as Tiwanaku transformed into a major urban center (400–600 CE), Kalasasaya embodied the transition from exclusively sandstone to sandstone-and-volcanic stone construction. Major construction began during Late Formative 2 and continued through the Tiwanaku period. The long north and south walls of its outer revetment consist of sandstone orthostats supporting segments of horizontally layered sandstone blocks. Kalasasaya's east and west walls incorporate massive andesite orthostats. Framing Kalasasaya's east wall are several massive diorite pilasters that were quarried in our Copacabana West (2) source on the Copacabana Peninsula (Figure 4.13). Consisting of light gray coarse and crumbling masses that

incorporate large silicate phenocrysts, these orthostats are now highly eroded. Framing Kalasasaya's west balcony wall are eleven massive andesite orthostats that had been quarried in Ccapia. The physical qualities of these orthostats differ markedly from their counterparts to the east. Like most large andesite blocks from Ccapia, the latter were bluish-gray in color, extremely durable, and fine in texture, with small silicate phenocrysts—as andesite goes, this was the good stuff. The east wall, with its Copacabana orthostats, was built early in Kalasasaya's construction history, most likely in Late Formative 2 (300–500 CE). The west balcony wall, with its Ccapia orthostats, was built relatively late in Kalasasaya's history, most likely in the early Tiwanaku period (500–700 CE; Janusek 2008:111–113; Ponce Sanginés 1981).

Kalasasaya institutionalized new spatial practices in Tiwanaku. Even in its Late Formative 2 incarnation, the structure was larger than any known monumental edifice in Tiwanaku or the southern Lake Titicaca basin (Figure 4.14).

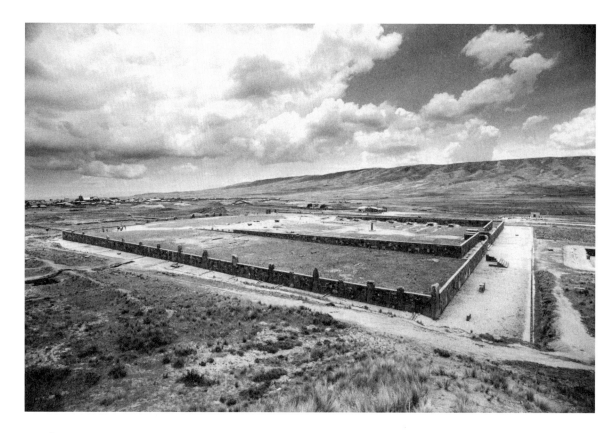

figure 4.14
Kalasasaya. (Photograph by Wolfgang Schüler.)

Furthermore, its axis, like that of the contemporaneous Dual Court Complex at Khonkho Wankane, aligns slightly askew of cardinal east–west. This spatial alignment ruptured the Late Formative north–south spatial axis of the sunken temple and of Tiwanaku's privileged relation with Late Formative Khonkho Wankane directly to the south (Janusek 2012). From this point forward, Tiwanaku's main monumental constructions prioritized east–west spatial orientations and corporeal engagements. Kimsachata, the most prominent portion of the Corocoro range that provided sandstone for Tiwanaku, no longer figured as centrally in monumental spatial alignments. East–west paths of ritual movement and corporeal transaction with monuments prioritized direct connections to the western horizon, the northernmost portion of which included the peak of Ccapia.

Kalasasaya married solar cycles to the terrestrial horizon (Benitez 2009; Janusek 2006;

Posnansky 1945). It afforded stunning views of solar rise and set points at specific times of the solar year, and the west balcony orthostats secured the best tested alignments to date. Archaeoastronomical analysis indicates that they mark solar set points on the western horizon (Figure 4.15).[2] An andesite platform located 45 meters east of the balcony wall served as a key observation point. Viewed from this platform, and keyed to the Middle Horizon, the programs indicate that the sun set over the southernmost pilaster on the austral summer (December) solstice, and over the northernmost pilaster on the austral winter (June) solstice (Benitez 2009). It sets near the middle pilaster on both equinoxes.

Putuni was built on the west side of the Kalasasaya in the sixth century CE (Alconini Mujica 1995; Janusek 2003).[3] It followed Kalasasaya's oblique east–west alignment. Putuni consisted of a shallow platform surrounding a large ceremonial courtyard (Couture and Sampeck 2003; Janusek 2004; Kolata

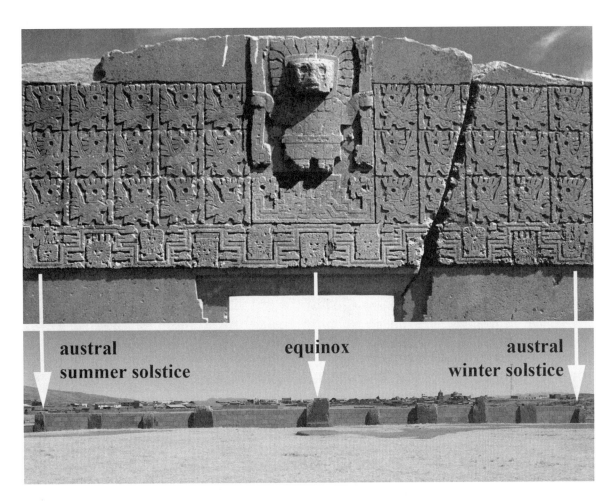

austral
summer solstice

equinox

austral
winter solstice

figure 4.15
Key celestial horizon points in Kalasasaya's west balcony wall in relation to key solar faces on the lower serpent band of the Sun Portal. (Image by John W. Janusek.)

1993). Its construction created a "canyon-like hall-way" (Vranich 2009:25) between Kalasasaya's towering west balcony and Putuni's east platform wall (Janusek et al. 2013:74–75), both of which consisted of impeccably carved andesite masonry (Figure 4.16). The hallway was even paved with andesite tiles. This volcanic hallway directed ritual officials and participants from the Kalasasaya and into the Putuni courtyard (Vranich 2009:25). It created a powerful new visual path toward Kimsachata's peak. During calendrical events that dramatized new solar observations relative to the western horizon and Ccapia, ritual processions through this space turned attention back—spatially, just over 90 degrees—toward the Corocoro range to the south. Kalasasaya and Putuni came to form an integrated campus.

Putuni epitomized the complementary use of sandstone and volcanic stone in Tiwanaku. Putuni's outer and inner platform facades were eminently visible to ritual participants funneling into the structure from Kalasasaya. The most exposed sections of the platforms consisted of andesite (Figure 4.17). The east and west walls of the inner platform incorporated a series of small chambers, seven to a side. While it is unclear what the chambers housed—perhaps ceremonial regalia, ritual objects, or mummified ancestors (Couture and Sampeck 2003; Kolata 1993)—each one was accessed by a sliding door (Intimayta Ramos 2010; Janusek 2004:209). The chambers consisted uniformly of sandstone walls. In Putuni, spaces dedicated to ritual procession and communal activity featured

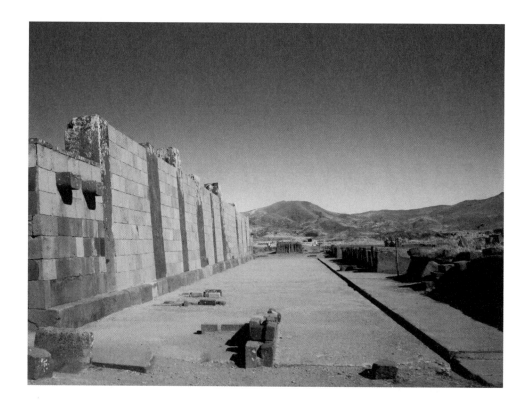

figure 4.16
The andesite
hallway between
Kalasasaya and
Putuni that frames
Mount Kimsachata.
(Photograph by
John W. Janusek.)

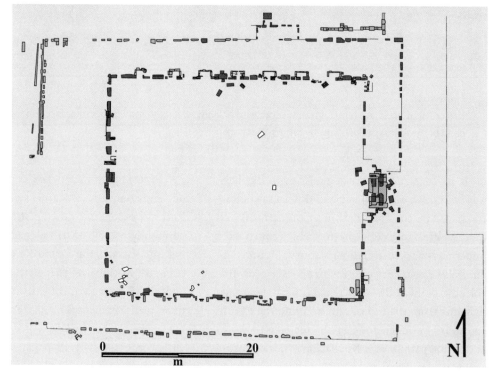

figure 4.17
Plan of the
Putuni complex,
emphasizing the
strategic employment
of sandstone and
andesite construction.
(Image by Sally Lynch
and John W. Janusek.)

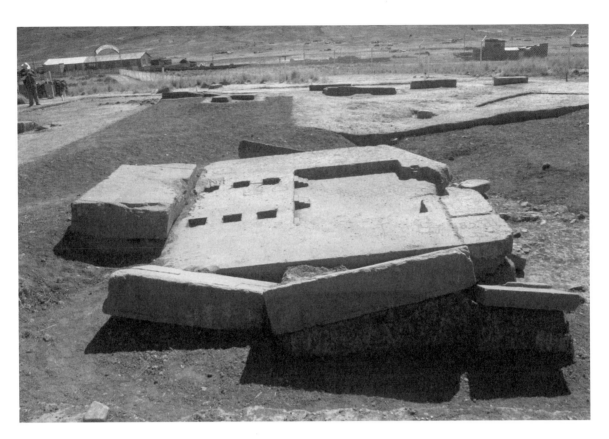

figure 4.18
The andesite maquette in the east inner sanctum of Kantatayita. (Photograph by John W. Janusek.)

state-of-the-art volcanic stone walls, while intimate chambers featured reliable sandstone foundations.

Some structures incorporated volcanic stones quarried from different sources. As previously discussed, the Kalasasaya is one key case; the Kantatayita temple northeast of Akapana is another. Kantatayita comprised two conjoined enclosures, and, like Pumapunku and Akapana, maintained a primary west entrance. The west enclosure provided access to the precinct and was paved with Ccapia blocks. It offered entry to Kantatayita's adjacent inner sanctum, which consisted of an intimate enclosure centered on a green-hued, massive andesite maquette (Figure 4.18). The maquette was carved to replicate a platform-enclosed courtyard replete with staircases and a primary entrance (Kolata 1993; Posnansky 1945). It may have served to choreograph ritual performances and accept offerings (Janusek 2008:126). While most other volcanic blocks in Kantatayita derived from Ccapia,

the maquette and one other large andesite block derived from a quarry in our Copacabana West source on the Copacabana Peninsula. The specific lithic origin, distinctive materiality, and strategic placement of these stones defined their significance in the monumental complex.

Monolithic Stelae in Sandstone and Andesite

Monolithic stelae spotlighted the distinction between sandstone and andesite. Throughout the Late Formative and Middle Horizon, monumental campuses directed attention toward the sculpted stelae that occupied important constructed spaces. Most such spaces were sunken courtyards at the terminus of ritual processions and where particularly dramatic gatherings occurred (Janusek 2006). Late Formative sandstone stelae are known from Khonkho Wankane and Tiwanaku. Those at Tiwanaku are found *ex situ,* and most have been ritually mutilated, undoubtedly because once

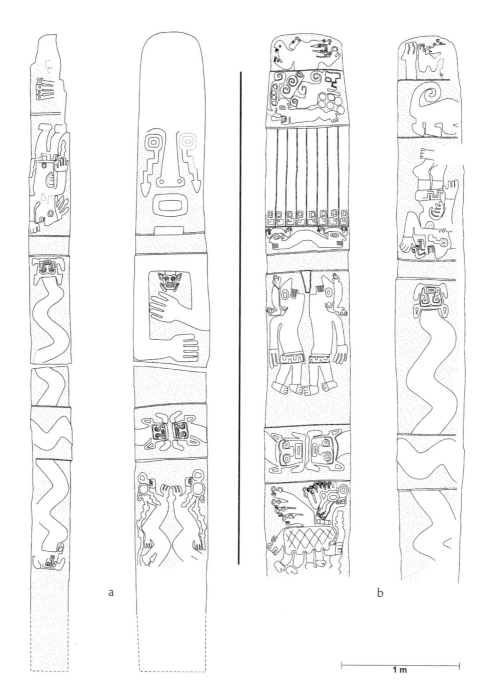

figure 4.19

Monolithic personages from Khonkho Wankane and Tiwanaku: a–b) the front and back, respectively, of two Late Formative sandstone personages from Khonkho Wankane; c) a stylistically similar Late Formative sandstone personage from Tiwanaku ("the decapitated monolith"); and d–e) the Tiwanaku-style sandstone Bennett (d) and andesite Ponce monoliths (e) from Tiwanaku. (Images by Arik Ohnstad [a–b], Claire Samuels [d], and John W. Janusek [c and e].)

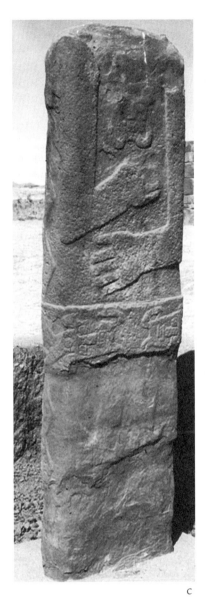
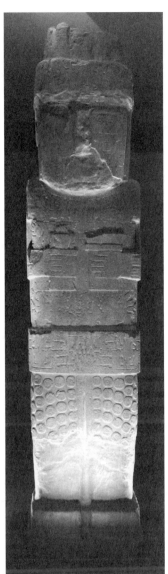
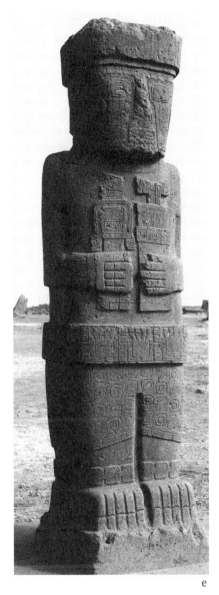

c d e

Tiwanaku expanded into a Middle Horizon city, its affiliated communities refashioned its Formative history. Yet stelae from Khonkho and Tiwanaku are uncannily similar (Figure 4.19a–c). Each depicts a central personage with an impassive facial expression, arms folded asymmetrically over the torso, and minimal clothing. Vital creatures in motion—sinuous neonate catfish, ascending felines, proto-human forms—decorate each personage, evoking terrestrial and aquatic realms. They are depicted without feet or legs, and were emplaced in the ground as if to emerge directly from the earth (Ohnstad 2013).

The strategic deployment of sandstone and volcanic stone for Middle Horizon construction correlated with a parallel production of sandstone and andesite stelae at Tiwanaku. Sandstone and andesite stelae occupied complementary spaces in Tiwanaku's expanding monumental core (Janusek et al. 2013:77). This shift correlated with a dramatic transformation in technologies of sculptural production and the presentation of sculpted beings. Though monoliths still embodied a central anthropomorphic personage, its focal gesture shifted markedly (Figure 4.19d–e). Each now presented symmetrically placed arms that held two iconic objects to its

torso; in the left hand, a *kero* containing fermented *chicha*, or corn beer, and in the right, a snuff tablet for ingesting psychotropic resins (Torres and Repke 2006:40–42). Intricate low-relief incision on both sandstone and andesite stelae emphasized woven clothing. Tiwanaku monolithic personages wore elaborately decorated tunics and anklets in addition to sashes and headgear. Carved with clearly incised legs and feet, these beings stood firmly on the earth.

Stelae at Khonkho and Tiwanaku likely embodied apical ancestors (Janusek 2006, 2015; Ohnstad 2013). Key material, gestural, and iconographic details of the stone personages shifted markedly between the Late Formative and the Middle Horizon. The size, impassive faces, and rigid stances of the personages continued to mark other-than-human status. Yet while Late Formative monoliths featured scarcely clothed bodies, their Middle Horizon counterparts featured personages in full regalia. The folded-arm gestures of Late Formative monoliths may have codified the pose of an interred, mummified ancestor (Janusek 2006). The symmetrical gestures of Middle Horizon monolithic figures enacted a presentation of objects critical to Tiwanaku ritual engagement (Bandy 2013; Janusek 2008). If Late Formative stelae depicted mythical ancestors as corporeal landscapes, Middle Horizon stelae presented either apical ancestors bedecked as elite persons or elite persons bedecked as apical ancestors—and this ambivalence may have been intentional. Middle Horizon Tiwanaku incorporated the first known elite residences in the southern Lake Titicaca basin (Couture and Sampeck 2003; Kolata 1993). New elite status was surely contested and at risk (Janusek 2004). Without overtly depicting ruling elite persons as ancestral deities, new lithic personages meshed the gestures and dress of ruling elites with the monolithic bodies of great ancestors. New monolithic productions embodied astute bids for legitimacy.

Tiwanaku as Political Ecology and Telluric Process

Functional and structural interpretations have subordinated the dynamic materiality of past urban production to the imperatives of abstract utilitarian or symbolic processes. Ponce Sanginés (1981) interpreted Tiwanaku as a city that "matured" with the construction of the Akapana and Pumapunku during his Tiwanaku IV period. Kolata (1993) cast Tiwanaku as the exemplary center of a hierarchical religious state. In both accounts, Tiwanaku became a finished project—it "achieved" the status of city—and its monuments passively reflected its role as center of state. Power in both accounts resided in abstract "DeMillian" political organizations that solely authorized monumental productions behind the scenes. We posit that Tiwanaku was perpetually under construction and that its fame resided not in abstracted metaphysical utilitarian or structural processes but in dramatic, sustained, ever-present tectonic practices. Tiwanaku ritual and political authority rested squarely in Tiwanaku's ongoing material, monumental production.

Tiwanaku's Tectonic Political Ecology

Late Formative monumental production in sandstone centered on the Corocoro range that separated Khonkho from Tiwanaku. Khonkho Wankane and Tiwanaku created parallel, paired circuits of sandstone quarrying, carting, and fine-working on either side of Corocoro. By 500 CE, the circuit that had focused on Khonkho Wankane withered and ceased; Lawakollu production for Khonkho was abandoned mid-production, leaving several impressive pilasters and anthropomorphic monoliths partially finished. Kaliri production for Tiwanaku, on the north face of Corocoro, continued as a primary source of sandstone for Tiwanaku (Janusek et al. 2013; Ponce Sanginés et al. 1971; Protzen and Nair 2013). By all accounts, it remained Tiwanaku's primary sandstone quarry throughout the Middle Horizon.

Volcanic monumentality generated entirely new circuits of lithic production and movement in the south Lake Titicaca basin. Just as Tiwanaku emerged as *the* primary urban center in the region, volcanic stone began to be quarried on a large scale in the foothills of Ccapia and at various places on and near the Copacabana Peninsula, far from Khonkho Wankane. These sources exclusively fed Tiwanaku and its emergent ritual-political

networks. New circuits of volcanic manufacture operated in tandem alongside the older productive circuits that continued to feed Corocoro sandstone to Tiwanaku.

Volcanic monumentality also required novel technologies of stone production and transportation (Protzen and Nair 2013). The shift to Tiwanaku centrality after 500 CE corresponded with new materialities and technologies of monumental production. New technologies coalesced as particular domains of expertise were learned and transmitted across generations. New skills included quarrying stone in Copacabana or Ccapia; carting the blocks to shore sites, such as Kanamarka; building the rafts that carted the heavy blocks across the lake, which itself demanded innovative engineering; and rough-working blocks at such key locales as Iwawe. Then, heavy volcanic stones had to be hauled 11 kilometers to Tiwanaku, more finely worked in dedicated locations at Tiwanaku, and painstakingly set in place as architectural elements that best manifested the political aesthetic that anchored Tiwanaku's emergent hegemonic mission.

Tiwanaku's emergent political ecology included the strategic incorporation of the Late Formative centers and political communities that occupied Lake Titicaca's hydrological axis. Tiwanaku leaders did not seek contiguous territorial control of the entire Titicaca region (Janusek 2008; Smith and Janusek 2014; Stanish 2003; Stanish et al. 1997); their hegemonic interests were attuned to specific landscapes and materials. They sought to incorporate vast swaths of the marshy, productive lakeshore to develop intensive farming technologies (Erickson 2000; Janusek and Kolata 2004; Kolata 1986, 1991; Ortloff 1996) and control crucial routes of aquatic movement on Titicaca's key tributaries and primary drainage, the Desaguadero River (Janusek 2008; Smith and Janusek 2014). Tiwanaku leaders also sought to control volcanic stone quarries for monumental production (Janusek 2006; Janusek et al. 2013), and, to this end, strategically incorporated the communities that controlled Ccapia and Copacabana. During the Late Formative, specific ethnic-like communities had controlled Titicaca's lakeshore and aquatic axis. Janusek (2008:182) has argued that a federation of communities generative of the later Uru—a historically documented ethnicity that occupied Titicaca's shores, controlled its waterways, and provided lacustrine recourses for inland communities—originally controlled the movement of many materials, including andesite. Their political incorporation provided access to the waterways, quarries, and materials that suddenly transformed Tiwanaku from a local ritual-political center to the primary center of a panregional polity. By 700 CE, Tiwanaku had monopolized volcanic stone quarries for monumental production.

Tiwanaku's new political mission may have been spurred by climatic changes that brought broadly wetter conditions to the Titicaca basin toward the end of the Late Formative (Abbott et al. 1997; Binford et al. 1997). These conditions may have ruptured Khonkho's and Tiwanaku's Late Formative reliance on perennial montane springs on either side of Corocoro. Yet whatever the role of climatic shift, regional geopolitics moved from an emphasis on inland, spring-dependent centers, such as Khonkho Wankane, toward centers located on Titicaca's lacustrine axis. It is significant that Lukurmata emerged as the second most important center in the southern basin under Tiwanaku hegemony (Bermann 1994; Janusek 2004). It is located on Lake Titicaca's shore just northwest of Tiwanaku, and its monumental complex was one of the few in the region to incorporate andesite foundations. These stones had been quarried in Ccapia.

Tiwanaku's Telluric Production

Lithic materiality was central to the long-term production of authority in the Lake Titicaca basin. Monumental construction at Khonkho Wankane and Tiwanaku celebrated the sandstone quarried on either side of the Corocoro range. Sandstone comprised the elegant foundations, facades, cornices, and orthostats of Late Formative monumental platforms and sunken courtyards, while constituting the monolithic ancestral personages that occupied key spaces in those monuments.

Stone production was profoundly ritualized during the Late Formative. Primary quarries for both sites were located near dramatic lithic

figure 4.20
Granitic plutons in Turiturini, near the Kaliri quarry on the north face of Corocoro. (Photograph by John W. Janusek.)

formations that remain powerful ritual locations (Astvaldsson 1997, 1998). Khonkho's sandstone was quarried near Salla, a geological formation of stepped sandstone outcrops that are today animated as the mythical center of a political community of ancient personages. Tiwanaku's sandstone was quarried near Turiturini, which features numerous granitic plutons that rise dramatically skyward (Figure 4.20). In oral traditions, the plutons are named and have ancient histories. Physical characteristics of these geological formations, we suggest, formed telluric prototypes for the monuments and monoliths their lithic essences constituted at Khonkho Wankane and Tiwanaku. Stepped platforms echoed the stepped character of Salla, while monumental masonry walls presented perfected, domesticated instantiations of the blocky

quadrangular forms that characterized the naturally exfoliated blocks of Kaliri. Monoliths arguably manifest humanly sculpted incarnations of the dramatic plutons in Turiturini. In short, quarries were located adjacent to remarkable animate landscapes that afforded their material efficacy.

Tiwanaku's emergent geopolitical hegemony was centered on innovative materials and technologies of monumental production. Tiwanaku celebrated the volcanic stone that constituted its monuments after 500 CE. Volcanic stone was incorporated strategically to create a powerful political aesthetic that tied new monumental complexes to distant landscapes. Andesite blocks constituted the most visible faces of the foundations, facades, and portals that most ritual participants would have engaged in any monumental complex.

This was an exclusive aesthetic; volcanic stone was uncommon at contemporaneous centers. Only a few other centers incorporated andesite stone in monumental constructions, and they included Iwawe and Lukurmata—lacustrine–riverine centers critical to Tiwanaku's emergent hegemony. Even so, volcanic monolithic sculptures were restricted to Tiwanaku itself.

Like Corocoro sandstone quarries, Ccapia and Copacabana are influential ritual places. Harvesting volcanic stone during the Middle Horizon itself shaped their significance as ritually potent locales. Survey in the foothills and on the shoreline of Ccapia revealed numerous sites dating to Late Formative and Tiwanaku phases, many with monumental architecture (Stanish 2003; Stanish et al. 1997). Ccapia is an incredibly powerful ritual place for native communities in the south central Andes (Orlove 2002); it is the subject of many contemporary narratives of human sacrifice.[4] Its volcanic slopes differ visually from surrounding landscapes, enhancing its alterity and sacredness. Key sources of volcanic stone in Copacabana included the mountainous outcrop of Cerro Pukara, on the east side of the Tiquina Strait (our Copacabana East source), and the lakeshore outcrop of Boca del Sapo on the Copacabana Peninsula itself (our Copacabana West). Cerro Pukara is a powerful local *achachila*, or animate ancestral mountain. Boca del Sapo is a volcanic outcrop that has achieved national fame (Figure 4.21). Located at the north edge of Copacabana and on Titicaca's shore, it is visited regularly by members of Bolivia's emerging middle class. Visitors burn offerings on its rocky face with the aid of ritual specialists.

Telluric matter was central to the constitution of Tiwanaku monumentality, and its specific qualities indexed relations to key landscape and skyscape phenomena. The red color and sandy texture of sandstone indexed its local Corocoro origin. The bluish-gray or green color and crystalline texture of andesite indexed its more distant, volcanic places of origin. The bluish-gray color of andesite also indexed the color of the lake and the recently incorporated lacustrine quarries that provided volcanic stone for Tiwanaku (Janusek 2006). Tiwanaku's

anthropomorphic stelae rendered such material–ecological distinctions palpable. Lithic portals funneled ritual participants into the monumental center, through labyrinthine hallways, and toward a courtyard that featured a particular anthropomorphic stela. Late Formative monolithic personages consisted of red sandstone quarried in Corocoro; Middle Horizon monolithic personages consisted of either red Corocoro sandstone or bluish-gray Ccapia andesite.

Engaging the lithic personage each stela embodied was central to the ritual experience that Tiwanaku monumentality facilitated. Like Tiwanaku's architectural blocks, ancestral stone personages materially embodied their distinctive mountains of origin. They did not just *represent* them; they *constituted* their telluric essence. Built monumental spaces created the contexts that rendered mountains and monoliths animate actors in the world of humans. The spatial assemblies and alignments of Tiwanaku temple complexes physically indexed those relations. Tiwanaku's Late Formative sunken temple created a visual index to the most prominent local mountain in the Corocoro range—the primary source of Tiwanaku sandstone—Mount Kimsachata. Later complexes prioritized physical indices to mountains east and west, including Ccapia, the primary source of Tiwanaku andesite.

These same monumental assemblies joined celestial movements to these terrestrial features, rendering the rituals that drew attention to them recurring and timeless. Late Formative sunken temples at Khonkho Wankane and Tiwanaku, located on the same north–south axis but oriented obliquely to facilitate celestial observations, dramatized particular nighttime observations, such as the heliacal rise of the yacana dark-cloud constellation. Late Formative 2 involved the production of monumental complexes oriented obliquely east–west. New orientations meshed distant peaks, such as Illimani and Ccapia, to multiple solar rise and set points on the east and west horizons (Posnansky 1945; Vranich 2009). Created in part as earthen technologies for marking recurring solar observations, new monumental complexes sought to

figure 4.21
The volcanic outcrop of Boca del Sapo on the north tip of Copacabana, with families making ritual offerings at its base. (Photograph by John W. Janusek.)

institutionalize more effective, comprehensive, and dramatic ritual and productive calendars.

Kalasasaya was particularly important for Tiwanaku. Its west balcony marked solar setting points on the western altiplano horizon through the annual cycle, from solstice to solstice. On June 21, the sun is farthest from Tiwanaku and the southern tropic. Viewed from inside of Kalasasaya, this sunset was particularly dramatic. The sun settled precisely over the northernmost andesite orthostat of the west balcony wall and directly over the peak of Mount Ccapia, from which the orthostat had been harvested and its very materiality embodied and indexed. This annual event enacted a perfect conjunction of telluric forces and celestial movements that punctuated ritual experience and codified a fixed calendar that effectively meshed

multiple productive rhythms with recurring ritual events. Calendrical rituals centered on Kalasasaya likely entreated the vital ancestral forces embodied in Ccapia and other peaks to ensure the well-being of the myriad communities that identified as Tiwanaku.

Far from a zero-sum proposition, volcanic monumentality constituted a particularly valorized and ritually potent set of materials, technologies, and indexical relations that complemented more established practices of monumental production. Andesite and sandstone were mutually constitutive, if differentially valued, elements of later Tiwanaku monuments. Middle Horizon builders orchestrated a strategic architectural juxtaposition of volcanic stone and Corocoro sandstone. Tiwanaku's courts featured both sandstone and

andesite monolithic personages. If monumental structures prioritized east–west trending relations to newly important landscape features and sky-scape events, then pivotal volcanic architectural elements directed attention to more established landscape and skyscape features. A basalt slab in the north wall of the sunken temple directed attention to the celestial meridian to the south, and the andesite hallway between Kalasasaya and Putuni facilitated a striking view of Kimsachata in Corocoro. Featuring andesite, these architectural elements physically appropriated Tiwanaku's early, Late Formative center of telluric gravity to a new set of physical orientations that educated ritual attention to more distant and dramatic peaks to the east and west. Strategically juxtaposing andesite from different volcanic sources in Kalasasaya and Kantatayita served parallel ends.

The lithic production of Khonkho Wankane and Tiwanaku manifested shifting monumental technologies of essence. We borrow this term from Lechtman's (1977) study of a Moche metallurgical technology known as depletion gilding. In depletion gilding, metallurgists bathed an alloyed metal object in acid to subtract relatively low-valued metal elements (e.g., copper) from the surface, leaving more highly valued elements (e.g., silver, gold) externally "purified" and visually resplendent. The point was not to create a facade or veneer, but to draw the most pure and essential form of the object to the surface.

Although monumental construction at Khonkho Wankane and Tiwanaku celebrated architectural facades, their lithic compositions emphasized similar technologies of essence. Monumental constructions showcased lithic materials considered to be the purest and most essential elements of the earth, a valuation that shifted with changing geopolitical histories. Monumental production in sandstone during the Late Formative featured the red-hued telluric essence of the Corocoro range and its local mythical locales. Later monumental production in Tiwanaku prioritized blue-hued andesite alongside Corocoro sandstone as the purer telluric essence of more distant and ancient volcanic formations. It featured andesite derived from montane landscapes more recently incorporated into Tiwanaku's expanding ritual–political network. Stone from particular volcanic locales—for example, Copacabana—may have been considered even purer for specific Tiwanaku monuments, such as Kantatayita.

Conclusions

The shift from strictly sandstone to sandstone and volcanic stone construction coincided with the transformation of Tiwanaku from a primus inter pares in the southern Lake Titicaca basin, in its privileged relation to Khonkho Wankane, to the primary center of a panregional political center during the Middle Horizon. Tiwanaku's emergent centrality was enacted in novel practices that included meshing new circuits of volcanic monumental production with more traditional circuits of sandstone production. This shift in material practices engendered an innovative political aesthetic and a resonant ritual vision that drove an emergent geopolitical mission hell-bent on incorporating extensive swaths of Lake Titicaca's hydrological axes.

Contemporary processes of urban production differ markedly from those that produced Tiwanaku. Tiwanaku did not reify "nature" as an other-than-human ontological domain. In predominant contemporary nature regimes, stones quarried from distant landscapes have no specific material significance or a celebrated material relation to their places of origin. Stones are utilitarian resources, and challenging conditions of their origin, transportation, and materiality are simply "expensive." In Tiwanaku, as in many other places of the Pre-Columbian Americas, material qualities and relations defined the choice and power of the stones that constituted specific monuments. As the most essential component of the earth, stone embodied its purest telluric power. The ongoing production of stone monuments sustained an extraordinary technology of essence that was Tiwanaku's ultimate source of fame and power.

Telluric techné describes Tiwanaku's ongoing monumental production and emergent fame.

It encapsulates the appropriation and reordering of animate forces considered to inhabit powerful earthly features, objects, and materials to produce celebrated monuments. This is not the production of strip malls and suburban subdivisions that directs attention away from the tectonic forces their materials embody and toward the consumptive practices they serve. Telluric techné refers to the skilled appropriation and reassembly of the lithic materials that constituted prominent earthly features and the production of subjects who considered those materials central to the crafting of their own political identities. It refers centrally to the production of subjects who were morally obligated to participate in and reproduce Tiwanaku ritual and political practices.

Thus, the most important *things* Tiwanaku produced were neither monuments nor monoliths but the human subjects who forged and identified with them (Costin, this volume, Introduction). Just as nation-states spend vast resources educating, disciplining, and otherwise producing citizens, so Tiwanaku's ongoing production of monumentality was a bid to produce particular sorts of human subjects. Ideally, those persons recognized the complementary values and animate power of the materials that constituted Tiwanaku monuments. Meanwhile, Tiwanaku's persons-in-production understood, honored, and replicated in their lives the ritual attitudes that monolithic personages enacted, which, by the Middle Horizon, meant consuming chicha and hallucinogens to fully participate in the practices that reproduced an animate cosmos centered on taypikala. Like contemporary nation-states, Tiwanaku was in the business of producing subjects.

NOTES

1 We refer here to Nancy Munn's (1986) notion of "fame" as the spatiotemporal expansion of the renown of a thing or place—in this case, a center—via the movement of people, objects, and narratives that create extemporaneous relations with that thing or place. Although we do not mean "fame" in the limited Hollywood sense, this is certainly one manifestation of Munn's encompassing notion.

2 An archaeoastronomy project Janusek directed in collaboration with Dr. Keivan Stassum of the Department of Physics and Astronomy at Vanderbilt confirmed the observations of solstice and equinox set points on the west horizon that were first published by Posnansky in the 1940s and by Leonardo Benitez in recent years.

3 Ceramic sherds from surfaces and occupation zones immediately below Putuni construction fill date to what Alconini Mujica and Janusek term the "Early Tiwanaku IV period," which dates to 500–600 CE.

4 Janusek has heard stories of human sacrifice on Ccapia since 1988. In 2010, an informant from near Yunguyu, at Ccapia's base, related narratives describing three sacrifices that had occurred on Ccapia over the prior seven years. They included two adults and one child. Whether apocryphal or "real," human sacrifice narratives communicate the spiritual and ritual significance of Ccapia in the lives of local communities. Furthermore, our informant indicated that Ccapia is the subject of relatively clandestine pilgrimages from vast regions of the Andes.

Abercrombie, Thomas A.

1998 *Pathways of Memory and Power: Ethnography and History among an Andean People.* University of Wisconsin Press, Madison.

Abbott, Mark B., Michael W. Binford, Mark Brenner, Jason H. Curtis, and K. R. Kelts

1997 A 3,500 ¹⁴C yr High Resolution Sediment Record of Lake Level Changes in Lago Titicaca, South America. *Quaternary Research* 47(2):169–180.

Alconini Mujica, Sonia

1995 *Rito, símbolo e historia en la Pirámide de Akapana, Tiwanaku: Un análisis de cerámica ceremonial prehispánica.* Editorial Acción, La Paz.

Astvaldsson, Astvaldur

1997 *Las voces de los wak'a: Fuentes principales del poder politico aymara.* Jesus de Machaca: La marka rebelde 4. CIPCA, La Paz.

1998 The Powers of Hard Rock: Meaning, Transformation, and Continuity in Cultural Symbols in the Andes. *Journal of Latin American Cultural Studies* 7(2):203–223.

Bandy, Matthew

2013 Tiwanaku Origins and Early Development: The Political and Moral Economy of a Hospitality State. In *Visions of Tiwanaku*, edited by Alexei Vranich and Charles Stanish, pp. 135–150. Cotsen Institute of Archaeology Press, Los Angeles.

Benitez, Leonardo

2009 Descendants of the Sun: Calendars, Myth, and the Tiwanaku State. In *Tiwanaku: Papers from the 2005 Mayer Center Symposium at the Denver Art Museum*, edited by Margaret Young-Sanchez, pp. 49–82. Denver Art Museum, Denver.

2013 What Would Celebrants See? Sky, Landscape, and Settlement Planning in Late Formative Southern Lake Titicaca Basin. In *Advances in Titicaca Basin Archaeology*, vol. 2, edited by Alexei

Vranich and Abigail Levine, pp. 89–104. Cotsen Institute of Archaeology Press, Los Angeles.

Bermann, Marc

1994 *Lukurmata: Household Archaeology in Prehispanic Bolivia.* Princeton University Press, Princeton, N.J.

Biersack, Aletta

2006 Reimagining Political Ecology: Culture/Power/History/Nature. In *Reimagining Political Ecology*, edited by Aletta Biersack and James B. Greenburg, pp. 3–42. Duke University Press, Durham, N.C.

Binford, Michael W., Alan L. Kolata, Mark Brenner, John W. Janusek, Matthew T. Seddon, Mark Abbott, and Jason H. Curtis

1997 Climate Variation and the Rise and Fall of an Andean Civilization. *Quaternary Research* 47(2):235–248.

Cobo, Bernabé

1990 [1653] *Inca Religion and Customs: Selections from Historia del Nuevo Mundo.* Translated and edited by Roland Hamilton. University of Texas Press, Austin.

Couture, Nicole C., and Kathryn Sampeck

2003 Putuni: A History of Palace Architecture in Tiwanaku. In *Tiwanaku and Its Hinterland: Archaeology and Paleoecology of an Andean Civilization*, vol. 2, edited by Alan L. Kolata, pp. 222–263. Smithsonian Institution Press, Washington, D.C.

Descola, Philippe

1996 Constructing Natures: Symbolic Ecology and Social Practice. In *Nature and Society: Anthropological Perspectives*, edited by Philippe Descola and Gísli Páalsson, pp. 82–102. Routledge Press, London.

Erickson, Clark

2000 The Lake Titicaca Basin: A Precolumbian Built Landscape. In *An Imperfect Balance: Landscape Transformations in the Precolumbian Americas*, edited by David L. Lentz, pp. 311–356. Columbia University Press, New York.

Escobar, Arturo

1999 After Nature: Steps to an Antiessentialist Political Ecology. *Current Anthropology* 40(1):1–30.

Forbes, David

1870 On the Aymara Indians of Bolivia and Peru. *Journal of the Ethnological Society of London* 2(3):193–305.

Gumbrecht, Hans Ulrich

2004 *Production of Presence: What Meaning Cannot Convey.* Stanford University Press, Redwood City, Calif.

Intimayta Ramos, Julio J.

2010 Informe final sobre los trabajos en arquitectura y conservación. In *Gobierno Municipal de Tiwanaku Proyecto Arqueológico Putuni: Informe final, Julio–Diciembre, 2009,* edited by Adolfo E. Pérez Arias, Julio J. Intimayta Ramos, Julio A. Ballivian Tórrez, and Ruth C. Fontenla Alvarez, pp. 1–103. Official Field Report submitted to the Municipal Government of Tiwanaku, Bolivia, and the Bolivian Viceministry of Culture.

Janusek, John W.

2003 Vessels, Time, and Society: Toward a Ceramic Chronology in the Tiwanaku Heartland. In *Tiwanaku and Its Hinterland: Archaeology and Paleoecology of an Andean Civilization,* vol. 2, edited by Alan L. Kolata, pp. 30–92. Smithsonian Institution Press, Washington, D.C.

2004 *Identity and Power in the Ancient Andes: Tiwanaku Cities through Time.* Routledge Press, London.

2006 The Changing "Nature" of Tiwanaku Religion and the Rise of an Andean State. *World Archaeology* 38(3):469–492.

2008 *Ancient Tiwanaku.* Cambridge Archaeological Press, Cambridge.

2012 Understanding Tiwanaku Origins: Animistic Ecology in the Andean Altiplano. In *The Past Ahead: Language, Culture, and Identity in the Neotropics,* edited by Christian Isendahl, pp. 111–138. Studies in Global Archaeology 18. Uppsala University, Uppsala, Sweden.

2015 Of Monoliths and Men: Human-Lithic Encounters in the Production of an Animistic Ecology at Khonkho Wankane. In *The Archaeology of Wak'as: Explorations of the Sacred in the Pre-Columbian Andes,* edited by Tamara L. Bray, pp. 335–365. University of Colorado Press, Boulder.

Janusek, John W., and Alan L. Kolata

2004 Top Down or Bottom Up: Rural Settlement and Raised Field Agriculture in the Lake Titicaca Basin, Bolivia. *Journal of Anthropological Archaeology* 23:404–430.

Janusek, John W., and Arik T. Ohnstad

n.d. Stone Stelae of the Southern Basin: A Stylistic Chronology of Ancestral Personages. In *The South American Iconographic Series,* edited by William H. Isbell. Cotsen Institute of Archaeology Press, Los Angeles, in press.

Janusek, John W., Patrick Ryan Williams, Mark Golitko, and Carlos Lémuz

2013 Building Taypikala: Telluric Transformations in the Lithic Production of Tiwanaku. In *Mining and Quarrying in the Andes: Sociopolitical, Economic, and Symbolic Dimensions,* edited by Nicolas Tripcevich and Kevin J. Vaughn, pp. 65–98. Springer, New York.

Kolata, Alan L.

1986 The Agricultural Foundations of the Tiwanaku State: A View from the Heartland. *American Antiquity* 51:748–762.

1991 The Technology and Organization of Agricultural Production in the Tiwanaku State. *Latin American Antiquity* 2(2):99–125.

1993 *Tiwanaku: Portrait of an Andean Civilization.* Blackwell, Cambridge.

Lechtman, Heather

1977 Style in Technology—Some Early Thoughts. In *Material Culture: Styles, Organization, and Dynamics of Technology,* edited by Heather Lechtman and Robert S. Merrill, pp. 3–20. West Publishing, New York.

Ohnstad, Arik

2013 The Stone Stelae of Khonkho Wankane.
 In *Advances in Titicaca Basin Archae-
 ology*, vol. 2, edited by Alexei Vranich
 and Abigail Levine, pp. 53–66. Cotsen
 Institute of Archaeology Press, Los
 Angeles.

n.d. Monoliths and Monolithic Iconography
 at Khonkho Wankane. In *Khonkho
 Wankane and Its Hinterland: Archaeo-
 logical Investigations of a Pre-Columbian
 Proto-Urban Center in the Bolivian
 Andes*. Cotsen Institute of Archaeology
 Press, Los Angeles.

Orlove, Ben

2002 *Lines in the Water: Nature and Culture
 at Lake Titicaca*. University of California
 Press, Berkeley.

Ortloff, Charles R.

1996 Engineering Aspects of Tiwanaku
 Groundwater-Controlled Agriculture.
 In *Tiwanaku and Its Hinterland:
 Archaeology and Paleoecology of an
 Andean Civilization*, vol. 1, edited by
 Alan L. Kolata, pp. 153–168. Smithsonian
 Institution Press, Washington, D.C.

Ponce Sanginés, Carlos

1968 Perspectiva arqueológica. In *Las andesi-
 tas de Tiwanaku*, 25–43. Publication no.
 18. Academia Nacional de Ciencias de
 Bolivia, La Paz.

1970 Examen arqueológico. In *Acerca de la
 procedencia del material lítico de los
 monumentos de Tiwanaku*, edited by
 Carlos Ponce Sanginés and Gerardo
 Mogrovejo Terrazas, pp. 11–188.
 Academica Nacional de Ciencias
 de Bolivia, La Paz.

1971 Examen arqueológico. In *Procedencia de
 las areniscas utilizadas en el temple pre-
 colombino de Pumapunku (Tiwanaku)*,
 edited by Carlos Ponce Sanginés, Arturo
 Castaños Echazu, Waldo Avila Salinas,
 and Fernando Urquidi Barrau, pp.
 13–206. Academia Nacional de Ciencias
 de Bolivia, La Paz.

1981 *Tiwanaku: Espacio, tiempo, y cultura*.
 Los Amigos del Libro, La Paz.

Ponce Sanginés, Carlos, Arturo Castaños Echazu,
Waldo Avila Salinas, and Fernando Urquidi
Barrau (editors)

1971 *Procedencia de las areniscas utiliza-
 das en el temple Precolombino de
 Pumapunku (Tiwanaku)*. Academia
 Nacional de Ciencias de Bolivia, La Paz.

Ponce Sanginés, Carlos, and Gerardo Mogrovejo
Terrazas (editors)

1970 *Acerca de la procedencia del material
 lítico de los monumentos de Tiwanaku*.
 Academia Nacional de Ciencias de
 Bolivia, La Paz.

Posnansky, Arthur

1904 Petrografía de Tiahuanacu. *Boletín
 de la Sociedad Geográfica de La Paz*
 18–20:207–211.

1945 *Tihuanacu: The Cradle of American
 Man*, vols. 1 and 2. J. J. Augustin,
 New York.

Protzen, Jean-Pierre

1983 Inca Quarrying and Stonecutting.
 Ñawpa Pacha 21:183–214.

1993 *Inca Architecture and Construction at
 Ollantaytambo*. Oxford University Press,
 New York.

Protzen, Jean-Pierre, and Stella Nair

2013 *The Stones of Tiahuanaco: A Study of
 Architecture and Construction*. Cotsen
 Institute of Archaeology Press, Los
 Angeles.

Smith, Scott C., and John W. Janusek

2014 Political Mosaics and Networks:
 Tiwanaku Expansion into the Upper
 Desaguadero Valley, Bolivia. *World
 Archaeology* 46(5):681–704.

Squier, Ephraim George

1877 *Incidents of Travel and Exploration in the
 Land of the Incas*. MacMillan, London.

Stanish, Charles

2003 *Ancient Titicaca: The Evolution of
 Social Complexity in Southern Peru
 and Northern Bolivia*. University of
 California Press, Berkeley.

Stanish, Charles, Edmundo de la Vega M., Lee
Steadman, Cecilia Chávez Justo, Kirk Lawrence
Frye, Luperio Onofre Mamani, Matthew T.
Seddon, and Percy Calisaya Chuquimia

1997 *Archaeological Survey in the Juli-
Desaguadero Region of the Lake Titicaca
Basin, Southern Peru*. Field Museum of
Natural History, Chicago.

Stübel, Alphons, and Max Uhle

1892 *Die Ruinenstätte von Tiahanaco
im Hochlande des alten Perú: Eine
Kulturgeschichtliche Studie auf Grand
selbsständiger Aufnahmen*. Karl W.
Hiersemann, Leipzig.

Torres, Constantino Manuel, and David B. Repke

2006 *Anadenanthera: Visionary Plant of
Ancient South America*. Haworth Press,
New York.

Vranich, Alexei

2001 La pirámide de Akapana: Reconsi-
derando el centro monumental de
Tiwanaku. In *Huari y Tiwanaku:
Modelos vs. evidencias*, vol. 2, edited
by Peter Kaulicke and William H.
Isbell, pp. 295–308. Fondo Editorial de
la Pontíficia Universidad Católica del
Peru, Lima.

2006 The Construction and Reconstruction
of Ritual Space at Tiwanaku (AD
500–1000), Bolivia. *Journal of Field
Archaeology* 31(2):121–136.

2009 The Development of the Ritual Core of
Tiwanaku. In *Tiwanaku: Papers from
the 2005 Mayer Center Symposium at the
Denver Art Museum*, edited by Margaret
Young-Sanchez, pp. 11–34. Denver Art
Museum, Denver.

Vranich, Alexei, Paul Harmon, and Chris Knutson

2005 Reed Boats and Experimental
Archaeology on Lake Titicaca.
Expedition 47(2):20–27.

Wolf, Eric R.

1972 Ownership and Political Ecology.
Anthropological Quarterly 45:201–205.

5

Encoded Process, Embodied Meaning in Paracas Post-Fired Painted Ceramics

LISA DELEONARDIS

Among the outstanding visual arts of the prehispanic Andes, the remarkable embroidered textiles and painted and incised ceramics from the Paracas of south coastal Peru (ca. 900 BCE–1 CE) are particularly distinguished. The Paracas valued a range of qualities in visual culture—texture, color, luminosity—and went to great lengths to acquire the materials necessary for techné. Meaning was embodied in the media that constituted works—the camelid or cotton fiber, clay, or colorants—and the process of transforming them was similarly valued, as attested by the rich visual record in which esoteric and shared knowledge was expressed.

Paracas ceramics have long been considered one of the hallmarks of ancient Andean art, prized for their planiform designs and iconography. Most familiar to us are the elaborate double-spout-and-bridge bottles, nearly synonymous with Paracas visual culture (Figure 5.1). A repertoire of forms has been fundamental to the establishment of the Early Horizon temporal framework, a seriation of attributes that formed the basis for a ten-phase relative chronology, or Ocucaje sequence (Menzel et al. 1964). Iconographic similarities between the ceramics and sculpture of distant cult centers to the north have served as a gauge of the sphere of Chavín religious ideology (Burger 1995; Kembel and Rick 2004; see Figures 5.2–5.3). In the broad scheme of complex Andean societies, the Paracas flourished during a period of "emerging social valuables," one in which artistic innovation and specialization surged (Burger 2012).

The color palette of Paracas ceramics has equally drawn attention. Vibrant color was achieved through the application of paint after the ceramics were fired. Post-fired paint figured in the structure and meaning of design and form while creating vulnerability in the use of the finished object. Indeed, the precarious nature of the paint may have been a desirable quality. The technique did not develop out of ignorance of conventional painting and firing methods. Over the course of Paracas history, slip-painted ceramics were produced alongside

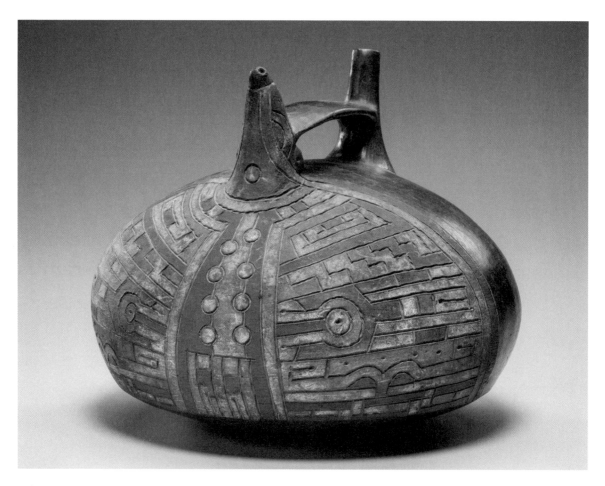

figure 5.1
Paracas post-fired painted and incised bottle, Teojate (Juan Pablo), upper Ica Valley. Indiana University Art Museum, Raymond and Laura Wielgus Collection, Gift of Mr. and Mrs. Allen Wardwell, 90.70. (Photograph by Michael Cavanagh and Kevin Montague.)

post-fired ceramics. Some ceramics show that both methods were employed on the same vessel (see Figure 5.3a). Nor were the Paracas unique in their approach (Cummins 1992; Inokuchi 2011; Jones 2010). What distinguishes Paracas ceramicists from other Andean practitioners are the methods and materials by which the color effect and durability were achieved. Moreover, the Paracas made the pictorial technique their own, and it materialized their social identity for nearly a millennium.

The processes involved in the creation of painted and incised ceramics, and the ceramicists responsible for cult objects—masks, effigies, and specialized forms beyond the purview of everyday use—are investigated in this chapter. Examination

of the production process, or "system of making," offers a view of the people, resources, and energy united in an organized set of interdependent relationships consistent with Paracas cultural values and imperatives (Bertemes and Biehl 2001; Dobres 2000). The creation of painted and incised ceramics required an understanding of design conventions as well as a knowledge of colorants and binders that bordered on alchemy. I maintain that successful objects—those most favored for ritual use, broadly defined—were guided by the hand of a master artist. I offer insights into the skills and range of expertise valued in the context of Paracas ceramic design and production and, by extension, the society at large.

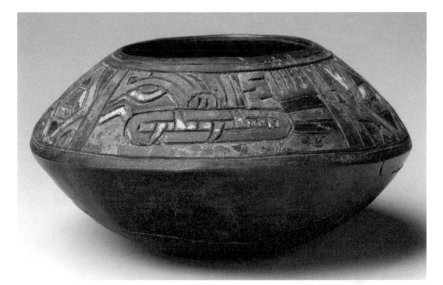

figure 5.2
Paracas post-fired painted and incised lenticular bowl, front (a) and side (b), from Chiquerillo, lower Ica Valley. The Metropolitan Museum of Art, Nathan Cummings Collection, 63.232.4. (© The Metropolitan Museum of Art / Art Resource, New York.)

a

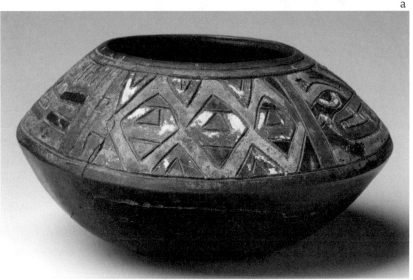

b

My analysis examines a number of variables relevant to assessing questions about techné (Costin 1991, 2007; Meskell 2005; Sofaer 2007). In the absence of written sources, the study of Paracas ceramic production prompts interdisciplinary methods to address and interpret visible patterns in the archaeological record (Costin 2007). My work is inspired by the concept of value as framed by Papadopoulos and Urton (2012). Indirectly, it draws from an ongoing inquiry about artists and agency in the prehispanic Andes (Nair 2007) as well as from an interest in the concept of *kamay* (or *camay)*, the vital essence of all things (DeLeonardis 2011a, 2012; see also Zori, this volume).

I consider archaeological contexts for all stages of production (Figure 5.4). Technical analysis of production methods (from forming to painting) reveals how ceramics were produced and provides important clues to the personnel, skill, and social relationships required to procure and process materials and to execute works. Language about color and the contexts for colorants and production tools are reviewed to offer further insight into how value is encoded in techné.

Implicit in the discussion are shifts in leadership that occur over time, which inform our understanding about the circulation of, and access to, materials and objects (see Cook 1999; DeLeonardis

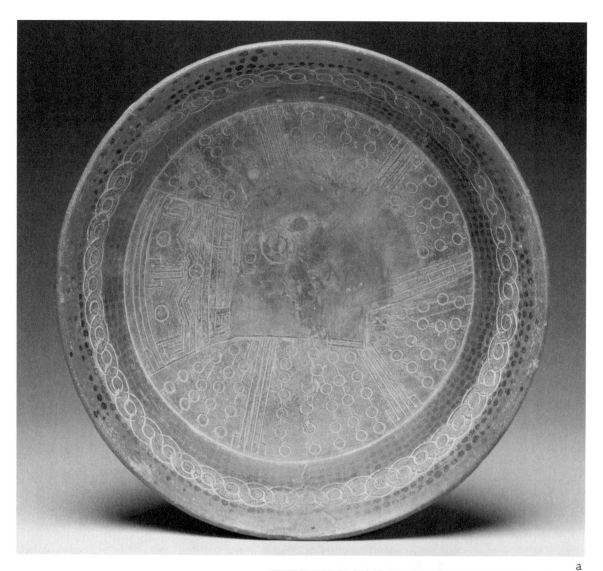

a

figure 5.3

a) Paracas red-slipped incised bowl with resist paint (dots) and post-fired painted designs. The guilloche, or twisted strand motif on the wall interior, mirrors the intertwined thread, or *axis mundi*, carved on the Lanzón stela in the Old Temple at Chavín de Huántar in the north central highlands. The Metropolitan Museum of Art, Nathan Cummings Collection, 63.232.20. (© The Metropolitan Museum of Art / Art Resource, New York.) b) Incised bowl fragments bearing twisted-strand motif, PV62D13, Callango. (Photograph by Lisa DeLeonardis.)

b

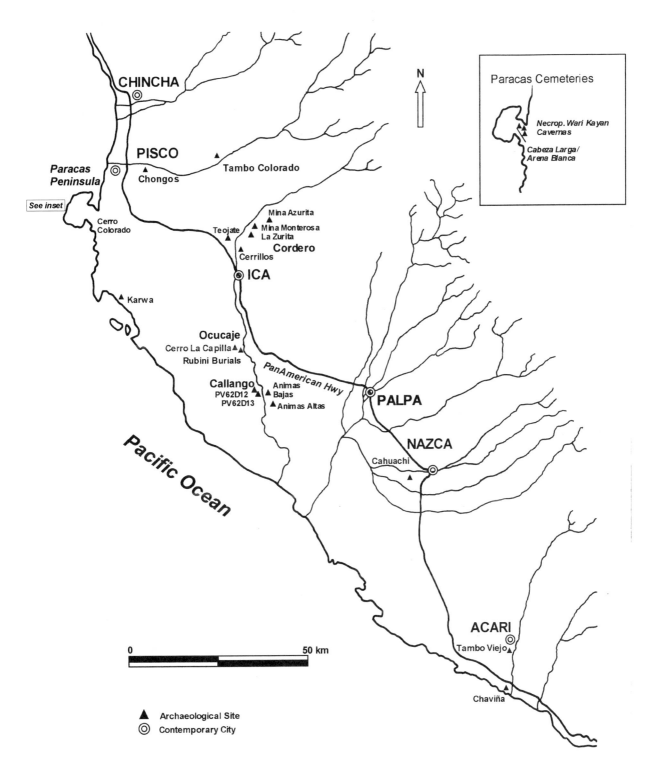

figure 5.4
Map of south coastal Peru, showing regions and sites mentioned in the text. (Drawing by Lisa DeLeonardis.)

Encoded Process, Embodied Meaning in Paracas Post-Fired Painted Ceramics 133

figure 5.5
Paracas post-fired painted
and incised bowl and
incurving vessel fragments
showing twisted strand design
units. a) Cerro la Capilla,
Ocucaje, lower Ica Valley.
The Metropolitan Museum
of Art, Nathan Cummings
Collection, 64.228.98. (© The
Metropolitan Museum of Art
/ Art Resource, New York.)
b–c) Cerrillos, upper Ica
Valley. (Photographs by Lisa
DeLeonardis.)

a

b

c

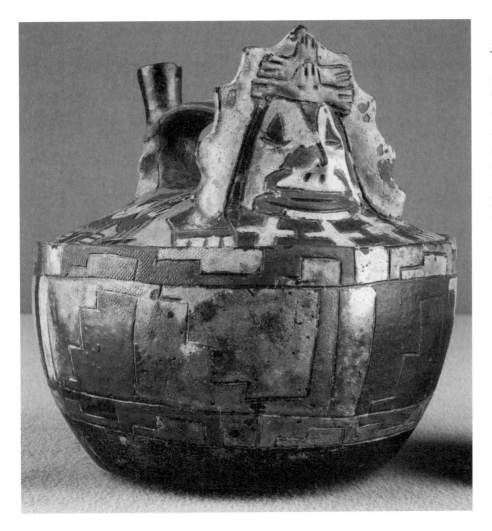

1991; Massey 1986, 1991; Peters 2013; Silverman 1994). Moreover, they provide insight into the centers of production and the leader-as-artist posed for middle-range societies (Helms 1993; Spielmann 1998, 2002). In this respect, technical properties and social meanings bear upon related questions of aesthetics, resource procurement and exchange, and the protocol of artists and regional authorities in the design and fabrication processes.

Assessing relationships entailed in the production of media other than clay is basic to understanding skill and knowledge bases among artists. Comparison of ceramic production to that of textiles and other works suggests that some ideas and technical knowledge were shared. This raises the question as to whether artists were active in more than one medium. In turn, this bears upon the social organization and skills of artists as well

as the degree to which knowledge was restricted. We know, for example, that shared motifs can be observed between portable objects, such as ceramics, and monumental geoglyphs (García Soto 2013; Reindel et al. 1999). Textile scholars make a convincing case that specific weaves appear as motifs on ceramics (Frame 1986:fig. 28; Paul 2000; see Figures 5.3 and 5.5). Motifs are also exchanged between ceramics, engraved gourds, metal ornaments, and painted mummy cloths, as Dawson (1979:86, 101–102) recognized. Conklin (1997) has long called attention to the structural consonance between textile weaves and the planiform design of architecture and ceramics. His (1978) and others' (Rowe 1996; Wallace 1991) observations about Paracas painted textiles raise questions about the compositional qualities of paints used in textiles and ceramics, and whether the painters

were the same. In practice, cloth enveloped whole or fragmentary ceramics in dedicatory offerings, an act thought to imbue sacredness to its contents (DeLeonardis 2012, 2013b; Tello and Mejía Xesspe 1979). Visible impressions left on ceramic surfaces attest to this practice (Figure 5.6). Taken together, these exchanges and practices between media indicate a coherent design canon based on relational or complementary qualities, and may refer to shared skills among artists.

Techné of Ritual Ceramics

The Paracas created a number of ceramic forms: containers, musical instruments, figurines, and masks (Menzel et al. 1964; Sawyer 1966; Tello 1959; Tello and Mejía Xesspe 1979). The most celebrated are bottles and effigies, which are incised with planiform (bas-relief) design patterns in panels (Figures 5.1 and 5.7). The repertoire also includes miniatures and oversize storage jars. Large containers doubled as funerary urns (DeLeonardis 2012:table 9.1; Strong 1957:11). Equally important to our understanding of techné are locally produced bowls and jars, which are incised, gashed, and punctate stamped with geometrical motifs (DeLeonardis 1997, 2005, 2013b). The amount and variation of incision on ceramics in all contexts attests to the plasticity of clay and the Paracas convention for impressing or marking it.

Although a strict line between fine and utilitarian wares is blurred, such descriptive terms are commonly used in the field and literature to distinguish between a sooted cooking olla on one end of the design spectrum and a painted and incised effigy on the other. In the context of rituals, the inclusion of a particular ceramic type is thought to be based, in part, on the intent of the ritual. In earlier studies (DeLeonardis 1997, 2013b), I observed that fine and plain wares are combined and burned with other exotic materials in household dedicatory offerings. In public ceremonies, such as temple closures, plain ware jars were inverted and buried with shell (see also Massey 1983). Fragments of both plain and fine wares, some enveloped in cloth, accompanied the burials of high-status persons,

even in the presence of more elaborate offerings, such as gold. These contexts demonstrate that the substance of the ceramic possesses meaning and value beyond the formal attributes by which we classify and interpret it.

Does this indicate that outward design is unimportant in ritual practice? On the contrary, the funerary contexts of high-status and special-status persons demonstrate that technical virtuosity (form, color, execution) was highly valued; however, the number of vessels interred with the dead alone does not a prestigious offering make. It is the combined excellence in shape, the complexity of the design and its execution, and color that should be considered. Time investment in the creation of pairs or miniatures is an additional factor to evaluate when gauging value and prestige. Weight is another. Two examples serve to illustrate this point. The first is a grave lot of thirteen ceramics from Cerro la Capilla in the Ocucaje region of the lower Ica Valley, illustrated by Sawyer (1966:fig. 104). Included in the lot are well-made shapes (jars, bottles, effigies), and sets of paired vessels, all of which are painted or painted and incised with the most important religious iconography. The double-spout-and-bridge bottle stands out, in particular, as an excellent example of ritual paraphernalia. These bottles are rarely found in contexts other than sumptuous burials (DeLeonardis 1991, 1997; Menzel et al. 1964). The spouts' narrow construction may have served to preserve liquids from evaporation, but the vessel is impractical as a liquid container other than for storing or pouring small amounts, such as libations. Many bottles are "blind" spouted, which means that one spout is modeled in figural relief, blocking the flow of liquid (see Figure 5.1). Others contain mechanisms to make the bottle whistle when liquid is poured out, thereby adding sound to accompany the ritual (see Figures 5.1 and 5.6). Almost all double-spout-and-bridge bottles are lightweight, and they are painted and incised with intricate designs. Many are elaborated to be zoomorphic or figural effigies (Figure 5.7). Paint or paint and incision may also be applied to the bridge surface, where the bottle is handled (Figure 5.8).

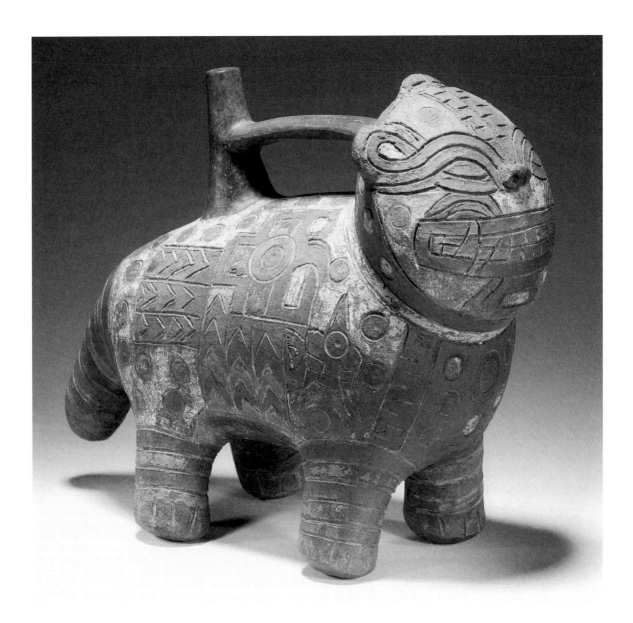

figure 5.7
Paracas post-fired painted and incised feline effigy bottle. The Metropolitan Museum of Art, The Michael C. Rockefeller Memorial Collection, 1979.206.1148. (© The Metropolitan Museum of Art / Art Resource, New York.)

A second example, the mask held in the Dumbarton Oaks Collection (henceforth referred to as the Dumbarton Oaks Mask), reinforces the combined qualities of form, color design, paint quality, and weight valued in highly elaborated ritual objects (Figure 5.9). The outward design of the mask shows a symmetrical arrangement of two bands containing stepped frets. The bands are bordered at the forehead by three figures whose arms and head are modeled. The mask's sculpted-in-the-round form follows the contours of the human face, enhanced by slightly exaggerated cheekbones, chin, and forehead. Two aspects of the mask are not immediately apparent. It is only 5 millimeters thick and weighs just over a pound (537 grams). Lightness and thinness combine with color and symmetry to produce a commanding design. Seventeen perforations along the outer band suggest that the mask was attached to a cloth headdress or headband and worn (Proulx 1996).

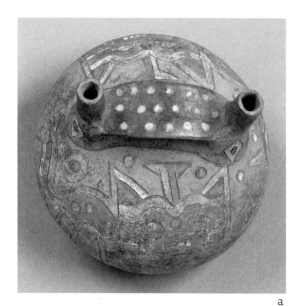

a

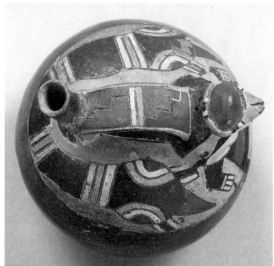

b

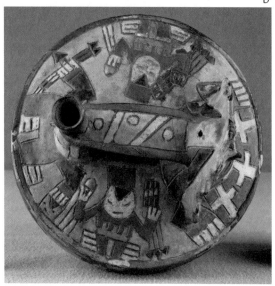

c

figure 5.8
Paracas double-spout-and-bridge bottles, showing extent of post-fire paint on handles. a–b) Saint Louis Art Museum 1255.1983, Bequest of Morton D. May, and Saint Louis Art Museum 368:1978, Gift of Morton D. May. c) National Museum of the American Indian, Smithsonian Institution, no. 23/7093. (Photograph by Emily Kaplan.)

Close examination shows the quality of the paint to be excellent, but its application overlaps the incisions, which are shallow and uneven (Figure 5.10). For masks that would have been viewed from afar, the overall effect of the color design may have been more important than line quality or paint application. I believe the color design outweighs line imperfections, which would have gone undetected by a distant audience. The reflective sheen of the hardened paint surface and the sculpted contours would have cast light and shadows, rendering the incisions invisible.

We must also be conscious of how the design contributes to the power of the mask—its perceived intrinsic power, or its effect on an audience, as Winter (2002) and Clifford (1988) advocate. An additional factor to consider in judging its success or evaluating its quality is its appearance, as worn, in relation to the attire and regalia of the wearer (Figure 5.11). Consonant with Paracas conventions for ritual paraphernalia, one expects color and fragility to have enhanced the prestige of the object as well as the prestige of the person who possessed it (DeLeonardis n.d.b; DeMarrais et al. 1996).

Archaeological contexts for masks suggest that they were valued as ritual objects of great importance and terminated with care. Some were cached or interred singly in tombs with the deceased, in either whole or fragmentary form (Lapiner 1976:146, 148, 150, 153–159). Others were interred alone, as object burials (Rubini Drago n.d.). Masks are represented as motifs on textiles and ceramics. The motif is associated with both supernatural and authority figures (Menzel et al. 1964:fig. 60a, d; Tello 1959:lam. LXIX–A).

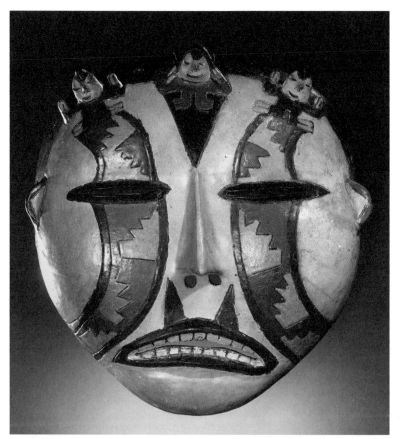

a

figure 5.9
Paracas painted and incised mask,
front (a) and back (b). The front
of the mask is painted by the
post-fire method, while the back
is reduction-fired and burnished
to produce a black, glossy surface.
Eye, nose, and mouth holes pierce
the ceramic fabric. Pre-Columbian
Collection, PCB 487, Dumbarton
Oaks Research Library and
Collection.

b

figure 5.10
Detail of mask, showing symmetry of form, color pattern, and reflective surface. Pre-Columbian Collection, PCB 487, Dumbarton Oaks Research Library and Collection.

figure 5.11
Hypothetical reconstruction of mask over model of Paracas Necrópolis figure. The slightly oversize mask would have covered the face, ears, and upper forehead. Pre-Columbian Collection, PCB 487, Dumbarton Oaks Research Library and Collection. *Model*: Ministerio de Cultura, Perú, s/n. (Photograph by Lisa DeLeonardis.)

Systems of Making: Value in Production

An examination of the production process establishes the activities, materials, and loci for ceramic manufacture and reveals a social and spatial network of artists and other personnel involved in related activities. In the creation of ritual objects, a master painter or designer who orchestrates the process is implicated.

As in the production processes of many ancient American societies, the Paracas model followed conventional methods for procuring clay and for forming and firing ceramics (Donnan 1992; Menzel et al. 1964; Sawyer 1966) (Figure 5.12). Pottery production could be undertaken year-round, but it was likely seasonal. Gathering resources, such as clay from riverbanks, would have been restricted

figure 5.12
Superficial sources for paint colorants (foreground) are found in the form of kaolinite, east of site PV62D12, Callango, facing south at Cerro Brujo (background). (Photograph by Lisa DeLeonardis.)

a

b

figure 5.13
Tools employed in the production of pottery recovered from archaeological sites in the lower Ica Valley: a) clockwise from top left: clay slag, turning plate fragment, burned clay, pottery scraper, burnishing stones PV62D13; and b) volcanic tufa pestle, PV62D12. (Photographs by Lisa DeLeonardis.)

figure 5.14
Arid environmental conditions on the South Coast were ideal for the production of ceramics. Local marshes and lakes provided cane reeds for stamping them and for the shafts of painting implements. Laguna Morón, Bernales, Pisco Valley. (Photograph by Lisa DeLeonardis.)

during seasonal floods (January through March), while strong winds (active July through September) would have made controlling pit fires difficult.

Pottery was coil- or slab-built and hand-formed on turning plates (Figure 5.13a). Two-piece molds were not used, but the shaping of spouts and bases may have been aided by the use of tubular bones and gourd husks (*zapallo*), respectively.[1] Ceramics were produced in pairs but never replicated en masse (DeLeonardis 2013b). Clay-rich slips were applied and carefully burnished to create smooth, glossy surfaces. Pit fire "kilns" produced soft, low-fired pastes. Reduction-firing resulted in smudged black and gray surfaces, and created resist, or negative designs (see Figure 5.3a).

Production tools have been identified at residential and ceremonial sites and in tombs, as offerings (Bachir Bacha and Llanos 2013:fig. 24;

DeLeonardis 1991, 1997, n.d.a; Isla et al. 2003:266–268, fig. 30; Tello and Mejía Xesspe 1979; see Figure 5.4). The materials shown in Figure 5.13 were mostly recovered from excavations at PV62D13, a residential site in Callango, and are common to sites where production activity has been identified. Mortars and pestles, perhaps used to grind minerals for paint colorants, have been found at sites in Callango and Cordero, but have not been chemically tested.[2] Chipped stone tools, half-shells, and small cloths used for wiping vessel interiors are found in association with other production tools at sites (DeLeonardis 1997:281, table 8.3; Splitstoser 2009:356). Stamping tools created from cane reed stalks (e.g., *caña brava*) are common to Cavernas and Ocucaje tombs, and have been preserved at Cerrillos (Figure 5.14). Clay slags and conical pellets, which result from the firing process, are

a b

figure 5.15

Lupenone-containing resins of Ramnaceaeae and Burseraceae may prove to yield the substance from which paint binders used by the Paracas are derived. a) Carana gum (*Protium* sp., Burseraceae), Rio Orinoco, Venezuela. b) Icica, Icicaritari, white pitch (Burseraceae), Para, Brazil. (Photographs courtesy of Royal Botanic Gardens, Kew, EBC 63396 and EBC 63403.)

frequently encountered (DeLeonardis 1997:pl. 4.17; see Figure 5.13a).

Tools used to apply paint are elusive. Paint may have been applied with cotton swabs, feathers, or bristles attached to cane shafts; with cloth; or by other methods. Conventional paint brushes are practically unknown in the archaeological record for the Paracas and their successors, the Nasca, who shared a cultural emphasis on painting. Silverman (1993:277–281) illustrates a number of instruments that the Nasca created from cane and wooden shafts (see also Shimada et al. 2006:cat. no. 054–055). Similar implements have been described by Tello and Mejía Xesspe (1979) for the Paracas Peninsula cemeteries, but their use as paint brushes is uncertain.

At the finishing stages, there are two processes at work: a conventional one for pottery that is slipped and fired, and one for post-fired paints. The latter process is distinct because post-fired paint need not be applied right away or even in the same space, thus introducing the possibility of alternate loci for painting.

The latter process is also compounded by the composition of post-fired paint and its preparation activities. Paracas post-fired paints are composed of two components: colorant and a binder.

The binder attaches the colorant to the surface and accounts for the glossy, lacquer-like effect seen on some vessels (see Figures 5.6 and 5.10).[3] To date, laboratory tests indicate that the colorants are mineral based (inorganic) and that the binder is an organic substance that can be considered neither a gum nor a resin by strict chemical definition (Kaplan 1999; Lohnas n.d.; Lohnas et al. 2015).[4] A team led by Emily Kaplan has identified lupenone in the binder, a triterpene characteristic of tree bark, yet neither the bark nor its point of origin has been identified (Kaplan 1999). Reference standards in chemical databases are still lacking for binder substances from the Andean region. A number of common trees have been ruled out (huarango, molle), including *Elaeagia* spp. (mopa mopa), the tree resin used for the binder applied to *q'ero* (Inka beakers; Newman et al. 2015). Several trees in which lupenone is present may prove to yield the binder substance; Ramnaceaeae and Burseraceae (from which copal is derived) are contenders (Mills and White 1977: 13, 21–22). Figure 5.15 illustrates the small, hard pellets that would have been ideal for transport. The properties of *Ampelozizyphus amazonicus* Ducke, a Ramnaceaeae, are anti-inflammatory and antimalarial, and are known to be an antidote to

snake venom. *Protium* has been used as a plaster to ameliorate respiratory illnesses (Figure 5.15a). Such properties would have been as attractive to healers as they were to painters.

When we consider the processing necessary for the resin binder used in q'eros, it is apparent that the process is time and labor intensive and that it requires expertise distinct from carving. Such processing involves a series of repeated steps that include harvesting the resin, heating it in water and manually manipulating it, stretching the resin into thin sheets, mixing the binder with colorants, and applying that mixture to the vessel surface, most likely with the aid of heat (Newman et al. 2015:123).

Heat is also implicated in the mechanics of processing binders and in paint application. In the Ica Valley, Menzel and colleagues (1964:56, 179) observed what they believed to be a black organic wash that was scorched onto ceramic surfaces. It has not been determined whether this is remnant binder or slip that poorly adhered. Paraphrasing Lawrence Dawson, Donnan (1992:21–22, 1996:192) hypothesizes that heating the vessel after it was fired and painted would have erased brush strokes and solidified the paint, thereby creating the crust or lacquer effect. Based on the melted appearance of some painted surfaces, it has also been suggested that the vessel was heated prior to paint application (see Donnan 1996:192; Lohnas n.d.). These observations are particularly important because they raise further questions about the stage at which ceramics were painted and whether colorant and binder were applied together.

In these respects, a number of extra steps in the production process (procurement and processing of colorants and binder substances) and a body of specialized knowledge to implement them were required (see also Cummins 2002). Judging by the variation in painted surfaces (preservation conditions considered), technical knowledge of post-fired painting may have been restricted. The observed variation in paint quality may be due to incorrect colorant–binder ratios formulated by novices, misapplication of heat, experimentation with binder substances, or differences in burial environment.

Workshops and Centers of Production

Spatially discrete pottery workshops have been difficult to identify within Paracas sites, although production activities and materials are apparent at a number of sites and virtually absent at others. In Callango, thirty-two Paracas sites were analyzed for evidence of production activity (DeLeonardis 1991:table 4.9); exposed clay surfaces, pottery scrapers, and waste associated with firing were in evidence at seven. Excavations at PV62D13, a one-quarter-hectare site, revealed tools, scrapers, and waste material, as well as an area of scorched earth and unfired objects where firing occurred (DeLeonardis 1997:210–213). The nearby site of PV62D12 shows a similar pattern, as does the much larger site of Animas Altas (Bachir Bacha and Llanos 2013). These wide-ranging contexts indicate, as Rice (1987:187–190) has noted, that household arrangements for production varied greatly and that intensification of production was not necessary for the specialization of particular forms.

In contrast to the evidence for production in Callango, Massey (1986:262) was unable to identify clay beds, waster concentrations, unfinished pottery, or other indications of Paracas pottery production in her work in the upper Ica Valley. Likewise, Tello and Mejía Xesspe (1979:472) expressed frustration with the question of workshops on the Paracas Peninsula, especially since the tools of the trade and ceramics were evident in a number of tombs. At ceremonial sites, such as Cerrillos—where there are extraordinary concentrations of ritual paraphernalia, high-status materials (such as gold and obsidian), and tools associated with weaving and metallurgy—the question of pottery production still looms (Splitstoser et al. 2009).[5] While archaeological visibility for workshop settings is often low, these findings suggest that either ceramic production sites are regionally dispersed or—more likely—that production occurred between sites or in areas detached from residences or ceremonial spaces.

A better case can be made for production centers—regional hubs for the production of ceramics generally, and for specific forms during certain phases. By "center," I am referring to regional loci rather than to particular sites. These hubs have

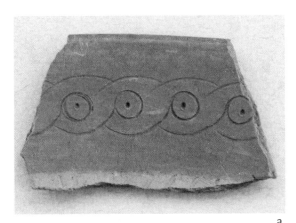

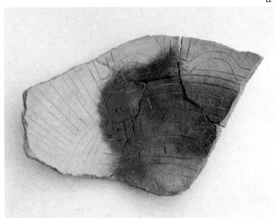

figure 5.16
Red-slipped grater bowls are a prevalent bowl form in Callango. a) Sherd with guilloche motif. b) Reconstructed burned interior, showing feline pattern. c) Sherd with perforation. PV62D13, Callango. (Photographs by Lisa DeLeonardis.)

been proposed by Menzel and colleagues (1964), based on ceramic style differences in sectors of the Ica Valley, and by Massey (1986:284–285), based on exchange network analysis. Massey (1986, 1991) and Cook (1999) have compared intervalley sectors, recognizing leadership and power shifts over time. Coordinating spheres of power with the persons recognized in high-status burials is tentative, but there appear to be authority figures centered in Palpa, Cordero, Ocucaje, Callango, the Paracas Peninsula, and Chongos. Given the current research of Charles Stanish at monumental sites in Chincha, more figures and centers are likely to be identified (see Tantaleán et al. 2013). The question of pottery production as linked to specific authorities is an ongoing subject of inquiry. At present, spheres of power are definable on the basis of site configurations, high-status graves, and concentrations of exotic materials, including painted and incised ceramics. What are less visible—and more difficult to map—are the pottery production loci associated with each of these spheres.

There is strong evidence that Callango was the center for the production of bowls described as "graters" in Ocucaje Phase 8 (Figure 5.16). The bowls are called graters because their roughened interiors are thought to have served a food-processing function. The bowls are of relatively uniform shape. They represent a good example of a Paracas ceramic type at the interstices of typological classification. Some are characterized by red-slipped walls and an unslipped interior base marked by deeply incised lines, worn from use (Figure 5.16a, c). Others show post-fired painted walls, zoomorphic patterns, and burned interiors (Figure 5.16b). Many show crack-laced repair holes. Identification of plant pollen from the bowls' interior grater marks has been inconclusive thus far.[6] Because many are shown to be burned or to contain a white powdery substance in the crevices of the incisions, they may have been used in some stage of the production of ceramics, perhaps as colorant grinders or as braziers. Identification of their function(s) will greatly clarify the related activities for which they were produced. There is good evidence to indicate that Callango served both as the production and the

distribution loci for the vessels. Massey's (1986:55–56) exchange analysis identified the bowls as trade ware in the upper Ica Valley.

Color Value

Among the constellation of design techniques employed by the Paracas, post-fired paint applied to incised pottery resulted in brilliant color that was otherwise impossible to achieve through conventional methods. Clearly, the Paracas valued color. It was essential to their cultural aesthetic and technological acumen, and they produced colorants for textiles and ceramics that still retain their vibrancy today.

The Paracas were inventive painters, using color in segmented, incised bands to create planiform designs that challenge the eye. Up to eight different colors are used on some ceramics—an arrangement that attests to the complexity of design as well as to the skill and creativity of the painter (Menzel et al. 1964:26; Strong 1957:18). Color was used as much to obfuscate incised patterns as it was to elucidate them (Figure 5.17).

Color achieved through post-fired paint appears to be of greater importance than the durability or functionality of the object. We see this, for example, on bowls that are painted on the interior (see Figure 5.17) or on objects that would have been handled frequently (see Figure 5.8). The impracticality of use imposed by post-fired painting does not seem to have hindered the use of objects in ritual, as the Dumbarton Oaks Mask attests. Post-fired painted ceramics are fragile, and this fragility may have been a desired quality, conferring special meaning to the object.

Painting in the manner practiced by the Paracas also created depth in the composition. While incision penetrates the ceramic fabric, painting, as its complement, raises or layers the surface, thereby adding a physical dimension to the design. Much like the three dimensions of textiles (warp, weft, and the space between the two), painting contributes a spatial dimension to incised bas-relief. As an act, painting enhances design, encodes or obfuscates

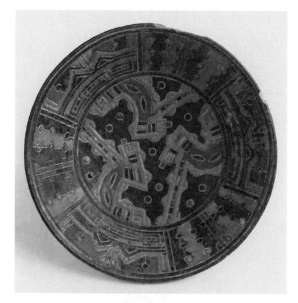

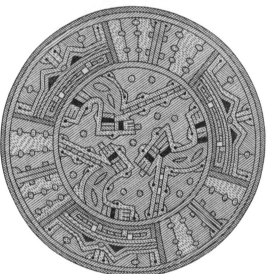

figure 5.17
Paracas post-fired painted and incised bowl. Museo Regional de Ica 179. (Drawing after Menzel et al. 1964:46-b; photograph by Lisa DeLeonardis.)

knowledge, and transforms the ceramic substance, adding fragility and texture. In these respects, painting charges the ceramic fabric with symbolic meaning and creates value.

It is also recognized that there are invisible attributes to color—symbolic meanings embedded in language that are difficult to extract. Gage (1999:109–110) points out that particular colors may signal direction (e.g., white associated with north)

but that there is no universal system. The question of color and direction, as understood from Mesoamerican painted books, is an intriguing one, yet unstudied in Paracas color systems. Color hierarchies—proposed for Coclé ceramic designs (Helms 1996) and recognized by the imperial Inka for khipu and woven materials (Murra 1962; Urton 2012)—are likewise critical research questions to pursue. Bottles, masks, and other ritual ceramics may prove to be color-coded to the rituals they represent, to the occasions in which they are used, or to specific persons or social ranks.

Language and Color

I examined Andean languages in historic and ethnographic sources to ascertain how colors are conceptualized and named (Table 5.1). As Martha Hardman (1981:66) shows, unlike the universal order of color terms and values proposed by Berlin and Kay (1969), there are only eight monomorphemic color terms in the Jaqaru language that have no meaning except for color.[7] She discovered that analogy and metaphor are more important in naming colors. The paucity of color terms recovered in historical sources mirror Hardman's (1981) ethnolinguistic study. Color terminology is embedded in nature: "sky blue" or "blood red." Given the number of colors employed by the Paracas in textiles and ceramics, it is likely that a more extensive, discriminating vocabulary was developed.

Early colonial dictionaries do provide insight into the act of painting. In Aymara, the verb to paint (*pintar*) is expressed as *pintatha* or *quellcatha*, while the painters (*pintor, pintora*) are *quellqueri ccosccori* (Bertonio 2005 [1612]:344). In Quechua, *quillca* refers to "painting or drawing," but the act, *quellccani*, is defined "to write, draw, carve on hard surfaces, to embroider, or to dye." This latter term suggests that the processes of carving, embroidering, and dyeing are conceptualized as similar. In the case of Paracas, these activities are precisely those that techné exemplifies.[8]

Chronological Trends, Technology, and Resources

When we consider a broad temporal use of post–fired paint colors over a valley-wide region, certain patterns are evident. Table 5.2 approximates these color-use trends. The basic colors—red, white, and black—show consistent use over time. Gray is used throughout the sequence but less frequently during Phases 6 through 8. Yellow is preferred in the upper Ica Valley but is absent in the lower valley during this time. The color green is widely used in early Paracas color palettes, then drops out abruptly, at least in the Ica Valley, before it reemerges late in the sequence (Menzel et al. 1964:193).[9] During the late phases, colors become darker. These patterns raise a number of questions about value, usage, resources and their availability, and exchange.

Technical analysis of colorants and binders contributes to our interpretation of these patterns and establishes parameters for inquiry. The findings of an early study on Ica Valley ceramic paints led by the Kaplan team (1999) are summarized in Table 5.3. This study has been expanded by a team led by Dawn Kriss (formerly Lohnas) on a larger sample that permits observations to be made about colorant composition over time and across regions of the Paracas interaction sphere (Lohnas n.d.; Lohnas et al. 2015; see Figure 5.4). Both teams found that colorants were created primarily from mineral compounds. The Kaplan team's identification of red and white colorants corresponds in principle to those identified in Callango, a region of the lower Ica Valley (see discussion below). In their sample, which included some ceramics from the Ica Valley, the Kriss team identified one of the brighter red colors on early-phase ceramics as cinnabar, or mercuric sulfide (see Figure 5.2). They also discovered the use of anatase for white colorants for the early phases. This latter substance is unstudied for the Paracas, and the source(s) utilized by them remain unknown. Kaplan and colleagues' (2012:18) q'ero study indicates that in their sample, a titanium-derived cristobalite-anatase was the earliest white colorant employed. A plausible source for the substance is the Giacomo Deposit near Tacna in southern Peru (Kaplan et al. 2012:19).

Yellow clays prevalent on the Paracas Peninsula and coastal mesas are those identified in the Kaplan team's (1999) analysis of minerals that produced the color yellow. Pararealgar, an arsenic sulfide, was not identified in the Kaplan team's

table 5.1

Andean languages and color

	AKARO		JAQARU	AYMARA		
	TELLO AND MEJÍA XESSPE 1979		HARDMAN 1981	BERTONIO 2005 [1612]	LUCCA 1983	COBO 1956 [1653]
COLOR	Illke	Color		Sama	Sama, Sami	
COLORED	Mellak	Colorado/ colored		Uila patarana Uila occa	Samini	
BLACK		Black	Tz'irara	Cchaara	Ch'iyara	
RED		Dark red	Milaku			
		Reddish brown	Ch'umpi			
		Wine red, Off-red	Chukupa			
	Wilu, Willu	Sangre/blood; "True red"	Wila	Uila panti	Wila panti	Tacu (iron oxide)
		Vermillion		Phako		
PINK		"Skocking" or "Day-Glo"	Mallaya			
ORANGE				Sisira yarita, huantura	Churi k'ellu	Tacu (iron oxide)
		Colored earth		Tacu		
YELLOW	Qarwaña	Amarillo/yellow		Kello	K'ellu	Tacu (iron oxide)
	Qaur	Amarillo/yellow		Choque	Choke	Quellu (ochre)
	Qarway	Amarillento/ yellowed		Vel Yuri	Yuri	
	Qarwa	Semiamarillo		Churi	Churi	
GREEN				Cchokhña	Ch'ojjña	
		(Metaphor) Plant	Qiwi		Q'intu	
BLUE		(Metaphor) Blue/ celeste	Patza	Laccampu	Azuela	
				Larama, cchua cchua	Larama, Jank'o Sajuna	
GRAY	Qellpe	Ceniza/ash			Ch'ejje	
		Gray	Uqi			
WHITE	Xanq'o	Blanco/white	Janhq'u	Hanko, Hanko oca	Jank'o wila	
	Mishti	Blanqear/snow white	Mishti			

test sample, but Kriss's team identified the mineral in yellow colorants over time and across regions of the Paracas interaction sphere (Lohnas et al. 2015). Pararealgar is found in Huancavelica. The nineteenth-century naturalist Antonio Raimondi noted that it is sometimes mixed with cinnabar in the mercury mine there (Raimondi 1878:167).

Colorants used to achieve green are of particular interest, given its absence in the Ica Valley during the middle phases. The Kaplan team's

table 5.2
Color use over time in the Ica Valley

	Ocucaje Phases	Phase 3–4		Phase 5–6		Phase 7–8		Phase 9		Phase 10	
Black											
Gray				Infrequent							
Brown											
Brown											
Red											
Pink											
Maroon											
Orange											
Yellow				Absent lower valley							
Dk. Yellow											
Green				Absent							
Pale Green											
Violet											
White											
Cream											
Tan											
Phases		3	4	5	6	7	8	9	9	10	10

(Chart compiled for visual purposes; colors are approximate) Source: Menzel et al. (1964)

table 5.3
Paint composition

COLORANT	COMPOSITION			
	Iron oxide	Copper compounds	Silicates	Carbon-based
	With clays and quartz	Malachite, paratacamite, brochantite	Clays, trace elements	
Red	X			
Yellow	X			
Brown	X			
Green		X		
Blue		X		
White			X	
Black				X

Source: Kaplan 1999

(1999) identification of green and blue colorant sources stands out because the copper compounds used to create them—paratacamite, brochamite and malachite—are non-local resources (Figure 5.18). The Kriss team's investigations correspond with Kaplan's for the early-phase use of copper-based greens (Lohnas n.d.; Lohnas et al. 2015). They find that during the middle phases, when the color is absent from Ica Valley ceramics, an iron-based green is in use. During the late phases, both iron- and copper-based greens are used.

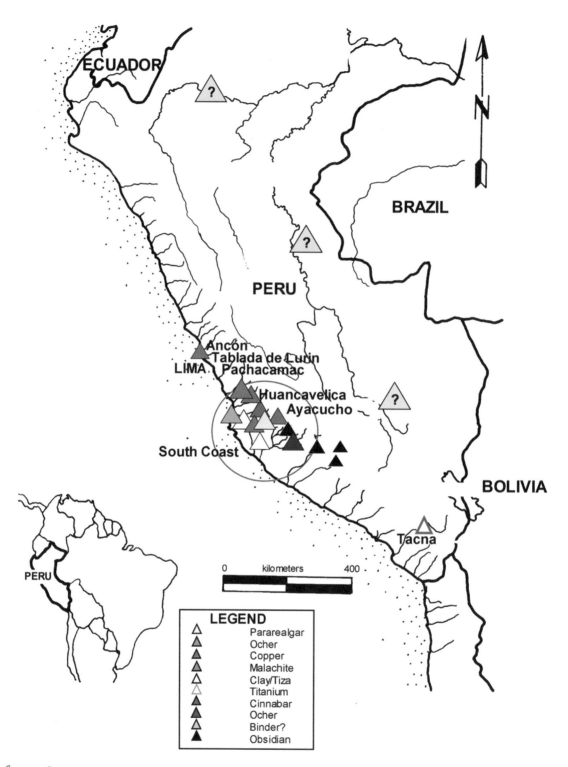

figure 5.18

Map of Peru and environs, showing locations of mineral sources and potential binder sources. (Drawing by Lisa DeLeonardis.)

Copper compounds used in the formulation of paints are well known for the viceregal era (Cobo 1956 [1653]; Seldes et al. 2002:228; Siracusano 2005; see also DeLeonardis 2013a) and are the recent subject of investigation for the ancient period. Promising research undertaken at mining and production sites in the upper Ica Valley has identified the related sites of Mina Azurita, Mina Monterosa, and La Zurita (Figure 5.4). At La Zurita, copper-ore matrices encompassing gold were processed. Ores were removed and pulverized, producing powdered copper ore, potentially for colorants, and gold, another substance valued by the Paracas (DeLeonardis 2011b; Massey 1986:257). Further tests of the ore powder may indicate whether the reemergence of green in the Ica Valley is linked to utilization of the mine and to gold metallurgy. Massey (1986) and Van Gijseghem et al. (2013) confirmed utilization of the mine during the late Paracas phases. Comparable research undertaken by Sepúlveda and colleagues (2013) links copper ores used for blue and green paints to the related practices of lapidary arts and metallurgy (see also Nordenskiöld 1931:98).

Malachite is mostly found in Huancavelica, although Raimondi (1878:82–85) procured samples near Ancón on the central coast and insisted that it was present coast-wide in the form of atacamite. According to the Jesuit Bernabé Cobo (1956 [1653]), malachite was thought to purge melancholy, reminding us that the properties of stone held meaning beyond their technical applications (Phipps et al. 2008; Seldes et al. 2002:231; Siracusano 2005; see also Pillsbury 2006:145 for a discussion of changes in color value among Inka and viceregal-Inka tunics [unku]).

None of these loci would pose a challenge to the procurement or exchange strategies of the Paracas. Early on, they were active in the long-distance exchange of obsidian, exotic feathers, and shell. These materials are found at modest sites, such as PV62D13, and in greater abundance at the central hubs of Cordero (Cerrillos), and Callango (Animas Bajas and Animas Altas). Given the sources of malachite, cinnabar, and pararealgar in Huancavelica, titanium near Tacna, and quarry sites in the upper Ica Valley for iron and copper ores and gold, the extent of the local and long-distance exchange network becomes clearer (Burger 2013; Burger and Matos 2002; Cooke et al. 2013). Based on an earlier study conducted on obsidian (DeLeonardis and Glascock 2013), I would expect that these rare materials would have found their way into established exchange routes (Figure 5.18).[10]

The results of technical analyses also bear upon our understanding of the painters' choices and the significance of those choices. In the Ica Valley, during the early Paracas phases, painters were using two substances simultaneously to each produce the colors red, white, and yellow—one local to the area and the other from a distant region. During the middle and late phases, certain colors are absent or used sparingly. It is not yet clear on what criteria the choice of one substance over another was based. Additional research is necessary to assess whether colorant choice is based on its hue, workability, intrinsic value, availability, or some combination of factors. It should also be noted that certain colors—yellow, blue, and green—can only be achieved on low-fired pottery by the post-fired method (Rice 1987:333). Their absence or scarcity thereby becomes a significant issue to a culture that values these colors and may bear upon the presence or absence of artists that possess certain skills.

A related question is why colors become darker in the late phases. Were new colorants used? Were colorants mixed to achieve darker hues? Binder material may also be a factor in the color shift, indicating the use of new or different binder–colorant proportions. According to the present results, bright vermillion that is produced by cinnabar is no longer in use and the addition of iron-based colorants partly explains the trend. Regional preferences (hub centers) or the aesthetic preferences of Ica Valley painters for specific color tones may also be at play. Further research aims to map out inter- and intra-valley trends to better address these and other questions.

Colors in Context

Mineral pigments used in the production of paint are found in a variety of archaeological contexts

table 5.4

Colorants in context

CONTEXT	DESCRIPTION	ASSOCIATIONS	REFERENCE
ICA VALLEY: CALLANGO			
PV62D13	Chunks of pigment	Pestles, clay slag, other craft	DeLeonardis 1997, 2013b
PV62D12	Chunks of pigment	Pestles, scraper, other craft	DeLeonardis 1991
PV62D24	Chunks of pigment	Pestles, scraper, other craft	DeLeonardis 1991, 2013b
PV62D2	Chunks of pigment	Scraper, paddle, other craft	Bachir Bacha and Llanos 2013; DeLeonardis 1991
ICA VALLEY: CORDERO			
Cerrillos	Chunks of pigment	Pestles, other tools	DeLeonardis n.d.a; Dwight Wallace (personal communication 2012)
ICA VALLEY: OCUCAJE			
Tomb K: Huaca L. Aparcana	Crucible with resinous, sulfurous yellow paint	Gold ornaments, copper, obsidian, paired ceramic vessels	Rubini Drago n.d.:12–13
Tomb 22: Pampa Pinilla	Sulfurous yellow paint	Fragment of panpipe, gold	Rubini Drago n.d.:39
Tomb 27: La Peña	Pouch purple pigment	Complex grave, obsidian	Rubini Drago n.d.:47–48
PARACAS PENINSULA: CAVERNAS			
Tomb 10, Terrace 1	Packet of yellow paint	Three adult, two juvenile	Tello and Mejía Xesspe 1979:120
Caverna II	Three hide packets mineral paint	Eight persons; gold, obsidian	Tello and Mejía Xesspe 1979:138
Caverna IV	Gourd with paint remains	Mummy IV–1	Tello and Mejía Xesspe 1979:155
Caverna IV	Hide packet with paint remains	Mummy IV–2; Craft production associations	Tello and Mejía Xesspe 1979:156–157, fig. 29–3
Caverna V	Hide pouch of paint	Mummy V–6	MAAUNMSM 2012:131–132
Caverna V	Three small pieces white rock	Mummy V–31	Tello and Mejía Xesspe 1979:177
PARACAS PENINSULA: NECRÓPOLIS			
Fardo 4	Packets of powdered paint	Adult male	MAAUNMSM 2012:52; PARR n.d.:inv. 4–18
Fardo 12	Skin bags containing paint	Gold, featherworks, clothing miniatures	PARR n.d.:inv. 382–79
Fardo 45 (internal)	Skin bag with gray substance	Young adult, no ceramics	PARR n.d.:inv. 45–3; Tello and Mejía Xesspe 1979:449–450

CONTEXT	DESCRIPTION	ASSOCIATIONS	REFERENCE
Fardo 78	Fragments emerald-colored mineral	Young adult, no ceramics	PARR n.d.:inv. 78–14
Cateo 99, Tomb 2	Skin bags with paint of diverse colors including green	Obsidian, gold	MAAUNMSM 2012:235; PARR n.d.:inv. 2–56
Fardo 114	Two bags powdered dye; gourd with six bags of paint	Adult male	MAAUNMSM 2012:319; PARR n.d.:inv. B74
Fardo 136	Green, blue, black, and brown paint pieces	Gold	PARR n.d.:inv. 136–145
Fardo 142	Bag of yellow mineral paint	Weavers' tools	MAAUNMSM 2012:284; PARR n.d.:inv. 142–13
Fardo 241	Hide pouch with paint	No ceramics internal to bundle	MAAUNMSM 2012:104, 150–151
Fardo 253 (internal)	Two skin bags of mineral paint	Gold, shell bracelets, featherworks	Tello and Mejía Xesspe 1979:435; PARR n.d.:inv. 253–73, 253–74
Fardo 310 (internal)	Cotton bag of powdered lime or gray mineral paint	Adult male	Paul 1991:175; Tello and Mejía Xesspe 1979:384
Fardo 358	Two packets of mineral paint	Ceramics	MAAUNMSM 2012:134; PARR n.d.:inv. 12/6904
Fardo 363	Hard rock, pyrite, or manganese	Adult	MAAUNMSM 2012:134; PARR n.d.:inv. 363–15
Fardo 382	Skin bag with mineral paint; zinc mineral blend, cinnabar, zinc, and arsenic	Adult female; gold ornaments	Fester and Cruellas 1934:155; MAAUNMSM 2012:468
Fardo 438	Zinc-iron blend, other mineral; atacamite, cinnabar, azurite, copper carbonate, malachite; ferric oxide	Sumptuous	Fester and Cruellas 1934:155; MAAUNMSM 2012:139
Fardo 451 (internal)	Three skin bags of mineral paint; two samples of bicolor paint	"Symbolic paint brush," gold	Tello and Mejía Xesspe 1979:360, Figure 100-c
Harvard Peabody Bundle	Thread bundle with zinc sulfide; raw cotton with zinc sulfide; seeds with zinc sulfide; chunk of zinc sulfide; bark fragment with attached thread		Peabody Museum of Archaeology and Ethnology, Harvard University n.d.:38–2830/4181, 38–2830/4181A, 38–28-30/4181C, 38–28-30/4181B, 38–28-30/4196

(Table 5.4). At PV62D13 and other Callango sites, the pigments are found in chunks that range from 2 to 12 centimeters in size. Eighty-five excavated samples from PV62D13 were streak-tested to determine color, suitability as paints, and frequency of particular colors. The pigments shown in Figure 5.19a fall within the range of earthy reds and show rich color streak. These pigments are abundant in natural clays. White pigments, as shown in Figure 5.19b, display similar qualities. Both red and white pigments are consistently used in the Paracas color sequence. Red pigments are especially prominent in the Callango region in the production of bowls and collared jars during Ocucaje Phase 8.

One question that I raise is whether the preponderance of red clay pigments represents colorants added to clay slips used for conventionally fired ceramics (see Figures 5.3 and 5.16). Chemical

a b

figure 5.19
Pigments recovered from Callango excavations, showing size and streak color. (Photographs by Lisa DeLeonardis.)

analysis is necessary to determine how these pigments compare to those identified as post-fired paint colorants. It is of interest as to whether the pigments are the same used in the production of the earth-toned painted textiles and mummy masks (Dawson 1979; Paul 1996; Wallace 1991).

In tombs in Ocucaje (Rubini Drago n.d.), and among the Cavernas and Necrópolis cemeteries of the Paracas Peninsula (Tello 1959; Tello and Mejía Xesspe 1979), small wrapped offerings of pigment are interred with the dead. Most pigments are contained in cloth or leather pouches, or in gourds, which may be how they were stored in life.

The Necrópolis mummies of Wari Kayan pose an interpretative challenge relative to post-fired painted ceramics. Pouches of colorants are mostly found among the Topará and Nasca mummies, yet these bundles contain few ceramics—or at least none that are post-fired painted. Some of the colorants have been identified as cloth dyes (Fester and Cruellas 1934), yet there is some overlap

with the findings of the Kaplan (1999) and Kriss teams (Lohnas n.d.) for ceramic paint colorants.[11] Regardless of the pigments' use as textile dyes or ceramic paints, the interment of them as burial offerings suggests that they held special meaning.

Value in Mastery: The Artists

When we view Paracas post-fired painted and incised ritual ceramics through the lens of techné and value, the profile of the maker—the artist or master ceramicist—begins to emerge. I have reviewed a number of questions in this chapter relative to artists' identities. Here, I summarize with a few observations.

Recognizable figures of artists or ceramicists are rare in Paracas visual arts. Two post-fired painted and incised figurines show well-attired persons who carry single pots on their backs. One is formed as a whistle (Figure 5.20a); the other is shown with a pectoral of rectangular gold sequins

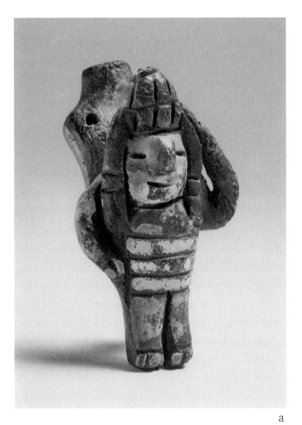
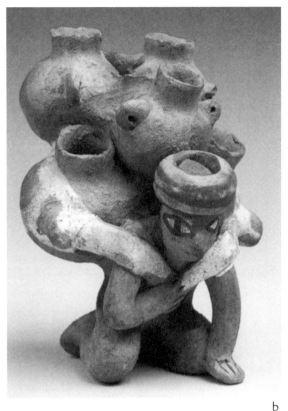

a

b

figure 5.20

a) Paracas post-fired painted and incised whistle. The Metropolitan Museum of Art, 2007.16. (© The Metropolitan Museum of Art / Art Resource, New York.) b) Nasca culture "porter." Ministerio de Cultura, Perú INC/86258. (Photograph by Lisa DeLeonardis.)

(*láminas*) indicating rank (Parsons 1980:fig. 440). It is unclear if the figures represent potters or porters. The latter is a common theme in Nasca figural sculpture, and the labor is shown to be performed by men (Figure 5.20b).

It is evident that the Paracas were transformers of clay, impressing their mark on nearly every ceramic they produced. Variation in the quality of paint and incision is observable, but it is apparent that technically excellent ceramics are by the hand of a seasoned expert. Paul (1991), Dawson (1979), and Wallace (1991) reached similar conclusions in their respective studies of textiles. Referring to the competence of artists who designed and wove Paracas Necrópolis textiles, Paul (1991:217) observed that "some were extraordinary artists, some were good but not brilliant, and a few were bad." In his study of painted mummy masks, Dawson (1979:83) judged

them to be of "frequently casual or artless painting, prepared hastily and not by specialists." Regarding the Carhua painted textiles that he examined, Wallace (1991:63–64) asserts, "the quality of painting ranges from highly controlled technique to incredibly sloppy work." From these perspectives, we see that even among extraordinary visual culture there is a range of expertise.

Paul and Niles (1985) propose a master–apprentice model for the embroidering of Necrópolis mantles. I am wary to apply the model to the production of painted and incised ceramics, although I agree with the logic of their argument for large collective endeavors, such as mantles. Instead, I see the design of complex patterns (e.g., effigy bottles) as a more solitary endeavor by few who possess both technical skill and access to design canons and their respective meanings (esoteric knowledge).

Because quality in ceramic form (shape) was clearly valued, it is possible that the sculptor, design carver, and painter were separate specialties. A collective eye would likely have been necessary, as would have the presence of the three at production, because at least two of the three would have needed to work quickly in sequence, as per the production process. Until we better understand the process and timing at which colorants and binder were applied in the production cycle, it is hard to judge whether the painter would have needed to be present, but each specialist (whether one or three) would have needed to share the same vision of the finished ceramic.

When we consider the near alchemy involved in achieving a successfully painted object, it is clear that both technological know-how and creative color sense were required. The painter's role stands out as among the most accomplished in this respect—and perhaps the most esteemed by a society that valued mythic transformation. Yet, the artist responsible for complex incised designs, if different from the painter, would have had to possess the design mastery to create a two-dimensional design over a three-dimensional form, as well as a keen understanding of the design's meaning. As Frame (2001) and others (e.g., Gell 1992; Helms 1993; Spielmann 1998, 2002) have noted, the artist creating ritual paraphernalia is technically virtuous, astute in esoteric knowledge, and a practitioner who supports the "panoramic inclusivity of the mythic web" (Frame 2001:88).

Exacting design skills also characterize weavers, and this raises questions about the relationship between specialists, as Conklin (1997) has done. The evidence reviewed in this study shows that there were experts and non-specialists involved in crafting. Given the exchange of weaving motifs between textiles and ceramics, some knowledge was obviously transferred between media. Perhaps the fabric of clay served as a design template for weavers, or vice versa. When we consider the ocher-colored pigments used for painted textiles as potentially the same used in conventionally fired ceramics, there is equal reason to assert that at least some technical knowledge was shared between painters of cloth and ceramics. Pyrotechnical expertise may have

been exchanged between the makers of pyroengraved gourds and other specialists, such as binder processors and metallurgists. In non-sumptuous burials, tools of both trades are found together, suggesting skill, or at least participation, in more than one craft activity (Tello and Mejía Xesspe 1979).

Identification of artists in the archaeological record has been challenging: in societies that value techné, the tools of the trade are interred with other valuables acquired by authority figures, or they are interred with them as funerary offerings from their kin (DeLeonardis 2012). That leaves us with significant members of society who possess sumptuous wealth *and* crafting tools, and hinders differentiation of their roles as patrons or artists. Cornejo's (2002) study of priest and weaver interments at Pachacamac, a good case study, is lucid because the cemetery occurs in a known sacred space and the interred are more likely to be esteemed priests or weavers. Likewise, Cárdenas's (1994) case study of a large number of graves excavated at once in the Tablada de Lurin enabled her to identify whole families of potters but no distinguished potters, based on the consistent interment of ceramic turning plates with the dead (see also DeLeonardis and Lau 2004).

In Paracas society, as in other middle-range societies, role differentiation is proposed to be less acute. The patron and artist are more likely to be the same person or bear a similar archaeological signature. Considering that post-fired painting and all it entails may have been perceived as an act of magic and, at minimum, an activity restricted to few, such a signature would also bear the markings of the shaman, ritual specialist, or healer.

Data that I compiled on powdered colorants from the cemeteries of Ocucaje, Cavernas, and the Necrópolis—roughly three hundred contexts—offer a more promising method to narrow the arena of substances most valued in the practice of techné and to help identify the individuals with whom the colorants are buried (see Table 5.4).

Considering the number of graves overall, only twenty-four contained pouches of powdered colorants (described as *pintura*), indicating their limited distribution. Among the seventy-eight Paracas tombs at Ocucaje, fourteen were shown to contain

objects associated with production; among them, three contained colorants. Unlike the peninsula group, where weaving implements outnumber ceramic production tools, all of the Ocucaje tombs that contained paint also contained ceramics and implements used in their production. Tomb 22 held a ceramic turning plate containing sulfurous yellow paint, a rare co-occurrence. A gold repoussée headband and panpipe fragment were present, but no weaving implements. A second Ocucaje tomb (Tomb K) held a crucible containing resinous yellow paint and packets of bird bones, as well as multiple ceramic vessels, a gold repoussée headband, copper, and obsidian. I interpret this group to be strong candidates for painters.

Among the Cavernas group, four tombs contained powdered colorants, but, unlike the Ocucaje group, there were no recognizable ceramic production tools in association. Tomb 10 is remarkable for its lack of prestige items. Two adults and two juveniles were interred together with weaving tools and a packet of yellow colorant. Caverna IV stands out for the number of interments—fifteen—but colorant was interred with only two persons: an adult man associated with sewing utensils and obsidian and an adult woman with weaving implements. As in Tomb 10, it is unknown whether the packets of colorants interred in Caverna IV are textile dyes, but the tools are associated with embroidering and weaving.

Both Cavernas IV and V contained the largest number of craft tools (including paints), and both contained iconic examples of post-fired painted and incised ritual ceramics (see MAAUNMSM 2009:121–190; Tello 1959:lam. Ia, c; lam. IVa–b). Judging by the ritual paraphernalia they encountered in Caverna V—snuff tubes with a powdery substance, black and white quartz crystals, obsidian blades, packets of human hair, and gold—Tello and Mejía Xesspe (1979:163–180) speculated that the tomb was that of a shaman. Probing more carefully, and given the presence of thirty-seven persons of diverse ages in the tomb, ritual paraphernalia were centered among four men—two adults and two youths—in the deepest (earliest) part of the cavern. Craft tools, mostly those associated with weaving and embroidering, were interred with six women

(and infants). Two hollow figures were recovered from Cavernas V. One figure, identified as male by Aponte (2009:fig. 10), is a slightly larger version of the three partially modeled figures shown atop the Dumbarton Oaks Mask (see Figure 5.9). The combined associations of crafting tools, mineral paints, ritual paraphernalia, and ceramic figures offer compelling evidence of the ritual specialist associated with arts or as-artist (Helms 1993; Spielmann 2002). As a whole, the tomb may represent kin-related artists; the interment of craft tools with infants may signal that the occupation was inherited.

A greater number of colorants—as well as the distinctive minerals from which they are derived—have been identified in the Necrópolis tombs. Among those that have been opened and published, about twenty mummy bundles contained colorants, some of which have been determined to be cloth dyes (Fester and Cruellas 1934). Fardo 438 contained the greatest number of colors in a single bundle, and the mummy in Tomb 2 (Cateo 99) contained a pouch of myriad colors. The green-producing minerals, malachite and atacamite, are substances used in the elusive green ceramic paint color and are found with very few mummies to date. All of these associations indicate that powdered minerals (some for dyes) are rare in number and substance as tomb offerings. Such materials as cinnabar and malachite represent those based in the exchange of exotic materials.

Encoded Process, Embodied Meaning

A directed study of the activities and materials entailed by techné reveals that the Paracas employed extraordinary measures to practice their craft. This is patently obvious in the polychrome embroidered textiles but perhaps less apparent, at first glance, in the creation of post-fired painted and incised ceramics. This chapter has attempted to unravel the processes involved in production and to locate and interpret the meaningful contexts for the materials and personnel relevant to their creation. Questions raised by the analysis, and by gaps in knowledge that have been exposed, stimulate further inquiry.

It is clear that the Paracas valued mastery of form and design in ritual objects, as well as object weight and color. Painting imbued objects with worth much in the sense that wrapping them in cloth added layers of significance to them at the end of their life cycles. As a medium, ceramics are easily breakable, and post-fired paint added another dimension to this fragility that I believe is consonant with ritual intent and aesthetic conventions.

In light of the investment of knowledge required to achieve a successfully painted object, and the evidence that distinguishes the emulators from the masters, knowledge of the technique and mastery of it must have been limited to few. This becomes more apparent when we consider that ceramics, as portable objects, could be widely distributed, but neither the objects nor the technique were broadly circulated. Much like the esoteric knowledge encoded in iconography, the technique and all that it entailed was coveted and secret.

In a real economic sense, production of post-fired ceramics was costly. The minerals necessary for the full spectrum of paint colors were not readily available. The knowledge and skill base in the preparation of clays and the formulation of correct binders and colorants exceed the norms for routine ceramic production. Acquisition of the colorants alone depended on long-distance exchange, and it is quite possible that the organic binder was likewise acquired at a great cost. These expenses are mirrored in tomb contexts where small packets of the paint minerals are interred as offerings of particular value. A higher value appears to have been placed on the pigments that were more difficult to acquire. Powdered colorants, the substance of painters and dyers, are transformed to become the social currency of key figures at death. Moreover, as long-distance acquisitions, these "pieces of places" confer prestige upon the acquirer during life (Helms 1993:96).

Both local and long-distance exchange were rigorous, a finding that is not particularly new considering that the Paracas imported exotic materials from as distant as the Amazon for their status-conscious authority figures. The exchange in minerals and binder substances must have further stimulated exchange on a more regular basis in order to supply the needs of both painters and other specialists. All would have benefited from the exchange of cinnabar, a colorant only recently identified in post-fired ceramic paint. Casting a wide exchange or procurement net reaps rewards. The quest for copper ores to maintain the supply of colorants may have led to the discovery of its inner matrices—gold, at least from our understanding of the ores at La Zurita. Likewise, the substance of binder material or exchange of its knowledge and processing may have been precipitated by exchange relationships developed through other materials. In this sense, the desire for colorants to accommodate one medium can be seen as an act that stimulated innovation in another.

Exchange is also implicated in the question of color use over time. One of the most fascinating aspects of the study is the lack of paint colors, particularly green, during certain times and in some regions, such as the Ica Valley. It is not clear whether the absence of the color reflects aesthetic preferences, changes in symbolic values, or disruptions in the exchange networks. Were color wars fought over such resources? Recent research on mine and quarry sites suggests that they were largely open and unguarded (Burger 2006; Burger and Matos 2002; Reindel et al. 2013; Van Gijseghem et al. 2013; Vaughn et al. 2013). Cobo (1956 [1653]) reminds us that potential conflicts may have been spiritual, as the exceptional appearances of some minerals were attributable to the presence of "some divinity residing in them." Such divinity was surely manifest in their therapeutic appeal as much as their color. Color and all of its social and symbolic significance is a subject for continued study. The presence or absence of one color or another over time may reflect a number of factors, including the assertion or protection of group identity.

The social organization of artists emerges from a range of evidence considered in this study. Post-fired painted and incised ritual ceramics are considered to have been produced by few at the finishing stages, yet a network of subspecialists is implied. These personnel are not thought to be operating in large sophisticated workshops, although production centers and their output do appear to shift

according to regional rhythms of power. The master artist as patron and shaman (priest, healer) is gleaned from the quality of design, the interment of production tools, prestige items, and the most coveted substances in tombs. Such key figures were likely to have maintained their power on their abilities to further the arts, even if they were not artists by definition. I propose that, as practitioners, they would have been perceived as alchemists (sacerdotes), because the transformations that they performed were precisely those valued by a society whose ethos privileged mythical transformation.

Acknowledgments

I would like to express my sincerest appreciation to Cathy Costin for the invitation to participate in the symposium and to Colin McEwan, Emily Jacobs, Katie Caruso, and Sara Taylor of Dumbarton Oaks for their gracious assistance. Research was carried out in a number of locations in the United States and Peru, and was supported by a Johns Hopkins University faculty research grant. Among the many scholars who assisted in the years-long process, I acknowledge a debt of gratitude to Joanne Pillsbury, Heidi King, and Ellen Howe of The Metropolitan Museum of Art; Juan Antonio Murro and Joe Mills of Dumbarton Oaks; Jeffrey Quilter and Allison McGloughlin of the Peabody Museum of Archaeology and Ethnology, Harvard University; Judith Levinson of the American Museum of Natural History; Matthew Robb and Amy Clark of the Saint Louis Art Museum; Mark Nesbitt of the Royal Botanic Gardens at Kew; and Susana Arce Torres and Rubén García Soto of the Museo Regional de Ica. My work benefited from a number of discussions with John Janusek, María Lumbreras, Stella Nair, and Aïcha Bachir Bacha. The collaboration with conservators Emily Kaplan, National Museum of the American Indian, and Dawn Kriss, American Museum of Natural History, and The Metropolitan Museum of Art, in this endeavor, is greatly appreciated.

NOTES

1 Utilizing radiography and CT scans on a sample of Paracas bottles at the American Museum of Natural History, Kriss detected uniform thicknesses in the base portions (Lohnas n.d.; Lohnas et al. 2015). She postulates that a press form may have been used in the production of certain bottles to achieve this uniformity. Her observations are consistent with those of Rubini Drago (n.d.:95). Gourd containers and husks are frequent in Paracas Cavernas and Ocucaje tombs (Tello and Mejía Xesspe 1979; Rubini Drago n.d.). Carrion-Cachot (1949:45) believed that the thin, uniform shapes of Paracas Topará vessels were created by pouring or pressing clay into gourd husks, which burned away during firing. Kroeber and Strong (1953:320–321) speculated about the use of gourds as models for post-fired painted ceramics.

2 See Logan and Fratt (1993:425), who caution against making inferences about pigment-tool use based on the morphology of the tool.

3 Binder material is also visible on object surfaces under magnification. It appears as a hard, clear, amber-colored substance. While I was analyzing the Dumbarton Oaks Mask, I noticed material between the teeth; it appeared to be a brown resin, a finding confirmed under the microscope. It will be necessary to determine its physical properties and whether it is contemporary with the mask's creation or a modern restoration addition. Comparable masks will sometimes have a projection emanating from the nose (e.g., Lapiner 1976:figs. 146, 148, 150) or mouth (Lapiner 1976:figs. 154, 159). If the substance is an adhesive, then it may indicate that the mask once held a tongue or other projection. Adhesives were used by the Paracas to secure threads and twine to the shafts of feather fans, to knife and spear points, and to the tines of "combs" (see Tello and Mejía Xesspe 1979:fig. 16).

4 Kaplan (1999), working in conjunction with chemist Richard Newman at the Boston Museum of

Fine Arts, examined forty-two paint samples from Paracas sherds in the Ica Valley (Cerrillos and Ocucaje). She examined the sherds under ultraviolet light and using Fourier–Transform Infared Spectroscopy (FTIR), gas chromatography/mass spectrometry (GC/MS), electron microprobe, and high-performance liquid chromatography (HPCL). Over the course of a two–year study, Kriss examined a large sample of Paracas painted and incised ceramics in the collection of the American Museum of Natural History under conservator Judith Levinson: twenty samples by X-ray fluorescence spectroscopy (XRF), five samples by polarized light microscopy (PLM), three samples by X-ray computed tomography (CT) for three-dimensional imaging, and four samples by X-radiography (Lohnas n.d.). She continued to test post-fired paint and binder composition at The Metropolitan Museum of Art, in collaboration with Ellen Howe, and scientists Adriana Rizzo and Federico Carò (Lohnas et al. 2015). Overall, she examined approximately four hundred ceramics in museum collections and tested about one hundred. Her work continues with field and museum collections.

5 Temple architecture has been the focus of excavations. The surrounding habitation areas, likelier loci for production and firing, have not been investigated.

6 Pollen analysis conducted at Texas A&M University on samples drawn from PV62D13 were inconclusive.

7 The language spoken by the Paracas is unknown. Jaqaru (Tello and Mejía Xesspe's [1979] "Akaro") is a language of the Jaqi linguistic family that is unrelated to Quechua, but it is uncertain whether the Paracas spoke a language related to the Jaqi or Quechua linguistic group.

8 I cite viceregal-era terminology here to express ideas about language and color, but I acknowledge that creative practices, such as sculpting, carving, and painting, and colors and their uses may have been conceived and described quite differently by the Paracas.

9 A bright, pale-green-colored paint is the exception.

10 In his analysis of a tool kit from the Ica Valley, Nordenskiöld (1931:99) shows that powdered obsidian was used in the production of Inka-era q'eros. The powdered stone was grayish-green in appearance. See also the discussion of hematite mines and quarrying for the Nasca in the Nazca drainage in Vaughn et al. (2013).

11 It is important to note that paints were also used for tattoos, body paint, and painting objects other than ceramics, such as wood and gourds (Aponte 2013). The pigments identified in the Wari Kayan tombs may represent caches used, in part, for those purposes.

REFERENCES CITED

Aponte, Delia

2009 Representaciones de género en Paracas Cavernas. *Cuaderno de investigación del Archivo Tello* 7:17–26.

2013 Ciclo de vida y marcas corporales en Paracas Necrópolis. In *Paracas*, edited by Museo Nacional de Arqueología, Antropología e Historia, pp. 40–49. Ministerio de Cultura, Lima.

Bachir Bacha, Aïcha, and Oscar Daniel Llanos

2013 ¿Hacia un urbanismo paracas en Ánimas Altas/Ánimas Bajas (valle de Ica)? *Boletín de arqueología PUCP* 17:169–204.

Berlin, Brent, and Paul Kay

1969 *Basic Color Terms: Their Universality and Evolution.* University of California Press, Berkeley.

Bertemes, François, and Peter F. Biehl

2001 The Archaeology of Cult and Religion: An Introduction. In *The Archaeology of Cult and Religion*, edited by Peter F. Biehl and François Bertemes, pp. 11–24. Archaeolingua Foundation, Budapest.

Bertonio, Ludovico

2005 [1612] *Vocabulario de la lengua aymara.* Ediciones El Lector, Arequipa.

Burger, Richard L.

1995 *Chavín and the Origins of Andean Civilization.* Thames and Hudson, London.

2006 Interacción interregional entre los Andes centrales y los Andes centro sur: El caso de la circulación de obsidiana. In *Esferas de interacción prehistóricas y fronteras nacionales modernas: Los Andes sur centrales,* edited by Heather Lechtman, pp. 423–447. Instituto de Estudios Peruanos, Lima, and Institute of Andean Research, New York.

2012 The Construction of Values during the Peruvian Formative. In *The Construction of Value in the Ancient World,* edited by John Papadopoulos and Gary Urton, pp. 288–305. Cotsen Institute of Archaeology Press, Los Angeles.

2013 In the Realm of the Incas: An Archaeological Reconsideration of Household Exchange, Long-Distance Trade, and Marketplaces in the Pre-Hispanic Central Andes. In *Merchants, Markets, and Exchange in the Pre-Columbian World,* edited by Kenneth G. Hirth and Joanne Pillsbury, pp. 319–334. Dumbarton Oaks Research Library and Collection, Washington, D.C.

Burger, Richard L., and Ramiro Matos

2002 Atalla: A Center on the Periphery of the Chavín Horizon. *Latin American Antiquity* 13(2):153–177.

Cárdenas M., Mercedes O.

1994 Platos de alfarero de entierros del Formativo Tardío en la costa central del Perú. In *Tecnología y organización de la producción cerámica prehispánica en los Andes,* edited by Izumi Shimada, pp. 173–200. Pontificia Universidad Católica del Perú, Fondo Editorial, Lima.

Carrión Cachot, Rebecca

1949 *Paracas cultural elements.* Corporación de Turismo, Lima.

Clifford, James

1988 *The Predicament of Culture.* Harvard University Press, Cambridge, Mass.

Cobo, Bernabé

1956 [1653] *Historia del nuevo mundo.* Edited by Francisco Mateos. Biblioteca de Autores Españoles, Madrid.

Conklin, William J.

1978 The Revolutionary Weaving Inventions of the Early Horizon. *Ñawpa Pacha* 16:1–12.

1997 Structure as Meaning in Andean Textiles. *Chungara* 29(1):109–131.

Cook, Anita G.

1999 Asentamientos Paracas en el valle bajo de Ica, Perú. *Gaceta arqueológica andina* 25:61–90.

Cooke, Colin A., Holger Hintelmann, Jay J. Ague, Richard L. Burger, Harald Biester, Julian P. Sachs, and Daniel R. Engstrom

2013 Use and Legacy of Mercury in the Andes. *Environmental Science and Technology* 47:4181–4188.

Cornejo, Miguel

2002 Sacerdotes y tejedores en la provincia Inka de Pachacamac. *Boletín de arqueología PUCP* 6:171–204.

Costin, Cathy Lynne

1991 Craft Specialization: Issues in Defining, Documenting, and Explaining the Organization of Production. In *Archaeological Method and Theory,* vol. 3, edited by Michael B. Schiffer, pp. 1–56. University of Arizona Press, Tucson.

2007 Thinking about Production: Phenomenological Classification and Lexical Semantics. *Archaeological Papers of the American Anthropological Association* 17(1):143–162.

Cummins, Tom

1992 Tradition in Ecuadorian Pre-Hispanic Art: The Ceramics of Chorrera and Jama-Coaque. In *Amerindian Signs: 5,000 Years of Precolumbian Art in Ecuador,* edited by Francisco Valdez and Diego Veintimilla, pp. 63–81. Ediciones Colibiri, Quito.

2002 *Toasts with the Inca: Andean Abstraction and Colonial Images on Quero Vessels.* University of Michigan Press, Ann Arbor.

Dawson, Lawrence E.

1979 Painted Cloth Mummy Masks of Ica, Peru. In *The Junius B. Bird Pre-Columbian Textile Conference*, edited by Ann P. Rowe, Elizabeth P. Benson, and Anne-Louise Schaffer, pp. 83–104. Dumbarton Oaks Research Library and Collection, Washington, D.C.

DeLeonardis, Lisa

1991 Settlement History of the Lower Ica Valley, Peru, 5th–1st Centuries, B.C. MA thesis, Department of Anthropology, Catholic University, Washington, D.C.

1997 *Paracas Settlement in Callango, Lower Ica Valley, 1st Millennium B.C., Peru.* PhD dissertation, Department of Anthropology, Catholic University, Washington, D.C.

2005 Early Paracas Cultural Contexts: New Evidence from the West Bank of Callango. *Andean Past* 7:27–55.

2011a Itinerant Experts, Alternative Harvests: *Kamayuq* in the Service of Qhapaq and Crown. *Ethnohistory* 58(3):445–490.

2011b An Aesthetic of Luster: Paracas Gold and the Body. Paper presented in the Ancient Society Lecture Series, Walters Art Museum, Baltimore, Md.

2012 Interpreting the Paracas Body and Its Value in Ancient Peru. In *The Construction of Value in the Ancient World*, edited by Gary Urton and John Papadopoulos, pp. 149–169. Cotsen Institute of Archaeology Press, Los Angeles.

2013a Corografía y derecho: Un mapa manuscrito de Pisco en el siglo XVII. *Revista del Archivo General de la Nación* 28:15–43.

2013b La sustancia y el contexto de las ofrendas rituales de la cerámica Paracas. *Boletín de arqueología PUCP* 17:205–229.

n.d.a *Preliminary Analysis of the Cerrillos Site PV6263: 1999 Excavations.* Report submitted to Dwight Wallace, California Institute of Peruvian Studies.

n.d.b *Dumbarton Oaks Pre-Columbian Collection PCB 487 Mask.* Object analysis notes, November 4, 2012. Manuscript submitted for object file, Dumbarton Oaks Research Library and Collection, Washington, D.C.

DeLeonardis, Lisa, and Michael D. Glascock

2013 From Queshqa to Callango: A Paracas Obsidian Assemblage from the Lower Ica Valley, Peru. *Ñawpa Pacha* 33(2):163–192.

DeLeonardis, Lisa, and George F. Lau

2004 Life, Death, and Ancestors. In *Andean Archaeology*, edited by Helaine Silverman, pp. 77–115. Blackwell, Malden, Mass.

DeMarrais, Elizabeth, Luis Jaime Castillo, and Timothy Earle

1996 Ideology, Materialization, and Power Strategies. *Current Anthropology* 37(1):15–31.

Dobres, Marcia-Anne

2000 *Technology and Social Agency: Outlining a Practice Framework for Archaeology.* Blackwell, Malden, Mass.

Donnan, Christopher B.

1992 *Ceramics of Ancient Peru.* Fowler Museum of Cultural History, Los Angeles.

1996 Paracas Double-Spout-and-Bridge Vessel. In *Affinities of Form: Arts of Africa, Oceania, and the Americas from the Raymond and Laura Wielgus Collection*, edited by Diane M. Pelrine, pp. 192–193. Prestel, Munich and New York.

Fester, Gustavo A., and José Cruellas

1934 Colorantes de Paracas. *Revista del Museo Nacional* 3 (1–2):154–163.

Frame, Mary

1986 The Visual Images of Fabric Structures in Ancient Peruvian Art. In *The Junius B. Bird Conference on Andean Textiles*, edited by Ann P. Rowe, pp. 47–80. Textile Museum, Washington, D.C.

2001 Blood, Fertility, and Transformation: Interwoven Themes in the Paracas Necropolis Embroideries. In *Ritual Sacrifice in Ancient Peru*, edited by Elizabeth P. Benson and Anita G. Cook, pp. 55–92. University of Texas Press, Austin.

Gage, John

1999 *Color and Meaning: Art, Science, and Symbolism.* University of California Press, Los Angeles.

García Soto, Rubén

2013 Geoglifos de la costa sur: Cerro Lechuza y Cerro Pico. *Boletín de Arqueología PUCP* 17:151–168.

Gell, Alfred

1992 The Technology of Enchantment and the Enchantment of Technology. In *Anthropology, Art, and Aesthetics*, edited by Jeremy Coote and Anthony Shelton, pp. 40–63. Clarendon Press, Oxford.

Hardman, Martha J.

1981 Jaqaru Color Terms. *International Journal of American Linguistics* 47(1):66–68.

Helms, Mary W.

1993 *Craft and the Kingly Ideal: Art, Trade, and Power.* University of Texas Press, Austin.

1996 Color and Creativity: Interpretation of Themes and Design Styles on a Panamanian Conte Bowl. *Res: Anthropology and Aesthetics* 29/30:290–302.

Inokuchi, Kinya

2011 Cronología y secuencia arqitectónica de Kuntur Wasi. In *Gemelos prístinos: El tesoro del templo de Kuntur Wasi*, edited by Yoshio Onuki and Kinya Inokuchi, pp. 63–94. Fondo Editorial del Congreso del Perú, Lima.

Isla, Johny, Markus Reindel, and Juan Carlos de la Torre

2003 Jauranga: Un sitio Paracas en el valle de Palpa, costa sur del Perú. *Beiträge zur Allgemeinen und Vergleichenden Archäologie* 23:227–274.

Jones, Kimberly L.

2010 *Cupisnique Culture: The Development of Ideology in the Ancient Andes.* PhD dissertation, University of Texas, Austin.

Kaplan, Emily

1999 *Technical Studies of Post-Fired Paint on Paracas Ceramics.* Paper presented in the Society for American Archaeology symposium "Issues in the Study of Complex Society: New Perspectives from South Coastal Peru," Chicago.

Kaplan, Emily, Ellen Howe, Ellen Pearlstein, and Judith Levinson

2012 The Qero Project: Conservation and Science Collaboration Over Time. *RATS Postprints* 3:1–22.

Kembel, Silvia Rodriguez, and John W. Rick

2004 Building Authority at Chavín de Huántar: Models of Social Organization and Development in the Initial Period and Early Horizon. In *Andean Archaeology*, edited by Helaine Silverman, pp. 77–115. Blackwell, Malden, Mass.

Kroeber, Alfred L., and William D. Strong

1953 *Paracas Cavernas and Chavín.* University of California Press, Berkeley.

Lapiner, Alan

1976 *Pre-Columbian Art of South America.* Harry H. Abrams, New York.

Lohnas, Dawn

n.d. American Museum of Natural History, Anthropology Intern Research Report on Paracas Ceramics (October 2012–May 2013). Manuscript on file, American Museum of Natural History, New York.

Lohnas, Dawn, Ellen Howe, Judith Levinson, Adriana Rizzo, and Federico Carò

2015 A Technological Study of Post-Fire Painted Paracas Ceramics. Paper presented at the Institute of Andean Studies Annual Meeting, Berkeley.

Logan, Erick N., and Lee Fratt

1993 Pigment Processing at Homol'ovi III: A Preliminary Study. *Kiva* 58(3):415–428.

Lucca D., Manuel de

1983 *Diccionario aymara–castellano, castellano–aymara.* Comisión de Alfabetización y Literatura en Aymara, La Paz.

Massey, Sarah

1983 Antiguo centro Paracas, Animas Altas. In *Culturas precolombinas, Paracas*, edited by Arturo Jiménez Borja, pp. 134–160. Banco de Crédito del Perú en la Cultura, Lima.

1986 *Sociopolitical Change in the Upper Ica Valley, 400 BC to AD 400: Regional States on the South Coast of Peru.* PhD dissertation, Department of Anthropology, University of California, Los Angeles.

1991 Social and Political Leadership in the Lower Ica Valley: Ocucaje Phases 8 and 9. In *Paracas Art and Architecture: Object and Context in South Coastal Peru*, edited by Anne Paul, pp. 313–345. University of Iowa Press, Iowa City.

Menzel, Dorothy, John H. Rowe, and Lawrence Dawson

1964 *The Paracas Pottery of Ica: A Study in Style and Time.* University of California Press, Berkeley.

Meskell, Lynn

2005 Introduction: Object Orientations. In *Archaeologies of Materiality*, edited by Lynn Meskell, pp. 1–17. Blackwell, Malden, Mass.

Mills, Johns S., and Raymond White

1977 Natural Resins of Art and Archaeology: Their Sources, Chemistry, and Identification. *Studies in Conservation* 22(1):12–31.

Murra, John V.

1962 Cloth and Its Function in the Inca State. *American Anthropologist* 64(4):710–728.

Museo de Arqueología y Antropología Universidad Nacional Mayor de San Marcos (MAAUNMSM)

2009 Disección de fardos funerários pertenecientes a la Caverna V–Paracas. *Cuaderno de investigación del Archivo Tello* 7:121–190.

2012 Paracas Wari Kayan. *Cuaderno de investigación del Archivo Tello* 9:7–550.

Nair, Stella

2007 Localizing Sacredness, Difference, and Yachacuscamcani in a Colonial Andean Painting. *Art Bulletin* 89(2):211–238.

Newman, Richard, Emily Kaplan, and Michele Derrick

2015 Mopa Mopa: Scientific Analysis and History of an Unusual South American Resin Used by the Inka and Artisans in Pasto, Colombia. *Journal of the American Institute for Conservation* 54(2):123–148.

Nordenskiöld, Erland

1931 Appendix 2: Ancient Inca Lacquer Work. *Comparative Ethnological Studies* 9:95–100. Göteborg.

Papadopoulos, John K., and Gary Urton

2012 Introduction: The Construction of Value in the Ancient World. In *The Construction of Value in the Ancient World*, edited by John K. Papadopoulos and Gary Urton, pp. 1–47. Cotsen Institute of Archaeology Press, Los Angeles.

Paracas Archaeology Research Resources (PARR)

n.d. Collections Database. Electronic document, http://www.arqueologia-paracas .net, accessed November 2013.

Parsons, Lee A.

1980 *Pre-Columbian Art: The Morton D. May and the Saint Louis Art Museum Collections.* Harper and Row, New York.

Paul, Anne

1991 Paracas Necrópolis Bundle 89: A Description and Discussion of Its Contents. In *Paracas Art and Architecture: Object and Context in South Coastal Peru*, edited by Anne Paul, pp. 172–221. University of Iowa Press, Iowa City.

1996 Paracas Textiles. In *Andean Art at Dumbarton Oaks*, vol. 2, edited by Elizabeth H. Boone, pp. 347–363. Dumbarton Oaks Research Library and Collection, Washington, D.C.

2000 Protective Perimeters: The Symbolism of Borders on Paracas Textiles. *Res: Anthropology and Aesthetics* 38:144–167.

Paul, Anne, and Susan A. Niles

1985 Identifying Hands at Work on a Paracas Mantle. *Textile Museum Journal* 23:5–15.

Peabody Museum of Archaeology and Ethnology, Harvard University

n.d. Collections Database. Electronic document, https://www.peabody.harvard .edu, accessed November 2013.

Peters, Ann H.

2013 Topará en Pisco: Patrón de asentimiento y paisaje. *Boletín de arqueología PUCP* 17:77–101.

Phipps, Elena, Nancy Turner, and Karen Trentelman

2008 Colors, Textiles, and Artistic Production in Murúa's *Historia General del Piru*. In *The Getty Murúa: Essays on the Making of Martín de Murúa's "Historia General del Piru," J. Paul Getty Museum Ms. Ludwig XIII 16*, edited by Thomas B. F. Cummins and Barbara Anderson, pp. 125–145. The Getty Research Institute, Los Angeles.

Pillsbury, Joanne

2006 Inca-Colonial Tunics: A Case Study of the Bandelier Set. In *Andean Textile Traditions*, edited by Margaret Young-Sánchez and Fronia W. Simpson, pp. 120–168. Denver Art Museum, Denver.

Proulx, Donald A.

1996 Paracas. In *Andean Art at Dumbarton Oaks*, vol. 1, edited by Elizabeth H. Boone, pp. 101–105. Dumbarton Oaks Research Library and Collection, Washington, D.C.

Raimondi, Antonio

1878 *Minerales del Perú o catálogo razonado*. Imprenta del Estado por J. Enrique del Campo, Lima.

Reindel, Markus, Johny Isla Cuadrado, and Klaus Koschmieder

1999 Vorspanische Siedlungen und Bodenzeichnungen in Palpa, Süd-Peru. *Beiträge zur Allgemeinen und Vergleichenden Archäologie* 19:313–381.

Reindel, Markus, Thomas R. Stöllner, and Benedikt Gräfingholt

2013 Mining Archaeology in the Nasca and Palpa Region, South Coast of Peru. In *Mining and Quarrying in the Ancient Andes*, edited by Nicholas Tripcevich and Kevin J. Vaughn, pp. 299–322. Springer, Berlin.

Rice, Prudence M.

1987 *Pottery Analysis: A Sourcebook*. University of Chicago Press, Chicago and London.

Rowe, Ann Pollard

1996 The Art of Peruvian Textiles. In *Andean Art at Dumbarton Oaks*, vol. 2, edited by Elizabeth H. Boone, pp. 329–345.

Dumbarton Oaks Research Library and Collection, Washington, D.C.

Rubini Drago, Aldo

n.d. Colección arqueológica de Aldo Rubini Drago. Manuscript in possession of the author.

Sawyer, Alan R.

1966 *Ancient Peruvian Ceramics: The Nathan Cummings Collection*. The Metropolitan Museum of Art, New York.

Seldes, Alicia, José Burucúa, Gabriela Siracusano, Marta S. Maier, and Gonzalo E. Abad

2002 Green, Yellow, and Red Pigments in South American Painting, 1610–1780. *Journal of the American Institute for Conservation* 41(3):225–242.

Sepúlveda R., Marcela, Valentina Figueroa L., and Sandrine Pagés-Camagna

2013 Copper Pigment-Making in the Atacama Desert (Northern Chile). *Latin American Antiquity* 24(4):467–482.

Shimada, Izumi, Baba Hisao, Ken-ichi Shinoda, and Masahiro Ono (editors)

2006 *Nasca, Wonder of the World: Messages Etched on the Desert Floor*. Topan, Tokyo.

Silverman, Helaine

1993 *Cahuachi in the Ancient Nasca World*. University of Iowa Press, Iowa City.

1994 Paracas in Nazca: New Data on the Early Horizon Occupation of the Río Grande de Nazca Drainage, Peru. *Latin American Antiquity* 5(4):359–382.

Siracusano, Gabriela

2005 *El poder de los colores: De lo material a lo simbólico en las prácticas culturales andinas, siglos XVI–XVII*. Fondo de Cultura Económica, Buenos Aires.

Sofaer, Joanna

2007 Introduction: Materiality and Identity. In *Material Identities*, edited by Joanna Sofaer, pp. 1–9. Blackwell, Malden, Mass.

Spielmann, Katherine A.

1998 Ritual Craft Specialists in Middle Range Societies. In *Craft and Social Identity*, edited by Cathy Lynne Costin and Rita P. Wright, pp. 153–159. American Anthropological Association, Arlington, Va.

2002 Feasting, Craft Specialization, and the Ritual Mode of Production in Small-Scale Societies. *American Anthropologist* 104(1):195–207.

Splitstoser, Jeffrey

2009 *Weaving the Structure of the Cosmos: Cloth, Agency, and Worldview at Cerrillos, An Early Paracas Site in the Ica Valley, Peru.* PhD dissertation, Department of Anthropology, Catholic University, Washington, D.C.

Splitstoser, Jeffrey, Dwight D. Wallace, and Mercedes Delgado

2009 Nuevas evidencias de textiles y cerámica de la época Paracas temprano en errillos, valle de Ica, Perú. *Boletín de arqueología PUCP* 13:209–235.

Strong, William Duncan

1957 *Paracas, Nazca, and Tiahuanacoid Relationships in South Coastal Peru.* Memoirs of the Society for American Archaeology 13. Society for American Archaeology, Salt Lake City.

Tantaleán, Henry, Charles Stanish, Michiel Zegarra, Kelita Pérez y Ben Nigra

2013 Paracas en el valle de Chincha: Nuevos datos y explicaciones. *Boletín de arqueología PUCP* 17:31–56.

Tello, Julio C.

1959 *Paracas, primera parte.* Institute of Andean Research, New York.

Tello, Julio C., and Toribio Mejía Xesspe

1979 *Paracas segunda parte: Cavernas y Necrópolis.* Universidad Nacional Mayor de San Marcos, Lima, and Instituto Andino de Nueva York, New York.

Urton, Gary

2012 Recording Values in the Inka Empire. In *The Construction of Value in the Ancient World*, edited by John K. Papadopoulos and Gary Urton, pp. 475–496. Cotsen Institute of Archaeology Press, Los Angeles.

Van Gijseghem, Hendrik, Kevin J. Vaughn, Verity H. Whalen, Moises Linares Grados, and Jorge Olano Canales

2013 Economic, Social, and Ritual Aspects of Copper Mining in Ancient Peru: An Upper Ica Valley Case Study. In *Mining and Quarrying in the Ancient Andes*, edited by Nicholas Tripcevich and Kevin J. Vaughn, pp. 275–298. Springer, Berlin.

Vaughn, Kevin J., Hendrik Van Gijseghem, Verity H. Whalen, Jelmer W. Eerkens, and Moises Linares Grados

2013 The Organization of Mining in Nasca during the Early Intermediate Period: Recent Evidence from Mina Primavera. In *Mining and Quarrying in the Ancient Andes*, edited by Nicholas Tripcevich and Kevin J. Vaughn, pp. 157–182. Springer, Berlin.

Wallace, Dwight

1991 A Technical and Iconographic Analysis of Carhua Painted Textiles. In *Paracas Art and Architecture: Object and Context in South Coastal Peru*, edited by Anne Paul, pp. 61–109. University of Iowa Press, Iowa City.

Winter, Irene J.

2002 Defining "Aesthetics" for Non-Western Studies: The Case of Ancient Mesopotamia. In *Art History, Aesthetics, Visual Studies*, edited by Michael Ann Holly and Keith Moxey, pp. 3–28. Clark Studies in the Visual Arts, Sterling and Francine Clark Art Institute, Williamstown, Mass.

Valuing the Local

Inka Metal Production in the Tarapacá Valley of Northern Chile

COLLEEN ZORI

LIKE MANY OTHER EMPIRES OF THE ANCIENT and modern worlds, the Inka were intent upon the extraction of metals from the lands they conquered. Mines, along with agricultural lands and camelid herds, were among the productive resources appropriated by the state upon conquest (Moore 1958; Murra 1980 [1962]). The richest mineral sources were retained as the property of the emperor and worked by miners supplied by local communities as partial fulfillment of their labor obligations to the state (Berthelot 1986; Van Buren and Presta 2010). In keeping with the imperial ideology of reciprocity, the Inka provided mine laborers with housing, food, *chicha* (corn beer), clothing, and tools (Salazar 2008; Salazar and Salinas 2008; Van Buren and Presta 2010), and similarly supported individual metalworkers and even whole community enclaves of gold- and silversmiths dedicated to the production of metal objects for the state (Cieza de León 1986 [1553]; Cobo 1990 [1653]:ch. 15).

Given this expenditure of effort, what did metals, such as gold, silver, and copper, mean to the Inka and their subjects? How did the mobilization of techné, technical skills and esoteric knowledge—whether in mining or in the conversion of unsmelted minerals into finished metal artifacts—contribute to the value of such objects? More importantly, if metals had such great worth, then how were the Inka able to motivate their subjects into extracting, working, and then relinquishing the gold, silver, and copper produced?

I begin by discussing how an animist worldview informed prehistoric Andean conceptualizations of metal-bearing ores and the processes by which they were transformed into metal objects. While the outlines of these understandings were broadly shared across the Andes, provincial peoples also had their own local systems of value in regard to minerals and metals. Using the Tarapacá Valley of northern Chile (Figure 6.1) as a case study, I address how the Inka transformed the metallurgical production process but simultaneously worked within local systems of value and meaning to promote cooperation with the new imperial economic order.

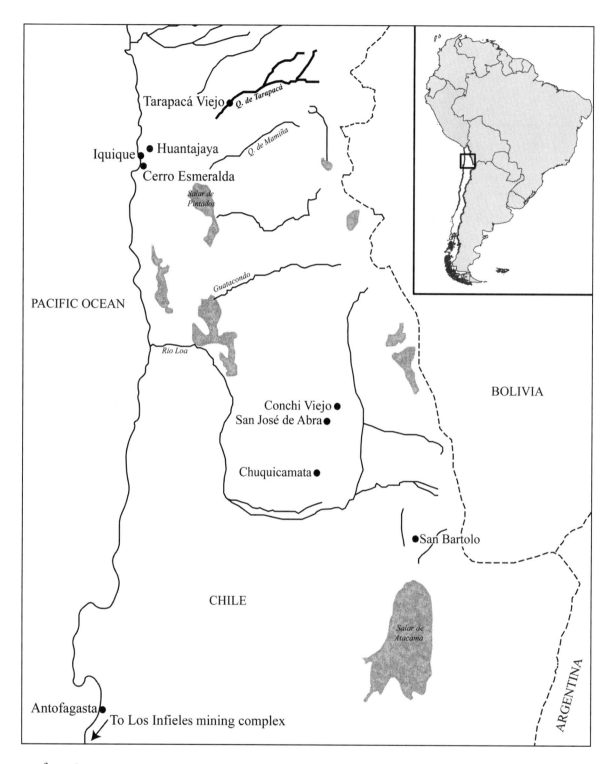

figure 6.1

Map of northern Chile, showing the Tarapacá Valley and the locations of sites mentioned in the text. (Map by Colleen Zori.)

Tarapacá metallurgists had been engaged in the production of copper and arsenical bronze, using wind-driven furnaces known as *huayras,* since at least the second half of the Late Intermediate Period (1000–1450 CE; see Zori 2011; Zori et al. 2013). Upon incorporation of northern Chile in the mid- to late fifteenth century, the Inka redirected some of the labor of their new subjects toward the extraction of previously unexploited silver-bearing ores at the Huantajaya mines and introduced new technologies for the purification of these minerals, including lead cupellation, in the Tarapacá Valley itself. Copper production did not cease under the Inka; instead, there appears to have been a significant reorganization and intensification of copper production in the valley, employing the local huayra technology, as well as the introduction of new techniques related to casting.

While imperial representatives relied on traditional Andean norms of reciprocity and feasting to encourage local people to participate in this new economic production system, another way that the Inka accomplished this involvement was through the provisioning of ground blue minerals. Drawing on ethnographic and archaeological data, I suggest that these blue minerals were of relatively less value to the Inka but of great significance to the inhabitants of the Tarapacá Valley. By co-opting this local system of value, the empire found a strategy for obtaining the resources it desired while simultaneously placating local interests.

Metals and Meaning in the Ancient Andes

Scholars have taken various approaches to interpreting the value of metals in the ancient Andes. One set of conceptualizations broadly shared throughout the Andes, and perhaps even the New World, focuses on the intrinsic characteristics of the metals themselves. Nicholas Saunders (1998, 2003), for instance, highlights the importance of the reflectivity and brilliancy of gold, silver, and copper. He suggests that native concepts of the value of metals drew on parallels with powerful and sometimes dazzling natural phenomena, including celestial bodies like the sun, moon, and stars, as well as lightning and other meteorological occurrences. Metals were "concretizations of light and light-laden natural phenomena . . . charged with cosmological power" (Saunders 2003:16; see also Maldonado, this volume). Heather Lechtman (1984, 1993, 2007) has drawn attention to the importance of color in metal objects and to the variety of techniques Andean metallurgists developed to bring gold and silver to the surface of objects that were made of primarily cupriferous alloys. Although working in Mesoamerica, Dorothy Hosler (1994, 2009) has demonstrated that even the capacity to produce sound was an important dimension in the significance of metal objects, such as bells.

How metals functioned in social and political contexts is another avenue to investigate their meaning. In the non-market economy of the prehistoric Andes, the primary value of gold and silver—and of metals in general—would not have been in their accumulation per se; it would have derived instead from their worth in creating vertical and horizontal social relationships through their bestowal, use, and exchange (Lechtman 1993, 2007; Owen 2001; Sallnow 1989). In interpreting the value of metals within the Inka empire more specifically, scholars have focused on the roles that metal objects played in the political economy and in mediating relationships with imperial subjects. Gold and silver were intimately associated with the origin myths of the ruling Inka dynasty, and these metals were overtly deployed in efforts to legitimize the rulers' divinity and political supremacy. Gold embodied the ideological and mytho-political linkage between the emperor and the sun god, Inti, from whom the Inka emperors reckoned their descent; silver was thought to represent the moon, associated with the women of the Inka imperial lineage (Berthelot 1986; Cieza de León 1986 [1553]; Cobo 1990 [1653]; Sallnow 1989). In the Inka empire, sumptuary laws regulated access to gold and silver, limiting their use to individuals upon whom the emperor had conferred the privilege (Betanzos 1996 [1557]; Moore 1958). As M. J. Sallnow (1989:223) explains, "all personal gifts and ornaments [of gold and silver] circulating in the empire could then be construed as fragments

of this celestial world, deriving—like the prestige and rank which they signaled—from the Inka king himself." Bestowal and display of the spectrum of metals—gold, silver, and copper—simultaneously created and emblemized social hierarchies.

Although significant insights into the value of metals in the ancient Andes have been gained by focusing on the inherent properties and social uses of metal objects, these perspectives take as their starting point only the terminal stages in the metal production process. I suggest that concentrating solely on the metals themselves or on finished metal objects overlooks earlier steps in the production sequence that also imbued gold, silver, and copper with meaning and value. A more nuanced interpretation of how metals were understood in the prehispanic Andes requires us to look to indigenous conceptions about the mountains and mines from which the ores were extracted, and the technological processes by which these minerals were transformed with skill and intent into metal objects with significant social meanings.

Mining a Living Landscape

To understand how the sources of metallic ores could contribute to their worth (see also Janusek and Williams, this volume), we must first set aside the rigid Cartesian distinctions between humans and nature, and between living and non-living, that underlie Western worldviews. Although local ontologies varied in detail from place to place, the prehistoric Andean worldview was underlain by an animist mentality, in which even elements of the natural world—rocks, caves, springs, and mountains—were believed to possess a vital animating force, known in Quechua as *camaquen* (or *kamaquen*; Bray 2009; Salomon 1991). These elements had the potential to shape human lives, whether for good or for ill. Interactions with this animate world took the form of establishing communications and, with any luck, beneficial relationships with certain objects and places on the landscape—known as *huacas*—that were thought to be privileged points of access to this supernatural realm. Reciprocal relationships mediated through offerings and the sharing of food and drink were one means to realize the latent power of the huaca to constructively affect human lives, although establishing these relations and harnessing the camaquen of the huacas required some degree of esoteric knowledge (Kolata 2013; Sillar 2009:370). Huacas were infused with camaquen through these acts of sacrifice and exchange with human communities; at the same time, they also were the source of the camaquen that brought individuals and groups into being and that continued to sustain them throughout their existence (Bray 2009:357; Salomon 1991:16).

This worldview translated into a dynamic relationship between miners and the mountains in which they toiled (Nash 1993; Platt 1983; Sallnow 1989). These mountains, and the mines themselves, were considered huacas. Ethnographic and ethnohistoric documents suggest that the relationships between miners and the huacas of the mines were complex and varied from place to place. In some conceptualizations, ore extraction was considered symbolically equivalent to the harvesting of crops, with offerings required to ensure a good "harvest" and the fertilization and regeneration of ores to replace those removed (Berthelot 1986; Nash 1993; Ruíz Arrieta 2011; Sillar 1996). Metal-bearing ores were viewed as seeds—giving the appearance of being inert, but containing within them the potential for animation and life. Holguín's Quechua dictionary (González Holguín 1952 [1608]) refers to a gold mine as a *cori chakra* ("gold field"), making explicit the connection between mines and agricultural cultivation, while mines or veins of silver were known as *coya*, a Quechua word with meanings that also include a furrow where crops are sown, and the wife of Inka himself (Bouysse-Cassagne 2004:65–66). Thérèse Bouysse-Cassagne makes the connection between the Inka queen (*capay coya*), inside whom grows the future sons of the sun, and the mines (*coya*), in which grow metals sacred to the sun and moon (see also Berthelot 1986).

In other parts of the Andes, mining was seen as a dangerous and potentially antagonistic interaction in which the extracted ores constituted the blood

and flesh of the sacred huacas (Bouysse-Cassagne 2004:66; Gose 1986). Ethnohistoric Aymara dictionaries, for instance, record that the words for a vein of gold or silver are the same as that used for a vein carrying blood (Bouysse-Cassagne 2004:66). The value appropriated by the removal of these somatic substances had to be reciprocated through frequent offerings of coca leaves, liquid libations, animal sacrifices, and sometimes even human lives (Gose 1986; Nash 1993). Skilled miners in the Inka empire were considered specialists, and the combination of their mining expertise and ability to negotiate the complex relationships with mining huacas can be considered a form of techné.

Whether viewed as the products of reproduction and harvest or as flesh and blood, the metal ores that were extracted from these mines also carried with them the vital force or camaquen of the mountain huaca. As Carolyn Dean (2010:35) noted, camaquen "was independent of form and could be embodied in various ways," such that even a small piece of the original sacred entity contained within it the essence of the original. This is an expression of the Andean principle of "continuous identity," as developed by historian Sabine MacCormack, by which "identity could be conceptualized as continuous even when its expression or representation changed" (1991:408–409). Ores obtained from a sacred huaca would thus have been seen as animated by the camaquen and the potency of its huaca of origin.

Camaquen and the Transformation of Ores to Metals

Through the acts of smelting, refining, and working metals, specialized metallurgical craftspeople also imbued finished metal objects with the animating life force of camaquen. Inka specialists were broadly known as *camayoc*, derived—as with the word camaquen—from the Quechua verb *camay*, meaning "to charge with being" or "to animate" (Salomon 1991:16). According to Tom Cummins (2002:28), this nomenclature suggests that "the master craftsmen of Tahuantinsuyu [the Inka empire] are associated, through their special skills,

with the capacity to infuse the objects of their production with this essence of being." This passage brings to mind Gell's notion of the "enchantment of technology," by which an object is invested with value and power because the difficulty for nonspecialists in understanding how such objects are produced makes them appear "explicable only in magical terms, something [that] has been produced by magical means" (Gell 1992:46). The complex and mysterious technologies by which ores were transformed into finished camaquen-bearing metal objects are another place where techné resided in the metal production process.

Objects of precious metal—such as drinking vessels used for sealing alliances (Cummins 2002) or figurines interred with human sacrifices and other ritual contexts (Bray 2009)—played vital roles in the interchanges through which Inka sociopolitical relationships were established and maintained. But perhaps more importantly, these crafted objects were more than simply symbols of particular relationships (Bray 2009:362). Rather, they were considered active social agents imbued with the ability to function as proxies for the Inka state *participating* in interactions with provincial subjects. Objects produced and given at the behest of the Inka—whether metal, cloth, or other—carried with them a certain sense of inalienability. They could not be fully transferred and possessed by another person because they bore the indelible imprint of the Inka and the ongoing relationship between the royal source and the recipient. As argued by Bill Sillar (2009:367), in the Andes, "objects that have had a prior relationship with other places, things, or people are thought to remain in communication even after their physical separation." In this sense, objects of precious metals would have been seen as simultaneously in communion with the huacas of their origins as well as with the Inka emperor himself, who was responsible for sponsoring the production and bestowal of metal objects. With the camaquen imbued by their numinous origins and through the transformations wrought by camayocs, gold and silver acted as animate participants in social interactions and as objects of memory (see Cummins 2002:29; Mills 2004:240). Metal

figure 6.2
The Inka administrative center of Tarapacá Viejo. (Photograph courtesy of Rodrigo Riveros Strange.)

objects materialized the history of social relationships that enmeshed local groups, the Inka himself, and the powerful huacas of the living landscape in a network of reciprocal obligations.

Value in the Provinces: A Case Study from the Tarapacá Valley, Northern Chile

With these Inka—and, more broadly, Andean—valuations of metal in mind, I now explore how both technical skill and esoteric knowledge were exercised in producing silver and copper in northern Chile's hyper-arid Atacama Desert during the Late Horizon. Using data from the Huantajaya mine and survey and excavations in the nearby Tarapacá Valley (Figure 6.1), I examine how the Inka played upon local conceptualizations of value—particularly the importance of ground blue minerals in a variety of ritual contexts—to motivate provincial communities to participate in the extraction and refining of metals.

I demonstrate that silver production was initiated at the behest of the Inka, who directed local labor toward the extraction of silver-bearing ores at Huantajaya and introduced the technique of lead cupellation for their refining in the Tarapacá Valley.

Copper production, which had been ongoing in the Tarapacá Valley since at least 1250 CE (Zori et al. 2013), was carried out on a larger scale during the Late Horizon and became increasingly centralized at the Inka administrative center of Tarapacá Viejo (Figure 6.2). Finally, contact with the Inka also led to the adoption of several new techniques that were incorporated into the casting stage of copper artifact production—namely, the use of a hole-in-base vessel to control the release of molten metal into molds and the use of bone ash to line casting molds and possibly even crucibles.

Silver refining using lead cupellation and the techniques related to casting copper/bronze were not part of the local Tarapacá metallurgical tradition of the Late Intermediate Period; they appear to have been introduced by the Inka. Nonetheless, these were not specifically Inka technologies: they likely originated elsewhere in the south central Andes as components of local metalworking traditions of peoples incorporated into the empire. In particular, the Titicaca basin had a long-standing tradition of silver refining using lead, dating to as early as the first centuries CE (Schultze 2013; Schultze et al. 2009), and may have been the source of the lead cupellation technology. The techniques associated with casting appear to have

originated in northwestern Argentina, where they were in use during the Late Intermediate Period (González 2004). These techniques then diffused to a number of Late Horizon Inka metal-production sites in northern Chile, most likely through the movement of metallurgical specialists mobilized by the empire (Zori and Tropper 2013; see also Plaza and Martinón-Torres 2015).

Inka Extraction of Silver-Bearing Ores at Huantajaya

The mines of Huantajaya are located on the northern Chilean coast (see Figure 6.1). Although colonial and modern mining activities have obliterated most archaeological evidence of prehistoric mining there, ethnohistoric sources relate that the silver mines of Huantajaya were an important center for the Inka extraction of silver and that these mines surpassed the better-known colonial mining centers of Porco and Potosí in their richness (Cobo 1979 [1653]:ch. 33). The mines, and surrounding mountain, appear to have been considered huacas. Father Bernabé Cobo (1979 [1653]:ch. 33) recounts that a productive vein or veins at Huantajaya were considered the sacred property of the sun and that large masses of native silver from the mine were themselves worshipped as huacas. This is corroborated by a description of the mines by Pedro Pizarro, who recounts that the region's first encomendero, Lucas Martínez Begazo, was working mines "where first they took out silver for the Inka," wherein there was "a vein that the Indians had tapped, that they said belonged to the Sun, two feet wide, all of fine silver" (Pizarro 1986 [1571]:189; my translation).

Efforts on the part of the Inka to establish a reciprocal and mutually beneficial relationship with this huaca took the form of a capacocha, or human sacrifice, carried out on nearby Cerro Esmeralda. This unusual low-altitude sacrifice is consistent with the Inka capacocha more typically found on high mountain summits, and comprised two individuals: a girl of nine and a young woman of eighteen to twenty years of age (Checura 1977). They had been strangled and then interred atop Cerro Esmeralda with a variety of offerings, including Inka-style ceramics and textiles, ornaments of gold and silver, coca leaves, food offerings, and complete shells of Spondylus princeps, or the spiny oyster, which was closely associated with water and fertility in the prehistoric Andes (Besom 2013; Checura 1977; for more on the symbolic meaning of Spondylus, see Moore and Vílchez, this volume). The relationship between these human sacrifices and the mining carried out at Huantajaya is evident in the inclusion of a miniature capacho, a basket typically used for carrying ores, which was found filled with coca leaves (Besom 2013). Silver-bearing ores removed from the mines would have borne the camaquen of this powerful huaca, simultaneously activated and propitiated through such a potent offering.

Given that the pre-Inka metallurgical tradition in the region focused on copper, the initiation of Inka mining activities at Huantajaya represents a redirection of mining efforts driven by the imperial valuation of silver ores. Ethnohistoric sources attest that the mines were worked on behalf of the Inka using labor drawn from the nearby valleys (Cobo 1979 [1653]:ch. 33). A close relationship between the Tarapacá Valley and the Huantajaya mines from even the earliest days of the colonial period—and most likely predating it—is further supported by the fact that the mines were originally called the "Tarapacá" mines by Pedro Pizarro, who wrote that they "have this name from a town that is found 90 leagues [50 km] from these mines" (Pizarro 1986 [1571]:189–192; my translation). This passage almost certainly refers to the Inka administrative center now known as Tarapacá Viejo, located in the lower Tarapacá Valley.

Refining of Silver-Bearing Ores in the Tarapacá Valley

Although Huantajaya yielded quantities of native silver, the mines also contain silver-bearing ores—such as galena (PbS), argentite (Ag_2S), chlorargyrite (AgCl), proustite (Ag_3AsS_3), and argentiferous polymetallic ores containing copper—that would have

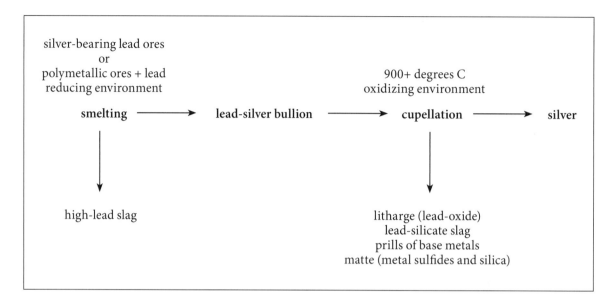

figure 6.3
Diagram of the cupellation process and the resulting products. (Diagram by Colleen Zori.)

required additional processing in order to extract the silver (Brown and Craig 1994; Maksaev et al. 2007). Because of the hyperaridity of the region surrounding Huantajaya, purification of these silver-bearing ores was carried out in nearby transverse valleys, which offered the necessary fuel for refining processes and the food and water to support the metallurgists. Full-coverage survey of 25 square kilometers of the Tarapacá Valley and excavation of eight test trenches at the administrative center of Tarapacá Viejo have yielded evidence that metallurgists here engaged in the purification of silver-bearing ores that likely derived from the Huantajaya mines (Zori and Tropper 2010, 2013). Silver refining was carried out via a process known as lead cupellation, a technique that appears to have been introduced by the Inka but that nonetheless incorporated technologies familiar to the Tarapacá metallurgists from their own local copper-working tradition. As such, the transformation of dull gray silver-bearing ores to gleaming silver metal would have joined the similar conversion of green copper-bearing ores into shiny copper as "an act of transformative creation, trapping and converting—in a sense recycling—the fertilizing energy of light into brilliant solid forms via technological choices whose efficacy stemmed

from a synergy of myth, ritual knowledge, and technical skill" (Saunders 2003: 21).

Lead played an important role in several stages of the prehistoric purification of silver-bearing minerals (Figure 6.3). In some cases, such as argentiferous galena, lead was already present in the silver ores to be smelted; in other cases, lead was added to the initial smelting of non-leaded silver ores. Lead has a strong affinity to silver and will preferentially bond with it, facilitating its separation—even if present in only small quantities—from the slag and chemically binding the silver to the main lead body (Howe and Petersen 1994; Schultze et al. 2009). Either case would have resulted in the formation of lead-silver bullion, which was then purified through cupellation. In this process, the lead-silver bullion is heated to a temperature of 900° C or higher in an oxidizing environment. This causes the removal of the lead through the formation of litharge, or lead oxide. Some lead is also volatized into the air. Silver, which does not oxidize easily, remains behind during the cupellation process and is then collected.

Cupellation sometimes takes place in a hearth lined with bone ash or another chalky material that absorbs the litharge as it forms, eventually

leaving behind an unoxidized button of pure silver (Tylecote 1964). Cupellation can also be carried out in an open ceramic vessel, or cupel. If the vessel is not lined with bone ash or other absorbent material, then silica in the clay of the ceramic vessel vitrifies when heated to such a high temperature, forming a lead silicate slag and blocking the absorption of the litharge (Bayley 1992; Söderberg 2004). Although more inefficient than absorption of the litharge by the hearth lining, the formation of this lead silicate slag nonetheless eliminates impurities from the silver by trapping base metals present in the original ores, as well as bits of the litharge. Because litharge is immiscible with the silver metal and has a lower density, however, the majority of the litharge floats to the top and can be skimmed off, leaving behind the heavier silver metal (Lechtman 1976; Tylecote 1964).

Although a handful of sites with direct evidence for the use of lead cupellation in purifying silver have been identified archaeologically throughout the Andes, beginning as early as the first century CE in the Titicaca basin (Schultze 2013; Schultze et al. 2009), we have generally had to rely on indirect indications of the use of this technology by the Inka. One approach examines changes in lead levels in lacustrine sediment cores, representing lead volatilized during the process of silver purification and subsequently deposited in these lakes. While cores from a number of highland lakes document relatively low levels of lead during the Late Intermediate Period, lead deposition—and presumably silver production—increased significantly in both quantity and geographic extent in tandem with the expansion of the Inka empire (Cooke et al. 2008). Another form of indirect evidence for the use of lead cupellation for silver extraction during the Late Horizon is the presence of between 0.5–1 percent lead in Inka-period silver artifacts from Machu Picchu and the Moquegua Valley (Gordon and Knopf 2007; Howe and Peterson 1994).

All of this amounts to indirect evidence for the process of silver production. In the Tarapacá Valley, by contrast, we have direct evidence of several stages in the Inka purification of silver. These include the use of wind-driven huayra furnaces to smelt pure lead or lead-silver bullion, and cupellation of lead-silver bullion in open ceramic vessels.

Use of Huayra Furnaces to Smelt Lead/Lead-Silver Bullion

Smelting in the Tarapacá Valley was carried out on windy hilltops using cylindrical clay furnaces known as huayras, a technology adopted prior to the Inka—probably around 1250 CE— for smelting copper (for a modern reconstruction of a huayra furnace, see Figure 6.4). Standing to a probable height of 75–85 centimeters, these furnaces had walls that were perforated with numerous circular or rectangular holes (Figure 6.5). Wind passing through them increased the rate of combustion and heat output of the burning charcoal and other fuels within, generating the high temperatures necessary for smelting. Tap holes located at the base allowed for the release of unwanted slag, and the

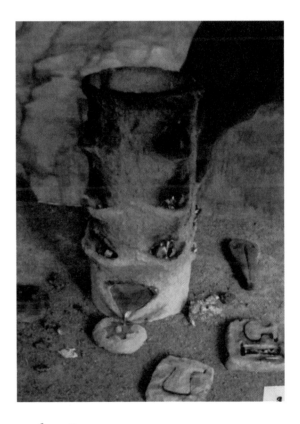

figure 6.4
Modern reconstruction of a huayra furnace at the Museo Nacional de Bolivia, La Paz. (Photograph by Colleen Zori.)

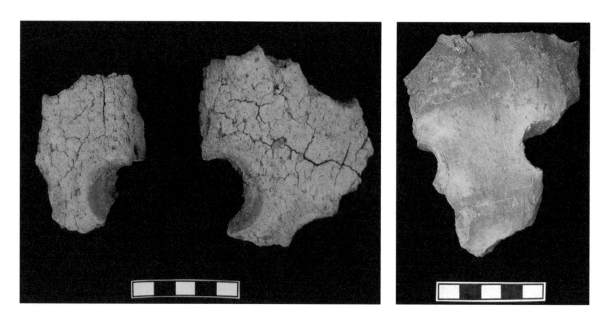

figure 6.5
Examples of furnace fragments recovered archaeologically in the Tarapacá Valley. (Photographs by Colleen Zori.)

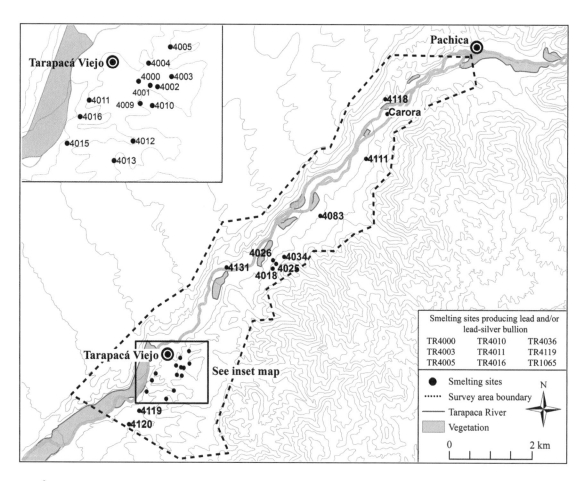

figure 6.6
Locations of smelting sites in the Tarapacá Valley. (Map by Colleen Zori.)

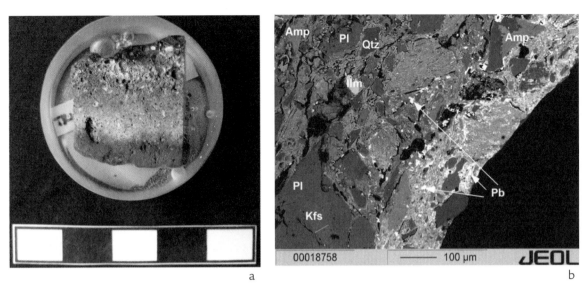

figure 6.7

Cross section of high-lead furnace fragment from TR4000 (a), with SEM image showing bright-white rim of lead-bearing glass (b). (Photograph of cross section by the author; SEM image courtesy of Dr. Peter Tropper, University of Innsbruck.)

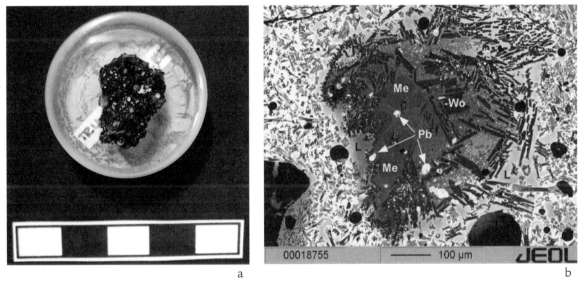

figure 6.8

Cross section of high-lead slag obtained from smelting site TR4000 (a), with SEM image showing the formation of lead (Pb) prills (b). (Photograph of cross section by the author; SEM image courtesy of Dr. Peter Tropper, University of Innsbruck.)

smelted metal pooled at the bottom of the furnace. Ethnographic studies suggest that the furnaces could be used for multiple smelts, perhaps even over several consecutive years, before deteriorating to the point that they were broken apart and a new furnace constructed (Van Buren and Mills 2005).

As has been documented ethnographically in the Andes (Rodríguez 1986) and elsewhere (see Van der Merwe and Avery 1987), successful smelting entailed propitiation of a variety of supernatural forces, and the combination of this esoteric knowledge and the mastery of the complex technologies

involved in smelting metals—what can be viewed as techné—likely endowed Tarapacá metallurgists with elevated status.

Hilltop smelting sites in the Tarapacá Valley are identifiable by the presence of hundreds and sometimes even thousands of furnace fragments, which are lined on their interior sides by slag from smelting. A total of twenty-six smelting sites were identified in the twenty-five-square-kilometer survey area (Figure 6.6). X-ray florescence analysis of 120 fragments drawn from these smelting sites revealed that the majority of the furnaces had been employed in smelting copper ores; however, a small number of fragments—just under 10 percent—demonstrated unusually high levels of lead relative to copper and other metals. These particular furnaces were likely used to smelt lead or produce lead-silver bullion for later cupellation. Spatial analysis demonstrates that the sites where those fragments were found are concentrated near the Inka administrative center of Tarapacá Viejo (see Figure 6.6).

Scanning electron microscopy and electron microprobe (SEM-EDS) analyses performed on a mounted cross section of one of these furnace fragments confirmed the presence of a thin rim of lead-bearing glass slag containing larger droplets, or prills, of pure lead metal (Figure 6.7; Zori and Tropper 2010, 2013). Three samples of high-lead slag from this site were also subjected to SEM-EDS testing, which revealed that they were primarily comprised of lead-bearing glass peppered with lead prills (Figure 6.8) and others in which copper grains were intergrown with lead (Zori and Tropper 2010, 2013). A high percentage weight of sulfur in at least one of the samples suggests that the ore smelted was lead sulfide, or galena, which supports the notion that the metallurgists were producing lead-silver bullion.

Refining of Lead-Silver Bullion by Cupellation

Carried out at two adjacent sites, Tarapacá Viejo and site TR4005, cupellation was used to purify the lead-silver bullion produced at the huayra smelting sites. Evidence for the use of this silver-refining technique comprises fragments of crucible linings and loose pieces of slag from Late Horizon contexts that contain extremely high levels of lead, with

traces of silver and other impurities that have been left behind. The cupellation vessels themselves were not produced specifically for metallurgical purposes; instead, these open vessels are repurposed ceramic bowls or fragments of larger vessels. Most are in the local Inka style—or what Costin (this volume) would likely call an "Inka-influenced" style—while the remainder date to the colonial period. Comparative analysis of these crucibles indicates that at least twenty unique cupellation vessels were recovered between these two sites.

Scanning electron microscopy of these crucibles documents the presence of lead silicate slag (Figure 6.9), while electron microprobe analysis of numerous prills in the crucible slags has determined that they comprise copper and silver intermixed (Zori and Tropper 2010, 2013). Lead oxide, or litharge, is present in high percentages in several of the samples, the result of lead oxidation and separation from the silver. Phase analyses indicate that the samples reached temperatures of 1000 °C, exceeding the minimum necessary for cupellation, while the presence of oxides of copper and lead is consistent with the interpretation that the reactions took place in the oxidizing environment also requisite for cupellation (Zori and Tropper 2013). Together, these data suggest that polymetallic bullion containing copper, lead, and silver was heated in the open-top crucibles, forming a lead silicate slag that removed some of the litharge, lead, and other base metal impurities, as well as traces of the silver. The remainder of the litharge must have been removed manually, leaving behind a button of purified silver. One final piece of evidence for the use of lead cupellation at TR4005 and Tarapacá Viejo consists of cupellation vessel fragments with detachment scars—circular depressions that indicate where the button of silver formed and was eventually removed. The implementation of complex technical skills and the esoteric knowledge needed for the rituals likely associated with these processes would have made the appearance of this silver seem almost magical, recalling the notion of the "enchantment of technology" (Gell 1992) and the impartment of camaquen to the silver metal through the techné involved in cupellation.

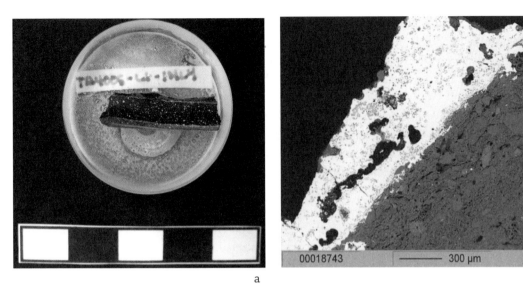

figure 6.9

Cross section of crucible from TR4005 (*a*), with SEM image showing the bright white rim of lead-bearing slag on the interior (*b*). (Photograph of cross section by the author; SEM image courtesy of Dr. Peter Tropper, University of Innsbruck.)

Silver-refining techniques appear to have been introduced by the Inka. Neither production debris indicative of silver refining nor silver artifacts themselves have been found in pre-Inka contexts in the valley. Lead smelting occurs only at sites with calibrated radiocarbon dates and ceramic assemblages that either include or are limited to the Inka period (Zori and Tropper 2010, 2013). Stylistically, all of the ceramics used in lead cupellation in the Tarapacá Valley date to either the Late Horizon or the colonial period. Because metalworkers in the valley employed vessels not specifically designed for metal production, it is likely that they chose vessels readily available at the time, supporting the assertion that the adoption of silver refining dates to the Inka period and then continued into the historic period. Finally, there is a strong spatial association between the Inka site of Tarapacá Viejo and sites used for lead smelting—all but one are located within 1.5 kilometers of the Inka administrative center (see Figure 6.6). Cupellation activities are even more spatially restricted, occurring exclusively at Tarapacá Viejo and TR4005, a site located only half a kilometer away. Together, these data speak to a strong likelihood that the technique of silver purification through lead cupellation was introduced, and probably controlled, by the Inka.

I argue that it was the same metallurgists, employing local pre-Inka smelting technology, who turned to smelting the lead-silver bullion that was later purified through cupellation. Having smelted copper ores in the huayra furnaces since their adoption around 1250 CE (Zori et al. 2013), Tarapacá metallurgists would have found it relatively simple to apply the same techniques to smelt lead metal or lead-silver bullion. Smelting lead would have actually been somewhat less challenging than producing copper, because the furnaces had only to reach the melting point of silver, which is 961.8° C, rather than the 1083° C melting point of copper. That it was the same metallurgists producing lead as those engaged in copper production is further supported by the fact that they did so at the same smelting sites: there is no smelting location devoted solely to the production of lead. Instead, copper and lead smelting were carried out side by side, by the same metallurgists at the same sites that had been in use since the second half of the Late Intermediate Period.

The technique of lead cupellation would also have been a relatively easy adoption for the

Tarapacá metallurgists. There is ample evidence at Tarapacá Viejo for the secondary refining of copper using crucibles, as demonstrated by the presence of crucible slags and open ceramic vessels with high-copper slags on their interiors (Zori et al. 2013). Lead cupellation would have applied many of the same technical skills that the Tarapacá metalworkers already possessed, including the management of temperature, maintenance of an oxidizing versus reducing environment, and manipulation of super-heated crucible vessels and molten metals.

The new technologies implemented in the Late Horizon—namely, the production of lead and its use in the purification of silver—represent local accommodation to imposed imperial demands for valuable silver metal. The expanded skill set of these camayoc and their value to the Inka also likely increased the social status of the metal workers themselves. The importance of their role in the new economic landscape is highlighted by the support accorded to them by the state: ethnohistoric documents testify to the fact that 640 families, numbering probably around 2,800 people, were moved by the Inka to the Tarapacá Valley from the Sama and Locumba Valleys, and the Tacna area, during the Late Horizon (Núñez 1984:60). These colonists were brought to the valley primarily to undertake the intensification of agricultural production needed to support the increased mining and metal production activities under the Inka.

Tarapacá Valley Copper Production in the Late Horizon

Incorporation into the Inka empire also had significant implications for the production of copper in the Tarapacá Valley. First, while initial processing technologies remained the same, contact with metallurgists mobilized by the Inka appears to have introduced two new techniques used in casting: a hole-in-base vessel for transferring molten metal into a casting mold, and the use of bone ash to line these molds. Second, the Late Horizon also saw increases in the centralization and scale of copper production.

Contact with the Inka facilitated the adoption of a new kind of metallurgical receptacle, one with a hole in the base that allowed heated metal to be released directly into a waiting casting mold (Figure 6.10; Zori et al. 2013). A plug-shaped artifact likely served as a stopper, and XRF testing of one example recovered archaeologically indicated traces of copper and tin remaining from its final use. Hole-in-base vessels and stoppers employing the same mechanism have been observed at other Inka metallurgical centers in Chile (Niemeyer et al. 1993) and Argentina (González 1997, 2002, 2010; Raffino et al. 1996).

The Inka also introduced the technique of lining molds, and perhaps cupellation vessels, with bone ash, which has been detected using X-ray diffraction as hydroxylapatite and observed as a whitish substance on mold interiors (Figure 6.11). Given the overwhelming prevalence of camelids in the faunal assemblage at Tarapacá Viejo (Zori 2011), it is likely that the ash had been derived from incinerating those bones. The bone ash would have protected the surface of the stone or ceramic mold from chemical interactions with the liquid metal, and would have caused the cast metal to contract slightly during solidification, facilitating its removal from the mold (Karageorghis and Kassianidou 1999). Phosphorous from the bone ash also served as a de-oxidizer, removing either free or combined oxygen from the copper or bronze, and thereby improving its fusibility and hardness (Karageorghis and Kassianidou 1999). Using bone ash to line metallurgical vessels is a technique that has also been documented at Inka metallurgical sites in both Chile (Niemeyer et al. 1993) and Argentina (González 2010; Raffino et al. 1996).

Inka incorporation of the Tarapacá Valley also had effects on the spatial organization and scale of copper production. In conjunction with the centralization of silver production in and around Tarapacá Viejo, we see a similar concentration of copper production activities near the site (Zori et al. 2013). Smelting sites dating to the second half of the Late Intermediate Period were found scattered throughout the valley (Figure 6.12a). They are uniformly small, characterized by a small number

figure 6.10

Interior (a), side view (b), and exterior (c) of a hole-in-base vessel and stopper (d) introduced through contact with the Inka. (Photographs by Colleen Zori.)

figure 6.11
Casting mold lined with bone ash. (Photograph by Colleen Zori.)

and low density of furnace fragments, averaging less than one hundred fragments within an area of approximately 2 to 8 square meters. In some cases, these sites probably represent debris from a single furnace. These data suggest that copper production was neither intensive nor centrally controlled by any type of political power during this period. By contrast, primary smelting sites with Inka ceramics and calibrated radiocarbon dates spanning the Late Horizon are concentrated almost exclusively within a 1.5-to 2-kilometer radius around Tarapacá Viejo, with few smelting sites yielding Inka ceramics found in the rest of the valley (Figure 6.12b). What is more, the smelting sites surrounding

Tarapacá Viejo are much larger and more intensively used than those of the preceding pre-Inka period or of contemporary smelting sites elsewhere in the valley. These large Late Horizon sites have areas that range between 15 and 50 square meters and contain upwards of 500 to 2,000 individual furnace fragments. Although a straightforward assessment of scale is complicated by uncertainty regarding the number of annual smelts per furnace or the number of consecutive years that a furnace could be used, greater numbers of fragments indicate that the smelting sites were used more intensively or over a longer period of time. That many of these larger sites date to the Late Horizon supports

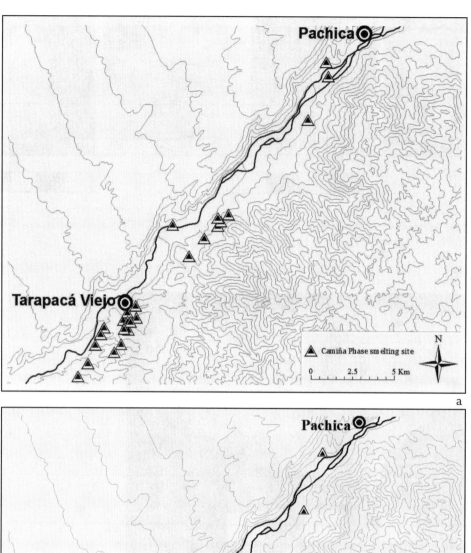

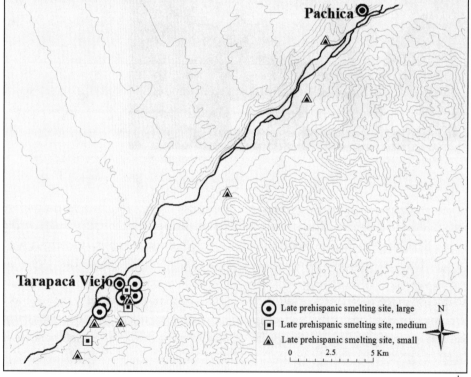

figure 6.12

a) Locations of Late Intermediate Period smelting sites, showing their dispersed distribution and uniformly small size; and b) locations of Late Horizon smelting sites, indicating an increase in site size and centralization in the area surrounding Tarapacá Viejo. (Maps by Colleen Zori.)

the interpretation that the increase in scale and output of copper metal was directly related to the Inka incorporation of the valley.

Surrendering Metals to the Empire: Feasting, Food Provisioning, and *Challa*

An important remaining question relates to the fate of the metals produced by the skilled metallurgists of the Tarapacá Valley. Excavations at Tarapacá Viejo revealed extensive evidence of the production of finished copper artifacts, including casting molds and production debris, as well as finished objects of copper and bronze that included both utilitarian tools and objects of personal adornment (Zori et al. 2013). If produced and bestowed at the behest of the Inka, these objects functioned as tangible reminders of the Inka's munificence and reinforced the notion that the relationship maintained by the emperor with his subjects was mutually beneficial. We can contrast the situation of copper with that of silver. Neither excavation at Tarapacá Viejo nor survey in the rest of the valley identified any evidence of the production of finished silver artifacts, nor of finished silver artifacts themselves (Zori and Tropper 2013). The recovery of debris from silver refining but no finished silver objects suggests that the final stages of production took place elsewhere and that the silver metal was therefore being produced for state, rather than local, consumption. This is consistent with ethnohistoric sources, which indicate that ores and precious metals from the provinces were conveyed to Cuzco and other imperial centers, where skilled metallurgical specialists attached to the state transformed them into sumptuary objects. Reducing the amount of weight by refining the silver-bearing ores through the process of cupellation observed in the Tarapacá Valley would have facilitated transport of this precious metal from the distant province to the capital.

The absence of silver artifacts in the Tarapacá Valley begs the question of how the Inka motivated the participation of the Tarapacá population in the production of silver. Data from excavations at Tarapacá Viejo suggest that the Inka may have sponsored large feasts and the provisioning of marine protein, relying on commensal hospitality to maintain the goodwill of the local people. In particular, when examining the distribution of stone tools used in food processing—namely, grinding implements and supports—there is a close spatial association between the highest concentrations of these tools and the highest concentrations of Inka ceramics (Figure 6.13; Zori 2011). We also encountered several Inka-period storage pits that contained significant quantities of *molle* seeds. Molle is one of the traditional bases of chicha production in the coastal south central Andes; elsewhere, the storage of large quantities of molle seeds has been linked to the production of this alcoholic beverage (Goldstein and Coleman 2004; Moseley et al. 2005). Finally, I have also documented a notable increase in the availability of marine protein during the Late Horizon, probably accessed via Inka-allied sites on the Pacific Coast (Zori 2011). In terms of shellfish, this translated into an almost exclusive focus on mussels, which provide a significantly larger meat package than do the multiple shellfish species (clams, oysters, scallops, and marine snails) found in Late Intermediate Period contexts. In a parallel manner, fish vertebrae were more common in Late Horizon contexts, and the fish appear to have been somewhat larger than those of the preceding periods.

I suggest, however, that the Inka were able to offer something else to the people of the Tarapacá Valley that was deemed valuable within the local ritual system: ground blue minerals. As noted previously, making offerings of liquid libations was one of the most important means of establishing a reciprocal relationship with the animate world—and huacas in particular. This practice, still maintained today, is known broadly throughout the south central Andes by the Aymara verb *ch'allar*. Conversations with modern informants in the Tarapacá Valley, however, indicate that locally, the noun *challa* has come to refer more specifically to ground blue minerals—such as turquoise, azurite, and chrysocolla, a mineraloid—that symbolize these liquid offerings made solid and eternal. Challa ranges from mineral dust to fragments up to a centimeter in diameter, but also sometimes

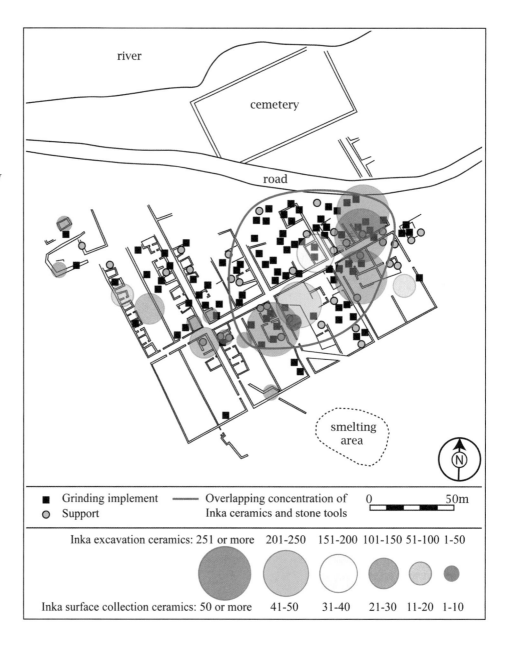

figure 6.13
Map of Tarapacá Viejo, comparing the spatial distribution of food processing tools and Inka ceramics. (Map by Colleen Zori.)

includes shaped pieces or beads, all sharing the color blue.[1] As with the ores from Huantajaya, these blue minerals may have borne with them the camaquen of their huaca mines, rendering even more potent their use as offerings.

Challa has been found in a variety of ceremonial contexts throughout northern Chile and into the adjacent highlands of Bolivia and northwestern Argentina, in sites dating from the Early Formative (1500–500 BCE) to the Late Horizon and probably into contemporary times (Carrasco 2003; Núñez 1999; Núñez et al. 2007; Pimentel 2009; Uribe and

Carrasco 1999). Concentrations of blue minerals are often encountered at potent places on the landscape, including Tarapacá Valley sites atop a high hill and in a dry ravine (Figure 6.14), suggesting that they were made as offerings to local huacas. Challa also played a vital role in rituals associated with camelid caravan trails, in which *caravaneros* made offerings for successful travel and trade (Núñez 1999; Pimentel 2009). Blue minerals are found particularly in association with *apachetas*, piles of stones and offerings situated at important summits and passes along caravan trails, including one located at the top of

figure 6.14

Examples of sites in the Tarapacá Valley that may have been huacas, receiving offerings of blue minerals known as *challa*. (Photographs by Colleen Zori.)

the final hill on the Inka road before it drops into the Tarapacá Valley (Figure 6.15). Finally, challa is often found in prehistoric cemeteries, where it appears to have played an important role in ongoing relationships between the living and the dead (Uribe and Carrasco 1999). In the Andean worldview, ancestors were recognized as once-living members of the social community who had, upon death, transitioned into a new state of being that was intensely charged with spiritual power (Kolata 2013). Just as ores carried with them the camaquen of the mine huacas, despite their change in form, the bodies of the ancestors too carried enduring camaquen and the capacity to positively influence the community of the living. Offerings of challa, presumably made to propitiate important ancestors, have been found in association with a number of cemetery sites in the Tarapacá Valley dating to the Late Intermediate Period and Late Horizon, most prominently in a cemetery/petroglyph site adjacent to the Inka center of Tarapacá Viejo.

Although green copper-bearing ores are common in the region surrounding the Tarapacá Valley, blue minerals are less common locally. There appears to have been extensive trade in minerals between northern Chile, Bolivia, and northwestern Argentina as early as the first centuries CE, and it escalated in the period immediately preceding the Inka incorporation of the region (Angiorama 2006). There is good evidence that the Inka intensified the extraction and subsequent distribution of these blue minerals. Recent work on Late Horizon mines in the Atacama Desert to the south of the Tarapacá Valley—specifically in the Rio Loa Valley, around San Pedro de Atacama, and further south in the Los Infieles area near the Elqui Valley (see Figure 6.1)—suggests that Inka efforts there were directed at extracting not metal-bearing ores but blue minerals, including turquoise and chrysocolla (Cantarutti 2013; Núñez 1999; Núñez et al. 2003; Salazar 2008).[2] These mining sites are often found in conjunction with ritual sites, including a possible capacocha on Mount Los Puntiudos (Cantarutti 2013), that attest to the reciprocal relationships with the mine huacas that the Inka state and the miners working under their charge endeavored to establish.

Although cupriferous, the blue stones obtained in these mines have very low percentages of copper. Chrysocolla, for instance, is a silicate mineraloid,

figure 6.15
Apacheta at the summit of the Inka road before it drops down into the Tarapacá Valley, where offerings of blue minerals were observed. (Photograph by Colleen Zori.)

and turquoise combines copper and aluminum phosphate, rendering both relatively difficult to smelt. Instead, their brilliant blue color and laminar structure make them ideal for the production of beads, pendants, and inlay, and as such would have had some importance in the Inka value system for the production of ornaments. It is very telling, however, that many of the Inka mining complexes in northern Chile include facilities equipped to crush, grind, and subsequently store the extracted blue minerals—unnecessary if they were being transported back to Cuzco or other imperial centers for use in lapidary production. Instead, as suggested by several of the scholars investigating these mining complexes, it is more likely that the blue minerals were essentially "reinvested" back into the reciprocal relationships maintained with local communities, who saw challa as critical to their ritual interactions with the ancestors and the living landscape (Cantarutti 2013; Salazar 2008). The abundance of challa in ritual sites in the Tarapacá

Valley suggests that the Inka may have provisioned the blue minerals mined to the south, in light of the state's appropriation of the silver produced there.

Discussion: Imperial Metal Extraction and Local Systems of Value

In sum, the Late Horizon saw several shifts in the techné of metal production in the Tarapacá Valley. While extraction of copper ores remained an important activity likely carried out in relatively small operations at the local level, miners from the Tarapacá Valley became involved in a larger and more complex relationship—economically and cosmically—with the silver mines at Huantajaya. There, skilled miners extracted silver-bearing ores to fulfill their labor obligations to the Inka state, which likely provisioned them with food, water, and the necessary tools. Mediating interactions with the Huantajaya mines were the Inka, who

attempted to establish reciprocal relations with the mountain huaca through the sacrifice of two young women on Cerro Esmeralda and by dedicating one of the largest veins of silver to the sun. Given ethnographic and ethnohistoric data from throughout the Andes, it is also likely that the miners of Tarapacá would have complemented their mining skills with efforts to propitiate this potentially dangerous huaca through frequent offerings of coca leaves, libations of chicha, and small sacrifices.

Under the Inka, refining extracted ores and subsequent metalworking also would have entailed new social relationships, as metallurgists and their production activities in the Tarapacá Valley became increasingly centralized at Tarapacá Viejo. Although the final outcome for copper remained more or less unchanged, with copper artifacts produced at Tarapacá Viejo circulating in the local political economy, the meaning of these objects would have been altered. Just as Inka influence appears to have been responsible for changes in the practical techné of the production process—including the increased centralization and scale of production and the introduction of some new techniques, like the use of bone ash and the hole-in-base receptacle for casting—so too did the empire insert itself as the source of finished copper artifacts bestowed upon provincial subjects. These objects would have carried the camaquen of the Inka himself, and served as tangible reminders of Inka generosity as well as the concurrent obligations of reciprocity and fealty.

Silver, by contrast, was so valued by the Inka that it was collected in its refined form and transported to Cuzco and other provincial administrative centers, where it was transformed into finished silver objects by full-time, state-sponsored camayocs. Inka representatives may have recognized that Tarapaqueño participation in the mining and purification segments of this production sequence could be facilitated through provisioning of the ground blue minerals requisite for communicating with huacas and the ancestors. While the Inka did not share the tradition of using ground blue minerals in ritual interactions with their huacas, this would not have been a foreign means of interacting with the supernatural. The Inka themselves were known to use ground *Spondylus* shell, known as *mullo*, in ritual contexts (see Moore and Vílchez, this volume). Perhaps one of the most dramatic uses of this pulverized shell was by processions of religious specialists, state officials, and sacrificial victims as they made their way from Cuzco to the capacocha sacrifice sites. The ground shell was mixed with llama blood and sprinkled at huacas and more generally over the earth in what has been described "as an act of communion between the Inca ruler and his dominion" (Bray et al. 2005:85, citing MacCormack 2000).

Provisioning of challa to the people of Tarapacá would have similarly implicated the Inka as an obligatory mediator in local relationships with the supernatural. In this light, the purification of silver ores—which themselves had little history in the local system of value—and the subsequent return of silver to the representatives of the empire would have been seen by Tarapacá Valley inhabitants as the reciprocal interactions driving their access to challa. In the end, the distinct conceptualizations of the inherent value of metals and minerals between the Inka and the local people of the Tarapacá Valley played a key role in facilitating the reorganization of metals production and the imperial efforts to gain access to precious silver metal. Meanwhile, this metal would have made its way into the heart of the Inka empire, still bearing the value imbued by the camaquen of its powerful huaca of origin and perhaps even of the skilled metallurgists of Tarapacá who had purified it.

Acknowledgments

These investigations were conducted under the Tarapacá Valley Archaeological Project (TVAP) and Proyecto FONDECYT 1030923. Financial support was provided by the National Science Foundation; the Cotsen Institute of Archaeology; the Institute of American Cultures at the University of California, Los Angeles; and the UCLA Department of Anthropology. The SEM-EDS analysis was carried out by Dr. Peter Tropper of the University of Innsbruck.

My sincerest gratitude to Mauricio Uribe, Ran Boytner, David Scott, Charles Stanish, and the students of UCLA and the Universidad de Chile for their help. I would also like to thank Cathy Costin for her invitation to participate in the 2013 Dumbarton Oaks Pre-Columbian Symposium and my fellow participants for their invaluable comments and feedback.

NOTES

1 Minerals on the greenish end of the spectrum—bluish-green and greenish-blue—are also found in these challa deposits.

2 Gabriel Cantarutti (personal communication, 2013) cautions that the apparent Inka emphasis on blue minerals in this region could result from the fact that we have a greater chance of finding turquoise and chrysocolla mines because they have less economic value at present than do mines of copper, silver, and gold. Evidence for the prehistoric exploitation of deposits of these metals is more difficult to find; traces have been obliterated by later colonial, republican, and modern mining operations.

REFERENCES CITED

Angiorama, Carlos

2006 ¿Mineros quebradeños o altiplánicos? La circulación de metales y minerales en el extremo noroccidental de Argentina (AD 1280–1535). *Intersecciones en antropología* 7:147–161.

Bayley, Justine

1992 Non-ferrous Metalworking in England, Late Iron Age to Early Medieval. PhD dissertation, University of London.

Besom, Thomas

2013 *Inka Human Sacrifice and Mountain Worship: Strategies for Empire Unification*. University of New Mexico Press, Albuquerque.

Betanzos, Juan de

1996 [1557] *Narrative of the Incas*. Translated by Roland Hamilton and Dana Buchanan. University of Texas Press, Austin.

Berthelot, Jean

1986 The Extraction of Precious Metals at the Time of the Inca. In *Anthropological History of Andean Polities*, edited by John Murra, Nathan Wachtel, and Jacques Revel, pp. 69–88. Cambridge University Press, Cambridge.

Bouysse-Cassagne, Thérèse

2004 El sol de adentro: *Wakas* y santos en las minas de Charcas y en el Lago Titicaca (siglos XV a XVII). *Boletín de arqueología PUCP* 8:59–97.

Bray, Tamara

2009 An Archaeological Perspective on the Andean Concept of *Camaquen*: Thinking Through Late Pre-Columbian *Ofrendas* and *Huacas*. *Cambridge Archaeological Journal* 19(3):357–366.

Bray, Tamara, Leah Minc, Maria Constanza Ceruti, Jose Antonio Chavez, Ruddy Perea, and Johan Reinhard

2005 A Compositional Analysis of Pottery Vessels Associated with the Inca Ritual of *Capacocha*. *Journal of Anthropological Archaeology* 24:82–100.

Brown, Kendall, and Alan Craig

1994 Silver Mining at Huantajaya, Viceroyalty of Peru. In *In Quest of Mineral Wealth: Aboriginal and Colonial Mining and Metallurgy in Spanish America*, edited by Alan Craig and Robert West, pp. 303–327. Louisiana State University Press, Baton Rouge.

Cantarutti, Gabriel

2013 Mining under Inca Rule in North-Central Chile: The Los Infieles Mining Complex. In *Mining and Quarrying in the Ancient Andes: Sociopolitical, Economic, and Symbolic Dimensions*, edited by Nicholas Tripcevich and Kevin Vaughn, pp. 185–211. Springer, New York.

Carrasco, Carlos

2003 Los artefactos de molienda durante los periodos Intermedio Tardío y Tardío en San Pedro de Atacama y Loa Superior. *Estudios atacameños* 25:35–53.

Checura, Jorge

1977 Funebria incaica en el Cerro Esmeralda. *Estudios arqueológicos* 5:125–141.

Cieza de León, Pedro de

1986 [1553] *Crónica del Perú*. Pontifica Universidad Católica del Perú, Lima.

Cobo, Bernabé

1979 [1653] *History of the Inca Empire: An Account of the Indians' Customs and Their Origin, Together with a Treatise on Inca Legends, History, and Social Institutions*. Translated by R. Hamilton. University of Texas Press, Austin.

1990 [1653] *Inca Religion and Customs*. Translated by Roland Hamilton. University of Texas Press, Austin.

Cooke, Colin, Mark Abbott, and Alexander Wolfe

2008 Late-Holocene Atmospheric Lead Deposition in the Peruvian and Bolivian Andes. *The Holocene* 18(2):353–359.

Cummins, Thomas

2002 *Toasts with the Inca: Andean Abstraction and Colonial Images on Quero Vessels*. University of Michigan Press, Ann Arbor.

Dean, Carolyn

2010 *A Culture of Stone: Inka Perspectives on Rock*. Duke University Press, Durham, N.C.

Gell, Alfred

1992 The Technology of Enchantment and the Enchantment of Technology. In *Anthropology, Art, and Aesthetics*, edited by Jeremy Coote and Anthony Shelton, pp. 40–63. Oxford University Press, Oxford.

Goldstein, David, and Robin Coleman

2004 *Schinus Molle L.* (Anacardiaceae) Chicha Production in the Central Andes. *Economic Botany* 58(4):523–529.

González Holguín, Diego

1952 [1608] *Vocabulario de la lengua general de todo el Perú llamada Qquichua, o del Inca*. Imprenta Santa María, Lima.

González, Luis

1997 Cuerpos ardientes: Interacción surandina y tecnología metalúrgica. *Estudios atacameños* 14:175–188.

2002 Hereduras el bronce: Incas y metalurgia en el sur del valle de Yocavil. *Intersecciones en antropología* 3:54–69.

2004 *Bronces sin nombre: La metalurgia prehispánica en el noroeste Argentino*. Fundación CEPPA, Buenos Aires.

2010 Fuegos sagrados: El taller metalúrgico del Sitio 15 de Rincón Chico (Catamarca, Argentina). *Boletín del Museo Chileno de Arte Precolombino* 15(1):47–62.

Gordon, Robert, and Robert Knopf

2007 Late Horizon Silver, Copper, and Tin from Machu Picchu, Peru. *Journal of Archaeological Science* 34:38–47.

Gose, Peter

1986 Sacrifice and the Commodity Form in the Andes. *Man* 21(2):296–310.

Hosler, Dorothy

1994 *The Sounds and Colors of Power: The Sacred Metallurgical Tradition of Ancient West Mexico*. The MIT Press, Cambridge, Mass.

2009 West Mexican Metallurgy: Revisited and Revised. *Journal of World Prehistory* 22:185–212.

Howe, Ellen, and Ulrich Petersen

1994 Silver and Lead in the Late Prehistory of the Mantaro Valley, Peru. In *Archaeometry of Pre-Columbian Sites and Artifacts*, edited by David Scott and Pieter Meyers, pp. 183–197. The Getty Conservation Institute, Los Angeles.

Karageorghis, Vassos, and Vasiliki Kassianidou

1999 Metalworking and Recycling in Late Bronze Age Cyprus—The Evidence from Kition. *Oxford Journal of Archaeology* 18(2):171–188.

Kolata, Alan

 2013 *Ancient Inca*. Cambridge University Press, New York.

Lechtman, Heather

 1976 A Metallurgical Site Survey in the Peruvian Andes. *Journal of Field Archaeology* 3(1):1–42.

 1984 Andean Value Systems and the Development of Prehistoric Metallurgy. *Technology and Culture* 25(1):1–36.

 1993 Technologies of Power: The Andean Case. In *Configurations of Power: Holistic Anthropology in Theory and Practice*, edited by J. S. Henderson and Patricia Netherly, pp. 244–280. Cornell University Press, Ithaca, N.Y.

 2007 The Inka, and Andean Metallurgical Tradition. In *Variations in the Expression of Inka Power*, edited by Richard Burger, Craig Morris, and Ramiro Matos Mendieta, pp. 313–355. Dumbarton Oaks Research Library and Collection, Washington D.C.

MacCormack, Sabine

 1991 *Religion in the Andes: Vision and Imagination in Early Colonial Peru*. Princeton University Press, Princeton, N.J.

 2000 Processions for the Inca: Andean and Christian Ideas of Human Sacrifice, Commission and Embodiment in Early Colonial Peru. *Archiv für Religionsgeschichte* 2, Band, Heft (1):110–140.

Maksaev, Victor, Brian Townley, Carlos Palacios, and Francis Camus

 2007 Metallic Ore Deposits. In *The Geology of Chile*, edited by Teresa Moreno and Wes Gibbons, pp. 179–199. The Geological Society, London.

Mills, Barbara

 2004 The Establishment and Defeat of Hierarchy: Inalienable Possessions and the History of Collective Prestige Structures in the Pueblo Southwest. *American Anthropologist* 106(2):238–251.

Moore, Sally Falk

 1958 *Power and Property in Inca Peru*. Columbia University Press, New York.

Moseley, Michael, Donna Nash, Ryan Patrick Williams, Susan de France, Ana Miranda, and Mario Ruales

 2005 Burning Down the Brewery: Establishing and Evacuating an Ancient Imperial Colony at Cerro Baul, Peru. *Proceedings of the National Academy of Sciences of the United States of America* 102(48):17264–17271.

Murra, John V.

 1980 [1962] *The Economic Organization of the Inka State*. JAI Press, Greenwich, Conn.

Nash, June

 1993 *We Eat the Mines and the Mines Eat Us: Dependency and Exploitation in Bolivian Tin Mines*. Columbia University Press, New York.

Niemeyer, Hans, Gaston Castillo, and Miguel Cervellino

 1993 Estrategia del dominio inca en el valle de Copiapó. *Actas del XII Congreso Nacional de Arqueología Chilena* 1:333–371.

Núñez, Lautaro

 1999 Valoración minero-metalúrgica circumpuneña: Menas y mineros para el Inka rey. *Estudios atacameños* 18:177–221.

Núñez, Lautaro, Carolina Agüero, Bárbara Cases, and Patricio de Souza

 2003 El campamento minero Chuquicamata-2 y la explotación cuprífera prehispánica en el Desierto de Atacama. *Estudios atacameños* 25:7–34.

Núñez, Lautaro, Patricio de Souza, Isabela Cartajena, and Carlos Carrasco

 2007 Quebrada Tulan: Evidencias de interacción circumpuñena durante el formativo temprano en el sureste de la cuenca de Atacama. In *Producción y circulación prehispánicas de bienes en el surandino*, edited by Axel Nielsen, M. Clara Rivolta, Verónica Seldes, María Vásquez, and Pablo Mercolli, pp. 287–303. Editorial Brujas, Cordoba.

Núñez, Patricio

 1984 La antigua aldea de San Lorenzo de Tarapacá, norte de Chile. *Chungará, revista de antropología chilena* 13:53–65.

Owen, Bruce

2001 The Economy of Metal and Shell Wealth Goods. In *Empire and Domestic Economy*, edited by Terry D'Altroy and Christine Hastorf, pp. 265–293. Kluwer Academic/Plenum Press, New York.

Pimentel, Gonzalo

2009 Las huacas del tráfico: Arquitectura ceremonial en rutas prehispánicas del desierto de atacama. *Boletín del Museo Chileno de Arte Precolombino* 14(2):9–38.

Pizarro, Pedro

1986 [1571] *Relación del descubrimiento y conquista de los reinos del Perú*. Pontificia Universidad Católica del Perú, Lima.

Platt, Tristan

1983 Conciencia andina y conciencia proletaria: *Qhuyaryna* y *aylluruna* en el norte de Potosí. *Revista latinoamericana de historia económica y social* 2:47–73.

Plaza, María Teresa, and Marcos Martinón-Torres

2015 Metallurgical Traditions under Inka Rule: A Technological Study of Metals and Technical Ceramics from the Aconcagua Valley, Central Chile. *Journal of Archaeological Science* 54:86-98.

Raffino, Rodolfo, Ruben Iturriza, Anahi Iacona, Aylen Caparelli, Diego Gobbo, Victoria Montes, and Rolanda Vásquez

1996 Quillay: Centro metalúrgico inka en el Noroeste argentino. *Tawantinsuyu* 2:59–69.

Rodríguez, Luis

1986 Precolumbian Metallurgy of the Southern Andes: A Regional Synthesis. In *Precolumbian American Metallurgy*, pp. 404–417. Banco de la Republica, Bogota.

Ruíz Arrieta, A. G.

2011 El *Quaraku* or *wilancha*: Prácticas y creencias religiosas entre los mineros de Huanuni, Bolivia. *(Con)textos: Revista d'antropologia i investigació social* 5:63–77.

Salazar, Diego

2008 La producción minera en San José del Abra durante el Periodo Tardío Atacameño. *Estudios atacameños* 36:43–72.

Salazar, Diego, and Hernan Salinas

2008 Tradición y transformaciones en la organización de los sistemas de producción mineros en el norte de Chile prehispánico: San José del Abra, siglos I al XVI d.C. In *Mina y metalurgia en los Andes del Sur desde la época prehispánica hasta el siglo XVII*, edited by Pablo Cruz and Jean-Joinville Vacher, pp. 163–200. Imprenta-Editorial Tupac Katari, Sucre.

Sallnow, M. J.

1989 Precious Metals in the Andean Moral Economy. In *Money and the Morality of Exchange*, edited by Jonathan Parry and Maurice Bloch, pp. 209–231. Cambridge University Press, Cambridge.

Saunders, Nicholas

1998 Stealers of Lights, Traders of Brilliance: Amerindian Metaphysics in the Mirror of Conquest. *Res: Anthropology and Aesthetics* 33:225–252.

2003 "Catching the Light": Technologies of Power and Enchantment in Pre-Columbian Goldworking. In *Gold and Power in Ancient Costa Rica, Panama, and Colombia*, edited by Jeffery Quilter and John W. Hoopes, pp. 15–47. Dumbarton Oaks Research Library and Collection, Washington, D.C.

Schultze, Carol A.

2013 Silver Mines of the Northern Lake Titicaca Basin. In *Mining and Quarrying in the Ancient Andes: Sociopolitical, Economic, and Symbolic Dimensions*, edited by Nicholas Tripcevich and Kevin Vaughn, pp. 231–251. Springer, New York.

Schultze, Carol A., Charles Stanish, David A. Scott, Thilo Rehren, Scott Kuehner, and James K. Feathers

2009 Direct Evidence of 1,900 Years of Indigenous Silver Production in the Lake Titicaca Basin of Southern Peru. *Proceedings of the National Academy of Sciences* 106(41):17280–17283.

Salomon, Frank

1991 Introductory Essay: The Huarochiri Manuscript. In *The Huarochiri Manuscript: A Testament of Ancient and Colonial Andean Religion*, edited by Frank Salomon and George L. Urioste, pp. 1–38. University of Texas Press, Austin.

Sillar, Bill

1996 The Dead and the Drying: Techniques
 for Transforming People and Things in
 the Andes. *Journal of Material Culture*
 1(3):259-289.

2009 The Social Agency of Things? Animism
 and Materiality in the Andes. *Cambridge
 Archaeological Journal* 19(3):367–377.

Söderberg, Anders

2004 Metallurgic Ceramics as a Key to Viking
 Age Workshop Organization. *Journal of
 Nordic Archaeological Science* 14:115–124.

Tylecote, Ronald

1964 Roman Lead Working in Britain. *The
 British Journal for the History of Science*
 2(1):25–43.

Uribe, Mauricio, and Carlos Carrasco

1999 Tiestos y piedras talladas de Caspana:
 La producción alfarera y lítica en el
 período tardío del Loa Superior. *Estudios
 Atacameños* 18:55–71.

Van Buren, Mary, and Barbara H. Mills

2005 *Huayrachinas* and *Tocochimbos*:
 Traditional Smelting Technology of
 the Southern Andes. *Latin American
 Antiquity* 16(1):3–25.

Van Buren, Mary, and Ana Maria Presta

2010 The Organization of Inka Silver
 Production in Porco, Bolivia. In
 *Distant Provinces in the Inka Empire:
 Toward a Deeper Understanding of
 Inka Imperialism*, edited by Michale
 Malpass and Sonia Alconini, pp. 173–192.
 University of Iowa Press, Iowa City.

Van der Merwe, Nikolaas J., and Donald H. Avery

1987 Science and Magic in African
 Technology: Traditional Iron Smelting
 in Malawi. *Africa* 57(2):143–172.

Zori, Colleen

2011 *Metals for the Inka: Craft Production and
 Empire in the Quebrada de Tarapacá,
 Northern Chile.* PhD dissertation,
 University of California, Los Angeles.

Zori, Colleen, and Peter Tropper

2010 Late Prehispanic and Early Colonial
 Silver Production in the Quebrada de
 Tarapacá, Northern Chile. *Boletín del
 Museo Chileno de Arte Precolombino*
 15(2):65–87.

2013 Silver Lining: Evidence for Inka Silver
 Refining in Northern Chile. *Journal of
 Archaeological Science* 40(8):3282–3292.

Zori, Colleen, Peter Tropper, and David Scott

2013 Copper Production in Late Pre-
 hispanic Northern Chile. *Journal of
 Archaeological Science* 40:1165–1175.

New World Metallurgy

A Comparative Study of Copper Production in the South Central Andes and West Mexico

BLANCA MALDONADO

THE DEVELOPMENT OF TECHNOLOGY IN THE New World followed its own path, both similar to and different from that of the Old World. The techné of metallurgy and metalworking emerged in the Andean region of South America. Subsequently, manifestations of the knowledge and technology gradually spread from south to north, as far as Mesoamerica, developing into local technological traditions. Copper and its alloys were the materials of choice for most Pre-Columbian metallurgical industries. These materials were fashioned mainly as ornaments used in religious ceremonies and for the enhancement of elite cultural status. Important aspects of the operational sequence for metal production can be inferred from a combination of ethnohistorical, archaeological, and archaeometric data. This chapter comparatively studies this metallurgical chain—including ore sources, mining technology, mineral processing, and extractive metallurgy—as well as the social and technological choices that governed this production in different regions in South America and

Mesoamerica, with an emphasis on northern Chile and west Mexico.

One of the principles of comparative analysis is the use of primary data (Drennan and Peterson 2006), which I have collected from two regions: central Michoacán, in western Mexico, and the San Pedro de Atacama region of northern Chile, in the south central Andes. I researched the former in the context of my doctoral research and the latter during more recent postdoctoral work. In order to deal with issues of data-set comparability, I have complemented this study with information collected by other regional specialists, as well as with relevant historical and ethnohistorical sources. I have focused on patterns copper production in these two areas, an industry with presumably the same southern Andean origin. This comparative study has found general similarities in the path of development of the industry, as well as important temporal and regional differences. I make no attempt to treat the full range of topics that might be considered within a comparative framework for

the mining and metallurgy of these two regions; rather, I have chosen to describe and analyze the different components of the production systems of metal goods to gain a deeper understanding of their meaning and value within their cultural contexts.

New World Metallurgy: Socio-technological Background

Some scholars have suggested that indigenous societies in the Americas share certain ideological precepts (see e.g., Hosler 1988a; Lathrap 1982; Willey 1962). Because technologies represent systems of beliefs (Lechtman 1975), the symbolism of Amerindian metallurgy has to also be considered as a part of the production process, where a particular worldview provided a structure for comprehending and controlling the world (Falchetti 2003). Substantial evidence suggests that most, if not all, Pre-Columbian societies perceived their universe as infused with spiritual brilliance, which manifested itself in natural phenomena—such as water, ice, rainbows, and celestial bodies—and in natural materials, including minerals, feathers, shells, and artifacts made of such matters. While the worldviews and the material and technological choices that underlay the significance of brilliance varied through time, and from culture to culture, the fundamental notion of this visual attribute appears to have been remarkably consistent (Saunders 1998, 1999, 2003).

Native societies throughout the Americas held a common worldview: light, bright colors, and shiny matter were reflections of the supernatural (Saunders 1998, 1999, 2003; for examples, see Furst 1976:46, 131; Kensinger 1995:221; Stuart 2010:288–289, 292; as well as Zori, this volume). Indigenous conceptions of brilliance were linked to notions of a mirror-image realm inhabited by bright spirits and immanent forces. This mirrored dimension was revealed to ritual practitioners, priests, and rulers in luminous visions (Saunders 1998, 2003; see also Falchetti 2003; Furst 1976:46, 131; Kensinger 1995:221). The fundamental structure of this worldview had consequences for the investment

of meaning in the production of material culture. Making shiny objects involved transforming the energy of light into substantial forms, by means of technological choices that were connected to a combination of ideology, ritual knowledge, and technical skill. Hence, meaning and value were granted to the production, exchange, and social and ritual display of brilliant objects (Falchetti 2003; Saunders 2003).

The production of metal and other prestige goods in the Pre-Columbian world was not only economic but also political and ideological in nature, often imbedded in specific publicly significant and value-laden acts or events (Hosler 1994; Lechtman 1975). Metalworking was conducted through the ritually defined manipulation of intangible powers, aided by the application of personal qualities and skills, believed to also derive from supernatural sources. By extension, craft producers became vehicles not only for technical knowledge but also—and especially—for symbolic qualities and for supernaturally or ancestrally sanctioned ethics, political ideology, and mythology. Moreover, by their own acts of creation and transformation, smiths and their patrons also actively maintained the vital links believed to connect the community and its people with the supernatural energies of the universe (see Helms 1993). In the following pages, I comparatively explore the technical choices made by Amerindian metallurgists and metalworkers, and demonstrate how they were reflections and expressions of cultural values and interests, as well as of environmental and material variables.

The *Chaîne Opératoire* of New World Metallurgy

The development of metallurgy required, from the start, an empirical understanding of myriad complex technological processes. Many individual stages are involved, and numerous choices need to be made to successfully transform metalliferous ore into finished metal objects. Each step can influence the final product. As such, the scientific

approach, which has dominated research in early metal production, has been essential in elucidating this production sequence. Technology, however, is pragmatic, concrete, variable, and context dependent (see Flyvbjerg 2001:56). As technology, metallurgy thus embodies social values and beliefs. Therefore, the study of the nature of early metal extraction and transformation requires a systemic approach that encompasses each step of the manufacturing process, including the selection of an ore or ore source; ore extraction and processing; smelting, melting, and alloying; casting and design of objects; circulation and use of these objects; and, throughout this chain, a knowledge of the required forms and symbols.

Despite gaps in our understanding of New World metallurgy, the production sequences of copper can be reconstructed and analyzed using the concept of *chaîne opératoire* (Leroi-Gourhan 1964). This theoretical-methodological approach offers an analytical framework for understanding techné—that is, the technical processes, their outcomes, and the choices behind them, but also the social, economic, political, and ritual contexts in which these technical systems took place. A relative reconstruction of Pre-Columbian metallurgy is only possible through the use of multiple data sources, including archaeological and ethnohistorical evidence, scientific and technological analyses, and cross-cultural comparisons. In studying the operational sequence of producing metal artifacts from mineral ore, the interplay between technology and culture could be observed from the moment the raw material had to be procured.

Prospecting and Mining

The vast geographical area that comprises Mesoamerica and the Andean region is characterized by high, precipitous mountain ranges, the Sierra Madres in Mexico and northern Central America, and the Andes in South America, which are part of the great continental chain of mountains known as the American Cordillera (Cunningham et al. 2005). This almost continuous sequence of mountain ranges holds many of the world's largest ore deposits, which represent the most important sources in the Western Hemisphere of some base and precious metals, including copper, lead, zinc, silver, and gold (Macfarlane 1999). Pre-Columbian populations made various uses of the wealth of minerals available to them. Metals—mainly copper, silver, and gold—were used in the Andes as early as the second millennium BCE (Aldenderfer et al. 2008; Petersen 1970; Schultze et al. 2009) to produce tools, adornments, and religious objects. In Mesoamerica this technology came much later, between 600 and 800 CE (Hosler 1994).

Mining, in its broadest sense, includes the various processes for extracting minerals from the earth. During these operations, miners face myriad technological choices, such as where to dig; what minerals are worth recovering and processing; whether such minerals will need to be combined with other materials in order to be useful; how to support the roof of the mine to prevent collapse, deal with presence of water, and reduce poisoning effects on miners; and how to transport the extracted minerals for further processing. Thus, mining requires specialized knowledge of the properties of a wide range of materials (Roddick and Klarich 2013; Vaughn and Tripcevich 2013). Although, on an economic level, the characteristics of the material being extracted largely determine the location of a mine, research suggests that in traditional societies, the choice of mine position often had ritual and symbolic dimensions, which may not directly reflect on the geological deposit or be the most cost-effective way of extracting the mineral (Vaughn and Tripcevich 2013).

In many cultures, materials from the earth simultaneously contain physical presence, social linkages to places where mining occurs, and sacred power derived from an animated landscape (Topping and Lynott 2005:181–191; Vaughn and Tripcevich 2013). In both the Andes and Mesoamerica, caves and mines were considered sacred. In the Andes, ethnohistoric sources often describe mines as *huacas*—sacred places or objects, manifestations of both the natural and the supernatural world (e.g., Cobo 1890 [1653]). Ethnographic work by sociocultural anthropologists has shown that this conception is still pervasive (for a full

discussion, see Vaughn and Tripcevich 2013; also Zori, this volume, and Janusek and Williams, this volume). In Mesoamerica, religious symbolism has important terrestrial components, and these are most often manifested as mountains and caves, which are the natural features considered to be the most sacred (Prufer and Brady 2005; Stuart 1997; Stuart and Houston 1994:86; Vogt 1969, 1997a, 1997b). Underground places, such as caves and mines, were thought to be entrances to the underworld, the realm of night and darkness, governed by spirits and deities of life, death, and fertility (Cajas 2009; Heyden 2005; Manzanilla 1994).

Mining in the South Central Andes

The Andes, the second-highest mountain range in the world, are particularly rich in mineral resources and have witnessed a long tradition of metallurgy and mining. Gold, silver, and tin abound, but copper was—and continues to be— the most important metal produced in the south central Andes (Cooke et al. 2008). Although copper ore is distributed throughout the broad region (Figure 7.1), the richest veins of copper are found in the Atacama Desert, where they occur as a product of ancient hydrothermal actions (Sillitoe 1988:89). Today, these veins are often seen in profile as exposed green mineral outcrops.

Evidence of prehispanic mining operations (Bird 1979; Iribarren 1972–1973) suggests that mineral exploitation took place as far back as the Early Ceramic period (1000 BCE to 500 CE) in the south central Andes. In the late nineteenth century, the discovery of the "Copper Man"—a desiccated body of a native miner killed by the collapse of a tunnel roof—provided some evidence of the ancient mining techniques. The body was surrounded by various tools: a hafted hammerstone, wooden pry sticks, and a slate-bladed shovel with a wooden handle (Bird 1979).

Over time, mining technology remained relatively simple in the Pre-Columbian Andes. Hard minerals were extracted using a fairly standard technology. Stone tools from the Peruvian North Coast (Shimada 1994), South Coast (Burger 2013), and Chile (Salazar et al. 2010) bear a resemblance to each other, and all closely correspond to the Chuquicamata "Copper Man's" tool kit (Bird 1979:figs. 3–10; Craddock et al. 2003). Although the tool kit and mining technology appeared to be similar across a broad region of the Andes, myriad techniques were employed to allow access to deposits, prevent erosion or collapse, and reduce the risks associated with mining (Vaughn and Tripcevich 2013). Among the earliest mining evidence in the New World, lateral buttressing allowed for the exploitation of trench mines (Salazar et al. 2011a).

Spanish chronicles offer some clues about the organization of mining, but direct evidence on the topic has been limited. Mining seems to have been a seasonal activity (Van Buren and Presta 2010). Berthelot (1986:74) states that in high altitudes, mining was done in the summer; only where the weather permitted was it carried out year-round. Some authors argue that mining was a small-scale itinerant activity (e.g., Lechtman 1976:41), and there is substantial archaeological evidence for an intense traffic of minerals via seasonal caravan routes (Núñez 1999; Salazar et al. 2001).

Recent evidence, however, suggests that in some contexts mining in the Andes was large scale and possibly state controlled (Vaughn and Tripcevich 2013). For example, Salazar (2008) has demonstrated that the Inka radically changed the organization of copper mining in the Atacama Desert by adding administrative facilities and controlling the distribution of food and water in the region. Furthermore, Schultze and colleagues (2009) argue, based on excavations in the Lake Titicaca basin, that metallurgy was complex and performed on a large scale prior to the Middle Horizon Tiwanaku. Analysis of levels of lead and other metals in lake sediments also suggests that mining and metallurgical processing increased during the Middle Horizon with the advent of the Tiwanaku state and the Wari empire (Abbott and Wolf 2003; Cooke et al. 2008; Cooke et al. 2009).

Ethnohistoric documents indicate that during the Late Period (ca. 1400–1540 CE), the Inka empire exercised a high level of control over mines in Tawantinsuyu. The Inka monopolized the empire's richest mines, which were exploited through *mit'a*

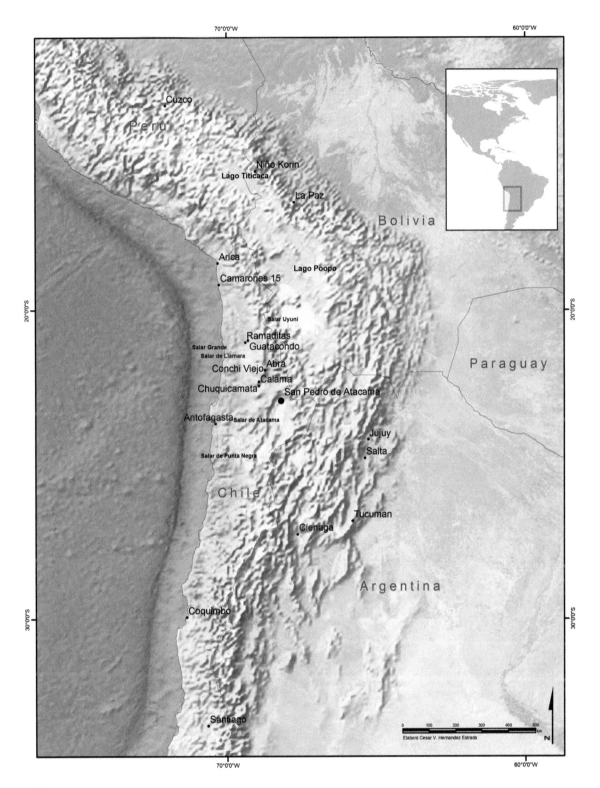

figure 7.1

The Atacama area in the context of the south central Andes. (Map by César Hernández.)

labor (Vaughn and Tripcevich 2013). The centralized power, however, did not claim all mines; some were exploited under the auspices of local *caciques* so that they would have appropriate gifts to give to the Inka (Cobo 1964 [1653]:249). Thus, while the largest and most productive mines were reserved for the Inka, smaller "community" mines were scattered around the empire and were subject to various levels of elite control (Berthelot 1986:72). Even with the ostensible autonomy given to local lords, the Inka installed supervisors who were responsible for monitoring mining and for collecting and

weighing ore in the provinces (D'Altroy 2002:301). Ultimately, the Inka had absolute authority over the size of the workforce and the collection of the minerals (Berthelot 1986:74).

West Mexican Mining

As is the case for the south central Andes, most of the west Mexican territory lies within a rich metalliferous zone (Hosler 1994; Ostroumov and Corona-Chávez 2000; Ostroumov et al. 2002; Figures 7.2 and 7.3). The variety of metal ores available in this zone is relatively high. Copper, tin,

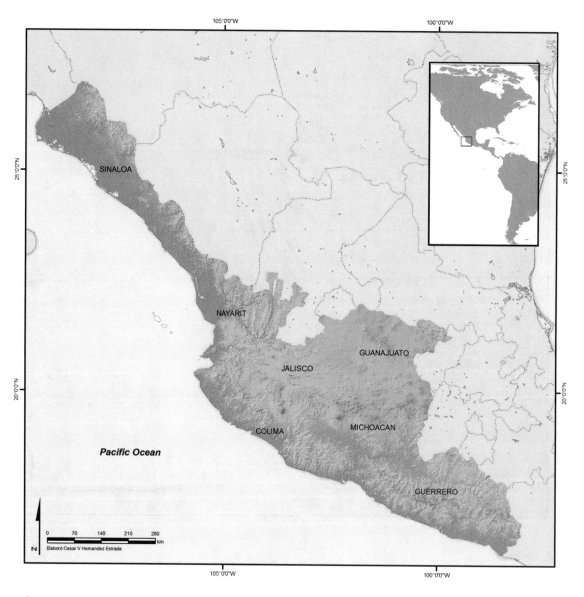

figure 7.2
West Mexico in the context of Mesoamerica. (Map by César Hernández.)

figure 7.3
The precious- and base-metal province of Mexico. (Map by César Hernández, based on data from the Mexican Geological Survey, http://www.sgm.gob.mx.)

lead, silver, and gold, as well as a number of alloys (Hosler 1994), were produced in prehispanic west Mexico. From the standpoint of the Mesoamerican peoples, however, copper was the most important metal, and it played a prominent role in the early metallurgy of Mesoamerica (Barrett 1987; Hosler 1994). Nevertheless, apart from references to several mines in Spanish colonial sources (e.g., Grinberg 1995; Hosler 1994; Pollard 1987; Roskamp 2001, 2004; Warren 1968), little is known about copper mining in Mesoamerica.

West Mexican mining seems to have followed a pattern similar to the one observed in the Andes. During the 1940s, Pedro Hendrichs (1940:315–316; 326; 1943–1944:1:194 ff.) located a number of open-pit mines in western Guerrero; they consisted essentially of large holes dug into hillsides in order to follow oxidized veins of copper. Evidence indicates that the tools used to excavate the mines and extract the ores comprised mainly stone hammers, probably made of diorite and andesite, and hafted

with wood. Hendrichs also reported the presence of large stone mortars, either portable or fixed on the mines' walls. Other implements include bone scrapers and digging sticks, ceramic ladles, obsidian blades, and wooden wedges. Remains of pine-wood torches and vegetal fibers impregnated with resin; baskets; ropes; and ceramic pots have also been recorded. Unfortunately, no systematic investigations of these features have been carried out in recent years.

Ethnohistoric documents from early colonial times represent a significant data source about mining and metallurgy in west Mexico. One such example is the *Legajo 1204* (dated to 1533), a colonial manuscript dealing with copper mines in Michoacan (Warren 1968). The document confirms that several mines were exploited for copper prior to the Spanish arrival (Hosler 1994; Pollard 1987; Warren 1989). Grinberg (1990, 1995, 1996, 2004), based on interpretations of indigenous accounts in the *Legajo*, conducted explorations near the town

figure 7.4
Mining area in the central Balsas River basin. (Map by César Hernández, based on data from the Mexican Geological Survey, http://www.sgm.gob.mx.)

of Churumuco and corroborated the existence of prehispanic copper mines there. The operations were open-pit mines, which seem to have been excavated using wooden or antler tools. The *Legajo* states that the indigenous people from Churumuco collected greenstones from the mines and extracted copper from them. This suggests that the mineral exploited was malachite, a copper carbonate. Presence of this mineral on the surface supports this idea (Grinberg 1990, 1996, 2004).

By 1450 CE, the Tarascan empire of Michoacan had become the most important center of prehispanic metalworking in Mesoamerica. Metallurgy played a significant role in the structure of political and economic power in the Tarascan empire.

Apparently, the bulk of the metal that moved into the Tarascan territory came in the form of regularly delivered tribute (see Paredes 1984; Pollard 1982, 1987). The primary supplier of copper was the central Balsas River basin, the region where the mining zones are located (Figure 7.4). Paredes (1984) and Pollard (1987) have suggested that during the last century of the Tarascan empire, the state took a more direct control of the copper resources of this particular region than simple tribute. This idea is largely based on accounts in the *Legajo 1204* (Warren 1968), which relates that the *Cazonci*—the paramount ruler of the Tarascan state—sent workers to extract copper from the mines of La Huacana to meet his needs (Pollard 1987:748; Warren 1968:47, 48). Other

mines, however, continued to be exploited through the tribute system (Pollard 1987:748).

The *Legajo* indicates that mining activities and smelting operations often took place at separate locations within the central Balsas River basin (Pollard 1987; Warren 1968). According to accounts in the *Legajo*, metalworkers from the La Huacana region owned and cultivated the fields at the foot of the hill where the copper veins were mined, which suggests that mining and metallurgy (at least at this particular location) were part-time activities, undertaken mostly outside of the growing season. The climatic variation between the rainy and dry seasons in the region supports this assumption. During the rainy season, the mines were probably flooded; during the dry season, agricultural production likely fell dramatically on account of the extreme aridity. The miners/smelters most likely alternated between metalworking and farming, according to the seasons as well as to royal demands (Grinberg 1996:433).

The scarcity of systematic archaeological studies of mining sites in the New World impedes a fully comparative understanding of how mining activities were organized and the degree to which the states were involved in the extractive operations of mineral resources. This seems even truer for western Mexico. Some general trends can, however, be identified from the available data for both the Mesoamerican and Andean areas: 1) one of the most common artifacts found at ancient mines are the stone tools used to extract raw material from mines; 2) mining often operated on a seasonal basis; 3) the process of mining was structured around economic, sociopolitical, and symbolic dimensions; and 4) expansionist states appear to have exercised considerable control over mines and their outputs, at least during the latest periods of Pre-Columbian history.

Extractive Metallurgy

Smelting is probably the most complex and least documented aspect of New World metallurgy. Extracting metal from ore involves a chemical reaction, which occurs by heating the ore with a reducing agent (often charcoal) and purifying substances in order to separate the pure molten metal from the

waste products. One of the major challenges in the development of metallurgy in the New World was the attainment of sufficiently high temperatures in this reduction process. In the ancient Old World, metalsmiths often attained those high temperatures in small furnaces with the aid of hand-operated bellows, which supplied a blast of air that increased the amount of oxygen into a mixture of ore and burning charcoal (e.g., Craddock 1991:63). This instrument, however, was unknown in the Americas prior to the arrival of the Europeans.

Smelting is a process that needs to be carried out within a fairly narrow margin of error or else the entire operation will fail. Scholars have suggested that the use of songs, rituals, and taboos facilitated recognition of the correct raw materials and memorization of the precise sequence and timing (e.g., Budd and Taylor 1995; Rowlands and Warnier 1993). The inevitable or deliberate restriction of such knowledge could have ensured that it remained in the hands of a few metal producers. The relationship of ancient metal smelters to their communities, however, remains understudied (Ottaway and Roberts 2008). The African ethnographic record, which approaches smelting from a symbolic perspective, shows that smelters can be either powerful men or community outcasts (e.g., Bisson 2000). We can only infer a prominent role of Amerindian smelters within their societies, from the transformative nature of their work and their association with supernatural energies.

SMELTING IN THE SOUTH CENTRAL ANDES
Early evidence for smelting activity in the south central Andes comes in the form of copper slag from the Wankarani site in Bolivia, dated between 900 and 700 BCE (Cooke et al. 2008; Ponce 1970). Additional data comes from the Ramaditas site in the Guatacondo Valley of northern Chile, where excavations revealed that copper smelting and sheet-metal working might have begun around 100 BCE (Graffam et al. 1994, 1996). According to Graffam and his colleagues, extractive metallurgy at Ramaditas was carried out on a small scale; smelting was performed on a periodic, episodic basis, and it was dispersed (Graffam 1994). Nevertheless,

figure 7.5
Benzoni woodcut,
showing blowpipes in
use with a crucible,
from Girolamo
Benzoni, *La historia
del Mondo Nuevo*
(1572), 3:170.

metalworkers achieved low-viscosity slags that allowed good separation of metal from slag during the smelting process. This characteristic indicates an efficient smelting operation. The efficiency of extraction is attributed to the high quality of copper ore in the Atacama Desert. The furnaces at the site were probably destroyed over time. People in northern Chile appear to have developed an efficient copper smelting technology as early as the Late Formative Period, and it eventually became the preferred smelting tradition in the south central Andes.

Although they did not use bellows, Andean smiths developed a blow tube made of a hollowed stem of cane through which workers would blow to direct an air blast toward the burning coals within a clay furnace (Figure 7.5). A ceramic nozzle, or *tuyère*, was placed on the furnace end of the tube to protect it from the coals. The temperature achieved in this process was high enough to smelt ore. Scores of broken nozzles have been found at the metallurgical site of Batán Grande in northern Peru (900–1000 CE; Shimada et al. 1983; Shimada and Merkel 1991). In some regions of the south central Andes,

figure 7.6
Drawing of a wind oven (*huayra*), used by Andean metallurgists to process high-grade ores, from Alonso Barba, *Arte de los metales* (1640), 78v.

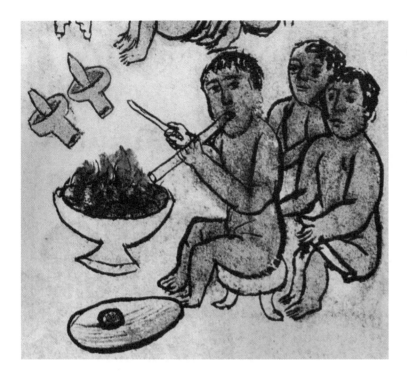

figure 7.7
Mesoamerican crucible and blow-
pipe, from Jerónimo de Alcalá,
Relación de Michoacán (2000),
pl. XIX.

however, wind-drafted furnaces lined with clay, or *huayras* (also known as *guayras* or *huayrachinas*; from Quechua, *wayra*: air, wind), appear to have been used to smelt metal ores (Figure 7.6; see Zori, this volume, for an extensive discussion of this type of device). Some huayras were made of rough stones that had been loosely assembled so that the wind could blow through the gaps and fan the fire. The more complex ones were built of stones set in clay where holes where left open to allow the wind to enter (Bakewell 1984; Peele 1893). Portable clay huayras were developed after the Spanish conquest; they were designed specifically for the extraction of silver (Bakewell 1984:15; Capoche 1959:110). Typically, all huayras were set on exposed ridges where the wind blew strongly (Bakewell 1984; Petersen 1970).

Smelting in Western Mexico

West Mexican metallurgists appear to have started to smelt copper metal around 600 CE (Hosler 1994). Ethnohistorical evidence reveals that Meso-american smiths also used a form of blowpipe for the smelting process. The *Relación de Michoacán* (Alcalá 2000:lám. XIX), for example, illustrates metalworkers sitting in front of a brazier, melting

metal by blowing through pipes (Grinberg 1996; Roskamp 2001, 2004; see Figure 7.7). Similar representations are found in other documents, such as the *Lienzo de Jicalán* (Grinberg 1996; Roskamp 2001, 2004) and the *Codex Mendoza* (Berdan and Anawalt 1992:70r). These illustrations, I believe, may represent melting of metal ingots for final processing, rather than smelting of ores. The actual smelting operations are more likely to have been carried out by heating small quantities of ore in shallow earthen pits, which were lined with a mixture of clay and ash, the heat intensified by workers blowing through cane tubes (Barrett 1987:15). Similar descriptions appear in the *Relación de Michoacán* (Alcalá 2000:lám. XXIX) and other documents, including the *Legajo 1204* (Warren 1968:46, 48).

With this method, however, it was necessary to heat the ore two or three times to produce metal of useful quality. I infer that part of this process may have actually involved roasting of the ore to remove impurities before smelting. When Spaniards took over the local copper industry of Michoacan in 1533, natives were employed as both miners and smelters, and for decades continued to use the metallurgical techniques they knew. The only significant technological change introduced by the Spanish

figure 7.8
Location of Itziparátzico within the Zirahuén basin and the State of Michoacan. (Map by César Hernández.)

occurred after 1599, with the replacement of blow-pipes by animal skin bellows (see Barrett 1987:15, 26, 64). The results of my own investigations in Michoacan (Maldonado 2006, 2008a, 2009; Maldonado et al. 2005; Maldonado and Rehren 2009) suggest that an alternative pyrometallurgical method (i.e., wind-assisted furnaces) might have been used by Mesoamerican peoples as a supplemental way to smelt complex ores.

Systematic research at the archaeological zone of Itziparátzico, located within the territory of the Tarascan empire (Figure 7.8), identified production areas where high concentrations of smelting slag were recorded (see Maldonado 2006, 2008; Maldonado et al. 2005; Maldonado and Rehren 2009). Both the nature and the density of archaeological artifacts seem to indicate that the area was occupied during the Late Postclassic period (1350–1520 CE). Although no identifiable metalworking structures (furnaces, hearths, or pits) were found at

Itziparátzico during the test-pitting, large amounts of slag were recovered from the excavation, together with lithics and ceramics. The absence of metallurgical materials other than slag (i.e., hearth structures, crucible fragments, mold fragments, stock metal, metal prills, failed castings, part-manufactured objects, and spillages, etc.) around Itziparátzico indicates that only primary copper production (smelting) was being carried out at this location.

Analyses of the slags indicate a smelting technology that involved the use of sulfidic ores and highly efficient (not blowpipe-operated) furnaces. The most outstanding feature of Itziparátzico is its location—about 125 kilometers away from the mines themselves (see Figure 7.4). The evidence suggests that the mineral ores were moved away from the mines for smelting at sites like Itziparátzico. Ores were probably transported to a number of other similar sites, exclusively for smelting. Final processing (alloying and fabrication,

surface treatment, and metalwork finishing) apparently was taking place at separate locations, likely in the Tarascan political core. This suggests that the copper industry was divided into minor sectors of production—mining, smelting, and final processing—and probably into a range of subdivisions within them (Maldonado 2006, 2008a).

Techné relates to the transformational process involved in making manifest things and ideas that already exist in another state. Smelting, as part of the techné of metallurgy, had many stages: building the furnace, choosing the number and position of the tuyères, selecting the type of fuel and the ratio of ore to fuel, timing the addition of ore and determining the length of the smelt, and observing the appropriate rituals prior to the smelt. It is likely that in both the Andes and Mesoamerica, smelting was a specialized craft, although not necessarily a full-time one. As it occurs in other cultural contexts (see, for example, Frazer 1978), the main smelter was probably assisted by a few apprentices who would know neither the full range of actions to be taken nor the choices that could be made during the operation. The full knowledge was probably kept by the main smelter, who would surround the technique with magic and taboos, thus heightening the sense of awe and the aura of meaning that surrounded the smelt.

Alloys and Metal Artifacts

A comparison of New World metallurgical traditions shows that different techniques were adopted by various indigenous societies, and then adapted to their own cultures and belief systems, to produce high-status goods used to enhance elite prestige and power. In the Central Andes, gold and silver were the most prominent metals, although copper was used extensively to produce an assortment of alloys. Metalworkers hammered copper into sheets to fashion objects that were then covered with extremely thin coatings of gold or silver so that the objects appeared to be made of those more precious metals (Falchetti 2003; Lechtman 1984, 1993). Copper-based metallurgy was also important in Mesoamerica, where smiths developed methods to create golden and silvery artifacts whose designs did not allow the use of gold or silver (Hosler 1994).

In the intermediate area of lower Central America, Colombia, and Ecuador, gold-copper alloys, or *tumbaga*, were particularly common and known locally as *guanín* (Falchetti 2003:345). Copper was thus the prime base metal in the Americas. The underlying concepts that governed its symbolism and its combination with other metals have to be considered in the light of the social and cultural values of Pre-Columbian peoples.

The association of metals with celestial bodies was common among different cultures, including Amerindian societies. Gold was linked with the "male" yellow power of the sun, while the pale color of silver was associated with the "female" energy of the moon (Falchetti 2003; Hosler 1994; Lechtman 1975). It has been suggested (e.g., Alva and Donnan 1993:223; Falchetti 2003:348) that the combination of these two metals represented a basic dualism, marked by balance between complementarity and cosmological forces. The sun is not subject to the universal laws of transformation—birth and death—and is therefore immortal. Immortality is an attribute ascribed to deities, and it links gold with the sun, because gold is incorruptible and eternal. The moon, on the other hand, is seen as "mortal," although its cycle is a symbol of periodic generation and rebirth (Eliade 1981; Falchetti 2003). Coppery red colors are related to blood, the feminine component of human beings. In certain contexts (see, e.g., Reichel-Dolmatoff 1981), copper is associated with female properties and to the transformations of the moon, apparently related to its capacity for transformation: it tarnishes and oxidizes. It is subject to change, deterioration, and "death," which is akin to the cycle of human life.

The cosmologically derived qualities of gold, silver, and copper help to explain the social meaning of these metals and their supernatural associations, and further helps to explicate how and why alloying was so important in New World metallurgical practices. The qualities of metals change, based on their combinations (Falchetti 2003; Hosler 1994). According to Falchetti (2003:16), the symbolic ties of metals to transformation suggest that for New World societies, metallurgical combinations represented more than technical advantages. Rather,

alloys incorporated the mixing of male and female properties of the metals involved. These combinations and transformations, influenced by cosmological and biological conceptions, reflected the prime concern of these peoples for the continuity of life and equilibrium of their world, which had to be encouraged and maintained through ritual and social activity. At the social level, the continuity of humanity was ensured through strategic marriage alliances. The symbolism of metal objects was transmitted to the people who used them during such occasions (Falchetti 2003:361).

THE SAN PEDRO DE ATACAMA REGION
Pre-Columbian metallurgy in the Andean region involved the extraction of metal from a variety of ores, as well as the production of alloys, including copper-silver, copper-gold, copper-silver-gold, copper-arsenic bronze, and copper-tin bronze. Arsenic and tin bronzes were the most prominent alloys

during the later periods, previous to the European arrival (Lechtman 1988). Northern Chile is particularly rich in copper deposits, has sustained metal production for well over three thousand years, and is still today home to some of the largest copper mines on Earth (Camus and Dilles 2001; Núñez 1999, 2006).

Recent investigations of the archaeometallurgy of copper and its alloys in the San Pedro de Atacama region (Maldonado et al. 2012, 2013a, 2013b) have looked to trace the production, movement, and role of metal within and between different societies in the area. The research has involved documentation and sampling of already excavated artifacts from the archaeological museum in San Pedro de Atacama (Figure 7.9). The artifact categories represented in the collection of the archaeological museum include: 1) adornments, such as beads, bracelets, pins, plates, rings, and metal sheets; 2) tools in the form of awls, axes, chisels, drills, maces, needles, and tweezers; and 3) production-related

figure 7.9
Different categories of artifacts from the collection of the archaeological museum in San Pedro de Atacama. (Photographs by Blanca Maldonado.)

figure 7.10
The location of San Pedro de Atacama and other oases in the region. (Map by César Hernández.)

products, which consist mostly of cast metal and other waste, as well as pre-forms, or ingots. The majority of the sampled objects are associated with Middle and Intermediate contexts (approximately 700–1470 CE), and have been recovered from funerary deposits of thirteen small agricultural oases of San Pedro (Figure 7.10).

Metallographic and mineralogic results confirmed the use of both oxides and sulfides in the production of metal artifacts in the samples analyzed (see Table 7.1). This is relevant, because the south central Andes are very rich in mineral sources, and

oxides tend to be abundant. Scholars have assumed (e.g., Lechtman and Macfarlane 2005) that Pre-Columbian miners focused largely on these easy-to-work minerals. The results of our analyses, however, indicate that they were, in fact, making use of different types of ores, including sulfides that are more difficult to access and work. This seems to confirm that, when it comes to technological choices, sometimes the reasons why people select a certain type of material go beyond natural availability.

About 22 percent of the analyzed samples consist of a ternary Cu-As-Ni alloy, which has been

table 7.1

Metal and alloy frequencies by artifact category

	Ag	Ag-Cu	Ag-Au-Cu	Cu	Cu-As	Cu-Sb	Cu-Sn	Cu-As-Ni	Cu-As-Ni-Sn	Cu-As-Sn	Cu-Sn-Sb	Sn	Pb
Adornment							1						
Awl				1									
Axe				6			1	8					
Bead				3			3	2		1			
Bracelet							1	1					
Chisel				6			3		1	1			
Drill				1				1					
Mace				1	1	1	1	1					
Min. mace													1
Needle					1		3						
No ID			1	4			1	2				1	1
Pin		1		1			3	2					
Plate			1	8	2	1	12	8	2	1			1
Pre-form								2					
Ring			1			3	6	2		1	1		
Sheet	4	2	1	3			1	1				1	1
Tweezer				1			1	4					
Waste				18			1						1
Totals	4	3	4	53	4	5	38	34	3	4	1	2	5

Sample 160

regarded as a cultural and technological marker of the Middle Period (400–1000 CE) in the Bolivian Altiplano and in northern Chile. Thus far, artifacts manufactured from this alloy have been recovered almost exclusively in Tiwanaku and San Pedro de Atacama (see Lechtman 1997, 2003a, 2003c; Lechtman and Macfarlane 2005). The ternary alloy in question coexists with Cu-Sn alloys, better known as tin bronze, which constitutes 24 percent of the sampled objects. The presence of tin bronze in the Atacama during the Middle Period has been attributed to influence from the Aguada complex from northwest Argentina (González 2002, 2004; Llagostera 1995). Objects made of unalloyed copper represent the most abundant class in the sample, reaching nearly 50 percent of the analyzed artifacts. This is significant because, until recently, it was believed that most, if not all, of the metal recovered in the San Pedro de Atacama region consisted of imported ritual objects made of exotic alloys (see Salazar et al. 2011b). Although unalloyed copper occurs both in the Bolivian Altiplano and in northwest Argentina, it is relatively rare during the Middle Period. Artifacts of pure copper have also been recorded in the neighboring El Abra (see Figueroa et al. 2010).

The above findings support the hypothesis that metal production was taking place locally in the Atacama during this time frame. Nevertheless, there are still no excavated furnaces, making it difficult to reconstruct the details of this technology. The presence of casting waste with small amounts of slag attached to them underlines the presence of practicing metalsmiths in the Atacama Desert, but

it still leaves open the crucial issue of which technology they used, whether it followed a genuinely local path and tradition, or whether it was inspired by external practices. Thus, our research has served to clarify the nature of some of the workshop debris and to confirm the local processing of metal, but has not yet reached the full aim of reconstructing the entire sequence of operations. Another significant finding is the presence of what appears to be axe pre-forms, or ingots, made of the ternary alloy. This indicates that at least part of the process of manufacture of the ternary alloy axes was taking place locally around San Pedro.

The evidence for Tiwanaku influence in the San Pedro de Atacama region—characterized by small, portable Tiwanaku-style artifacts—and a lack of Tiwanaku residential or ceremonial sites has been discussed extensively by scholars (e.g., Berenguer 1978; Berenguer et al. 1980; Browman 1986; Le Paige 1961; Llagostera 1996; Núñez 1991). The explanations for the presence of foreign Tiwanaku artifacts in the San Pedro de Atacama region are quite varied. Some researchers (e.g., Berenguer et al. 1980) have hypothesized that the artifacts were brought by exchange networks and were traded for the rich metallic minerals and semiprecious stones found near the oasis. Llagostera (1996), for example, specifically emphasizes the associations of power and status in non-local objects—such as snuff tablets, rich textiles, and axes and other items made of the ternary Cu-As-Ni alloy—and argues that local elites gained power through their control of non-local goods. The results of our research, however, demonstrate that most of the artifact types associated with this alloy—and with tin bronze—appear also in the form of unalloyed copper. The evidence for local copper production raises the question of whether the Atacamenian metalworkers were adapting imported practices to local materials. This open problem reflects the complexity of the technological choices behind the use of metals and alloys.

FINAL PROCESSING IN WESTERN MEXICO

In Mesoamerica, copper was not only the predominant metal but also the most extensively used base material. From circa 650 to 1200/1300 CE,

west Mexican metalsmiths appear to have worked almost exclusively with native copper and easily smelted oxidized copper ores. But from about 1300 CE to the Spanish conquest in 1521, an assortment of copper-based alloys started to be produced, and they included binary alloys (such as copper-silver, copper-gold, copper-arsenic, and copper-tin) and ternaries (such as copper-silver-gold, copper-silver-arsenic, copper-arsenic-antimony, and copper-arsenic-tin) (Hosler 1994). Recent data from the Sayula basin in Jalisco, however, seem to indicate a much earlier development of copper-tin and copper-arsenic bronzes. Metal objects recovered mainly from burials at a number of sites in this region date to 1040–1300 CE (García 2007).

According to Hosler (1994), west Mexican smiths explored the properties of binary and ternary alloys to optimize the designs of metal objects and to alter their colors; they allowed thinner, harder, and finer artifacts, as well as shiny golden and silvery ritual and status items. Copper-silver alloys, for instance, were derived mainly by smelting copper ores and silver ores separately and then melting the two metals together; from this combination, metalworkers created extremely thin designs with silvery, highly reflective surfaces (Grinberg 1996; Hosler 1988c, 1994, 1995). Copper-tin bronzes in west Mexico date to around 1200 CE (although see above for the earlier dates from the Sayula basin). West Mexican metalsmiths made copper-tin alloys through deliberate alloying of copper smelted from chalcopyrite and tin smelted mainly from cassiterite (Hosler 1994). The *Relación de Michoacán* (1540–1541) describes goods made of copper alloys of gold or silver, and copper-tin and copper-arsenic bronzes (Alcalá 2000:65, 203, 211).

Hosler (1994) argues that audible properties also shaped the development of west Mexican metallurgy, because bells and other rattling instruments figure prominently in ritual and ceremony. Cast bells were indeed among the most distinctive metal objects produced in Mesoamerica, frequently found in funerary contexts as jewelry placed around the neck, wrists, or ankles of the deceased. In several documents written around the time of the Spanish conquest (e.g., the *Florentine Codex*), bells

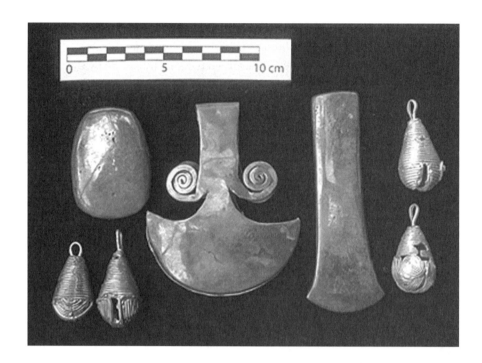

figure 7.11
Experimental replicas
of Tarascan copper
artifacts. (Photographs
by Blanca Maldonado.)

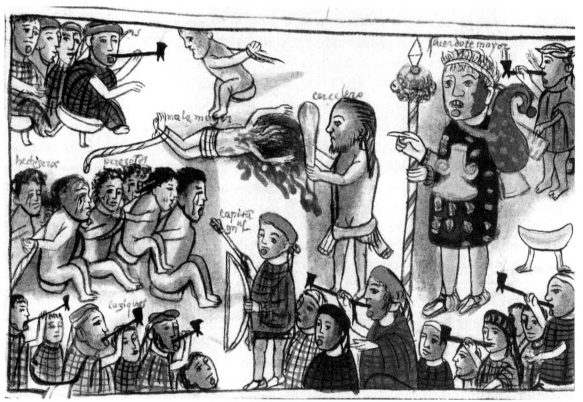

figure 7.12
Tarascan priest wearing a metal tweezer, from Jerónimo de Alcalá, *Relación de Michoacán* (2000), pl. II.

are represented attached to musical instruments as well as the garments of elites and deities. The deities most frequently associated with bells represent fertility, life, and regeneration (Hosler 1994). In the early stages of metallurgy, most of these bells were cast in copper. Later on, tin-bronze was also widely used for their manufacture (Hosler 1990, 1994).

In the Late Postclassic period, Tarascan metalsmiths alloyed copper with tin and/or arsenic to produce bronzes, or mixed it with various concentrations of silver and gold (or both) to fashion bells, ornamental tweezers, rings, and body ornaments (Figure 7.11). Although bronzes were also used to manufacture such tools as axes, hoes, and needles, the main focus of Tarascan metallurgy was on sumptuary objects that reflected fundamental religious and political agendas (Figure 7.12). Metals were directly associated with particular deities, and the Cazonci, as the human representative on earth of the patron god Curicaueri, similarly shared this association (Hosler 1994; Pollard 1987, 1993).

Discussion

Numerous questions arise from the notion that metal items functioned as symbolic valuables in the different Pre-Columbian societies of the south central Andes and west Mexico. Foremost among them is whether and how value was produced and managed by centralized political control. Although, as mentioned before, current data on mining and metallurgy in both areas are sparse and unclear, important aspects of the operational sequence for metal production—including ore deposit and mining, smelting, and final processing—have been inferred from a combination of ethnohistorical and archaeological data. Bringing comparative analyses more fully into the process of reconstruction or interpretation, however, has required disentangling the different lines of evidence for individual analysis of the different regions. Despite the significant variances in chronology—and perhaps in the size and composition of productive units, in productive scale and intensity, and in the mechanisms of distribution—this exercise has allowed us to identify

certain patterns and regularities in the two production systems.

The following are the patterns observed throughout the sequence of metallurgical development in the Andes and Mesoamerica: 1) employment of rudimentary mining techniques to extract minerals and of basic methods to process metals; 2) mastering of sophisticated metalworking technology; 3) an extensive metallurgical tradition based on copper and its alloys; 4) use of metal products not just as luxury goods for the elite but also as basic material expressions of political ideology; and 5) a certain level of control from large centralized polities (e.g., Tiwanaku, the Inka, and the Tarascans) over the mines, the production systems, and the distribution of finished products. It is worth mentioning, however, that this socio-technological system developed early and was probably associated with societies organized as chiefdoms. The implication is that there may have been little control over the production at this initial stage. The relations between craft producers and institutions tend to be both multiple and multidimensional, with varying degrees of autonomy and interdependence, and much production can occur outside the control of a state (Sinopoli 2003). Two main issues relevant to the study of the political economy of complex societies are often addressed in archaeology: the relations of artisans to institutions, and the roles of craft goods in political economies.

This final point ties into the central question of this volume: How did artisans, patrons, and consumers use techné to create and control the value and meaning of the most politically, socially, and ritually precious crafts in the ancient Americas? The diverse arenas of metal production—from mining through to the finished product—in the south central Andes and western Mexico present varied pictures in terms of the forms and degrees of craft specialization and elite involvement and control. As in other contexts of production and consumption of specialist craft products, individuals and groups were bound together in intricate webs of interdependence and interaction. Mining and metallurgy involved social groups of various sizes, including raw material procurers or producers, which may

include other specialists—for example, miners, charcoal producers, and smelters who provided ores and smelted materials to forgers or casters—to people involved in various stages of production and distribution. Producers also interacted with those who acquired and used their products (i.e., elite patrons). A common link can be observed throughout this entire production system: the promotion of certain status symbols by the elite, who acted as transmitters of cosmic truth.

Royal lineages and other privileged individuals obtained power from their personal relationship to the supernatural forces immanent in metal and other materials. The elite would presumably use this force on behalf of the commoners for the general good. We have come to realize, from certain aspects of the political and ideological symbolism—expressed in this association between status, power, and authority, and precious objects—that the products of techné are fundamentally expressive of political authority and influence, and assist in their implementation. By extension, such products also define and make tangible exceptional qualities believed either to be assumed by or to be inherent in those who produced them.

Concluding Thoughts

The way people were placed in relation to each other was fundamental to the distinctive character of New World cultures. Political and religious rituals impelled the consumption of goods, as did the need to cement alliances and curry favor. Gift giving was a practice deeply embedded in Pre-Columbian cultures (Bauer 2001). Long-distance exchange, one of the practices through which intensive interaction

between different peoples and regions occurred, was centrally concerned with obtaining materials used for marking distinctions between commoners and nobles (Blanton et al. 1993; D'Altroy and Earle 1985; Hirth 1992, 1996; Stanish 1992; Vaughn 2006). Costume, a major means of delineating differences between distinct social groups in Mesoamerica and the Andes, and for signaling the roles of different people, was typically composed of rich textiles (see, e.g., Anawalt 1981; Orr and Looper 2014; Schevill 1986). Feathers, polished mirrors, metal, and carved greenstone ornaments were all important components of costumes, and they indicated special status, rank, and prestige, as well as power derived from sources other than economics.

The Mesoamerican and the Andean worlds, as discrete social systems, were thus to a great extent defined by their ritually laden elite prestige system. This world came into existence around 1000 BCE, and it developed within the same basic structure for more than two millennia (Blanton et al. 1993; Stanish 1992). I argue that the prestige system, as a regulator, played a key role in the functioning and dynamics of ancient New World technologies. The present work has been an attempt to get away from technological determinism and look at the concept of metallurgical technology as a social phenomenon—that is, as a product of techné. Metallurgy in the Americas followed its own trajectory of innovations and developments, which could be reflections of social organization or the structure and worldview of local communities, sometimes coupled with environmental factors within those regions. Further and more in-depth comparative analyses will be necessary to better understand the patterns of development of past economic and social structures in these areas.

REFERENCES CITED

Abbott, Mark B., and Alexander P. Wolf

2003 Intensive Pre-Incan Metallurgy
 Recorded by Lake Sediments
 from the Bolivian Andes. *Science*
 301(5641):1893–1895.

Alva, Walter, and Christopher Donnan

1993 *Royal Tombs of Sipán.* Fowler Museum
 of Cultural History, Los Angeles.

Alcalá, Jerónimo de, Fray

2000 *Relación de las ceremonias y rictos y
 población y gobernación de los indios de
 la provincia de Mechuacan.* El Colegio
 de Michoacán, Zamora.

Aldenderfer, Mark S., Nathan M. Craig, Robert J.
Speakman, and Rachel Popelka-Filcoff

2008 Four-Thousand-Year-Old Gold Artifacts
 from the Lake Titicaca Basin, Southern
 Peru. *Proceedings of the National
 Academy of Sciences* 105:5002–5005.

Anawalt, Patricia Rieff

1981 *Indian Clothing Before Cortés: Meso-
 american Costume from the Codices.*
 University of Oklahoma Press, Norman.

Bakewell, Peter J.

1984 *Miners of the Red Mountain: Indian
 Labor in Potosí, 1545–1650.* University
 of New Mexico Press, Albuquerque.

Barrett, Elinore M.

1987 *The Mexican Colonial Copper Industry.*
 University of New Mexico Press,
 Albuquerque.

Bauer, Arnold J.

2001 *Goods, Power, History: Latin America's
 Material Culture.* Cambridge University
 Press, Cambridge.

Berdan, Frances F., and Patricia Rieff Anawalt

1992 *The Codex Mendoza.* University of
 California Press, Berkeley.

Berenguer, José

1978 La problematica Tiwanaku en Chile:
 Vision retrospectiva. *Revista chilena
 de antropologia* 1:17–40.

Berenguer, José, Victoria Castro, and Osvaldo Silva

1980 Reflexiones acerca de la presencia de
 Tiwanaku en el norte de Chile. *Estudios
 arqueologicos* 5:81–92.

Browman, David

1986 Prehispanic Aymara Expansion, the
 Southern Altiplano, and San Pedro
 de Atacama. *Estudios atacameños*
 7:236–252.

Berthelot, Jean

1986 The Extraction of Precious Metals at the
 Time of the Inka. In *Anthropological
 History of Andean Politics,* edited by
 John Murra, Nathan Wachtel, and
 Jacques Revel, pp. 69–88. Cambridge
 University Press, Cambridge.

Bird, Junius B.

1979 The "Copper Man": A Prehistoric Miner
 and His Tools from Northern Chile.
 In *Pre-Columbian Metallurgy of South
 America,* edited by Elizabeth P. Benson,
 pp. 105–132. Dumbarton Oaks Research
 Library and Collection, Washington,
 D.C.

Bisson, Michael S.

2000 Precolonial Copper Metallurgy:
 Sociopolitical Context. In *Ancient
 African Metallurgy: The Sociocultural
 Context,* edited by Michael S. Bisson,
 pp. 83–145. Altamira Press, Walnut
 Creek, Calif.

Blanton, Richard E., Stephen A. Kowalewski, Gary M.
Feinman, and Laura M. Finsten

1993 *Ancient Mesoamerica: A Comparison
 of Change in Three Regions.* 2nd ed.
 Cambridge University Press, Cambridge.

Budd, Paul, and Tim Taylor

1995 The Faerie Smith Meets the Bronze
 Industry: Magic versus Science in the
 Interpretation of Pre-Historic Metal-
 Making. *World Archaeology* 27:133–143.

Burger, Richard L.

2013 Some Thoughts on Mining and
 Quarrying in the Ancient Andes. In
 *Mining and Quarrying in the Ancient
 Andes: Sociopolitical, Economic,
 and Symbolic Dimensions,* edited by
 Nicholas Tripcevich and Kevin J.
 Vaughn, pp. 325–334. Interdisciplinary
 Contributions to Archaeology. Springer,
 New York.

Cajas, Antonieta

2009 Caves and Mesoamerican Culture. *FLAAR Reports on Maya Archaeology* 2009:1–15.

Camus, Francisco, and John H. Dilles

2001 A Special Issue Devoted to Porphyry Copper Deposits of Northern Chile. *Economic Geology* 96(2):233–237.

Capoche, Luis

1959 *Relaciones histórico-literarias de la América Meridional: Relación general de la villa imperial de Potosí.* Ediciones Atlas, Madrid.

Cobo, Bernabe

1890 [1653] *Historia del nuevo mundo.* Edited by Marcos Jiménez de la Espada. Imp. de E. Rasco, Seville.

1964 [1653] *Historia del nuevo mundo.* Biblioteca de Autores Españoles, vols. 91 and 92. Ediciones Atlas, Madrid.

Cooke, Colin A., Mark B. Abbott, and Alexander P. Wolfe

2008 Metallurgy in Southern South America. In *Encyclopedia of the History of Science, Technology, and Medicine in Non-Western Cultures*, vol. 2, edited by H. Seline, pp. 1658–1662. Kluwer Science, Dordrecht.

Cooke, Colin A., Prentiss H. Balcomb, Harald Biester, and Alexander P. Wolfe

2009 Over Three Millennia of Mercury Pollution in the Peruvian Andes. *Proceedings of the National Academy of Sciences of the United States of America* 106(22):8830–8834.

Craddock, Paul T.

1991 Mining and Smelting in Antiquity. In *Science and the Past*, edited by Sheridan Bowman, pp. 57–73. University of Toronto Press, Toronto.

Craddock, Brenda R., Caroline R. Cartwright, Paul T. Craddock, and W. B. Wray

2003 Hafted Stone Mining Hammer from Chuquicamata, Chile. *Mining and Metal Production through the Ages*, edited by Paul T. Craddock and Janet Lang, pp. 52–68. The British Museum, London.

Cunningham, Charles G., Michael L. Zientek, Walter J. Bawiec, and Greta J. Orris

2005 Geology and Nonfuel Mineral Deposits of Latin America and Canada. *U.S. Geological Survey, Open-File Report 2005-1294B.* Electronic document, http://pubs.usgs.gov/of/2005/1294/b, accessed November 12, 2015.

D'Altroy, Terence N.

2002 *The Incas.* Blackwell, Oxford.

D'Altroy, Terence N., and Timothy K. Earle

1985 Staple Finance, Wealth Finance, and Storage in the Inka Political Economy. *Current Anthropology* 26(2):187–206.

Drennan, Robert D., and Christian E. Peterson

2006 Patterned Variation in Prehistoric Chiefdoms. *Proceedings of the National Academy of Sciences* 103:3960–3967.

Eliade, Mircea

1981 *Tratado de historia de las religiones.* Biblioteca Era, Mexico City.

Falchetti, Ana María

2003 The Seed of Life: The Symbolic Power of Gold-Copper Alloys and Metallurgical Transformations. In *Gold and Power in Ancient Costa Rica, Panama, and Colombia*, edited by Jeffrey Quilter and John W. Hoopes, pp. 345–381. Dumbarton Oaks Research Library and Collection, Washington, D.C.

Figueroa, Valentina, Ignacio Montero, and Salvador Rovira

2010 Estudio tecnológico de objetos procedentes de cerro turquesa (San José del Abra, II Región). *Actas del XVII Congreso Nacional de Arqueología Chilena* 2:1135–1147.

Flyvbjerg, Bent

2001 *Making Social Science Matter.* Cambridge University Press, Cambridge.

Frazer, James G.

1978 *The Golden Bough: A Study in Magic and Religion.* Macmillan, London.

Furst, Peter T.

1976 *Hallucinogens and Culture.* Chandler and Sharp, San Francisco.

García, Johan S.

2007 Arqueometalurgia del occidente de México: La cuenca de Sayula, Jalisco como punto de conjunción de tradiciones metalúrgicas precolombinas. Licenciatura thesis, Universidad Autónoma de Guadalajara, Guadalajara.

Graffam, Gray J., Mario Rivera, and Alvaro Carevic

1994 Copper Smelting in the Atacama: Ancient Metallurgy at the Ramaditas Site, Northern Chile. In *In Quest of Mineral Wealth: Aboriginal and Colonial Mining and Metallurgy in Spanish America*, edited by Alan K. Craig and Robert C. West, pp. 75–92. Louisiana State University Press, Baton Rouge.

1996 Ancient Metallurgy in the Atacama: Evidence for Copper Smelting During Chile's Early Ceramic Period. *Latin American Antiquity* 7(2):101–113.

González, Luis R.

2002 A sangre y fuego: Nuevos datos sobre la metalurgia aguada. *Estudios atacameños* 24:21–37.

2004 *Bronces sin nombre, la metalurgia prehispánica en el noroeste Argentino*. Ediciones Fundación Ceppa, Buenos Aires.

Grinberg, Dora M. K. de

1990 *Los señores del metal: Minería y metalurgia en Mesoamérica*. Pangea, México.

1995 El Legajo 1204 del Archivo General de Indias, el Lienzo de Jucutacato y las Minas Prehispánicas de Cobre del Ario, Michoacán. In *Arqueología del norte y occidente de México*, edited by Barbo Dahlgren and Ma. Dolores Soto de Arechavaleta, pp. 211–265. Universidad Nacional Autónoma de México, Instituto de Investigaciones Antropológicas, Mexico City.

1996 Técnicas minero-metalúrgicas en Mesoamérica. In *Mesoamérica y los Andes*, edited by Mayán Cervantes, pp. 427–471. Centro de Investigaciones y Estudios Superiores de Antropología Social, Mexico City.

2004 ¿Qué sabían de fundición los antiguos habitantes de Mesoamérica? *Ingenierías* 7(22): 64–70.

Helms, Mary W.

1993 *Craft and the Kingly Ideal: Art, Trade, and Power*. University of Texas Press, Austin.

Hendrichs, Pedro

1940 Datos sobre la técnica minera prehispánica. *México antiguo* 5:148–160, 179–194, 311–238.

1943–1944 *Por tierras ignotas: Viajes y observaciones en la región del Río de las Balsas*. 2 vols. Editorial Cultura, Mexico City.

Heyden, Doris

2005 Rites of Passage and Other Ceremonies. In *In the Maw of the Earth Monster: Mesoamerican Ritual Cave Use*, edited by James E. Brady and Keith M. Prufer, pp. 21–34. University of Texas Press, Austin.

Hirth, Kenneth G.

1992 Interregional Exchange as Elite Behavior: An Evolutionary Perspective. In *Mesoamerican Elites: An Archaeological Assessment*, edited by Diane Z. Chase and Arlen F. Chase, pp. 18–29. University of Oklahoma Press, Norman.

1996 Political Economy and Archaeology: Perspectives on Exchange and Production. *Journal of Anthropological Research* 4(3):203–239.

Hosler, Dorothy

1988a Ancient West Mexican Metallurgy: South Central American Origins and West Mexican Transformations. *American Anthropologist* 90(4):832–855.

1988b Ancient West Mexican Metallurgy: A Technological Chronology. *Journal of Field Archaeology* 15(2):191–217.

1988c The Metallurgy of Ancient West Mexico. In *The Beginning of the Use of Metals and Alloys*, edited by Robert Maddin, pp. 328–343. The MIT Press, Cambridge, Mass.

1990 The Development of Ancient Mesoamerican Metallurgy. *Journal of the Minerals Metals and Materials Society* 42(5):44–46.

1994 *The Sounds and Colors of Power*. The MIT Press, Cambridge, Mass.

1995 Sound, Color and Meaning in the Metallurgy of Ancient West Mexico. *World Archaeology* 27:100–115.

2009 West Mexican Metallurgy: Revisited and Revised. *Journal of World Prehistory* 22:185–212.

Iribarren, Jorge

1972–1973 Una mina de explotación incaica: El Salvador, provincia de Atacama. *Actas del VI Congreso de Arqueología Chilena*: 267–283.

Kensinger, Kenneth M.

1995 *How Real People Ought To Be*. Waveland Press, Prospect Heights, Ill.

Lathrap, Donald W.

1982 Complex Iconographic Features Shared by Olmec and Chavin and Some Speculations on Their Possible Significance. In *Primer Simposio de Correlaciones Antropológicas Andino-Mesoamericanas*, edited by Jorge G. Marcos y Presley Norton, pp. 301–327. Escuela Superior Politécnica del Litoral, Guayaquil.

Lechtman, Heather N.

1975 Style in Technology: Some Early Thoughts. In *Material Culture Styles, Organization, and Dynamics of Technology*, edited by Heather N. Lechtman and Robert S. Merril, pp. 3–20. West Publishing, Cambridge.

1976 A Metallurgical Site Survey in the Peruvian Andes. *Journal of Field Archaeology* 3(1):1–42.

1984 Precolumbian Surface Metallurgy. *Scientific American* 250(6):56–63.

1988 Traditions and Styles in Central Andean Metalworking. In *The Beginning of the Use of Metals and Alloys*, edited by Robert Maddin, pp. 344–378. The MIT Press, Cambridge, Mass.

1993 Technologies of Power: The Andean Case. In *Configurations of Power: Holistic Anthropology in Theory and Practice*, edited by John S. Henderson and Patricia J. Netherley, pp. 244–280. Cornell University Press, Ithaca, N.Y.

1997 El bronce arsenical y el horizonte medio. In *Arqueología, antropología e historia en los Andes: Homenaje a María Rostworowski,* edited by R. Varón and Javier Flores E., pp. 153–86. Instituto de Estudios Peruanos, Lima.

2003a Ethnocategories and Andean Metallurgy. In *Los Andes: Cincuenta años después, 1953–2003; Homenaje a John Murra*, edited by Ana María Lorandi, Carmen Salazar-Soler, and Nathan Wachel, pp. 115–138. Pontificia Universidad Católica del Perú, Lima.

2003b Middle Horizon Bronze: Centers and Outliers. *In Patterns and Process*, edited by Lambertus van Zelst, pp. 248–268. Smithsonian Center for Materials Research and Education, Washington, D.C.

2003c Tiwanaku Period (Middle Horizon) Bronze Metallurgy in the Lake Titicaca Basin: A Preliminary Assessment. In *Tiwanaku and Its Hinterland*, vol. 2, edited by Alan L. Kolata, pp. 404–434. Smithsonian Institution Press, Washington, D.C.

Lechtman, Heather N., and Andrew W. Macfarlane

2005 La metalurgia del bronce en los Andes sur centrales: Tiwanaku y San Pedro de Atacama. *Estudios atacameños* 30:7–27.

Le Paige, Gustavo

1961 Cultura de tihuanaco en San Pedro de Atacama. *Anales* 1:19–23.

Leroi-Gourhan, André G.

1964 *Le geste at la parole*. Albin Michelle, Paris.

Llagostera, Agustín

1995 El componente cultural aguada en San Pedro de Atacama. *Boletín del Museo Chileno de Arte Precolombino* 6:9–34.

1996 San Pedro de Atacama: Nodo de complementariedad reticular. In *La integracion sur andina cinco siglos después*, edited by Xavier Albó, María Inés Anatia, Jorge Hidalgo, Lautaro Nuñez, Augustín Llagostera, María Isabel Remy, and Bruno Revesz, pp. 17–42. Universidad Catolica del Norte de Antofogasta, Antofogasta.

Macfarlane, Andrew W.

1999 Isotopic Studies of Northern Andean Crustal Evolution and Ore Metal

Sources. *Society of Economic Geologists,* special publication series 7:195–217.

Maldonado, Blanca

2006 Preindustrial Copper Production at the Archaeological Zone of Itziparátzico, a Tarascan Location in Michoacán, México. PhD dissertation, Department of Anthropology, Pennsylvania State University, University Park.

2008a A Tentative Model of the Organization of Copper Production in the Tarascan State. *Ancient Mesoamerica* 19(2):283–297.

2008b Exploring the Possibility for the Use of Wind Power for Copper Smelting in Mesoamerica. Paper presented at the 73rd Annual Meeting of the Society of American Archaeologists, British Columbia, Canada.

2009 Metal for the Commoners: Tarascan Metallurgical Production in Domestic Contexts. *Archeological Papers of the American Anthropological Association* 19(1):225–238.

Maldonado, Blanca, and Thilo Rehren

2009 Early Copper Smelting at Itziparátzico, Mexico. *Journal of Archaeological Science* 36(9):1998–2006.

Maldonado, Blanca, Thilo Rehren, and Paul R. Howell

2005 Archaeological Copper Smelting at Itziparátzico, Michoacan, Mexico. In *Materials Issues in Art and Archaeology,* vol. 7, edited by Pamela B. Vandiver, Jennifer L. Mass, and Alison Murray, pp. 231–240. Materials Research Society, Pittsburgh.

Maldonado, Blanca, Thilo Rehren, Ernst Pernicka, Lautaro Núñez, and Alexander Leibbrandt

2012 The Copper from the Atacama Desert, Northern Chile. *Metalla* 5:122–126.

Maldonado, Blanca, Carlos Morales-Merino, and Hans J. Hans-Joachim Mucha

2013a Ancient Technology, Modern Science: Archaeometallurgy in Northern Chile. *Metalla* 6: 70–74.

Maldonado, Blanca, Thilo Rehren, Ernst Pernicka, Lautaro Núñez, and Alexander Leibbrandt

2013b Early Copper Metallurgy in Northern Chile. *The Open Journal of Archaeometry* 1(1):128–130.

Manzanilla, Linda

1994 Las cuevas en el mundo mesoamericano. *Ciencias* 36:59–66.

Núñez, Lautaro

1991 *Cultura y conflicto en los oasis de San Pedro de Atacama.* Editorial Universitaria, Santiago.

1999 Valoración minero-metalúrgica circumpuneña: Menas y mineros para El Inka Rey. *Estudios atacameños* 18:177–222.

2006 La orientación minero-metalúrgica de la producción atacameña y sus relaciones fronterizas. In *Esferas de interacción prehistóricas y fronteras nacionales modernas: Los Andes sur centrales,* edited by Heather N. Lechtman, pp. 205–260. Instituto de Estudios Peruanos, Lima.

Orr, Heather, and Matthew Looper

2014 *Wearing Culture Dress and Regalia in Early Mesoamerica and Central America.* University Press of Colorado, Boulder.

Ostroumov, Mikhail, and Pedro Corona-Chávez

2000 Yacimientos minerales en Michoacán: Aspectos geológicos y metalogenéticos. *Revista ciencia nicolaita* 23:7–22.

Ostroumov, Mikhail, Pedro Corona Chávez, Jorge Díaz de León, Alfredo Victoria Morales, and Juan Carlos Cruz Ocampo

2002 Taxonomía y clasificación cristaloquímica moderna de los minerales: Recursos electrónicos de la Universidad Michoacana. Electronic document, http://smm.iim.umich.mx/catalogo.htm.

Ottaway, Barbara S., and Ben Roberts

2008 The Emergence of Metalworking. In *Prehistoric Europe: Theory and Practice,* edited by Andrew Jones, pp. 193–225. Blackwell, Oxford.

Paredes M., Carlos S.

1984 El tributo indígena en la región del lago de Pátzcuaro. In *Michoacán en el siglo XVI,* edited by Carlos S. Paredes M., pp. 21–104. Colección Estudios Michoacanos VII, FIMAX Publicistas, Morelia.

Peele, Robert, Jr.

1893 A Primitive Smelting Furnace. *School of Mines Quarterly* 15:8–10.

Petersen, Georg G.

1970 *Minería y metalurgia en el antiguo Perú.*
 Arqueológicas 12. Museo Nacional de
 Antropología y Arqueología, Lima.

Ponce S., Carlos

1970 *Las culturas Wankarani y Chiripa y su
 relación con Tiwanaku.* Editorial Los
 Amigos del Libro, La Paz.

Pollard, Helen P.

1982 Ecological Variation and Economic
 Exchange in the Tarascan State. *American
 Ethnologist* 9(2):250–268.

1987 The Political Economy of Prehispanic
 Tarascan Metallurgy. *American
 Antiquity* 52 (4):741–752.

1993 *Tariacuri's Legacy: The Prehispanic
 Tarascan State.* University of Oklahoma
 Press, Norman.

Prufer, Keith M., and James E. Brady

2005 Concluding Comments. In *In the Maw
 of the Earth Monster: Mesoamerican
 Ritual Cave Use*, edited by James E.
 Brady and Keith M. Prufer, pp. 403–411.
 University of Texas Press, Austin.

Reichel-Dolmatoff, Gerardo

1981 Things of Beauty Replete with Meaning:
 Metals and Crystals in Colombian
 Indian Cosmology. In *Sweat of the Sun,
 Tears of the Moon: Gold and Emerald
 Treasures of Colombia*, edited by Peter
 T. Furst, pp. 17–33. Natural History
 Museum Alliance of Los Angeles
 County, Los Angeles.

Roddick, Andrew, and Elizabeth Klarich

2013 Arcillas and Alfareros: Clay and Temper
 Mining Practices in the Lake Titicaca
 Basin. In *Mining and Quarrying in the
 Ancient Andes: Sociopolitical, Economic,
 and Symbolic Dimensions*, edited by
 Nicholas Tripcevich and Kevin J.
 Vaughn, pp. 99–122. Interdisciplinary
 Contributions to Archaeology Series.
 Springer, New York.

Roskamp, Hans

2001 Historia, mito y legitimación: El lienzo
 de Jicalán. In *La tierra caliente de
 Michoacán*, edited by Eduardo Zárate
 Hernández, pp. 119–151. El Colegio de
 Michoacán, Gobierno del Estado de
 Michoacán, Zamora.

2004 Los caciques indígenas de Xiuhquilan y
 la defensa del las minas en el siglo XVI:
 El lienzo de Jicalán. In *Ritmo del fuego:
 El arte y los artesanos de Santa Clara
 del Cobre, Michoacán, México*, edited
 by Michele Feder-Nadoff, pp. 186–197.
 Fundación Cuentos, Chicago.

Rowlands, Michael, and Jean-Pierre Warnier

1993 The Magical Production of Iron in
 the Cameroon Grassfields. In *The
 Archaeology of Africa: Food, Metals,
 and Towns*, edited by T. Shaw, B. Andah,
 P. Sinclair, and A. Okpoko, pp. 512–550.
 Routledge, New York and London.

Sahagún, Fray Bernardino de

1950–1982 *Florentine Codex: General History of
 the Things of New Spain.* Edited and
 translated by Arthur J. O. Anderson
 and Charles E. Dibble. 13 vols. School of
 American Research, Santa Fe, N. Mex.

Salazar, Diego

2008 La producción minera en San José del
 Abra durante el período tardío ataca-
 meño. *Estudios atacameños* 36:43–72.

Salazar, Diego, Carolina Jiménez, and Paulina
Corrales

2001 Minería y metalurgia: Del cosmos a
 la tierra, de la tierra al Inka. In *Tras
 la huella del Inka en Chile*, edited by
 L. Cornejo y C. Aldunate, pp. 60–73.
 Museo Chileno de Arte Precolombino
 y Banco Santiago, Santiago.

Salazar, Diego, Victoria Castro, Jaie Michelow,
Hernán Salinas, Valentina Figueroa, and
Benoît Mille

2010 Minería y metalurgia en la Costa Arreica
 de la región de Antofagasta, norte de
 Chile. *Boletín del Museo Chileno de Arte
 Precolombino* 15(1):9–23.

Salazar, Diego, Donald Jackson, J. L. Guendon,
Hernán Salinas, Diego Morata, Valentina
Figueroa, Germán Manríquez, and Victoria Castro

2011a Early Evidence (ca. 12,000 BP) for Iron
 Oxide Mining on the Pacific Coast of
 South America. *Current Anthropology*
 52(3):463–475.

Salazar, Diego, Valentina Figueroa, Diego Morata, Benoit Mille, Germán Manríquez, and Ariadna Cifuentes

2011b Metalurgia en San Pedro de Atacama durante el período medio: Nuevos datos, nuevas preguntas. *Revista Chilena de Antropología* 23:123–148.

Saunders, Nicholas J.

1998 Traders in Brilliance: Amerindian Metaphysics in the Mirror of Conquest. *Anthropology and Aesthetics* 33:225–252.

1999 Biographies of Brilliance: Pearls, Transformations of Matter, and Being, c. AD 1492. *World Archaeology* 31(2):243–257.

2003 "Catching the Light": Technologies of Power and Enchantment in Pre-Columbian Goldworking. In *Gold and Power in Ancient Costa Rica, Panama, and Colombia*, edited by Jeffrey Quilter and John W. Hoopes, pp. 15–47. Dumbarton Oaks Research Library and Collection, Washington, D.C.

Schevill, Margot

1986 *Costume as Communication: Ethnographic Costumes and Textiles from Middle America and the Central Andes of South America in the Collections of the Haffenreffer Museum of Anthropology, Brown University, Bristol, Rhode Island.* The Museum, Bristol.

Schultze, Carol A., Charles Stanish, David A. Scott, Thilo Rehren, Scott Kuehner, and James K. Feathers

2009 Direct Evidence of 1,900 Years of Indigenous Silver Production in the Lake Titicaca Basin of Southern Peru. *Proceedings of the National Academy of Sciences of the United States of America* 106(41):17280–17283.

Shimada, Izumi

1994 Pre-Hispanic Metallurgy and Mining in the Andes: Recent Advances and Future Tasks. In *In Quest of Mineral Wealth: Aboriginal and Colonial Mining and Metallurgy in Spanish America*, edited by Alan K. Craig and Robert C. West, pp. 37–73. Louisiana State University Press, Baton Rouge.

Shimada, Izumi, Stephen M. Epstein, and Alan K. Craig

1983 The Metallurgical Process in Ancient North Peru. *Archaeology* 35(5):38–45.

Shimada, Izumi, and John F. Merkel

1991 Copper-Alloy Metallurgy in Ancient Peru. *Scientific American* 265(1):80–86.

Sillitoe, Richard H.

1988 Epochs of Intrusion-Related Copper Mineralization in the Andes. *Journal of South American Earth Sciences* 1(1):89–108.

Sinopoli, Carla M.

2003 *The Political Economy of Craft Production: Crafting Empire in South India, c. 1350–1650.* Cambridge University Press, Cambridge.

Stanish, Charles

1992 *Ancient Andean Political Economy.* University of Texas Press, Austin.

Stuart, David

1997 The Hills Are Alive: Sacred Mountains in the Maya Cosmos. *Symbols*:13–17.

2010 Shining Stones: Observations on the Ritual Meaning of Early Maya Stelae. In *The Place of Stone Monuments: Context, Use, and Meaning in Mesoamerica's Preclassic Transition*, edited by Julia Guernsey, John E. Clark, and Barbara Arroyo, pp. 283–298. Dumbarton Oaks Research Library and Collection, Washington, D.C.

Stuart, David, and Stephen Houston

1994 *Classic Maya Place Names.* Studies in Pre-Columbian Art and Archaeology 33. Dumbarton Oaks Research Library and Collection, Washington, D.C.

Topping, Peter, and Mark J. Lynott

2005 *The Cultural Landscape of Prehistoric Mines.* Oxbow Books, Oxford.

Van Buren, Mary, and María Presta

2010 The Organization of Inka Silver Production in Porco, Bolivia. In *Distant Provinces in the Inka Empire: Toward a Deeper Understanding of Inka Imperialism*, edited by Michael Malpass and Sonia Alconini, pp. 173–192. University of Iowa Press, Iowa City.

Vaughn, Kevin J.

2006 Craft Production, Exchange, and
 Political Power in the Pre-Incaic Andes.
 Journal of Archaeological Research
 14(4):313–344.

Vaughn, Kevin J., and Nicholas Tripcevich

2013 Introduction. In *Mining and Quarrying
 in the Ancient Andes: Sociopolitical,
 Economic, and Symbolic Dimensions*,
 edited by Nicholas Tripcevich and
 Kevin J. Vaughn, pp. 3–19. Interdisci-
 plinary Contributions to Archaeology
 Series. Springer, New York.

Vogt, Evon Z.

1969 *Zinacantan: A Maya Community in the
 Highlands of Chiapas.* Belknap Press,
 Cambridge, Mass.

1997a Maya Ritual and Cosmology in
 Contemporary Zinacantan. *Symbols*:
 9–12.

1997b Zinacanteco Astronomy. *Mexicon*
 19(6):110–117.

Warren, J. Benedict

1968 Minas de cobre de Michoacán, 1533.
 Anales del Museo Michoacano 6:35–52.

1989 Información del Licenciado Vasco de
 Quiroga sobre el cobre de Michoacán,
 1533. *Anales del Museo Michoacano*
 1:30–52.

Willey, Gordon R.

1962 The Early Great Styles and the Rise
 of the Pre-Columbian Civilizations.
 American Anthropologist 64:1–14.

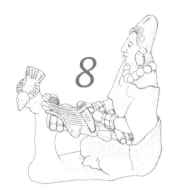

Spondylus and the Inka Empire on the Far North Coast of Peru

Recent Excavations at Taller Conchales, Cabeza de Vaca, Tumbes

JERRY D. MOORE AND CAROLINA MARIA VÍLCHEZ

It is good, at certain hours of the day and night,
to look closely at the world of objects at rest.
—Pablo Neruda, *Toward an Impure Poetry* (1935)

"A PRIMARY GOAL AND/OR CONSEQUENCE of imperial incorporation," Carla Sinopoli (2007:444) has observed, "is the extraction of wealth, in the form of subsistence and other resources (including human labor)." This was undeniably true of the Inka empire (Bauer 2004; D'Altroy 1992, 2002; D'Altroy and Earle 1985; Hyslop 1984, 1990; Julien 1982; McEwan 2006; Murra 1956; Rostoworowski de Diez Canseco 1999; Rowe 1944, 1946, 1982). Tawantinsuyu's broad imperial project was implemented via a variety of strategies, resulting in a complex pattern of political integration—similar to what Schreiber (1992), in reference to the Wari empire, has referred to as "a mosaic of control"—particularly evident on the frontiers of the Inka empire (see, e.g., Alconini 2004, 2008; Bray 2003; Covey 2008; D'Altroy et al. 2000; Hyslop 1998; Malpass and Alconini 2010;

Pärssínen et al. 2010; Salomon 1986, 1987; Santoro et al. 2004; Schreiber 1993).

As one aspect of its complex imperial project, the Inka state organized craft production through a range of tactics, including the creation of state-supported groups of attached full-time craft specialists; the periodic extraction of production from independent producers; and the diversion of household production from domestic contexts (Costin 1991, 1998a; Murra 1975). Such variations in the organization of Inka artisanal activities have been documented for ceramics (Costin 1986; Costin and Hagstrum 1995; D'Altroy and Bishop 1990; Hayashida 1995, 1998; Spurling 1992), textiles (Costin 1993, 1998b; Murra 1975:145–170), and lithic objects (Russell 1988). In addition, the Inka obtained precious and exotic materials, such as objects made from gold, silver, copper, and the lustrous shells of *Spondylus princeps*, the thorny oyster, and *Spondylus calcifer*, the large rock oyster (Carter 2008, 2011; Mackey and Pillsbury 2013; Owen 2001; Paulsen 1974; Pillsbury 1996). *Spondylus* shells were

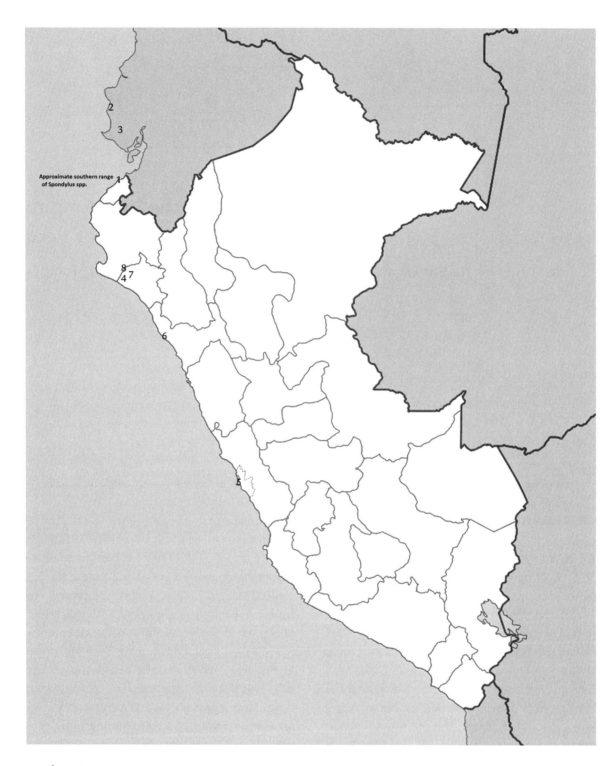

figure 8.1

Map of Peru, showing the location of sites discussed in the text: 1) Cabeza de Vaca/Taller Conchales; 2) Manteño sites; 3) El Azucar; 4) La Viña; 5) Pachacamac; 6) Huaca del Dragon; 7) Pampa Grande; and 8) Tucumé. (Illustration by Jerry D. Moore and Carolina Maria Vílchez.)

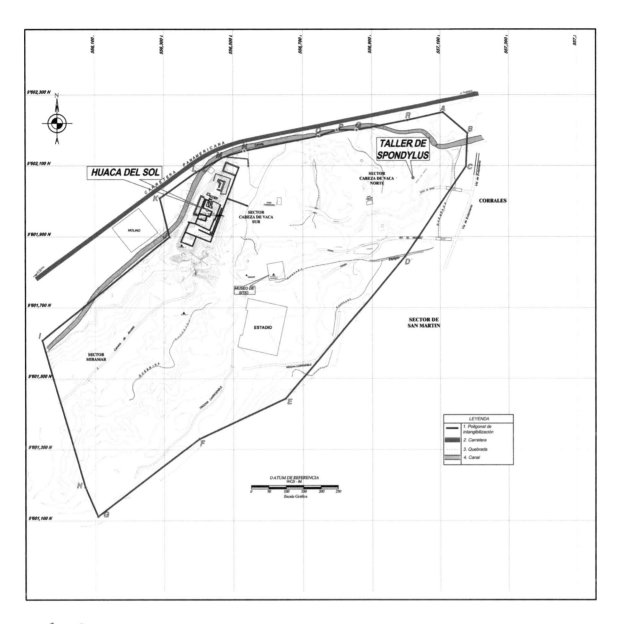

figure 8.2
Plan of Cabeza de Vaca and Taller Conchales, Tumbes, Peru. (Illustration by Carolina Maria Vílchez.)

a highly valued category of exotic items referred to by the Quechua term *mullu* (Gonzalez Holguin 1952 [1608]:249). Even today, *Spondylus* is esteemed, worked by artisans into beads (*chaquira*) and other jewelry (Bauer 2007; Meisch 2005:149–153; Robles and Méndez 1989).

Simultaneously, the production of *Spondylus* objects articulated with a remarkably resilient association between the mollusk and water rituals in the prehispanic Andes (Glowacki and Malpass 2003; Mackey and Pillsbury 2013; Moore 2013; Murra 1975:255–268; Pillsbury 1996) and the challenges that artisans encountered in transforming *Spondylus* shells into specific classes of artifacts. The techné of craft workers is evident in their ability to use a highly variable raw material—the individual valves of *Spondylus*—to make very different classes of objects—pendants, trapezoidal plaques, geometric figures for inlays, figurines, and disk beads—with a high level of uniformity within

each class of objects. As a once-living raw material, *Spondylus* shells vary greatly, and the properties of an individual valve limit the range and number of artifacts that can be produced from it. The spines on *Spondylus* shells provide a topography to which marine plants and animals attach, thus camouflaging the mollusk (Feifarek 1987) but also damaging the shell. Invasive epifauna may drill through the colorful exterior of the shells, creating a pocked layer unsuitable for bead manufacture but acceptable for pendants, trapezoidal plaques, or figurines.

In this chapter, we present new archaeological data for the Inka state's organization of *Spondylus* craft production at Taller Conchales, located at the Inka provincial center of Cabeza de Vaca in the department of Tumbes, Peru (Figures 8.1 and 8.2). These data illuminate the different *chaînes operatoires* involved in producing *Spondylus* objects—production that reflects political decisions, ritual practice, and the techné of artisans.

The Tumbes region was the only place in South America where the Inka empire's administrative network directly overlapped the natural distribution of *Spondylus* species, and Taller Conchales is the only archaeologically known *Spondylus* workshop that was directly administered by the Inka empire. Although Tumbes has received relatively little archaeological attention (but see Hocquenghem et al. 1993; Ishida 1960; Izumi and Terada 1966; Kauffmann Doig 1987; Richardson et al. 1990), recent research projects have produced major advances in our knowledge of the region (Moore 2010a, 2010b; Moore et al. 1997, 2005, 2008; Puell Mendoza et al. 1996; Vílchez 1999, 2010; Vílchez and Rodríguez 2012; Vílchez et al. 2007). It is clear that Tumbes played a significant role on the northern, coastal frontier of the Inka empire. Articulated with the rest of Tawantinsuyu via the Inka road network (Astahuaman 2008), Tumbes was pivotal in the acquisition of *Spondylus* shells—highly valued raw materials that were transformed into precious objects and ritual items that were exchanged over vast regions of South America. Taller Conchales at Cabeza de Vaca was pivotal in this state-organized production and distribution.

The archaeological data to support these inferences are discussed below.

Previous Studies of *Spondylus* and Shell Workshops

The genus *Spondylus* includes marine mollusks that were widely distributed in warm waters and whose shells were prized by ancient and traditional societies from the Aegean to Melanesia (e.g., Chapman et al. 2011; Ifantidis and Nikolaidou 2011; Malinowski 1922). *Spondylus princeps* and *Spondylus calcifer* are two species found in the eastern Pacific Ocean (Figure 8.3). Living in waters with temperatures from 80 to 85 °F (27–29 °C), their modern habitats range from the Gulf of California to just north of Cabo Blanco, Peru, where the cold-water Peruvian (or Humboldt) Current encounters the warm waters of the Equatorial Counter Current (Keen 1971:96). Although it has been long asserted that the Gulf of Guayaquil formed the southern limit of the *Spondylus* habitat (e.g., Paulsen 1974), the mollusks are, in fact, found as far south as Punta Sal, Peru, approximately 65 kilometers south of Tumbes, where *Spondylus calcifer* lives in sufficient densities—three to four individual mollusks per square meter, at depths of 10 to 12 meters—that artisans collect the shells today (Carter 2008:118–119).

Spondylus princeps and *Spondylus calcifer* were highly prized over a broad area of Andean South America, appearing in religious iconography of various periods from the Early Horizon (ca. 1500–400 BCE) until the Late Intermediate Period (ca. 900–1470 CE), and exchanged as whole valves, worked objects, and beads throughout prehistory and well into the early colonial period (Carter 2008, 2011; Cordy-Collins 1990, 2001; Dransart 1995; Hocquenghem 1993, 2010; Marcos 1977–1978; Murra 1975; Paulsen 1974; Pillsbury 1996; Saunders 1999:247–248). The spatial range of this exchange is striking, with *Spondylus* objects found on Inka mountaintop shrines at elevations of 5,300 meters in northwestern Argentina (Ceruti 2004), which is more than 3,200 kilometers south of the nearest

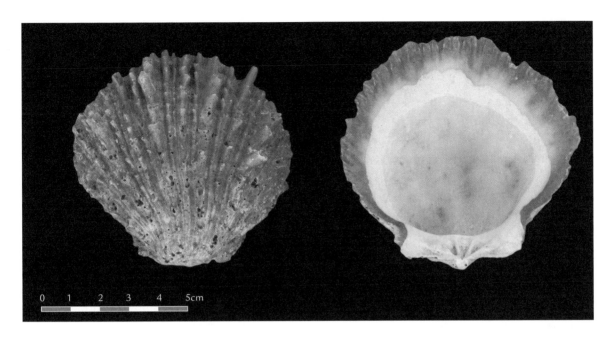

figure 8.3
Spondylus calcifer. (Photographs by Jerry D. Moore and Carolina Maria Vílchez.)

Spondylus habitat. The volume of this exchange is equally impressive, although difficult to quantify. Some sense of the magnitude of *Spondylus* exchange is indicated by a 1612 report on Jesuit efforts to extirpate idolatry near Lima; it relates that one Father Pedro de Uñate had recovered fourteen *cargas* of *Spondylus* beads in the process of sacking a single, unnamed huaca (Polia Meconi 2012:220). If one assumes, based on Vaca de Castro's *Ordenanzas de Tambos* (1908 [1543]:468), that a *carga* should be a maximum of thirty *libras* (a libra was approximately 0.46 kilograms) and a kilogram of beads would contain some eighteen thousand to nineteen thousand beads (extrapolated from Carter 2008:89, table 4.2), then fourteen cargas represent roughly 3.5 million beads from that one huaca alone.

The prehispanic transformation of *Spondylus* into beads and other objects has been documented at sites from the coastal zones of Panama and Ecuador, where craft production of varying levels of complexity and sophistication occurred in domestic contexts. For example, Mayo and Cooke (2005) report on excavations of the Pacific Coast site of Cerro Juan Díaz, Panama, a village dating to

between 700 and 900 CE, that contained modified shells and shell beads from *Spondylus* sp. and other mollusks. Evidence for shell working was found in a midden that also contained ceramics, food remains, and other domestic debris. A detailed analysis of production stages led Mayo and Cooke (2005:297) to infer that this economic activity was the work of craft specialists based on "their manufacturing process. Each stage involved the use of a specific technique," and the manufacturing process was "marked by technical complexity, one of the characteristics of craft specialization at Cerro Juan Díaz" (translation ours).

In contrast, Masucci (1995) documented extensive evidence for less complex shell bead and ornament manufacture from residential contexts at El Azucar, a Middle Guangala Phase (ca. 100–600 CE) site in southwestern Ecuador. Located approximately 25 kilometers inland, El Azucar had indisputable evidence for shell bead production, including 37 whole beads, 597 unfinished beads, and a staggering 1,257 stone drill bits recovered from an excavated area of 4 meters by 1 meter (4.6 cubic meters). At El Azucar, the evidence for working *Spondylus* and other shells came from domestic

contexts characterized by hearths, utilitarian ceramics, and faunal and macrobotanical remains that indicate food preparation and other household activities. Masucci (1995:79) writes, "Shell working and bead manufacture appear to have taken place within domestic contexts at small sites characterized by individual households devoted as much or more to subsistence activities as to craft activities."

The production of beads from *Spondylus* and other mollusks was widespread in coastal Ecuador in the provinces of Guayas and Manabí, particularly at Manteño sites dating from circa 900 to 1532 CE (e.g., Guinea 2006). The Manteño apparently were organized into a loose confederation of chiefdoms, with several major political and economic centers surrounded by smaller coastal towns, villages, and inland homesteads (McEwan and Delgado-Espinoza 2008). Beginning in the Early Intermediate Period and continuing thereafter, demand for *Spondylus* objects—especially beads—intensified: Manteño households produced beads in domestic contexts and production increased in response to external demands (Martin 2001, 2009; Martin and Lara 2010). Benjamin Carter (2008, 2011) has conducted an exhaustive analysis of *Spondylus* bead production at Late Guangala/Early Manteño (700–1300 CE) and Late Manteño (1200/1250–1532 CE) sites, providing an encyclopedic summary of the available archaeological data from coastal Ecuador. Carter also concludes that bead production occurred within domestic contexts. Further, his study of assemblages from six sites analyzed 7,650 *Spondylus* beads, as well as unfinished beads and stone drills; this analysis led him to identify two distinct chaînes opératoires, in which the earlier "Chaîne I" was more sophisticated than the later "Chaîne II." According to Carter (2008:498–499), "Procurement appears to be quite different for the two chaînes opératoires. Chaîne I beads are produced from whole shells or large chunks of shell, including, and possibly limited to, *Spondylus*. Chaîne II beads appear to be made mainly, though not exclusively, from *conchilla,* small water-worn shell fragments found along the beach; very few of these show the characteristic colors of *Spondylus*." Carter (2008:25–26) hypothesizes:

One of the factors that kept Manteño shell bead artisans making *chaquira* was the high demand from elites in the highlands of Ecuador and the north coast of Peru. The loss of these consumers did not produce an immediate drop in the supply of shell beads, but production of the smallest of the beads slowed and the [mean diameters] gradually increased in size. Finally, production of small regular beads gave way almost completely to the production of large irregular beads made from beach-worn shell . . . *Spondylus* continued to be used in great quantities by communities in Peru, but after c. AD 1200/50 they were not consuming shell beads, but using it as whole shells, as inlay in wooden figures (e.g., among the Chimú . . .) and as small figurines (among the Inka . . .). There is even sufficient evidence to suggest that the Inka actively participated in trade networks within southwestern Ecuador.

To summarize, a number of studies of workshops have identified *Spondylus* production as being conducted within domestic contexts by independent artisans who possessed varying levels of technical expertise. A high level of technical skill and uniform outcome is suggested for Cerro Juan Dios (Mayo and Cooke 2005), but not for the Guangala artisans at El Azucar (Masucci 1995). Among Manteño craftsmen, relatively high levels of uniformity in production gave way to somewhat greater variation in production techniques. Ultimately, a more complex technological process was replaced by a more expedient one (Carter 2008). In all of these cases, however, *Spondylus* objects were created in domestic contexts by unattached craft specialists.

Although *Spondylus* is widely found in archaeological contexts in the Central Andes and beyond, few workshops from Peru have been described in detail. At Pachacamac, dense deposits of *Spondylus* have been found as offerings and in fill layers, including items from various stages of production—whole valves, worked fragments, beads, and reduction debris (Eeckhout 2004:table 7)—and worked *Spondylus* debris was recovered by Max Uhle (University of Pennsylvania Museum

Object 225442), but no specific workshop has been identified (Peter Eeckhout, personal communication, 2012). Monge Olortugui and colleagues (1995) briefly describe *Spondylus* debris from Chimú contexts at Huaca de la Dragon and the Huaca de la Luna in the Moche Valley but provide no data on any associated workshops.

At Túcume in the Lambayeque Valley, Sandweiss uncovered a small complex of rooms "that contained abundant evidence of shell-bead manufacture," the earliest level of which dated to circa 1390–1480 CE (Sandweiss 1995:145), which was interpreted as associated with the Chimú occupation. Excavations recovered evidence of *Spondylus* bead production in which "[t]he entire shell reduction sequence was present—from whole shells, to cut shells, to perforated square disks awaiting the next final step of grinding into a circular shape, to finished beads" (Sandweiss 1995:145). *Spondylus* was not the only material made into ornaments in this workshop; worked pieces of other kinds of shell were found, as were beads of stone and copper. Manufacturing tools were recovered from the Túcume workshop, including abraders and polishing stones. Finally, it is important to note that the Túcume shell workshop was located in a nondomestic context (Daniel Sandweiss, personal communication, 2011).

Another *Spondylus* workshop was discovered by Shimada at the Moche V settlement of Pampa Grande (Shimada 1978, 1994). In addition to offerings of *Spondylus* beads, pendants, and cut-and-polished, narrow trapezoidal "plaques," other surface remains suggested the presence of small, dispersed workshops, one of which was selected for excavation (Shimada 1994:214–215). The excavated workshop was in a room (8 × 7.5 m) with a single entrance. Thirty-two whole *Spondylus* valves were recovered, in addition to extensive debris (Shimada 1994:215). Shimada (1994:216) writes that the Pampa Grande *Spondylus* workshop "was distinguished from other crafts by isolated production loci and the high-status or ceremonial value of the products." The so-called *Spondylus* House was a non-residential context characterized by "exclusive, tightly controlled production and use of *Spondylus* products."

More recently, Shimada has reported on the discovery of the partially intact Late Horizon burial of an adult male associated with an assemblage of *Spondylus* debris, finished artifacts, and tools from the regional Inka center of La Viña in the lower La Leche Valley (Shimada 2010). The site was exposed by erosion during the 1998 El Niño/Southern Oscillation event, and much of the skeleton was lost, but, fortuitously, tools, raw materials, and artifacts made from *Spondylus* that had been placed in the burial along with a Chimú-Inka ceramic vessel remained intact. Approximately 152 *Spondylus* fragments were recovered along with 19 fragments of *Conus fergusoni* and a few fragments identified as pearl oyster shells. A comparison of the figurines and debris suggests that the La Viña shell worker pursued craft methods and produced objects very similar to those seen at Taller Conchales (discussed below). Unfortunately, this burial does not illuminate the contexts of *Spondylus* production in the lower La Leche Valley.

Spondylus objects of various levels of complexity and sophistication were produced in different settings in prehispanic South America. On the one hand, workshops from Panama to the coast of Ecuador—regions with direct access to *Spondylus*—were in domestic contexts. On the other hand, the two workshops known from coastal Peru—where, presumably, the raw material was obtained through long-distance exchange—were located in non-residential architectural settings where access was controlled. These variations contrast with the organization of *Spondylus* production associated with the Inka Empire in the Tumbes region.

Tumbes and the Inka Empire

Andeanists have largely overlooked far northern Peru, a curious oversight given the prominent role the region had in the Spanish conquest of the Andes. When Francisco Pizarro and Diego de Almagro received their 1528 authorization to conquer (*La capitulación de Toledo*), Tumbes was the most impressive settlement that the conquistadores had encountered in their previous expeditions

in South America. The Tumbes region was also important for the Inka empire. The Inka administrative center at Cabeza de Vaca was a complex of enormous walled compounds on a river terrace above the west bank of the lower Rio Tumbes (Figure 8.4). Colonial-period accounts describe the site. In 1535, the conquistador Don Alonzo Enriquez de Guzman (1862 [1550]:95) observed: "The great city of Tumbes is inhabited entirely by Indians. It is on the sea-shore; and in it there is a great house, belonging to the lord of the country, with walls built of adobes, like bricks, very beautifully painted with many colors and varnished [sic] so that I never saw anything more beautiful. The roof is of straw, also painted, so that it looks like gold, very strong and handsome." Cieza de León provided a detailed description, noting:

> and in the port of Tumbes there had been made a royal fortress [of Huayna Capac], although some Indians state it that the building is older.

Huayna Capac arrived, who commanded a Temple of the Sun to be built next to the fortress of Tumbes and gathered together more than two hundred virgins, the most beautiful to be found in the regions, daughters of the *principales* of the pueblos. And in this fortress (that then was not ruined and, they say, was a thing marvelous to see) Huaynacapac established his captain or deputy with a great number of *mitimaes* and many storerooms filled with precious things. . . . And in this fortress of Tumbes there were a great number of silversmiths who made vessels of gold and silver and many other types of jewels for the service and decoration of the temple, which they held sacrosanct, as well as for their service of said Inka and to cover with this metal the walls of the temples and palaces. And the women were dedicated to the service of the temple and did nothing more than to spin and weave the finest woolen cloth which they did with great delicacy (Cieza de León 1973 [1553]:142–143).

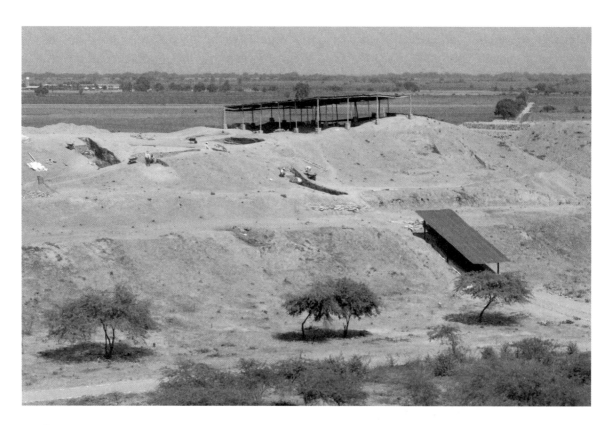

figure 8.4
Excavations in progress, Cabeza de Vaca. (Photograph by Carolina Maria Vílchez.)

figure 8.5
Mural fragments, Cabeza de Vaca. (Photograph by Carolina Maria Vílchez.)

Given these historical references to the Inka administrative center at Tumbes, it is puzzling why the site at Cabeza de Vaca has been overlooked by archaeologists who discuss the northern Inka Empire (e.g., Covey 2008:817, 820, 826)

The protected zone of Cabeza de Vaca covers 69.39 hectares on a terrace on the west bank of the Rio Tumbes; archaeological remains extend beyond those limits (see Figure 8.2). After the 1982–1983 El Niño/Southern Oscillation floods in the lower Tumbes Valley, local residents have built houses and damaged portions of the site. Since 2007, the Ministry of Culture has developed archaeological investigations within the protected zone, documenting the significance of Cabeza de Vaca in the Inka imperial infrastructure.

The structure known as the Huaca del Sol is in the central sector of the compound and consists of a multitiered edifice constructed from large adobe bricks. It is rectangular at its base and measures 300 by 100 meters; it is approximately 15 meters tall (Vílchez 2010). Although today it appears to be a solid mass, excavations in 2007 and 2010 defined internal architectural features, construction techniques, and building sequences. The Huaca del Sol contains a complex of enclosures, patios, and corridors formed by walls 1.5 to 3 meters thick that still stand 2 to 7 meters tall. Intact sections of painted walls have traces of red paint; other painted fragments have been recovered from fill layers (Figure 8.5). In addition, intact sectors of the uppermost portion of the Huaca del Sol have the remains of seven Inka-style trapezoidal niches that, although heavily damaged, retain traces of murals depicting *chakanas,* the stepped Andean cross. A 3-meter-tall perimeter wall surrounded the Huaca del Sol.

Archaeological excavations have focused on the protected zone of Cabeza de Vaca, but additional information about the site's unprotected

areas comes from salvage excavations, construction monitoring, and survey projects. Surface survey in the area due east of the Huaca del Sol, now covered by modern barrios, identified large wall foundations that form multiple terraces on the hill slope—apparently, defensive walls defining the "Fortaleza." In 2005, construction monitoring to the north of the main compound identified traces of a large cobblestone wall, approximately 1 meter wide and located underneath the Pan-American Highway, associated with a small room, possibly a storeroom, measuring 2.54 by 2.08 meters. Elsewhere, construction monitoring and limited test excavations encountered additional 1-meter-thick adobe walls and cobblestone foundations associated with abundant provincial Inka ceramics, including a ceramic mold, which may indicate the location of a ceramic workshop. Domestic middens nearby may indicate the presence of residential areas for craft workers located on the margins of the workshops (Vílchez 2010; Vílchez and Rodriguez 2012).

Other archaeological traces reflect Inka infrastructure and influence in the Tumbes region. A few segments of the Canal de los Inkas are still present on the western margin of the Rio Tumbes floodplain; the canal is associated with the Inka-period site of Vaqueria and terminates at Cabeza de Vaca (Moore et al. 1997; Vílchez 2010). Traces of stone alignments indicate that an ancient roadway, 8 kilometers long and 8 meters wide, connected Cabeza de Vaca to a natural port in the mangrove lagoons near the mouth of the Rio Tumbes. From Cabeza de Vaca, the Inka road ran along the west bank of the Rio Tumbes to the settlement of Riccaplaya, another Late Horizon settlement with traces of provincial Inka masonry walls and evidence of shell workshops (Hocquenghem and Peña Ruiz 1994). From Riccaplaya, the Inka road turned south and through the Cerro de Amotope, passing the *tambo* at Guineal—a 15-hectare site with abundant provincial Inka pottery in a small drainage named "Quebrada Cusco"—before entering the upper Chira drainage, and from there continuing to Piura and the coastal route of the Inka road network (Astahuaman 2008; Hyslop 1990; Petersen

1962). The provincial center at Cabeza de Vaca was a substantial investment of political power and was integrated into the Inka imperial network. It is within this political context and constructed setting that *Spondylus* shells were transformed into valued objects at Taller Conchales.

Situated between the Manteño producers and the Central Andean consumers, Carter (2008) suggested that archaeological investigations in the Tumbes region would be essential for understanding diachronic shifts in *Spondylus* production and exchange. Carter observed that because *Spondylus* live on the far northern coast of Peru, the presence of *Spondylus* in Central Andean sites does not necessary imply contact with coastal Ecuador: "it is quite possible that much of the *Spondylus* was acquired, worked, and traded in areas near Tumbes" (Carter 2008:120).

Previous archaeological investigations of *Spondylus* production in the Tumbes region were conducted by Hocquenghem and Peña (Hocquenghem 1993, 2010; Hocquenghem et al. 1993; Hocquenghem and Peña Ruiz 1994), who described *Spondylus* and other shells worked at Cabeza de Vaca and at Riccaplaya, including objects from Taller Conchales. The objects from Taller Conchales were unsystematically surface collected in 1983 by a group of local educators; although no maps or notes were made of the surface collection, Peña had access to this collection. Hocquenghem and Peña described the raw material, artifacts, and tools in the collection, as well as the iconography and representations of the shell objects. The authors also suggested that Cabeza de Vaca served as a port of trade for *Spondylus* valves brought by sea from coastal Ecuador to Tumbes, where they were transformed into objects and transported south via llama-pack trains. Acknowledging the limits of the unsystematic surface collection, Hocquenghem and Peña (1994:228) argued for the need for archaeological excavations to address key research questions, such as the storage and distribution of raw material and finished artifacts within the site, the organization of production within the workshops, and the nature of craft specialization. The 2011 excavations in Taller Conchales were designed to address these

and other questions through a program of systematic data recovery and analysis.

The 2011 Taller Conchales Excavations: Methods and Results

Taller Conchales is located on a small ridge approximately 750 meters northeast of the Huaca del Sol. Originally, the workshop covered a minimum area of approximately 50 by 25 meters (Hocquenghem and Peña Ruiz 1994:211), although it may have covered a larger area of approximately 150 by 55 meters of the ridge top (Wilson Puell Mendoza, personal communication, 2011). The presence of modern houses restricted the scope of the 2011 excavations to a relatively small area controlled by the Ministry of Culture (Figure 8.6).

Contiguous horizontal excavations were laid out as blocks of 2-by-2-meter units covering an area of 112 square meters, which was then excavated with trowel and brushes in cultural strata. The surface of the workshop was very shallow, generally less than 10 centimeters deep. Materials exposed during the excavations were point-provenienced. Plan views were drawn at 1:20 scale. All excavated materials were dry-screened through 2-millimeter mesh to retrieve beads, drill bits, shell detritus (Figure 8.7), and other small items. Accelerator Mass Spectrometry (AMS) dating run directly on samples of *Spondylus calcifer* indicate that Taller Conchales dates to the late fifteenth to early sixteenth century (Table 8.1). Because the Inka expansion to the northern Andes dates to circa 1470 CE, and because Tumbes had been sacked and burned by their rivals from Isla Puna when Pizarro returned in 1532, we infer that Taller Conchales was in operation from circa 1470 to 1532 CE.

Evidence of domestic activities are scarce at Taller Conchales, especially when compared to Loma Saavedra, another Late Horizon residential site excavated in 2006 with similar recovery techniques (Vílchez et al. 2007). At Loma Saavedra, a block excavation of 104 square meters exposed house floors, post holes, other domestic features, and a variety of artifacts that indicated a residential

context dating circa 1428 to 1625 CE (Beta 222685: 430 ± 50 BP) and that were associated with Chimú-Inka and provincial Inka ceramics. Common household implements—such as utilitarian ceramics, spindle whorls, and flake tools—were recovered from Loma Saavedra, as were abundant food remains. Several living floors were exposed at Loma Saavedra. Floor 1 extended 4.2 by 3.9 meters (16.2 m²). Ceramics recovered from the surface of Loma Saavedra's Floor 1 (i.e., not from midden deposits) totaled some 4,812 grams of diagnostic ceramics—representing plates, *ollas*, jars, and *tinajas*— and 22,458 grams of body sherds. At Taller Conchales, in contrast, only fourteen diagnostic sherds (139 grams) and 345 body sherds (2,204.7 grams) were recovered from an area nearly seven times the size of Loma Saavedra's Floor 1. Similarly, food remains were underrepresented at Taller Conchales, when compared to Loma Saavedra (Moore et al. 2005; Vílchez et al. 2007). For example, *Anadara tuberculosa* (*concha prieta*) comprised 70 to 90 percent of the shell by weight at Loma Saavedra (Moore et al. 2007, 2008); at Taller Conchales, this commonly consumed shellfish contributed less than 2.2 percent of the molluscan assemblage. Finally, hearths and storage pits were absent at Taller Conchales but present at Loma Saavedra. Taller Conchales lacked deposits of domestic debris or features known from domestic sites within the Tumbes region and in other sectors of the Cabeza de Vaca.

Although Taller Conchales lacked residential architecture, other traces of wall segments define a large and open patio surrounded by relatively tall adobe walls. The major wall located on the western margin of the excavated area was 1.6 meters wide at its base; it was made from adobes ranging from 48 to 50 centimeters by 30 to 35 centimeters and set in a light gray mortar. Although only one course of adobes was preserved, the 1.6-meter-wide base suggests a wall height of 2.5 to 3 meters, based on other intact walls at Cabeza de Vaca. No perpendicular walls, post holes, or other evidence of roof supports were uncovered in the excavations. The archaeological evidence from Taller Conchales indicates that the manufacture of objects from

figure 8.6
Area excavated in 2011 at Taller Conchales. (Photograph by Jerry D. Moore and Carolina Maria Vílchez.)

figure 8.7
Spondylus reduction
debris from
Taller Conchales.
(Photograph by
Jerry D. Moore and
Carolina Maria
Vílchez.)

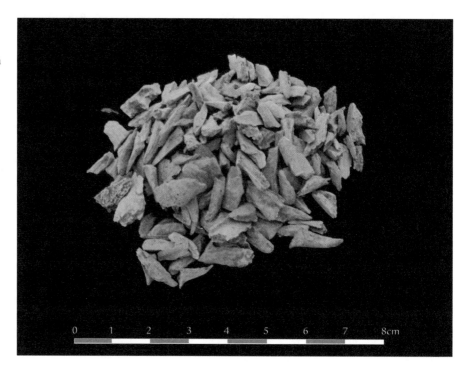

table 8.1

AMS dates on spondylus from Taller Conchales

PROVENIENCE	LAB NUMBER	CAL AD RANGE		
G5-1; Cabeza de Vaca, PE. S3, Q G5, L1	R_Date UCI-111929	1496	1648	95.4
G5-2; Cabeza de Vaca, PE. S3, Q G5, L2	R_Date UCI-111928	1456	1616	95.4
G5-3; Cabeza de Vaca, PE. S3, Q G5, L3	R_Date UCI-111927	1446	1576	95.4
	Delta_R LocalMarine	142	236	95.4

Spondylus occurred in an open patio—literally attached to the monumental architecture at Cabeza de Vaca.

Analysis of Materials Recovered from Taller Conchales

A total of 51,824 grams of *Spondylus* were recovered during the Taller Conchales excavation: 110,196 artifacts range from whole valves, cut hinges, and various classes of production debris to beads and other finished objects (Table 8.2). *Spondylus calcifer* and *princeps* comprise 96.8 percent by number and 89.7 percent by weight of the mollusk shells recovered during the excavations. Two other molluskan species were worked: *Pinctada mazatlantica* (n= 9,480; mass= 2,838.9 g) and *Anadara grandis* (n=17; mass=398 g). The principal craft activity was the manufacture of *Spondylus* objects.

Based on the objects recovered from the 2011 excavations, and on others in private collections, at least five distinct types of shell objects were manufactured from *Spondylus* at Taller Conchales: 1) pendants; 2) trapezoidal plaques; 3) geometric forms for appliqué; 4) figurines; and 5) disk beads that range in color from white to red/orange/pink (ROP). This list represents an implicit and approximate scale of labor intensity from least to most labor intensive. Pendants consist of either whole or large pieces of *Spondylus* valves whose spines have been removed. The shell was abraded until smooth, and one or more perforations were drilled, presumably to allow for the piece to be worn from a cord. Trapezoidal plaques were created by removing the

valve hinge, either through percussion or by cutting, and then making two roughly parallel cuts on the long axis of the shell to the outer lip; such plaques were often ground or abraded on their dorsal surfaces. Geometric forms for appliqué are cut triangular, rectangular, or elliptical artifacts that tend to be polished; presumably, they were manufactured as inlay for carved wooden objects. Figurines include a diverse class of uniformly small (less than 2 × 2 cm) artifacts depicting a wide array of objects: the seeds of domesticates, marine birds, ceramic vessels, and miniature *Spondylus* shells. White disk beads recovered from Taller Conchales were made from two species, *Anadara sp.* and the calcareous portion of *S. calcifer*. They are distinguished by their surfaces: the *Anadara* beads have a chalky matte surface, while the *S. calcifer* beads have a lustrous sheen. Finally, ROP disk beads

table 8.2

Spondylus production debris from the 2011 Taller Conchales excavations

	N	G
Spondylus valves	28	5,163
Cut-hinge fragments	554	2,946
Cut-valve lips	3,251	4,101
Spines	2,014	341
Cortex fragments	56,104	15,633
White fragments	46,944	14,715
Worked block "pre–pre-forms"	334	4,407
Polished "pre–pre-forms"	543	4,242
Polished pre-forms	424	276
	110,196	51,824

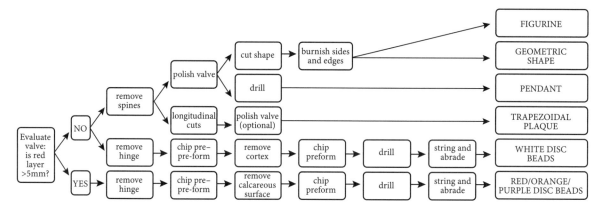

figure 8.8
Divergent chaînes opératoires, Taller Conchales. (Illustration by Cathy Lynne Costin.)

were made from the highly prized red margins of the *Spondylus* shells. Each of these artifact classes involved overlapping but distinct chaînes opératoires (Figure 8.8).

Evaluating the Shell

Production of these different objects began with evaluation of the shell. An initial assessment can be made by holding a valve up to a light source: light passes through a thin or porous shell, indicating raw material only suitable for pendants or trapezoidal plaques. Artisans at Taller Conchales also assessed the shell by removing the hinge, either through percussion or by cutting with a stone saw, thus exposing the shell at its thickest point. From this initial point, the chaînes opératoires diverged.

Pendant Production

Pendants were made from whole or large portions of *Spondylus* valves. The chaîne opératoire involved: a) assessing the material; b) removing the spines; c) abrading the dorsal surface of the valve until smooth; and d) drilling one or more holes through the shell, usually near the hinge (Figure 8.9). These perforations were made with quartz crystal drill bits, fifty-nine of which were recovered from Taller Conchales. Use traces near the tip of the quartz drill bits—scratches and nicks perpendicular to the drill shaft—are visible at 40× magnification (Figure 8.10). Measurements of the quartz crystal drills with intact tips (n=44) indicate

a mean diameter of 3.29 millimeters, although most drills (n=24) have tip widths between 1.99 and 3 millimeters. In contrast, disk shell beads' interior diameters average 1.40 millimeters (n=152); only ten beads have interior diameters of 2 millimeters or more. Obviously, the quartz drills were not used for bead manufacture, but they rather neatly fit the perforations in *Spondylus* pendants. Only two pendants were recovered during the excavations, but the large number of quartz drills suggests that these objects were important items produced at Taller Conchales.

Trapezoidal Plaques

These artifacts (n=11) consist of relatively large pieces of the valve that have been made by cutting the shell lengthwise, creating a long and relatively narrow object (Figure 8.11). The objects may retain the unmodified lip of the shell but do not have traces of the hinge, suggesting that the first step is to remove the hinge from the valve by sawing off the hinge with a stone tool or possibly by cutting at an angle to avoid the hinge entirely. Basalt saws were recovered from Taller Conchales. Cutting *Spondylus* with stone tools is labor intensive; Velázquez Castro and colleagues demonstrated that cutting a 2.5-centimeters-thick piece of *Spondylus* with a stone tool took four hours and fifty-five minutes (Velázquez Castro et al. 2006:29.) After cutting, all the spines were removed, and the trapezoidal plaque was polished. Trapezoidal plaques were found as

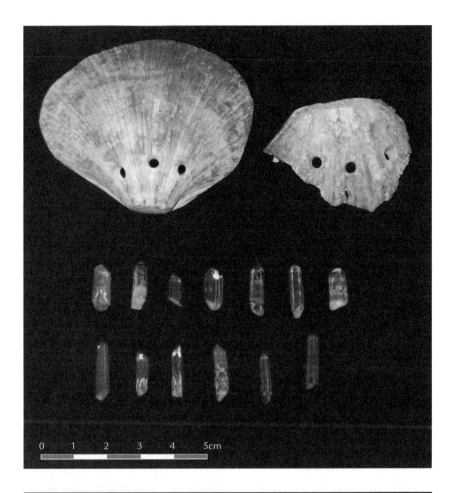

figure 8.9
Spondylus pendants and quartz drill bits from Taller Conchales. (Photograph by Jerry D. Moore and Carolina Maria Vílchez.)

figure 8.10
Quartz drill bit showing nicks and use-wear at 40× magnification. (Photograph by Jerry D. Moore and Carolina Maria Vílchez.)

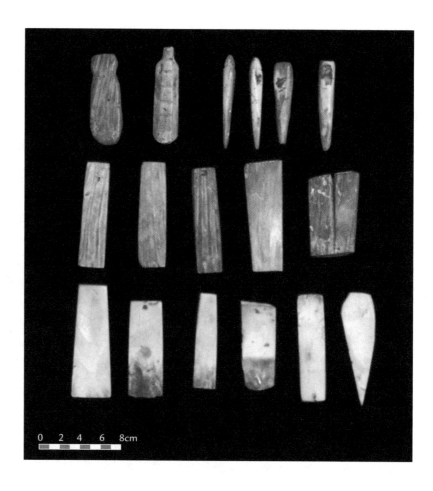

figure 8.11

Trapezoidal plaques from Taller Conchales. (Photograph by Jerry D. Moore and Carolina Maria Vílchez.)

offerings at Pampa Grande (Shimada 1994:214), and similar pieces were perforated and strung on a necklace associated with the Offering Assemblage S-II on the summit of Llullaillaco (Reinhard and Ceruti 2010:83) and used in Aymara miniatures (Arnold and Yapita 1998:258n17).

Geometric Forms for Appliqué

A small number (n=10) of objects in various geometric shapes—triangles, disks, and trapezoids—were made from *Spondylus* (Figure 8.12a). In addition to their shapes, these artifacts are notable for the high degree of polishing on both sides and for the absence of perforations. Initially, the circular examples were classified as bead pre-forms, but further analysis demonstrated that bead pre-forms were drilled before their edges were finished. Instead, these circular and other geometric pieces apparently were made to be incorporated into complex, shell-inlaid wooden objects similar to those known from Chimú sites (e.g., Jackson 2004; Uceda 1997). Interestingly, no evidence for woodworking was recovered from Taller Conchales (cf. Moore 1985:280–283), suggesting that these geometric objects were manufactured for use by a different set of craft specialists, although it is impossible to know if those woodworkers were located at Cabeza de Vaca or distant workshops.

Figurines

Figurines constitute a significant class of products at Taller Conchales (Figures 8.12b–c, 8.13–8.14). These artifacts are consistently small, delicately worked pieces depicting well-defined sets of subjects, including domesticated plant seeds, marine birds, ceramic vessels, and miniature *Spondylus* shells. Only twelve figurines were recovered during the 2011 excavations; they represent maize kernels (n=10), a small marine bird figure, and the head of a mammal, possibly a llama. Additional

examples are available from two private collections made by residents in the immediate vicinity of Taller Conchales: the Muñoz collection (Figure 8.12c), which was created in the areas of Taller Conchales and studied by Vílchez, and the Guerra collection, which was photographed by Moore in 1996 (Figure 8.13). Señora Tranquilina Guerra gathered these items over the years when she swept the hard-packed dirt floor of her house, which is located approximately 8 meters north of the 2011 excavations.

Some tentative patterns are evident from these figurines. First, there is a consistent emphasis on the size of the finished object, regardless of its subject: marine birds are the same size as maize kernels; sea shells the same size as cooking pots. All figurines are less than 2 by 2 centimeters in size. Second, it is interesting that the figurines tend to emphasize domesticated crops, with depictions of maize kernels, common beans, and broad beans comprising seventy percent (42 of 60) of the objects in these collections (Table 8.3). This category is followed by depictions of several different objects that can loosely be thought of as "domestic": ollas (n=5), tall vessels, or tinajas (n=2), pestles (n=6), and a mortar/open-mouthed bowl (n=1). Next are various objects associated with the sea, such as marine birds (n=9), fish (n=1), a seashell (n=1; possibly *Anadara* sp.), and exquisite depictions of *Spondylus* valves (n=4). Other objects, such as carved pips (n=5), other birds (n=5), and various quadrupeds (n=3) comprise the balance of the collection. Given the similarity of objects made at Taller Conchales to objects found elsewhere in the Inka Empire, it seems probable that the craft workers were responding to well-defined cultural expectations. But rather than rote production, careful manipulation of a highly variable raw material produced these culturally defined modalities, requiring artisans' assessments and skills, and expressing the techné of craft workers at Taller Conchales.

Interestingly, some classes of *Spondylus* objects found at other Inka sites apparently were *not* manufactured at Taller Conchales. For example, Heyerdahl and colleagues (1995:108–110) describe two human figurines that were discovered with an

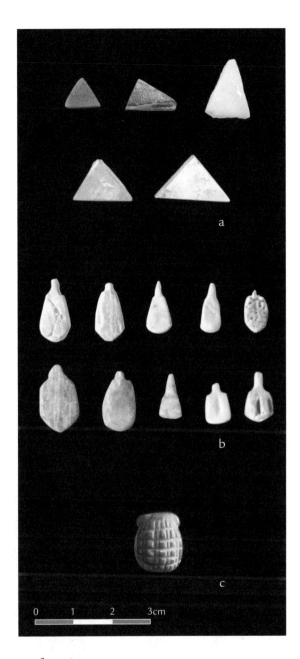

figure 8.12
Spondylus objects from Taller Conchales:
a) geometric forms for appliqué; b) figurines
recovered during the 2011 excavations; and
c) figurine from the Muñoz collections.
(Photographs by Jerry D. Moore and
Carolina Maria Vílchez.)

table 8.3

Figurines from the Taller Conchales collections

	2011 EXCAVATIONS	GUERRA COLLECTION	MUÑOZ COLLECTION	TOTALS
maize	10	14	1	25
common bean		7		7
broad bean		5		5
marine bird	1	3	5	9
other avian		5		5
Spondylus		3	1	4
Anadara		1		1
fish			1	1
llama (?)	1	1	1	3
olla		5		5
tinaja		2		2
mortar (?)		1		1
pestle		6		6
carved "pip"		5		5
worked/unfinished		7	3	10
worked broken		1		1
	12	66	12	90

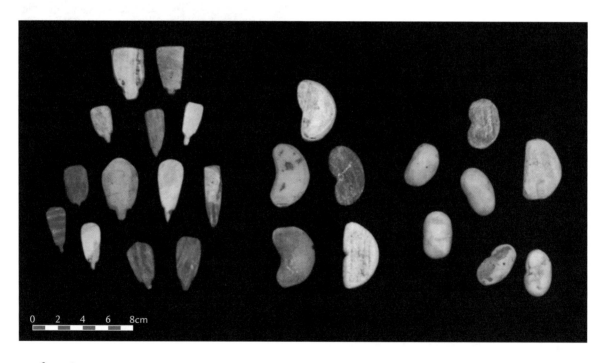

figure 8.13

Spondylus figurines from the Guerra collections, photographed 1996. (Photograph by Jerry D. Moore and Carolina Maria Vílchez.)

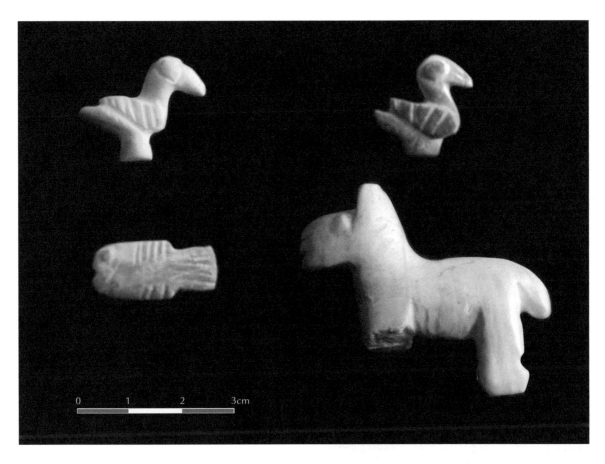

figure 8.14
Spondylus figurines from the Muñoz collections, photographed 2012. (Photographs by Jerry D. Moore and Carolina Maria Vílchez.)

Inka-period offering at Túcume: a male figurine 6.4 centimeters tall and a female figurine 5.4 centimeters tall, both carved from *Spondylus*. The Túcume figurines are broadly similar to the offerings associated with the high elevation (6,739 m) *capacocha* site on the summit of Llullaillaco, where six male figurines, ranging from less than 3 to 4.5 centimeters in length, and six female figurines ranging from 3 to 6 centimeters in length, were found; all were made from a thick piece of red *Spondylus*— almost certainly *Spondylus princeps*—and they were richly dressed in fine-made miniature garments and feathered headdresses (Reinhard and Ceruti 2010). No anthropomorphic figurines were recovered from Taller Conchales, although it is unclear why. Abundant and sufficiently large valves were available as raw materials, and the artisans of

Taller Conchales were sufficiently skilled to produce such figurines—but apparently they did not.

Disk Beads

Disk beads were the most numerous class of finished shell objects recovered from excavations (n=152). The majority were white beads made from *Spondylus calcifer* (n=69), followed by white beads from *Anadara* (n=46), red/orange/purple beads from *Spondylus* (n=35), and *P. mazatlantica* (n=2). Finished beads and drill bits were measured for maximum exterior diameter, maximum interior diameter, and thickness, using Mitutoyo 500 calipers and methods outlined by Carter (2008). Each stage of bead production was represented by the Taller Conchales materials (Figure 8.15). After assessing the relative thickness of the red versus

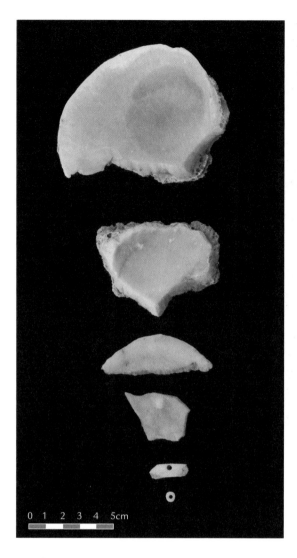

figure 8.15
Disk-bead production sequence, resulting in white beads from *S. calcifer*. (Photographs by Jerry D. Moore and Carolina Maria Vílchez.)

white layers of the *Spondylus* shell, the spines were abraded, the hinge was removed either by cutting or percussion, and the valve was either broken or cut into irregular chunks or "pre–pre-forms." These pieces were further worked into rough pre-forms, usually 2 by 2 centimeters or smaller in size, before the hole was drilled using microdrills chipped from quartzite and chert. The drilled pre-forms were presumably strung and abraded to form disk beads of an appropriate size.

The craft workers at Taller Conchales had a very specific ideal in terms of the size of shell

beads, regardless of whether the beads were made from the white calcareous portions of *Spondylus* or *Anadara*, or the ROP portions of the shell. As shown in Table 8.4, bead dimensions are uniform, regardless of color, with mean exterior dimensions ranging from 4.17 millimeters (ROP *Spondylus*) to 4.68 millimeters (white *Spondylus*), and mean interior dimensions ranging from 1.34 millimeters (*Anadara*) to 1.42 millimeters (white *Spondylus*). Calculating Student's t, pair wise comparisons of the three classes of beads indicates that these sets of beads were not significantly different at the 95-percent confidence level (see Table 8.4). The same techniques were used and the same outcomes were achieved in producing all of the beads.

Shell Objects from Taller Conchales: Divergent Chaînes Opératoires

The production of these different *Spondylus* objects involved distinct, although partially overlapping, chaînes opératoires (see Figure 8.8). *Spondylus* acquisition was followed by shell evaluation, done either through simple inspection or by removing the hinge to expose the maximal thicknesses and porosity of the colored prismatic surface versus the white calcareous portions. The *S. calcifer* valves from Taller Conchales rarely had large proportions of workable pink shell, but hinge removal showed the possibilities. After the hinge was cut, the spines were removed and the exterior was polished smooth.

At this point the various chaînes opératoires diverge. The steps for making figurines and plaques were relatively straightforward: the valves were cut into pieces somewhat larger than the final object, and then they were carved with flake tools and/or drilled. Bead manufacturing involved more steps.

Regardless of the final product, the initial steps in the process resulted in significant quantities of *Spondylus* debris: large chunks of irregularly cut valves, spines, miniscule "debitage" from cutting the valves, fragments of prismatic layer, and other materials. The initial stages of production are particularly well represented, while objects from the latter stages are underrepresented—presumably because the highly prized finished artifacts were not casually discarded.

table 8.4

Comparison of exterior and interior bead dimensions for disc beads from Taller Conchales

	EXTERIOR DIAMETER				INTERIOR DIAMETER		
	ANADARA	SPONDYLUS WHITE	SPONDYLUS ROP		ANADARA	SPONDYLUS WHITE	SPONDYLUS ROP
ANADARA	—	t=0.7758 p=0.4394	t=0.3882 p=0.6989	ANADARA	—	t=0.8044 p=0.4228	t=0.471 p=0.6396
SPONDYLUS WHITE		—	t=2.0534 p=0.0426	SPONDYLUS WHITE		—	t=0.1624 p=0.8713
SPONDYLUS ROP			—	SPONDYLUS ROP			—
	not significant at 95% level				not significant at 95% level		
	MEAN	STANDARD DEVIATION			MEAN	STANDARD DEVIATION	
ANADARA (N=46)	4.373	2.957		ANADARA (N=46)	1.335	0.819	
SPONDYLUS WHITE (N=70)	4.68	1.22		SPONDYLUS WHITE (N=70)	1.424	0.368	
SPONDYLUS ROP (N=34)	4.165	1.62		SPONDYLUS ROP (N=34)	1.41	0.525	

Discussion

The archaeological data from Taller Conchales illuminate a number of issues regarding *Spondylus*, craft production, the organization of labor on the far northern frontier of the Inka empire, and the Inka empire's involvement in rituals concerning water and agriculture. First, the excavations have documented the production of a variety of shell objects from *Spondylus calcifer*, *S. princeps,* and other mollusks. Commenting on Hocquenghem and Peña's publication, Carter (2008:193) wrote, "If *S. calcifer* is present at the site in different stages of production, this would be the only indication of such efforts in Peru." The 2011 excavations demonstrated that that is exactly the case. Second, the number of whole valves and the extraordinary quantities of *Spondylus* debris—particularly of *S. calcifer*—strongly suggest that artisans had ready and direct access to the raw material. Whole valves and large workable pieces were discarded rather than curated, indicating that access was not a problem. This abundant raw material supports Carter's observation about the availability of *Spondylus* along the extreme North Coast of Peru, although

Spondylus may have been shipped by sea from coastal Ecuador and off-loaded at Cabeza de Vaca (Hocquenghem and Peña Ruiz 1994). Nonetheless, the Inka provincial center at Tumbes was a point of production and not solely a port of entry.

Third, production of *Spondylus* objects occurred in non-domestic, specialized workshops at Taller Conchales. Spondylus production at Cabeza de Vaca fundamentally differed from the organization of bead production at Guangala and Manteño sites (Carter 2008; Martin 2009; Martin and Lara 2010; Masucci 1995), although it appears analogous to workshops described at Sicán/Lambayeque and Chimú sites (Sandweiss 1995; Shimada 1994). The absence of domestic objects and features indicates that Taller Conchales was a specialized production area, not a place where household life and craft production overlapped. It is unknown whether the artisans were full-time specialists, but when they were in Taller Conchales, they primarily focused on *Spondylus* craft production.

Fourth, when compared to the patterns at Guangala and Manteño sites, the data from Taller Conchales indicate different production goals. As noted above, Carter (2008:25–26) hypothesized

that demand during the Late Horizon shifted from beads to figurines, whole valves, and other objects—a change in production that resulted in the decline of *Spondylus* bead manufacturing along the Ecuadorian coast. This hypothesized shift in production is not supported by the Taller Conchales data. Although bead manufacture was an important goal of craft production at Taller Conchales, it was accompanied by the manufacture of other *Spondylus* objects: pendants, plaques, geometric pieces for appliqué, and figurines. These objects point to multiple uses: personal adornment, incorporation into composite artifacts, and offerings.

The objects produced at Taller Conchales were more than just prestige items produced for elites. We suggest that some of the figurines—particularly those depicting domesticated seeds, marine birds, and ceramic vessels that held liquids—were destined for agricultural or water rituals (Murra 1975; Zuidema 1978). These shell objects were so deeply implicated in Inka religion and, thus, idolatry that the extirpator Father José de la Arriaga instructed priests to ensure that "no Indian, male or female, will have mullu" (1999 [1621]:174; our translation). Bernabe Cobo observed: "These Indians were also accustomed to sacrifice seashells, especially when they made offering to the springs. They said this was a very appropriate sacrifice because the springs are the daughters of the sea, which is the mother of the waters.... This sacrifice was offered to the above mentioned springs after the planting was done so that the springs would not dry up that year and so that these springs would flow with abundance and irrigate their sown fields as had happened in past years" (Cobo 1990 [1653]:117).

Thus, *Spondylus* was a significant component in rituals associated with rainfall and agriculture. It was an association bolstered by the shapes of the figurines produced in Taller Conchales and possibly indirect expressions of what Peter Gose has called a

central metaphysical issue motivating the rise of the Inka empire.... [E]mbodied in its political structure was how to control a complex cycle that linked death and the regeneration of life in Andean thought. Here human death was

thought to create sources of water that lay outside the boundaries of the local political unit, such as Lake Titicaca and the Pacific Ocean. These sources had to be coaxed or coerced into sending water back to the local level for agricultural purposes. If these distant places could be subject to imperial control, then the complex cycle linking human death and agricultural fertility might be directly administered (Gose 1993:481–482).

Rather than a response to a specific drought, offerings of *Spondylus* to ensure water sources was a continual effort of what Tamara Bray (2009) has called "thinking through things." The use of *Spondylus* in water ritual was an expression of the Inka worldview that embodied the notion of *camaquen* (or *kamaquen*)—broadly defined as "the energizing of extant matter... a continuous act that works on a being as long as it exists" (Salomon 1991:16). In this specific exemplification, *Spondylus* shells were the daughters of the sea, who was the mother of all waters, and offerings of mullu expressed this reenergizing force of camaquen. Gose (1993:501) notes that "the sea was represented as the ultimate source of water in this cosmological system, even in Lake Titicaca, its highland counterpart.... [T]he paramount highland deities depended on the sea for the water they distributed. All highland peoples valued these shells as offerings, not just to major deities but primarily for local springs, to make them produce water." Given these conceptual frameworks, peoples of the Central Andes attempted to ensure precipitation by increased offerings to springs, mountains, and other huacas associated with water, and these offerings necessarily included *Spondylus* shells. This was not a simple response to paleo-environmental change: data from the Quelccaya ice core indicate sustained dry periods from circa 1100 to 1500 CE, whereas 1500 CE marked the beginning of a two-century-long period of wetter-than-normal conditions (Thompson et al. 1985, 1986). Rather, access to and control of the production of *Spondylus* items—and the creation of Taller Conchales—was one element of a larger aspect of the Inka Empire's attempt to control water resources and agricultural yields,

but it was an effort that was delineated by a specific worldview. As Gose (1993:509) points out, "Under the Inkas, the administration of water was probably more developed as ritual than it was at a purely utilitarian level. Yet the evidence . . . does not support the idea that Andean hydraulic ritual was a purely expressive practice. On the contrary, those who developed this elaborate ritual complex undoubtedly thought it was a practical way to manage a scarce resource. But, like all judgments of utility, this one was mediated by a specific cultural understanding of the world."

Conclusion

Given the value, ritual meanings, and political significance associated with *Spondylus*, Central Andean societies apparently employed different strategies to gain access to the material. As Carter (2008) has documented, a significant upsurge in Manteño bead production reflects the intensified demand for *Spondylus* by North Coast elites beginning in the Early Intermediate Period, as first Moche and then Lambayeque/Sicán societies sought access to these products. Based on current archaeological knowledge from the Tumbes region, there is no reason to think that North Coast polities—including the Chimú—had a direct or permanent presence in the Tumbes region, although there is some evidence of exchange of Lambayeque/ Sicán ceramics (Moore et al. 1997). Archaeological evidence from Tumbes prior to the Late Horizon supports the models advanced by Carter (2008), Marcos (1977–1978), Masucci (1995), and Martin (2001, 2009; Martin and Lara 2010), who envision a noncentralized production and exchange network, perhaps coordinated by coastal Ecuadorian elites who organized land and sea trade expeditions that linked coastal Ecuadorian household producers and Central Andean consumers.

The hypothesis that the Chimú Empire expanded northward to Tumbes and established administrative centers in the region to gain access to *Spondylus* (Hocquenghem 1993:713; Netherly 2009; Paulsen 1974; Richardson et al. 1990) is not supported by archaeological data, despite programs of survey and excavation explicitly designed to search for evidence of the Chimú presence in the region (Moore and Mackey 2008; Moore et al. 1997, 2008). Further, although it had been suggested that Cabeza de Vaca was originally a Chimú administrative center later co-opted by the Inka, excavations have not encountered a Chimú component (Vílchez 1999, 2010). Rather, the Chimú gained access to *Spondylus* either through commercial or elite exchanges, possibly maintaining some of the trading ties previously established by the Lambayeque/Sicán polity or through maritime exchange with Late Manteño chiefdoms (Moore and Mackey 2008). The actual nature of these exchange relations remains unclear, but it is certain that the Chimú did not conquer and establish an imperial infrastructure in the Tumbes Valley to gain access to *Spondylus*.

The Inka Empire's strategy was different: they established a complex imperial infrastructure within the Tumbes Valley. Tawantinsuyu's interest in the Tumbes region was not limited to acquiring *Spondylus*; rather, it was part of the empire's broader program of northern expansion. The Inka established a major presence in the Tumbes Valley, a chain of imperial installations anchored by the large religious and administrative center at Cabeza de Vaca. The evidence for the construction of extensive irrigation canals, the creation of a Huaca del Sol, and the ethnohistoric references to other forms of craft specialization all point to imperial goals that were broader than mere *Spondylus* acquisition. Nonetheless, beads and objects made from *Spondylus calcifer* and *S. princeps* were clearly important to the Inka, and the empire directly organized the production of *Spondylus* objects by attached craft specialists in Taller Conchales of Cabeza de Vaca—items crafted from the daughters of the sea that were carried south to the distant reaches of Tawantinsuyu.

Acknowledgments

The research at Taller Conchales was conducted under the auspices of the Ministro de Cultura's

Qhapaq Ñan Project and its "Proyecto de Investigación Arqueológica Cabeza de Vaca con fines de Diagnóstico para su Puesta en Uso Social," directed by Lic. Maria Carolina Vílchez. The authors are grateful for the support of Gian Carlo Marcone Flores, Secretario Técnico del Proyecto Qhapaq Ñan; Janie Gómez Guerrero, Coordinadora del los Proyectos Integrales del Proyecto Qhapaq Ñan; and Fanny Rodríguez Enríquez, Arqueóloga del Proyecto Integral Cabeza de Vaca. Additional support was provided by a project grant in Pre-Columbian Studies, Dumbarton Oaks Research Library and Collection. We thank Dr. Joanne Pillsbury and Dr. Mary Pye for their support. We also thank Dr. Colin McEwan for his support of the research and for the opportunity to participate in the October 2013 symposium from which the present volume derives. Additional support was provided to Moore by the College of Natural and Behavioral Sciences, California State University Dominguez Hills. Moore also thanks Dr. Benjamin Carter (Muhlenberg College), Dr. Daniel Sandweiss (University of Maine), and Dr. Izumi Shimada (Southern Illinois University) for responding to queries about their work on *Spondylus* workshops. Finally, we thank Dr. Cathy Costin for the invitation to participate in the symposium and volume.

REFERENCES CITED

Alconini, Sonia

2004 The Southeastern Inka Frontier against the Chirguanos: Structure and Dynamics of the Inka Imperial Borderlands. *Latin American Antiquity* 15(4):389–418.

2008 Dis-embedded Centers and Architecture of Power in the Fringes of the Inka Empire: New Perspectives on Territorial and Hegemonic Strategies of Domination. *Journal of Anthropological Archaeology* 27:63–81.

Arnold, Denise, and Juan De Dios Yapita

1998 *Río de Vellón, Río de Canto: Cantar a los Animales, una Poética Andina de la Creación.* Instituto de Lengua y Cultura Aymara, La Paz.

Arriaga, José de la

1999 [1621] *La extirpación de la idolatría en el Piru.* Centro Bartolomé de las Casas, Cuzco.

Astahuaman, Cesar

2008 Inka Settlements in the Sierra de Piura, Northern Peru. PhD dissertation, University College, London.

Bauer, Brian

2004 *Ancient Cuzco: Heartland of the Inka.* University of Texas Press, Austin.

Bauer, Daniel

2007 The Reinvention of Tradition: An Ethnographic Study of Spondylus Use in Coastal Ecuador. *Journal of Anthropological Research* 63(1):33–50.

Bray, Tamara

2003 *Los efectos del imperio inkaico en la frontera septentrional: Una investigación arqueológica.* Abya-Yala Press, Quito.

2009 An Archaeological Perspective on the Andean Concept of Camaquen: Thinking Through Late Pre-Columbian Ofrendas and Huacas. *Cambridge Archaeological Journal* 19(3):357–366.

Carter, Benjamin

2008 Technology, Society, and Change: Shell Artifact Production among the Manteño (AD 800–1532) of Coastal Ecuador. PhD dissertation, Washington University, Saint Louis.

2011 *Spondylus* in South American Prehistory. In *Spondylus in Prehistory: New Data and Approaches—Contributions to the Archaeology of Shell Technologies,* edited by F. Ifantidis and M. Nikolaidou, pp. 63–89. British Archaeological Reports International Series 2216. Archaeopress, Oxford.

Ceruti, Constanza

2004 Human Bodies as Objects of Dedication at Inka Mountain Shrines (Northwestern Argentina). *World Archaeology* 36(1):103–122.

Chapman, John, Bisserka Gaydarska, Evangelia Skafida, and Stella Souvatzi

2011 Personhood and the Life Cycle of Spondylus Rings: An Example from Late Neolithic, Greece. In *Spondylus in Prehistory: New Data and Approaches—Contributions to the Archaeology of Shell Technologies*, edited by F. Ifantidis and M. Nikolaidou, pp. 139–160. British Archaeological Reports International Series 2216. Archaeopress, Oxford.

Cieza de León, Pedro

1973 [1553] *La crónica del Perú.* PEISA, Lima.

1987 [1553] *Crónica del Perú: Tercera parte.* Edited by Francesca Cantù. Fondo Editorial de la Pontificia Universidad Católica del Perú, Lima.

Cobo, Bernabe

1990 [1653] *Inca Religion and Customs.* Translated and edited by Roland Hamilton. University of Texas Press, Austin.

Cordy-Collins, Alana

1990 Fonga Sigde, Shell Purveyor to the Chimú Kings. In *The Northern Dynasties: Kingship and Statecraft in Chimor*, edited by Michael Moseley and Alana Cordy-Collins, pp. 393–417. Dumbarton Oaks Research Library and Collection, Washington, D.C.

2001 Blood and the Moon Priestesses: Spondylus Shells in Moche Ceremony. In *Ritual Sacrifice in Ancient Peru,* edited by Elizabeth Benson and Anita Cook, pp. 35–53. University of Texas Press, Austin.

Costin, Cathy Lynne

1986 From Chiefdom to Empire State: Ceramic Economy among the Prehispanic Wanka of Highland Peru. PhD dissertation, University of California, Los Angeles.

1991 Craft Specialization: Issues in Defining, Documenting, and Explaining the Organization of Production. In *Archaeological Method and Theory*, vol. 3, edited

by Michael Schiffer, pp. 1–56. University of Arizona Press, Tucson.

1993 Textiles, Women, and Political Economy in Late Prehispanic Peru. *Research in Economic Anthropology* 14:3–28.

1998a Concepts of Property and Access to Nonagricultural Resources in the Inka Empire. In *Property in Economic Context*, edited by Robert C. Hunt and Antonio Gilman, pp. 119–137. Monographs in Economic Anthropology 14. University Press of America, Lanham, Md.

1998b Housewives, Chosen Women, and Skilled Men: Cloth Production and Social Identity in the Late Prehispanic Andes. In *Craft and Social Identity*, edited by Cathy Lynne Costin and Rita Wright, pp. 123–144. Archeological Papers of the American Anthropological Association 8. Washington, D.C.

Costin, Cathy Lynne, and Melissa Hagstrum

1995 Standardization, Labor Investment, Skill, and the Organization of Ceramic Production in Late Prehispanic Peru. *American Antiquity* 60:619–639.

Covey, R. Alan

2008 The Inka Empire. In *Handbook of South American Archaeology*, edited by Helaine Silverman and William Isbell, pp. 809–830. Springer, New York.

D'Altroy, Terence

1992 *Provincial Power in the Inka Empire.* Smithsonian Institution Press, Washington, D.C.

2002 *The Inkas.* Blackwell, Malden, Mass.

D'Altroy, Terence, and Ronald Bishop

1990 The Provincial Organization of Inka Ceramic Production. *American Antiquity* 55:120–138.

D'Altroy, Terence, and Timothy Earle

1985 Staple Finance, Wealth Finance, and Storage in the Inka Political Economy. *Current Anthropology* 26:187–206.

D'Altroy, Terence N., Ana María Lorandi, Veronica I. Williams, Milena Calderari, Christine A. Hastorf, Elizabeth DeMarrais, and Melissa B. Hagstrum

2000 Inka Rule in the Northern Calchaquí Valley, Argentina. *Journal of Field Archaeology* 27(1):1–26.

Dransart, Penny

1995 *Elemental Meanings: Symbolic Expression in Inka Miniature Figurines.* Institute of Latin American Studies, Occasional Research Paper 40. University of London, London.

Eeckhout, Peter

2004 Relatos míticos y Practica Rituales en Pachacamac. *Boletín del Instituto Frances de Estudios Andinos* 33(1):1–54.

Eeckhout, Peter, and Lawrence Owens

2008 Human Sacrifice at Pachacamac. *Latin America Antiquity* 19(4):375–398.

Enriquez de Guzman, Alonzo

1862 [1550] *The Life and Acts of Don Alonzo Enriquez de Guzman: A Knight of Seville, of the Order of Santiago, A.D. 1518 to 1543.* Translated and edited by Clement Markham. Hakylut Society, London.

Feifarek, Brian

1987 Spines and Epibionts as Antipredator Defenses in the Thorny Oyster *Spondylus americanus* Hermann. *Journal of Experimental Marine Biology and Ecology* 105(1):39–56.

Glowacki, Mary, and Michael Malpass

2003 Water, Huacas, and Ancestor Worship: Traces of a Sacred Wari Landscape. *Latin American Antiquity* 14(4):431–448.

Gonzalez Holguin, Diego

1952 [1608] *Vocabulario de la lengua general de todo el Perú llamada lengua quichua o del Inca.* Edited by Raúl Porras Barrenechea. Universidad Nacional Mayor de San Marcos, Lima.

Gose, Peter

1993 Segmentary State Formation and the Ritual Control of Water under the Incas. *Comparative Studies in Society and History* 35(3):480–514.

Guinea, Mercedes

2006 Un sistema de producción artesanal de cuentas de concha en un contexto domestico manteño: Japoto (provincia de Manabí, Ecuador). *Bulletin de l'Institut Français d'Études Andines* 35(3):299–312.

Hayashida, Frances

1995 State Pottery Production in the Inka Provinces. PhD dissertation, Department of Anthropology, University of Michigan, Ann Arbor.

1998 New Insights into Inka Pottery Production. In *Andean Ceramics: Technology, Organization, and Approaches,* edited by Izumi Shimada, pp. 313–338. MASCA Research Papers in Science and Archaeology, Supplement to Volume 15. University of Pennsylvania Museum, Philadelphia.

Heyerdahl, Thor, Daniel Sandweiss, and Alfredo Narvaez

1995 *Pyramids of Tucume: The Quest for Peru's Forgotten City.* Thames and Hudson, New York.

Hocquenghem, Anne Marie

1991 Frontera entre "áreas culturales" norandinas y centroandinas en los valles y en la costa del extremo norte peruano. *Bulletin de l'Institut Français d'Etudes Andines* 20(2):309–348.

1993 Rutas de intercambio del mullu. *Bulletin de l'Institut Français d'Etudes Andines* 22(3):701–719.

2010 El *Spondylus príceps* y la edad de bronce en los Andes centrales: Las rutas de intercambios. In *Producción de bienes ornamentales y votivos de la América antigua,* edited by Emiliano Melgar Tísoc, Reyna Solís Ciriaco, and Ernesto González Licón, pp. 34–49. Syllaba Press, Deale, Fla.

Hocquenghem, Anne Marie, Jaime Idrovo, Peter Kaulicke, and Dominique Gomis

1993 Bases de intercambio entre sociedades norperuanas y surecuatorianas: Una zona de transición entre 1500 A.C. y 600 D.C. *Bulletin de l'Institut Français d'Etudes Andines* 22(2):443–466.

Hocquenghem, Anne Marie, and Manuel Peña Ruiz

1994 La talla de material malacológico en el extremo norte del Perú. *Bulletin de l'Institut Français d'Etudes Andines* 23(2):209–229.

Hyslop, John

1984 *The Inka Road System.* Academic Press, New York.

1990 *Inka Settlement Planning.* University of Texas Press, Austin.

1998 Las fronteras estatales extremas de Tawantinyu. In *La frontera del estado Inka*, edited by Tom Dillehay and Patricia Netherly, pp. 33–70. Fundación Alexander von Humboldt/Editorial Abya-Yala, Quito.

Ishida, Eiichirō

1960 *Andes: The Report of the University of Tokyo Scientific Expeditions to the Andes in 1958.* Bijutsu Shuppan Sha, Tokyo.

Izumi, Seichii, and Kazuo Terada

1966 *Andes 3: Excavations at Pechiche and Garbanzal, Tumbes Valley, Perú, 1960.* Kadokawa Publishing, Tokyo.

Ifantidis, Fotis, and Marianna Nikolaidou (editors)

2011 *Spondylus in Prehistory: New Data and Approaches—Contributions to the Archaeology of Shell Technologies.* British Archaeological Reports International Series 2216. Archaeopress, Oxford.

Jackson, Margaret

2004 The Chimú Sculptures of Huacas Tacaynamo and El Dragon, Moche Valley, Perú. *Latin American Antiquity* 15:298–322.

Julien, Catherine

1982 Inca Decimal Administration in the Lake Titicaca Region. In *The Inka and Aztec States 1400–1800: Anthropology and History*, edited by George A. Collier, Renato I. Rosaldo, and John D. Wirth, pp. 119–147. Academic Press, New York.

Kauffmann Doig, Frederico

1987 Notas arqueológicas sobre la Costa Extremo Norte. *Boletin de Lima* 49:53–57.

Keen, Angeline

1971 *Seashells of Tropical West America: Marine Molluscs from Baja California to Peru.* Stanford University Press, Stanford, Calif.

Mackey, Carol, and Joanne Pillsbury

2013 Cosmology and Ritual on a Lambayeque Beaker. In *Pre-Columbian Art and Archaeology: Essays in Honor of Frederick R. Mayer*, edited by Margaret Young-Sánchez, pp. 115–141. Denver Art Museum, Denver.

Malinowski, Bronislaw

1922 *Argonauts of the Western Pacific: An Account of Native Enterprise and Adventure in the Archipelagoes of Melanesian New Guinea.* Routledge, London.

Malpass, Michael, and Sonia Alconini (editors)

2010 *Distant Provinces in the Inka Empire: Towards A Deeper Understanding of Inka Imperialism.* University of Iowa Press, Iowa City.

Marcos, Jorge

1977–1978 Cruising to Acapulco and Back with the Thorny Oyster Set: A Model for a Lineal Exchange System. *Journal of the Steward Anthropological Society* 9(1–2):99–132.

Martin, Alexander

2001 The Dynamics of Spondylus Trade Across the South American Central Pacific Coast. MA thesis, Department of Anthropology, Florida Atlantic University.

2009 The Domestic Mode of Production and the Development of Sociopolitical Complexity: Evidence from the Spondylus Industry of Coastal Ecuador. PhD dissertation, Department of Anthropology, University of Pittsburgh.

Martin, Alexander, and Catherine Lara

2010 La trayectoria social del desarrollo social precolombino en el sur de Manabí. *Antropología: Cuadernos de Investigación* 8:121–147.

Masucci, Maria

1995 Marine Shell Production and the Role of Domestic Craft Activities in the Economy of the Guangala Phase, Southwest Ecuador. *Latin American Antiquity* 6(1):70–84.

Mayo, Julia, and Richard Cooke

2005 La industria prehispánica de conchas marinas en Gran Coclé, Panamá. *Archaeofauna* 14:285–298.

McEwan, Colin, and Francisco Delgado-Espinoza

2008 Late Pre-Hispanic Polities of Coastal Ecuador. In *Handbook of South American Archaeology*, edited by Helaine Silverman and William Isbell, pp. 505–525. Springer, New York.

McEwan, Gordon

 2006 *The Incas: New Perspectives*. ABC-Clio Press, Santa Barbara, Calif.

Meisch, Lynn

 2005 Why Do They Like Red? Beads, Ethnicity, and Gender in Ecuador. In *Beads and Bead Makers: Gender, Material Culture, and Meaning*, edited by Lidia Sciama and Joanne Eicher, pp. 147–155. Berg, Oxford.

Monge Olortugui, Manuel, Jorge Quijano Rojas, and Luis Zavaleta Nureña

 1995 Una aproximación al estudio de las técnicas y herramientas en la manufactura de objetos de Spondylus, Cultura Chimú. Informe de prácticas pre-profesionales, Facultad de Ciencias Sociales, Universidad Nacional de Trujillo.

Moore, Jerry

 1985 Household Economics and Political Integration: The Lower Class of the Chimú Empire. PhD dissertation, Department of Anthropology, University of California, Santa Barbara.

 2010a Architecture, Settlement, and Formative Developments in the Equatorial Andes: New Discoveries in the Department of Tumbes, Peru. *Latin American Antiquity* 21:147–172.

 2010b Making a Huaca: Memory and Praxis in Prehispanic Far Northern Peru. *Journal of Social Archaeology* 10(3):531–555.

 2013 The Multivalent Mollusk: Spondylus, Ritual, and Politics in Prehispanic Peru. Paper presented at the 2013 American Anthropological Association Annual Meeting, Chicago.

Moore, Jerry, and Carol Mackey

 2008 The Chimú Empire. In *The Handbook of South American Archaeology*, edited by Helaine Silverman and William Isbell, pp. 783–808. Springer, New York.

Moore, Jerry, Bernardino Olaya Olaya, and Wilson Puell Mendoza

 1997 Investigaciones del Imperio Chimú en el valle de Tumbes, Perú. *Revista del Museo de Arqueología, Antropología e Historia* 7:173–184.

Moore, Jerry, Carolina Maria Vílchez, Bernardino Olaya Olaya, and Eva Pajuelo (editors)

 2007 Informe técnico: El Proyecto Arqueológico Tumbes; Excavaciones en El Porvenir y Loma Saavedra, Temporada 2006. Technical report submitted to the Instituto Nacional de Cultura, Lima.

Moore, Jerry, Carolina Maria Vílchez, Bernardino Olaya Olaya, Eva Pajuelo, and Andrew Bryan

 2005 Informe técnico: 2003 Excavaciones en el sitio Loma Saavedra. Technical report submitted to the Instituto Nacional de Cultura, Lima.

Moore, Jerry, Daniel Dávila Manrique, and Eva Pajuelo (editors)

 2008 Informe técnico: El Proyecto Arqueológico Tumbes; Excavaciones en Santa Rosa y Uña de Gato, Temporada 2007. Technical report submitted to the Instituto Nacional de Cultura, Lima.

Murra, John

 1956 The Economic Organization of the Inka State. PhD dissertatation, University of Chicago.

 1975 *Formaciones económicas y políticas del mundo andino*. Instituto de Estudios Peruanos, Lima.

Netherly, Patricia

 2009 Landscapes as Metaphors: Resources, Languages, and Myths of Dynastic Origins on the Pacific Coast from the Santa Valley (Peru) to Manabí (Ecuador). In *Landscapes of Origin in the Americas: Creation Narratives Linking Ancient Places and Present Communities*, edited by Jessica Christie, pp. 123–152. University of Alabama Press, Tuscaloosa.

Owen, Bruce

 2001 The Economy of Metal and Shell Wealth goods. In *Empire and Domestic Economy*, edited by Terence N. D'Altroy and Christine A. Hastorf, pp. 265–296. Kluwer Academic/Plenum, New York.

Pärssínen, Martii, Risto Kesseli, and Juan Faldin

 2010 Paria: The Southern Inka Capital Rediscovered. *Chungará* 42(1):235–246.

Paulsen, Allison

1974 The Thorny Oyster and the Voice of God: *Spondylus* and *Strombus* in Andean Prehistory. *American Antiquity* 39:597–607.

Petersen, George

1962 Las primeras operaciones militares de Francisco Pizarro en el Perú. *Actas y Trabajos del II Congreso Nacional de Historia del Perú* 2:359-383. Lima.

Pillsbury, Joanne

1996 The Thorny Oyster and the Origins of Empire: Implications of Recently Uncovered Spondylus Imagery from Chan-Chan, Peru. *Latin American Antiquity* 8:313–340.

Polia Meconi, Mario

2012 Siete cartas inéditas del Archivo Romano de la Compañia de Jesús (1611–1613): Huacas, mitos y ritos andinos. *Anthropologica* 14(14):209–259.

Puell Mendoza, Wilson, Bernardino Olaya, and Carolina Vílchez

1996 Reconocimiento y evaluación de sitios arqueológicos en la sub Región Tumbes, 1ra Parte. Technical report submitted to the Instituto Nacional de Cultura, Tumbes.

Reinhard, Johan, and Maria Constanza Ceruti

2010 *Inka Rituals and Sacred Mountains: A Study of the World's Highest Archaeological Sites.* Cotsen Institute of Archaeology Press, Los Angeles.

Richardson II, James, Mark McConaughy, Allison Heaps de Peña, and Elenca Décima Zamecnik

1990 The Northern Frontier of the Kingdom of Chimor: The Piura, Chira and Tumbez Valleys. In *The Northern Dynasties: Kingship and Statecraft in Chimor,* edited by Michael Moseley and Alana Cordy-Collins, pp. 419–445. Dumbarton Oaks Research Library and Collection, Washington, D.C.

Robles, Americo, and Matilde Méndez

1989 Moluscos comerciales del litoral de Tumbes y Piura. *Boletin de Lima* 63:47–70.

Rostworowski de Diez Canseco, Maria

1999 *History of the Inka Realm.* Cambridge University Press, Cambridge.

Rowe, John

1944 *An Introduction to the Archaeology of Cuzco.* Papers of the Peabody Museum of American Archaeology and Ethnology 27. The Peabody Museum, Cambridge, Mass.

1946 Inca Culture at the Time of the Spanish Conquest. In *The Andean Civilizations.* Vol. 2 *of Handbook of South American Indians,* edited by Julian H. Steward, pp. 183–330. Bureau of American Ethnology Bulletin 143. Smithsonian Institution Press, Washington, D.C.

1982 Inka Policies and Institutions Relating to the Cultural Unification of the Empire. In *The Inka and Aztec States 1400–1800: Anthropology and History,* edited by George A. Collier, Renato I. Rosaldo, and John D. Wirth, pp. 93–118. Academic Press, New York.

Russell, Glenn

1988 The Impact of Inka Policy on the Domestic Economy of the Wanka, Peru: Stone Tool Production and Use. PhD dissertation, University of California, Los Angeles.

Salomon, Frank

1986 Vertical Politics on the Inka Frontier. In *Anthropological History of Andean Polities,* edited by John V. Murra, Nathan Wachtel, and Jacques Revel, pp. 89–117. Cambridge University Press, New York.

1987 A North Andean Status Trader Complex under Inka Rule. *Ethnohistory* 34(1):63–77.

1991 Introduction. In *The Huarochirí Manuscript: A Testament of Ancient and Colonial Andean Religion,* edited and translated by Frank Salomon and George Urioste, pp. 1–38. University of Texas Press, Austin.

Sandweiss, Daniel H.

1995 Life in Ancient Túcume: Sector V. In *Pyramids of Túcume: The Quest for Peru's Forgotten City*, edited by Thor Heyerdahl, Daniel Sandweiss, and Alfredo Narváez, pp. 142–168. Thames and Hudson, New York.

Santoro, Calogero M., Alvaro R. Guevara, Vivien G. Standen, and Amador Torres

2004 Continuidad y cambio en las comunidades locales, periodos Intermedio Tardio y Tardio, valles occidentales del área centro sur andino. *Chungará* 36:235–247.

Saunders, Nicholas

1999 Biographies of Brilliance: Pearls, Transformations of Matter, and Being, c. AD 1492. *World Archaeology* 31(2):243–257.

Schreiber, Katharina

1992 *Wari Imperialism in Middle Horizon Peru*. Museum of Anthropology, University of Michigan, Ann Arbor.

1993 The Inka Occupation of Andamarca, Lucanas, Peru. In *Provincial Inka: Archaeological and Ethnohistorical Assessment of the Impact of the Inka State*, edited by Michael Malpass, pp. 77–116. University of Iowa Press, Iowa City.

Shimada, Izumi

1978 Commodity and Labor Flow at Moche V Pampa Grande, Peru. *American Antiquity* 43:569–592.

1994 *Pampa Grande and the Mochica Culture*. University of Texas Press, Austin.

2010 Shell Artifact Manufacturing: Insight from a Late Horizon Shellworker's Tool Kit. Paper presented at the 75th Annual Meeting of the Society for American Archaeology, Sacramento.

Sinopoli, Carla

2007 Empires. In *Archaeology at the Millennium: A Sourcebook*, edited by Gary Feinman and T. Douglas Price, pp. 439-471. Springer, New York.

Spurling, Geoffrey

1992 The Organization of Craft Production in the Inka State: The Potters and Weavers of Milliraya. PhD dissertation, Cornell University, Ithaca, N.Y.

Thompson, Lonnie G., Ellen Mosley-Thompson, John F. Bolzan, and Bruce R. Koci

1985 A 1500-Year Record of Tropical Precipitation in Ice Cores from the Quelccaya Ice Cap, Peru. *Science* 229(4717):971–973.

Thompson, Lonnie G., Ellen Mosley-Thompson, Willi Dansgaard, and Pieter M. Grootes

1986 The Little Ice Age as Recorded in the Stratigraphy of the Tropical Quelccaya Ice Cap. *Science* 234(4774):361–364.

Uceda, Santiago

1997 Esculturas en miniatura y una maqueta en madera. In *Investigaciones en la Huaca de la Luna 1995*, edited by Santiago Uceda, Elias Mujica, and Ricardo Morales, pp. 151–176. Universidad Nacional de La Libertad, Trujillo.

Vaca de Castro, Cristobal

1908 [1543] Ordenanzas de tambos, distancias de unos a otros, modo de cargar los indios y obligaciones de las justicias respectivas hechas en la ciudad del Cuzco en 31 de mayo de 1543. *Revista histórica* 3:427–494.

Velázquez Castro, Adrián, E. Melgar Tísoc, and Anne-Marie Hocquenghem

2006 Análisis de las huellas de manufactura del material malacológico de Tumbes, Perú. *Bulletin de l'Institut Français d'Études Andines* 35(1):21–35.

Vílchez Carrasco, Carolina

1999 Diseño arquitectónico y secuencia constructiva de la Cabeza de Vaca, valle de Tumbes. Tesis de licenciatura, Escuela de Arqueología, Universidad Nacional de Trujillo.

2010 Informe final: Proyecto de investigación arqueológica Cabeza de Vaca, Temporada 2009. Technical report submitted to the Instituto Nacional de Cultura, Lima.

Vílchez Carrasco, Carolina, and Fanny Rodríguez (editors)

2012 Informe final: Proyecto de investigación arqueológica y puesta en uso social Cabeza de Vaca; Excavación en el taller malacológico. Technical report submitted to the Instituto Nacional de Cultura, Lima.

Vílchez Carrasco, Carolina, Jerry Moore, and Eva Pajuelo (editors)

2007 Informe final: Proyecto Arqueológico Tumbes; Excavaciones en El Porvenir y Loma Saavedra, departamento de Tumbes, Temporada 2006. Technical report submitted to the Instituto Nacional de Cultura, Lima.

Zuidema, R. Thomas

1978 Shaft Tombs and the Inka Empire. *Steward Journal of Anthropology* 9(1–2): 133–178.

9

The Artistry of Moche Mural Painting and the Ephemerality of Monuments

LISA TREVER

STANDING MERE INCHES FROM THE PAINTED surfaces of the temple murals, which my field project discovered within the monumental adobe architecture of the late Moche site of Pañamarca, Peru, in 2010,[1] I was able to observe the minute details of form and facture that go unnoticed in photography or illustration. Within ancient Andean art, the Pañamarca murals are remarkable for their narrative iconography: scenes of processional dances, ceremonies of ritual presentations of goblets, and cycles of mythological battles. But during this sustained period of close inspection, I could see that the paintings were not especially well made. Incised outlines had been quickly sketched, and errant strokes were common. Hands, arms, and bodies were often misshapen. Drips of paint frequently marred the white backgrounds of the walls, and paint sometimes splattered the floors as well. My in situ scrutiny revealed that the murals were hastily executed, hardly what one would expect of products

of techné, defined for this volume as "socially purposeful skilled crafting" (Costin, this volume, Introduction).

It might be tempting to dismiss the Pañamarca paintings as poorly made Moche art based on the criterion of skilled crafting alone. These paintings do not exhibit the same careful finish or deft handling of materials observed in metal ornaments from the tombs of Sipán or Loma Negra, in Moche fineline ceramic painting, or in the sculptural mastery of Moche "portrait" vessels. It would be easy to judge these murals as technically inferior, provincial works of art produced by unskilled painters in the cultural periphery of the Nepeña Valley at the far south of the Moche world. But in their hasty facture the Pañamarca murals are not unique within the corpus of Moche murals; indeed, there is evidence elsewhere for expedient image making on temple walls, even in the most important monumental architecture (*huacas*) of the "heartland" of the Moche and Chicama Valleys to the north.

253

The central locations of such paintings make clear that these were highly significant images and that focus on technical skill alone cannot satisfy the search for either meaning or value produced in this medium. Clearly, these paintings—which were created within the most restricted precincts of Moche ceremonial architecture—were meaningful, were valued, and had great social utility. But if meaning and value were not created through skilled execution, then the bases of their significance must lie elsewhere.

This essay approaches the artistry of Moche murals in four parts. First, I discuss the mid-twentieth-century origins of the reputation of Moche artists as "Mastercraftsmen" who created highly revered, museum-quality objects of gold and silver, stone and shell, and ceramic. I juxtapose that modern assessment with rare depictions of artistic and craft production found in Moche visual culture itself. Second, in broadly considering the genre of mural painting and painted relief, I demonstrate how the rift between connoisseurial expectations and ancient practices grows wider, especially in late contexts. Third, I present observations on the corpus of paintings at Pañamarca to discuss artistic practice, cross-media references, narrative content, and what I argue is a contiguous relationship between dynamic processes of painting and ongoing practices of ritual gesture and response, as evidenced by libations and graffiti on painted walls. Finally, I invoke cross-cultural examples of impermanent architecture and disappearing sculpture to call for a broader reconsideration of the material ephemerality of the adobe medium itself, as it may inform interpretations and evaluations of expedient practices of image making. By relocating interpretive focus from technical skill to possible conceptualizations of painted huacas as mortal entities, I argue for a parallel relocation of the valuation of Pre-Columbian art and architecture—one that moves away from traditional connoisseurial modes and toward a more profound appreciation of the social utility of apparently *unskilled* crafting, as valued within the ephemeral contexts of ritual experience and performance.

Reconsidering the Moche "Mastercraftsmen"

The reputation of the Moche as great artists and highly skilled craft producers emerged in mid-twentieth-century museum contexts and in developments of relative chronology for Pre-Columbian Peru. At present, the Moche polities of north coastal Peru and the recognizable material culture that their artists created are most accurately dated to circa 200 to 900 CE (Koons and Alex 2014), though refinement of chronologies and models of political organization continue to occupy the field (Quilter and Castillo 2010). The establishment of standardized chronologies for ancient South America has long concerned archaeologists and curators.[2] In their 1949 book *Andean Culture History*, published by the American Museum of Natural History, Wendell Bennett and Junius Bird defined a series of cultural phases, including what they called the "Mastercraftsman Period" of Peruvian prehistory. They judged this phase, which they dated to 600 to 1000 CE, as a developmental stage that represented "the acme of technology and craftsmanship" (Bennett and Bird 1949:153), characterized by "the mastery of agricultural techniques, by ambitious monumental architecture, by skilled craftsmanship in ceramics, weaving, and metallurgy, and by a florescence of art styles" (Bennett and Bird 1949:155). Within this artistic and technological florescence, the authors included highland and coastal cultures of Moche, Nasca, Lima, Recuay, and Pucara, which they saw as culminations of earlier "Experimenter" cultures.

Twenty years later, the Guggenheim Museum in New York invoked Bennett and Bird's designation more generally in the title of its exhibition *Mastercraftsmen of Ancient Peru* (Sawyer 1968; see also Sawyer 1954:2). Although the expression lingers in Andeanist literature—for example, in framing the Moche and the Nasca as "The Great Artisans" (Richardson 1994)—for the most part usage of the "Mastercraftsman Period" was short-lived in Andean archaeology. The developmental chronology was soon replaced by the ostensibly

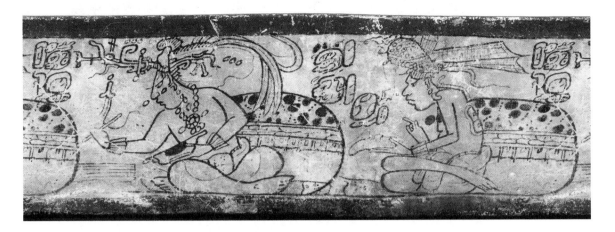

neutral Horizon and Period sequence developed by John H. Rowe (1960, 1962), based on the work of Alfred Kroeber and Max Uhle (Pozorski and Pozorski 1987; Rice 1993; Stone-Miller 1993).

Yet, even as the developmental stage was discarded, the idea of the Moche and their contemporaries as exceptionally skilled craftsmen remained. According to Rowe (1960:629): "In some areas, such as the north and south coasts, the regional cultures of the Early Intermediate Period marked a *peak of artistic originality and skill*, but there are indications that artistic excellence was not characteristic of all cultures of this period" (my emphasis). Today, the reputation of the Moche as exceptional craftsmen among their contemporaries persists in celebratory art historical accounts and in exhibitions of the objects they produced.

The finest Moche objects have inspired recent comparisons to the art produced by their northerly contemporaries, the Classic Maya, and to other figural artistic traditions of ancient Mesoamerica (Pasztory 1998). Some scholars have perceived similarities between facets of Moche and Maya society, including the social importance of artists and artisans (Benson 2010:35–36). But whereas the artist as painter, scribe, or sculptor—both human and divine (Figure 9.1)—enjoyed a celebrated place in Classic Maya iconography and inscriptions

(Coe and Kerr 1998; Reents-Budet 1994; see also Houston, this volume), very few images of Moche artists or artisans at work have survived. The rare examples that do exist are among the only indications of how the Moche, who left no written testimonies, directly articulated the status of artists and the esteem that may have been accorded to skilled craft production in their own visual culture.[3]

In the corpus of Moche painting one finds scarce depictions of weavers: one painted on the interior of a flaring vase (*florero*) in the British Museum (Figure 9.2) and another painted on the face of a recently excavated adobe bench (Figure 9.3) within the New Temple (Platform III) of Huaca de la Luna in the Moche Valley (Uceda et al. 2010:103; Uceda et al. 2011:99). Elsewhere in collections of sculpted ceramics are rare images of other forms of craft production: metalworking and the preparation of food or drink (e.g., Donnan 1978:figs. 15, 105). As in later periods of Andean history (Lechtman 1996; Phipps et al. 2004), the Moche may have considered cloth and metal among the most materially valuable media. Enduring indigenous systems of material value could account for the explicit illustration of these particular forms of production within the corpus of Moche ceramics.

It is surprising, given the acclaim that has been afforded the "Mastercraftsmen," that there are no

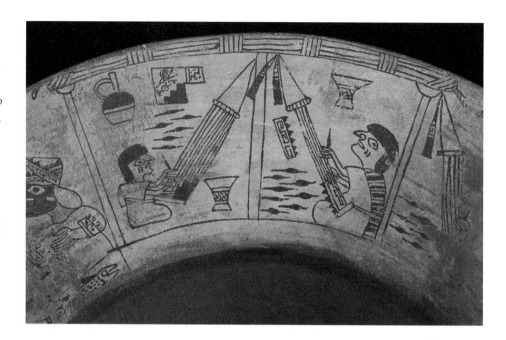

figure 9.2
Detail of the interior painting on a Moche *florero* depicting weavers. (© Trustees of the British Museum, Am1913,1025.1.)

figure 9.3
Mural painting of weavers from the New Temple of Huaca de la Luna. (Photograph by Lisa Trever.)

clear representations of painters painting or sculptors sculpting yet known within Moche visual culture. As a possible exception, Elizabeth Benson (2010:36, 2012:51) has proposed that a recurring type of sculpted ceramic vessel may depict a sculptor smoothing the surface of an anthropomorphic ceramic jar (Figure 9.4). In these depictions, a seated man holds an implement—sometimes rounded, sometimes flat—against what appears to be a large and presumably hollow ceramic figurine. Through comparison to the broader ceramic corpus, however, I propose an alternative identification of the subject as a musician, shown striking or tapping the hollow ceramic body as a percussive instrument.[4] Other images of musicians hold similar implements against the sides or tops of drums (e.g., Benson 1972:figs. 5–15; Donnan 1978:figs. 167, 173). In those few Moche illustrations of weaving, metallurgy, and beverage production, artisans are depicted wearing modest garments and head wraps, but musicians are more elaborately dressed.[5] The seated man holding the figurine, illustrated

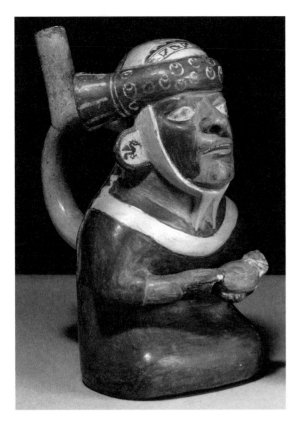

figure 9.4
A Moche stirrup-spout bottle in the form of a well-dressed man holding what appears to be a large ceramic figurine. (Photograph © Trustees of the British Museum, Am1909,1218.9.)

here in Figure 9.4, wears earspools decorated with birds and a fancy headdress depicted as if it were adorned with gold disks. He lifts his chin and gaze, lips parted, as if in song or chant (see also Benson 2010:fig. 22). Within the finite parameters of Moche visual culture, images like this one would be anomalous as representations of ceramicists, but as musicians they conform to the subject of musical performance and ritual action that is pervasive throughout the Moche plastic tradition (e.g., Donnan 1982).

The salient point here is that—although Moche artworks have been placed among the greatest technical and aesthetic accomplishments of the Pre-Columbian world—Moche artists were not widely celebrated within their own visual culture. Where visual representations do survive, they depict the

creation of sumptuary objects and ornaments (tapestries and metalwork), the preparation of food or drink, and ephemeral performances of music, dance, and sacrifice. They do not emphasize painting and sculpture, those acts so revered by the Classic Maya and in dominant European narratives of art history since Giorgio Vasari's 1550 *Le Vite de' più eccellenti pittori, scultori, e architettori*. One does not find the elevation of the genres of painting and sculpture over what might be considered the minor arts,[6] but the opposite: the visual presentation of what in other cultural contexts might be considered craft and domestic production. Nor is there a widespread celebration of visual and material artistry as a noble and self-conscious practice within Moche visual culture, as for the Classic Maya. This comparison of modern curatorial standards with Moche self-presentation of the arts demonstrates discontinuous interests and values in media and modes of production. Moche pictorial interest in weaving, metalworking, and other practices of production may be compatible with the idea of techné, though the case of ceramics remains ambiguous when viewed through this lens. That is, the potential for identifying a Moche construct of techné does not manifest evenly across media. In turning this consideration of Moche artistry from the production of objects to the creation of wall painting, the gulf expands between connoisseurial expectations and the ancient social, religious, and aesthetic contexts that motivated visual production.

Locating Artistry in Moche Mural Painting

Mural painting and adobe relief sculpture are ancient art forms on the Pacific Coast of the central Andean region. The earliest known example of Andean mural painting, at present, is the four-thousand-year-old image of deer caught in a net that Ignacio Alva and Walter Alva discovered in 2007 at Ventarrón in the Lambayeque Valley (Alva Meneses 2012). Adobe walls were painted and sculpted with images of plants, animals, human figures, and fanged supernaturals since the formative periods of Peruvian prehistory at places like

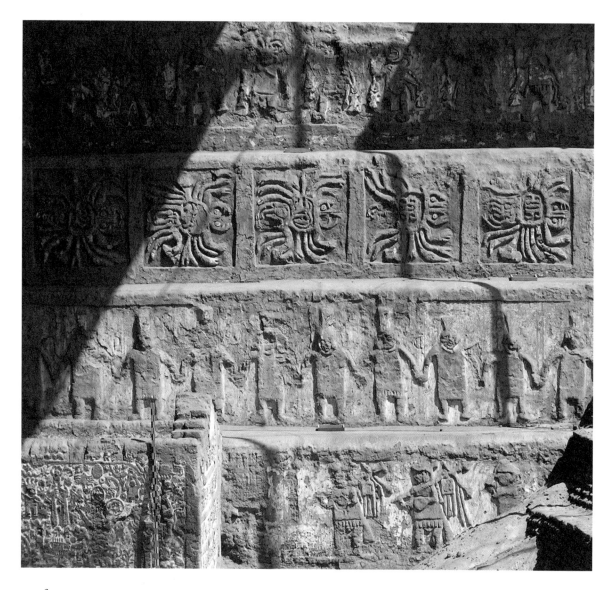

figure 9.5
View of the north facade of the Old Temple of Huaca de la Luna. (Photograph by Lisa Trever.)

Garagay, Moxeke, Cerro Sechín, and Huaca de los Reyes (Bonavia 1985; Donnan 1985). Early examples of the tradition include the exquisitely sculpted feline relief recently discovered in near pristine condition by Koichiro Shibata (2011) at Huaca Partida in the Nepeña Valley, just up valley from Pañamarca.

For this genre of monumental art, however, it is the Moche corpus that is best known from the ancient Andes. Decades before the inception of the permanent research projects at Huacas de Moche and Huaca Cao within the El Brujo archaeological complex (see, for example, Mujica Barreda 2007; Uceda 2001; Uceda and Morales 2010), the late archaeologist Duccio Bonavia singled out Moche achievements in this medium, writing: "Moche mural paintings are the best-known expressions of this Andean art. They must have abounded in the area influenced by that culture, although few examples have survived to our time" (Bonavia 1985:47). The discoveries of mural paintings and painted reliefs over the last thirty years at Huaca de la Luna, Huaca Cao, Pañamarca, and elsewhere have completely reshaped the state of this field from

what Bonavia observed. The burgeoning corpus of painted Moche walls continues to grow with each field season, as ongoing excavations and conservation work on the North Coast reveal long-buried monuments. Any assessment of the artistry of this medium must, therefore, bear the dynamic state of the field in mind, at the risk of prematurely generalizing a yet-emerging subject of study. What follows is thus an exploratory assessment of the forms of artistry (and their limits) that can be located within the known corpus of painted walls of the Moche huacas, with a focus on the southern Moche world.

Moche huacas are ziggurat-like platform complexes that served as central nodes within the social, political, and artistic networks and ritual landscapes of the North Coast of Peru, both during the Moche era of 200 to 900 CE and after, as later people continued to bury their dead and make offerings within the massive ruins. With little exception, the Moche built this religious architecture out of sun-dried adobe bricks. Many huacas were decorated, inside and out, with relief sculpture and polychrome painting (Figure 9.5), although many painted surfaces have now been lost to erosion.

There seems to have been little inherent distinction, for the Moche, between what art historians might consider separate genres of mural painting and painted relief. An example from Huaca Cao within the El Brujo archaeological complex in the Chicama Valley illustrates the point. The two techniques appear together within the ceremonial patio of the second building phase, in two registers of a single composition of geometricized marine life: flat surface above and sculpted below (Mujica Barreda 2007:110–111). Elsewhere within the same platform structure, wood and bone armatures were used to support especially high adobe relief (Mujica Barreda 2007:118, 159); in other parts, painted walls are entirely flat (Mujica Barreda 2007:122–131). Further evidence for the dimensional flexibility of the genre is found in the north facade of the Old Temple (Platform I) of Huaca de la Luna, which was alternately arrayed with sculpted (Edificio C), then mostly flat (Edificio B), then again sculpted images (Edificio A) as the iconography of the temple's monumental facade was reproduced with varying

technique in each of its final three phases (Uceda 2001). The presence or absence of relief seems to have been less closely controlled, as was the subject matter depicted. I therefore include both flat painting and painted relief within the broader category of Moche wall painting discussed here.

In the Moche world, unlike that of the Maya—where stucco was used in abundance—adobe walls to be painted were coated with only the thinnest layer of white, calcium-rich paint, probably prepared from ground shells, certainly not limestone. Specialists have debated the next step in the process. Based on his study of Pañamarca's Mural E, Bonavia (1959:24, 1974:55, 1985:49) concluded that the adobe wall was coated with clay plaster and painted white while the surface was still wet. Once the wall was dry, the underdrawing was incised and then painted in polychrome. Our work at Pañamarca in 2010 confirmed this technique for most murals at the site. Lines scratched in the dry white surfaces create, in effect, very low relief. Bonavia (1984) resisted accepting conservator Ricardo Morales's (1982) description of a slightly different mural technique at Huaca de la Luna. There, Morales had found that walls were primed with white paint and also incised while still damp, and then painted with colors, as one also finds at Huaca Cao (Figure 9.6). Indeed, the processes employed by the mural painters of these centers differed, revealing that painting techniques were not homogenous across the Moche world.

Once the prepared white walls were incised with underlying designs—or, sculpted and then painted white, in the case of adobe reliefs—artists would apply paints with camelid-hair brushes as they filled in areas of color (Morales 2000:242–243). Véronique Wright's (2008) archaeometric work has identified many of the materials used by painters on the walls at Huacas de Moche, El Brujo, Huancaco, and Sipán. She has demonstrated that colors were produced from a variety of mineral and organic sources. In some cases, she has determined that pigments were mixed with juice of the San Pedro cactus that served as binder. What meaning the Moche might have attributed to the presence of mescaline-containing cactus juice as binder

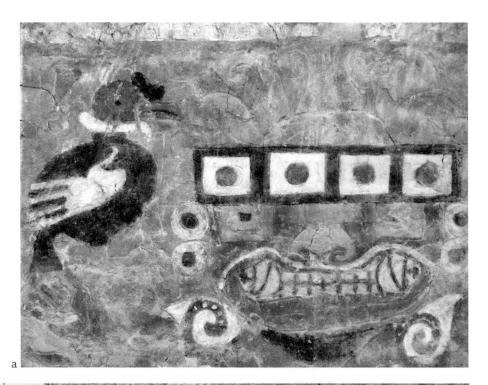

figure 9.6
Detail of incisions (a) visible under the painting of a mural (b) within Huaca Cao in the El Brujo archaeological complex. (Photographs by Lisa Trever.)

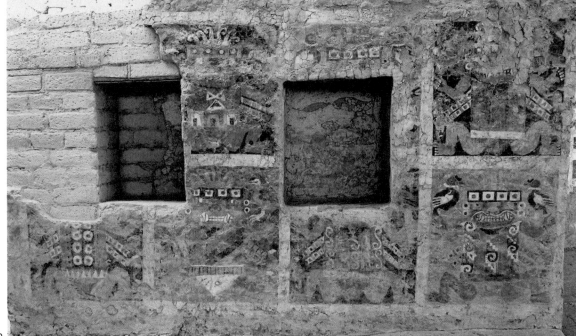

remains a provocative question. Use of the cactus might have been a simple utilitarian decision in the arid coastal setting, or the materiality of the hallucinogenic substance on the walls could have been premeditated and ritually symbolic. In a final pass, finishing lines were painted over the incisions. For the most part, areas of color in Moche murals without relief appear flat and lack volumetric illusionism. The uniformity of line, flat color, and shallow depth are more like central Mexican wall painting of Teotihuacan, Cacaxtla, or Tenochtitlan than the virtuosic calligraphy and layered washes of color

a

b

figure 9.7
Detail of the
incised grid
(a) visible under
the painting of a
mural (b) within
Huaca Cao.
(Photographs by
Lisa Trever.)

of Classic Maya wall painting (Brittenham 2009; Herring 2005; López Luján et al. 2005).

In painting the walls of the huacas, Moche muralists excelled in pictorial composition, chromatic design, and visual effect. At times, walls were scored with a grid before painting (Figure 9.7), which may conjure an anachronistic vision of a field of colored pixels. Or, the scored wall might more appropriately be conceived of as a design field beholden to the conceptual structure of warps and wefts stretched on a loom. Indeed, murals that began with scored under-incisions were often

figure 9.8
Painted relief of stripped prisoners in procession on the interior wall of the great plaza of the Old Temple at Huaca de la Luna. (Photograph by Lisa Trever.)

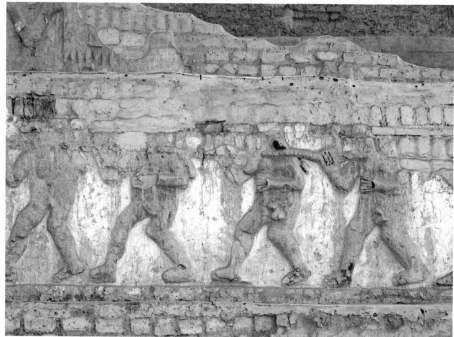

figure 9.9
Painted relief of stripped prisoners in procession on the north facade of Huaca Cao. (Photograph by Lisa Trever.)

elaborated into varieties of geometric compositions that evoke sumptuous tapestries. Like later Chimú architectural sculpture, which Joanne Pillsbury (2009:84) has described as "adobe tapestry," many Moche murals and painted reliefs—especially during the early and middle periods—appear to emulate the textile arts. Interior walls of patios and courtyards were often wrapped in textile-inspired patterns of marine motifs and geometric forms, sometimes punctuated with the emerging, fanged heads of ancient deities. Jeffrey Quilter (2007:144–152) has described the mathematical complexities

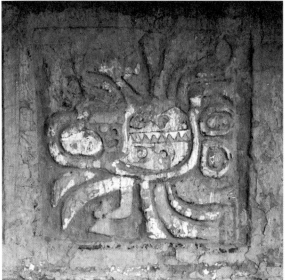

figure 9.10
Examples of stylistic and formal variation in the painted reliefs of spiders on the north facade of the Old Temple at Huaca de la Luna. (Photographs by Lisa Trever.)

and "geometrical games" of the Maritime Frieze at Huaca Cao, which he argues produced a visual effect on viewers comparable to Alfred Gell's (1998) "enchantment."

In contrast to the geometric designs presented on patio walls, the final phases of the soaring north facades of the Old Temple at Huaca de la Luna and Huaca Cao were masterpieces of enlivened architecture (see Figure 9.5). These facades are animated by the lifelike assemblies of perpetually processing lines of prisoners and captors (Figures 9.8 and 9.9), and by files of repeating, menacing supernatural bodies built of adobe and paint. Some friezes are organized with decorative, cellular frames that contain individual figures (Benson 2010:21, fig. 6; Uceda 2001:54, fig. 9). Even the life-size painted reliefs of prisoners and warriors are only partly narrative in content and still highly repetitive in composition. Fully narrative mural painting recounting mythological events does not appear with frequency on temple walls until the later Moche period.

Although many Moche murals and painted reliefs are beautifully made, at other times, even within the most sacred ceremonial enclosures, one does not find the carefully wrought surfaces

that might be expected of the celebrated art of the Moche. The earlier Formative tradition of skilled crafting exemplified by the Huaca Partida feline appears to continue into the early and middle Moche periods (for example, Huaca Cao's Maritime Frieze and the early phase Edificio D of the Old Temple at Huaca de la Luna), but was transformed by the late Moche period (ca. 550–900 CE) into more rapid practice. Late Moche mural painting in particular tends to be technically less refined and more hastily executed than elite Moche works created in other media. This is especially apparent in the last phase of painted architecture (Edificio A) at the Old Temple at Huaca de la Luna (see Figure 9.8) and at the southern Moche site of Pañamarca (Trever 2013a; Trever et al. 2013). At Huaca de la Luna, especially when compared to the same visual program at Huaca Cao (Figure 9.9), the adobe bodies of painted prisoners and warriors appear misshapen, perhaps in part because the Moche repeatedly repainted the reliefs.

Even Bennett and Bird observed in 1949 that Moche monumental architecture, though "ambitious," was not well made—an outlier within their Mastercraftsman Period. They wrote: "The

Mochica erected immense public buildings and temples which display only limited architectural skill, but certainly suggest well organized mass labor" (Bennett and Bird 1949:178). Since then, archaeologists have interpreted makers' marks on adobe bricks at Huaca de la Luna and elsewhere as evidence of a labor tax, perhaps comparable to the later Inka practice of *mit'a* (Hastings and Moseley 1975). Similar practices might also be observed in the making of the monumental pictorial program on the Old Temple's facade. There is great variation in skill and execution, for example, in the forms of monstrous spiders (each nearly 2 meters across) depicted carrying ceremonial *tumi* knives and severed human heads (Figure 9.10), which crawl across the temple's final facade (Edificio A; Uceda 2001:53). These enormous painted-adobe arachnids appear to be the productions of many unevenly trained hands that looked to a general template as their guide. The many variations in style and skill apparent in these spider reliefs suggest the use of corporate labor practices, not only in the construction of the huaca but also in its decoration and maintenance (replastering and repainting). Andean textile specialists have also perceived the work of multiple hands in the creation of large embroidered textiles from Paracas on the South Coast of Peru (Paul 1992; Paul and Niles 1985). Collaborative processes of monumental fabrication in adobe, stone, and thread may typify artistic production in the ancient Andes, as in many other cultural settings (see Houston, this volume).

This general assessment of the artistry of Moche murals reveals that the construction of huacas and the painting of their walls—with or without relief—were materially and socially complex processes of design and execution. The painted and sculpted designs are visually striking and effective throughout the histories of these monuments, but a turning point might be identified, circa 550 to 650 CE, when the prominence of skilled crafting was reduced. Masterful sculpting and painting seems to have been replaced, by the time of the last rebuilding of Huaca de la Luna's Old Temple, for example, by a desire for larger and more rapidly created painted monuments.

Painting as Process at Pañamarca

The wall paintings of Pañamarca, a late Moche (ca. 650–800 CE) center in the lower Nepeña Valley, are some of the most frequently reproduced murals of the ancient Moche world (e.g., Stone 2012:101), but they have also been among the least understood. Although relatively little archaeological work has been conducted at the site, compared to the decades-long research programs at Huaca de la Luna and Huaca Cao, Pañamarca is well known in Pre-Columbian studies for the mid-twentieth-century discovery of figural wall paintings in its great plaza and in the ruins of one of the three large temple platforms (Platform II) within its monumental center. The corpus today consists of those first documented in the twentieth century by Toribio Mejía Xesspe (Tello 2005), Richard Schaedel (1951), Duccio Bonavia (1959, 1985), and Lorenzo Samaniego Román (n.d.), and those discovered by our research project in 2010.

Despite Pañamarca's location in the far south of the Moche world, the subjects painted on its temple walls conform to an orthodox canon of Moche religious iconography. These include the Moche "Presentation Theme," or "Sacrifice Ceremony," led by a goblet-bearing priestess (Figures 9.11 and 9.12); images of dancing and processing warriors; and scenes of battles between the Moche hero or deity called Ai Apaec (elsewhere "Wrinkle Face") and a series of mythical foes (Figure 9.13).[7] The imagery of the wall paintings has more iconographic affinities to fineline painted ceramics from the Moche and Chicama Valleys, far to the north, than to ceramic styles produced more locally in the Virú, Santa, or Nepeña Valleys (see, for example, Chapdelaine 2008). This iconographic correspondence may indicate that religious imagery came to Pañamarca via imported vessels produced in the north.

The chromatic interpretation of the imagery on the walls at Pañamarca, however, is a radical departure from the predominant bichromy of its possible ceramic models (Figure 9.14). All of the wall paintings at Pañamarca consist of polychrome figures set against stark white backgrounds, bounded by red borders. The use of color is at times remarkable

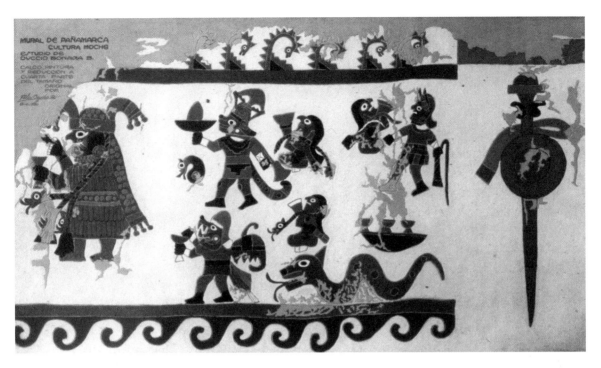

figure 9.11

Scale replica of Pañamarca's Mural E made by Félix Caycho Quispe for Duccio Bonavia in 1958–1959. (Photograph by Duccio Bonavia, used by permission of Bruna Bonavia-Fisher.)

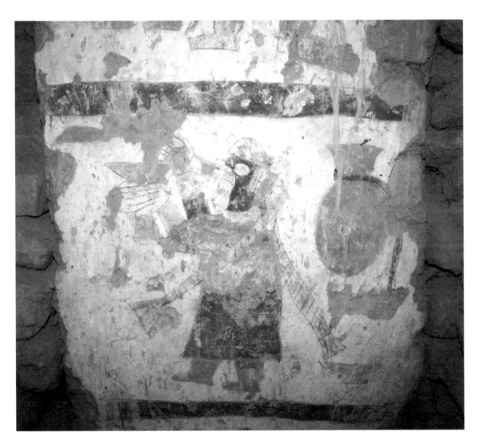

figure 9.12

Painting of a Moche priestess with goblet and large jar on a newly discovered pillar at Pañamarca. (Photograph by Lisa Trever.)

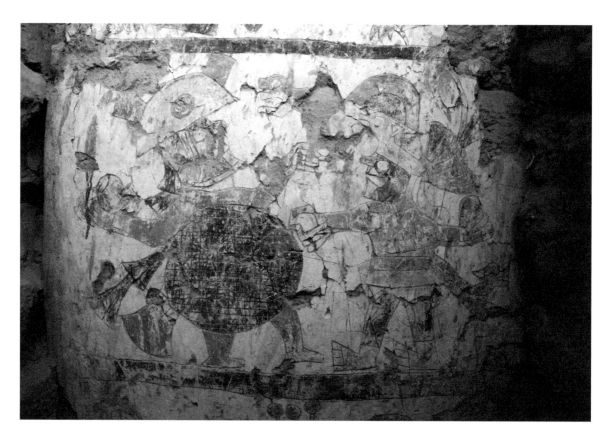

figure 9.13
Painting of a mythological battle on a pillar at Pañamarca. (Photograph by Lisa Trever.)

figure 9.14
Detail of the interior painting of a Moche florero depicting the same mythological battle as the Pañamarca mural illustrated in Figure 9.13. (Photograph courtesy of the Museo Larco, Lima, ML018882.)

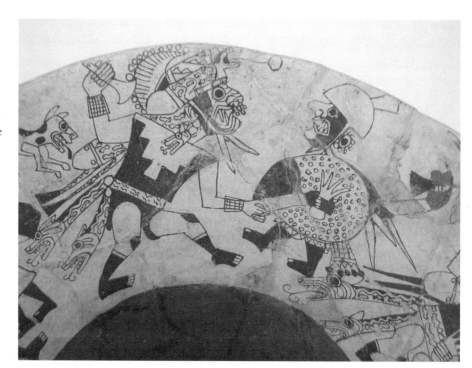

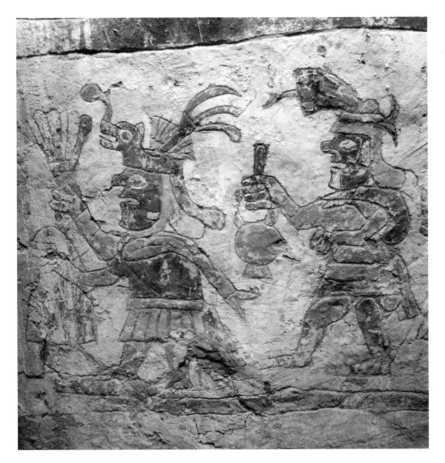

figure 9.15
Detail of a mural recently
discovered at Pañamarca
depicting a procession of
priests or devotees bearing
objects that include a feather
fan and a stirrup-spout
bottle. (Photograph by
Lisa Trever.)

within the larger corpus of Moche wall painting. The Pañamarca paintings contain multiple tones of red, yellow, blue-gray, and sometimes purple. In some especially well-preserved paintings, one witnesses the thoughtful application of contrasting colors to outline and accent the forms and details of bodies and garments. In a newly discovered painting on a wide pillar (Figure 9.15), thin red lines delineate the pale blue feathers of the fan worn in the fox headdress of a priest or attendant. Horizontal yellow lines mark the pink body of the stirrup-spout bottle carried by the man who processes behind him. In another painting, also discovered in 2010, a maritime scene exhibits a rare instance of painterly naturalism in the artist's calculated layering of blue-gray over hematite red to create an iridescent purple appropriate to the sleek flesh of the fish (Figure 9.16).

None of the Pañamarca paintings directly reference geometric woven designs; however, the composition of these paintings might nonetheless point to a textile referent. Although most known Moche textiles bear repeating geometric patterns, there is a small surviving subset of textiles with figural imagery that is relevant to these murals. Fragments of an unprovenienced textile in the collection of the Cleveland Museum of Art, for example, contain many of the same compositional features as the murals (Figure 9.17).[8] In the textile, polychrome figures are framed in red against a white ground. The border of striding felines evokes the appearance of parading felines found elsewhere in the Pañamarca paintings (Mural F). Although most mural borders are plain red bands, the bird-headed, stepped-wave motif that frames the top of the famous example of the priestess mural studied by Bonavia (see Figure 9.11) may reference woven forms. In the Pañamarca murals, cross-media references are complex: the narrative iconography of late Moche ceramics (and perhaps figural textiles) appears coupled to the expressive chromatic potential of textiles.

Although the painted walls may have been designed to present canonical religious imagery

figure 9.16
Detail of a ray and a small fish in a mural at Pañamarca. (Photograph by Lisa Trever.)

known from ceramics or other media within the sumptuous visual language of tapestry, the actual execution of the Pañamarca murals is hurried. At times it might even be called crude. The painters' gestures remain perceptible in the surfaces of the white backgrounds, where broad circular patterns of paint-soaked cloth rubbed on the walls are visible. In one location, we recovered the actual cloth, still stuck to the white floor of a narrow ramp within a painted temple. The painted walls themselves are often peppered with inclusions of shell, charcoal, and botanicals, including maize (Figure 9.18). Liberal drips of red and yellow paint are found in abundance on floors and on the surfaces of some of the site's most significant mural paintings.

It might not be coincidental that the new emphasis on narrative content in mural painting accompanied a reduced investment in fine execution, as if the complexities of visual content trumped technical mastery. In earlier Moche

murals, imitation of the woven structures of patterned textiles (see Figures 9.6 and 9.7) resulted in a more fixed, formal, and often more refined painted or sculpted wall. In these later paintings, the appearance of narrative images with temporal content is paralleled by more expressive gesture in the paintings' creation. The Pañamarca murals may be part of a broader Moche shift from an earlier emphasis on abstraction and repetition to a new interest in more lyrical, narrative scenes. This is also seen at Huaca de la Luna in the late paintings within the New Temple, especially in the Revolt of the Objects mural, which depicts a mythological scene of animated weapons and ornaments taking human captives (Krickeberg 1928; Kroeber 1930; Lyon 1981; Quilter 1990; Seler 1912). Among other scenes recently discovered within this same painted chamber is the unusual mural of the weavers (Uceda et al. 2011), a cross-media reference to a process of material production (see Figure 9.3). Like

figure 9.17
Fragment of a Moche textile composed of cotton and camelid fiber, from the North Coast of Peru. The Cleveland Museum of Art, John L. Severance Fund, 2007.2.3. (© The Cleveland Museum of Art.)

the painters at Pañamarca, the mural painters of the New Temple eschewed the more time-intensive practice of modeling adobe relief in favor of entirely flat painting.[9]

Expedience in mural painting is not isolated to Pañamarca or to late Moche painting practices; it can be identified elsewhere in the Pre-Columbian world. In Classic Maya mural painting, hasty execution is thought to be limited to tomb paintings at places like Caracol and Rio Azul, where the exigent circumstances of death and decay in the tropical forest may have necessitated the speedy completion of painted funerary chambers (Stephen Houston, personal communication 2013; see also Miller 1999:168). But even in non-mortuary Maya painting, such as the lively scenes of vendors and feasting recently discovered at Calakmul (Carrasco Vargas

and Cordeiro Baqueiro 2012:fig. 9), dripped paint—easily and often overlooked—can be seen amid the elegant brushwork.

To judge the Pañamarca paintings as inferior works for their unskilled appearance is to privilege Western aesthetic and technical criteria over the objectives of the Moche muralists. The Moche might have failed to invest as much time and artistic expertise as expected in the technical refinement of these paintings, not because they were incapable of such an investment but rather because they chose not to. The emphasis in much of Moche mural art is on the creation of visual effects—the illusion of textiles, the animacy of processing warrior bodies, or the visualization of mythology and ceremony—within built environments themselves devoted to ephemeral forms of ritual experience and performance. Careful crafting, skilled execution, and accompanying investments of labor seem to have been secondary concerns within this dynamic setting.

Evidence for splashed libations and so-called graffiti on the Pañamarca murals—two types of gesture apparently antithetical to techné—may help to deepen understanding of this corpus. On two pillars excavated at Pañamarca in 2010, splattered stains mar the surfaces of paintings of the mythical battles of Ai Apaec and the goblet-bearing priestess (see Figures 9.12 and 9.13). The liquid was splashed on the walls in a late Moche episode of architectural reopening, libation, and feasting. The substance appears to be a mixture of organic materials, possibly brewed San Pedro cactus or maize *chicha* mixed with ground *espingo*, a seed thought to create hallucinations that was also found as whole, perforated seeds in excavations of the pillared building. The ritual use of espingo mixtures is well documented in early ethnohistoric sources and would not be surprising to find here within the painted temples of Pañamarca (Montoya Vera 1999; Wassen 1976).[10]

The surfaces of these and other painted walls were also marked in places with incisions that appear to be graffiti (more precisely, *sgraffiti*).[11] The painting of the priestess with the large sacrificial jar, for example, is marked with a small image of a jar scratched into its white ground (Figure 9.19). The

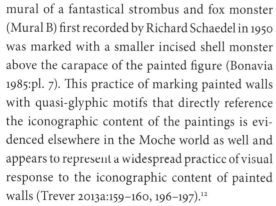

figure 9.18
Detail of the jar painted to the right of the priestess illustrated in Figure 9.12. Note the presence of maize and charcoal embedded in the surface of the painting. (Photograph by Lisa Trever.)

figure 9.19
Detail of the image of a jar incised into the white ground of the priestess mural illustrated in Figure 9.12. Note the drips of red paint below the graffito. (Photograph by Lisa Trever.)

mural of a fantastical strombus and fox monster (Mural B) first recorded by Richard Schaedel in 1950 was marked with a smaller incised shell monster above the carapace of the painted figure (Bonavia 1985:pl. 7). This practice of marking painted walls with quasi-glyphic motifs that directly reference the iconographic content of the paintings is evidenced elsewhere in the Moche world as well and appears to represent a widespread practice of visual response to the iconographic content of painted walls (Trever 2013a:159–160, 196–197).[12]

These ancient acts of splashing and incision should not be interpreted as anti-artistic gestures of defacement. Rather, as traces and markings of processes of engagement between beholders and religious images, they are central to appreciating how the Moche actively experienced these paintings within the performative spaces of the Pañamarca temples. These gestural acts of reception and response can be understood as contiguous with the dynamic act of painting itself, as well as with the ongoing processes of rebuilding, replastering, and repainting.

The Ephemerality of Monuments

The ravaging effects of time and environment have blurred the original clarity of many Moche murals and painted reliefs, at Pañamarca and elsewhere, and complicate assessments of the technical and artistic quality of these painted walls. The Moche

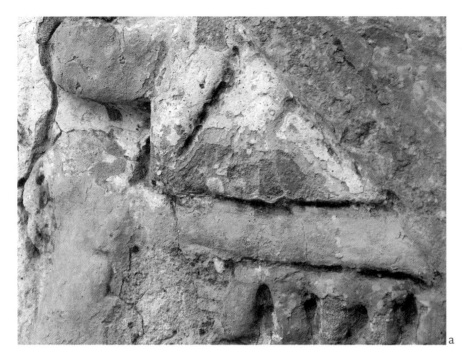

figure 9.20
Detail of the multiple layers of paint (a) on the pairs of battling warriors (b) on a wall within the great plaza of the Old Temple at Huaca de la Luna. (Photographs by Lisa Trever.)

a

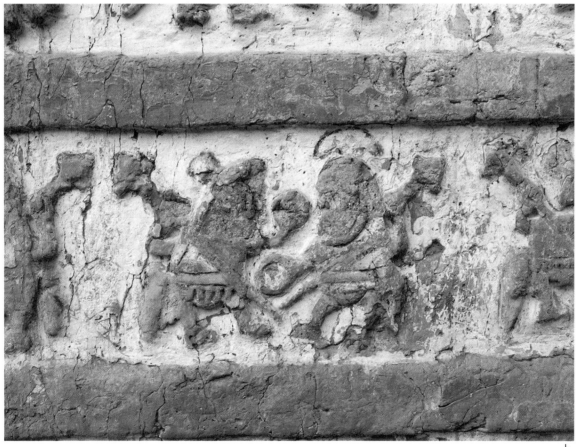

b

The Artistry of Moche Mural Painting and the Ephemerality of Monuments 271

also keenly felt the effects of these effacing forces. Adobe is an exceptionally plastic material and lends itself very well to sculptural manipulation. But as a relatively soft and soluble material, it is vulnerable to wind, salinity, and periodic El Niño rains. To maintain the appearances of brightly painted temples in the face of these constant forces, the Moche would often repaint their images. In some places within our excavations at Pañamarca, we observed areas where paintings had been retouched; elsewhere, we found that walls and pillars were entirely replastered and repainted up to eight times, each time with a different iconographic program. At Huaca de la Luna, some reliefs on the north facade of the Old Temple are covered with a dozen or more layers of paint that have left the original formal definition muddled and bloated (Figure 9.20). Painted temples were also periodically encased with adobe bricks and built anew—sometimes finished with the same pictorial program as before.

The futility of the monument's materials is a critical point for understanding meaning and value in this medium. By nature of their vulnerable adobe substance, Moche huacas can be conceived of as potentially ephemeral monuments. By the most traditional definitions, a monument is a building, sculpture, or object of durable substance erected to commemorate specific people or events. A monument is meant to last. But adobe huacas and their paintings cannot last without care and maintenance. It is noteworthy that stone was available to Moche builders and sculptors. Quarries adjacent to the ruins of Pañamarca provided stone for construction of the Late Formative masonry temple that sits just to the side of the site's largest Moche stepped platform. Just across the valley, the earlier center of Caylán is built of stone and earthen plaster (Helmer et al. 2012). Perhaps because the Moche wished to build higher and faster than building in stone could allow, they chose to work in adobe and thus traded durability for ambition. The use of adobe cannot be fully explained by material determinism or by environmental limitations, but rather represents one of many distinct cultural choices made in the process of monumental construction and figural elaboration.

The idea of the fully disappearing monument emerges elsewhere in the history of art. Some examples may help to open up alternative ways of conceiving of monuments, their materiality, (in)visibility, and potential impermanence in order to cast new light on the ancient Andean subject. One might look, for example, to the cyclical creation of Igbo *mbari* shrines in eastern Nigeria, which have been called "clay sculpture museums" (Nwanna-Nzewunwa 1995:15). Painted houses and tableaux built of clay collected from termite hills were made as divine intercessions, "for pacification, thanksgiving for mercies received, and . . . for anticipated blessings" (Nwanna-Nzewunwa 1995:13). After the sculptures and their related festivals were completed, the earthen structures were left exposed to the environment and, as Herbert M. Cole (1982:220) describes, "the bush invades, and the mbari ultimately melts and disintegrates; it fuses again with the very earth of which it was made and which . . . called it into being."

Disappearing monuments are found elsewhere as well, for example, in late twentieth-century Germany. James E. Young (1996:240) has discussed Jochen Gerz and Esther Shalev-Gerz's "counter-monument" in Hamburg-Harburg in such terms. The *Monument against Fascism* of 1986 was a twelve-meter-high aluminum pillar that was designed for visitors to sign and mark with graffiti, and then be progressively lowered into the ground. By 1993, all that remained visible was the upper surface of the vanished monument, which was then capped with a tombstone. The dramatic absconding of the postmodern monument served to memorialize the trauma of profound human loss.

Of course, unlike the Igbo and German examples, the Moche huacas were not meant to disappear, but their potential ephemerality was never far from reality. In their time, the adobe huacas were not intentionally abandoned to the elements or allowed to disintegrate. Rather, their makers and keepers were aware of the exigencies of their materiality and paid near constant attention to ensure their longevity and to stave off ruination. Such apparent concerns with the palpable effects of time, change, and the contingency of the

monumental also mark the beginning of the modern era. As Kurt Forster (1982:15) has written in his essay "Monument/Memory and the Mortality of Architecture" on Alois Riegl's early twentieth-century writing on monuments and ruins: "At the heart of the matter beats the destructive force of time; and beneath it, like a murmur of the heart, the mortality of culture itself."

For the Moche, the very substance of the huacas may have been conceived in organic, mortal terms. The huacas may have been perceived as living, breathing, even hungering monumental presences to be sustained and nourished, especially when one considers that some reliefs were built upon both human and animal bones and that many huacas contained the tombs and bodies of potent ancestors. Their shapes may echo sacred, life-giving mountains akin to Inka *apus,* the apotheoses of apical ancestors (Jackson 2008:20). The images painted and sculpted in adobe on the temple walls were not frozen, fired, or forged into durable forms as in ceramic or metal. They were—like the huacas—effectively transient and contingent.

It may have been with this awareness of the mortality of the medium that the Moche did not always choose to invest time and artistic expertise in the creation of these earthen works, as they did with portable media. Throughout the wider corpus of Moche art and visual culture, one finds naturalistic handling of human form, intense sculptural interest in the mortification of flesh through violence and disease, and a profound attention to the inescapable material processes of bodily sacrifice

and death (Bourget 2006; Trever 2013b), which might point to something like a Moche *Kunstwollen* (if the debt to Riegl [1893, 2000] is extended)—that is, an aesthetic worldview, "artistic volition," or "formative will of art" (Elsner 2006; Panofsky 2008). The Moche huacas and their painted, earthen imagery may be similarly implicated in ancient Andean aesthetics and cultural sensitivities to corporeality, death, and processes of decay and disintegration.

In considering the artistry of Moche mural painting, neither the image of the Moche artist as Mastercraftsman, which emerged in mid-twentieth-century museological contexts, nor the present application of techné provide adequate standards for evaluation. These murals appear to have been created according to quite different aesthetic and cultural criteria. In the friable, potentially ephemeral images painted and sculpted on the walls of their monumental architecture, the Moche often elevated visual effects, performative gestures, and ritual experience over careful crafting. This tendency is most evident at the southern Moche center of Pañamarca and in the late phases of painted architecture at Huaca de la Luna. The applicability of techné as "socially purposeful skilled crafting" might be more appropriately expanded for the subject of Moche murals, however, by setting aside latent connoisseurial interests and broadening the idea of "skilled" to encompass "effective." That is, attention to processes of visually and materially effective crafting, and the social meaning that they generate, may be more useful in locating Pre-Columbian forms of techné.

NOTES

1 The 2010 Pañamarca project was designed and carried out by the author with codirectors Jorge Gamboa Velásquez and Ricardo Toribio Rodríguez, and with conservation advisor Richard Morales Gamarra. The field project formed the foundation of my dissertation research (Trever 2013a), which was generously supported by grants from the Fulbright-Hays DDRA program, The Wenner-Gren Foundation for Anthropological Research, Harvard University, and Dumbarton Oaks Research Library and Collection. The full results of the field project are in preparation (Trever et al. n.d.).

2 Until recently, conventional dates for Moche art had been presented as significantly earlier: varying between 1 to 800 CE (Stone 2012:91) and 200 BCE to 600 CE (Pasztory 1998:129), the latter based on dates for the "Early Intermediate Period" of Peruvian pre-history (Moseley 1992:161). Recently, archaeologists have reassessed Moche radiocarbon dates and have moved up the date range to 200 to 900 CE (Koons and Alex 2014), or to as late as 300 to 900 CE (Quilter and Koons 2012). Additionally, at least in the Moche and Chicama Valleys, it now seems that there had been two major Moche periods separated by crisis and social change around the year 600 CE (Uceda 2010; Koons and Alex 2014).

3 Of course there are many archaeological avenues by which to infer the status and esteem held by Moche artists, such as the study of workshops, associated households, and burial contexts, as presented in this volume and elsewhere (e.g., Benson 2012:50–51; Bernier 2010; Costin 2004; Donnan and McClelland 1999; Millaire 2008; Rengifo, this volume; Russell et al. 1998; Shimada 2001; Uceda and Armas 1998; Uceda and Rengifo 2006).

4 These observations are based on research conducted in the Christopher B. Donnan and Donna McClelland Moche Archive at Dumbarton Oaks. Images of musicians are found within the archive's Category 86 (Music). The so-called potters are located within Category 11 (Figures with a Small Figure).

5 For example, *Vessel in the Form of a Courtly Musician*, Art Institute of Chicago, Gift of Nathan Cummings, 1957.414.

6 See Miller 2006 for discussion of the issue of major and minor genres in Maya painting.

7 On the iconography of this figure, see Castillo 1989; Donnan and McClelland 1979; and Golte 1994.

8 The multiple fragments in Cleveland may come from one or two distinct textiles (2007.2.1–6). I am grateful to Sue Bergh for calling my attention to the location of these fragments in the Cleveland Museum of Art.

9 Likewise, the iconography of the Revolt of the Objects mural is remarkably similar to that of stirrup-spout bottles in Munich and Berlin (Quilter 1990). Note also the close correspondence between the painted scenes of weaving on the ceramic vase and the painted bench, also within the New Temple at Huaca de la Luna (Figures 9.2 and 9.3). The earlier murals and painted reliefs of the Old Temple at Huaca de la Luna do not bear such striking resemblances to the ceramic arts.

10 Molecular analysis of an exported sample of this residue recovered from the painted wall is in process.

11 Instances of Maya graffiti at Tikal have been recorded and interpreted in various ways—as evidence of hallucinogenic visions (Haviland and Haviland 1995) and as children's drawings (Hutson 2011).

12 These graffiti could be enfolded within a broader Moche practice of iconic marking that includes the pictorial notations found on the exteriors of some ceramic molds that Margaret Jackson (2008:93–114) interprets as iconographic abbreviations of the ceramic forms produced by the molds.

REFERENCES CITED

Alva Meneses, Ignacio

2012 *Ventarrón y Collud: Origen y auge de la civilización en la costa norte del Perú*. Ministerio de Cultura del Perú, Lambayeque.

Bennett, Wendell C., and Junius B. Bird

1949 *Andean Culture History*. American Museum of Natural History Handbook Series 15. American Museum of Natural History, New York.

Benson, Elizabeth P.

1972 *The Mochica: A Culture of Peru*. Praeger, New York and Washington.

2010 Maya Political Structure as a Possible Model for the Moche. In *New Perspectives on Moche Political Organization*, edited by Jeffrey Quilter and Luis Jaime Castillo B., pp. 17–46. Dumbarton Oaks Research Library and Collection, Washington, D.C.

2012 *The Worlds of the Moche on the North Coast of Peru*. University of Texas Press, Austin.

Bernier, Hélène

2010 Craft Specialists at Moche: Organization, Affiliations, and Identities. *Latin American Antiquity* 21(1):22–43.

Bonavia, Duccio

1959 Una pintura mural de Pañamarca, valle de Nepeña. *Arqueológicas* 5:21–54.

1974 *Ricchata Quellccani: Pinturas murales prehispánicas*. Fondo del Libro del Banco Industrial del Perú, Lima.

1984 Nota: Pinturas murales mochicas; Algunas consideraciones. *Histórica* 8(1):89–95.

1985 *Mural Painting in Ancient Peru*. Translated by Patricia J. Lyon. Indiana University Press, Bloomington.

Bourget, Steve

2006 *Sex, Death, and Sacrifice in Moche Religion and Visual Culture*. University of Texas Press, Austin.

Brittenham, Claudia

2009 Style and Substance, or Why the Cacaxtla Paintings Were Buried. *Res: Anthropology and Aesthetics* 55/56:135–155.

Carrasco Vargas, Ramón, and María Cordeiro Baqueiro

2012 The Murals of Chiik Nahb Structure Sub 1-4, Calakmul Mexico. In *Maya Archaeology 2*, edited by Charles Golden, Stephen Houston, and Joel Skidmore, pp. 8–59. Precolumbia Mesoweb Press, San Francisco.

Castillo, Luis Jaime

1989 *Personajes míticos, escenas y narraciones en la iconografía mochica*. Pontificia Universidad Católica del Perú, Lima.

Chapdelaine, Claude

2008 Moche Art Style in the Santa Valley: Between Being "à la Mode" and Developing a Provincial Identity. In *The Art and Archaeology of the Moche*, edited by Steve Bourget and Kimberly L. Jones, pp. 129–152. University of Texas Press, Austin.

Coe, Michael D., and Justin Kerr

1998 *The Art of the Maya Scribe*. Harry N. Abrams, New York.

Cole, Herbert M.

1982 *Mbari: Art and Life among the Owerri Igbo*. Indiana University Press, Bloomington.

Costin, Cathy Lynne

2004 Craft Economies of Ancient Andean States. In *Archaeological Perspectives on Political Economies*, edited by Gary M. Feinman, Linda M. Nicholas, and James M. Skibo, pp. 189–223. University of Utah Press, Salt Lake City.

Donnan, Christopher B.

1978 *Moche Art of Peru: Pre-Columbian Symbolic Communication*. Museum of Cultural History, University of California, Los Angeles.

1982 Dance in Moche Art. *Ñawpa Pacha* 20:97–120.

Donnan, Christopher B. (editor)

1985 *Early Ceremonial Architecture in the Andes: A Conference at Dumbarton Oaks, 26 and 27 October 1982*. Dumbarton Oaks Research Library and Collection, Washington, D.C.

Donnan, Christopher B., and Donna McClelland

1979 *The Burial Theme in Moche Iconography*. Dumbarton Oaks Research Library and Collection, Washington, D.C.

1999 *Moche Fineline Painting: Its Evolution and Artists*. Fowler Museum of Cultural History, Los Angeles.

Elsner, Jas'

2006 From Empirical Evidence to the Big Picture: Some Reflections on Riegl's Concept of *Kunstwollen*. *Critical Inquiry* 32(4):741–766.

Forster, Kurt W.

1982 Monument/Memory and the Mortality of Architecture. *Oppositions* 25:2–19.

Gell, Alfred

1998 *Art and Agency: An Anthropological Theory*. Clarendon Press, Oxford and New York.

Golte, Jürgen

1994 *Iconos y narraciones: La reconstrucción de una secuencia de imágenes Moche.* Instituto de Estudios Peruanos, Lima.

Hastings, C. Mansfield, and M. Edward Moseley

1975 The Adobes of Huaca del Sol and Huaca de la Luna. *American Antiquity* 40(2):196–203.

Haviland, William A., and Anita de Laguna Haviland

1995 Glimpses of the Supernatural: Altered States of Consciousness and the Graffiti of Tikal, Guatemala. *Latin American Antiquity* 6(4):295–309.

Helmer, Matthew, David Chicoine, and Hugo Ikehara

2012 Plaza Life and Public Performance at the Early Horizon Center of Caylán, Nepeña Valley, Peru. *Ñawpa Pacha* 32(1):85–114.

Herring, Adam

2005 *Art and Writing in the Maya Cities, A.D. 600–800: A Poetics of Line.* Cambridge University Press, Cambridge.

Hutson, Scott R.

2011 The Art of Becoming: The Graffiti of Tikal, Guatemala. *Latin American Antiquity* 22(4):403–426.

Jackson, Margaret A.

2008 *Moche Art and Visual Culture in Ancient Peru.* University of New Mexico Press, Albuquerque.

Koons, Michele L., and Bridget A. Alex

2014 Revised Moche Chronology Based on Bayesian Models of Reliable Radiocarbon Dates. *Radiocarbon* 56(3):1–17.

Krickeberg, Walter

1928 Mexikanish-peruanische Parallelen: Ein Uberlick und eine Ergänzung. In *Festschrift, Publication d'hommage offerte au P. W. Schmidt*, edited by W. Koppers, pp. 378–393. Mechitharisten-Congregations-Buchdruckerei, Vienna.

Kroeber, Alfred Louis

1930 Archaeological Explorations in Peru: Part II, The Northern Coast. *Field Museum of Natural History, Anthropology Memoirs* 2(2):45–116.

Lechtman, Heather

1996 Cloth and Metal: The Culture of Technology. In *Andean Art at Dumbarton Oaks*, edited by Elizabeth Hill Boone, pp. 33–43. Dumbarton Oaks Research Library and Collection, Washington, D.C.

López Luján, Leonardo, Giacomo Chiari, Alfredo López Austin, and Fernando Carrizosa

2005 Línea y color en Tenochtitlan: Escultura policromada y pintura mural en el recinto sagrado de la capital mexica. *Estudios de cultura náhuatl* 36:15–45.

Lyon, Patricia J.

1981 Arqueología y mitología: La escena de "los objetos animados" y el tema de "el alzamiento de los objetos." *Scripta etnológica* 6:105–108.

Millaire, Jean-François

2008 Moche Textile Production on the Peruvian North Coast: A Contextual Analysis. In *The Art and Archaeology of the Moche: An Ancient Andean Society of the Peruvian North Coast*, edited by Steve Bourget and Kimberly L. Jones, pp. 229–245. University of Texas Press, Austin.

Miller, Mary Ellen

1999 *Maya Art and Architecture.* Thames and Hudson, London.

2006 Maya Painting in a Major and Minor Key. *Anales del Instituto de Investigaciones Estéticas* 89:59–70.

Montoya Vera, María del Rosario

1999 Polvos de espingo. *Revista arqueológica SIAN* 4:8(1999):5–17.

Morales, Ricardo

1982 Técnica mural Moche. *Histórica* 6(2):217–226.

2000 Max Uhle: Murales y materiales pictóricos en las Huacas de Moche (1899–1900). In *Investigaciones en la Huaca de la Luna 1997*, edited by Santiago Uceda, Elías Mujica, and Ricardo Morales, pp. 235–266. Facultad de Ciencias Sociales, Universidad Nacional de Trujillo, Trujillo.

Moseley, Michael E.

　　1992　*The Incas and Their Ancestors: The Archaeology of Peru.* Thames and Hudson, London.

Mujica Barreda, Elías (editor)

　　2007　*El Brujo: Huaca Cao, Centro ceremonial Moche en el Valle de Chicama.* Fundación Wiese, Lima.

Nwanna-Nzewunwa, Oledinma P.

　　1995　*Mbari-Owerri: Its Cultural Significance among the Owerri Igbo; A Lecture Presented at the Cultural Week of the Owerri Students Association, Uniport Chapter, 1995.* Eddy-Joe, Ughelli, Nigeria.

Panofsky, Erwin

　　2008　On the Relationship of Art History and Art Theory: Towards the Possibility of a Fundamental System of Concepts for a Science of Art. (Translated by Katharina Lorenz and Jas' Elsner.) *Critical Inquiry* 35:43–71.

Pasztory, Esther

　　1998　*Pre-Columbian Art.* Cambridge University Press, Cambridge.

Paul, Anne

　　1992　Procedures, Patterns, and Deviations in Paracas Embroidered Textiles: Traces of the Creative Process. In *To Weave for the Sun: Ancient Andean Textiles in the Museum of Fine Arts, Boston,* edited by Rebecca Stone-Miller, pp. 25–33. Thames and Hudson, New York.

Paul, Anne, and Susan A. Niles

　　1985　Identifying Hands at Work on a Paracas Mantle. *Textile Museum Journal* 23:5–15.

Phipps, Elena, Johanna Hecht, and Cristina Esteras Martín (editors)

　　2004　*The Colonial Andes: Tapestries and Silverwork, 1530–1830.* Metropolitan Museum of Art, New York.

Pillsbury, Joanne

　　2009　Reading Art without Writing: Interpreting Chimú Architectural Sculpture. In *Dialogues in Art History, from Mesopotamian to Modern: Readings for a New Century,* edited by Elizabeth Cropper, pp. 72–89. National Gallery of Art, Washington, D.C.

Pozorski, Shelia, and Thomas Pozorski

　　1987　Chronology. In *The Origins and Development of the Andean State,* edited by Jonathan Haas, Shelia Pozorski, and Thomas Pozorski, pp. 5–8. Cambridge University Press, Cambridge.

Quilter, Jeffrey

　　1990　The Moche Revolt of the Objects. *Latin American Antiquity* 1(1):42–65.

　　2007　Representational Art in Ancient Peru and the Work of Alfred Gell. In *Art's Agency and Art History,* edited by Robin Osborne and Jeremy Tanner, pp. 135–157. Blackwell, Malden, Mass.

Quilter, Jeffrey, and Luis Jaime Castillo B. (editors)

　　2010　*New Perspectives on Moche Political Organization.* Dumbarton Oaks Research Library and Collection, Washington, D.C.

Quilter, Jeffrey, and Michele L. Koons

　　2012　The Fall of the Moche: A Critique of Claims for the New World's First State. *Latin American Antiquity* 23(2):127–143.

Reents-Budet, Dorie

　　1994　*Painting the Maya Universe: Royal Ceramics of the Classic Period.* Duke University Press, Durham, N.C.

Rice, Don Stephen

　　1993　The Making of Latin American Horizons: An Introduction to the Volume. In *Latin American Horizons: A Symposium at Dumbarton Oaks, 11 and 12 October 1986,* edited by Don Stephen Rice, pp. 1–13. Dumbarton Oaks Research Library and Collection, Washington, D.C.

Richardson, James B.

　　1994　*People of the Andes.* St. Remy Press, Montreal.

Riegl, Alois

　　1893　*Stilfragen: Grundlegungen zu einer Geschichte der Ornamentik.* G. Siemens, Berlin.

　　2000　The Main Characteristics of the Late Roman *Kunstwollen* (1901). In *The Vienna School Reader: Politics and Art Historical Method in the 1930s,* edited by Christopher S. Wood, pp. 87–103. Zone Books, New York.

Rowe, John Howland

1960 Cultural Unity and Diversification in Peruvian Archaeology. In *Men and Cultures: Selected Papers of the Fifth International Congress of Anthropological and Ethnological Sciences, Philadelphia, September 1–9, 1956,* edited by Anthony F. C. Wallace, pp. 627–631. University of Pennsylvania Press, Philadelphia.

1962 Stages and Periods in Archaeological Interpretation. *Southwestern Journal of Anthropology* 18(1):40–54.

Russell, Glenn S., Banks L. Leonard, and Jesús Briceño Rosario

1998 The Cerro Mayal Workshop: Addressing Issues of Craft Specialization in Moche Society. In *Andean Ceramics: Technology, Organization, and Approaches,* edited by Izumi Shimada, pp. 63–89. MASCA Research Papers in Science and Archaeology, Supplement to Volume 15. Museum Applied Science Center for Archaeology, University of Pennsylvania Museum of Archaeology and Anthropology, Philadelphia.

Samaniego Román, Lorenzo

n.d. *Monumentos arqueológicos del norte del Perú.* Editorial Progreso, Chimbote.

Sawyer, Alan R.

1954 *The Nathan Cummings Collection of Ancient Peruvian Art (Formerly Wassermann-San Blás Collection); Handbook.* Chicago.

1968 *Mastercraftsmen of Ancient Peru.* Solomon R. Guggenheim Foundation, New York.

Schaedel, Richard P.

1951 Mochica Murals at Pañamarca. *Archaeology* 4(3):145–154.

Seler, Eduard

1912 Archäologische Reise in Süd- und Mittel-Amerika. *Zeitschrift für Ethnologie* 44(1):201–242.

Shibata, Koichiro

2011 Cronología, relaciones interregionales y organización social en el Formativo: Esencia y perspectiva del valle bajo de Nepeña. In *Arqueología de la costa de Ancash,* edited by Milosz Giersz and Iván Ghezzi, pp. 113–134. Andes 8, Boletín del Centro de Estudios Precolombinos de la Universidad de Varsovia. Centro de Estudios Precolombinos de la Universidad de Varsovia, Warsaw, and Instituto Francés de Estudios Andinos, Lima.

Shimada, Izumi

2001 Late Moche Urban Craft Production: A First Approximation. In *Moche Art and Archaeology in Ancient Peru,* edited by Joanne Pillsbury, pp. 176–205. National Gallery of Art, Washington, D.C.

Stone, Rebecca R.

2012 *Art of the Andes: From Chavín to Inca.* 3rd ed. Thames and Hudson, London.

Stone-Miller, Rebecca

1993 An Overview of "Horizon" and "Horizon Style" in the Study of Ancient American Objects. In *Latin American Horizons: A Symposium at Dumbarton Oaks, 11 and 12 October 1986,* edited by Don Stephen Rice, pp. 15–39. Dumbarton Oaks Research Library and Collection, Washington, D.C.

Tello, Julio C.

2005 *Arqueología del valle de Nepeña: Excavaciones en Cerro Blanco y Punkurí.* Museo de Arqueología y Antropología, Universidad Nacional Mayor de San Marcos, Lima.

Trever, Lisa

2013a Moche Mural Painting at Pañamarca: A Study of Image Making and Experience in Ancient Peru. PhD dissertation, Department of History of Art and Architecture, Harvard University, Cambridge, Mass.

2013b Portraits, Potatoes, and Perception: Toward a Sense of Moche Artistic Vision. Paper presented at the College Art Association 101st Annual Conference, New York.

Trever, Lisa, Jorge Gamboa Velásquez, Ricardo Toribio Rodríguez, and Ricardo Morales Gamarra

n.d. *The Archaeology of Mural Painting at Pañamarca, Peru.* Dumbarton Oaks Research Library and Collection, Washington, D.C. (forthcoming)

Trever, Lisa, Jorge Gamboa Velásquez, Ricardo
Toribio Rodríguez, and Flannery Surette

 2013 A Moche Feathered Shield from the
Painted Temples of Pañamarca, Peru.
Ñawpa Pacha 33(1):103–118.

Uceda, Santiago

 2001 Investigations at Huaca de la Luna,
Moche Valley: An Example of Moche
Religious Architecture. In *Moche Art
and Archaeology in Ancient Peru*, edited
by Joanne Pillsbury, pp. 46–67. National
Gallery of Art, Washington, D.C.

 2010 Theocracy and Secularism: Relation-
ships between the Temple and Urban
Nucleus and Political Change at the
Huacas de Moche. In *New Perspectives
on Moche Political Organization*, edited
by Jeffrey Quilter and Luis Jaime
Castillo B., pp. 132–158. Dumbarton
Oaks Research Library and Collection,
Washington, D.C.

Uceda, Santiago, and José Armas

 1998 An Urban Pottery Workshop at the
Site of Moche, North Coast of Peru.
In *Andean Ceramics: Technology,
Organization, and Approaches*,
edited by Izumi Shimada, pp. 91–110.
MASCA Research Papers in Science
and Archaeology, supplement to
Vol. 15. Museum Applied Science
Center for Archaeology, University of
Pennsylvania Museum of Archaeology
and Anthropology, Philadelphia.

Uceda, Santiago, and Ricardo Morales (editors)

 2010 *Moche: Pasado y presente*. Patronato
Huacas del Valle de Moche, Trujillo.

Uceda, Santiago, and Carlos E. Rengifo Chunga

 2006 La especialización del trabajo: Teoría
y arqueología; El caso de los orfebres
mochicas. *Bulletin de l'Institut Francais
d'Études Andines* 35(2):149–185.

Uceda, Santiago, Moisés Tufinio C., and Elías
Mujica B.

 2011 El templo nuevo de Huaca de la Luna:
Primera parte; Evidencias recientes
sobre el Moche tardío. *Arkinka: Revista
de arquitectura, diseño y construcción*
184:86–99.

Uceda, Santiago, Henry Gayoso, and Ricardo Tello

 2010 Las investigaciones arqueológicas. In
Moche: Pasado y presente, edited by
Santiago Uceda and Ricardo Morales,
pp. 23–107. Patronato Huacas del Valle
de Moche, Trujillo.

Vasari, Giorgio

 1550 *Le Vite de' più eccellenti pittori, scultori,
ed architettori*. Lorenzo Torrentino,
Florence.

Wassen, S. Henry

 1976 Was *Espingo* (*Ispincu*) of Psychotropic
and Intoxicating Importance for the
Shamans in Peru? In *The Realm of the
Extra-Human: Agents and Audiences*,
edited by Agehananda Bharati,
pp. 55–62. Mouton, The Hague.

Wright, Véronique

 2008 *Étude de la polychromie das reliefs
sur terre crue de la Huaca de la Luna
Trujillo, Pérou*. Paris Monographs
in American Archaeology 21, BAR
International Series 1808. Archaeopress,
Oxford.

Young, James E.

 1996 Memory/Monument. In *Critical Terms
for Art History*, edited by Robert S.
Nelson and Richard Shiff, pp. 234–247.
University of Chicago Press, Chicago.

Techné and Ceramic Social Valuables
of the Late Preclassic Maya Lowlands

MICHAEL G. CALLAGHAN

CERAMIC CONTAINERS PLAYED A CRIT-ical role in the political economy of Pre-Columbian Maya polities. In the Late Classic period (600–800 CE), they were used as serving ware in ritual gatherings, gifted by elites to materialize political relations or social debt, and, in some instances, transformed into inalienable possessions from which individuals and groups derived their authority (Ball 1993; Callaghan 2013a; Coe 1978; Foias 2007; Reents-Budet 1994, 1998; Reents-Budet and Bishop 2012; Rice 2009). While these vessels gained value and meaning from the ways in which they were used and from the people who owned them, they also gained value through the production process and the actions of the artisans who created them (Reents-Budet 1994, 1998). Through knowledge and control of material or ideological aspects of specific stages of production, artisans engaged in historically and regionally particular suites of techné that also added value to their products.

Although years of research have yielded remarkable insight into artisanal techné, distribution networks, and contexts of use for Classic-period polychromes, much less is known about ceramic social valuables of the preceding Late Preclassic period (300 BCE–250 CE). Study of ceramic social valuables during this period is an important issue, because it is during the Late Preclassic that many of the characteristics of Classic Maya society—including urbanization, long-distance exchange, institutionalized religion, and the concept of divine kingship—emerged or experienced their first florescence. How did the production and use of ceramic vessels factor into the development of these social, economic, religious, and political institutions? Was there a political economy of ceramic vessels in the Late Preclassic similar to that of the Late Classic period? If so, how did artisanal techné add value to these vessels, and what was that techné? To address these questions, I begin this chapter by identifying potential Late Preclassic–period ceramic social valuables. I then discuss the material, social, and ideological aspects of techné that imbued these ceramic vessels with value. Techné in this chapter

closely follows Costin's definition: "socially purposeful skilled crafting" or "skilled crafting to produce something with social utility" (Costin, this volume, Introduction). This skill and knowledge is learned or passed down from one generation of potters to the next and not acquired through trial and error alone. Most importantly, this knowledge includes more than an understanding of the material properties of raw materials and the skill/experience required to produce objects: it involves an intimate understanding of the values and prevailing ideological systems of Preclassic Maya society. This knowledge allowed potters to create vessels that embodied culturally specific notions of quality in form, color, and even paste fabrication. I specifically demonstrate how the social utility of these Preclassic-period vessels figures directly into contexts of feasting and funerary rights. Using this lens, I integrate data on Late Preclassic–period ceramic techné into a model concerning the relationship between ceramic valuables, artisanal techné, and Maya sociopolitical process in the Late Preclassic period. I conclude by arguing how using a lens of techné to analyze Late Preclassic–period ceramic social valuables can better aid our understanding of the dynamics of ancient Maya political economy and the major changes in lowland Maya sociopolitical process before the Classic period.

Contexts for Identifying Ceramic Social Valuables of the Late Preclassic Period

During the Late Preclassic period, some of the largest lowland Maya polities experienced dramatic demographic increases and their first cultural florescence (see Thompson 1965a; for more recent syntheses, see Estrada-Belli 2010; Hansen 2012; see also Figure 10.1). It was also during this period that many hallmarks of later Classic-period culture underwent major development and spread throughout the lowlands, including writing (Thompson 1965b); the calendar system (Satterhwaitte 1965); the stela-altar monument complex (Proskouriakoff 1965); temple-pyramid construction (Lhuillier 1965); and the institution of divine kingship (Freidel and

Schele 1988; for more recent syntheses of these developments, see Estrada-Belli 2010; Sharer and Traxler 2005:71–137). But one aspect of Classic-period culture that has no direct precedent in the Late Preclassic period is the production of polychrome painted pottery (Smith and Gifford 1965). Polychrome ceramics were essential to Classic-period political economy, as indicated by their use in feasting events (LeCount 2001; Reents-Budet 2000), funerary rites (Coe 1978), ritual caching (Chase and Chase 1998; Coe 1965a), gifting, and exchange (Callaghan 2013a; Foias 2007; Reents-Budet 1994). While Classic-period polychrome pottery has developmental connections to earlier Late Preclassic–period ceramics (as I will discuss below), the specific tradition of Classic-period polychrome painting does not exist before approximately 150 CE (Brady et al. 1998; Callaghan 2008, 2013b; Freidel and Schele 1988; Houston et al. 2009: 76; Pring 2000). If polychrome painted ceramic vessels were such a critical part of Classic-period political economies, and if this tradition of pottery did not exist prior to 150 CE, then this raises questions about which kinds of vessels constituted the ceramic political economy of the Late Preclassic period—and how these vessels might have functioned as social valuables within larger Late Preclassic–period systems of symbols and meaning.

Identifying valuable ceramic vessels of the Late Preclassic period, and their associated techné, is not an easy task for a number of reasons. The first is that Late Preclassic–period ceramics can appear homogenous to researchers when they begin their analyses using the established system of ceramic type-variety classification in the Maya Lowlands. Type-variety emphasizes classification and analysis based primarily on attributes associated with surface finish and decoration (Gifford 1960; Smith et al. 1960). This method may be helpful for classifying and analyzing ceramics of the Early and Late Classic periods, as surface-related attributes figure prominently into the definition of ceramic type-varieties of those eras, but this is not the case for Late Preclassic–period ceramics. Red, black, and cream monochrome slip groups dominated Late Preclassic–period ceramic complexes

figure 10.1
Map of the Maya Lowlands, showing locations of sites mentioned in the text. (Map by Michael G. Callaghan.)

of lowland Maya sites (Callaghan 2008; Culbert 1993; Forsyth 1989; Gifford 1976; Kosakowsky 1987; Sabloff 1975; Smith and Gifford 1966). Despite this lack of diversity in slip color, Late Preclassic monochrome ceramics do exhibit great variation in attributes related to paste, form, and firing; however, if analysts use only type-variety analysis, then such variations in shape, paste recipes, and surface traits other than slip color (e.g., incising, impressing, modeling, etc.) can go unnoticed. The type-variety system has been critiqued for a number of reasons, ranging from the theoretical and methodological (see Dunnell 1970, 1971a, 1971b, 1986; Hammond 1972; Rice 1976; Smith 1979) to the regionally specific (see Ball 1977, 1979; Culbert and Rands 2007; Forsyth 1989; for more detailed recent syntheses, see Adams and Adams 1991:263–326; Aimers 2013; Rice 2013). But it is not my intention to critique type-variety any more than it has been. I agree with Rice (2013:26), who points to the advantages of the type-variety system of classification in the Maya Lowlands and who also suggests that, while initially helpful for classification purposes, type-variety is not theoretically equipped to answer every question about human behavior that involves the use of ceramic containers. Type-variety's shortcomings become apparent in the present study, and this is why I advocate the use of supplemental methods of analysis to identify and interpret Late Preclassic–period ceramic techné.

Another reason why Late Preclassic ceramic valuables are difficult to identify is because the depositional contexts that analysts traditionally use to distinguish between elites and non-elites in the Classic period are less visible in the Late Preclassic period. More specifically, royal tombs with ceramic vessels do not appear in the archaeological record of the Maya Lowlands until the end of the Preclassic period, making it difficult to establish which kinds of vessels may have been linked to some type of Preclassic-period ceramic political economy. Even at sites with extensive Late Preclassic–period burials that include ceramic vessels, clear evidence of vessels that belong to a ceramic political economy is not apparent (Berry et al. 2004; Kosakowsky 1987; Robin 1989; Storey 2004).

In an effort to alleviate this problem and to help identify Late Preclassic–period ceramic social valuables and their respective value-additive techné, I propose the following suggestions. First, it may be helpful to work backward from the end of the Late Preclassic period, when the earliest royal Maya tombs were constructed (see below). Second, we must view ceramics in these "elite" tomb contexts, and other ritual or funerary deposits, as more than status markers. Such an approach leads us away from the search for ceramic vessels that primarily mark prestige and social difference, and toward the search for ceramic vessels that indicate importance or value in other cultural domains. In this way, we are not looking for ceramic "prestige goods" per se, but for ceramic "social valuables" (Helms 1993; Spielmann 2002; see also Costin, this volume, Introduction). As Wells (2006:285) explains, this distinction shifts "the emphasis from hierarchical relations of prestige structures to consideration of the diverse ways in which goods condense and encode social principles, cultural or economic values, and sacred tenets." In other words, ritual and religious practices involving the use of pottery may have contributed to the creation of prestige. Finally, in order to overcome the analytical bias toward surface traits (i.e., slip color and decoration), I suggest looking to other aspects of ceramic analysis (and corresponding artisanal techné)—such as forming, firing, and paste preparation—to identify attributes that may have made a vessel valuable (see also Aimers 2013; Culbert and Rands 2007).

Late Preclassic–Period Ceramic Social Valuables

A useful place to begin looking for ceramic social valuables is in tombs at sites that date to the end of the Late Preclassic period. Before continuing, I want to qualify why I focus specifically on Late Preclassic–period tomb contexts from the Maya Lowlands at the exclusion of contexts in the neighboring southern Maya area (i.e., Guatemalan Highlands, Salvadoran Highlands, and Pacific slope of Guatemala and Mexico). While it is important to

note that lowland Maya complex society (and its corresponding traditions of ceramic techné) was not evolving in isolation during the Late Preclassic period, lowland Maya ceramic material culture was in many ways markedly different from that of its aforementioned neighbors to the south. Love (2011a:17, 2011b:48, 65) and Kaplan (2011) confirm this fact in their recent volume on the origins of complexity in the southern Maya area; in it, they make repeated references to the differences in material culture (including ceramics) between the Maya Lowlands and the contemporaneous southern Maya area (for specific differences on the level of traits and wares, see Poponoe de Hatch 1997:119–152; Rands and Smith 1965). It is true that some ceramic technologies (such as variations in the Usulutan mode of decoration) and some specific trade pieces (such as brown incised bowls) representative of material culture in the southern Maya area are present in some of the contexts I mention below; however, the majority of social valuables were part of well-established lowland ceramic production systems.

Returning to the topic of archaeological contexts, an excellent place to begin identifying Late Preclassic–period elite tombs is Krejci and Culbert's (1999) study of Late Preclassic– and Early Classic–period funerary contexts. Krejci and Culbert (1999:tables 10–11) used the presence and quantity of jade, shell, obsidian eccentrics, pearls, mosaics, red pigment, stingray spines, and earflares to identify three wealth classes of burials that spanned the Late Preclassic through Early Classic periods (BCE 100–400 CE) in the Maya Lowlands. Class 1, or "royal," burials were distinguished by formal tomb construction; the use of red pigment on artifacts or bones; "significant" offerings of jade, shell, and obsidian; and the presence of earflares and stingray spines. All but one such burial included thirteen ceramic vessels or more. Krejci and Culbert (1999:108) argued that the individuals in these burials belonged to a "superelite" class and in some cases may have been royalty. Class 2, or "intermediate," burials were distinguished by the presence of four or five of the artifact markers, but generally lacked stingray spines and earflares. Krejci

and Culbert (1999:109) did not recognize a consistent third wealth class. Their hesitancy to define a third wealth class is understandable—at the time, they failed to find any significant quantitative and qualitative patterns in the remaining burials in their sample. Despite this lack of patterning among remaining burials that did not fit into Class 1 or 2 categories, I chose to include these remaining contexts in the present study for two reasons.

First, Late Preclassic Class 1 and 2 contexts are extremely rare. Of the twenty-five contexts listed in Krejci and Culbert's table of Class 1 and 2 burials, only four date to the Late Preclassic period and all come from the site of Tikal. Class 1 burials 166, 167, and 85 were deposited in formal tomb-like constructions located in the North Acropolis platform at Tikal, and all date to the Cauac ceramic complex (0–150 CE; see Coe 1965b, 1990; Culbert 1993). Class 2 burial 128 also dates to the Cauac complex, but was located in the platform supporting Structures 6E-25 and 6E-26, approximately 500 meters southeast of the North Acropolis (Coe 1965b, 1990; Culbert 1993). Since the publication of Krejci and Culbert's (1999) study, the list of Class 1 and 2 Late Preclassic–period burials has not grown, despite much additional excavation. Of six examples of Late Preclassic–period tomb-like deposits, one barely meets the criteria for inclusion in a Class 1 burial, and the other five would not even be considered elite using Class 2 criteria. Specifically, a formal tomb containing the remains of a single individual was found at the site of Chan Chich in the Belize River valley (Houk et al. 2010). This individual was associated with eleven ceramic vessels; jade artifacts, including earflares and a bib-head pendant signifying Late Preclassic royal authority (Freidel and Schele 1988); and a possible wooden scepter. Houk and colleagues (2010:240) date the tomb to the very end of the Late Preclassic period, 200 to 400 CE. At K'o in northeastern Guatemala, a Late Preclassic–period sealed *chultun*, located below a domestic structure in Patio 4, contained the remains of a single individual and eight vessels, one of which displayed iconography associated with Preclassic-period leadership (Tomasic and Bozarth 2011; also see below). At San Bartolo, Guatemala, Tomb 1 in

the Jabalí Group on Platform 110 contained a burial with six vessels, one of which included a greenstone figurine in a shape reminiscent of the sun god, K'inich Ahau (Pellecer 2006). Finally, at the site of Wakna, Guatemala, near El Mirador, three formal tombs were located in Structure 3 and built during the Late Preclassic period (Hansen 1992:16, 1998:90). Unfortunately, all three tombs were found looted, and exact vessel counts and types are not possible; however, some vessels were left behind and an interview with one looter provided some insight into how many and what kinds of vessels were in the tombs (Hansen 1998:90; and discussed below). In summary, it is possible that the Chan Chich tomb could be classified as a Class 1 burial and perhaps also the Wakna tombs, if more information were available; however, the San Bartolo and K'o contexts lack the vessel counts and other associated artifacts to include them in either Class 1 or 2 contexts.

My second reason for using seemingly "nonelite" material culture categories in this discussion of Late Preclassic–period ceramic social valuables is because commoners played an active role in the creation and institutionalization of the symbolic systems associated with elites (see Hutson 2010; Gonlin and Lohse 2007; Lohse and Valdez 2004; Love 1999; Robin 2013). As I explain below, Late Preclassic–period elite authority and the symbols associated with it arose out of domestic communal ritual involving feasting and veneration of the dead (Freidel and Schele 1988; McAnany 1995, 2004; McAnany et al. 1999; Robin 2013). Therefore, it is only appropriate that we look to commoner "structured" deposits (Richards and Thomas 1984) in an effort to discover which ceramic vessels were considered valuable. Through analyzing vessel kinds and frequencies from both elite and commoner contexts, we can begin to identify the ceramic social valuables of the Late Preclassic period and the corresponding artisanal techné that created or increased their value. In the sections below, I identify ceramic social valuables and their associated techné in reference to form, surface finish and decoration, and paste preparation. I then discuss changes in ceramic techné as they relate to the evolution of lowland Maya political organization.

Aspects of Form

Reents-Budet (2006; Fields and Reents-Budet 2005) has suggested that vessel form may have been the primary medium through which Late Preclassic–period ceramic artisans conveyed symbolic messages and, consequently, added value to their products (see also Costin, this volume, ch. 11). As I will explain below, many of these vessels exhibit forms that would also have required a great deal of skill (i.e., experience, training, and talent) to produce. Reents-Budet (2006:213) speaks to the mastery of techné involved in making these vessels:

> These early wares represent a technically and aesthetically sophisticated ceramic tradition in both forming of the vessel and the decoration of its surface. Whether of simple or composite form, Preclassic vessels are elegantly proportioned, their angles and curved surfaces coalescing into a harmonious ensemble of shape. The fired slip paints produce a hard surface characterized by a smooth, waxy finish, visually rich in coloration and resistant to wear damage. The surface clarity and durability, expert firing, and formal aesthetic refinement of Preclassic wares imply production by accomplished craftspeople who must have been at least part-time, if not full-time specialists.

I agree with Reents-Budet and have long wanted to further quantify these observations. Therefore, in order to test the proposition that embellishment in vessel form added value to a vessel, I applied Lesure's (1999) concept of "gradations of value"— the idea that certain objects within an artifact class can have more value than others of the same artifact class—to Preclassic- and Classic-period ceramic forms. Lesure (1999) identified gradations of value in Preclassic-period greenstone artifacts of Mesoamerica. He found that the color and shape of greenstone artifacts could essentially be conceived as comprising separate spectrums, in which certain colors and forms were more valued than others (see also Filloy, this volume). In the present study, I suggest surface decoration (e.g., slip, incising, impression, fluting, chamfering, appliqué, etc.)

table 10.1

Frequencies and ratio of forms to types at lowland Late Preclassic sites with available data

	TOTAL VARIETIES (SURFACES)	TOTAL FORMS	RATIO	REFERENCE
UAXACTUN				
Preclassic	37	35	1.057	Smith 1955 (form charts)
Classic	149	107	1.392	
TIKAL				
Preclassic	131	136	0.963	Culbert 1993
Classic	90	85	1.058	
HOLMUL				
Preclassic	60	180	0.333	Callaghan and Nievens de Estrada n.d.
Classic	43	82	0.524	
ALTAR DE SACRIFICIOS				
Preclassic	96	133	0.721	Adams 1971 (form charts)
Classic	169	142	1.19	
SEIBAL				
Preclassic	33	43	0.767	Sabloff 1975
Classic	45	33	1.363	
EL MIRADOR				
Preclassic	45	142	0.316	Forsyth 1989
Classic	58	158	0.367	
CUELLO				
Preclassic	73	284	0.257	Kosakowsky 1987
Classic	n/a	n/a		
CERROS				
Preclassic	54	220	0.245	Robertson-Freidel 1980
Classic	n/a	n/a		

and form could comprise two separate spectrums or domains of value in Maya ceramics. By counting the number of gradations or categories within each spectrum (i.e., number of surface decorations and number of forms) for Preclassic- and Classic-period ceramic types, I anticipated being able to identify which spectrum—surface decoration or form—would have contributed to the value of a vessel more during the Preclassic and Classic periods. To quantify the number of gradations within the surface-decoration spectrum, I counted the number of ceramic type-varieties for lowland sites with published data. Because type-varieties are classified according to surface decoration, this was an efficient and reliable way to establish the number of gradations within the surface-decoration

table 10.2

Forms and types of vessels from Tikal Burial 85

FINISH COLOR	TYPE-VARIETY	FORM	REFERENCE
Black	Polvero Black	Jar, narrow-mouth short-neck	Culbert 1993:fig. 6 c
Black	Polvero Black	Jar, narrow-mouth short-neck	Culbert 1993:fig. 6 g
Brown-black	Unnamed	Vase, outflaring side	Culbert 1993:fig. 5 c
Brown-black	Unnamed	Vase, outflaring side	Culbert 1993:fig. 5 d
Brown-black	Unnamed	Vase, outflaring side	Culbert 1993:fig. 5 e
Brown-black	Unnamed	Vase, outflaring side	Culbert 1993:fig. 6 a
Red	Altamira Fluted	Bowl, small outcurving side	Culbert 1993:fig. 6 c
Red	Sierra Red	Dish, medial flange simple silhouette	Culbert 1993:fig. 7 a
Red	Sierra Red	Dish, medial flange simple silhouette	Culbert 1993:fig. 7 b
Red	Sierra Red	Dish, medial flange with break	Culbert 1993:fig. 7 c
Red	Sierra Red	Dish, medial flange with break	Culbert 1993:fig. 7 d
Red	Sierra Red	Dish, medial flange with break	Culbert 1993:fig. 7 e
Red	Sierra Red	Dish, medial flange with z-angle	Culbert 1993:fig. 7 f
Red	Sierra Red	Dish, round-side with incurved rim and tab at lip	Culbert 1993:fig. 4 b
Red	Sierra Red	Jar, narrow-mouth short neck	Culbert 1993:fig. 6 e
Red	Sierra Red	Jar, narrow-mouth short neck	Culbert 1993:fig. 6 f
Red	Sierra Red	Jar, spout with tall neck	Culbert 1993:fig. 4 c
Red	Altamira Fluted	Jar, urn tall	Culbert 1993:fig. 5 a
Red	Altamira Fluted	Jar, urn tall	Culbert 1993:fig. 5 b
Red fire-clouded	Sierra Red	Jar, narrow-mouth short neck	Culbert 1993:fig. 6 d
Red-on-orange, Black-on-orange	Caramba Red-on-orange: Chic Variety	Jar, small wide-mouth with nubbin supports	Culbert 1993:fig. 4 a
Red, orange, and brown	Metapa Trichrome	Jar, spout with tall neck	Culbert 1993:fig. 4 d
Unslipped	Achiotes Unslipped	Bowl, small straight-side	Culbert 1993:fig. 6 b
Unslipped	Morfin Unslipped	Dish, outflaring side	Culbert 1993:fig. 7 g
Unslipped	Achiotes Unslipped	Jar, narrow-mouth short neck	Culbert 1993:fig. 6 c

spectrum. Determining the number of gradations in form was slightly more difficult, as form is not built into type-variety classification. Gradations in form were determined by counting the number of different forms listed for each type-variety of the Preclassic and Classic periods at the same sites used in the surface-decoration part of the study. A list of the sites, with references to the ceramic monographs I consulted, appears in Table 10.1. The data

suggest that the number of forms in relation to the number of surface decorations was slightly higher during the Preclassic period. This relationship changes during the Classic period, with the number of surface treatments increasing and in some cases outnumbering the number of forms. These data indicate that during the Preclassic period, the category of vessel form had the potential to contain more gradations of value and therefore contribute

table 10.3

Forms and types of vessels from Tikal Burial 166

FINISH COLOR	TYPE-VARIETY	FORM	REFERENCE
Black	Polvero Black	Jar, narrow-mouth short neck	Culbert 1993:fig. 11a 1
Black	Polvero Black	Jar, narrow-mouth short neck	Culbert 1993:fig. 11a 3
Cream	Flor Cream	Dish, medial flange with break	Culbert 1993:fig. 10b
Red	Sierra Red	Bowl, outcurving side	Culbert 1993:fig. 9b 1
Red	Altamira Fluted	Dish, outcurving side with everted rim	Culbert 1993:fig. 9b 2
Red	Altamira Fluted	Dish, outcurving side with everted rim	Culbert 1993:fig. 9b 3
Red	Altamira Fluted	Jar, urn tall	Culbert 1993:fig. 9b 4
Red	Sierra Red	Dish, restricted orifice medial flange	Culbert 1993:fig. 10a
Red	Sierra Red	Dish, medial flange with break	Culbert 1993:fig. 10c
Red	Sierra Red	Dish, round-side with incurved rim	Culbert 1993:fig. 10e
Red	Sierra Red	Miniature, bowl with round side	Culbert 1993:fig. 10f
Red	Sierra Red	Miniature, bowl with round side	Culbert 1993:fig. 10g
Red	Sierra Red	Jar, narrow-mouth short neck	Culbert 1993:fig. 11a 5
Red-on-orange	Caramba Red-on-orange: Chic Variety	Jar, spout with tall neck	Culbert 1993:fig. 9b 5
Red-on-orange	Caramba Red-on-orange: Chic Variety	Dish, round-side	Culbert 1993:fig. 10d
Red-on-orange	Caramba Red-on-orange: Chic Variety	Jar, narrow-mouth short neck	Culbert 1993:fig. 11a 6
Red-on-orange	Caramba Red-on-orange: Chic Variety	Jar, narrow-mouth short neck	Culbert 1993:fig. 11a 7
Unslipped	Sapote Striated	Jar, wide-mouth short neck	Culbert 1993:fig. 10h
Unslipped	Achiotes Unslipped	Jar, narrow-mouth short neck	Culbert 1993:fig. 11a 2
Unslipped	Sapote Striated	Jar, narrow-mouth short neck	Culbert 1993:fig. 11a 4

to the overall value of a ceramic vessel. The value of certain Late Preclassic vessel forms is reflected in Class 1 burials at Tikal.

The highest frequency of vessels found in the Class 1 burials at Tikal are dishes, bowls, and jars belonging to the Sierra Red serving-ware tradition of the Late Preclassic period (Tables 10.2–10.5). Sierra Red is a ubiquitous type of ceramic material in Late Preclassic–period sites and may lead one to suggest that it was unrestricted in terms of distribution; however, some Sierra Red forms

are extremely elaborate and rarely found in non-funerary contexts (Culbert 1993). The two most prominent examples of ornate forms are what Culbert (1993) classifies as "funerary urns" (Figure 10.2) and "jars with spouts" (Figure 10.3). Funerary urns are also often termed "tall vases," or *floreros*. Hansen (1998:90) reports that funerary urns were found in the looted tombs at Wakna. A red fluted funerary urn of the Altamira Fluted type was also found in Jabalí Tomb 1 at San Bartolo (Pellecer 2006). Fields and Reents-Budet (2005:211) have

table 10.4

Forms and types of vessels from Tikal Burial 167

FINISH COLOR	TYPE-VARIETY	FORM	REFERENCE
Brown-black	Unnamed	Vase, outflaring side	Culbert 1993:fig. 12b
Brown-black	Unnamed	Vase, outflaring side	Culbert 1993:fig. 12c
Cream	Flor Cream	Dish, round-side	Culbert 1993:fig. 13f
Red	Laguna Verde Incised: Usulutan Variety	Dish, outcurving side	Culbert 1993:fig. 12d
Red	Sierra Red	Bowl, wide outcurving with grooved lip	Culbert 1993:fig. 12e
Red	Sierra Red	Bowl, outcurving side with groove lip	Culbert 1993:fig. 13a
Red	Sierra Red	Dish, restricted orifice medial flange	Culbert 1993:fig. 13b
Red	Laguna Verde Incised: Usulutan Variety	Dish, lip-flange	Culbert 1993:fig. 13d
Red	Sierra Red	Dish, incurved rim	Culbert 1993:fig. 13e
Red	Sierra Red	Miniature, jar	Culbert 1993:fig. 13g
Red-on-orange	Caramba Red-on-orange: Chic Variety	Bowl, urn	Culbert 1993:fig. 12a
Red-on-orange	Caramba Red-on-orange: Chic Variety	Dish, medial flange	Culbert 1993:fig. 13c
Red and white on black	Unnamed	Jar, urn tall	Culbert 1993:fig. 11b
Unslipped	Morfin Unslipped	Bowl, outcurving side with groove lip	Culbert 1993:fig. 12e

table 10.5

Frequencies of forms from Burials 85, 166, and 167 and PD 1 at Tikal

CONTEXT	PLATES	DISHES/ BOWLS	VASES	JARS
Bu. 85		10	4	11
Bu. 166		11		10
Bu. 167		10	2	2
PD. 1	3	30		17
Total	3	61	6	40

suggested that these tall jars were used for serving liquid cacao.

Also related to cacao consumption was the second elaborate form category present in the Tikal burials: "jars with spouts" (Culbert 1993). Archaeologists have referred to these vessels as "pitchers" or "chocolate pots." In an extensive study of Late and Terminal Preclassic–period spouted jars, Powis and colleagues (2002) found that such vessels were an important part of the burial assemblage of many Late Preclassic–period elites; specific evidence comes from the burial of sacred ancestors at the smaller sites of Cuello and K'axob, Belize. At Cuello in Mass Burial 1, the two primary seated individuals surrounded by secondary interments were associated with a spouted jar (Robin 1989:241). Also present was an extremely rare amphora-like jar (see Rosenswig and Kennett 2008 for the only other examples in the Maya Lowlands). The finding of these two rare vessel forms with the primary seated individuals in this mass burial deposit further supports the idea that exceptional vessel forms (and the items they contained) were associated with expressions of value. Spouted jars were also found in association with the remains of

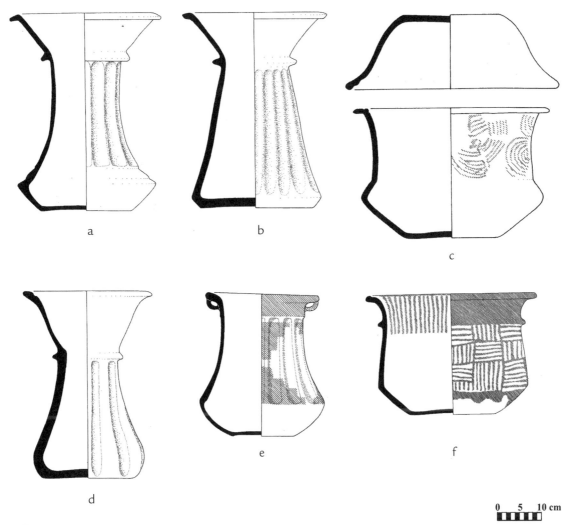

figure 10.2

Funeray urns from Class 1 burials at Tikal: a) urn from Burial 85 (Culbert 1993:fig. 5a); b) urn from Burial 85 (Culbert 1993:fig. 5b); c) urn from Burial 128 (Culbert 1993:fig. 8b 1); d) urn from Burial 166 (Culbert 1993:fig. 9b 4); e) urn from Burial 167 (Culbert 1993:fig. 11b); and F) urn from Burial 167 (Culbert 1993:fig. 12a). All vessels are shown at one-eighth size.

figure 10.3

Jars with spouts from Class 1 burials at Tikal: a) spouted vessel from Burial 85 (Culbert 1993:fig. 4c); b) spouted vessel from Burial 85 (Culbert 1993:fig. 4d); and c) spouted vessel from Burial 166 (Culbert 1993:fig. 9b 5). All vessels are shown at one-eighth size.

figure 10.4

Jars with spouts and "additives of prestige" from Late Preclassic sites in the Maya Lowlands: a) jars with spouts from Tomb 2 Chan Chich, Belize (Houk et al. 2010:fig. 7); b) jar with spout, stucco, and paint from Holmul Building B, Group II, Room 8 vault (drawing by Fernando Alvarez); c) jar with spout and incision from Holmul Building B, Group II, Room 9 (drawing by Fernando Alvarez); d) red spouted vessel from Burial 12 at K'axob (McAnany et al. 1999:fig. 13, drawing by Labadle, courtesy of K'axob Archaeological Project); e) red spouted effigy vessel from Burial 10 at K'axob (McAnany et al. 1999:fig. 11, drawing by Harrison and Labadle, courtesy of K'axob Archaeological Project); f) red spouted effigy vessel from Burial 13 at K'axob (McAnany et al. 1999:fig. 12, drawing by Labadle, courtesy of K'axob Archaeological Project); and g) red spouted vessel from Burial 2 at K'axob (McAnany et al. 1999:fig. 14, drawing by Labadle, courtesy of K'axob Archaeological Project).

venerated ancestors at the site of K'axob. Berry and colleagues (Berry et al. 2004), McAnany and colleagues (McAnany et al. 1999), and Storey (2004) note that spouted forms can be embellished with molded or appliqué effigy features (see Figures 10.3, 10.4, and 10.6). McAnany and colleagues (1999) and Powis and colleagues (2002) suggest that these embellishments may have functioned as "additives of prestige" (Reents-Budet 1994, 1998). Citing

Reents-Budet's work on Late Classic–period polychromes (Reents-Budet 1994, 1998), Powis and colleagues (2002) further suggest that these embellishments may have been the hallmark of regionally specific production groups or individual artisans.

The production of spouted jar forms and elaborate funerary jars would have required a great amount of skill on the part of those responsible for forming these vessels. Here, I follow Costin

figure 10.5
Repasto Black-on-red ceramics from burial contexts at Tikal: a) cuspidor from Burial 126 (Culbert 1993:fig. 2d 1); b) plate from Burial 126 (Culbert 1993:fig. 3a); c) small urn jar from PNT 001 (Laporte and Fialko 1995:fig. 10); and d) large urn jar from PNT 001 (Laporte and Fialko 1995:fig. 10). All vessels are shown at one-eighth size.

a

b

c

d

0 5 10 cm

and Hagstrum (1995:623) and define skill as a combination of "experience, proficiency, and talent." Quantifying skill using ceramic products is a difficult but not impossible task that has been successfully applied in a few notable cases to vessels from the American Southwest (Bagwell 2002; Crown 1999; Hagstum 1985), South America (Costin and Hagstrum 1995), and Syria (Blackman et al. 1993). Although the spouted jars and funerary urns in this chapter were not studied directly, available figures and documentation suggest they display high levels of skill, as characterized by some of the attributes used in previous studies (see specifically Bagwell 2002:95). They include: 1) coiled construction technique; 2) no visible cracks; 3) symmetry when viewed from above; 4) evenness of rim; 5) consistency of rim thickness; 6) consistency of wall angle when viewed from the side; 7) a flat base; and 8) an overall form that identifies with a specific ceramic tradition. Both jar forms also reflect a higher level of labor intensity: their complicated construction, in addition to frequently corresponding elaborate surface decoration (see below), reflects more steps in the production process and therefore more time

figure 10.6

Vessels with wavy-line or resist decoration from Class 1 deposits at Tikal: a) spouted effigy jar from Burial 85 (Culbert 1993:fig. 3d); b) spouted jar from Burial 166 (Culbert 1993:fig. 9b 5); c) urn jar from Burial 128 (Culbert 1993:fig. 8b 1); d) urn jar from Burial 167 (Culbert 1993:fig. 12a); e) jar from Burial 166 (Culbert 1993:fig. 11a 7); f) jar from Burial 166 (Culbert 1993:fig. 11a 6); g) composite bowl from Burial 167 (Culbert 1993:fig. 12d); h) composite bowl from Burial 167 (Culbert 1993:fig. 13d); i) bowl from Burial 166 (Culbert 1993:fig. 10d); j) composite bowl from Burial 128 (Culbert 1993:fig. 8b 2); and k) composite bowl from Burial 167 (Culbert 1993:fig. 13c). All vessels are shown at one-eighth size.

and effort to produce these kinds of vessels. In relation to my argument above regarding ornate forms adding value to a vessel, it appears that this value could have been related to the greater amount of labor and skill invested in shaping these vessels.

Surface Finish and Decoration

Although form may have been a more regular medium through which artisans employed techné in order to produce vessels of value during the Late Preclassic period (see also Costin, this volume, ch. 11),

surface finish and decoration also added value and positioned vessels in Pan-Mesoamerican systems of ritual meaning. Noted earlier, the highest frequency of vessels in Late Preclassic–period ritual contexts belongs to the Sierra Red type. Along with the vessels' high occurrence in the archaeological record, the homogenous color palette of Late Preclassic–period monochrome slipped ceramics may suggest that the technology behind slip preparation, application, and polishing were commonplace and even unsophisticated; however, slips are vibrant, thick,

waxy, burnished to a shine, and extremely hard. This results from experience and skill in sorting, mixing, settling, and refining slips; application and burnishing of the slipped surface; and controlled open firing, which occurred at higher temperatures than in the Classic period, as pastes and slips of these red vessels are quantifiably harder than Classic-period counterparts (see Callaghan 2008).

Although Classic-period black-and-red-on-orange polychrome decoration did not appear until the end of the Late Preclassic period, Preclassic artisans created bichrome and trichrome surfaces through a number of sophisticated technologies. Some of the earliest ceramic valuables found in burial deposits at Tikal, dating to the early part of the Late Preclassic period there (i.e., Chuen 350 BCE–0 CE and Cauac 0–150 CE complexes), incorporate black-on-red resist decoration (Culbert 1993; Laporte and Fialko 1995). Designs included quadripartite motifs on the bottoms of plates and the sides of elaborately formed jars that were possibly symbolic of cosmological centering events, as well as the depiction of monkeys on an elaborate funerary urn jar (Figure 10.5). Scholars have associated monkeys on Late Classic–period polychromes with artisans (Coe 1977) and with creation myths contained in the *Popol Vuh* (Coe 1977; Tedlock and Tedlock 1985). While I hesitate to assign the same significance to monkeys depicted on Late Preclassic–period vessels, the least I can say is that monkeys (like the mat pattern and quincunx discussed below) seem to be an enduring symbol for the lowland Maya. Bichrome ceramics were also created by painting with slip, as exemplified by Sierra Red bowls with the quadripartite motif on their bases found in burials at the site of K'axob, Belize (Berry et al. 2004). Multiple applications of slip were used to create "streaky" red surfaces, as exemplified by Society Hall–type serving vessels most commonly found in Belize and the northeast Peten (Callaghan 2008; Gifford 1976; Kosakowsky 1987). Finally, differential firing of vessel surfaces was also used to create those bichrome ceramics in which the exterior bases appear cream colored and the rest of the vessel red (Callaghan 2008; Gifford 1976; Kosakowsky 1987).

Jars with spouts and composite silhouette bowl forms were the most common media for another early type of surface coloring—that which is often referred to in Maya archaeological ceramic literature as the "Usulutan" style of decoration (Demarest and Sharer 1982; Sharer and Gifford 1970). This decoration type results from many different technologies and must be determined on a vessel-by-vessel basis (see Culbert 2003:56; Hopkins 1986; Lothrop 1933:51; Sharer 1978:134–135; Shook and Kidder 1952:100; Wetherington 1978:101). One variant is created when artisans apply red slip in thin wavy lines to vessels that have been previously slipped orange; this technique appears on the Caramba Red-on-orange and Metapa Trichrome types of vessels found in early burials at Tikal (see Figure 10.6). Usulutan decoration can also be created through what Culbert (2003:56) describes as double-slipping, or wiping away the second slip while it is wet. Wavy lines can also be created by resist technology in which vessel surfaces are first slipped light red, designs are created using heat-resistant liquid, and then surfaces are slipped a darker shade of red. This process results in what looks like "negative" painted designs. Red-on-orange decoration is usually found on elaborately formed vessels, such as spouted jars or urns. Like black-on-red decoration, red-on-orange decoration can depict symbols of established Maya cosmology and authority. Examples include the weave or mat pattern on an urn jar from Burial 167 at Tikal (see Figure 10.6d). The mat pattern has significant history in Mesoamerica and is commonly believed to represent elite status and even rulership during the Classic periods (Freidel and Schele 1988; Marcus and Flannery 1996; Robicsek 1975; Taube 2005).

Water may be another important concept represented by a suite of design motifs associated with wavy-line decoration and surface modeling. While seemingly simple, wavy-line patterns could be representative of water and those metaphysical concepts associated with it, including the cosmos, death, and the underworld (Finamore and Houston 2010; Hellmuth 1987). This idea is strengthened when wavy-line decoration appears on elaborately modeled effigy vessels that bear resemblance to

water animals, such as frogs or turtles (see Figure 10.6a). Ornately formed vessels with wavy-line decoration were often associated with burial contexts (Culbert 1993; Pellecer 2006), and tombs are thought to be representative of the watery underworld from which venerated ancestors would be resurrected in emulation of the first Maya ancestor, the maize god (Hellmuth 1987; Reilly 1994). During the Early Classic period, polychrome vessels with elaborate forms that included composite bowls with basal flanges and lids figured prominently into this symbolic system (Finamore and Houston 2010:48–51; Hellmuth 1987). The vessels' exteriors were often separated into two or three decorative surfaces. Exterior vessel walls often depicted water-related symbolism (e.g., droplets, wavy lines, and naturalistic or abstract water-related flora and fauna). Vessel lids with effigy handles could boast sky-related motifs (e.g., celestial birds or sun-related imagery) or animals associated with death, sacrifice, and the underworld (e.g., jaguars or the head of a deceased ancestor). In this way, ceramic vessels placed in tombs with deceased ancestors could be conceived of as miniature representations of the Maya universe separated into three parts: 1) the watery underworld; 2) the earth offerings found within the vessel; and 3) the sky or celestial realm (see Fields and Reents-Budet 2005:147). The elaborately formed and wavy-lined decorated pottery found in Late Preclassic–period tombs could be considered early painted ceramic expressions of water symbolism and its connection to death, the underworld, and Maya cosmos. In summary, it appears that elaborately formed vessels, along with surface decorations depicting early representations of Classic-period authority, were associated with burial contexts of seemingly high-status individuals and ritual caches, suggesting that these attributes marked social valuables during the Late Preclassic period.

Paste

With few exceptions (Bartlett 2004), petrographic and chemical paste composition data are not usually reported for vessels found in Late Preclassic–period lowland ritual contexts.[1] Therefore, we do not yet have a model of Late Preclassic–period production and exchange networks of ceramic social valuables based on paste composition. Despite this lack of information, we can still use the data we have to offer some conservative speculations about paste preparation and value-additive artisanal techné. As I mentioned above, the high frequency of vessels found in the first royal tombs at Tikal (and in ritual contexts at other sites) belong to the Sierra Red ceramic group (see Tables 10.2–10.5). During the Middle and especially the Late Preclassic periods in the Maya Lowlands, forms of red serving-ware were often tempered with crushed sherd inclusions, or "grog" (Adams 1971; Callaghan 2008; Forsyth 1989; Gifford 1976; Sabloff 1975; Smith 1955). After the Late Preclassic period, this type of temper technology completely ceased. Potters at lowland sites in the Classic periods instead opted to use calcite inclusions, quartz sand, and imported volcanic ash. I have argued elsewhere (Callaghan et al. 2013) that the inclusion of grog temper in serving-ware of the Late Preclassic period was a type of technological style encoded with social or ideological meaning. Specifically, the crushing up and recycling of older vessels and their reuse in the paste of new ones served as a way to integrate earlier community members and ritual events into the production of new pottery and its associated ritual events—thus creating a connection between past and present ritual activities (also see Bartlett 2004:160; Smith 1989:61; Sterner 1989:458). The cessation of this technique during the Classic period implies not only a break from this paste-preparation technology but also a break in the link to previous vessel consumers and ritual events.

Admittedly, this is a difficult assertion to support and test with the available data, but I am inclined to believe that the inclusion of grog temper had more than functional utility during the Preclassic periods for the following reasons. First, my own studies show that grog only appears as a secondary inclusion in Preclassic vessels, with crystalline calcite being the primary or major inclusion (see Callaghan 2008:476–484, 504–511, 542–558; Callaghan et al. 2013). This leads me to believe that grog was not completely necessary to

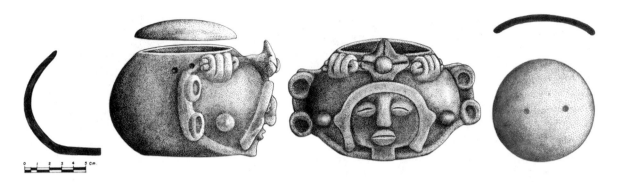

figure 10.7
Chunhinta Black effigy bowl from K'o, Guatemala. (Drawing by Fernando Alvarez.)

create a successfully functioning formed and fired pot; potters could have easily excluded grog from their paste recipes and exclusively used crystalline calcite—as they did in many other contemporaneous Preclassic-period ceramics (see Callaghan 2008:314–360). Second, as I mention above, the inclusion of grog temper completely ceases at the beginning of the Early Classic period, when paste recipes are substituted at every lowland Maya site in favor of crystalline calcite, volcanic ash, quartz sand, or a combination of the three (see also Jones 1986). This leads me to believe that the inclusion of grog temper must have had some kind of social, even ideological, significance and was not simply a practical solution to the problem of tempering (see also Rye 1976:108–110 for potter's choice in tempering materials). To take my argument a step further, I suggest that the cessation of grog temper-use could even be evidence of changing political strategies materialized in the techné of the paste preparation process, which I discuss below.

Heirlooms, Inalienable Possessions, and Trade-wares

Social valuables of the Late Preclassic period also included heirlooms and possible inalienable possessions from the Middle Preclassic (see also Barber et al. 2013; Callaghan 2013a; Clark and Colman 2013; Inomata 2013; Kovacevich 2013; Kovacevich and Callaghan 2013; Lohse 2013; Mills 2004, 2013; Novotny 2013; Weiner 1992; Wells 2013). Heirlooms and potential inalienable possessions were found in tomb contexts at the sites of K'o and San Bartolo,

Guatemala (see Figure 10.1). In both cases, these vessels are monochrome-slipped effigy bowls with modeling and appliqué. At K'o, among the eight ceramic vessels in the sealed chultun located beneath a Late Preclassic–period household platform was a black-slipped bowl of the Chunhinta Black type (Tomasic and Bozarth 2011; Figure 10.7). The bowl displays the image of a modeled and incised human face emerging from a black monochrome–slipped exterior. Incised lines on the image are filled with reddish-purple pigment. Framing this face is what Tomasic and Bozarth (2011) identify as a headdress with chinstrap and trefoil jewel. Comparing the headdress, jewel, and chinstrap elements to other Preclassic- and Classic-period iconography, the authors conclude that the image on the bowl may represent the head of a king wearing an early version of the Jester God headdress. If this were the case, it would push the concept of divine kingship back into the Middle Preclassic period, when Chunhinta Black ceramics were produced. A more conservative interpretation comes from the work of Freidel and Guenter (2006), whose studies of Maya cache bowls suggest the K'o vessel could represent a sacred bundle that contained the soul of an earlier venerated ancestor, what they term a "white soul flower" cache. In this scenario, the image on the bowl represents the ancestor's soul that the vessel contains. In relation to the notion of value-additive techné, the K'o bowl displays the same higher order gradations of value as those of vessels found in other Late Preclassic–period structured deposits—namely, elaborate form, effigy

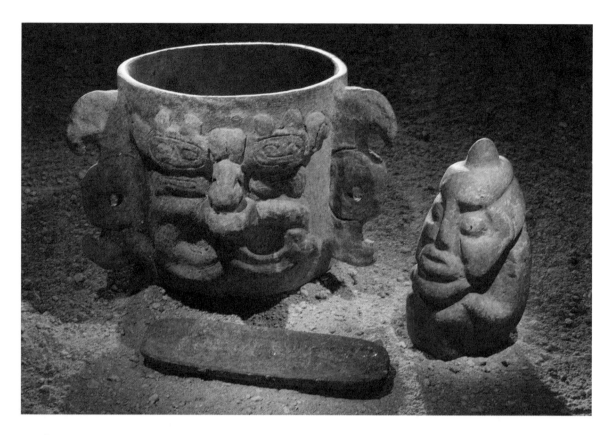

figure 10.8
Joventud Red effigy bowl from the Jabalí Group, San Bartolo, Guatemala. (Photograph by Kenneth Garrett.)

modeling, and incising. This piece would have served as an important social and material link between the individual buried in the tomb and the powerful individual or group for whom it was first made during the Middle Preclassic period. In this way, the K'o effigy vessel may have served as an inalienable possession (Callaghan 2013a; Kovacevich and Callaghan 2013; Weiner 1992) that encoded the identity of previous ancestors, linking the interred individual and his or her family to powerful individuals in the past as well as serving as a vehicle of legitimation in the present.

The second example of a Middle Preclassic–period heirloom and possible inalienable possession appearing in a Late Preclassic–period tomb context occurs at the site of San Bartolo. Tomb 1 in the Jabalí Group contained a burial with seven vessels; one was a monochrome red-slipped vase with modeling, appliqué, and incising (Figure 10.8). It is unlike the K'o vessel not only in slip color but

also in content of the sculptural image. The red-slipped Joventud-type vessel displays the face of what Pellecer (2006:1028) classifies as a supernatural being. Like the K'o vessel, the San Bartolo vessel is related to concepts of early rulership. The San Bartolo vessel contained a small greenstone figurine in the shape of what Pellecer identifies as a form of the sun god K'inich Ahau. Also like the K'o vessel, the San Bartolo vessel dates to the Middle Preclassic period, which suggests that it was a highly prized heirloom and perhaps an inalienable possession that was curated for hundreds of years and eventually deposited in this tomb context. It may also have been removed from an earlier Middle Preclassic–period context to be reburied with the important individual in the tomb.

One final category of Late Preclassic–period ceramic social valuables is long-distance trade-wares. Trade-wares are surprisingly rare. Out of all the contexts used in this study, trade-wares were

figure 10.9
Brown-incised vases from Class 1 burials at Tikal: a) vase from Burial 85 (Culbert 1993:fig. 5c); b) vase from Burial 85 (Culbert 1993:fig. 5d); c) vase from Burial 85 (Culbert 1993:fig. 5e); d) vase from Burial 85 (Culbert 1993:fig. 6a); e) vase from Burial 167 (Culbert 1993:fig. 12b); and f) dish from Burial 167 (Culbert 1993:fig. 12c). All vessels are shown at one-eighth size.

identified only in Burials 85 and 167 at Tikal. In these contexts, Culbert identifies brown-slipped vases with incised designs as seemingly unlike local Tikal ceramics (Culbert 1993:figs. 5, 6, 12; Figure 10.9). He suggests that these vases originate from the highlands of Guatemala, possibly at or near the site of Kaminaljuyu. The absence of ceramic trade-wares during the Late Preclassic period is surprising because we know long-distance trade in obsidian and jade was taking place between the highlands and lowlands. Furthermore, there

is evidence of ceramic trade-wares in the preceding Middle Preclassic period in the form of fine-orange paste vessels of Mars Orange ware, thought by archaeologists to have been produced at sites in the Belize River valley. Although vessels with wavy-line or drip-line decoration of the Usulutan style were previously suggested to have been imported from the southeastern highlands at sites in El Salvador (Sharer and Gifford 1970), studies have shown that the majority of Usulutan-style vessels found at Late Preclassic–period lowland sites were

produced locally (Brady et al. 1998; Demarest and Sharer 1982; Hammond 1977).

There could be a number of reasons for a lack of ceramic trade-wares in important Late Preclassic–period ritual deposits. The first is simply that ceramic vessels, or their contents, were not part of long-distance exchange; another may be related to problems associated with the type-variety system of ceramic classification and its use on Late Preclassic ceramic types. It is possible that monochrome-slipped vessels were being traded between sites; however, because of similarities in surface features, analysts may have overlooked differences in paste recipes and the possibility that these vessels were not produced locally. If this were the case, petrographic and chemical composition studies of pastes of Late Preclassic–period monochrome-slipped vessels could reveal patterns of long-distance exchange.

Artisan Identity and Its Relation to Late Preclassic Ceramic Techné

Following a discussion of value-additive techné and its relation to vessel form, firing, and surface techniques, it is appropriate to comment on the identity of the Late Preclassic–period ceramic producers responsible, in whole or in part, for the production of social valuables destined for use in important feasts or funerary ceremonies, as aspects of their identity may have also factored into their ability to employ techné. In what follows, I use ethnographic and archaeological evidence to argue that female potters were greatly involved in the production process of Late Preclassic ceramic social valuables and that their gender was a necessary component of ceramic techné (see also Callaghan n.d.).

Ethnoarchaeological studies of Guatemalan and highland Mexican potters show that women are responsible for the majority of production stages in many contemporary potting communities (Arnold 1978:330–331; Reina and Hill 1978:200–201). Reina and Hill believe that the strong pattern they observed in Guatemalan potting communities likely existed for centuries: "In settlements where pottery is still made using traditional Maya techniques, pottery production in general is in the hands of women. . . . There can be little doubt that pottery manufacture by women in Guatemala is an ancient pattern and that the bulk of prehistoric Maya utilitarian pottery was also made by women" (Reina and Hill 1978:21). In her work with non-Maya pottery-making families in San Marcos Acteopan in Puebla, Mexico, Druc (2000:79) also observes the participation of women in multiple stages of the production process. Here, women begin by pre-forming clay into disk-shaped patties they call "tortillas." Then, men place these pre-forms on molds and create vessel rims and handles. After this step, women smooth the handles and decorate the rims. Children then carry the vessels outside to dry in the sun. The entire production sequence is completed beneath a roofed working area within the family's larger household. Men and women work side by side, with children helping at certain intervals. Similar to Druc's example, Philip Arnold (1991:32) notes multiple producers involved in different stages of ceramic manufacture in the non-Maya potting communities of Las Tuxtlas, Mexico. Similar to the other studies mentioned here, Arnold (1991:28) found a positive correlation between the female gender and pottery production among the five communities he studied in the Las Tuxtlas region. Deal (1988, 1998:23–36) finds patterns similar to those discussed above for the highland communities of Chanal and Aguacatenango, Mexico. There, pottery production also takes place within the household and is conducted almost exclusively by women with the occasional assistance of children.

Turning back to the lowland Maya area, we see comparable patterns reflected in the archaeological evidence of the Late Classic period, which may have extended back to the Late Preclassic period. First, it appears that the majority of ceramic production took place in the household compound at prehistoric Maya sites (Becker 1973, 2003; Freter 1996; Rice 2012; Sheets 1992; Sweely 1999) and even those in highland Mexico (Millon 1981; Pool 2009; Widmer and Storey 1993). Furthermore, the majority of vessels produced were associated with other women's activities, such as food and beverage preparation and water collection (Joyce 1993). Related to this argument, at least three of the four major

stages of ceramic production encompassed technologies that women would have experience with—namely, paste and slip preparation (i.e., grinding, kneading, mixing); forming (i.e., food preparation, specifically shaping maize dough); and firing (i.e., cooking, as women would have had excellent knowledge of controlling open-firing temperatures of the hearth). These activities would have been considered "associated technologies" or "associated arts," to use the terms of Amarin (1965) and Wright (1991:203). In other words, the mechanical motions and technological knowledge of food and beverage preparation were not only similar to those required for pottery production, they also would have taken place in the same activity areas (i.e., the household setting) and have been performed by the same producers (i.e., primarily women).

It is important to note that while the ethnographic and archaeological studies above focus on the production of utilitarian or quotidian vessels, this does not preclude the involvement of elite women in the paste preparation or forming of social valuables destined for feasting and, eventually, funerary purposes. Houston and Inomata (Houston, this volume; Houston and Inomata 2009:257–270; Inomata 2001) and Reents-Budet (1998) argue that elite males and females engaged in crafting as part of the practice of being elite. These authors extend their argument further, implying that elite crafting was more than an obligatory vocation: scribal work (in the case of men) and weaving (in the case of women) were productive and regenerative activities that not only legitimated a person's position in society but also constituted elite identity itself. I argue an extension of this idea: elite women were involved in at least the forming and firing (and perhaps some aspects of finishing) of Late Preclassic–period ceramic social valuables, just as their non-elite counterparts were responsible for similar stages in the ceramic production process of more quotidian vessels.

Finally, we can turn to Maya hieroglyphic inscriptions and art to find a potential link between gendered labor and pottery production during the Late Classic period, which may have extended back into the Late Preclassic period. By combining ideals of Maya gender complementarity depicted in Classic-period art and iconography with contemporary folklore that associates women with the earth, clay, and pottery making, Carolyn Tate (1999:85–89, 2000) makes the argument that Classic Maya women may have formed ceramic vases and men painted them. This segmented and gender-specific production pattern correlates well with data from the archaeological and ethnographic record outlined above. Further support for her argument comes in the form of hieroglyphs. Tate (1999:86) notes that "the title for women in Classic-period hieroglyphics is an inverted ceramic water jar infixed with a sun sign. This seems to refer to the woman as a maker of pottery, a bearer of water, and a womb in which the male element has been introduced." Joyce (1992) also notes that women are commonly associated with baskets or jars in monumental art of the Late Classic period. Tate (1999:85–89, 2000) further argues that women produced paper and men wrote on it—similar to women forming vases and men painting on them. This practice is reflected in the archaeological record by the discovery of bark-beaters, used in the process of making paper, being found almost exclusively in domestic household contexts (elite or non-elite) and associated spatially with other material culture related to women's work (Kovacevich 2007:80; McAnany 2010:122–123; Tate 1999:86; Willey et al. 1994:241). Tate argues that the engendered, segmented production of vessels/painting and paper/writing embodied the principles of gender complementarity idealized by the Maya in the figure of the androgynous maize god Hun Nal Ye. The suggestion is that to properly worship the maize god and invoke the male/female regenerative powers associated with that deity, ritual specialists must employ material objects created through the productive labor of both men and women. That is to say, because the maize god itself is an androgynous being, a ritual specialist could not impersonate the god without the social and material contributions of both genders. Evidence to support this hypothesis has been presented by Looper (2002) in the form of political elites portrayed on monuments and ceramic vessels. Looper argues that elites depicted

on monuments and ceramics are frequently dressed in items symbolizing both male and female genders. The monuments and ceramics often contain related glyphic inscriptions that he believes signify the individuals as taking on a third gender. Common combinations of male and female dress include the jade net skirt, a *Spondylus* belt ornament, and war paraphernalia (e.g., helmets and weapons). Looper (2002) cites specific examples of this phenomenon on monuments at Quirigua, Palenque, Naranjo, and Tikal.

Both Tate (1999, 2000) and Looper (2002) imply that the Classic Maya viewed creative or productive forces as necessitating both male and female components—or perhaps a third gender category that combines aspects of male and female. What I suggest here is that the production process of these highly valued vessels destined for important feasting and funerary contexts should have intrinsically reflected the creative powers of both male and female identities. Segmented production in which women formed vessels and men were responsible for surface decoration may have been a way that Preclassic Maya producers constituted a form of ceramic techné and integrated important ideological principles into the production process. While this proposition is no way definitive, circumstantial evidence, such as the examples above, at least make this assertion strong enough to be tested in future studies of Late Preclassic Maya ceramic production.

Having now provided insight into what Late Preclassic–period ceramic social valuables may look like, what types of techné imbued them with meaning and value, and where these vessels can be found, I would like to address the relation of these valuables and their associated techné to well-documented changes in lowland Maya political organization from the Preclassic to Classic periods.

The Evolution of Sociopolitical Complexity and Ceramic Social Valuables

Underlying this study is a hypothesis regarding the evolution of political power in the Maya Lowlands and the role that ceramic vessels played in

it. Research suggests that emerging political elites may have promoted a sense of community and at the same time created hierarchy by steadily integrating the practice of kin-based ancestor worship into community-wide rituals that had previously focused on more generalized cosmological forces (Lucero 2003; McAnany 1995; McAnany et al. 1999; Schele and Freidel 1990). As in later periods, the production and use of ceramic vessels would have played a vital role in these rituals and subsequent shift in ideology.

This process begins at Middle Preclassic-period sites, where communal spaces were ritually activated through feasting and caching events. Well-known examples of sites with evidence of such ritual activation include Cival (Bauer 2005; Estrada-Belli 2010) and Seibal (Smith 1982), Guatemala, where quadripartite caches—representing the four cardinal directions of the cosmos and the raising of the earth and sky from the watery underworld—were excavated into main plaza floors. At Tikal, a similar pattern is seen with Problematical Deposit 1, located in a chultun carved into bedrock in the plaza of Group 5G-1 (McGinn 1999:70). Ceramics from this deposit date to the Eb Complex (800–600 BCE) and include jars, plates, and wide open-bowl and dish forms (Culbert 1993:figs. 116–121; Table 10.6). Vessel forms in all of these earliest ritual deposits emphasize community-accessible feasting events. The large jars with restricted necks would have been used to hold water or beverages consumed by many people during feasting events. The majority of wide, open-plate forms found in the Eb deposit at Tikal also emphasize the serving of large amounts of food destined to be consumed by many people, not just a select few.

Following these initial activation events, community rituals continued to take place in plazas; households simultaneously conducted their own funerary rituals involving the burial and veneration of ancestors within specific household compounds (McAnany 1995, 2004; Robin 1989; Robin and Hammond 1991; Storey 2004). But this pattern of caching community valuables in public areas and burying individuals in household areas changed slowly throughout the Late Preclassic period and

table 10.6

Forms and types of vessels from Tikal Problematical Deposit 1

FINISH COLOR	TYPE-VARIETY	FORM	REFERENCE
Black	Chunhinta Black	Dish, outcurving side	Culbert 1993:fig. 118i
Black	Chunhinta Black	Bowl, vertical side	Culbert 1993:fig. 121b
Buff	Calam Buff	Bowl, vertical side and bolstered lip	Culbert 1993:fig. 117a
Buff	Calam Buff	Bowl, vertical side and bolstered lip	Culbert 1993:fig. 117b
Buff	Calam Buff	Bowl, vertical side and bolstered lip	Culbert 1993:fig. 117c
Buff	Calam Buff	Bowl, vertical side and bolstered lip	Culbert 1993:fig. 117d
Orange	Ainil Orange	Dish, outcurving side	Culbert 1993:fig. 118j
Orange	Aguila Orange	Dish, round-side with tripod supports	Culbert 1993:fig. 121c
Orange	Aguila Orange	Jar, narrow-mouth	Culbert 1993:fig. 121e
Red	Joventud Red	Tecomate	Culbert 1993:fig. 116a
Red	Joventud Red	Tecomate	Culbert 1993:fig. 116b
Red	Guitara Incised: Simple-Incised	Jar	Culbert 1993:fig. 116c
Red	Guitara Incised: Simple-Incised	Bowl, round-side	Culbert 1993:fig. 116d
Red	Joventud Red	Bowl, round-side	Culbert 1993:fig. 116f
Red	Joventud Red	Bowl, round-side	Culbert 1993:fig. 116h
Red	Joventud Red	Bowl, round-side	Culbert 1993:fig. 116i
Red	Joventud Red	Bowl, round-side	Culbert 1993:fig. 116j
Red	Guitara Incised: Simple-Incised	Bowl, round-side	Culbert 1993:fig. 116k
Red	Joventud Red	Plate, round-side	Culbert 1993:fig. 117e
Red	Joventud Red	Plate, round-side	Culbert 1993:fig. 117f
Red	Joventud Red	Dish, round-side	Culbert 1993:fig. 117g
Red	Joventud Red	Dish, round-side	Culbert 1993:fig. 117h
Red	Joventud Red	Dish, round-side	Culbert 1993:fig. 117i
Red	Joventud Red	Dish, outcurving side	Culbert 1993:fig. 118b
Red	Joventud Red	Dish, flat lip	Culbert 1993:fig. 118c
Red	Joventud Red	Dish, flat lip	Culbert 1993:fig. 118d
Red	Joventud Red	Dish, flat lip	Culbert 1993:fig. 118e
Red	Joventud Red	Dish, flat lip	Culbert 1993:fig. 118f
Red	Joventud Red	Dish, flat lip	Culbert 1993:fig. 118g
Red	Joventud Red	Dish, outcurving side	Culbert 1993:fig. 118h
Red	Joventud Red	Dish, flat lip	Culbert 1993:fig. 118k
Red	Guitara Incised: Simple-Incised	Plate, widely everted rim	Culbert 1993:fig. 118l

table 10.6—continued

FINISH COLOR	TYPE-VARIETY	FORM	REFERENCE
Red	Joventud Red	Jar, narrow-mouth	Culbert 1993:fig. 119g
Red	Joventud Red	Jar, miniature	Culbert 1993:fig. 119h
Red	Joventud Red	Bowl, deep with flange	Culbert 1993:fig. 121a
Red and Unslipped	Unnamed	Bowl, round-side	Culbert 1993:fig. 116e
Red and Unslipped	Joventud Red	Dish, flat lip	Culbert 1993:fig. 118a
Red-on-buff	Ahchab Red-on-buff	Jar, spout and narrow-mouth	Culbert 1993:fig. 119f
Unslipped	Cabcoh Striated	Jar, wide-mouth short neck	Culbert 1993:fig. 119a
Unslipped	Cabcoh Striated	Jar, wide-mouth	Culbert 1993:fig. 119b
Unslipped	Cabcoh Striated	Jar, wide-mouth	Culbert 1993:fig. 119c
Unslipped	Canhel Unslipped	Jar, wide-mouth	Culbert 1993:fig. 119d
Unslipped	Canhel Unslipped	Jar, narrow-mouth	Culbert 1993:fig. 119e
Unslipped	Cabcoh Striated	Jar, wide-mouth	Culbert 1993:fig. 120a
Unslipped	Cabcoh Striated	Jar, wide-mouth	Culbert 1993:fig. 120b
Unslipped	Cabcoh Striated	Jar, wide-mouth	Culbert 1993:fig. 120c
Unslipped	Cabcoh Striated	Jar, wide-mouth	Culbert 1993:fig. 120d
Unslipped	Cabcoh Striated	Jar, wide-mouth	Culbert 1993:fig. 120e
Unslipped	Cabcoh Striated	Jar, wide-mouth	Culbert 1993:fig. 120f
Unslipped	Achiotes Unslipped	Jar, wide-mouth	Culbert 1993:fig. 121d

then abruptly circa 100 BCE. Burial assemblages and their locations changed, indicating a shift from ritual focused on open community-related supernatural forces in the Middle Preclassic period to restricted lineage-based ancestors by the end of the Late Preclassic (Freidel and Schele 1988). At K'axob, Belize, Storey (2004) and McAnany et al. (1999) report that the earliest interments were primary extended burials cut into paleosol beneath Middle Preclassic domestic structures in Group 1. By the end of the Late Preclassic period, interments included large groups of incomplete secondary deposits surrounding single-seated primary deposits in public plazas. Storey (2004) and McAnany (2004; McAnany et al. 1999) interpret this pattern as a "gathering of ancestors" in which high-status lineages began to bury their deceased in a public place. This public place soon became the ritual place of a single lineage and was likened to a domestic structure inhabited and owned by a specific lineage (see also Brown and Garber 2008 for Blackman

Eddy, Belize). A similar pattern is seen in Mass Burials 1 and 2, dating to approximately 400 BCE at the site of Cuello, where two seated primary deposits were surrounded by twenty-one incomplete secondary deposits (Robin and Hammond 1991). Ancestor burial in public spaces continued into the Late Preclassic period with construction of the first royal tombs at Tikal, Guatemala (Coe 1965b), and Chan Chich, Belize (Houk et al. 2010). This process culminated in the burial of kings in monumental platforms at the end of the Late Preclassic period in the E Group in the Mundo Perdido complex at Tikal (Laporte and Fialko 1995) and possibly at Wakna, Guatemala (Hansen 1998). Finally, as I mentioned at the beginning of this essay, while I hesitate to compare material culture from the southern Maya area to that of the lowlands, similar social practices may have been taking place there. Investigations at sites in the southern Maya area show similar shifting patterns in feasting, sculpture, and architecture, reflecting: 1) an elite appropriation

of previously domestic feasting and ritual; and 2) a movement away from communal feasting and ritual to restricted and exclusionary practices (see Clark and Blake 1994; Guernsey 2012; Love 1991, 1999; Rosenswig and Kennett 2007).

Ceramic containers played an integral role in the evolution of lowland Maya political organization and religious ritual. Their production and use factored heavily into community ritual in the Middle Preclassic period and restricted lineage-based ancestor veneration of the Late Preclassic period, and I argue that the types of ceramic social valuables found in the first Tikal royal tombs and the techné used to produce them are material manifestations of Late Preclassic political power. During the Late Preclassic period, political elites would have been steadily transforming and co-opting aspects of traditional community-based rituals and symbols of authority in an effort to elevate their own lineages. In this context, vessels used in rituals would have to transmit messages of similarity and difference to large groups of people. It may be for this reason that vessel form, and its corresponding techné, was emphasized as a means to transmit ideological and social messages. Elaborate vessel forms would be easily identifiable by large numbers of people in community feasting and ritual events—much more so than painting and other surface decoration, which would convey messages better in small gatherings (see Moore 1996). Furthermore, the fact that these sophisticated vessels were part of the established Sierra Red serving-ware tradition may have been a way for elites to maintain an idea of community with existing groups—through surface finish—while simultaneously creating difference and hierarchy—through form. Also related to changes in vessel form were changes in vessel sizes. The average diameter of serving vessels in PD 1 (belonging to the Eb Complex at Tikal, or 800–600 BCE) is about five centimeters larger than that of serving vessels in the Late Preclassic Burials 85, 166, and 167 (Table 10.7). Serving vessel forms in PD 1 also include more wide, shallow plates, dishes, and bowls than do Burials 85, 166, and 167. A decrease in wider bowls and dishes and an increase in smaller-diameter serving vessels indicates a shift

away from community-accessible feasting toward more restricted feasting of a select few (see also Costin and Earle 1989).

It is important to remember that spouted vessels and urns were forms often associated with burials of prestigious individuals during the Late Preclassic period. Such ceramics were traditionally believed to function as serving pitchers; however, some scholars believe that the angle at which the spout attaches to the vessel is too extreme to make pouring effective. Instead, they suggest the spout was used as an air intake for frothing chocolate beverages (McAnany et al. 1999; Powis et al. 2002). In either case, the form of the vessel and its presence in high-status burials is significant. If it did function as a pitcher, it would be the container through which groups of people were served, and its relation to the interred individual may signify her or his position as a provider or acquirer of important resources. But if the spouted vessel functioned as an individual chocolate pot, then it would also indicate a shift away from sharing important social resources with the community to consuming them in more private, restricted events. The presence of individually owned chocolate pots becomes well documented in the Early Classic and continues through the Late Classic period (LeCount 2001, 2010; McNeil 2009). In this way, we see the establishment of another elite tradition of the Classic period dating back to the Late Preclassic period.

Finally, elaboration in surface decoration, specifically the smaller-scale medium of painting, at the end of the Late Preclassic period may have been

table 10.7

Statistics of diameter (in centimeters) of serving vessels from Tikal Problematical Deposit 1 (Middle Preclassic period) and Burials 85, 166, and 167 (Late Preclassic period)

	PD 1 (N=37)	BURIALS 85, 166, 167 (N=33)
MEAN	25.78	20.18
MEDIAN	22.35	19.9
MODE	17.57	12.39

an indicator that pottery was being used in more restricted, smaller gatherings, where messages of value and prestige could be transmitted more intimately (see also Houston et al. 2009; Moore 1996). This could be another sign of the shift from community-based ritual power, which was practiced on the large scale, to the kin-based divine rule that was practiced among smaller groups. It is during the end of the Late Preclassic period that polychrome painted pottery, similar in content and style to that of the Early Classic period, emerged and spread throughout the northeastern Maya Lowlands. Considering the evidence provided above, it is not surprising that Classic-period–style polychrome painting first appeared on elaborately formed, smaller serving bowls and plates. This indicates a true mixture of Late Preclassic– and Early Classic–period aesthetics and artisanal techné. It also indicates the continued emphasis on restricted, smaller group or individual serving sizes. I have argued elsewhere that composite bowl forms with polychrome decoration were likely part of a new ceramic political economy that emerged at the end of the Late Preclassic period and encompassed sites of the northeastern and central Maya Lowlands, including Holmul, Nohmul, Tikal, Uaxacatun, and multiple sites in the Belize River valley (Callaghan 2008, 2013a; Callaghan et al. 2013). All of these sites experienced an apogee during the Early Classic period, and their inclusion in the polychrome painted ceramic distribution sphere no doubt played an integral role in their political florescence.

Conclusion

In this chapter, I attempted to distinguish ceramic social valuables of the Late Preclassic period, identify the techné used in their production, and relate this techné to the evolution of social hierarchy and political organization during the Late Preclassic period. I argued that the inability of archaeologists to identify ceramic valuables of the Late Preclassic period was due, in part, to basing our studies of Late Preclassic ceramics on Classic-period patterns of material culture. I suggest the best places to look

for Late Preclassic–period ceramic social valuables are not only the first lowland Maya tombs but also all burial and ritual deposits dating to the Late Preclassic period. This shifts emphasis away from the search for ceramics that materialize only relations of power and prestige, and toward ceramics that encode other principles of value and meaning.

Where ceramic social valuables do exist, their worth appears to have been increased through artisanal techné related to form, surface treatment, paste, and producer identity. Elaborate forms—such as spouted pitchers, urns, and modeled effigy vessels—are found in burial contexts and are often associated with high-status individuals. These ornately formed vessels also served as the vehicles for sophisticated surface decoration, including resist technology, positive painting, and modeling with incision. I demonstrated continuity in artisanal techné related to the forms and surface decorations of Late Preclassic– and Classic-period ceramic social valuables, specifically in an increasing emphasis on composite bowl forms and iconography related to water and death. I also argued that techné related to paste preparation also contributed to a vessel's value. Specifically, the inclusion of grog temper, or crushed sherd from previous vessels, was a type of technological style that symbolically connected new vessels to old ones—and, consequently, events and peoples of the present to those of the past.

I suggested that ceramic technologies were closely related to how pottery was used to consolidate sacred and secular power, and the specific ways in which this power was made manifest in social events. The earliest structured deposits in the Maya Lowlands emphasized ritual related to core concepts of Mesoamerican cosmology that focus on the centering of sites in place and time, and the significance of the agricultural cycle. These deposits, found in plaza areas, included jars for holding beverages and open plates for foods. The location of these deposits and the presence of these vessel forms suggest unrestricted participation in the associated ritual events. It is plausible that ritual events materialized by these early deposits were community affairs with little to no restricted access; however,

public and domestic ritual deposits steadily transformed over the course of the Late Preclassic period, with evidence of restriction to smaller groups of people and an emphasis on the worship of specific ancestors. The number of smaller dishes and bowls increased in these deposits, indicating restricted access to comestibles or individual consumption. Gradations of value appear in forms with the most elaborate shapes reserved for deposition in high-status burials—namely, spouted jars and urn forms in elite burials of the Late Preclassic period. Burial locations move from domestic to public contexts, first in plazas and then in monumental platforms, indicating individual ancestors and specific families had become the focus of religious worship, and ceramic techné played a critical role in this sociopolitical process. Like the elite political actors associated with them, valuable ceramic vessels created difference yet maintained homogeneity through a combination of shape and surface attributes. Seemingly homogenous Sierra Red serving-ware was transformed into a unique and distinct social valuable through the artisanal manipulation of form. It has been suggested elsewhere (McAnany et al. 1999; Powis et al. 2002) that differences in form could be linked to the actions of specific groups of potters, and that identification with these potters could serve as yet another value-enhancing additive of prestige (Reents-Budet 1998). In reference to the identity of artisans responsible for the production of these elaborately formed vessels, I used ethnohistoric and ethnographical data to suggest that women played a large role in the process. More than likely, they would have been charged with the production of domestic and socially valuable pottery on a daily basis, and their participation in the forming stages of highly charged ritual vessels could have been ideologically sanctified, as suggested by Tate (1999, 2000), for the Classic period.

Through the application of the concept of techné to Late Preclassic–period pottery, we are able to see how the work of artisans contributed to the creation of ceramic social valuables and also played an important role in Maya sociopolitical evolution. While continuity in techné exists between Late Preclassic– and Classic-period ceramic social valuables,[2] if our goal is to learn more about how ceramic vessels mediated and materialized social relations during the Preclassic period, then I suggest we pay as much attention to the differences as to the similarities among ceramic data sets at this time. By approaching Late Preclassic–period ceramic data sets through the theoretical concept of techné, we not only begin to understand how the Preclassic Maya created value through aspects of production but also how seemingly simple ceramic containers contributed to social process and major shifts in sociopolitical organization.

NOTES

1 Note that this is not the case in highland areas. See, for example, Arnold et al. 1991; Neff et al. 1990; Neff et al. 1989; Neff et al. 1988; Rice 1977.

2 That is, largely calcite and sand-based paste recipes; basic vessel forms including bowls, jars, and dishes; coiling and molding in the forming process; controlled open firing; and common slip colors like red, black, and white.

Adams, Richard E. W.

1971 *The Ceramics of Altar de Sacrificios.* Papers of the Peabody Museum of Archaeology and Ethnology 63, no. 1. The Peabody Museum, Cambridge, Mass.

Adams, William Y., and Richard W. Adams

1991 *Archaeological Typology and Practical Reality: A Dialectical Approach to Artifact Classification and Sorting.* Cambridge University Press, New York.

Aimers, James John (editor)

2013 *Ancient Maya Pottery: Classification, Analysis, and Interpretation.* University Press of Florida, Gainesville.

Amarin, R.

1965 Beginnings of Pottery-Making in the Near East. In *Ceramics and Man,* edited by Frederick R. Matson, pp. 240–247. Viking Fund publications in Anthropology 41. Wenner Gren Foundation for Anthropological Research, New York.

Arnold, Dean E.

1978 The Ethnography of Pottery Making in the Valley of Guatemala. In *The Ceramics of Kaminaljuyu,* edited by Ronald K. Wetherington, pp. 327–400. Pennsylvania State University Press, University Park.

Arnold, Phillip

1991 *Domestic Ceramic Production and Spatial Organization: A Mexican Case Study in Ethnoarchaeology.* Cambridge University Press, Cambridge.

Arnold, Dean E., Hector Neff, and Ronald L. Bishop

1991 Compositional Analysis and "Sources" of Pottery: An Ethnoarcheological Approach. *American Anthropologist* 93(1):70–90.

Bagwell, Elizabeth

2002 Ceramic Form and Skill: Attempting to Identify Child Producers at Pecos Pueblo, New Mexico. In *Children in the Prehistoric Puebloan Southwest,* edited by Kathryn A. Kamp, pp. 90–107. University of Utah Press, Salt Lake City.

Ball, Joseph

1977 *The Archaeological Ceramics of Becan, Campeche, Mexico.* Middle American Research Institute Publication 43. Tulane University, New Orleans.

1979 On Data, Methods, Results, and Reviews: A Reply to Michael E. Smith. *American Antiquity* 44(4):828–831.

1993 Pottery, Potters, Palaces, and Politics: Some Socioeconomic and Political Implications of Late Classic Maya Ceramic Industries. In *Lowland Maya Civilization in the Eighth Century AD,* edited by Jeremy Sabloff and John Henderson, pp. 243–272. Dumbarton Oaks Research Library and Collection, Washington, D.C.

Barber, Sarah B., Andrew Workinger, and Art Joyce

2013 Situational Inalienability and Social Change in Formative Period Coastal Oaxaca. In *The Inalienable in the Archaeology of Mesoamerica,* edited by Brigitte Kovacevich and Michael G. Callaghan, pp. 38–53. American Anthropological Association, Arlington, Va.

Bartlett, Mary Lee

2004 The Potter's Choice of Clays and Crafting Technologies. In *K'axob: Ritual, Work, and Family in an Ancient Maya Village,* edited by Patricia McAnany, pp. 143–168. Monumenta Archaeologica 22. Cotsen Institute of Archaeology Press, Los Angeles.

Bauer, Jeremy

2005 Between Heaven and Earth: The Cival Cache and the Creation of the Mesoamerican Cosmos. In *Lords of Creation: The Origins of Sacred Maya Kingship,* edited by Virginia M. Fields and Dorie Reents-Budet, pp. 28–29. Scala, Los Angeles.

Becker, Marshall J.

1973 Archaeological Evidence for Occupational Specialization among the Classic Period Maya at Tikal, Guatemala. *American Antiquity* 38(4):396–406.

2003 A Classic-Period Barrio Producing
 Fine Polychrome Ceramics at Tikal,
 Guatemala: Notes on Ancient Maya
 Firing Technology. *Ancient Mesoamerica*
 14(1):95–112.

Berry, Kimberly A., Sandra L. Lopez Varela, Marry
Lee Bartlett, Tamarra Martz, and Patricia A.
McAnany

2004 Pottery Vessels of K'axob. In *K'axob:
 Ritual, Work, and Family in an Ancient
 Maya Village,* edited by Patricia A.
 McAnany, pp. 193–262. Monumenta
 Archaeologica 22. Cotsen Institute of
 Archaeology Press, Los Angeles.

Blackman, M. James, Gil J. Stein, and Pamela B.
Vandiver

1993 The Standardization Hypothesis and
 Ceramic Mass Production: Technologi-
 cal, Compositional, and Metric Indexes
 of Craft Specialization at Tell Leilan,
 Syria. *American Antiquity* 58(1):60–80.

Brady, James, Joseph Ball, Ronald Bishop, Duncan
Pring, Norman Hammond, and Rupert Housley

1998 The Lowland Maya Protoclassic: A
 Reconsideration of Its Nature and Sig-
 nificance. *Ancient Mesoamerica* 9:17–38.

Brown, M. Kathryn, and James F. Garber

2008 Establishing and Reusing Sacred
 Space: A Diachronic Perspective from
 Blackman Eddy, Belize. In *Ruins of
 the Past: The Use and Perception of
 Abandoned Structures in the Maya
 Lowlands,* edited by Travis W. Stanton
 and Aline Magnoni, pp. 147–170.
 University Press of Colorado, Boulder.

Callaghan, Michael G.

2008 Technologies of Power: Ritual Economy
 and Ceramic Production in the
 Terminal Preclassic Period Holmul
 Region, Guatemala. PhD disserta-
 tion, Department of Anthropology,
 Vanderbilt University, Nashville, Tenn.

2013a Maya Polychrome Vessels as Inalienable
 Possessions. In *The Inalienable in the
 Archaeology of Mesoamerica,* edited
 by Brigitte Kovacevich and Michael G.
 Callaghan, pp. 112–127. American
 Anthropological Association,
 Arlington, Va.

2013b Politics through Pottery: A View
 of the Preclassic-Classic Transition

 from Building B, Group II, Holmul,
 Guatemala. *Ancient Mesoamerica*
 24(2):1–35.

n.d. Observations on Invisible Producers:
 Engendering Pre-Columbian Maya
 Ceramic Production. In *Gendered
 Labor in Specialized Economies,* edited
 by Sophie Kelly and Traci Ardren.
 University Press of Colorado, Boulder.

Callaghan, Michael G., Francisco Estrada-Belli, and
Nina Neivens de Estrada

2013 Technological Style and Terminal
 Preclassic Orange Ceramics in the
 Holmul Region, Guatemala. In *Ancient
 Maya Pottery: Classification, Analysis,
 and Interpretation,* edited by John
 James Aimers, pp. 121–141. University
 of Florida Press, Gainesville.

Callaghan, Michael G., and Nina Neivens de Estrada

n.d. *The Ceramic Sequence of the Holmul
 Region, Guatemala.* Anthropological
 Papers of the University of Arizona.
 University of Arizona Press, Tucson.

Chase, Diane Z., and Arlen F. Chase

1998 The Architectural Context of Caches,
 Burials, and Other Ritual Activities for
 the Classic Period Maya (as Reflected
 at Caracol, Belize). In *Function and
 Meaning in Classic Maya Architecture,*
 edited by Stephen D. Houston, pp. 299–
 332. Dumbarton Oaks Research Library
 and Collection, Washington, D.C.

Clark, John E., and Arlene Colman

2013 Olmec Things and Identity: A Reas-
 sessment of Offerings and Burials at
 La Venta, Tabasco. In *The Inalienable
 in the Archaeology of Mesoamerica,*
 edited by Brigitte Kovacevich and
 Michael G. Callaghan, pp. 14–37.
 American Anthropological Association,
 Arlington, Va.

Clark, John E., and Michael Blake

1994 The Power of Prestige: Competitive
 Generosity and the Emergence of Rank
 Societies in Lowland Mesoamerica.
 In *Factional Competition and Political
 Development in the New World,* edited
 by Elizabeth M. Brumfiel and John W.
 Fox, pp. 17–30. Cambridge University
 Press, Cambridge.

Coe, Michael

1977 Supernatural Patrons of Maya Scribes and Artists. In *Social Process in Maya Prehistory*, edited by Norman Hammond, pp. 327–347. Academic Press, London.

1978 *Lords of the Underworld*. Princeton University Press, Princeton, N.J.

Coe, William

1965a Caches and Offertory Practices of the Maya Lowlands. In *Handbook of Middle American Indians: Archaeology of Southern Mesoamerica*, vol. 3, part 1, edited by Gordon R. Willey, pp. 462–468. University of Texas Press, Austin.

1965b Tikal, Guatemala, and Emergent Maya Civilization. *Science*, n.s., 147(3664):1401–1419.

1990 *Excavations in the Great Plaza, North Terrace, and North Acropolis of Tikal*. University Museum Monograph 14, no. 61. The University Museum, Philadelphia.

Costin, Cathy Lynne, and Timothy Earle

1989 Status Distinction and Legitimation of Power as Reflected in Changing Patterns of Consumption in Late Prehispanic Peru. *American Antiquity* 54(4):691–714.

Costin, Cathy Lynne, and Melissa Hagstrum

1995 Standardization, Labor Investment, Skill, and the Organization of Ceramic Production in Late Prehispanic Highland Peru. *American Antiquity* 60(4):619–639.

Crown, Patricia

1999 Socialization in American Southwest Pottery Production. In *Pottery and People: A Dynamic Interaction*, edited by James M. Skibo and Gary M. Feinman, pp. 25–43. University of Utah Press, Salt Lake City.

Culbert, T. Patrick

1993 *The Ceramics of Tikal: Vessels from the Burials, Caches, and Problematical Deposits*. University Museum Monograph 81. University of Pennsylvania Press, Philadelphia.

2003 The Ceramics of Tikal. In *Tikal: Dynasties, Foreigners, and Affairs of State*, edited by Jeremy A. Sabloff,
pp. 47–82. School of American Research Press, Santa Fe, N. Mex.

Culbert, T. Patrick, and Robert L. Rands

2007 Multiple Classifications: An Alternative Approach to the Investigation of Maya Ceramics. *Latin American Antiquity* 18(2):181–190.

Deal, Michael

1988 An Ethnoarchaeological Approach to the Identification of Maya Domestic Pottery Production. In *Ceramic Ecology Revisted, 1987: The Technology and Socioeconomics of Pottery*, edited by Charles C. Kolb, pp. 111–142. BAR International Series 436. British Archaeological Reports, Oxford.

1998 *Pottery Ethnoarchaeology in the Central Maya Highlands*. University of Utah Press, Salt Lake City.

Demarest, Arthur A., and Robert Sharer

1982 The Origins and Evolution of Usulutan Ceramics. *American Antiquity* 47(4):810–822.

Druc, Isabelle

2000 Ceramic Production in San Marcos, Acteopan, Puebla, Mexico. *Ancient Mesoamerica* 11(77–89).

Dunnell, Robert

1970 Seriation Method and Its Evaluation. *American Antiquity* 35:305–319.

1971a Sabloff and Smith's "The Importance of Both Analytic and Taxonomic Classification in the Type-Variety System." *American Antiquity* 36(1):115–118.

1971b *Systematics in Prehistory*. Free Press, New York.

1986 Methodological Issues in Americanist Artifact Classification. *Advances in Archaeological Method and Theory* 9:149–207.

Estrada-Belli, Francisco

2010 *The First Maya Civilization*. Routledge, London.

Fields, Virginia M., and Dorie Reents-Budet

2005 *Lords of Creation: The Origins of Sacred Maya Kingship*. Scala Publishers, London.

Finamore, Daniel, and Stephen D. Houston

2010 *Fiery Pool: The Maya and the Mythic Sea.* Peabody Essex Museum, Salem, Mass.

Foias, Antonia

2007 Ritual, Politics, and Pottery Economies in the Classic Maya Southern Lowlands. In *Mesoamerican Ritual Economy: Archaeological and Ethnological Perspectives*, edited by E. Christian Wells and Karla Davis-Salazar, pp. 167–196. University Press of Colorado, Boulder.

Forsyth, Donald W.

1989 *The Ceramics of El Mirador, Peten, Guatemala.* New World Archaeological Foundation 63. New World Archaeological Foundation, Brigham Young University, Provo, Utah.

Freidel, David, and Stanley Paul Guenter

2006 Soul Bundle Caches, Tombs, and Cenotaphs: Creating the Places of Resurrection and Accession in Maya Kingship. In *Sacred Bundles: Ritual Acts of Wrapping and Binding in Mesoamerica*, edited by Julia Guernsey and F. Kent Reilly, pp. 59–79. Boundary End Archaeological Research Center, Charlottesville, Va.

Freidel, David A., and Linda Schele

1988 Kingship in the Late Preclassic Maya Lowlands: The Instruments and Places of Ritual Power. *American Anthropologist* 90(3):547–567.

Freter, Anne Corrine

1996 Rural Utilitarian Ceramic Production in the Late Classic Period Copan Maya State. In *Arqueología mesoamericana: Homenaje a William T. Sanders,* vol. 2, edited by A. G. Mastache, pp. 209–229. INAH, Mexico City.

Gifford, James C.

1960 The Type-Variety Method of Ceramic Classification as an Indicator of Cultural Phenomena. *American Antiquity* 25(3):341–347.

1976 *Prehistoric Pottery Analysis and the Ceramics of Barton Ramie in the Belize Valley.* Memoirs of the Peabody Museum of Archaeology and Ethnology 18. Harvard University Press, Cambridge, Mass.

Gonlin, Nancy, and Jon C. Lohse (editors)

2007 *Commoner Ritual and Ideology in Ancient Mesoamerica.* University Press of Colorado, Boulder.

Guernsey, Julia

2012 *Ritual and Power in Stone: The Performance of Rulership in Mesoamerican Izapan Style Art.* University of Texas Press, Austin.

Hagstrum, Melissa

1985 Measuring Prehistoric Ceramic Craft Specialization: A Test Case in the American Southwest. *Journal of Field Archaeology* 12:65–76.

Hammond, Norman

1972 A Minor Criticism of the Type-Variety System of Ceramic Analysis. *American Antiquity* 37(3):450–452.

1977 Ex Oriente Lux: A View from Belize. In *The Origins of Maya Civilization*, edited by R. E. W. Adams, pp. 45–76. University of New Mexico Press, Albuquerque.

Hansen, Richard

1992 Proyecto Regional de Investigaciones Arqueológicas del Norte de Petén, Guatemala: Temporada 1990. In *IV Simposio de Investigaciones Arqueológicas en Guatemala, 1990,* edited by Juan Pedro Laporte, Hector Escobedo, and S. Brady, pp. 1–28. Museo Nacional de Arqueología y Etnología, Guatemala City.

1998 Continuity and Disjunction: The Preclassic Antecedents of Classic Maya Architecture. In *Function and Meaning and in Classic Maya Architecture*, edited by Stephen Houston, pp. 49–122. Dumbarton Oaks Research Library and Collection, Washington, D.C.

2006 The First Cities—The Beginnings of Urbanization and State Formation in the Maya Lowlands. In *Maya: Divine Kings of the Rainforest*, edited by Nicholai Grube, pp. 50–65. Könemann, Cologne.

Hellmuth, Nicholas M.

1987 *The Surface of the Underwaterworld: Iconography of the Gods of Early Classic Maya Art in Peten, Guatemala*, vol. 1. Foundation for Latin American Anthropological Research, Guatemala City.

Helms, Mary W.

 1993 *Craft and the Kingly Ideal: Art, Trade, and Power.* University of Texas Press, Austin.

Hopkins, Mary R.

 1986 Appendix 9: Analyses of the Technique of Izalco-type Usulután Decoration. In *The Archaeology of Santa Leticia and the Rise of Maya Civilization,* edited by Arthur A. Demarest, pp. 239–250. Middle American Research Institute, Publication 52. Tulane University, New Orleans.

Houk, Brett A., Hubert R. Robichaux, and Fred Valdez Jr.

 2010 An Early Maya Royal Tomb from Chan Chich, Belize. *Ancient Mesoamerica* 21(2):229–248.

Houston, Stephen D., Claudia Brittenham, Cassandra Mesick, Alexandre Tokovinine, and Christina Warinner

 2009 *Veiled Brightness: A History of Ancient Maya Color.* University of Texas Press, Austin.

Houston, Stephen D., and Takeshi Inomata

 2009 *The Classic Maya.* Cambridge University Press, New York.

Hutson, Scott

 2010 *Dwelling, Identity, and the Maya: Relational Archaeology at Chunchucmil.* Altamira Press, Lanham, Md.

Inomata, Takeshi

 2001 The Power and Ideology of Artistic Creation: Elite Craft Specialists in Classic Maya Society. In *Current Anthropology* 42(3):321–349.

 2013 Negotiation of Inalienability and Meanings at the Classic Maya Center of Aguateca, Guatemala. In *The Inalienable in the Archaeology of Mesoamerica,* edited by Brigitte Kovacevich and Michael G. Callaghan, pp. 128–141. American Anthropological Association, Arlington, Va.

Jones, Lea D.

 1986 *Lowland Maya Pottery: The Place of Petrological Analysis.* British Archaeological Reports no. 288. British Archaeological Reports, Oxford.

Joyce, Rosemary

 1992 Images of Gender and Labor Organization in Ancient Maya Society. In *Exploring Gender Through Archaeology: Selected Papers from the 1991 Boone Conference,* edited by Cheryl Claessen, pp. 63–70. Monographs on World Archaeology 2. Prehistory Press, Madison, Wis.

 1993 Women's Work: Images of Production and Reproduction in Pre-Hispanic Southern Central America. *Current Anthropology* 34(3):255–274.

Kaplan, Jonathan

 2011 Conclusion: The Southern Maya Region and the Problem of Unities. In *The Southern Maya in the Late Preclassic,* edited by Michael Love and Jonathan Kaplan, pp. 387–412. University Press of Colorado, Boulder.

Kosakowsky, Laura J.

 1987 *Pre-Classic Maya Pottery at Cuello, Belize.* Anthropological Papers of the University of Arizona 47. University of Arizona Press, Tucson.

Kovacevich, Brigitte

 2007 Ritual, Crafting, and Agency at the Classic Maya Kingdom of Cancuen. In *Mesoamerican Ritual Economies: Archaeological and Ethnological Perspectives,* edited by E. Christian Wells and Karla Davis-Salazar, pp. 67–114. University Press of Colorado, Boulder.

 2013 The Inalienability of Jades in Mesoamerica. In *The Inalienable in the Archaeology of Mesoamerica,* edited by Brigitte Kovacevich and Michael G. Callaghan, pp. 95–111. American Anthropological Association, Arlington, Va.

Kovacevich, Brigitte, and Michael G. Callaghan

 2013 Introduction: Inalienability, Value, and the Construction of Social Difference. In *The Inalienable in the Archaeology of Mesoamerica,* edited by Brigitte Kovacevich and Michael G. Callaghan, pp. 1–13. American Anthropological Association, Arlington, Va.

Krejci, Estella, and T. Patrick Culbert

1999 Preclassic and Classic Burials and Caches in the Maya Lowlands. In *The Emergence of Lowland Maya Civilization: The Transition from the Preclassic to the Early Classic,* edited by Nikolai Grube, pp. 103–116. Verlag Anton Saurwein, Möckmühl.

Laporte, Juan Pedro, and Vilma Fialko

1995 Un reencuentro con mundo perdido, Tikal, Guatemala. *Ancient Mesoamerica* 6(1):41–94.

LeCount, Lisa J.

2001 Like Water for Chocolate: Feasting and Political Ritual among the Late Classic Maya at Xunantunich, Belize. *American Anthropologist* 103(4):935–953.

2010 K'akaw Pots and Common Containers: Creating Histories and Collective Memories among the Classic Maya of Xunantunich, Belize. *Ancient Mesoamerica* 21(2):341–351.

Lesure, Richard

1999 On the Genesis of Value in Early Hierarchical Societies. In *Material Symbols: Culture and Economy in Prehistory,* edited by John Robb, pp. 23–55. Center for Archaeological Investigations, Occasional Paper no. 26. Southern Illinois University, Carbondale.

Lhuillier, Alberto Ruz

1965 Tombs and Funerary Practices of the Maya Lowlands. In *Handbook of Middle American Indians: Archaeology of Southern Mesoamerica,* vol. 3, part 1, edited by Gordon R. Willey, pp. 441–461. University of Texas Press, Austin.

Lohse, John C.

2013 Alienating Ancient Maya Commoners. In *The Inalienable in the Archaeology of Mesoamerica,* edited by Brigitte Kovacevich and Michael G. Callaghan, pp. 81–94. American Anthropological Association, Arlington, Va.

Lohse, Jon C., and Fred Valdez, Jr. (editors)

2004 *Ancient Maya Commoners.* University of Texas Press, Austin.

Looper, Matthew

2002 Women-men (and Men-women): Classic Maya Rulers and the Third Gender. In *Ancient Maya Women,* edited by Traci Ardren, pp. 171–202. Altamira Press, Walnut Creek, Calif.

Lothrop, Samuel K.

1933 *An Archaeological Study of Ancient Remains on the Borders of Lake Atitlan, Guatemala.* Carnegie Institution of Washington Publication 444. Washington, D.C.

Love, Michael

1991 Style and Social Complexity in Formative Mesoamerica. In *The Formation of Complex Society in Southeastern Mesoamerica,* edited by William R. Fowler, pp. 47–76. CRC, Boca Raton, Fla.

1999 Ideology, Material Culture, and Daily Practice in Pre-Classic Mesoamerica: A Pacific Coast Perspective. In *Social Patterns in Pre-Classic Mesoamerica,* edited by David G. Grove and Rosemary A. Joyce, pp. 127–154. Dumbarton Oaks Research Library and Collection, Washington, D.C.

2011a Critical Issues in the Southern Maya Region in the Late Preclassic Period. In *The Southern Maya in the Late Preclassic,* edited by Michael Love and Jonathan Kaplan, pp. 3–24. University Press of Colorado, Boulder.

2011b Cities, States, and City-State Culture in the Late Preclassic Southern Maya Region. In *The Southern Maya in the Late Preclassic,* edited by Michael Love and Jonathan Kaplan, pp. 47–76. University Press of Colorado, Boulder.

Lucero, Lisa

2003 The Politics of Ritual: The Emergence of Classic Maya Rulers. *Current Anthropology* 44(4):523–558.

McAnany, Patricia A.

1995 *Living with the Ancestors.* University of Texas Press, Austin.

2004 Situating K'axob within Formative Period Lowland Maya Archaeology. In *K'axob: Ritual, Work, and Family in an Ancient Maya Village,* edited by Patricia A. McAnany, pp. 1–9. Monumenta Archaeologica 22. Cotsen Institute of Archaeology Press, Los Angeles.

2010 *Ancestral Maya Economies in Archaeological Perspective.* Cambridge University Press, Cambridge.

McAnany, Patricia A., Rebecca Storey, and Angela K. Lockard

1999 Mortuary Ritual and Family Politics at Formative and Early Classic K'axob, Belize. *Ancient Mesoamerica* 10:129–146.

McGinn, John J.

1999 *Excavations in Residential Areas of Tikal: Groups with Shrines.* Tikal Reports 104. University of Pennsylvania Museum, Philadelphia.

McNeil, Cameron L. (editor)

2009 *Chocolate in Mesoamerica: A Cultural History of Cacao.* University Press of Florida, Gainesville.

Marcus, Joyce, and Kent V. Flannery

1996 The Emergence of Rank and the Loss of Autonomy. In *Zapotec Civilization: How Urban Society Evolved in Mexico's Oaxaca Valley*, edited by Joyce Marcus and Kent V. Flannery, pp. 93–110. Thames and Hudson, London.

Mills, Barbara J.

2004 The Establishment and Defeat of Hierarchy: Inalienable Possessions and the History of Collective Prestige Structures in the Pueblo Southwest. *American Anthropologist* 106(2):238–251.

2013 Land, Labor, Bodies, and Objects: Comments on Inalienability and Mesoamerican Social Life. In *The Inalienable in the Archaeology of Mesoamerica*, edited by Brigitte Kovacevich and Michael G. Callaghan, pp. 142–149. American Anthropological Association, Arlington, Va.

Millon, Rene F.

1981 Teotihuacan: City, State, and Civilization. In *Supplement to the Handbook of Middle American Indians*, vol. 1, *Archaeology*, edited by Victoria R. Bricker and Jeremy A. Sabloff, pp. 198–243. University of Texas Press, Austin.

Moore, Jerry D.

1996 The Archaeology of Plazas and the Proxemics of Ritual: Three Andean Traditions. *American Anthropologist* 98(4):789–802.

Neff, Hector, Ronald L. Bishop, and Dean E. Arnold

1990 A Re-examination of the Compositional Affiliations of Formative Period Whiteware from Highland Guatemala. *Ancient Mesoamerica* 1(2):171–180.

Neff, Hector, Ronald L. Bishop, and Frederick J. Bove

1989 Compositional Patterning in Ceramics from Pacific Coastal and Highland Guatemala. *Archeomaterials* 3(2):97–109.

Neff, Hector, Ronald L. Bishop, and Edward V. Sayre

1988 A Simulation Approach to the Problem of Tempering in Compositional Studies of Archaeological Ceramics. *Journal of Archaeological Science* 15(2):159–172.

Novotny, Anna C.

2013 The Bones of the Ancestors as Inalienable Possessions: A Bioarchaeologial Perspective. In *The Inalienable in the Archaeology of Mesoamerica*, edited by Brigitte Kovacevich and Michael G. Callaghan, pp. 54–65. American Anthropological Association, Arlington, Va.

Pellecer Alecio, Mónica

2006 El Grupo Jabalí: Un complejo arquitectónico de patrón triádico en San Bartolo, Petén. In *XIX Simposio de Investigaciones Arqueológicas en Guatemala, 2005*, edited by Juan Pedro Laporte, Barbara Arroyo, and Hector Mejía, pp. 1018–1030. Museo Nacional de Arqueología y Etnología, Guatemala City.

Pool, Christopher

2009 Residential Pottery Production in Mesoamerica. In *Craft Production and Domestic Economy in Mesoamerica*, edited by Kenneth G. Hirth, pp. 115–132. American Anthropological Association, Arlington, Va.

Poponoe de Hatch, Marion

1997 *Kaminaljuyu/San Jorge: Evidencia arqueologia de la actividad economica en el valle de Guatemala 300 a.C. a 300 d.C.* Universidad del Valle, Guatemala City.

Powis, Terry G., Fred Valdez Jr., Thomas R. Hester, W. Jeffrey Hurst, and Stanley M. Tarka Jr.

2002 Spouted Vessels and Cacao Use among the Preclassic Maya. *Latin American Antiquity* 13(1):85–106.

Pring, Duncan C.

2000 *The Protoclassic in the Maya Lowlands.* BAR International Series 908. British Archaeological Reports, Oxford.

Proskouriakoff, Tatiana

1965 Sculpture and Major Arts of the Maya Lowlands. In *Handbook of Middle American Indians: Archaeology of Southern Mesoamerica*, vol. 3, part 1, edited by Gordon R. Willey, pp. 469–497. University of Texas Press, Austin.

Rands, Robert L., and Robert E. Smith

1965 Pottery of the Guatemalan Highlands. In *Handbook of Middle American Indians: Archaeology of Southern Mesoamerica*, vol. 3, part 1, edited by Gordon R. Willey, pp. 95–145. University of Texas Press, Austin.

Reents-Budet, Dorie

1994 *Painting the Maya Universe: Royal Ceramics of the Classic Period.* Duke University Press, Durham, N.C.

1998 Elite Maya Pottery and Artisans as Social Indicators. In *Craft and Social Identity*, edited by Cathy Lynne Costin and Rita P. Wright, pp. 71–92. American Anthropological Association, Arlington, Va.

2000 Feasting among the Classic Maya: Evidence from the Pictorial Ceramics. In *The Maya Vase Book*, vol. 6, edited by Barbara Kerr and Justin Kerr, pp. 1032–1037. Kerr Associates, New York.

2006 The Social Context of Kakaw Drinking Among the Ancient Maya. In *Chocolate in Mesoamerica: A Cultural History of Cacao,* edited by Cameron McNeil, pp. 202–223. University Press of Florida, Gainesville.

Reents-Budet, Dorie, and Ronald L. Bishop

2012 Classic Maya Painted Ceramics: Artisans, Workshops, and Distribution. In *Ancient Maya Art at Dumbarton Oaks*, edited by Joanne Pillsbury, Miriam Doutriaux, Reiko Ishihara-Brito, and Alexandre Tokovinine, pp. 289–299. Dumbarton Oaks Research Library and Collection, Washington, D.C.

Reilly, F. Kent, III

1994 Enclosed Ritual Spaces and the Watery Underworld in Formative Period Architecture: New Observations on the Function of La Venta Complex A. In *Seventh Palenque Round Table 1989*, edited by Virginia M. Fields, pp. 125–135. Pre-Columbian Art Research Institute, San Francisco.

Reina, Ruben E., and Robert M. Hill II

1978 *The Traditional Pottery of Guatemala.* University of Texas Press, Austin.

Rice, Prudence

1976 Rethinking the Ware Concept. *American Antiquity* 41(4):538–543.

1977 Whiteware Pottery Production in the Valley of Guatemala: Specialization and Resource Utilization. *Journal of Field Archaeology* 4(2):221–233.

2009 Late Classic Maya Pottery Production: Review and Synthesis. *Journal of Archaeological Method and Theory* 16:117–156.

2012 Ceramic Technology and Production. In *The Oxford Handbook of Mesoamerican Archaeology*, edited by Deborah L. Nichols and Christopher A. Pool, pp. 607–615. Oxford University Press, Oxford.

2013 Type-Variety: What Works and What Doesn't. In *Ancient Maya Pottery: Classification, Analysis, and Interpretation*, edited by James John Aimers, pp. 11–28. University Press of Florida, Gainesville.

Richards, C., and Julian Thomas

1984 Ritual Activity and Structured Deposition in Later Neolithic Wessix. In *Neolithic Studies: A Review of Some Current Research*, edited by Richard Bradley and J. Gardiner, pp. 189–218. BAR International Series 133. British Archaeological Reports, Oxford.

Robertson Freidel, Robin A.

1980 The Ceramics from Cerros: A Late Preclassic Site in Northern Belize. PhD dissertation, Department of Anthropology, Harvard University.

Robicsek, Francis

1975 *A Study in Maya Art and History: The Mat Symbol.* Museum of the American Indian, Heye Foundation, New York.

Robin, Cynthia

1989 *Preclassic Maya Burials at Cuello, Belize.* BAR International Series 480. British Archaeological Reports, Oxford.

2013 *Everyday Life Matters: Maya Farmers at Chan.* University Press of Florida, Gainesville.

Robin, Cynthia, and Norman Hammond

1991 Ritual and Ideology: Burial Practices. In *Cuello: An Early Maya Community in Belize,* edited by Norman Hammond, pp. 204–225. Cambridge University Press, Cambridge.

Rosenswig, Robert M., and Douglas J. Kennett

2007 Beyond Identifying Elites: Feasting as a Means to Understand Early Middle Formative Society on the Pacific Coast of Mexico. *Journal of Anthropological Archaeology* 26(1):1–27.

2008 Reassessing San Estevan's Role in the Late Formative Political Geography of Northern. *Latin American Antiquity* (19)2:123–145.

Rye, Owen S.

1976 Keeping Your Temper under Control: Materials and the Manufacture of Papuan. *Archaeology and Physical Anthropology in Oceania* 11(2):106–137.

Sabloff, Jeremy A.

1975 Ceramics. In *Excavations at Seibal, Department of Peten, Guatemala.* Memoirs of the Peabody Museum of Archaeology and Ethnology, vol. 13, no. 2. Harvard University Press, Cambridge, Mass.

Satterthwaite, Linton

1965 Calendrics of the Maya Lowlands. In *Handbook of Middle American Indians: Archaeology of Southern Mesoamerica,* vol. 3, part 2, edited by Gordon R. Willey, pp. 603–631. University of Texas Press, Austin.

Schele, Linda, and David Freidel

1990 *A Forest of Kings: The Untold Story of the Ancient Maya.* William Morrow, New York.

Sharer, Robert (editor)

1978 *Pottery and Conclusions: The Prehistory of Chalchuapa, El Salvador,* vol. 3. University of Pennsylvania Press, Philadelphia.

Sharer, Robert, and James C. Gifford

1970 Preclassic Ceramics from Chalchuapa, El Salvador, and Their Relationships with the Lowland Maya. *American Antiquity* 35:441–462.

Sharer, Robert J., and Loa Traxler

2005 *The Ancient Maya.* 6th ed. Stanford University Press, Stanford, Calif.

Sheets, Payson D.

1992 *The Ceren Site: A Prehistoric Village Buried by Volcanic Ash in Central America.* Harcourt Brace Jovanavich, Fort Worth.

Shook, Edward M., and Alfred V. Kidder

1952 *Mound E-III-3, Kaminaljuyu, Guatemala.* Publication 596. Carnegie Institution of Washington, Washington, D.C.

Smith, A. Ledyard

1982 Major Architecture and Caches. In *Excavations at Seibal, Department of Peten, Guatemala.* Memoirs of the Peabody Museum of Archaeology and Ethnology, vol. 15, no. 1. Harvard University Press, Cambridge, Mass.

Smith, Fred T.

1989 Earth, Vessels, and Harmony among the Gurensi. *African Arts* 22(2):60–65.

Smith, Michael E.

1979 A Further Criticism of the Type-Variety System: The Data Can't Be Used. *American Antiquity* 41:283–286.

Smith, Robert E.

1955 *Ceramic Sequence at Uaxactun, Guatemala.* Middle American Research Institute Publication 20. Tulane University, New Orleans.

Smith, Robert E., and James C. Gifford

1965 Pottery of the Maya Lowlands. In *Handbook of Middle American Indians: Archaeology of Southern Mesoamerica,* vol. 3, part 1, edited by Gordon R. Willey, pp. 498–534. University of Texas Press, Austin.

1966 *Maya Ceramic Varieties, Types, and Wares at Uaxactun: Supplement to "Ceramic Sequence at Uaxactun, Guatemala".* Middle American Research Institute Publication 28. Tulane University, New Orleans.

Smith, Robert E., Gordon R. Willey, and James C. Gifford

1960 The Type-Variety Concept as a Basis for the Analysis of Maya Pottery. *American Antiquity* 25(3):330–340.

Spielmann, Katherine A.

2002 Feasting, Craft Specialization, and the Ritual Mode of Production in Small-Scale Societies. *American Anthropologist* 104:195–207.

Sterner, Judy

1989 Who is Signaling Whom? Ceramic Style, Ethnicity, and Taphonomy among the Sirak Bulahay. *Antiquity* 63:451–459.

Storey, Rebecca

2004 The Ancestors: The Bioarchaeology of the Human Remains of K'axob. In *K'axob: Ritual, Work, and Family in an Ancient Maya Village,* edited by Patricia A. McAnany, pp. 109–138. Monumenta Archaeologica 22. Cotsen Institute of Archaeology Press, Los Angeles.

Sweely, Tracy L.

1999 Gender, Space, People, and Power at Ceren, El Salvador. In *Manifesting Power: Gender and the Interpretation of Power in Archaeology,* edited by Tracy L. Sweely, pp. 155–172. Routledge, London.

Tate, Carolyn

1999 Writing on the Face of the Moon: Women's Products, Archetypes, and Power in Ancient Maya Civilization. In *Manifesting Power,* edited by Tracy Sweely, pp. 81–102. Routledge, London.

2000 Writing on the Face of the Moon: Women as Potters, Men as Painters in Classic Maya Civilization. In *The Maya Vase Book,* vol. 6, edited by Barbara Kerr and Justin Kerr, pp. 1056–1071. Kerr Associates, New York.

Taube, Karl

2005 The Symbolism of Jade in Classic Maya Religion. *Ancient Mesoamerica* 16(1):23–50.

Tedlock, Barbara, and Dennis Tedlock

1985 Text and Textile: Language and Technology in the Arts of the Quiche Maya. *Journal of Anthropological Research* 41(2):121–146.

Thompson, J. Eric S.

1965a Archaeological Synthesis of the Southern Maya Lowlands. In *Handbook of Middle American Indians: Archaeology of Southern Mesoamerica,* vol. 3, part 1, edited by Gordon R. Willey, pp. 331–359. University of Texas Press, Austin.

1965b Maya Hieroglyphic Writing. In *Handbook of Middle American Indians: Archaeology of Southern Mesoamerica,* vol. 3, part 2, edited by Gordon R. Willey, pp. 632–658. University of Texas Press, Austin.

Tomasic, John, and Stephen Bozarth

2011 New Data from a Preclassic Tomb at K'o Guatemala. Paper presented at the 77th Annual Meeting of the Society of American Archaeology, Sacramento, Calif.

Weiner, Annette B.

1992 *Inalienable Possessions: The Paradox of Keeping-while-Giving.* University of California Press, Berkeley.

Wells, E. Christian

2006 Recent Trends in Theorizing Prehispanic Mesoamerican Economies. *Journal of Archaeological Research* 14(4):265–312.

2013 Cultivated Landscapes as Inalienable Wealth in Southeastern Mesoamerica. In *The Inalienable in the Archaeology of Mesoamerica,* edited by Brigitte Kovacevich and Michael G. Callaghan, pp. 66–80. American Anthropological Association, Arlington, Va.

Wetherington, Ronald K.

1978 *The Ceramics of Kaminaljuyu, Guatemala.* Monograph Series on Kaminaljuyu. The Pennsylvania State University Press, University Park.

Widmer, Randolph J., and Rebecca Storey

1993 Social Organization and Household
 Structure of a Teotihuacan Apartment
 Compound of the Tlajinga Barrio. In
 *Prehispanic Domestic Units in Western
 Mesoamerica*, edited by Robert S.
 Santley and Kenneth G. Hirth, pp.
 87–104. CRC Press, Boca Raton, Fla.

Willey, Gordon R., Richard M. Leventhal, Arthur A.
Demarest, and William L. Fash. Jr.

1994 *Ceramics and Artifacts from Excavations
 in the Copan Residential Zone.* Peabody
 Museum of Archaeology and Ethnology
 80. Harvard University, Cambridge,
 Mass.

Wright, Rita P.

1991 Women's Labor and Pottery Production
 in Prehistory. In *Engendering Archaeol-
 ogy: Women and Prehistory*, edited by
 Joan M. Gero and Margaret Conkey,
 pp. 194–223. Basil Blackwell, Oxford.

11

Crafting Identities Deep and Broad

Hybrid Ceramics on the Late Prehispanic North Coast of Peru

CATHY LYNNE COSTIN

IN THIS CHAPTER, I CONSIDER HOW THE production of material culture reflected varying degrees of coercion, co-option, and accommodation during the expansion of the Inka empire at the end of the Pre-Columbian era in South America. In this ethnically, linguistically, and culturally diverse empire, skilled artisans—working under the patronage of the state as the Inka established its imperial structure—manipulated culturally specific technologies, forms, and motifs to create objects that embodied social identities and that reflected the tension between acculturation and assimilation on the one hand, and the maintenance of separate social categories on the other. To demonstrate this dynamic, I focus my analysis on a specific class of ceramic objects: those that systematically combined local and Inka characteristics. Found throughout the empire, these hybrids embodied the Inka policy of partially assimilating conquered elites into the upper echelons of society. Artisans deployed techné— skilled crafting—in its many manifestations to create these objects, just as their patrons used techné to

craft new social identities and new social relations as part of the formation of the empire. Objects that combined specific aspects of state and local technology, forms, and motifs served, didactically, to link local elites co-opted into the Inka bureaucracy with the Inka ruling class while, at the same time, signaling that they were not wholly a part of it.

In *The Interpretation of Cultures* and elsewhere, Clifford Geertz (Geertz 1974, 1982) argues that art, religion, and ideology have social and psychological roles, giving meaning to symbols in order to naturalize and reify beliefs that ensure a sense of place in the social world and foster appropriate behavior. It has become axiomatic among archaeologists that material things—artifacts, buildings, landscapes—materialize beliefs and ideologies, inculcating "right" behavior in social actors. For example, unconsciously echoing Geertz in his recent introduction to a special issue of the *Journal of Archaeological Method and Theory* on materiality and representation, Stratos Nanoglou (2009:159) noted that material representations "constitute a

rather firm framework in which people accustom themselves to a world and get to know the proper way to inhabit it." An approach that considers how objects—as symbols—serve to inculcate expected behavior is particularly applicable to times of imperial conquest and integration, periods of social and political upheaval during which social knowledge and conceptions of the social order must be reified and materialized (cf. Moore 2004). During times of stress, style actively conveys information about identity (Jones 1997). As conquerors and conquered adjust to changed circumstances, both the process and the outcomes of negotiating this new sociopolitical world are given material expression. To this extent, then, "material culture encapsulates colonial experience" (Webster 2001:213).

As Geertz (1974:1478) notes, given the power of the aesthetic response to motivate or prompt critique of behavior, we can not only view objects as "elaborate mechanisms for defining social relationships, sustaining social rules, and strengthening social values" but also consider how they "materialize a way of experiencing; bring a particular cast of mind out into the world of objects, where men can look at it." I argue that the artisans who made these hybrid vessels, and the patrons who sponsored their production, manipulated and recombined symbols of social, ethnic, and political identity as a means of instilling in the conquered populace acceptance of the naturalness of the developing Inka social order. In the larger picture, I suggest that by controlling the production and distribution of objects with specific degrees and kinds of "Inkaness," the state was able to manipulate the degree of separation between elite ethnic-Inkas and the local, non-Inka elites who filled key roles in the provincial bureaucracies. Moreover, I suggest that this specific use of hybrids reflected deeply rooted, distinctively Andean ideologies of unity and separation. That hybrids simultaneously reflected the creation of a social whole and maintained subgroup boundaries within that whole was, I think, a representation of a concept known as *tinquy* in the Andes. Well documented from the colonial period forward, tinquy likely has a long Pre-Columbian heritage in the performance of intra- and interethnic relations.

The Andean concept of tinquy—the conjoining of oppositional forces—helps us to understand how both the conquered and the conquerors may have adjusted to the new social and political "realities" brought about by the Inka expansion.

The idea that material culture reflects and embodies identity is, of course, not a new one in the Andes, and there is a wealth of literature on the subject generally (for the Andes, see, for example, Janusek 2002, 2005; Menzel 1976; Morris 1991, 1995; Rodman and Fernández López 2005; more generally, see Chernela 2008; Hodder 1982; Schortman et al. 2001; Wiessner 1984). In particular, this study is deeply indebted to Dorothy Menzel's (1976) argument that stylistic variation in late prehispanic ceramics from the Ica Valley reflected social variation and changes in political affiliation over a two-century period. I expand upon her ideas to suggest that the manner of hybridization—which elements were combined and how—reflects how ideas about identity and personhood were created and conceptualized.

In the Inka system—where social identity determined social, political, and economic prerogatives—the state was deeply concerned with expressing and reinforcing the social and physical place of subjugated populations in the empire. At the same time, local groups most certainly sought to retain their identities and resources. In a world without the written word, "emblematic artifacts" that clearly marked social identity played a key role in negotiating and communicating the identities upon which individuals claimed rights to land and labor, privilege, and prerogative. It is not at all surprising that material culture had the potential to reflect the tensions of assimilation and separation associated with Inka imperial policies and local responses to the conquest, as the state usurped primary claims to productive resources and redeployed them to meet new demands in the changing sociopolitical landscape.

Theorizing Hybridity

Cultural mixing—variously called hybridization, fusion, syncretism, creolization, and *mestizaje* in

the literature—has become an important theme in post-colonial studies in many disciplines, including literature, music, linguistics, folklore, art history, social history, and, of course, anthropology (see, for example, Brah and Coombes 2000; Card 2013; García Canclini 2005; Hale 1996a; Joseph and Fink 1999; Kapchan and Strong 1999; Pilcher 1998; Rahier 2003). The interest in both process and product is part of a broader rethinking of colonialism and colonization. In this chapter, I use "hybrid," "hybridity," and "hybridization" as inclusive terms encompassing "all manner of creative [in the sense of generative] engagements in cultural exchange" (Hutnyk 2005:83). The terminology has been much debated and dissected in the literature (see, for example, Alonso 2004; de la Cadena 2005; Hale 1996b, 1999; Hutnyk 2005; Kapchan and Strong 1999; Liebmann 2013; Palmié 2013). I concur with García Canclini (2000:42) that such terms as "syncretism," "mestizaje," and "fusion" are too narrow in their application and that none of the criticisms launched against the terms "hybridity" and "hybridization" is so insurmountable as to preclude their use.

While some see hybridization in material culture as a largely aesthetic process (e.g., Ybarra Frausto 1966), I argue that it is at least as much social or political. Indeed, hybridity is never neutral, much less wholly benign. Hybridization occurs mainly in contexts of non-egalitarian, asymmetric power relations, although change is rarely one-sided (cf. Dommelen 1997; Ferguson 1992; Webster 2001). Thus, analyses of hybridity and the processes of hybridization provide opportunities to understand interactions among groups as well as structural inequality and asymmetries of power and prestige (García Canclini 2005:xxx). In this vein, Alonso (2004) distinguishes between authoritative and contestatory hybridity—that is, between hybridity that is imposed on subordinates by a hegemonic power and hybridity that is asserted by subpopulations resisting either an enforced "tradition" or assimilation. Authoritative hybridity can develop as a means of creating a national identity (Pilcher 1998) or to mask inequalities (cf. Hale 1999; Rahier 2003). Contestatory hybridity, in contrast, encompasses rebellion and critique; it is subversive

and transgressive (cf. Bhabha 2004). Rather than interpreting specific instances of hybridity as either authoritative or contestatory, I suggest hybridity can be a negotiated response to changing sociopolitical relations in which all parties have some agency—albeit not always equal—in generating the outcome; that is, I suggest we see hybridization as a strategic balancing act that creates new identities for some or all parties in contact, colonial, or globalizing situations. As Homi Bhabha (2004:64) points out, hybridity is a reflection of the liminality and ambivalence of many of those enmeshed in a colonial situation. Rather than assume a priori that hybridity reflects either domination or resistance, a careful analysis of its specific manifestation allows us to "[explore] who maneuvers, redirects, deploys, and subverts colonialism and how they do so" (Silliman 2005:67).

According to Mikhail Bakhtin (1981:360), intentional hybridization mixes elements in such a way as to draw attention to and create a "dialogue" between them. This "polyphony" allows one to appropriate symbols and use them *with intentionality* to create new meanings in new contexts. As Stephan Palmié (2013:465) has noted recently, "'hybrids' and 'hybridity' are always and everywhere the products of the operation of classificatory regimes." Hybridization, then, is part of a process of negotiation and translation, the arranging and rearranging of the autochthonic "old" and the foreign "new" to reevaluate and rearticulate identities and positions in periods of social and political change.

Inka Society and Material Culture

The Inka as a Colonial Power

Tawantinsuyu—the Inka empire—had its roots in a small chiefdom in the Urubamba Valley of the central Andean highlands during the Late Intermediate Period (ca. 1100–1460 CE; Bauer 1992; D'Altroy 2002). It began its expansion through western South America in the first part of the fifteenth century and, at the beginning of the Late Horizon (ca. 1460–1470 CE), defeated the populous and sociopolitically complex kingdom of Chimor in a

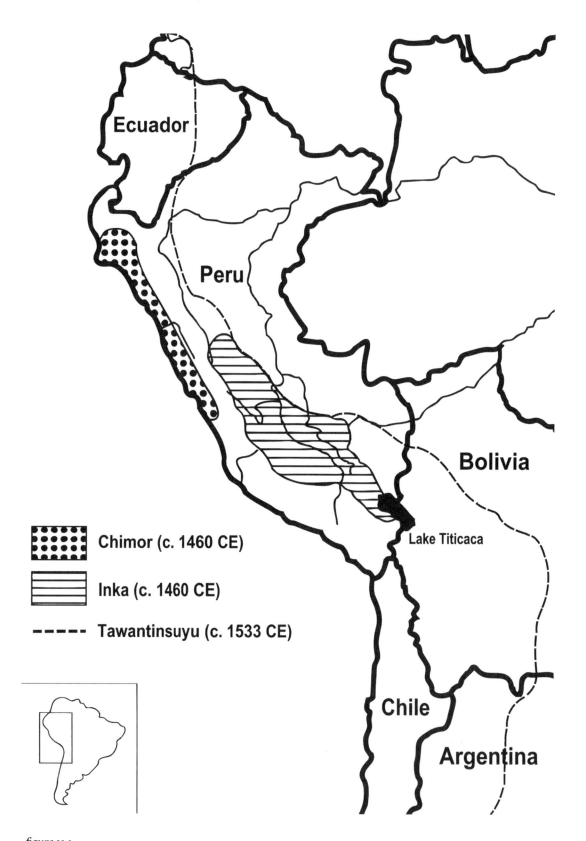

figure 11.1

Map of Andean polities in 1460. Although the Inka polity was physically larger than Chimor, the coastal polity was significantly more densely populated. (Map drawn by Brittany Bankston.)

series of battles described in later colonial documents. Although the empire continued to expand until the Inka themselves were conquered by the Spanish in 1532/1533 CE, most of its physical growth occurred in a relatively short period of time, and the five or so decades prior to the Spanish overthrow were largely given over to consolidating and integrating the eighty to eighty-five culturally distinct groups that comprised the empire.

The conquest of Chimor was significant in the expansion of Tawantinsuyu for a number of reasons. When the two powers confronted each other, they were well matched in territorial and population size (Figure 11.1). It is likely that the Chimú were both technologically and politically more complex than the fledgling Inka empire, suggesting that the Chimú could have had a strong impact on Inka material and political culture. Indeed, it is widely accepted that large numbers of highly skilled Chimú artisans were pressed into the state-sponsored production system (Topic 1990) and that the Chimú imperial system might have strongly influenced Inka statecraft (Conrad 1981; Rowe 1946; Shimada 2000:104). Yet only recently have scholars begun to seriously investigate the nature of the Inka impact on the North Coast (Aland 2013; Costin 2011, n.d.; Hayashida 1995, 2003; Mackey 2003, 2006; Tate 2007).

In the past two decades, Inka studies have increasingly focused on the strategies used to integrate and rule the highly stratified, polyglot, multiethnic Inka empire, where one's place in the hierarchy was defined by gender, ethnicity, socioeconomic status, and role in the complex system of occupational specialization. While many scholars have discussed how the visual arts figured into Inka imperial strategies (Bray 2000; Cummins 1998, 2007; Morris 1995; Pease G. Y. et al. 2004; Zuidema 1991), most studies of Late Horizon art and material culture have centered on the Inka "imperial" style, largely downplaying or ignoring the social and political implications of stylistic and formal variation within the empire.[1]

Late Horizon Material Culture on the North Coast

Archaeologists often classify Late Horizon material culture—and ceramics in particular—based on a subjective assessment of how closely it replicates what are thought to be imperial formal, stylistic, and technological canons. Cuzco-Inka ceramics adhere closest to the canons associated with ceramics recovered in and around Cuzco, and are identified largely on the basis of their morphology, design motifs and layout, labor intensiveness, and perceived artisan skill (Figure 11.2a). Provincial Inka ceramics are those that hold to the basic morphological, iconographic, and design canons of Cuzco-Inka pottery but that exhibit visually distinctive morphological details, proportions, hues and shades, or raw material usage (Figure 11.2b). It is assumed that these ceramics were manufactured in the provinces by "local" artisans working with Cuzco-Inka templates.[2] In both variants, "Inka" designs are rendered using colored paints applied to the surfaces of oxidized vessels. Also found throughout the empire are instances in which individual morphological elements or motifs from Cuzco-Inka and Provincial Inka ceramics have been grafted onto what are otherwise local styles and forms (Figure 11.2c). These Inka-influenced types can be quite important in developing chronologies; however, I suggest they are largely aesthetic flourishes and that they represent very different social and political processes than does the intentional hybridization that is the focus of this chapter. For this reason, I argue for a restrictive use of labels that imply hybridization, such as Chimú-Inka, just as Donnan (2012) distinguishes between what he calls Late Phase and Chimú-Inca ceramics at Huaca Chotuna and Chornancap.

The Chimú style, which spread throughout the North Coast in the Late Intermediate Period (1100–1460 CE), is itself emblematic of the expansionist kingdom of Chimor, centered in the Moche Valley (Figure 11.2d). In contrast with Inka-style pottery, Chimú-style pottery is largely characterized by modeled or impressed designs on reduction fired vessels. Chimú-style pottery continued to be made and used after the Inka conquest; indeed, it was more widely distributed in the Late Horizon than in the Late Intermediate Period at the height of Chimú imperial power. Late Intermediate Period pottery on the North Coast is not well studied, and

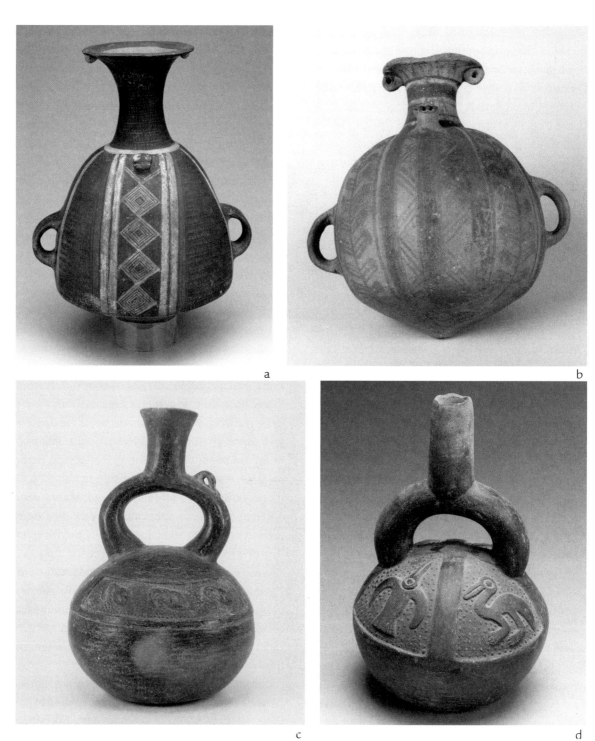

a

b

c

d

figure 11.2

Late prehispanic ceramic types on the North Coast: a) Cuzco-Inka (Minneapolis Institute of Arts, 1153725, The William Hood Dunwoody Fund / Bridgeman Images); b) Provincial Inka (© Phoebe A. Hearst Museum of Anthropology and the Regents of the University of California, catalogue no. 4-3945, photograph by Alicja Egbert); c) Inka-influenced (photograph courtesy of the Museo Larco, Lima, ML023134); and d) Chimú blackware stirrup-spout vessel (photograph by Joaquín Otera Ubeda, courtesy of the Museo de América, Madrid, 10285). Inka-influenced vessels are heterogeneous. In example (c), the "influence" consists of the flaring neck, a form not typically found on the North Coast prior to the Inka conquest.

increasingly scholars are taking a corpus that was once all called Chimú and differentiating among types associated with more localized regional polities, many of which were eventually incorporated into the Chimú polity through alliance or conquest (Mackey 2009, 2011; Shimada 2009; Vogel 2011).

Given the size and importance of the Chimú kingdom to the Inka, there is a somewhat surprising paucity of Inka-style material culture on the North Coast, which distinguishes it from many other parts of the empire. Rather than building in the distinctive state style, the conquerors either remodeled and reused existing administrative centers—for example, Farfán (Mackey 2003, 2006), Manchan (Mackey and Klymyshyn 1990), and Túcume (Heyerdahl et al. 1995)—or built new ones in the North Coast style (e.g., Chiquitoy Viejo [Conrad 1977]), although there are subtle differences between pre- and postconquest architecture (Mackey 2006, 2010, 2011). Textiles—the markers par excellence of social identity in the Andes— also continued to be made largely in the Chimú style (Rowe 1984), although the Inka reorganized their production (Costin 2011, 2015b). Inka-style pottery is also rare on the North Coast (Collier 1955; Hayashida 1995; Shimada 1990; Willey 1953). Many archaeologists have largely explained away the rarity of "Inka" material culture on the North Coast as a reflection of the Inka's hands-off approach to governance in the region. For example, Rowe (1984:15–16) argued that Chimú "prestige" was so high that the Inka didn't impose imperial traditions on that particular conquered population (cf. Menzel 1977).

Hybrid Ceramics in the Late Horizon

In this chapter, I focus on Chimú-Inka hybrids: ceramics that consciously combine elements from the Inka and Chimú styles (Figure 11.3). These Chimú-Inka style vessels are a good place to start an investigation of hybrid material culture in the Inka empire because the hybridization is often so easy to "see" because the two types are so different from one another, in everything from their technologies to their vessel forms and decoration (compare Figures 11.2a and 11.2d; Table 11.1). The study collection consisted of nearly two hundred "hybrid" vessels in museum collections in Peru, the United States, and Europe, as well as hundreds of Cuzco-Inka and Provincial Inka vessels that are part of my long-running study of Inka style. I examined some directly, some in high-resolution photographs (often from multiple angles), and a few only from publications and museum catalogues.[3] For vessels I could not examine directly, I have included only those examples whose form and surface decoration were abundantly clear. While technological attributes are best identified by direct examination of the objects, in many cases it was possible to see elements of technology—such as the use of two-part molds—in the high-resolution photographs. Perhaps the greatest weakness of this study is that few objects are from scientifically excavated proveniences.

In the abstract, hybridization might take one of three forms: Inka-style decoration on local forms, local decoration on Inka forms, or vessels combining an idiosyncratic mixture of local and imperial elements (Bonavia B. and Ravines 1971). Several authors

table 11.1

Differences between Chimú- and Inka-style ceramics

ATTRIBUTE	CHIMÚ	INKA
Formation technique(s)	Mold made; paddle and anvil	Handmade, coiled
Firing	Reduction/smudged	Oxidized
Surface treatment/color	Blackware	Bichrome or polychrome
Type of decoration	Generally figurative	Generally geometric
Decorative technique(s)	Press-molded; modeled; paddle-stamped	Painted
Diagnostic forms	Stirrup-spout; rounded-bottom jars	Aríbalo; shallow plates

(e.g., Conrad 1977; Hayashida 1995) claim that on the North Coast, local forms with Inka designs are more common than are Inka forms with local designs. However, it is probable that body sherds from Inka forms bearing local designs are significantly underrepresented in many analyses of excavated materials, because only diagnostic rim and base sherds are consistently identified as coming from Inka forms. It is likely that body sherds manufactured with local technology and exhibiting local surface treatment and design elements are catalogued as local without analysts considering the possibility that they came from Inka forms. Because it is imperative that vessel form be identified correctly, I have limited my analysis to whole or nearly whole vessels.

Inka Designs on Local Forms

My study of whole vessels suggests that Inka designs are rarely depicted on North Coast vessel forms. Bonavia and Ravines (1971:figs. 1–15) illustrate a number of stirrup-spout vessels, the iconic North Coast form, with painted design motifs that they identify as "Inka"; however, with the exception of one vessel that bears Inka rhomboids (Bonavia B. and Ravines 1971:fig. 6), the other design elements are geometric motifs that have clear analogs with pre-Inka coastal designs. Even a motif as strongly associated with the Inka as the rows of triangles found on imperial Inka *aríbalos* has parallels in earlier Chimú art (see Martinez 1986:figs. 674–679).

The one "local" form that consistently bears quasi-Inka design motifs is a variant of the double-chamber-and-bridge form (Bonavia B. and Ravines 1971:figs. 16–25; Matos Mendieta 2004:151). Although there is a long tradition of double-chambered vessels on the coast, this particular version was manufactured only during the Late Horizon. These vessels bear a hodgepodge of Inka and coastal designs; like Inka-style vessels, they are oxidized pottery with painted surface treatment. In general, painted designs are rare on Chimú ceramics but are found on North Coast ceramics dating to a few centuries before the Inka conquest (see, for example, Mackey 2009:fig. 119, pl. 64; Martinez 1986:figs. 105, 106, 109). A fruitful line of future research might be to investigate the relationships

among late prehispanic painted types on the North Coast, in terms of both their techniques of manufacture and their organization of production. I speculate that there was a distinct group of artisans responsible for the production of oxidized painted wares in the Late Intermediate Period, and that these might have been the artisans tapped by the Inka to produce Inka-style painted wares after the conquest.[4]

Local Designs on Inka Forms

Most of the hybrids in my study collection consist of an Inka form with local decoration. The vast majority of the vessels I have identified as Chimú-Inka hybrids are aríbalos (see Figure 11.3), the most common Inka form recovered outside the imperial heartland (Bray 2004). Rare examples of other Inka forms with Chimú decoration include shallow "bird" plates[5] (Martinez 1986:fig. 395); a strap handled jar (Bonavia B. and Ravines 1971:fig. 26; Burger and Salazar 2004:136); a spherical bottle with a long, slender neck (Bonavia B. and Ravines 1971:fig. 36); and a wide-mouthed vessel with a conical base (Matos Mendieta 2004:155).

I have analyzed more than 175 Chimú-Inka aríbalos. Nearly half are highly polished but otherwise undecorated blackware (see Figure 11.3a). Face-neck aríbalos are common (see Figure 11.3b), as are vessels with press-molded or incised geometric designs (see Figures 11.3c and 11.3d). Approximately one-third of all hybrid aríbalos boast press-molded zoomorphic and anthropomorphic designs (see Figure 11.3e). Overall, the design layouts on these Chimú-Inka hybrids are quite similar to those on Late Intermediate Period Chimú vessels and quite different from most Cuzco-Inka and Provincial Inka ceramics. Almost all of the motifs I have identified on Chimú-Inka aríbalos have antecedents in preconquest Chimú or earlier pottery and, importantly, textiles.

Crafting Hybridity

In creating these vessels, artisans did not draw randomly from Chimú and Inka traditions; rather,

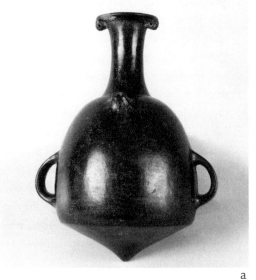

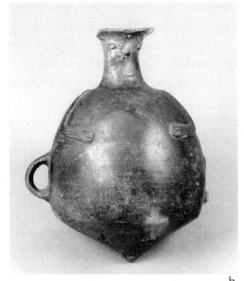

a

b

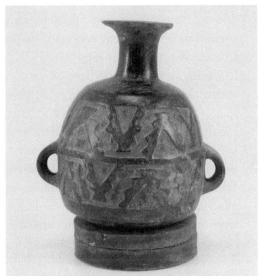

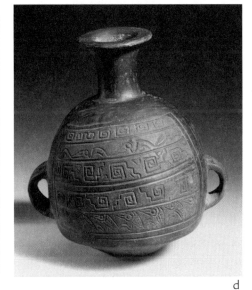

c

d

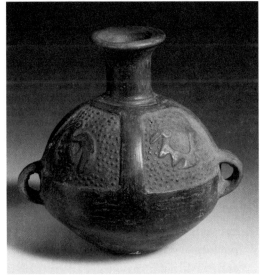

e

figure 11.3
Chimú-Inka vessels: a) plain Inka (© Phoebe A.
Hearst Museum of Anthropology and the Regents
of the University of California, catalogue no. 4-9139,
photograph by Alicja Egbert); b) face-neck Inka
(© Phoebe A. Hearst Museum of Anthropology
and the Regents of the University of California,
catalogue no. 4-4012, photograph by Alicja Egbert);
c) press-molded geometric (photograph courtesy
of the Museo Larco, Lima, ML027597); d) incised
geometric (photograph courtesy of the Division of
Anthropology, American Museum of Natural History,
B_5092); and e) zoomorphic (photograph courtesy of
the Division of Anthropology, American Museum
of Natural History, B_5099).

they systematically combined elements of form, technology, the organization of production, and design motifs to communicate ideas about identity, authority, hierarchy, and control after the Inka subjugated the North Coast.[6] In so doing, these artisans employed many elements of techné: technical skill, genealogical knowledge, understanding of the factional complexity of the coast, and fluency in North Coast symbology and iconography.

The Significance of the Organization of Production

Archaeologists have long recognized that the organization of production has profound economic, social, and political implications. Beyond issues of wealth and power, the organization of production likely had deep symbolic meaning, derived from the identities of the artisans and the nature of control over labor, and the disposition of the products of that labor (Callaghan 2014; Costin 1998, n.d.; Inomata 2001; Lohse 2013).

The organization of ceramic production on the North Coast changed after the Inka conquest (Costin 2010, 2015a, 2015b). There is little evidence that ceramic production was centralized under or administered by the Chimú state. In contrast, the Inka established state-sponsored ceramic workshops after they subjugated the region. These Late Horizon workshops produced a range of goods, including cooking and serving vessels, small quantities of Inka-style vessels, and the hybrids that are the focus of this chapter (Donnan 1997b; Hayashida 1995; Mackey 2011). The workshops were likely staffed with local artisans recruited as part of their corvée obligations to the state. Highly skilled "master" potters might have created the matrices and molds, while less-skilled workers formed and finished the vessels. Thus, the organization of production evoked both region and state, but it clearly signaled the hierarchical relationship between Inka overlords and the defeated local population.

The Significance of Technology

Technology itself is a mode of constructing meaning (Looper 2006:82; see also Helms 1981; Lechtman 1977, 1984, 1993). Technological style and choices are often tied to cultural identity (e.g., Degoy 2008; Gosselain 2000; Lau 2010; Lemonnier 1993; Stark 1998; Stark et al. 2000). North Coast artisans formed Chimú-Inka aríbalos in vertical molds, as they had made pottery for at least one thousand years prior to Inka domination (Donnan 1965; Sawyer 1954; Sidoroff 2005). This technology distinguishes North Coast ceramics from those in other parts of the Andes, where pottery was hand-built using coil or slab methods. The evidence suggests that the Inka did not impose on conquered populations a particular technological style, even for the production of Inka-style pottery (Costin 1986, 2001; Costin and Hagstrum 1995; D'Altroy et al. 1998; Hayashida 1995, 1998, 1999). It is much more difficult to train potters to hand-build vessels than it is to use molds (Arnold 2008), which might explain, in part, why vertical-mold technology continued on the North Coast under Inka domination.

Designs were usually created with molds or stamps, a technique also typical of the North Coast that stands in stark contrast with the predominant imperial Inka decorative technique of painting. Hybrids are almost all reduction fired "black" wares—a third technology associated with the North Coast—although there are a few red, (unintentionally?) oxidized examples. In sum, the technology of hybrid production was almost entirely local.

The Significance of Form: Aríbalos as the Body of the Empire

Unlike the North Coast technology used to manufacture the hybrid vessels, the aríbalo shape is associated solely with the Inka: it was not manufactured prior to the Late Horizon and is "never" found outside of the empire.[7] Aríbalos make up more than half of all Inka-related ceramics recovered throughout the empire (Bray 2004).[8] They are clearly associated with official state activities: feasting, storage, and the production, transport, and consumption of state-distributed chicha. Thus, the aríbalo form is a direct indicator of the presence of the state. It also has deeper meaning. Many aríbalos, both stylistically Inka and hybrid, are anthropomorphized. Several motifs found on Cuzco-Inka and Provincial Inka pottery have parallels in textile

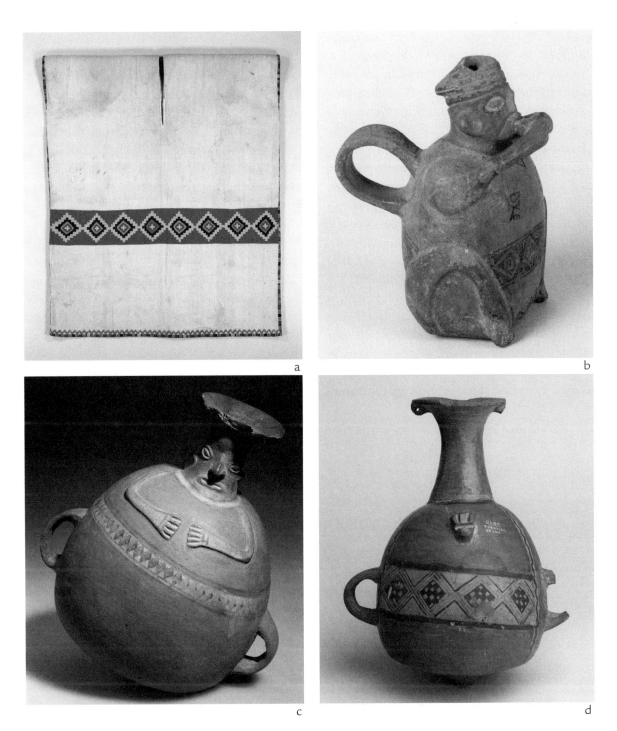

figure 11.4

Inka aríbalo as a dressed body: a) Inka man's tunic with diamond waistband (The Metropolitan Museum of Art, Rogers Fund, 1982.365, www.metmuseum.org); b) figure of Inka man wearing a tunic with a diamond waistband (© Phoebe A. Hearst Museum of Anthropology and the Regents of the University of California, catalogue no. 4-4012, photograph by Alicja Egbert); c) anthropomorphized face-neck Inka aríbalo with diamond band (photograph courtesy of the Division of Anthropology, American Museum of Natural History, 411.8084); and d) aríbalo with diamond band (© President and Fellows of Harvard College, Peabody Museum of Archaeology and Ethnology, Harvard University, PM#45-32-30/4322 [digital file #991700002]).

designs, and their placement on ceramic vessels reinforces an interpretation of these vessels as dressed bodies (Figure 11.4). Mary Douglas (1996) argues the body is a "natural symbol" for society (cf. Cummins 2007). Thus, the aríbalo may embody notions of the empire, its rulers, its power, or its personnel (cf. Bray 2000).

Generally, aríbalos were made in two sizes: small and large (Miller 2004). The larger ones were used for transporting and serving liquids, primarily chicha, probably in association with state-sponsored feasts and other imperial activities. Smaller vessels were likely used as canteens and, given their small size, would have been items of personal use. The hybrids are all small vessels, which is significant for two reasons. First, personal objects often communicate social identity or affiliation. Because the hybrids are not singularities—there are many examples of "multiples" of the same design—they likely represent membership in a group or category

of persons. These containers were likely gifted, used, and displayed at public events, conveying the identities of their individual owners. Second, the absence of large hybrid aríbalos indicates that the state maintained symbolic control over the sponsorship of feasts, an important political dynamic that signaled the nature of imperial patron–local client relations. One can imagine the powerful symbolism of filling a small hybrid aríbalo with chicha or some other liquid from a large, Inka-style vessel!

The Significance of Iconography: Aríbalo Designs and Claims of Authority

As with technology, the motifs found on the hybrid aríbalos derive from a North Coast tradition, with deep antecedents in the iconography of the region. The study collection contains many face-neck vessels and others that bear press-molded anthropomorphic figures. Relations of power and authority are represented in complex ways on the face-neck

a b

figure 11.5
Aríbalos with possible insignia of office. (Photographs by Cathy Lynne Costin, courtesy of the Division of Anthropology, American Museum of Natural History, B_8323 [a] and B_8463 [b].)

figure 11.6
"Dressed" Chimú face-neck vessels. (Photographs © Trustees of the British Museum, Am 1929_305_22 [a] and Am +5447 [b].)

figure 11.7
"Hunchbacked" face-neck Chimú-Inka aríbalo. (Photograph courtesy of the Museo Larco, Lima, ML027605.)

a

b

c

figure 11.8
Chimú-Inka aríbalos with lord and flanking
attendants inside a stepped panel. (Photographs
courtesy of the Division of Anthropology,
American Museum of Natural History, 41.2.7814
[a]; Christopher Donnan [b]; and the Museo Larco,
Lima, ML027601 [c].)

figure 11.9
Late Intermediate Period North Coast vessel
with lord and flanking attendants. (Photograph
courtesy of the Museo Nacional de Arqueología,
Antropología e Historia del Perú, C.33987.)

a

vessels. On the one hand, many of the Chimú-Inka face-neck vessels wear regalia or carry items that might indicate high rank. Although these insignia are only minimally represented, there does seem to be a parallel between the pre-Inka Chimú and Chimú-Inka examples (Figure 11.5). On the other hand, the face-neck vessels display several subtle attributes that suggest subordination. First, the "bodies" of these vessels are plain; that is, they are "undressed." This stands in contrast with face-neck jars made before the Inka conquest, which often show elements of dress, albeit faintly (Figure 11.6). In Andean ideological systems, generally, to strip someone of his or her clothing is to strip away his or her identity. Second, many of these vessels have a protuberance on their backs, which may be interpreted as representing a hunchback (Figure 11.7). Hunchbacks frequently served as attendants in the Inka royal courts, and this convention might reflect the subservient status of North Coast lords after the conquest (cf. Burger and Salazar 2004:136).

There are also many examples of press-molded vessels with a motif that depicts several anthropomorphic figures—usually a large, central individual flanked by two smaller ones—framed by a

b

figure 11.10

a) Anthropomorphized hybrid neck vessel from Huaca Chotuna, depicting a lord wearing a zigzag tunic and flanked by attendants (photograph courtesy of Christopher Donnan); and b) Chimú zigzag tunic (photograph courtesy of the Textile Museum, Washington, D.C., 91.732, acquired by George Hewitt Myers in 1957).

figure 11.11
Moche representation of stepped pyramid.
(Photograph by John Bigelow Taylor, New York,
courtesy of the Division of Anthropology, American
Museum of Natural History, 41.2/8022).

stepped panel (Figure 11.8). Similarly posed anthropomorphic figures appear regularly on Chimú and Sicán vessels and are usually interpreted as powerful lords and attendants (Figure 11.9). In a Late Horizon vessel from Huaca Chotuna, a Chimú lord with a precisely rendered North Coast–style tunic is literally incorporated into an Inka flaring rim (Figure 11.10). Stepped objects appeared in North Coast art a thousand years before the Chimú and are interpreted as representations of stepped pyramids (Figure 11.11; see also Wiersema 2015). Presumably powerful individuals are often

depicted seated atop these structures, and I suggest that the figures within the stepped panels on the hybrid arίbalos represent a variant of these images. In sum, then, the hybrids evoke representations of both authority and subservience—the typical position of local lords who have been co-opted into a colonial administration!

Many of the vessels with press-molded decoration bear zoomorphic motifs. Most commonly, these are birds (Figures 11.12a–d). They are generally recognizable as seabirds, often identified as pelicans. Several examples combine these seabirds with other animals, such as deer and a possible feline (Figure 11.12e). The deer has a deep history as a symbol of powerful North Coast elites (Donnan 1997a). There are also examples of vessels with serpents (Figure 11.12f), bats, a ray/serpent, and a probable caiman, although these are depicted much less frequently.

A wide variety of geometric motifs comprises the other main category of designs. The sample includes several vessels with two horizontal panels of serrated zigzags (Figure 11.13a; see also Figures 11.3c and 11.16c). Some of these vessels appear so similar to one another that they likely came from the same mold or from molds made from the same matrix. Other geometric motifs include key and fret elements and volutes (Figures 11.13b–c). These are sometimes depicted with rows of small birds.

The full range of motifs observed on Chimú-Inka hybrid arίbalos can be found on ceramics that presumably predate the Inka occupation (Figure 11.14).

Almost all the motifs identified on Chimú-Inka arίbalos also have direct analogs in textiles—for example, the zigzag tunics illustrated in Figure 11.10 (compare with Figure 11.13a). In the textiles, zigzags and serrated lines are strongly associated with birds and serpents (Rowe 1984:fig. 27). The use of serrated lines occurs across media; I think it intentionally evokes textile structure and textile technology (cf. Looper 2006). Both horizontal and vertical stripes are found on Chimú tunics, and it is not uncommon for there to be geometric motifs—such as frets, small birds, and other small

Figure 11.12
Zoomorphic motifs on Chimú-Inka aríbalos: a) birds (© Phoebe A. Hearst Museum of Anthropology and the Regents of the University of California, catalogue no. 4-9142, photograph by Alicja Egbert); b) birds, details from American Museum of Natural History, B 5292 (drawing by Brittany Bankston); c) birds, details from British Museum, AM +2808 (drawing by Brittany Bankston); d) birds, details from British Museum, Am 1954, 05.100 (drawing by Brittany Bankston); e) mammals, detail from American Museum of Natural History, B 5136 (drawing by Brittany Bankston); and f) serpents (photograph courtesy of the Division of Anthropology, American Museum of Natural History, 41.2.7815).

a

b

c

figure 11.13
Geometric motifs on Chimú-Inka aríbalos: a)
press-molded zigzags (photograph by Cathy Lynne
Costin, courtesy of the Division of Anthropology,
American Museum of Natural History, 41.2.7447);
b) incised volutes (photograph courtesy of the
Museo Larco, Lima, ML027593); and c) incised step-
frets and birds (© Trustees of the British Museum,
Am 1909 1207).

a

b

figure 11.14

Comparison of Late Intermediate Period and Chimú-Inka bird motifs: a) Late Intermediate Period stirrup-spout vessel (photograph by Joaquín Otero Ubeda, courtesy of the Museo de América, Madrid, 10286); and b) Chimú-Inka aríbalo (© The Art Institute of Chicago, Gift of Nathan Cummings, 1958.679.)

figures—woven into the stripes or background (e.g., Stone-Miller 1992:pl. 43a), much like the aríbalo illustrated in Figure 11.13c.

The figurative motifs also have direct analogs in Chimú textiles. Birds—especially seabirds—are frequently depicted on elaborate late prehispanic North Coast textiles (Figure 11.15; compare with Figure 11.12a–d). Pelicans are often shown being carried on litters (Rowe 1984:fig. 103 and pl. 17), indicating that they represent high status, as only high nobles and royalty were carried on litters in the Andes. Moreover, these birds are often shown with fish or other birds dangling from their beaks, as they are in the hybrid ceramic vessels (see, for example, Rowe 1984:pl. 16; Stone-Miller 1992:pl. 50). The motif of a large anthropomorphic figure flanked by two smaller figures also appears on

North Coast textiles of the Late Intermediate Period (Stone-Miller 1992:pl. 38); these figures are sometimes depicted atop inverted stepped-platform mounds (Amano and Tsunoyama 1979:pl. 3).

Not only is there a strong concordance between the Chimú-Inka aríbalo designs and Chimú textile and ceramic designs, but also both have strong antecedents in North Coast textiles (and ceramics) from nearly a thousand years earlier.[9] Although we have few well-preserved textiles from earlier periods, tunic designs are illustrated with great attention to detail in Moche ceramic art in particular. Preliminary analysis demonstrates continuity in textile design for at least one thousand years. For example, the same geometric motifs found on late prehispanic textiles and ceramics also appear on Moche tunics (Figures 11.16 and 11.17; compare

Figure 11.17 with Figures 11.3d and 11.13c). Sawyer (1954) long ago suggested that many of the geometric motifs on Moche pottery were textile designs.

Moche garments, as represented in ceramic art, bore figurative motifs much less frequently than did Chimú garments; however, we do see parallels and continuities. There is even an example depicting a tunic with two large birds—a direct analog for both North Coast tunics and the Late Horizon hybrid aríbalos (Figure 11.18). Although bird shirts are rarely depicted in Moche art, seabirds—particularly pelicans—were associated with high-status individuals in Moche figurative ceramics (Figure 11.19). We also see continuity in the representation of serpents (Figure 11.20) and often highly stylized rays (Figure 11.21).

I also suggest continuity in tunic construction over this same period of time, which might be echoed in some ceramic vessels' design layouts. Chimú tunics were usually made of two panels with a central seam. I suggest that the propensity for the Moche to depict tunics with two large blocks and the arrangement of designs into blocks on many Chimú-Inka aríbalos also reflects a tradition of textile construction that lasted for a thousand years (Figure 11.22). North Coast–style tunics stand in sharp contrast with Inka-style tunics, which were constructed of a single panel and usually sleeveless (see Costin 2011:table 6.1).

Combining Inka forms with local design formats is the preponderant form of hybridization in other parts of the empire as well. For example, Dorothy Menzel (1976) identifies a South Coast hybrid style she calls Ica-Inca. Although most motifs in the Ica style are geometric—making it somewhat more difficult to differentiate between "Ica" and "Inka" motifs—Menzel's careful analysis indicates that the motifs and design schemes on Ica-Inca pottery are largely indigenous to the South Coast, and they are almost always applied to Inka forms (see Acuto A. 2010 for an example from Argentina).

a

c

b

figure 11.16
Continuity in zigzag motif: a) Moche figure holding a tunic with partial zigzag motif (photograph courtesy of the Museo Larco, Lima, ML012871); b) Chimú loincloth with zigzag motif (The Metropolitan Museum of Art, Fletcher Fund, 59.135.2c, www.metmuseum.org); and c) Chimú-Inka hybrid aríbalo with zigzag motif (photograph courtesy of the Museo Larco, Lima, ML027591).

a

b

c

figure 11.17
Continuity in motifs: a) Moche figure holding tunic with steps, frets, and volutes (photograph courtesy of the Museo Larco, Lima, ML013335); b) Moche figure wearing tunic with steps and volute motifs (drawing by Brittany Bankston, after Anton 1972:fig. 142); and c) Chimú tunic with zigzags, birds, and volutes (photograph courtesy of the Textile Museum, Washington, D.C., 91.849, acquired by George Hewitt Myers in 1958).

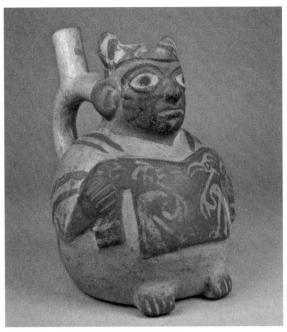

a

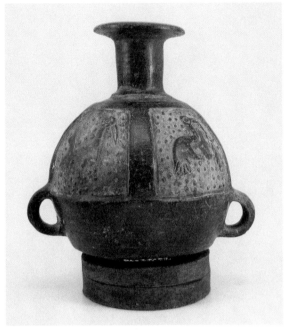

c

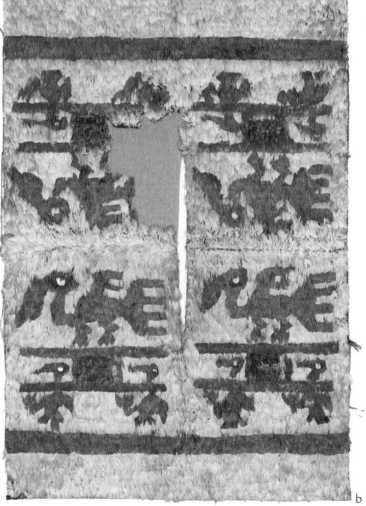

b

figure 11.18

Continuity in bird motifs in ceramics and textiles: a) Moche figure holding tunic with birds (The Metropolitan Museum of Art, Gift of Nathan Cummings, 67.167.33, www.metmuseum.org); b) Chimú tunic with pelicans (photograph courtesy of the Textile Museum, Washington, D.C., 91.395, acquired by George Hewitt Myers in 1941); and c) Chimú-Inka hybrid with birds (photograph courtesy of the Museo Larco, Lima, ML027589).

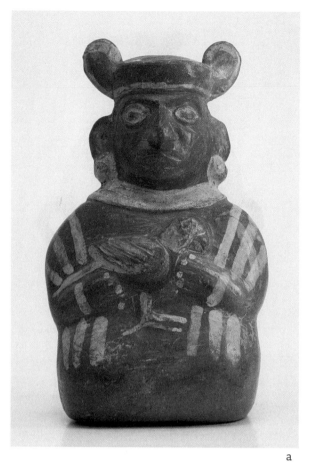
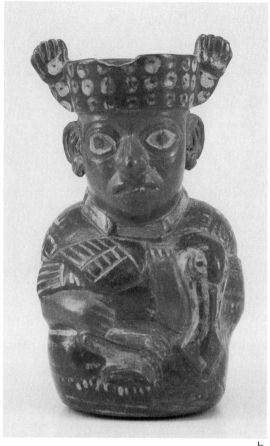

a

b

figure 11.19
High-status Moche individuals holding birds. (Photographs courtesy of the Museo Larco, Lima, MLoo1148 [a] and ML013646 [b].)

The connection between textile and ceramic designs is critical for understanding the meaning of the hybrids. Using clothing to distinguish among ethnic groups was established in Inka foundation myths and codified in their legal system. The connection between clay vessels, their designs, clothing, and identity is made clear in the creation story recorded by Cobo (1990 [1653]:13), wherein it is recounted that "in Tiaguanaco the creator used clay to form all the nations that there are in this land; he painted each one with the clothing to be used by that nation."[10] Inka policies required conquered populations to maintain their traditional dress, housing, and pottery (Cobo 1979 [1653]:196–197). Bray (2000:176) and Cummins (2007) have suggested that common Inka motifs found in a variety of media reference ideas about origins, genealogy, ancestors, and therefore claims to territory and power (see also Zuidema 1991). The local motifs the hybrid vessels "wear" have deep antiquity, are associated with individuals with high status and power, and therefore reference long-standing, autochthonic claims to authority.

In invoking not only textile motifs but also some of the structural characteristics of cloth in the specific way that the motifs are rendered and arranged, the hybrids become a sort of skeuomorph. Skeuomorphism is a particularly powerful mode of intentional communication, a way of metaphorically and semantically marking an object so that the meaning and function of one thing is carried over to another (Houston 2014:57–58; Looper 2006:82). According to Houston (2014:59),

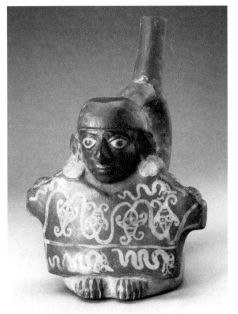
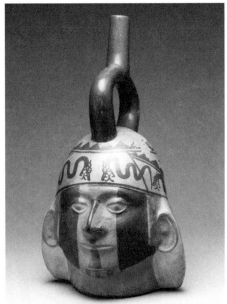

a

b

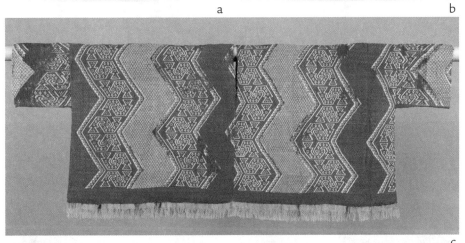

c

d

e

figure 11.20
Continuity in representations of serpents: a) Moche figure holding a tunic with serpent (© The Art Institute of Chicago, Gift of Nathan Cummings, 1957.417); b) Moche man wearing cloth headdress with serpents (The Metropolitan Museum of Art, Gift of Mr. and Mrs. Nathan Cummings, 64.228.21, www.metmuseum. org); c) Chimú textile with serpents (The Metropolitan Museum of Art, The Michael C. Rockefeller Memorial Collection, Bequest of Nelson A. Rockefeller, 1979.206.592, www. metmuseum.org); and d–e) Chimú-Inka hybrid with serpents (photographs courtesy of the Division of Anthropology, American Museum of Natural History, 41.2.7816).

a

figure 11.21

Continuity in representation of rays: a) Moche figure holding a tunic with rays (drawing by Brittany Bankston, after Von Hagen 1964:pl. 5); b) Moche ray motifs (drawing by Cathy Lynne Costin, after Sawyer 1954:fig. 11.27); c) Moche portrait head jar with ray cloth headdress (© The Art Institute of Chicago, Kate S. Buckingham Endowment, 1955.2338); and d) Chimú-Inka hybrid with ray motif (photograph courtesy of the Museo Nacional de Antropología, Arqueología, e Historia del Peru).

b

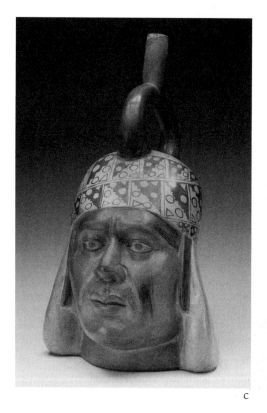

c

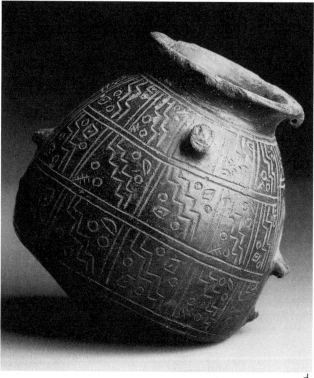

d

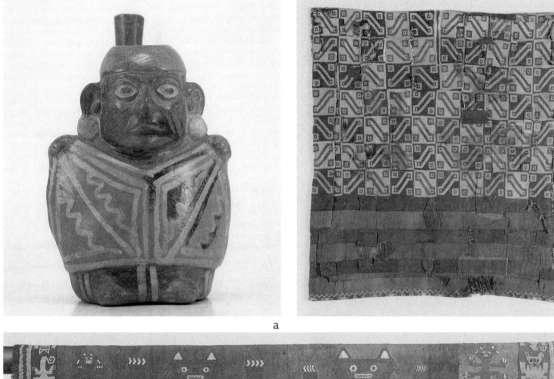

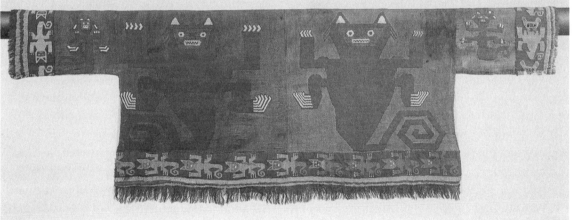

figure 11.22
Comparative tunic structures: a) Moche (photograph courtesy of the Museo Larco, Lima, ML013331); b) Chimú (The Metropolitan Museum of Art, The Michael C. Rockefeller Memorial Collection, Bequest of Nelson A. Rockefeller, 1979.206.955, www.metmuseum.org); and c) Inka (© The Cleveland Museum of Art, 1957.136).

skeuomorphs are a particularly potent means of marking asymmetries, because they both establish resemblances and delineate points of difference. In the case of the Chimú-Inka aríbalos, hybridity and skeuomorphism mutually reinforced the complex construction and performance of social identity in the Inka empire. And in masterfully manipulating these iconographic referents, technology, and form, ceramic artisans demonstrated their techné.

Interpreting Hybridity

So, what are we to make of imperial bodies, dressed in local garb, created by local artisans working in a context of colonial patron–client relations? Bray (2000:173) suggests that the aríbalo form "was intentionally meant to represent the body of the Inca overlords" and that Cuzco-style aríbalos served as mnemonic devices to remind

participants at politically charged feasts and state rituals throughout the empire of the origins of the Inka rulers and the "naturalness" of their power and authority. What about the hybrid vessels that "wear" local symbols? A relatively straightforward reading of Inka arríbalos bearing Chimú (and other local) motifs is that they literally represent the Inka emperor dressed in local garments. It is well documented that the emperor dressed in the local style when he visited the conquered provinces (Betanzos 1987 [1551]:185) and that the wives of local provincial elites wove garments—presumably in their traditional styles—to offer as "gifts" to the Inka and other high-level bureaucrats (Costin 1998). Hybrid vessels, then, might commemorate imperial visits or the straightforward incorporation of conquered regions into the empire. As I have noted elsewhere (Costin 2011), the Inka had strong economic, administrative, and logistical incentives to "welcome" the Chimú into their social order, and while they were ruthless in their treatment of belligerent foes, they welcomed those who would cooperate. Although non-Inka elites generally ranked below most ethnic Inka, the elite of the Chinchasuyu province—which was comprised largely of the former kingdom of Chimor—ranked highest of the nobles from among the four conquered quarters (Zuidema 1991:155). Hybrids, then, might reflect imperial accommodation of local leaders.

Perhaps local elites co-opted into the system appropriated Inka forms of expressing identity to declare their own indigenous claims to continued prestige and prerogative on the North Coast. The adoption of Inka vessel forms might be a case of voluntary emulation of imperial symbols of power and status. During the period of postconquest volatility, local elites might have sought to maintain or enhance their social standing, in part, by embracing the symbols of their new overlords, thereby signaling their willingness to cooperate. Or the local colonized elites might have been simultaneously representing both their recognition of their subjugation and their resistance to the Inka's total authority (cf. Dean 1999). In her study of style and sociopolitical change on the South Coast, Menzel (1976) suggests that local nobles used hybrid

Ica-Inka vessels to legitimize claims to positions and prerogatives that were simultaneously sanctioned by their local history and by their service to the Inka state.

There are, however, two problems with this latter interpretation. First, hybridization almost always consists of local motifs on imperial vessel forms. We rarely find potent Inka designs on local vessel forms, at least not as entire design schemes and especially not on labor-intensive, well-made vessels likely to be used in highly visible political or ritual contexts. Why? Local vessel forms might not have had the symbolic significance that the aríbalo enjoyed. Moreover, the state might have been reluctant to condone the adoption of genealogical symbols of Inka identity by local populations, as this would lay open to them claims of more pure "Inkaness." Isolated and truncated Inka motifs or formal elements might have been tolerated on new forms or on slightly modified local ones if they lost their potent symbolism when broken apart into meaningless constituent elements, or if they were part of the active construction of new, sanctioned identities, as might have been the case at Milliraya in the Lake Titicaca basin (Spurling 1992:388).

Second, the evidence suggests that hybrids were manufactured in state-sponsored workshops throughout the empire, not just on the North Coast (e.g., Acuto A. 2010; Hyslop 1993). Thus, the imperial administration itself was a key participant in constructing and communicating the new identities materialized in the hybrid ceramics. Even if the activities of these workshops were under the operational supervision of local elites acting as imperial agents, I doubt that the state would have allowed these local elites to manipulate imperial symbols of prestige and prerogative without consent.

I suggest that the Inka sponsored the production and distribution of stylistic hybrids in order to control how symbols and material culture were created, thus enabling those in power to restrict and manipulate claims of authority and legitimacy. First, the Cuzco overlords could establish and maintain their legitimacy through the use of symbols that resonated strongly with the subject population. By fusing symbols of "native" claims to power with

those associated with the state, they could inculcate in the users and observers a sense of the "reality" or "naturalness" of the newly imposed imperial order. At the same time, such claims fit closely with Inka ideologies of power, as identity was bound up with narratives of descent and recollections of ancestral homelands. Second, the hybrids would serve the imperial strategy of maintaining class and status distinctions among its subjects while creating social identities for individuals and groups filling new roles in the expanding state bureaucracy and social system. In particular, I suggest that stylistic hybrids served the important function of signaling the dual identities of ethnic elites co-opted into the Inka bureaucratic system. The particular symbolism invested in these hybrids and the specific ways symbols were combined also allowed the state to control how "hybrid" social identities were formed and defined.

At the same time, local lords must have been collaborators in the creation of both the identities and the objects that signified them. They would have served as sources knowledgeable in the meaning and use of traditional symbols. Hybrids most likely reflected negotiated identities that served the interests of both the imperial authorities and the local leaders they co-opted into the provincial bureaucracy. As multivocal symbols, hybrids were likely read somewhat differently by different actors. On the one hand, these vessels encapsulated Inka ideas about identity and strategies for ruling. It was the state that acted consciously to literally incorporate local claims to power and authority while at the same time providing state authorization for the work of local elites. But local leaders—who oversaw most of the daily operations of the provincial bureaucracy—also needed to assert the bases of their power; their legitimacy came from both state and autochthonic claims. The Inka at least tolerated such displays of local pride, perhaps as a way to minimize resistance and ensure the cooperation of the local elites, while local adoption of Inka vessel forms reflected the Chimú elite's acceptance of their political dependence on Cuzco. Hybrids, then, served as powerful reminders of what it meant to belong to a conquered—formerly ruling, now subservient—elite.

I suggest that hybrid ceramic types reflect a new and important class in Inka society as it became an empire. Occupying an intermediary rung in the imperial social hierarchy, these conquered elites also occupied the cultural interstices between their local subjects and their imperial overlords. Inka provincial administration relied on local leaders to fill key roles in the imperial bureaucracy, mediating between ethnically Inka administrators (who filled the highest roles in the administrative hierarchy) and the local subject populations who were expected to submit and provide goods and service to the state. For the local nobles, successful mediation between the demands of the state and the wishes of their "traditional" followers likely fostered as well as depended on some form of emerging hybrid identity.

That the hybrids materialized a newly defined interstitial status is evidenced by the limited information we have about their provenience. Those that have archaeological provenience come from burials distinguished from other contemporary elites in one or more ways. For example, at Huaca Chotuna (Donnan 2011) and Farfan (Mackey 2011), none of the burials with hybrids contained provincial- or imperial-style Inka objects. Given that the Inka required people to retain their native dress and other items of material culture (Cieza de León 1959 [1553]; Cobo 1979 [1653]) to maintain ethnic distinctions, I think it is unlikely that the hybrids were used by ethnically Inka administrators. On the South Coast, hybrid Ica-Inca pottery is found in the burials of the highest-ranking local nobility. These tombs contrast with other burials containing artifacts that indicate the individuals interred therein were direct state functionaries, probably *yanacona* (Menzel 1976).

Local leaders who were co-opted into the bureaucratic system did not become Inka; this would violate the Inka class system that based identity on ethnic origin as much as on sociopolitical status. The Inka pulled cooperative local leaders into the constellation of imperial consiglieri much the same way the state co-opted the deities and huacas of subject populations as subordinate but respected components of the imperial pantheon

and ritual structure. The nature of hybridization in ceramic art—placing Chimú symbols with deep, local antiquity on Inka "bodies"—suggests that the Inka might have co-opted Chimú genealogies into their own system in order to justify and legitimize the role of Chimú leaders in the imperial structure. The Inka legitimized their authority over conquered populations by manipulating general Andean ideologies of kinship (Moore 2004; Zuidema 1990). As Moore (2004:84) points out, "the Inka conceptualized social order by extending a ramifying, lineage-based system that allowed for ranking and inclusion." Further, the Inka acknowledged human "hybrids" in their social ranking, recognizing the offspring between ethnic Inka elites and their "secondary" provincial wives as occupying an intermediary "kin" or status group (Silverblatt 1987:68; Zuidema 1990).

More broadly, after conquest the Inka rewrote local origin myths to unite them into a single Inka genesis, drawing local mythohistories into large Inka imperial ideologies (Cummins 2007; Zuidema 1982). Such an interpretation is reinforced if we accept Cummins's (2007:292–293) suggestion that Inka *toqapu* designs—found on textiles, ceramics, and other objects—were "signifying devices" that represented territorial units and their ruling social groups. The placement of North Coast icons on imperial vessels further emphasized the incorporation of Chimú territory and royalty into the Inka physical and social universes, materializing a social topography of sorts (cf. Cummins 2007:295).

Tinquy and Relations Between Conquered and Conqueror

As Homi Bhabha (2004:49) notes, subjugated populations present a challenge to their conquerors, socially, politically, and culturally: "The incalculable colonized subject—half acquiescent, half oppositional, always untrustworthy—produces an unresolvable problem of cultural difference for the very address of colonial cultural authority." Hybridity allows people to be part of two groups at the same time (Gilchrist 2005), while demonstrating the interconnections among them. Hybridity also allows for an articulation between

antagonistic or contradictory elements (Bhabha 2004:37). Thus, hybrids might also have represented the Andean concept of tinquy, "the ambivalent pairing of two members of a relationship that simultaneously connotes completeness and antagonism" (Covey 2002:395). Tinquy refers conceptually to a wide range of actions that bring together or combine complementary (or contradictory) people and things, including copulation. In the Andean worldview, this coming together of opposites is necessary for continuity. In the Andes today, the tinquy is a ritual dance-battle, usually enacted between neighboring villages. While the tinquy is performed to create social unity, it does so through the expression of both complementary opposition and boundary maintenance between groups (Allen 2002; Bolin 1998). Although the specific term *tinquy* is Quechua, the concept might be more broadly Andean. Donnan (2001) and others (Bourget 2001; Castillo 2000), for example, have suggested that the battles depicted on Moche ceramics represent a form of ritual battle—that is, tinquy. And Dean (1999) has suggested that colonial Cuzco elites consciously framed their interstitial role as mediators between Spanish colonial authorities and the native population as a position of tinquy in order to empower themselves in their hybrid roles; it is not inconceivable that this idea had roots in Pre-Columbian times.

Summary and discussion

During the period of Inka colonial dominance on the North Coast of Peru, local artisans working under the auspices of the Inka empire but likely under the routine supervision of local lords, skillfully and consciously combined morphological, technological, and stylistic attributes from two distinct political and cultural traditions to create hybrid objects that embodied and communicated ideas about identify and power. Neither the selection of attributes nor the overall combination was arbitrary. They do not reflect aesthetic "flourishes," nor are they a hodgepodge of Inka and North Coast attributes combined idiosyncratically by

imaginative or uninformed potters; North Coast artisans were adroit cultural interlocutors. The pattern for combining elements was quite specific: North Coast technology and design motifs, Inka vessel form and organization of production. This combination was meaningful on a number of levels, probably in different—but complementary—ways to the various factions striving for power, authority, and control after the Inka conquest. To some extent, choices were pragmatic: the Inka recruited local potters to work in the state pottery workshops because a skilled, local labor pool existed, and local technologies were used because it is difficult to teach potters new techniques. But technology was also meaningful. Vessels that embodied the new regime were made in the old way—the old ways were quite literally pressed into the service of the new social and political order.

The vessel form chosen for hybrids was also meaningful, embodying the state through its exclusive association with the Inka and its implicit or explicit anthropomorphization. Analysis of the motifs used on the hybrid vessels indicates two things: first, the practice of representing textile designs—emblems of social identity—on these anthropomorphized ceramic vessels, and second, Inka co-option of regional mythology/local leaders' assertions of authority. Mackey (2011) suggests that Inka and local leaders called upon earlier mythologies to ease social and political tensions. I think it was deeper than that, with both the state and complicit local elites manipulating indigenous claims to authority as access to power was reorganized under Inka rule.

The pattern in which elements were hybridized—local garments on Inka bodies, Inka bodies created by local artisans working under the auspices of the state—speaks to the complexity of state and local lords accommodating themselves to each other and to how identities were constructed. But "hybrid" identities only went so far, and it appears that the locals were required to accommodate more than the conquerors. This is not a case of the creation of one new overarching sovereign identity. While the local lords became something new, the Inka held themselves apart. The evidence strongly suggests that "Inka" administrators and "local" lords lived side by side in different styles of buildings, used different styles of goods, and were buried separately (Donnan 2011; Heyerdahl et al. 1995; Mackey 2011; Mackey and Klymyshyn 1990; Menzel 1976; Morris 2004).

It is likely that only some local lords were recruited into the new sociopolitical hierarchy and their incorporation was only partial, reflecting fundamental distrust on both sides. The Inka went to great lengths to break up Chimor, relocating large numbers of people to other regions as *mitmaqkuna,* or artisan retainers (Topic 1990; Topic and Topic 1993). The widespread reorganization of production—particularly textile production—was a strategy to lessen the power and influence of local leaders (Costin 2010, 2015b). This approach should be reflected in other, symbolic aspects of material culture. One area that requires future research is a more thorough cataloguing of which North Coast icons are and are not represented on aríbalos. Only a subset of North Coast motifs were used, perhaps representing the specific factions within the larger North Coast political realm who found favor under the Inka. One "missing" image is readily apparent: the ubiquitous "moon animal" does not appear on hybrid vessels, although it does appear on Late Horizon Chimú vessels. The kingdom of Chimor itself was an ethnically and linguistically diverse polity when the Inka conquered it. The Chimú had had their own challenges pacifying and incorporating conquered peoples before the Inka arrived (e.g., Mackey 2011), and it stands to reason that existing tensions would have influenced Inka strategies once the Inka seized the North Coast. This paper has treated "North Coast" technology and iconography in broad strokes. Future work might be able to more carefully parse out variability in how artisans incorporated ethnically distinct motifs and techniques in order to identify local "winners" and "losers" in the now subjugated realm.

In focusing on this one particular locus of hybridization, I don't mean to suggest that it is representative of Inka strategies or local responses throughout the empire. The primary case discussed here—the relationship between the Chimú and the

Inka—is an interesting one, because the conquerors and conquered were relatively evenly matched in terms of size and sociopolitical complexity at the time of the Inka conquest. One could even make an argument that the Chimú were more politically experienced, administratively practiced, and technologically sophisticated. The situation on the North Coast, where the Inka faced incorporating relatively complex societies into their imperial structure, stands in stark contrast to other parts of the empire, such as the Mantaro Valley and Huanuco, where the Inka imposed themselves administratively and stylistically on less complex groups, creating an unambiguous hierarchy of imperial lords and local consiglieri (D'Altroy 1992; Morris and Thompson 1985). This latter strategy is reflected, in part, by much clearer distinctions between local and imperial material culture. And in some areas of the empire, entirely "new" styles emerged, such as in the southern altiplano, where resettled potters not only made pottery in the Cuzco-Inka style but also developed a novel, high-quality style that is a pastiche of Cuzco-Inka, local, and original elements (Spurling 1992). Other, more localized hybridizations and innovations surely occurred throughout the empire, as the Inka worked out strategies to best rule under the varying social and political circumstances they encountered (cf. Wernke 2006).

The sum of the evidence on the North Coast suggests the push–pull of co-option into the conquering state: the Inka redefined identity, but local lords must have been part of the negotiation. This case study demonstrates that even in parts of the Inka empire where there appears to be little material culture in classic imperial style, conquest by and incorporation into the empire brought highly meaningful changes to local material culture. While the adoption of isolated elements of form or motif might reflect creative or aesthetic decisions and provide temporal markers for present-day culture historians, I suggest that a broader analysis of how attributes were systematically hybridized can yield insight into how identity was conceptualized, constructed, and communicated in times of status and class redefinition. In doing so, it is well to remember that all aspects of skilled crafting—the deployment of technique; artisan identity; and the organization of production, form, and style—contribute to objects' meanings. One additional area of future inquiry concerns the specific identities of the artisans who created these objects. In many societies, elites took a direct role in the production of particularly meaningful or valuable goods. I would like to know more about these artisans, who—as the creators of emblematic objects that communicated identity, authority, power, and, likely, resistance—played a key role in the negotiations that took place in this case of imperial expansion.

Acknowledgments

My deepest thanks to Joanne Pillsbury, Lisa Trever, Julia Guernsey, Bill Sillar, Carol Mackey, Christopher Donnan, and Erika Brandt, all of whom helped in myriad ways. Thanks also to the chapter's anonymous reviewers for their comments. Their insights greatly strengthened my argument; I take full responsibility for any errors resulting from my not accepting their advice.

1 Variation has largely been used to study the organization of production in the empire. A notable exception to this generalization is Menzel (1976).

2 Specific objects that we could call ceramic templates have not been found (other pots could serve as templates). Interestingly, Mackey and Klymyshyn (1980–1983) recovered a set of wooden boards covered with textile motifs at the North Coast administrative center of Manchan. The authors argue that these boards were templates used by local weavers who were recruited to weave for the state.

3 I did not include any vessels held in private collections in my study, although I have been contacted several times by individuals familiar with my work who wished to share with me their holdings.

4 Much earlier—under the dominance of the Moche culture—oxidized painted pottery predominated on the North Coast. It was replaced by impressed and stamped reduction-fired wares after the collapse of the Moche polities. Understanding the ecological, social, and political contexts of this transition is the object of a new research project (Costin 2015a).

5 Menzel (1976) reports a large number of hybrid Ica-Inka plates from the South Coast.

6 In a paper published after this chapter was initially reviewed, Anne Tiballi (2014) argued that the *aqllakuna* weavers working at the Central Coast site of Pachacamac created and expressed their own hybrid identities through the production and wearing of a combination of Inka and non-Inka garments. In this case, individual cloth items were not hybrids, but the women themselves were marked as having hybrid identities by wearing Inka and provincial-style garments as part of the same "outfit."

7 Pärssinen and Siiriäinen (1997) have suggested that some Inka-style pottery began appearing in the southern Lake Titicaca area prior to the conquest, perhaps through gift or marital exchange. Importantly, however, the Inka-style vessel forms recovered do not include aríbalos, bolstering the idea that the form, even more than the design, was symbolic of the state.

8 Hyslop (1993), relying on different data, suggested that plates were the most common Inka form outside the Cuzco heartland.

9 Burger (1976) has traced what he calls "Moche archaism" in Chimú ceramics. I suggest that this reflects broader continuity in North Coast iconography, symbology, and genealogical claims to power and authority. Thus, the Inka tapped into a deep tradition.

10 As DeLeonardis notes in her chapter in this volume, the Quechua terms for painting, drawing, embroidering, and dyeing were related to one another, suggesting that all forms of "decorating" were conceptually related.

REFERENCES CITED

Acuto A., Felix

2010 Living under the Imperial Thumb in the Northern Calchaqui Valley, Argentina. In *Distant Provinces in the Inka Empire: Toward a Deeper Understanding of Inka Imperialism*, edited by Michael A. Malpass and Sonia Alconini, pp. 108–150. University of Iowa Press, Iowa City.

Aland, Amanda S.

2013 Imperial Adaptation of Santa Rita B, Chao Valley: Local Perspectives on Chimu and Inka Imperial Strategies on the North Coast of Peru. PhD dissertation, Southern Methodist University, Dallas.

Allen, Catherine

2002 *The Hold Life Has: Coca and Cultural Identity in an Andean Community.* Smithsonian Institution Press, Washington, D.C.

Alonso, Ana María

2004 Conforming Disconformity: "Mestizaje," Hybridity, and the Aesthetics of Mexican Nationalism. *Cultural Anthropology* 19(4):459–490.

Amano, Yoshitaro, and Yukihiro Tsunoyama

 1979 *Textiles of the Andes: Amano Collection.* HEIAN International, San Francisco.

Anton, Ferdinand

 1972 *The Art of Ancient Peru.* Putnam, New York.

Arnold, Dean E.

 2008 *Social Change and the Evolution of Ceramic Production and Distribution in a Maya Community.* University Press of Colorado, Boulder.

Bakhtin, Mikhail M.

 1981 *The Dialogic Imagination: Four Essays.* University of Texas Press, Austin.

Bauer, Brian S.

 1992 *The Development of the Inca State.* University of Texas Press, Austin.

Betanzos, Juan de

 1987 [1551] *Suma y narración de los inkas.* Ediciones Atlas, Madrid.

Bhabha, Homi K.

 2004 *The Location of Culture.* Routledge, New York.

Bolin, Inge

 1998 *Rituals of Respect: The Secret of Survival in the High Peruvian Andes.* University of Texas Press, Austin.

Bonavia B., Duccio, and Roger Ravines

 1971 Influence inca sur la côte nord du Pérou. *Bulletin Société suisse des Américanistes* 35:3–18.

Bourget, Steve

 2001 Rituals of Sacrifice: Its Practice at Huaca de la Luna and Its Representation in Moche Iconography. In *Moche Art and Archaeology in Ancient Peru*, edited by Joanne Pillsbury, pp. 89–109. National Gallery of Art, Washington, D.C.

Brah, Avtar, and Annie E. Coombes (editors)

 2000 *Hybridity and Its Discontents: Politics, Science, Culture.* Routledge, London.

Bray, Tamara L.

 2000 Inca Iconography: The Art of Empire in the Andes. *Res: Anthropology and Aesthetics* 38:168–178.

 2004 Imperial Inka Pottery: A Comparison of State Ceramics from the Cuzco Heartland and the Provinces. *Chungará* 36(2):135–146.

Burger, Richard L.

 1976 The Moche Sources of Archaism in Chimu Ceramics. *Ñawpa Pacha* (14):95–104.

Burger, Richard L., and Lucy C. Salazar

 2004 *Machu Picchu: Unveiling the Mystery of the Incas.* Yale University Press, New Haven, Conn.

Callaghan, Michael G.

 2013 Maya Polychrome Vessels as Inalienable Possessions. In *The Inalienable in the Archaeology of Mesoamerica*, edited by Brigitte Kovacevich and Michael G. Callaghan, pp. 112–127. American Anthropological Association, Arlington, Va.

Card, Jeb J. (editor)

 2013 *The Archaeology of Hybrid Material Culture.* Center for Archaeological Investigations Occasional Paper 39. Southern Illinois University Press, Carbondale.

Castillo B., Luis Jaime

 2000 *La ceremonia del sacrificio: Batallas y muerte en el arte mochica.* Museo Arqueológico Rafael Larco Herrera, Lima.

Chernela, Janet

 2008 Translating Ideologies: Tangible Meaning and Spatial Politics in the Norwest Amazon of Brazil. In *Cultural Transmission and Material Culture: Breaking Down Boundaries*, edited by Miriam T. Stark, Brenda J. Bowser, Lee Horne, and Carol Kramer, pp. 130–149. University of Arizona Press, Tucson.

Cieza de León, Pedro

 1959 [1553] *The Incas of Pedro de Cieza de León.* Edited by Victor Wolfgang von Hagen. Translated by Harriet de Onís. University of Oklahoma Press, Norman.

Cobo, Bernabé

 1979 [1653] *History of the Inca Empire: An Account of the Indians' Customs and Their Origin, Together with a Treatise on Inca Legends, History, and Social Institutions.* University of Texas Press, Austin.

1990 [1653] *Inca Religion and Customs*. Translated and edited by Roland Hamilton. University of Texas Press, Austin.

Collier, Donald

1955 *Cultural Chronology and Change as Reflected in the Ceramics of the Virú Valley, Peru*. Fieldiana Anthropology 43. Chicago Natural History Museum, Chicago.

Conrad, Geoffrey W.

1977 Chiquito Viejo: An Inca Administrative Center in the Chicama Valley, Peru. *Journal of Field Archaeology* 4(1):1–18.

1981 Cultural Materialism, Split Inheritance, and the Expansion of Ancient Peruvian Empires. *American Antiquity* 46(1):3–26.

Costin, Cathy Lynne

1986 From Chiefdom to Empire State: Ceramic Economy Among the Prehispanic Wanka of Highland Peru. PhD dissertation, Department of Anthropology, University of California, Los Angeles.

1998 Housewives, Chosen Women, Skilled Men: Cloth Production and Social Identity in the Late Prehispanic Andes. In *Craft and Social Identity*, edited by Cathy Lynne Costin and Rita P. Wright, pp. 123–141. American Anthropological Association, Arlington, Va.

2001 Production and Exchange of Ceramics. In *Empire and Domestic Economy*, edited by Terence N. D'Altroy and Christine Ann Hastorf, pp. 203–242. Kluwer Academic/Plenum Publishers, New York.

2010 Attached or Independent? Paper presented at the 109th Annual Meeting of the American Anthropological Association, New Orleans.

2011 Textiles and Chimu Identity Under Inka Hegemony on the North Coast of Peru. In *Textile Economies: Power and Value from the Local to the Transnational*, edited by Walter E. Little and Patricia McAnany, pp. 101–124. AltaMira Press, Lanham, Md.

2015a Ceramic Technology on the Peruvian North Coast: Stability and Change over the Long Durée and Its Socio-Political Implications. Paper presented at the University College of London Institute of Archaeology, London.

2015b Crafting Identity and Wealth on the North Coast of Peru. Paper presented at the 80th Annual Meeting of the Society for American Archaeology, San Francisco.

n.d. Gendered Divisions of Labor in the Chimu and Inka Political Economies. In *Gendered Labor in Specialized Economies: Archaeological Perspectives on Male and Female Work*, edited by S. E. Kelly and Traci Ardren. University Press of Colorado, Boulder.

Costin, Cathy Lynne, and Melissa B. Hagstrum

1995 Standardization, Labor Investment, Skill, and the Organization of Ceramic Production in Late Prehispanic Highland Peru. *American Antiquity* 60(4):619–639.

Covey, R. Alan

2002 Review: Mediation, Resistance, and Identity in Colonial Cuzco. *Comparative Studies in Society and History* 44(2):395–401.

Cummins, Tom

1998 Let Me See! Reading Is for Them: Colonial Andean Images and Objects "como es costumbre tener los caciques senores." In *Native Traditions in the Postconquest World*, edited by Elizabeth Hill Boone and Tom Cummins, pp. 91–148. Dumbarton Oaks Research Library and Collection, Washington, D.C.

2007 Queros, Aquillas, Uncus, and Chulpas: The Composition of Inka Artistic Expression and Power. In *Variations in the Expression of Inka Power*, edited by Richard L. Burger, Craig Morris, and Ramiro Matos Mendieta, pp. 267–311. Dumbarton Oaks Research Library and Collection, Washington, D.C.

D'Altroy, Terence N.

1992 *Provincial Power in the Inka Empire*. Smithsonian Institution Press, Washington, D.C.

2002 *The Incas*. Blackwell, Malden, Mass.

D'Altroy, Terence N., Ana Maria Lorandi, and
Veronica Williams

1998 Ceramic Production and Use in the
Inka Political Economy. In *Andean
Ceramics: Technology, Organization, and
Approaches*, edited by Izumi Shimada,
pp. 283–312. MASCA Research Papers
in Science and Archaeology. Museum
Applied Science Center for Archaeology,
University of Pennsylvania Museum
of Archaeology and Anthropology,
Philadephia.

de la Cadena, Marisol

2005 Are Mestizos Hybrids? The Conceptual
Politics of Andean Identities. *Journal of
Latin American Studies* 37(2):259–284.

Dean, Carolyn

1999 *Inka Bodies and the Body of Christ:
Corpus Christi in Colonial Cuzco, Peru.*
Duke University Press, Durham, N.C.

Degoy, Laura

2008 Technical Traditions and Cultural
Identity: An Ethnoarchaeological
Study of Andhra Pradesh Potters. In
*Cultural Transmission and Material
Culture: Breaking Down Boundaries*,
edited by Miriam T. Stark, Brenda J.
Bowser, Lee Horne, and Carol Kramer,
pp. 199–222. University of Arizona
Press, Tucson.

Dommelen, Peter van

1997 Colonial Constructs: Colonialism and
Archaeology in the Mediterranean.
World Archaeology 28(3):305–323.

Donnan, Christopher B.

1965 Moche Ceramic Technology. *Ñawpa
Pacha* 3:115–134.

1997a Deer Hunting and Combat: Parallel
Activities in the Moche World. In
The Spirit of Ancient Peru, edited by
Kathleen Berrin, pp. 51–59. Thames and
Hudson. London.

1997b A Chimu-Inka Ceramic-Manufacturing
Center from the North Coast of Peru.
Latin American Antiquity 8(1):30–54.

2001 Moche Ceramic Portraits. In *Moche Art
and Archaeology in Ancient Peru*, edited
by Joanne Pillsbury, pp. 126–139. National
Gallery of Art, Washington, D.C.

2011 *Chotuna and Chornancap: Excavating
an Ancient Peruvian Legend.* Cotsen
Institute of Archaeology Press,
Los Angeles.

2012 Dressing the Body in Splendor:
Expression of Value by the Moche of
Ancient Peru. In *The Construction
of Value in the Ancient World*, edited
by John K. Papadopoulos and Gary
Urton, pp. 186–196. Cotsen Institute
of Archaeology Press, Los Angeles.

Douglas, Mary

1996 *Natural Symbols: Explorations in
Cosmology.* Routledge, London.

Ferguson, Leland

1992 *Uncommon Ground: Archaeology
and Early African America, 1650–
1800.* Smithsonian Institution Press,
Washington, D.C.

García Canclini, Néstor

2000 The State of War and the State of
Hybridization. In *Without Guarantees:
In Honour of Stuart Hall*, edited by Paul
Gilroy, Lawrence Grossberg, and Angela
McRobbie, pp. 38–52. Verso, London.

2005 *Hybrid Cultures: Strategies for Entering
and Leaving Modernity.* University of
Minnesota Press, Minneapolis.

Geertz, Clifford

1974 Art as a Cultural System. *MLN (Modern
Language Notes)* 91(6):1473–1499.

1982 *The Interpretation of Cultures.* Basic
Books, New York.

Gilchrist, Roberta

2005 Introduction: Scales and Voices in
World Historical Archaeology. *World
Archaeology* 37(3):329–336.

Gosselain, Oliver

2000 Materializing Identities: An African
Perspective. *Journal of Archaeological
Method and Theory* 7(3):187–217.

Hale, Charles R.

1996a Introduction. *Journal of Latin American
Anthropology* 2(1):2–3.

1996b Mestizaje, Hybridity, and the
Cultural Politics of Difference in
Post-Revolutionary Central America.
Journal of Latin American Anthropology
2(1):34–61.

1999 Travel Warning: Elite Appropriations of Hybridity, Mestizaje, Antiracism, Equality, and Other Progressive-Sounding Discourses in Highland Guatemala. *Journal of American Folklore* 112:297–315.

Hayashida, Frances

1995 State Pottery Production in the Inka Provinces. PhD dissertation, University of Michigan, Ann Arbor.

1998 New Insights into Inka Pottery Production. In *Andean Ceramics: Technology, Organization, and Approaches*, edited by Izumi Shimada, pp. 313–338. MASCA Research Papers in Science and Archaeology. Museum Applied Science Center for Archaeology, University of Pennsylvania Museum of Archaeology and Anthropology, Philadelphia.

1999 Style, Technology, and State Production: Inka Pottery Manufacture in the Leche Valley, Peru. *Latin American Antiquity* 10(4):337–352.

2003 Leyendo el registro arqueologico del dominio inka: Reflexiones desde la costa norte del Peru. *Boletin de Arqueologia de PUCP* 7:305–321.

Helms, Mary W.

1981 Precious Metals and Politics-Style and Ideology in the Intermediate Area and Peru. *Journal of Latin American Lore* 7(2):215–237.

Heyerdahl, Thor, Daniel H. Sandweiss, and Alfredo Narvaez (editors)

1995 *Pyramids of Túcume: The Quest for Peru's Forgotten City.* Thames and Hudson, New York.

Hodder, Ian

1982 *Symbols in Action: Ethnoarchaeological Studies of Material Culture.* New Studies in Archaeology. Cambridge University Press, Cambridge.

Houston, Stephen

2014 *The Life Within: Classic Maya and the Matter of Permanence.* Yale University Press, New Haven, Conn.

Hutnyk, John

2005 Hybridity. *Ethnic and Racial Studies* 28(1):79–102.

Hyslop, John

1993 Factors Influencing the Transmission and Distribution of Inka Cultural Materials Throughout Tawantinsuyu. In *Latin American Horizons*, edited by Don Stephen Rice, pp. 337–356. Dumbarton Oaks Research Library and Collection, Washington, D.C.

Inomata, Takeshi

2001 The Power and Ideology of Artistic Creation. *Current Anthropology* 42(3):321–349.

Janusek, John W.

2002 Out of Many, One: Style and Social Boundaries in Tiwanaku. *Latin American Antiquity* 13(1):35–61.

2005 Of Pots and People: Ceramic Style and Social Identity in the Tiwanaku State. In *Us and Them: Archaeology and Ethnicity in the Andes*, edited by Richard Martin Reycraft, pp. 34–53. Monograph 53. Cotsen Institute of Archaeology Press, Los Angeles.

Jones, Sian

1997 *The Archaeology of Ethnicity.* Routledge, London.

Joseph, May, and Jennifer Fink (editors)

1999 *Performing Hybridity.* University of Minnesota Press, Minneapolis.

Kapchan, Deborah A., and Pauline Turner Strong

1999 Theorizing the Hybrid. *Journal of American Folklore* 112:239–253.

Lau, George

2010 The Work of Surfaces: Object Worlds and Techniques of Enhancement in the Ancient Andes. *Journal of Material Culture* 15(3):259–286.

Lechtman, Heather

1977 Style in Technology, Some Early Thoughts. In *Material Culture: Styles, Organization, and Dynamics of Technology*, edited by Heather Lechtman and Robert S. Merrill, pp. 3–20. West Publishing, St. Paul, Minn.

1984 Andean Value Systems and the Development of Prehistoric Metallurgy. *Technology and Culture* 25(1):1–36.

1993 Technologies of Power: The Andean Case. In *Configurations of Power: Holistic Anthropology in Theory and Practice*, edited by John S. Henderson and Patricia J. Netherly, pp. 244–280. Cornell University Press, Ithaca, N.Y.

Lemonnier, Pierre (editor)

1993 *Technological Choices: Transformation in Material Cultures Since the Neolithic.* Routledge, London.

Liebmann, Matthew

2013 Parsing Hybridity: Archaeologies of Amalgamation in Seventeenth-Century New Mexico. In *The Archaeology of Hybrid Material Culture*, edited by Jeb J. Card, pp. 25–49. Southern Illinois University Press, Carbondale.

Lohse, Jon C.

2013 Alienating Ancient Maya Commoners. In *The Inalienable in the Archaeology of Mesoamerica*, edited by Brigitte Kovacevich and Michael G. Callaghan, pp. 81–94. American Anthropological Association, Arlington, Va.

Looper, Matthew G.

2006 Fabric Structures in Classic Maya Art and Ritual. In *Sacred Bundles: Ritual Acts of Wrapping and Binding in Meso-america*, edited by Julia Guernsey and Kent F. Reilly, pp. 80–104. Boundary End Archaeology Research Center, Barnardsville, N.C.

Mackey, Carol

2003 La transformación socioeconómica de Farfán bajo el gobierno inka. *Boletín de Arqueología PUCP* 7:321–353.

2006 Elite Residences at Farfan: A Comparison of the Chimu and Inka Occupations. In *Palaces and Power in the Americas: From Peru to the Northwest Coast*, edited by Jessica Joyce Christie and Patricia J. Sarro, pp. 313–352. University of Texas Press, Austin.

2009 Los estilos alfareros costenos de lo periodos tardios. In *De Cupisnique a los Incas: El arte del valle de Jequetepeque*, edited by Luis Jaime Castillo and C. Pardo, pp. 268–277. Museo de Arte de Lima, Lima.

2010 The Socioeconomic and Ideological Transformation of Farfan under Inka Rule. In *Distant Provinces in the Inka Empire: Toward a Deeper Understanding of Inka Imperialism*, edited by Michael A. Malpass and Sonia Aconini, pp. 221–259. University of Iowa Press, Iowa City.

2011 The Persistence of Lambayeque Ethnic Identity: The Perspective from the Jequetepeque Valley. In *From State to Empire in the Prehistoric Jequetepeque Valley, Peru*, edited by Colleen M. Zori and Ilana Johnson, pp. 149–168. BAR International Series 2310. Archaeopress, Oxford.

Mackey, Carol, and Ulana Klymyshyn

1980–1983 Chimu and Chimu-Inca Textiles from Manchan. *Research Reports: National Geographic Society* 21:273–278.

1990 The Southern Frontier of the Chimu Empire. In *The Northern Dynasties: Kingship and Statecraft in Chimor*, edited by Michael E. Moseley and Alana Cordy-Collins, pp. 195–226. Dumbarton Oaks Research Library and Collection, Washington, D.C.

Martinez, Cruz

1986 *Cerámica prehispánica norperuana: Estudio de la cerámica chimú de la Colección del Museo de América de Madrid.* BAR International Series 323(ii). British Archaeological Reports, Oxford.

Matos Mendieta, Ramiro

2004 Inca Ceramics. In *The Incas: Art and Symbols*, edited by Franklin G. Y. Pease et al., pp. 108–165. Banco de Credito del Peru, Lima.

Menzel, Dorothy

1976 *Pottery Style and Society in Ancient Peru: Art as a Mirror of History in the Ica Valley, 1350–1570.* University of California Press, Berkeley.

1977 *Peruvian Archaeology and the Work of Max Uhle.* R. H. Lowie Museum of Anthropology, Berkeley, Calif.

Miller, George R.

2004 An Investigation of Cuzco-Inca Ceramics: Canons of Form, Proportion, and Size. *Ñawpa Pacha* 25–27:127–150.

Moore, Jerry D.

2004 The Social Basis of Sacred Spaces in the Prehispanic Andes: Ritual Landscapes of the Dead in Chimú and Inka societies. *Journal of Archaeological Method and Theory* 11(1):83–124.

Morris, Craig

1991 Signs of Division, Symbols of Unity: Art in the Inka Empire. In *Circa 1492: Art in the Age of Exploration*, edited by Jay A. Levenson, pp. 521–528. National Gallery of Art, Washington, D.C.

1995 Symbols to Power: Styles and Media in the Inka State. In *Style, Society, and Person*, edited by Christopher Carr and Jill E. Neitzel, pp. 419–433. Plenum Press, New York.

2004 Enclosures of Power: The Multiple Spaces of Inca Administrative Palaces. In *Palaces of the Ancient New World*, edited by Susan T. Evans and Joanne Pillsbury, pp. 299–324. Dumbarton Oaks Research Library and Collection, Washington, D.C.

Morris, Craig, and Donald E. Thompson

1985 *Huánuco Pampa: An Inca City and Its Hinterland*. Thames and Hudson, New York.

Nanoglou, Stratos

2009 The Materiality of Representation: A Preface. *Journal of Archaeological Method and Theory* 16:157–161.

Palmié, Stephan

2013 Mixed Blessings and Sorrowful Mysteries: Second Thoughts about "Hybridity." *Current Anthropology* 54(4):463–482.

Pärssinen, Martti, and Ari Siiriäinen

1997 Inka-Style Ceramics and Their Chronological Relationship to the Inka Expansion in the Southern Lake Titicaca Area (Bolivia). *Latin American Antiquity* 8(3):255–271.

Pease G. Y., Franklin, et al. (editors)

2004 *The Incas: Art and Symbols*. Banco de Credito del Peru, Lima.

Pilcher, Jeffrey

1998 *Que vivan los tamales!: Food and the Making of Mexican Identity*. University of New Mexico Press, Albuquerque.

Rahier, Jean Muteba

2003 Mestizaje, Mulataje, Mestigagem in Latin American Ideologies of National Identities. *Journal of Latin American Anthropology* 8(1):40–51.

Rodman, Amy O., and G. A. Fernández López

2005 North Coast Style after Moche: Clothing and Identity at El Brujo, Chicama Valley, Perú. In *Us and Them: Archaeology and Ethnicity in the Andes*, edited by Richard Martin Reycraft, pp. 115–133. Cotsen Institute of Archaeology Press, Los Angeles.

Rowe, Ann Pollard

1984 *Costumes and Featherwork of the Lords of Chimor: Textiles from Peru's North Coast*. Textile Museum, Washington, D.C.

Rowe, John

1946 Inca Culture at the Time of the Spanish Conquest. In *Handbook of South American Indians*, edited by Julian Haynes Steward, pp. 183–330. Bulletin 143, Vol. 2. Bureau of American Ethnology, Washington, D.C.

Sawyer, Alan R.

1954 *The Nathan Cummings Collection of Ancient Peruvian Art*. Art Institute of Chicago, Chicago.

Schortman, Edward M., Patricia A. Urban, and Marne Ausec

2001 Politics with Style: Identity Formation in Prehispanic Southeastern Mesoamerica. *American Anthropologist* 103(2):312–330.

Shimada, Izumi

1990 Cultural Continuities and Discontinuities on the Northern North Coast of Peru, Middle to Late Horizons. In *The Northern Dynasties: Kingship and Statecraft in Chimor*, edited by Michael E. Moseley and Alana Cordy-Collins, pp. 297–392. Dumbarton Oaks Research Library and Collection, Washington, D.C.

2000 The Late Prehispanic Coastal States. In *The Inca World: The Development of Pre-Columbian Peru, A.D. 1000–1534*, edited by Laura Laurencich Minelli, pp. 49–110. University of Oklahoma Press, Norman.

2009 Who Were the Sican? Their Development, Characteristics, and Legacies. In *The Golden Capital of Sican*, edited by I. Shimada, K.-i. Shinoda, and M. Ono, pp. 25–61. Tokyo Broadcasting System, Tokyo.

Sidoroff, Maria-Louise

2005 The Process behind Form and Decoration: Defining North Coast Ceramic Technological Style, Peru. PhD dissertation, Union Institute and University, Cincinnati.

Silliman, Stephen W.

2005 Culture Contact or Colonialism? Challenges in the Archaeology of Native North America. *American Antiquity* 70(1):55–74.

Silverblatt, Irene

1987 *Moon, Sun, and Witches: Gender Ideologies and Class in Inca and Colonial Peru*. Princeton University Press, Princeton, N.J.

Spurling, Geoffrey

1992 The Organization of Craft Production in the Inka State: The Potters and Weavers of Milliraya. PhD dissertation, Cornell University, Ithaca, N.Y.

Stark, Miriam T. (editor)

1998 *The Archaeology of Social Boundaries*. Smithsonian Institution Press, Washington, D.C.

Stark, Miriam T., Ronald L. Bishop, and Elizabeth Miksa

2000 Ceramic Technology and Social Boundaries: Cultural Practices in Kalinga Clay Selection and Use. *Journal of Archaeological Method and Theory* 7(4):295–331.

Stone-Miller, Rebecca

1992 *To Weave for the Sun: Andean Textiles in the Museum of Fine Arts, Boston*. Museum of Fine Arts, Boston.

Tate, James Patrick

2007 The Late Horizon Occupation of the El Brujo Site Complex, Chicama Valley, Peru. PhD dissertation, Department of Anthropology, University of California, Santa Barbara.

Tiballi, Anne

2014 Weaving the Body Politic: The Integration of Technological Practice and Embodied Social Identity in the Late Prehispanic Andes. In *Textiles, Technical Practice, and Power in the Andes*, edited by Denise Y. Arnold and Penny Dransart, pp. 140–158. Archetype Publications, London.

Topic, John

1990 Craft Production in the Kingdom of Chimor. In *The Northern Dynasties: Kingship and Statecraft in Chimor*, edited by Michael E. Moseley and Alana Cordy-Collins, pp. 145–176. Dumbarton Oaks Research Library and Collection, Washington, D.C.

Topic, John, and Theresa Topic

1993 A Summary of the Inca Occupation of Huamachuco. In *Provincial Inka: Archaeological and Ethnohistorical Assessment of the Impact of the Inca State*, edited by Michael A. Malpass, pp. 17–43. University of Iowa Press, Iowa City.

Vogel, Melissa

2011 Style and Interregional Interaction: Ceramics from the Casma Capital of El Purgatorio. *Ñawpa Pacha* 31(2):201–224.

Von Hagen, Victor Wolfgang

1965 *The Desert Kingdoms of Peru*. New York Graphic Society Publishers, Greenwich, Conn.

Webster, Jane

2001 Creolizing the Roman Provinces. *American Journal of Archaeology* 105(2):209–225.

Wernke, Steven A.

2006 The Politics of Community and Inka Statecraft in the Colca Valley, Peru. *Latin American Antiquity* 17(2):177–208.

Wiersema, Juliet B.

2015 *Architectural Vessels of the Moche: Ceramic Diagrams of Sacred Space in Ancient Peru*. University of Texas Press, Austin.

Wiessner, Polly

1984 Reconsidering the Behavioral Basis
 for Style: A Case Study among the
 Kalahari San. *Journal of Anthropological
 Archaeology* 3(3):190–234.

Willey, Gordon R.

1953 *Changing Settlement Patterns in the Viru
 Valley, Peru.* Smithsonian Institution
 Press, Washington, D.C.

Ybarra Frausto, Tomas

1966 The Chicano Movement/The Movement
 of Chicano Art. In *Beyond the
 Fantastic: Contemporary Art Criticism
 from Latin America*, edited by Gerardo
 Mosquera, pp 165–182. The MIT Press,
 Cambridge, Mass.

Zuidema, R. Tom

1982 Bureacracy and the Systematic Knowl-
 edge in Andean Civilization. In *The

*Inca and Aztec States, 1400–1800:
Anthropology and History*, edited by
George Allen Collier, Renato Rosaldo,
and John D. Wirth, pp. 419–458.
Academic Press, New York.

1990 Dynastic Structures in the Andean
 Cultures. In *The Northern Dynasties:
 Kingship and Statecraft in Chimor*,
 edited by Michael E. Moseley and
 Alana Cordy-Collins, pp. 489–506.
 Dumbarton Oaks Research Library and
 Collection, Washington, D.C.

1991 Guaman Poma and the Art of Empire:
 Toward an Iconography of Inca Royal
 Dress. In *Transatlantic Encounters:
 Europeans and Andeans in the Sixteenth
 Century*, edited by Kenneth J. Andrien
 and Rolena Adorno, pp. 151–202.
 University of California Press, Berkeley.

12

Shaping Local and Regional Identities

Techné in the Moche Presence at Cerro Castillo, Nepeña Valley, Peru

CARLOS RENGIFO

Moche craft production has tradi-tionally been approached from the basis of core-periphery models, which consider Moche material culture to be the expression of a mono-lithic political unit (Larco 2001; Shimada 1994; Willey 1953; Wilson 1988). Current studies, however, suggest a case of valley-based political entities with varying degrees of cohesion and fragmentation (Castillo and Uceda 2008; Pillsbury 2001; Quilter and Castillo 2010). Recent investigations at the Pre-Columbian settlement of Cerro Castillo, in the Nepeña Valley, problematize these views, question-ing the passive secondary role usually attributed to these communities in their own development and in regional affairs. This chapter discusses how crafts-manship has been approached in Moche studies, particularly from archaeological identification of artisans' workshops and burials in large-scale set-tlements. Then, it presents Cerro Castillo as a case study of Moche sociopolitical organization dur-ing the years circa 600 to 850 CE. The essay exam-ines the site's most important occupation and its relationship with the Moche culture, and uses craft production–related evidence to explore the way in which the meaning and value of Moche material culture affected Cerro Castillo's life and identity.

The Nature of Moche Culture and Sociopolitical Organization

The Moche culture developed along the North Coast of Peru from circa 100 to 850 CE (Figure 12.1). Its generally high levels of socioeconomic complex-ity are manifested in the archaeological remains of urban centers, monumental temples, irrigation sys-tems, funerary practices, and finely made artifacts; however, our understanding of the specific nature of Moche sociopolitical organization has changed over time (Castillo and Uceda 2008; Quilter and Castillo 2010; Uceda and Mujica 1994, 2003).

One of the earliest Moche scholars, Rafael Larco Hoyle (1948, 2001), argued that the Moche constituted a single theocratic, expansionist state.

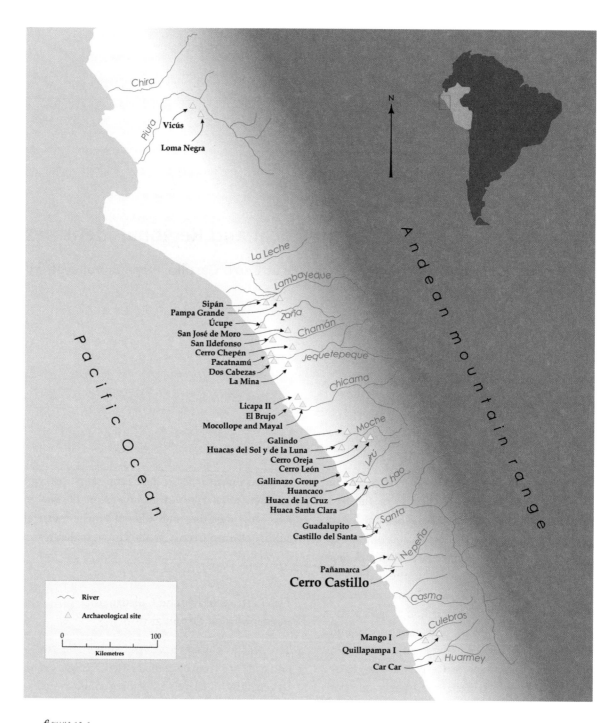

figure 12.1

Map of the North Coast of Peru, indicating the locations of the main Moche sites and Cerro Castillo. (Courtesy of the Cerro Castillo Archaeological Project Image Archive.)

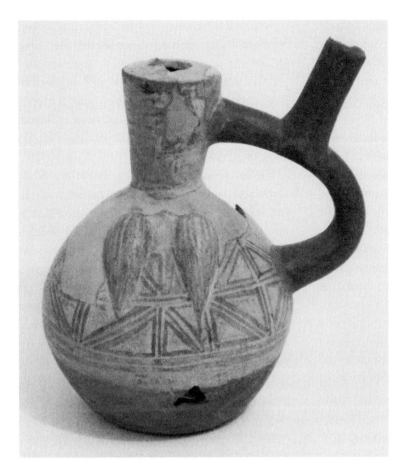

figure 12.2
Stirrup-spout bottle with a false neck found in Cerro Castillo's Cemetery 1, associated with the Moche IV phase of Larco's sequence. (Courtesy of the Cerro Castillo Archaeological Project Image Archive.)

For Larco, the Moche territory stretched from the Chicama Valley to the Nepeña Valley. One of Larco's most important contributions to Moche studies was the chronology he developed. Based on pottery analyses and stratigraphic observations from his excavations, Larco subdivided Moche history into five phases (I to V; Figure 12.2 shows an example of a Moche phase IV stirrup-spout bottle). Subsequent archaeological work on the North Coast—as exemplified by the Viru Valley Project (Willey 1953), the Chan Chan–Moche Valley Project (Moseley and Day 1982), and the Pampa Grande Project (Shimada 1994)—as well as systematic archaeological surveys in the Santa (Wilson 1988) and Nepeña (Proulx 1968, 1973, 1985) Valleys appeared to corroborate Larco's reconstruction of Moche history, in part, by tracing the appearance of Moche ceramics at different points in the chronological sequence. Most of these projects attributed Moche expansion to military conquest.

Of particular importance for our present study was Donald Proulx's (1968, 1973, 1985) comprehensive survey in the Nepeña Valley, which documented two hundred and twenty sites, thirty-seven of them associated with Moche pottery. One of those sites was the temple of Pañamarca (see Trever, this volume), interpreted as the Moche provincial capital of the valley. As did many contemporary scholars, Proulx (1985) interpreted the abrupt appearance of Moche pottery depicting warriors and battle scenes, as well as the presence of monumental architecture, as evidence of the conquest of these territories by a political entity coming from the Moche Valley.

Shimada's work at Pampa Grande, a large settlement in the Lambayeque Valley, expanded Moche studies to include the valleys north of the Paiján Desert. The site proved to be a short-lived Moche enterprise, whose establishment and abandonment would have occurred between 600 and

750 CE. Unlike its predecessors, the Pampa Grande Project suggested that the end of the Moche was not a consequence of one factor but of several: environmental alterations, political and social instability, and external influence from the Wari state (Shimada 1994).

The idea of a single expansionist Moche state was significantly challenged in 1987, with the discovery of Moche royal tombs at the site of Huaca Rajada, Sipán (300–600 CE), in the Lambayeque Valley (Alva and Donnan 1993), and the tombs of the Priestesses at San José de Moro (600–850 CE; Donnan and Castillo 1992). These finds—along with later investigations of opulent graves at Loma Negra (Makowski 1994), Úcupe (Atwood 2010), Dos Cabezas (Donnan 2008), and El Brujo (Mujica et al. 2007)—further led scholars to question the centralized character of the Moche state, as royal tombs were found away from the core area of Chicama and Moche.

Investigations at San José de Moro also introduced a refined Moche ceramic chronology applicable to the Piura, Lambayeque, and Jequetepeque Valleys, where Larco's five-phase sequence did not apply effectively. The new sequence—Early Moche, Middle Moche, Late Moche—was developed on the basis of the pottery collections reported from several key sites (Castillo and Donnan 1994).

During the early 1990s, the discovery of Moche royal tombs, temples, and urban centers led Moche studies into a reformulation stage (Uceda and Mujica 1994, 2003). These new data called into question many long-standing assumptions about Moche statehood, particularly its territorial and political organization (Quilter and Castillo 2010). Territorially, the spread of Moche material culture turned out not to be restricted to the valleys south of the Paiján Desert (from Chicama to Nepeña); it also included the northern valleys of Jequetepeque, Lambayeque, and Piura (Alva and Donnan 1993; Castillo and Donnan 1994; Makowski 1994), as well as Culebras and Huarmey southward (Makowski 2010). Castillo and Donnan (1994) stressed the dissimilarities between the ceramics reported from the valleys north of the Paiján Desert and those recorded at the core area of Chicama–Moche and southward. These authors suggested that the Paiján Desert was a natural boundary that separated two political regions: Northern Moche (composed of independent valley-based polities) and Southern Moche (an expansive state with its capital at Huacas de Moche; see Castillo and Donnan 1994; Castillo and Uceda 2008).

Even more recent studies have further problematized the view of a Moche expansive state in the Southern Moche region. In the Virú Valley, for instance, excavations at Huancaco led Bourget (2003) to deduce that, contrary to what had been assumed, the site was not a Moche capital; rather, he concluded that Huancaco was a multifunctional palace associated with the Gallinazo polity from about 400 to 700 CE, and stressed that no evidence exists for a dependency link with the ruling elites of the Moche Valley (Bourget 2003).

For the Santa Valley, Chapdelaine (2010) proposed a gradual sociopolitical process that entailed intrusion, migration, and colonization of the lower Santa Valley by lords from the Moche Valley beginning around 300 and lasting to at least 700 CE (Chapdelaine 2010). Addressing the relationship between Moche and local populations, he suggests that Moche groups would have started settling in sectors that had not been intensively occupied by the locals, which turned into a colonization of and eventual control over the Santa Valley by the leaders of the Moche Valley (Chapdelaine 2010).

This reexamination of the Moche territory and its sociopolitical organization led scholars to revise the nature of the Moche phenomenon itself. Rather than understanding Moche material culture as an expression of a sociopolitical entity, Bawden (1996) has argued that it corresponds with the physical manifestation of a religious system, essentially an elite ideology (see also Richards and Van Buren 2000). In this regard, Donnan (2010) considers that Moche ritual practices, in particular the Sacrifice Ceremony, constituted the pivotal unifying force of a state religion. This view further suggests that "the Moche" were politically independent but ideologically bounded valley-based

social units (Bawden 1996). Although these units may have maintained varying levels of political independence, it was the shared regional ritual practices that held them together in a common culture, across a vast territory, and during nearly eight centuries (Donnan 2010).

This chapter subscribes to the idea that what archaeologists have identified as Moche in the archaeological records corresponds to the physical manifestations of an institutionalized belief system. This system would involve religious, ideological, political, and philosophical dimensions—effectively, a cultural phenomenon as characterized by Geertz (1966; see also Costin, this volume, ch. 11). These aspects, in turn, would conform to a certain lifestyle and to predictable behaviors that, if present, can be traced archaeologically. This cultural phenomenon also would have been based on the visual representations of key events in the lives of a number of prominent characters (i.e., rulers or deities), who were repeatedly depicted in artworks and a variety of media (Donnan 2010). Adherents of Moche produced, promoted, and consumed such material culture—imbued with meaning and value—which also suggests that they conducted their social practices within the behavioral lines of this belief system.

In the remainder of this chapter, I consider these premises to characterize the Moche presence at Cerro Castillo, by looking at archaeological evidence of production, circulation, and consumption of Moche material culture at Cerro Castillo.

Studies of Moche Art: Assessing Moche Techné

Parallel to archaeological investigations, studies of Moche art and media have received significant academic attention (Bourget and Jones 2008; Donnan 1978; Donnan and McClelland 1999; Jackson 2009). Scholars have approached Moche art by integrating art history notions, historical sources, and archaeological contexts. Most of these studies agree on the premise that Moche imagery was a symbolic system of communication shared over a long time span throughout a vast territory. What it communicated, however, remains unclear.

Approaches to Moche art have presumed the existence of a code or canon that can be deciphered if studied systematically. In this regard, one of the most important works is Donnan's thematic approach to Moche art. He posited that, despite giving the impression that Moche painters depicted a wide variety of subject matters, they actually represented a limited number of basic themes and characters. The whole of Moche art, therefore, can be organized according to a finite number of themes, which can simultaneously be part of a larger subject matter (Donnan 1978). Additionally, this approach suggested that artists were circumscribed to a specific set of canons, implying a limited freedom for artistic creation—that is, images were not independent nor were they created out of the artist's will.

Several researchers have drawn upon Donnan's work. Recent studies have gone into a stage of narrative approaches, which implies the existence of a storyline that can be reconstructed through imagery analyses (Quilter 1997). Accordingly, themes share common iconographic features that endow them not only with meaning but also with a sense of chronological succession.

Based on the premises above, it can be said that Moche imagery is one of the most significant features that characterize the North Coast societies from 100 to 850 CE. Hence, for the purpose of this chapter, Moche artworks and imagery are seen as the physical manifestations of Moche techné—a form of knowledge that entailed "crafting with skill and intent to produce something with social utility" (see Costin, this volume, Introduction).

This chapter argues that Moche techné played a pivotal role in the shaping of the sociopolitical trajectories and cultural identities of these communities. It crucially contributed to the materialization and spread of a set of ideas (DeMarrais et al. 1996) that ultimately affected the social practices of these groups; however, as the following sections will show, the sociopolitical contexts and mechanisms through which the Moche techné developed and spread may have varied over time and space.

Approaches to Moche Crafting

It has been pointed out that the crafting and distribution of finely made objects are fundamental to the strategies of power relationships and essential in assessing the social differentiation that is typical of complex societies (Brumfiel and Earle 1987; Clark 1995; Costin 2005; Shimada 2007). In Moche studies, craftspeople have been considered to have been "attached" (Costin 2004) to the ruling spheres—that is, such artisans were a group commissioned by the elites to create, on their behalf, the material symbols that legitimized their positions of power (also see Russell and Jackson 2001; Shimada 1994). Morales (2003) posits that architects and mural painters made the architectural-iconographic works of temples as part of an activity scheduled by the ruling elite.

More recently, and alternatively, Moche artisans have been thought to operate as "embedded specialists" (Uceda and Rengifo 2006)—that is, they played an integral role in the household, where their work was not defined in terms of class or economy but in terms of kinship (Ames 1995). This view implies that the notion of group affiliation prevailed over other aspects of status (Uceda and Rengifo 2006). At Huacas de Moche, for instance, the idea of Moche embedded specialists finds support in two tombs associated with two consecutive occupations of a pottery workshop (Uceda and Armas 1998), which suggests that these artisans were different generations of the same or extended family.

Most scholars argue that Moche artisans led the manufacturing processes of objects imbued with meaning and value (e.g., Jackson 2009; Shimada 2001; Uceda and Armas 1998). Moche archaeological data and artifact collections feature a variety of objects and manufacturing qualities, which would correspond with a wide range of producers in terms of skills and social dependencies. Evidence from Moche settlements suggests that ceramists, metallurgists, and lapidaries were frequently involved in trade networks with the highest segments of societies (Russell and Jackson 2001; Shimada 2001; Uceda and Rengifo 2006). Generally, finely made objects are found in elite contexts (e.g., temples, royal tombs), whereas middle-range–quality artifacts tend to have a wider distribution in the archaeological record (e.g., residences, rubbish deposits). Bearing the above discussion in mind, the following paragraphs review two of the ways in which craft specialization has been approached in Moche studies: the study of workshops and the burials of artisans.

Moche Workshops

The archaeological identification of workshops has been essential in studies that address crafting in Moche material culture. Investigations at Huacas de Moche have documented the urban aspects of the site, including the presence of workshops for manufacturing ceramics, metals, textiles, and stone (Bernier 2005; Millaire 2008; Uceda and Armas 1998; Uceda and Rengifo 2006). Workshops have also been identified at other Moche sites, such as Cerro Mayal (Russell and Jackson 2001) and Pampa Grande (Shimada 2001), the latter including areas for the production of *Spondylus*, cotton, metal, and pottery artifacts.

Workshops shed light on the social and political contexts of specialized production. They offer the opportunity to study the remains of craft activity, which are mostly found in association with urban contexts (Manzanilla 1986; Shimada 1994). Their locations, features, and distribution within a given settlement might have been a result of a planned urban design that conceived specific spaces to be constantly used for productive activities (Uceda and Armas 1998). Alternatively, they could have resulted from the sudden necessity and increasing demand of sumptuary goods from the urban populations (Shimada 2001). The analyses of tools, raw materials, production debris, and flawed artifacts, usually found inside workshops, provide valuable information about production technologies and the *chaîne opératoire* (Costin 2005; Shimada 1994; Uceda and Armas 1998).

Moche workshops have often been found attached to residential areas; therefore, it can be inferred that specialists lived together as part of family groups within a given community (Uceda

and Rengifo 2006). Archaeological evidence suggests that specialists' activities were intimately connected to the daily practices of the urban centers. At Huacas de Moche, for instance, architectural blocks functioned as urban spaces associated with different corporate groups (Uceda 2010). Each group was headed by a member of the Moche elite, who controlled the economic activities performed within that block. Crafted products would have circulated through networks established by the corporate groups inside—and probably also outside—the urban center.

In addition, scholars suggest that high-ranked individuals were directly involved in production activities. At Huacas de Moche, ceramic, metal, textile, and lapidary workshops were documented as part of large elite residences, which enjoyed a preferential location near the religious temple of Huaca de la Luna, the main roads of the city, public plazas, and other centers of production (Uceda and Armas 1998; Uceda and Rengifo 2006).

Cases such as Pampa Grande also suggest a scenario in which workshops were located next to elite residential structures in places with restricted access (Shimada 1994, 2001)—often a sign of controlled production (Costin 2004). Indeed, Shimada (2001) argues that Pampa Grande elite administrators supervised craft production. He also posits that a few master specialists and several assistants or apprentices would have carried out crafting activities (Shimada 2001:189). Similar to those in Huacas de Moche, workshops in Pampa Grande were part of a complex urban network where residences, administrative centers, and temples functioned at the same time.

At Cerro Mayal in the Chicama Valley, one of the largest workshops of Moche pottery archaeologically studied, scholars suggest that the production and distribution of ceramics was based on a patronage relationship between Cerro Mayal's leaders and the elites of the nearby community of Mocollope. The latter would have acquired a significant share of the artisans' production to subsequently redistribute it following reciprocal obligations in the context of ritual displays (Russell and Jackson 2001).

Burials of Artisans

The study of burials of artisans represents another approach to Moche craft specialization (Castillo and Rengifo 2008). Scholars have argued that, in the past, symbolic objects were essential in materializing the distinctive powers and activities of high-status individuals, such as leaders, priests, warriors, and elites in general (Alva and Donnan 1993; DeMarrais et al. 1996; Donnan and Castillo 1992). Accordingly, most of the objects placed in elite funerary contexts have been interpreted as the physical reflection of the status of the buried individual and his or her defining social personae (Tainter 1978). In the case of burials of specialists, the interred objects seem to have been used to highlight the artisans' roles as producers as well as their close relationships with the political power structures (Castillo et al. 2008; Uceda and Armas 1998).

Specialists' tombs found at San José de Moro suggest that the artisans' role and status were celebrated in their funerary practices (Castillo et al. 2008; Rengifo and Castillo 2015). Excavations at the site revealed Middle Moche tombs of elderly individuals that contained high-quality ceramics alongside tools used in metal production (e.g., hammers, punchers, chisels, and tweezers). Burials from the post-Moche/Transitional Period (850–1000 CE) show individuals interred with a selection of tools related to weaving and carving activities (e.g., carved bone spindles, metal needles, chalk balls, etc.).

The production-related nature of these burials is even more noticeable when compared to other funerary contexts—that is, burials of non-artisans. The best-known Moche royal tombs, for instance, often feature elements related to the high-status characters of the Sacrifice Ceremony of Moche art, which suggest their relationship with those ritual identities. Royal burials also boast a significant amount of offerings—whether fine pottery, metalworks, or others—that indicate the high status and wealth of the individuals; however, these royal contexts show only a few, if any, elements that could directly relate them to crafting activities. A similar aspect can be found in non-royal tombs, where the funerary assemblage, usually composed of a

variable number of ceramics, does not include items that could directly relate to production activities.

The contexts of specialists' burials suggest an inseparable connection between the interred person and the roles he or she performed in life. It is noticeable that the funerary identity of these individuals centered upon their specialized position, a distinction that was made concrete in the presence of artifacts linked to their production roles. It could be argued that the emphasis on placing production tools in the artisans' burials was based on the idea that these individuals were supposed to continue performing their tasks in an afterlife stage. Other roles—not necessarily associated with craft production—have also been documented in the burials of Huacas de Moche. Donnan and Mackey (1978) documented burials probably associated with personages that in Moche art representations are referred to as "the runners" (Donnan and McClelland 1999).

In most cases, however, the preservation of the Huacas de Moche tombs represents a limitation in archaeologists' analyses. Objects made of perishable materials rarely survived the subsoil conditions of the site. The vast majority of grave goods consist of ceramics, which have allowed for general comparisons of quality and quantity of the funerary assemblages (Tello et al. 2003). Certainly, the status of these people was celebrated in their burials; however, assessing their specific roles has not been a straightforward matter. Archaeologists, in order to expand the scope of their interpretations, have had to consider other aspects of the funerary contexts, which may be related to the decision-making process of the burial group; one such decision is the burial location.

Two burials found in a compound associated with pottery production shed light on this matter (Uceda and Armas 1998; Uceda et al. 2003). These graves did not contain artifacts or tools that could directly relate to such activity. The high status of these individuals, though, was clearly reflected in the quality and quantity of vessels associated with their remains. Their role as artisans, however, was determined on the basis of the location of their tombs within the pottery workshop and confirmed through physical anthropological analyses.

According to these studies, the skeletal remains show evidence of "professional injuries" (Uceda et al. 2003).[1] It could be argued, therefore, that the familial and social recognition of their status in death eclipsed their role as craftspeople.

The archaeological evidence discussed above sheds light on Moche artisans' standing and their relationship with the elites. First, at least some artisans held a privileged status in life. Evidence indicates that they lived in urban centers, and their workshops were generally part of high-status residences. This inclusion suggests a close relationship between artisans and elites; whether that relationship was a one of patronage or of another kind remains open to discussion. Second, the artisans' privileged status was also celebrated in death. This is attested by the quality and quantity of the funerary offerings placed in specialists' graves. In some cases, the presence of production tools as part of the funerary assemblage stresses the inseparable link between these individuals and the production role they played in their communities.

Investigations at Cerro Castillo

Cerro Castillo is a mid-valley site located on the right margin of the Nepeña River, part of the Pañamarca Archaeological Complex. Composed of several hills, artificial mounds, and flat areas, it covers approximately 60 hectares (Figure 12.3). Topographically, Cerro Castillo presents a rough terrain and is surrounded by agricultural plots of land bordering the Nepeña River to the southeast and the Pañamarca temple to the northeast (see Trever, this volume). Since 2010, the Cerro Castillo Archaeological Project has run archaeological investigations at the site, aiming to assess its Pre-Columbian occupation (Rengifo 2014). So far, the project has opened nineteen excavation units across Cerro Castillo, unveiling evidence of a densely inhabited settlement (Figure 12.4) where residential, production, funerary, and ceremonial activities took place.

Prior to our investigations, the site had been largely overlooked in scholarly research; the only bibliographic reference about the site was Proulx's

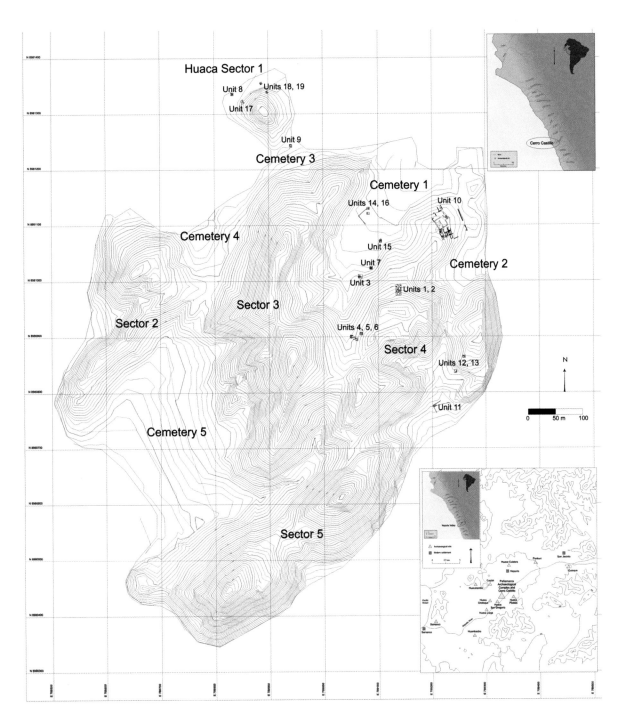

figure 12.3

Plan of Cerro Castillo, indicating the sectors of the site and the location of the excavation units. (Courtesy of the Cerro Castillo Archaeological Project Image Archive.)

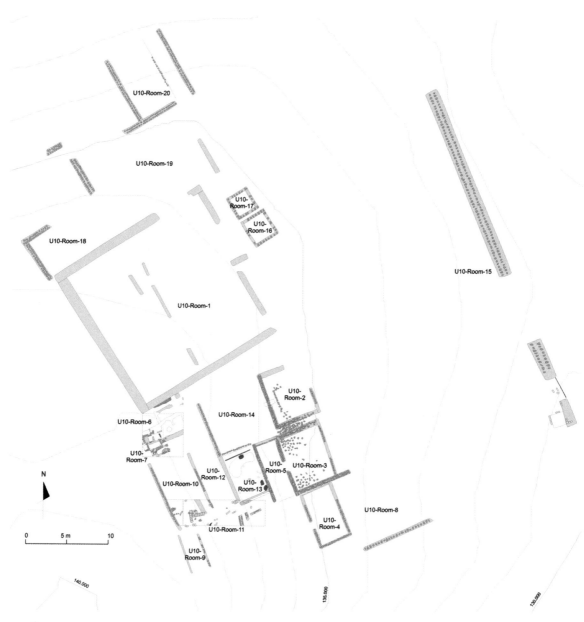

figure 12.4

Plan of Cerro Castillo's Unit 10, where excavations revealed residential and public architecture. (Courtesy of the Cerro Castillo Archaeological Project Image Archive.)

survey report (Proulx 1985). He mentions the presence of an artificial mound on the northern side of the site (PV 31-40, referred to as "Huaca Sector 1" in this chapter), graveyards in the foothills of the complex, and seemingly platformed structures (Proulx 1985). One of the main preconceptions about the site—and about the Pañamarca Archaeological Complex in general—was its frontier nature and dependency on the elites of the Moche Valley.

Indeed, the Nepeña Valley has traditionally been considered the southern boundary of a Moche state, having the southernmost milestone of its militaristic expansion in the temple of Pañamarca (Proulx 1985; Shimada 1994; Trever, this volume).

Recently collected and interpreted archaeological evidence from Cerro Castillo conflicts with the conventional core-periphery theoretical model of the relationship between Moche and the Nepeña

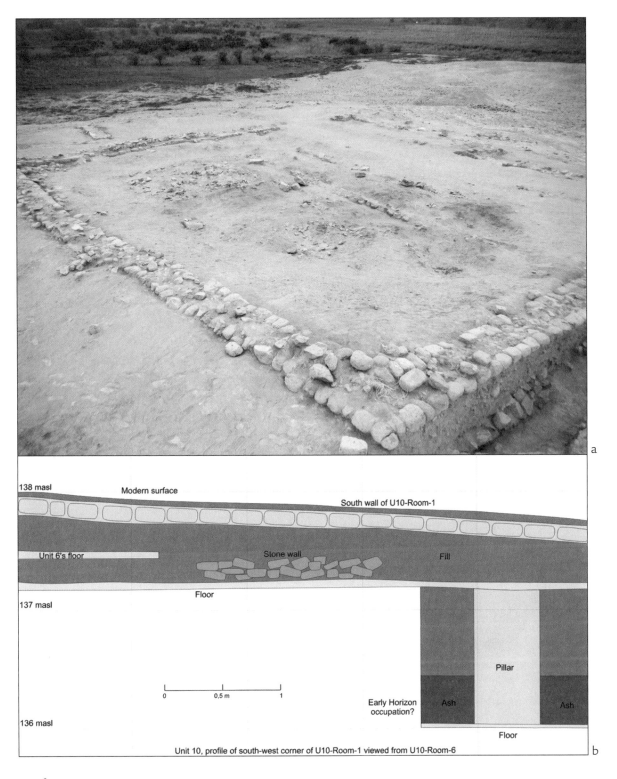

figure 12.5
a) View of the plaza U10-Room-1; and b) stratigraphy of the south wall of the plaza U10-Room-1. Note the pillar that may be associated with an Early Horizon version of this plaza. (Courtesy of the Cerro Castillo Archaeological Project Image Archive.)

Valley (Chapdelaine 2010; Proulx 1985; Shimada 1994). Our investigation at the site suggests that this was not a history of populations under Moche control, nor was it a case of population replacement. Rather, this chapter posits that, far from a scenario of a subjected periphery, the Moche presence at Cerro Castillo represented a time of major local development and creativity. At Cerro Castillo, the arrival of Moche material culture (and arguably the ideas imbued in it) boosted the site's life in a distinctive way.

Not an Unoccupied Area

Archaeological evidence indicates that prior to the appearance of Moche material culture, the Nepeña Valley had been a prosperous region inhabited by a vibrant society with a unique and lasting cultural tradition (Chicoine 2006; Ikehara and Chicoine 2011). Evidence from important sites, such as Punkurí, Huambacho, and Caylán, supports the view that the Early Horizon (ca. 900 BCE–100 CE) and the Early Intermediate Period (ca. 100–700 CE)

saw the forging of regional identities that emerged within pan-Andean trends.

At Cerro Castillo, evidence of the earliest—and, so far, least documented—occupation corresponds with a few, yet significant, architectural features and ceramic fragments. Excavations at the plaza U10-Room-1 (part of Unit 10) revealed a pillar associated with the earliest occupational layers of Unit 10 (Figure 12.5). This type of pillar has been reported at the neighboring Early Horizon site of Huambacho, where patio areas had colonnades of rectangular pillars associated with clean floors and little material remains (Chicoine 2006).

In the same vein, excavations at Unit 14 (in Cerro Castillo's Cemetery 1) and a superficial cleaning of its surroundings exposed a large orthostatic wall (Figure 12.6). Like the colonnades previously discussed, orthostatic walls have been documented at the Early Horizon site of Caylán (Ikehara and Chicoine 2011). Due to the high level of disturbance of archaeological deposits in Cemetery 1, no materials were found in reliable association with

figure 12.6
Orthostatic wall found in the Cemetery 1 of Cerro Castillo, possibly associated with an Early Horizon occupation at the site. (Courtesy of the Cerro Castillo Archaeological Project Image Archive.)

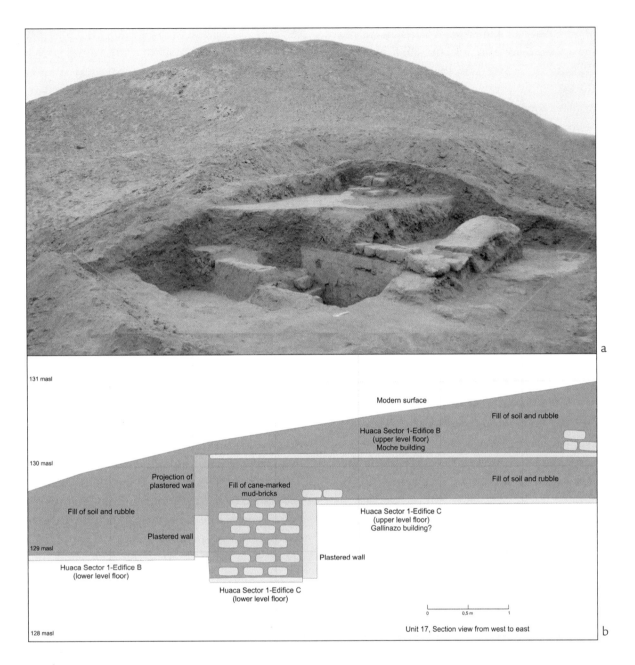

131 masl

Modern surface

Fill of soil and rubble

Huaca Sector 1-Edifice B
(upper level floor)
Moche building

130 masl

Projection of
plastered wall

Fill of cane-marked
mud-bricks

Fill of soil and rubble

Fill of soil and rubble

Huaca Sector 1-Edifice C
(upper level floor)
Gallinazo building?

Plastered wall

129 masl

Plastered wall

Huaca Sector 1-Edifice B
(lower level floor)

Huaca Sector 1-Edifice C
(lower level floor)

0 0,5 m 1

128 masl

Unit 17, Section view from west to east

a

b

figure 12.7

a) View of excavations at Huaca Sector 1, Unit 17; and b) section drawing illustrating how Huaca Sector 1-Edifice B
was built on top of Huaca Sector 1-Edifice C, the latter possibly associated with a Gallinazo component at the site.
(Courtesy of the Cerro Castillo Archaeological Project Image Archive.)

its orthostatic wall. Nevertheless, its architectural
characteristics (similar to those of Caylán's struc-
tures) suggest that it was built during the end of
the Early Horizon or the beginning of the Early
Intermediate Period. In addition to the features
above, an Early Horizon structure at the top of

the monumental area of the Pañamarca Complex
backs the idea that the area's prestige dates back to
those times.

Finally, works at Huaca Sector 1, an artificial
mound on the north side of Cerro Castillo (see Fig-
ure 12.3), revealed the use of an architectural fill

of cane-marked mud-bricks to cover an early version of the edifice: Huaca Sector 1-Edifice C (Figure 12.7). The use of cane-marked mud-bricks is generally associated with the Gallinazo tradition, which is understood to be a North Coast phenomenon of the Early Intermediate Period that preceded and then coexisted alongside the Moche (Millaire and Morlion 2009). The presence of cane-marked mud-bricks at Huaca Sector 1 may be an indicator of a Gallinazo component in the history of Cerro Castillo—and therefore of an Early Intermediate Period/pre-Moche occupation at the site. Given the ceremonial nature of Huaca Sector 1, this Gallinazo factor may have been related to ritual practices. It goes without saying, though, that more excavations are needed to confirm the Gallinazo association of this construction.

Neither Subjugated nor Replaced: Life in Cerro Castillo

The archaeological data from Cerro Castillo offers evidence that problematizes the traditional core-periphery approaches when explaining the site's history and its relationship with Moche culture (Proulx 1985; Schaedel 1951). Certainly, it is difficult to archaeologically confirm whether the changes seen in the material culture resulted from large numbers of people moving into the Nepeña Valley from elsewhere. It is worth noting, however, that migrations are not always the cause of cultural transformations and political shifts; cultural change can also be brought about by insiders, who often generate even more dramatic effects than do invaders (e.g., Beach et al. 2009). Hard evidence—particularly ceramics and murals, such as those discussed by Trever in this volume—indicates that the Moche culture made its way into the Nepeña Valley, but to conclude that a state's expansionist agenda was the driving force seems to be an assumption rather than an evidence-supported explanation.

Our excavations at Cerro Castillo indicate that between 600 and 850 CE, the site was a fully functioning settlement with everything required for daily life (Rengifo 2014). At its peak, most of the slopes might have been terraced to hold residential and public compounds. Sector 4 was probably the most populated area, as attested by the remains of terraced constructions. Works here revealed varied patterns of residential architecture. Structures documented at different compounds (e.g., Units 1, 2, 5, 7, 10, and 13) may correspond to residences of large households or corporate multi-household units that administered a number of primary resources as well as accessed valued commodities (Figure 12.8).

Economic life at Cerro Castillo likely focused on agriculture. Preliminary observations of food

figure 12.8
Excavations at Cerro Castillo's Units 1 and 2. Note the foundations of walls, whose configuration suggests high-quality architecture. (Courtesy of the Cerro Castillo Archaeological Project Image Archive.)

remains indicate that inhabitants grew traditional crops, such as maize (*Zea mays*), potatoes (*Solanum tuberosum*), lúcuma (*Pouteria lucuma*), and custard apple (*Annona cherimola*). Evidence also shows that Cerro Castillo's residents exploited llamas and guinea pigs; remains of both species have been found in association with kitchens and public areas (e.g., Units 4, 7, and 10). The use of llamas along with the exploitation of cotton would have boosted local textile production, providing weavers with essential raw materials.

The north side of the site features the platformed building Huaca Sector 1 (see Figures 12.3 and 12.7). Its size and architectural quality indicate its ceremonial nature and perhaps an intended political agenda. Although more data are necessary, its general architectural features suggest that the construction of Huaca Sector 1 followed shared regional conventions for ceremonial buildings—that is, mud-brick platforms, one on top of the other, finished with clay-plastered outer surfaces and good-quality flooring (Uceda 2001).

Life in Cerro Castillo was also closely related to perceptions and activities of death. The site's flatlands include evidence of funerary practices. Excavations at Units 14–16 revealed that people associated with the Moche (see Figure 12.2), local, Casma, and Chimú cultural traditions were all buried in Cemetery 1. This is worth noting, as it attests to the persistent use of the area as a burial ground as well as to the site's relationships with different cultural traditions. In addition, disturbed materials collected from looters' pits reveal that ceramics of varying quality were placed as offerings in the tombs of this graveyard, which, in turn, suggests that people from diverse social segments were buried in this cemetery.

Ceramic Findings

Ceramic analyses and contextual associations indicate a broad circulation and consumption of fancy wares across all the excavated compounds occupied from circa 600 to 850 CE. A previous work examined an assemblage of 879 decorated sherds recovered from excavations at Cerro Castillo (Rengifo 2014). The sample was organized in seven categories

named after the cultural styles identified in the sample: Moche (55.9%), local (16.6%), Gallinazo (3.6%), Wari (1%), Cajamarca (1.3%), Casma (7.8%), and Chimú (13.8%). For the purpose of this study, the following paragraphs will examine the presence of Moche and local ceramics, which were found in association with one another.

The vast majority of Moche wares of the Cerro Castillo sample are associated with the Moche phase-IV ceramic style; only a few sherds may be related to the Moche phase V or to the northern Late Moche style (Castillo and Donnan 1994). To date, there is no evidence of Moche phases I, II, or III, nor of Early or Middle Moche wares. Bearing this in mind, it can be argued that the Moche presence at Cerro Castillo happened during the peak of the Moche phase-IV ceramic style and the development of Moche phase V, roughly 600 to 850 CE.[2]

The assemblage consists largely of broken parts of well-known Moche vessel forms (e.g., stirrup-spout bottles, flaring bowls, and sculpted shapes; see Figures 12.2, 12.9c, and 12.9h). Moche-style wares were found in all of the excavated compounds. This evidences a wide circulation of Moche artifacts across the site and may attest to a spreading interest from Cerro Castillo's inhabitants in the consumption of these items.

The sample also boasts the elaborate fineline painting technique (Figures 12.9h and 12.9j), fragments with scenes in relief (Figures 12.9e and 12.9f), and fragments with human face attributes (Figures 12.9a and 12.9c). This find indicates an important circulation of pictorial and sculpted ceramics throughout Cerro Castillo, which, in turn, suggests consumption of and knowledge about the imagery depicted in this type of media. The identification of Moche characters and subject matter in the Cerro Castillo's pottery sample—for example, representations of "runners"—supports this idea (compare Figure 12.9d with Donnan and McClelland 1999:204, fig. 6.27). In this respect, it is worth stressing that scholars have already pointed out the evocative nature of Moche art (Donnan 1978).

At Cerro Castillo, the evidence of vessels featuring Moche imagery leads us to posit that the site's inhabitants had knowledge, or at least a fair

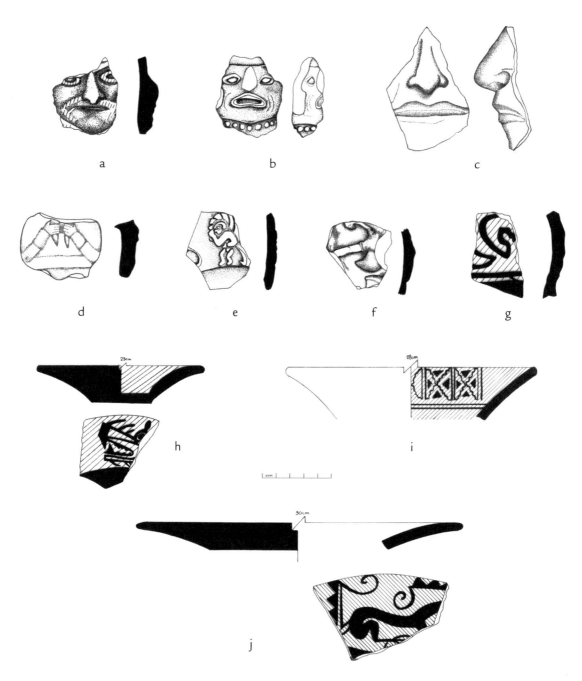

figure 12.9

Examples of Moche-style sherds found at Cerro Castillo: a) representation of an elite character; b) character with a wrinkled face; c) part of a portrait vessel; d) representation of a "runner"; e) death figure, possibly in motion; f) hand holding a knife, part of combat scene, possibly associated with the Sacrifice Ceremony; g) wave motif; h) zoomorphic character painted in a flaring bowl; i) stepped symbol painted in a flaring bowl; and j) supernatural character, probably the "moon animal," painted in a flaring bowl. (Courtesy of the Cerro Castillo Archaeological Project Image Archive.)

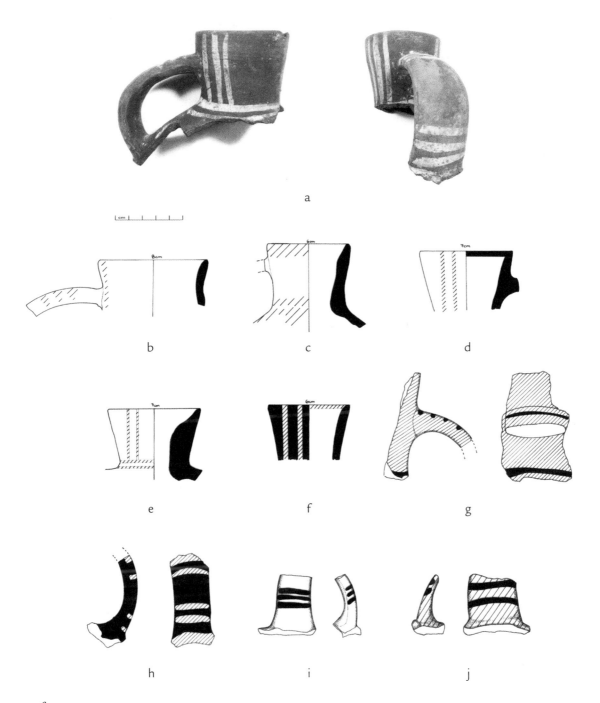

figure 12.10
Broken parts of strap-handle jugs found at Cerro Castillo. Such vessels may correspond with a local ware. (Courtesy of the Cerro Castillo Archaeological Project Image Archive.)

understanding, of the politico-ideological agenda encoded in Moche art. Moche art consumers could understand its meaning and also be affected by its agency. At this point, it is important to note the Moche imagery reported in the temple of Pañamarca (see Trever, this volume).[3] The mural painting, with its characters from Moche art, undoubtedly attests to a solid Moche presence in the area; however, the relationship between Cerro Castillo's residents and the temple of Pañamarca (e.g., whether they had access to its interior imagery) requires further investigation.

Excavations at Cerro Castillo also revealed a significant number of broken parts of strap-handle jugs, which make up 16.6 percent of the sample (Figure 12.10). Although no complete strap-handle jug has been found during the excavations, fragments corresponding with different parts of this vessel form show painted decoration, which mostly consists of parallel lines painted on the strap or on the jug's neck. Additionally, these strap-handle jugs may display either a rough or a polished surface. Like Moche pottery, fragments of strap-handle jugs have been reported in all of the excavated compounds, attesting to their wide circulation across the site.

It is worth noting that little is known about this specific type of vessel. To date, as far as our investigations have gone, these strap-handle jugs are almost absent in the related literature. Their stratigraphic association at Cerro Castillo, however, suggests that strap-handle jugs circulated throughout the site, as did other pottery traditions, such as Moche. Strap-handle jugs and Moche ceramics were consistently found together in all the compounds excavated, which demonstrates the consumption preferences of the site's inhabitants. On this basis, this research suggests that strap-handle jugs may correspond with ceramics associated with local groups of Cerro Castillo—arguably a visual expression of the local techné.

In sum, archaeological evidence suggests that between 600 and 850 CE, Cerro Castillo was as a fully functioning community like some other contemporaneous settlements in the region, such as Guadalupito, Pampa Grande, or Huacas de Moche

(Chapdelaine 2010; Shimada 1994; Uceda 2010). However, this evidence does not support a clear "colonization" model. Few, if any, archaeological contexts of Cerro Castillo indicate military operations, social struggle, or population replacement and they do not point to a classic case of new settlement in an unoccupied area, as has been suggested for the Santa Valley (Chapdelaine 2010). Cerro Castillo's architecture and urban plan (i.e., residential and ceremonial buildings, lack of defensive structures, and accessibility through open flatlands) do not seem consistent with any military orientation or practice. In general, as far as current data show, there is little indication of attack, or threat of attack, by foreign Moche warriors. Rather, there is another line of evidence that may better explain Cerro Castillo's economic boost and the nature of its cultural associations—that is, local craft production.

Craft Production at Cerro Castillo

At Cerro Castillo, proof of craft production was noticeable on the surface of the western slope of Sector 4. Excavations in Units 3 and 7 confirmed these observations, revealing remains of good-quality constructions associated with high-ranked people involved in productive activities. These architectural spaces were built on a leveled surface; given the limited extent of the excavations, whether the constructions in this area were terraced is yet to be confirmed. People may have transited around these buildings through the natural gradient of the slope, while circulation inside the compounds would have happened via corridors and access ways. Only brickwork and wattle and daub were utilized to build structures in this area; no stone masonry was found.

The materials recorded in Unit 3 suggest that pottery production took place within and around these premises (Figure 12.11). Specifically, we recovered remains of wooden and metal tools, as well as ceramic molds, to manufacture both Moche and local ceramics (Figure 12.12). Moreover, some fragments of molds were collected from the surface of the surrounding area. Unit 3 presents worn floors associated with remains of hearths and

figure 12.11
Excavations at Cerro Castillo's Unit 3, an area associated with pottery manufacture. (Courtesy of the Cerro Castillo Archaeological Project Image Archive.)

earth furnaces; such condition indicates the constant use of these spaces (Figure 12.11). The presence of a small (empty) storeroom further supports this claim, as it is a feature that has also been recorded in other workshops on the North Coast (Shimada 1994; Uceda and Rengifo 2006).

The good construction quality of these spaces (e.g., brickwork and well-made flooring) suggests a context associated with privileged individuals; evidence of wall and ceiling painting found in the nearby Unit 7 reinforces this idea. It is also important to note that the molds discovered in Unit 3 point toward a context of artisans producing both Moche and local ceramics. If that were indeed the case, then production of fancy pottery at Cerro Castillo would not have been a mandate of a governmental body, nor would it have been controlled by an elite from another valley; rather, it seems to have been the response of local artisans to the cultural preferences of the site's inhabitants (in this case, a demand for fancy Moche and local vessels).

Although further research will permit an accurate distinction between locally produced and imported ceramics, it is likely that the Cerro Castillo pottery sample covers both scenarios. It is plausible to think that first Moche material culture arrived at the site (possibly through trade) and subsequently grew popular, which eventually led to its local production.

At Cerro Castillo, the most solid evidence for a fancy-vessels production area has, so far, been found at Unit 3; however, it is possible that pottery manufacture occurred at more than one place at

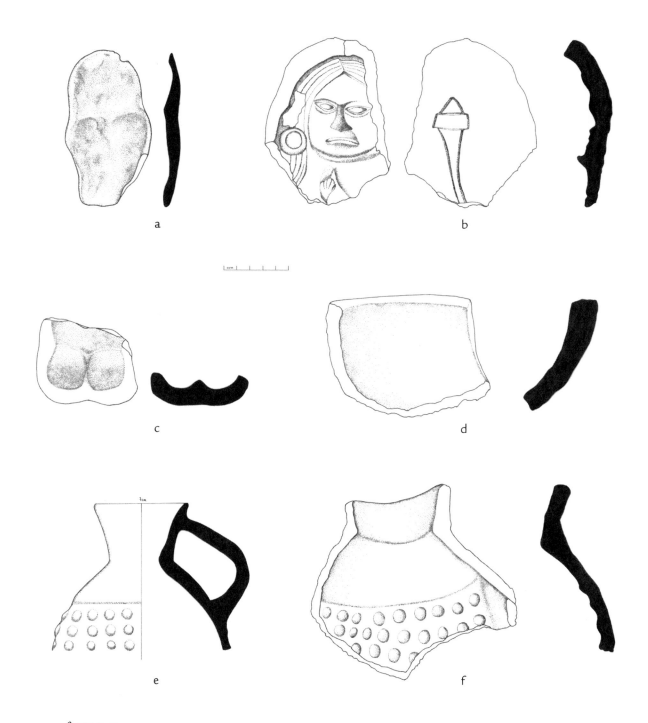

figure 12.12
Molds found at Cerro Castillo's Unit 3: a–b) mold for a Moche-style vessel, with a war-club motif incised in the outer face of the mold; c–d) fragments of molds for unidentified vessels; and e–f) mold for a strap-handle jug. (Courtesy of the Cerro Castillo Archaeological Project Image Archive.)

a

b

figure 12.13
a) Excavations at Cerro Castillo's Unit 7, showing the room U7-Room-1 and the patio U7-Room-2; and b) remains of an earth furnace found in association with several pottery fragments in U7-Room-2. (Courtesy of the Cerro Castillo Archaeological Project Image Archive.)

figure 12.14
Artifacts associated with textile production at Cerro Castillo: a, b, and d) weaving bobbins encountered in Unit 7; c) weaving spindle found in Unit 7; and e) weaving bobbins encountered in the plaza U10-Room-1. (Courtesy of the Cerro Castillo Archaeological Project Image Archive.)

the site. Also, it is important to consider that some production tasks may have taken place at open non-specialized areas, such as patios, or simply anywhere outdoors.

Excavations at Unit 7 also revealed evidence of residential and production activities associated with a high-ranked residence refurbished at least twice. The area contained a well-preserved square room (U7-Room-1) of good-quality flooring and an internal lateral bench (Figure 12.13a). Although U7-Room-1's traits suggest a resting place, several camelid-related materials (camelid skin, fur, and bones) were recovered from inside this structure, which points toward a place for camelid exploitation.

The room's southwest corner presented an access way that connected to another space, U7-Room-2, which may correspond with a patio area (see Figure 12.13a). Remains of wall painting were found in association with this space. It is also

worth noting the variety of artifacts found all over this occupation's floor outside the northeast corner of U7-Room-1: camelid hair, textile shreds, copper needles, weaving spindles, and bobbins (Figure 12.14). The patio, U7-Room-2, may have been used for activities involving controlled firing: an earthen kiln was encountered along with a cut containing several ceramic fragments corresponding with at least twelve vessels of middle-range quality, as well as two carved *Spondylus* shells (Figure 12.13b). It is possible that these sherds correspond with broken pieces of vessels fired in that specific furnace.[4]

Work at Unit 10, sited on the northern side of Sector 4, revealed a series of constructions associated with domestic, production, and public activities. The architectural layout, as well as the materials found inside the structures, suggests that Unit 10 was a highly transited area (see Figure 12.4). Given the gradient of the terrain, building on this area required

figure 12.15
Excavations at U10-Room-7. Note the storeroom containing remains of food on the left side of the photo. (Courtesy of the Cerro Castillo Archaeological Project Image Archive.)

considerable amounts of fill, which was composed of rubble and soil configuring successive terraced levels. The structures of Unit 10 were built combining both brickwork and stonemasonry. Likewise, the flooring of such structures corresponds with earthen floors and tamped surfaces.

The structure U10-Room-1 is a large plaza (19 × 19 m; see Figure 12.5a). This plaza was surrounded by terraced rooms that varied in size, content, and presumably also in function (see Figure 12.4). Remains of clothing and weaving tools found in this area indicate that textile production took place in the plaza or in the nearby spaces (see Figure 12.14). Evidence of fine and domestic pottery, as well as food remains, may attest to economic transactions and public

relations of different kinds (feastings and trade meetings) held at the premises (e.g., Campana 1994:fig. 15.9). Moreover, aspects of U10-Room-6 and U10-Room-7, located southwest of the plaza U10-Room-1, correspond with a group of storerooms for food and possibly other goods, such as textiles and basketry. Indeed, one of these structures contained evidence of seeds, shells, and corncobs (Figure 12.15). Similar conditions have been suggested for the urban center of Huacas de Moche (Uceda 2010).

The archaeological evidence for pottery and textile production at Cerro Castillo indicates that skilled crafting was an important component of the site's life. Also, our evidence suggests that artisans enjoyed a privileged status. Whether or not

members of the highest spheres of power, they certainly played a pivotal role in the site's economic and cultural development. I argue that at Cerro Castillo, the production of artifacts with meaning and value (particularly Moche and local ceramics) was a manifestation of the populace's cultural adherence and preferences rather than a sign of dominance from a (local or foreign) political or military entity.

The Moche Presence at Cerro Castillo: The Spread of the Moche Techné

Evidence suggests that Cerro Castillo was a community that only joined the Moche world during the late stages of Moche development (ca. 600–850 CE). Excavations at the site have revealed significant material evidence of a community that lived its heyday during this period. Remains of residential and public architecture associated with different pottery styles suggest a span of time when Cerro Castilloans were attuned to, and interested in, the different cultural developments that were already shaping other parts of the Central Andes. By that time, cultural traditions—such as Wari—were emerging and spreading from the central highlands toward the coast (Isbell 1986). Nevertheless, it was Moche—an already prestigious and consolidated culture—that made its way into the heart of the settlement.

The presence of Moche culture at Cerro Castillo was a breakthrough in the site's history. It is plausible to infer that Moche art embodied a prestigious cultural phenomenon that Cerro Castilloans wanted to be identified with, a sophisticated ceremonial world of mythical characters that had brought cohesion and balance to societies. Regardless of our ignorance about the details of the story underlying Moche art, its meaning and value certainly had enormous attraction; like many other stories, it inspired the imagination of artists for centuries across many communities, as it did at Cerro Castillo. Ceramic sherds recovered at the site attest to the presence of Moche subject matter, such as images associated with the powerful and ubiquitous

Sacrifice Ceremony (see Figure 12.9f), supernatural characters (see Figure 12.9h), representations of ritual runners (see Figure 12.9d), and portraits of elite characters (see Figure 12.9a). There is also evidence of other evocative icons, such as the stepped symbol (see Figure 12.9i), the wave (see Figure 12.9g), and the war club (see Figure 12.12b). Although excavations at Cerro Castillo have revealed evidence for the local production of Moche pottery, it is likely that there was also significant importation of Moche ceramics from other valleys, and further research will allow an accurate distinction between locally produced and imported ceramics.

Moche imagery may be the result of the way in which several generations perceived their world. It was an evocative idea, dramatic, and full of meaning (see also Donnan 1978; Jackson 2009). Evidence of Moche craft production across the North Coast of Peru suggests that it was promoted not only by leaders but also by artisans who, commissioned or not, embraced a narrative of themes that explained the origin and destiny of their world. In many regards, Moche imagery reflects the development of a cultural identity of regional scope. It goes without saying that this is a matter of major complexity to which archaeologists have limited access; however, the increasing identification of Moche substyles (Donnan 2011) is surely leading us closer to the recognition that such stylistic differences not only correspond with hierarchical levels of skill and artistry but also with particular ways of living and perceiving Moche practices.

At Cerro Castillo, the tail end of Moche was a period of dynamic cultural ferment. The emergence of large-scale constructions and complex imagery suggests that the spread of Moche ideas—and the techné used to express them in material form—brought a new way of thinking, which is a cultural element that normally eludes the archaeological record. Hard evidence indicates that at Cerro Castillo, the Moche phenomenon made its way into aristocrat's and commoners' lives alike. There was high circulation and consumption of Moche art not just in elite spheres but throughout households of various socioeconomic orders. Such consumption of Moche imagery reveals a generalized interest

in exploring new and complex worldviews, and knowledge was an essential part of that concern—knowledge of the images, mythology, characters, and evocative meanings behind them. This seems to be a case of Nepeñeans adopting Moche cultural practices, and evidence suggests that the Moche techné played a pivotal role in this development.

There is proof that Moche portraits circulated at the site (e.g., Figures 12.9a and 12.9c). Whether imported or locally produced, such portraits suggest fluid contacts between Cerro Castilloans and high-ranking Moche personages from other valleys (see also Donnan 2004). Trade and cooperation may have driven intervalley interactions that led to the reinforcement of relationships through marriages, goods exchange, and regional ceremonies, among other things. Regional ceremonial centers, such as San José de Moro, exemplify this type of scenario (Castillo et al. 2008). At Cerro Castillo, public spaces (e.g., Unit 10's plaza) and ceremonial spaces (e.g., cemeteries) would have been the arenas where trade and interaction occurred.

The presence of the Moche culture, however, did not prevent Cerro Castilloans from producing and consuming materials associated with other traditions. People of different social segments continued to acquire local fancy pottery (e.g., decorated strap-handle jugs), which circulated in both domestic and ritual contexts. It is worth mentioning that, to date, the strap-handle jugs from Cerro Castillo represent a type of pottery that could not be matched to any other ceramic style, suggesting a highly localized tradition.

Instead of assuming warfare-driven relationships, this investigation suggests that the rise of Cerro Castillo would have occurred under circumstances of competing Moche groups in different North Coast valleys. Power and prestige may have intermittently shifted from one valley to the other, which explains the variant periods of proliferation and stagnation of Moche sites along the North Coast. The Nepeña Valley was a late participant in the history of Moche, yet it played a significant role in times of alleged sociopolitical turmoil in the Moche Valley (Uceda 2010). It has been argued that around 600 to 700 CE, Huacas

de Moche experienced a population drain: artists moved northward to the Jequetepeque Valley, which eventually originated the fineline painting style of San José de Moro (Castillo et al. 2008). Following this hypothesis, and considering craft production–related evidence from Cerro Castillo, it can be argued that people also moved southward to the Santa and Nepeña Valleys (though, more evidence is needed to sustain this argument). If that was the case, then what Cerro Castillo had to offer to other valleys' populations is a matter for future investigation.

Final Comments

Craft specialization played a fundamental role in shaping the identity of ancient communities. Artisans were directly involved in the materialization of the meaning and value of Moche and its material culture, providing it with the physical forms that enabled its spread over a large territory during several years (Bawden 1996; DeMarrais et al. 1996). Inomata (2001) points out that crafted objects not only can help to support and communicate certain ideological elements, but also that craft production itself is often strongly charged with ideological meanings and connotations. In addition, Helms (1993) argues that in many traditional societies, craftsmanship goes far beyond the mastery of a manufacture technique—craftsmen are also linked to magic or supernatural powers. The production processes may imply complex rituals, and the knowledge needed for craft production may not be limited to raw materials and technology realms; it may also include religious, historic, and cosmic-visual components. Moche artisans had an active part in the creation of symbols of power (Bawden 1996) as well as in the generation of knowledge. Different lines of evidence (e.g., workshops and burials) attest to their high levels of mastery, high status, and extensive relationships with the different segments of their communities.

From 600 to 850 CE, Cerro Castillo's identity was greatly influenced by the Moche culture. The

Moche presence at the site represented a period of cultural boost in a time of profound regional transformations. Cerro Castillo's architecture and artifacts typify the affluence as well as the social upheaval of the era. Excavations suggest that, at Cerro Castillo's peak, the site featured an estimated ten built hectares, occupying large parts of the hillsides; the flatlands would have been used for funerary purposes.

That objects with meaning and value circulated suggests that Cerro Castilloans aligned themselves with regional styles and ideas. They used Moche art to formulate and express a new aspect of their cultural identity. It is worth noting, though, that parallel to the wide consumption of Moche pottery was a significant production of strap-handle jugs—arguably a distinct local vessel. Regardless of the popularity of Moche pottery, this local type of ceramic was produced, keeping its own distinctive visual attributes (i.e., shape, paint colors, surface treatment). Furthermore, our evidence suggests that artisans produced Moche and local ceramics at the same places.

This chapter argues that the transformations in Cerro Castilloans' lives between 600 and 850 CE came not from a wave of invasions but from a prolonged period of contact with neighboring regions. The wide consumption of Moche artifacts did not make these populations politically dependent on the polities of the Moche Valley by default. Rather, this chapter suggests a scenario in which people from Cerro Castillo adopted new fashions and shifted their political allegiances in order to keep up with the changing times.

NOTES

1 The bones and joints showed injuries that resulted from long hours in certain positions. The injuries consisted of arthritis in the hands (a consequence of a constant activity that requires having the hands wet, such as in the preparation of the clay), spine, and knees (a consequence of a stooped or crouched position, which is commonly assumed in pottery making).

2 These considerations find support in excavations and radiocarbon dates from the site of Guadalupito in the Santa Valley, which is stylistically associated with Moche phase IV (Chapdelaine 2010). Chapdelaine has posited that the Moche IV occupation in the lower Santa Valley lasted until circa 700 to 800 CE (not until 600 CE, as previously thought). Furthermore, these dates match the late Moche IV occupation at Huacas de Moche (Uceda 2010), pointing out a longer length of the Moche phase IV across the region. In addition, scholars have recently suggested the contemporaneity between the temple of Pañamarca and the New Temple of Huaca de la Luna in the Moche Valley, the latter dated 600 to 850 CE (Uceda 2010; see also Trever, this volume).

3 Both Cerro Castillo and Pañamarca were part of the same settlement: the Pañamarca Archaeological Complex. An approximately 300-meter ditch, made during the expansion of agricultural lands in the 1960s, is what currently separates both compounds.

4 The total dimensions of this patio are still unknown, but it is likely to have covered more than twelve square meters, which makes the area suitable for controlled firing.

Alva, Walter, and Christopher B. Donnan

1993 *Royal Tombs of Sipán.* Fowler Museum of Cultural History, Los Angeles.

Ames, Kenneth

1995 Chiefly Power and Household Production on the Northwest Coast. In *Foundations of Social Inequality*, edited by T. Douglas Price and Gary M. Feinman, pp. 155–187. Plenum Press, New York and London.

Atwood, Roger

2010 Lord of Úcupe. *Archaeology* 63:21.

Bawden, Garth

1996 *The Moche.* Blackwell, Oxford.

Beach, Hugh, Dmitri Funk, and Lennard Sillanpää (editors)

2009 *Post-Soviet Transformations: Politics of Ethnicity and Resource Use in Russia.* Uppsala University Library, Uppsala.

Bernier, Hélène

2005 Étude archéologique de la production artisanale au site Huacas de Moche, côte nord du Pérou. PhD dissertation, Department of Anthropology, University of Montreal, Montreal.

Bourget, Steve

2003 Somos diferentes: Dinámica ocupacional del sitio Castillo de Huancaco, Valle de Virú. In *Moche: Hacia el final del milenio*, vol. 1, edited by Santiago Uceda and Elías Mujica, pp. 245–267. Pontificia Universidad Católica del Perú, Lima, and Universidad Nacional de Trujillo, Trujillo.

Bourget, Steve, and Kimberly Jones (editors)

2008 *The Art and Archaeology of the Moche: An Ancient Andean Society of the Peruvian North Coast.* University of Texas Press, Austin.

Brumfiel, Elizabeth, and Timothy Earle (editors)

1987 *Specialization, Exchange, and Complex Societies.* Cambridge University Press, Cambridge.

Campana, Cristóbal

1994 El entorno cultural en un dibujo mochica. In *Moche: propuestas y perspectivas*, edited by Santiago Uceda and Elías Mujica, pp. 449–473. Universidad de La Libertad, Trujillo, and Instituto Francés de Estudios Andinos y Asociación Peruana para el Fomento de las Ciencias Sociales, Lima.

Castillo, Luis Jaime, and Christopher Donnan

1994 Los Mochicas del norte y los Mochicas del sur. In *Vicús*, edited by Krzysztof Makowski et al., pp. 143–181. Banco de Crédito del Perú, Lima.

Castillo, Luis Jaime, and Carlos Rengifo

2008 El género y el poder: Una aproximación desde San José de Moro. In *Los señores de los reinos de la luna*, edited by Krzysztof Makowski, pp. 165–181. Colección Arte y Tesoros del Perú, Banco de Crédito del Perú, Lima.

Castillo, Luis Jaime, Julio Rucabado, Martín Del Carpio, Katiusha Bernuy, Karim Ruiz, Carlos Rengifo, Gabriel Prieto, and Carole Fraresso

2008 Ideología y poder en la consolidación, colapso y reconstitución del estado mochica del Jequetepeque: El Proyecto Arqueológico San José de Moro (1991–2006). *Ñawpa Pacha* 29:1–86.

Castillo, Luis Jaime, and Santiago Uceda

2008 The Mochicas. In *Handbook of South American Archaeology*, edited by Helaine Silverman and William H. Isbell, pp. 707–729. Springer Science, New York.

Chapdelaine, Claude

2010 Moche Political Organization in the Santa Valley: A Case of Direct Rule through Gradual Control of the Local Population. In *New Perspectives in Moche Political Organization*, edited by Jeffrey Quilter and Luis Jaime Castillo, pp. 252–279. Dumbarton Oaks Research Library and Collection, Washington, D.C.

Chicoine, David

2006 Early Horizon Architecture at Huambacho, Nepeña Valley, Peru. *Journal of Field Archaeology* 31(2):1–22.

Clark, John E.

1995 Craft Specialization as an Archaeological Category. *Research in Economic Anthropology* 16:267–294.

Costin, Cathy Lynne

2004 Craft Economies of Ancient Andean States. In *Archaeological Perspectives on Political Economies*, edited by Gary Feinman, Linda Nicholas, and James Skibo, pp. 189–223. Foundations of Archaeology Inquiry Series. University of Utah Press, Salt Lake City.

2005 Craft Production. In *Handbook of Archaeological Methods*, edited by Herbert D. G. Maschner and Christopher Chippindale, pp. 1032–1105. AltaMira Press, Walnut Creek, Calif.

DeMarrais, Elizabeth, Timothy Earle, and Luis Jaime Castillo

1996 Ideology, Materialization, and Power Strategies. *Current Anthropology* 37:15–31.

Donnan, Christopher

1978 *Moche Art of Peru: Pre-Columbian Symbolic Communication*. Museum of Cultural History, Los Angeles.

2004 *Moche Portraits from Ancient Peru*. University of Texas Press, Austin.

2008 *Moche Tombs at Dos Cabezas*. Cotsen Institute of Archaeology Press, Los Angeles.

2010 Moche State Religion: A Unifying Force in Moche Political Organization. In *New Perspectives in Moche Political Organization*, edited by Jeffrey Quilter and Luis Jaime Castillo, pp. 47–69. Dumbarton Oaks Research Library and Collection, Washington, D.C.

2011 Moche Substyles: Keys to Understanding Moche Political Organization. *Boletín del Museo Chileno de Arte Precolombino* 16(1):105–118.

Donnan, Christopher, and Luis Jaime Castillo

1992 Finding the Tomb of a Moche Priestess. *Archaeology* 45(6):38–42.

Donnan, Christopher, and Donna McClelland

1999 *Moche Fineline Painting: Its Evolution and Its Artists*. Fowler Museum of Cultural History, Los Angeles.

Donnan, Christopher, and Carol Mackey

1978 *Ancient Burial Patterns of the Moche Valley, Peru*. University of Texas Press, Austin.

Geertz, Clifford

1966 Religion as a Cultural System. In *Anthropological Approaches to the Study of Religion*, edited by Michael Banton, pp. 1–46. ASA Monographs 3. Tavistock Publications, London.

Helms, Mary W.

1993 Craft *and the Kingly Ideal: Art, Trade and Power*. University of Texas Press, Austin.

Ikehara, Hugo, and David Chicoine

2011 Hacia una reevaluación de Salinar desde la perspectiva del valle de Nepeña, costa de Anchas. In *Arqueología de la costa de Ancash*, edited by Milosz Giersz and Iván Ghezzi, pp. 153–184. Travaux de l'Institute Français d'Etudes Andines 290. Centro de Estudios Precolombinos de la Universidad de Varsovia, Warsaw, and Instituto Francés de Estudios Andinos, Lima.

Inomata, Takeshi

2001 The Power and Ideology of Artistic Creation: Elite Craft Specialists in Classic Maya Society. *Current Anthropology* 42:321–349.

Isbell, William

1986 Emergence of City and State at Wari, Ayacucho, Peru, during the Middle Horizon. In *Andean Archaeology: Papers in Memory of Clifford Evans*, edited by R. Matos, Solveig A. Turpin, and Herbert H. Eling, pp. 189–200. Monograph 27. Institute of Archaeology, University of California, Los Angeles.

Jackson, Margaret

2009 *Moche Art and Visual Culture in Ancient Peru*. University of New Mexico Press, Albuquerque.

Larco Hoyle, Rafael

1948 *Cronología arqueológica del norte del Perú*. Biblioteca del Museo de Arqueología Rafael Larco Herrera, Lima, and Sociedad Geográfica Americana, Buenos Aires.

2001 *Los Mochicas*. 2 vols. Museo Arqueológico Rafael Larco Herrera, Lima.

Makowski, Krzysztof

1994 Los señores de Loma Negra. In *Vicús*, edited by Krzysztof Makowski et al., pp. 83–141. Colección Arte y Tesoros del Perú, Banco de Crédito del Perú, Lima.

2010 Religion, Ethnic Identity, and Power in the Moche World: A View from the Frontiers. In *New Perspectives on Moche Political Organization*, edited by Jeffrey Quilter and Luis Jaime Castillo, pp. 280–305. Dumbarton Oaks Research Library and Collection, Washington, D.C.

Manzanilla, Linda

1986 Introducción. In *Unidades habitacionales mesoamericanas y sus áreas de actividad*, edited by Linda Manzanilla, pp. 9–18. Arqueología Serie Antropológica 76. Instituto de Investigaciones Antropológicas, Universidad Nacional Autónoma de México, Mexico City.

Millaire, Jean-François

2008 Moche Textile Production on the Peruvian North Coast: A Contextual Analysis. In *The Art and Archaeology of the Moche: An Ancient Society of the Peruvian North Coast*, edited by Steve Bourget and Kimberly Jones, pp. 229–245. University of Texas Press, Austin.

Millaire, Jean-François, and Magali Morlion (editors)

2009 *Gallinazo: An Early Cultural Tradition on the Peruvian North Coast*. Cotsen Institute of Archaeology Press, Los Angeles.

Morales, Ricardo

2003 Iconografía litúrgica y contexto arquitectónico en Huaca de la Luna, valle de Moche. In *Moche: Hacia el final del milenio*, vol. 1, edited by Santiago Uceda and Elías Mujica, pp. 425–476. Pontificia Universidad Católica del Perú and Universidad Nacional de Trujillo, Lima and Trujillo.

Moseley, Michael, and Kent Day (editors)

1982 *Chan Chan: Andean Desert City*. University of New Mexico Press, Albuquerque.

Mujica Barreda, Elías, Régulo Franco Jordán, César Gálvez Mora, Jeffrey Quilter, Antonio Murga Cruz, Carmen Gamarra de la Cruz, Víctor Hugo Ríos Cisneros, Segundo Lozada Alcalde, John Verano, and Marco Aveggio Merello

2007 *El Brujo: Huaca Cao, centro ceremonial Moche en el valle de Chicama*. Fundación Wiese, Lima.

Pillsbury, Joanne (editor)

2001 *Moche Art and Archaeology in Ancient Peru*. Studies in the History of Art 63. National Gallery of Art, Washington, D.C.

Proulx, Donald

1968 *An Archaeological Survey of the Nepeña Valley, Peru*. Research Report 2. Department of Anthropology, University of Massachusetts, Amherst.

1973 *Archaeological Investigations in the Nepeña Valley, Peru*. Research Report 13. Department of Anthropology, University of Massachusetts, Amherst.

1985 *An Analysis of the Early Cultural Sequence of the Nepeña Valley, Peru*. Research Report 25. Department of Anthropology, University of Massachusetts, Amherst.

Quilter, Jeffrey

1997 The Narrative Approach to Moche Iconography. *Latin American Antiquity* 8(2):113–133.

Quilter, Jeffrey, and Luis Jaime Castillo (editors)

2010 *New Perspectives on Moche Political Organization*. Dumbarton Oaks Research Library and Collection, Washington, D.C.

Rengifo, Carlos

2014 Moche Social Boundaries and Settlement Dynamics at Cerro Castillo, Nepeña Valley, Peru (c. AD 600–1000). PhD dissertation, University of East Anglia, Norwich.

Rengifo, Carlos, and Luis Jaime Castillo

2015 The Construction of the Social Identity: Tombs of Specialists at San Jose de Moro. In *Funerary Practices and Models in the Ancient Andes*, edited by Peter Eeckhout and Laurence S. Owens, pp. 117–136. Cambridge University Press, Cambridge.

Richards, Janet, and Mary Van Buren (editors)

2000 *Order, Legitimacy, and Wealth in Ancient States.* Cambridge University Press, Cambridge.

Russell, Glenn, and Margaret Jackson

2001 Political Economy and Patronage at Cerro Mayal, Peru. In *Moche Art and Archaeology in Ancient Peru*, edited by Joanne Pillsbury, pp. 159–175. Studies in the History of Art 63. National Gallery of Art, Washington, D.C.

Schaedel, Richard

1951 Mochica Murals at Pañamarca (Peru). *Archaeology* 4(3):145–154.

Shimada, Izumi

1994 *Pampa Grande and the Mochica Culture.* University of Texas Press, Austin.

2001 Late Moche Urban Craft Production: A First Approximation. In *Moche Art and Archaeology in Ancient Peru*, edited by Joanne Pillsbury, pp. 177–205. Studies in the History of Art 63. National Gallery of Art, Washington, D.C.

Shimada, Izumi (editor)

2007 *Craft Production in Complex Societies: Multicraft and Producer Perspectives.* Foundations of Archaeological Inquiry. University of Utah Press, Salt Lake City.

Tainter, Joseph

1978 Mortuary Practices and Study of Prehistoric Social Systems. In *Advances in Archaeological Method and Theory*, vol. 1, edited by Michael B. Schiffer, pp. 105–141. Academic Press, London.

Tello, Ricardo, José Armas, and Claude Chapdelaine

2003 Prácticas funerarias moche en el complejo arqueológico Huacas del Sol y de la Luna. In *Moche: Hacia el final del milenio*, edited by Santiago Uceda and Elías Mujica, pp. 151–187. Pontificia Universidad Católica del Perú, Lima, and Universidad Nacional de Trujillo, Trujillo.

Uceda, Santiago

2001 Investigations at Huaca de la Luna, Moche Valley: An Example of Moche Religious Architecture. In *Moche Art and Archaeology in Ancient Peru*, edited by Joanne Pillsbury, pp. 47–67. Studies in the History of Art 63. National Gallery of Art, Washington, D.C.

2010 Theocracy and Secularism: Relationships between the Temple and Urban Nucleus and Political Change at the Huacas de Moche. In *New Perspectives in Moche Political Organization*, edited by Jeffrey Quilter and Luis Jaime Castillo, pp. 132–158. Dumbarton Oaks Research Library and Collection, Washington, D.C.

Uceda, Santiago, and José Armas

1998 An Urban Pottery Workshop at the Site of Moche, North Coast of Peru. *MASCA Research Papers in Science and Archaeology*, supplement, 15:91–110. University of Pennsylvania Museum of Archaeology and Anthropology, Philadelphia.

Uceda, Santiago, José Armas, and Mario Millones

2003 Entierros de dos alfareros en la zona urbana de Huaca de la Luna. In *Proyecto Arqueológico Huaca de la Luna, Informe Técnico 2002*, edited by Santiago Uceda and Ricardo Morales, pp. 97–212. Universidad Nacional de Trujillo, Trujillo.

Uceda, Santiago, and Elias Mujica (editors)

1994 *Moche: Propuestas y perspectivas.* Instituto Francés de Estudios Andinos, Trujillo.

2003 *Moche: Hacia el final del milenio.* Pontificia Universidad Católica del Perú, Lima, and Universidad Nacional de Trujillo, Trujillo.

Uceda, Santiago, and Carlos Rengifo

2006 La especialización del trabajo: Teoría y arqueología; El caso de los orfebres mochicas. *Bulletin de l'Institut Français d'Études Andines* 35:149–185.

Willey, Gordon

1953 *Prehistoric Settlement Patterns in the Viru Valley, Peru.* Smithsonian Institution, Bureau of American Ethnology, Bulletin 155. Smithsonian Institution, Washington, D.C.

Wilson, David

1988 *Prehispanic Settlement Patterns in the Lower Santa Valley, Perú: A Regional Perspective on the Origins and Development of Complex North Coast Society.* Smithsonian Series in Archaeological Inquiry. Smithsonian Institution Press, Washington D.C.

Crafting Credit

Authorship among Classic Maya Painters and Sculptors

STEPHEN HOUSTON

ANY TEXT OR IMAGE LIES AT A BUSY CROSS-roads: intentions, makers, viewers, and readers bustle through the work. In this sense, the Pre-Columbian world is sometimes at a disadvantage to scholars. For the most part, there are no named artisans, and the social roles and meanings of their craft remain a matter of reasoned inference.[1] The Classic Maya (ca. 300–850 CE) are unique in this respect. Through "signatures" or "autographs," they left explicit statements about the creators of certain paintings or sculptures. As we shall see, this evidence can sometimes elude ready explanation; not all questions are answerable. Yet most autographs seem consistent with the dynastic and courtly setting of their works, which were created in a world where rulers and royal courts either permitted or disallowed their use. At any one moment, a king or those directly supervising a work could decide to authorize such signatures while others did not. Ultimately, the practice, a sixth-century innovation, disappeared in the turbulence of the Maya collapse, and

what had been appropriate became, in later carvings and paintings, unnecessary or unwelcome. For some cities, it was always deemed inappropriate. That Maya literates could still create such statements—literacy continued to varying degree up to and beyond the Spanish conquest (Houston 2008:248)—proved irrelevant to a broader shift in scribal decorum.

No earlier study has examined Maya signatures in a comprehensive manner, although there are general comments, including their initial identification (Stuart 1989a, 1989b; see also Coe and Kerr 1997; Houston 2000), along with more focused reports on particular sites or reigns (Montgomery 1995). That analysis will be done here. The pertinent questions are hard ones: What do autographs reveal about ancient practice and the ontology of things? How do they express identity and reconcile the manifold tensions of authorial credit? The available evidence will show that beneath the mere fact of signatures lie deeper layers of motivation and social import.

Naming Hands

In 1986, David Stuart (1987, 1989a, 1989b) discovered that the Maya sometimes signed their paintings and carvings. In a few cases, painters wrote **u-tz'i-ba**, *u tz'ihb*, or **u-tz'i-bi**, *u-tz'ib*, "his painting" or "his writing," to be followed by their names (Figure 13.1a). The statements were always in the third person. It would seem at first glance that the Maya observed no distinction between writing and text. Emphasis was placed instead on process and technique, the linear brush- or quill-work that produced designs on a flat surface.[2]

Nonetheless, glyphs always appear in such scenes, and texts rather than imagery per se were likely to be the main referent: as in classical Greece, "[w]riting on pots attracts writing," and sculptural "signatures almost never appear alone" (Osborne 2010:246). Another of Stuart's decipherments linked three-dimensional work to a particular artist (Figure 13.1b; Stuart 1989a:154). Here, the Maya employed a term that focused less on technique or variable color than on a more general property of relief—whether incised, carved, or molded—in stone, clay, or stucco (e.g., K3844, K4931, K6538, K8017, K9261).[3] As with the *tz'ihb*, the tag was prefixed by a third-person pronoun and appended the name of the artist.[4] In all such cases, context meant everything. Mayan syntax can lump the maker of an image with its owner—grammar does not clearly distinguish between the two. True signatures are identifiable by their occurrence at the end of texts or when floating in a visual field, disconnected from other passages. The names of owners or patron occur nearby in longer, more obtrusive statements.[5] Often they are in elevated blocks that are closer to the viewer's eye. The names of artists are only rarely dynastic ones; they tend to employ titles of literati or, at a few sites, occur on several works (see below). The chance that they are mere tags for patrons or workshops is made implausible by such titles, personal names, and by multiple occurrences with other sculptors' names. The idiosyncrasy of these references and their varying styles of carving, as on El Peru Stela 34 in Guatemala, betoken anything but generic allusion. In addition,

a

figure 13.1
Introductions to signatures: a) *u tz'ihb*, "his painting" (Hellmuth Archive, Dumbarton Oaks © President and Fellows of Harvard College, Peabody Museum of Archaeology and Ethnology); and b) "his carving" (University of Pennsylvania Museum Archives © University of Pennsylvania Museum, University of Pennsylvania.)

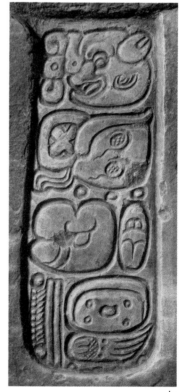

b

the larger the monument the greater the likelihood of multiple signatures—presumably to expedite a more elaborate commission.[6] That, too, would signal the involvement of individual sculptors, not collective entities.

Stuart's insights led to other studies (e.g., Herring 1998; Montgomery 1995; Tate 1994; Van Stone 2005), yet many details continue to be unclear. For example, the expression for "carving" has several transparent elements—**yu**, **lu**, **IL/li**—and one that is opaque, the head of a bat. The first glyph offers both a possessive, prevocalic pronoun in the third person and the initial vowel of the word for "carving."[7] A proposed reading for the head is **xu**, with a plausible outcome of *yuxul*, "slicing, cutting," for the entire spelling (Looper 1991, citing Nikolai Grube).[8] The problem is that certain examples, including early ones, throw doubt on spelling order. Contrary to the proposed reading, they frequently place the **lu** syllable before the supposed **xu**. It may be that another term, found in Yukatek Maya as *yul*, "polish, make smooth, make lustrous," is closer to the original, albeit with details to be elucidated, including the bat head itself (Barrera Vásquez 1980:982).[9]

A third decipherment, reported by Nikolai Grube (1998), bridges the painter and sculptor's signatures. It consists of a third phrase, *cheheen* or *che'een*, "it is said." This emphasizes content and casts writing as an act of speech, a nod to its essential bond with orality. In a sense, the phrase identifies an author—the craftsman of an utterance and not merely a maker—a feature stressed, too, in signed vases of classical Greece (Steiner 2007:72–73; Svenbro 1993:41–43, 164).[10] Another nuance is that it appears to reflect the very cusp of transmission from mouth to written record. One pot makes this overt by declaring, *cheheen "God D" ti-4-te' Chuween*, "so says God D to the 4 monkeys," a set of beings ties to scribal craft. A separate set of creatures—a dog (*ook*), opossum (*uch*), and vulture (*us*)—appear to peruse written materials below, including a book or number-scroll (Figure 13.2). Two examples on pots tie *cheheen* to the status of "wise" or "skilled person," '*itz'aat* (Robiseck and Hales 1981:33, also K5453, '**i-tz'a-ti SAK-MO'-'o** and

figure 13.2
Cheheen statement (Chuween Vase). (Drawing by Stephen Houston, after http://www.mayavase.com /God-D-Court-Vessel.pdf.)

'['**i**]**tz'a-ti AJ-'Ch'en-month**'), another to a painter (K1775). Sculpture, too, had several such statements that linked carving to speech and titles of knowledge and discernment, as on Ceibal Hieroglyphic Stairway 1 and Itsimte Stela 7 (e.g., Graham 1996:61).

A Quill of Scribes

The number of known calligraphers' signatures is limited (n=17; Figure 13.3 and Table 13.1; Houston 2000:152, fig. 4; Just 2012:132–153, 185–189; Stuart 1987:5–8, figs. 6–12; Tokovinine and Zender 2012:60–61, table 2.2). The list might be extended slightly if it included those examples after *cheheen* statements (see above). Two occur in rim or in basal bands, earmarked for rapid detection and tied glyphically to the owner of a pot (#3 and #15 in Table 13.1 and Figure 13.3). Others materialize in the image below; they are separable from other captions only because they do not match any particular figure (#6, #7, #8, #9, #12, #13). Their presence implies a participatory role much like that of other named figures, if usually at the end of texts or in interstitial spaces at the margins of scenes. Nearby is usually the lowest-ranking person within the image. Denied a place in imagery,

a

b

c

d

e

f

g

h

i

j

k

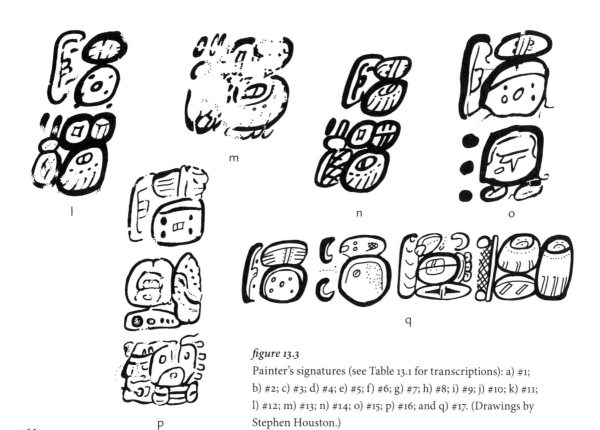

figure 13.3
Painter's signatures (see Table 13.1 for transcriptions): a) #1;
b) #2; c) #3; d) #4; e) #5; f) #6; g) #7; h) #8; i) #9; j) #10; k) #11;
l) #12; m) #13; n) #14; o) #15; p) #16; and q) #17. (Drawings by
Stephen Houston.)

table 13.1
Calligrapher signatures

PROVENIENCE	LOCATION IN TEXT	TRANSCRIPTION	DATE
1. JOL	Group 4, P6:A1–A3	?-?	Late Classic
2. NJT	D88:B9	ni-chi-K'AHK'	692 CE
3. CV	J1–K1	?-bu	ca. 700–750 CE
4. K1484	Q3–T1?	IK' 'i[tz'a] ti YAX ch'a?-k'a K'INICH	ca. 700–750 CE
5. K2295	K1–K5	'a-IK'-'a? OCH-K'IN-ni 7-tzu[ku]	ca. 700–750 CE
6. K2784	T1–V1	ku-lu ba?	ca. 726 CE
7. TV	I1–I5	ku?-lu ba ?K'ABA' ?-?-ma	ca. 726 CE
8. K1599	H1–J1	AKAN SUUTZ'	735 CE
9. NJT	D66:J1–N1	WAY?-si-ma-la KAN-na a-ku ch'o-ko	754 CE
10. K791	U1–W1	?-na 11 la-ja	755 CE
11. K793	H1	?-na	ca. 755 CE
12. K5418	N1–N2	tu-ba-AJAW	756 CE
13. K1463	Q1–Q2	tu-ba-AJAW	765 CE?
14. K3054	M1–M2	tu-ba-AJAW	768 CE
15. NGV	K1–K2	3-IK'-wa	ca. 760 CE
16. K7750	E'1–E'3	l o-'o-TOOK' AKAN-xo-ko	ca. 770 CE
17. K635	D'1–G'1	ya-li-? le-TI'-'i[tz'a]-ti AJ-ma-xa-ma	ca. 790 CE

JOL = Jolja'; CV = Chuween Vase; TV = Throckmorton Vase; NJT = Naj Tunich; NGV = National Gallery of Victoria

they still take credit for the painting and shift slyly into a scene with dynastic actors. With two exceptions, all such signatures come from a relatively small area, the eastern Peten of Guatemala. Two-thirds (n=11) relate in some way to the so-called Ik' dynasty, a family that flourished in the eastern half of Lake Peten Itza.[11] These royals governed a series of sites that include Motul de San José and, probably, the less-explored settlements of Flores, Nixtun-Ch'ich', and Tayasal (Halperin and Foias 2010:398–405). Of these texts, several represent the probable commissions of Ik' painters by foreign kingdoms (#3, #4, #5). Three others show work *for* the Ik' dynasty by painters of lordly rank from the foreign site of **tu-ba** (#12, #13, #14). Yet others are Ik' commissions that, for unknown reasons—gifts of state?—highlight foreign lords (#6, #7). Two other pots were made for the Ik' dynasty yet do not overtly tag the origin of the painter (#10, #11). The pots' chemical diversity suggests different places of manufacture, although only two pots with signatures have chemical assays, of which both belong to the so-called Motul Group 2 (Reents-Budet et al. 2012:90–93, table 3.2). On vessels, five accompany mythic scenes (#3, #4, #10, #11, #16), seven purely dynastic images, all from little more than a thirty-year period (#6, #7, #8, #12, #13, #14, #15), and two appear in vessels with vegetal motifs and angled texts (#5, #17).

Thus, a relatively small region assigned extraordinary credit to master painters. In comparison, not one scribe is named for other distinguished traditions, such as the "codex-style" vessels of northern Guatemala and southern Campeche (e.g., Robicsek and Hales 1981). For Greek pots, Beazley noted a similar pattern, in which most such names were attested only once (Beazley 1946:34–35); some, such as the Copenhagen painter, signed, it seems, with great reluctance, and then to highlight unusual productions, including scenes that deviated from the Athenian norm (Pevnick 2010:242–243). There are no identifiable painters for an ambitious production like the Bonampak murals (Miller and Brittenham 2013). Notably, too, the glyphic dates of the Ik' pots spread across little more than forty years. This span is plausible for one or two generations of painters

that almost certainly knew each other or trained in the same ateliers. A burst of crediting helps scholars recover their names. But this must be seen as a selective novelty. Other pots can be credited to certain painters, yet most Ik'-style ceramics (many dozen exist) have no such signatures. Two of the painters appear on multiple vessels (**tu-ba-AJAW** and **?-na**).[12] This could be a matter of sampling—all of the pots were retrieved by grubbing looters, not archaeologists, and many more such finds remain to be made. However, it could also hint at some special distinction, including an acknowledgment of rare ability or, in the case of **tu-ba-AJAW**, lordly status.[13]

Signatures not directly related to the Ik' dynasty fall into several categories. One pot may be from the area of the Petexbatun, in southeastern Peten. Its date, however, along with its varied tones and precise quality of line match those of the Ik' pots (#8). A second category consists of those from the area of Naranjo, Guatemala, some 70 kilometers from Motul de San José. The texts in this category follow the same structure: (1) the names of the owner, a ruling king of Naranjo; (2) his mother, a foreign princess; (3) the local father, an earlier ruler of Naranjo; and, in final flourish, (4) the autograph of the calligrapher (#16, #17). One painter, said to be an *itz'aat*, a "wise person," is assigned to the physical location of Naranjo (#17, **AJ-ma-xa-ma**, *Aj maxam*; Stuart and Houston 1994:21, 23, fig. 23).[14] The other vessel reveals that the mother of the Naranjo lord came from the **tu-ba** dynasty that offered a painter for Ik'-site productions (#14). As with the Ik' vessels, the Naranjo texts show a restricted span, in the neighborhood of twenty years.

A final set comes from caves. One is from Jolja' in Chiapas, far distant from the other examples (Bassie 2002). Its details are barely legible, but, to judge from diagnostic spellings on texts painted nearby (e.g., **u-ba-hi** and **le-ke?-HIX**), there can be no doubt of its Late Classic date. More exactly fixed in time are two other cave texts, Naj Tunich Drawings 88 and 66 (#1 and #9), dating, respectively, to 692 and 754 CE. The first involved an illegible action but seemingly took place under the auspices of Caracol, and the other occurred at an unidentified site known as **ju-t'u**.[15] The event was a

visit to the cave by a lord who may have come from Xultun, Guatemala, the painting being made by a younger brother or offspring of that ruler.[16] A longer text, Drawing 23, records a visit to the cave in the following year by the same party, now joined by a third male, possibly from Xultun (Stone 1995:fig. 8-28). The painter is clearly identified as a "youth," *ch'ok*—as we shall see, a common epithet for sculptors—and as an *'itz'aat*, a "wise" or skilled person. Around the corner of the cave floats a third autograph, a single text without explanatory date or event (Stone 1995:fig. 8-30). Only the princely painter of **tu-ba** has comparable status, among the most telling evidence yet found for the exalted rank of certain painters. In contrast, the other calligraphers are identified by generic epithets tied to place or talent (the *Ik'-'itz'aat* [#3] and *. . .'itz'aat Aj Maxam* [#17]), or by personal names unattested in dynastic settings. The compressed timing of these vessels, which becomes more noteworthy when the Ik' pots are set apart from those at Naranjo, confirm that calligraphic autographs involve a few people of close acquaintance. Authorized by a handful of kings, it was a fashion more ephemeral than most.

The Company of Carvers

There are at least 114 carvers known from the Classic period (Table 13.2).[17] This number is sure to be low, not least because certain texts may be signatures but are illegible or their sculptures fragmentary. Autographs can be detected when prefixed by the "bat" expression with possessive pronoun, although a few examples, as on the New Orleans Panel or Itsimte Stela 8, appear to float on a visual field without need of such cues. It is the presence of *'itz'aat* titles or complementary evidence from other monuments where they are identified as sculptors that makes the identification likely. These signatures contrast with the more impersonal use of "sculpture" or "carving" in three contexts: (1) as a possessed object in the formulae known as the Primary Standard Sequence (always with the –li/IL suffix used in inanimate

possession); (2) as a verb or verb-like phrase; and (3) as a carved stone owned by a particular ruler. The first are abundant (see, for example, the earliest known instance, on Resbalon Hieroglyphic Stairway 3, Step A, also Ek' Balam Miscellaneous Text 2, Lacadena García-Gallo 2004:fig. 24, and a plural example in the Museo Popol Vuh, #2005-0032); examples of the second include the Emiliano Zapata Panel (**'i-u-'BAT'[lu]ji**, Stuart 1990) and the El Palmar Hieroglyphic Staircase at the Guzmán Group (**u-'BAT'[lu]-ja**, Tsukamoto and Esparza Olguín 2014). The third is featured on sculptures like Tonina Monument 146 (Figure 13.4, **yu-'BAT'[lu] K'AN-TUUN-ni**, Graham et al. 2006:79, position E1).[18]

Without exception, every signature dates from the sixth century CE on. The earliest may be on El Zotz Stela 1 or an unprovenienced carved bone, although their exact dates are unclear. One such case has all the features that would appear later. Inscribed on a lapidary object, the text tucks under the tail of an elderly deity in a shell (Figure 13.5, and see below; Easby 1966:no. 446; Hellmuth 1987:figs. 706–709). The name of the carver begins with a reference to his craft, **AJ-'BAT'[lu]**, and his patron's names and title follow (see below). The last example dates to 864 CE, appearing as two texts flanking the main figure (Figure 13.6; Miller and Martin 2004:fig. 51). With a pronounced flourish, the texts flank and dominate the figure at the center of the image. The distribution of the autographs in spans of fifty years shows an accelerating trend, with a disproportionate number in the final half of the eighth century (five in 550–600 CE; two in 600–650 CE; ten in 650–700 CE; nine in 700–750 CE; twenty-four in 750–800 CE; four in 800–850 CE; and one in 850–900 CE). Nine occur in a single decade, from 780 to 790 CE, if at a variety of sites. Notably, the signatures concentrate in the records of a few dynasties. Most come from the area of the middle Usumacinta region or points nearby; a scattering exists in other parts of the Peten. Celebrated for their carvings, the dynasties of Caracol, Copan, Dos Pilas, Quirigua, Tikal, Tonina, and Xultun appear to have no interest in acknowledging their sculptors. A few, such as Calakmul and Naranjo,

table 13.2

Sculptor's autographs on dated monuments, with number of sculptors (n=114+)

DATE	MONUMENT	DATE	NUMBER
December 6, 573 CE	El Zotz Stela 1	*9.7.0.0.0 7 Ajaw *3 K'ank'in	1
December 6, 573 CE	ARP St. 6	9.7.0.0.0 *7 Ajaw * K'ank'in	1
December 6, 573 CE	Los Alacranes Stela 1	(9.7.0.0.0 7 Ajaw) 3 K'ank'in	1?
May 18, 587 CE	BPK Lin. 4	(9.7.13.11.11) 4 Chuwen 4 Zotz'	1
May 10, 613 CE	Campeche Museum stela	9.9.0.0.0 3 Ajaw 3 Zotz'	1
May 13, 613 CE	ARP St. 1	9.9.0.0.0 3 Ajaw 3 Zotz'	1
September 23, 614 CE?	BPK Panel 4	(9.9.1.7.1) 10 Imix 19 Yax	1
November 20, 651 CE	La Corona HS 2, Block 8	(9.10.19.1.10) 7 Ok 3 K'ank'in	1?
October 12, 652 CE	PNG St. 34	(9.11.0.0.0) 12 Ajaw 8 Keh	3?
October 9, 658 CE	PNG Panel 4	(9.11.6.1.8) 3 Lamat 3 Keh	1?
August 21, 662 CE	Río Azul St. 2	9.11.(10.0)0 11 Ajaw (18 Ch'en)	1
September 6, 668 CE	Deletaille Panel	(9.11.16.18.2.8) 9 Lamat 16 Yax	1
June 29, 672 CE?	PRU St. 31	(9.12.0.0.0) *12 Ajaw 8 *Ceh	1?
February 23, 681 CE	YAX Lintel 45	(9.12.8.14.1) 12 Imix 4 Pop	1
April 12, 687 CE	PNG St. 6	9.12.15.0.0 2 Ajaw 13 Sip	7
March 16, 692 CE	PRU St. 34	(9.13.0.0.0) 8 Ajaw 8 Wo	8?
March 16, 692 CE	PAL Death's Head	(9.13.0.0.0) 8 Ajaw 8 Wo	1
January 23, 702 CE	PRU St. 43	(9.13.10.0.0) 7 Ajaw (3 Kumk'u)	1?
October 25, 709 CE	YAX Lintel 24	(9.13.17.15.12) 5 Eb 15 Mac	1
November 15, 713 CE	YAX Lintel 46	*9.14.1.17.14 5 Ix 17 K'ank'in	1
June 22, 726 CE	YAX Lintel 26	*9.14.14.13.16 5 Kib 14 Yaxk'in	1
August 19, 731 CE	CLK St. 51	(9.15.0.0.0 4 Ajaw 13 Yax)	2?
August 19, 731 CE	CAY Alt. 4	(9.)15.0.0.0 4 Ajaw 13 Yax	1
December 27, 733 CE	DO:K2–3	(9.15.2.7.1) 7 Imix 4 K'ayab	1
July 13, 738 CE?	NPT St. 2	(9.15.7.0.0 2 Ajaw 18) Mol	1
June 27, 741 CE	PRU St. 27	9.15.10.0.0 3 Ajaw *3 Mol	4?
ca. May 6, 751 CE	"San Lucas" Stela	c. 9.16.0.0.0 2 Ajaw 13 Tzek	1
March 14, 761 CE?	PNG St. 14	(9.16.10.0.0 1 Ajaw 1 Sip)	6
March 14, 761 CE	ITS St. 8	(9.16.10.0.0) 1 Ajaw 1 Sip	1?
March 21, 764 CE?	Stavenhagen Panel	(9.16.13.1.3) 11 Ak'bal 11 Sip	2
January 21, 771 CE	PNG St. 13	9.17.0.0.0 13 Ajaw 18 K'umk'u	3
January 21, 771 CE	ITS St. 7	(9.).17.0.0.0 13 Ajaw 18 K'umk'u	1?
ca. January 21, 771 CE	MTL St. 2	(9.17.0.0.0 13 Ajaw 18 Kumk'u)	3?
December 8, 771 CE	"La Pasadita Lin. 4"	(9.17.0.16.1) 9 Imix 14 Pax	1
ca. December 8, 771 CE	Metropolitan Mus. Pan.	(9.17.0.16.1 9 Imix 14 Pax)	1
November 29, 780 CE	BPK St. 1	*9.17.10.0.0 13 Ajaw 18 Kumk'u	3
March 25, 782 CE	PNG Pan. 3	(9.17.11.6.1) 12 Imix 19 Sip	3?
August 20, 783 CE	Kimbell Panel	(9.17.12.13.14) 5 Ix 7 Zac	1

DATE	MONUMENT	DATE	NUMBER
February 5, 784 CE	NAR St. 14	9.17.13.4.3 5 Ak'bal 11 Pop	1
November 3, 785 CE	PNG Thr. 1	(9.17.)15.0.0 5 Ajaw 3 Muwan	2
November 3, 785 CE	PNG St. 15	*9.17.15.*0.*0 *5 Ajaw * 3 Muwan	4
November 3, 785 CE	La Mar St. 1	(9.17.15.0.0) 5 Ajaw 3 Muwan	2?
January 5, 787 CE	BPK Lin. 2	(9.17.16.3.8) 4 Lamat 6 Kumk'u	1

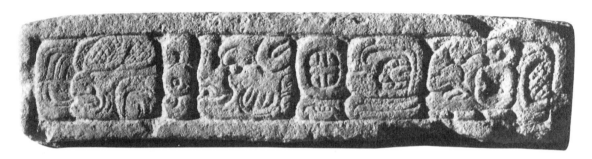

figure 13.4
Tonina Monument 146 (Graham et al. 2006:79 © President and Fellows of Harvard College, Peabody Museum of Archaeology and Ethnology.)

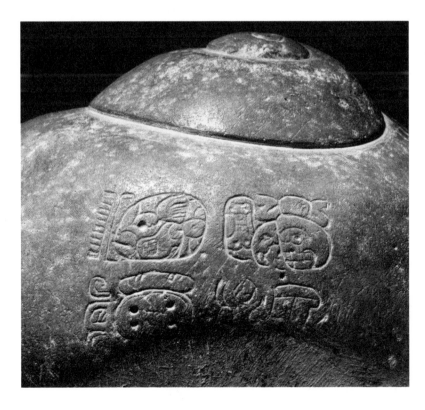

figure 13.5
Sculptor's name, stone effigy, 2013-78 a-b, Princeton University Art Museum. (Photograph courtesy of Bryan Just.)

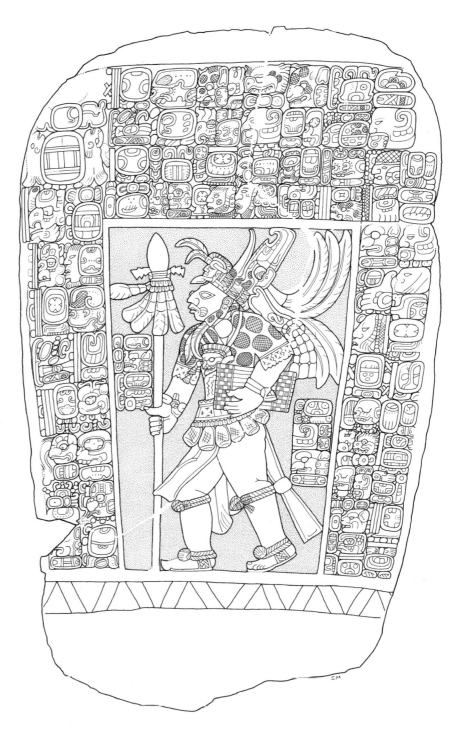

figure 13.6
The Josefowitz
Stela. The
signature appears
to either side
of the figure.
(Drawing by
Simon Martin.)

mention only a few artisans, although at Calakmul, as at Xultun, the problem could be the poor preservation of stelae. The royal family of Dos Pilas, an offshoot of Tikal's, began like its cousins with a studied avoidance of signatures. By the end of the dynasty, especially at the secondary capital of Aguateca, the final ruler refers to a number of sculptors. Proximity made no difference. Dos Pilas had no autographs, while the adjacent family of Arroyo de Piedra and Tamarindito, only a few kilometers away, recorded several. In this respect, there is less a unitary history of signing for the Classic Maya than site-by-site histories responding to local circumstance. This pattern accords with the wayward trajectories of signatures in classical Greece (Osborne 2010:243, tables 1–3).

figure 13.7
Sculptor's signature cut into belt ornaments of a queen, El Peru Stela 33. (Photograph by Ian Graham © President and Fellows of Harvard College, Peabody Museum of Archaeology and Ethnology.)

Classical epigraphers refer to the practices of *ordinatio*, the preparation and arrangement of text on a surface (Keppie 1991:12). Most autographs on Maya carvings display a certain reticence, a melting into the background. Often incised, flush with the surface, they require close proximity to be seen. Almost all were cut as short texts to the side of royal bodies, interspersed on recessed areas, and squeezed into small spaces not otherwise obscured by royal clothing or dress. A few invade personal space, as on the belt ornaments of queens at El Peru, Guatemala (Figure 13.7). These names appear right over the groin, hinting at some gendered or even erotic connotation; two other signatures, on a stela at the Museum aan de Stroom in Antwerp (MAS.IB.2010.017.083), flank and almost protect the figure of a queen. A ranking within multiple signatures on a monument is suggested by a slight border around the name of one sculptor—the New Orleans Panel from the area of Piedras

Negras distinguishes itself in this manner—as well as by higher position on the monument or closeness to the face (see below, for detailed evidence from Piedras Negras). The New Orleans Panel, Itsimte Stela 8, and Piedras Negras Panel 3 are distinctive in another respect: the reader is expected to understand that the names are signatures without any name tag to show such credit (Figure 13.8). There is no explicit marking other than the use of such titles as "**ba-'BAT'-lu**," "head carver," by the name of the first sculptor listed on Piedras Negras Panel 3 or, on the New Orleans Panel, "he of the carving." Itsimte Stela 8 simply refers to some of the sculptors as *'itz'aat*, "wise" or "knowledgeable man."

The names of sculptors exhibit a number of patterns. Many rulers use theonyms, deity names that reflect some aspect of a god (Colas 2004:133–141). These are attested for sculptors, with one special emphasis: many carvers in the Usumacinta were identified with Chahk, the ax-wielding god

figure 13.8
Itsimte Stela 8; the signatures are dispersed in upper half of carving. (Photograph by Kenneth Garrett.)

(Table 13.3; Sculptors 27, 31, 35, 36, along with Yaxchilan Lintel 45, 46). The link between a sculptor and a deity associated with this implement, a probable allusion to lightning strikes by Chahk, may not be coincidental, although it is equally possible that the name reflects some family association among carvers. Another theonym, of a *ch'ok ajaw* or "young lord" on El Cayo Altar 4, records "Turtle Born in the Sky." His title ties him to Piedras Negras, and there is a solid chance that this name, "Turtle" being common in that dynasty, marks him as a younger member of the royal line. What draws special attention is that theonyms are ordinarily applied to kings; the appearance here hints at the high status of carvers. Other names stress birds: macaws (*ye' mo'*, "macaw beak," Itsimte Stelae 7, 8); a hummingbird (*tz'unun*, Deletaille Panel); a raptor (*muwaan?*, Calakmul Stela 52); even a turtledove (*mukuuy*, El Peru Stela 34). A final feature is that at least two use numbered days as names (4 Ajaw [Museum aan de Stroom Stela], 5 K'an [Palenque Death Head]). This practice is well attested in Mesoamerica, among the colonial-period Maya in particular, and in three other Classic-era texts (Campbell 1988:373, 376; Palenque Initial Series Vase [6 Kimi], Palenque-area Notre Dame Panel [Aj-Ajaw], Naj Tunich Drawing 65). It may reflect a widespread sort of name that generally failed to surface in elite records.

figure 13.9
Middle sculptor's autograph on Motul de San José Stela 2. (Photograph by Ian Graham © President and Fellows of Harvard College, Peabody Museum of Archaeology and Ethnology.)

The signatures contain a range of more general titles, too. Several sculptors are said to be *ch'ok*—that is, under or close to twenty years old (see Table 13.2; El Cayo Altar 4; El Peru Stela 34, Naranjo Stela 12; Piedras Negras Stela 12; "San Lucas" Stela; Yaxchilan Lintel 45). This milestone implies that the capacity to carve a stela came early to the Late Classic Maya, involving apprenticeship at a young age. Most such sculptors did not work alone, however, and usually are listed with other sculptors or companions—Yaxchilan Lintel 45 is one of the only exceptions.[19] Perhaps an important commission could not be trusted to a stripling. The youth could be exalted in rank, as on El Cayo Altar 4 and, especially, Motul de San José Stela 2 (Figure 13.9). Both held the title of "lord," *ajaw*. The sculptor at Motul was apparently working at his home city; as a particular distinction, his signature sits squarely on the axis of the sculpture. Most current evidence indicates that, in Classic society, an *ajaw* was the offspring of a ruler, perhaps a second son or an heir to the throne, although this is still under debate.[20] *Ajaw* rank is also attested on stelae on Aguateca Stela 7, Arroyo de Piedra Stela 1, and El Peru Stela 34. A remarkable attribute of these figures is that they all come from foreign families— a lord from La Florida(?) helped to carve El Peru Stela 34, another from Tamarindito contributed to Aguateca Stela 7, and Arroyo de Piedra patronized a princely sculptor from *chih-witz*, "hill of the deer" (Figure 13.10).[21] This crafting by the illustrious

figure 13.10
Sculptor's signature on Arroyo de Piedra Stela 1. (Drawing by Stephen Houston.)

figure 13.11
Models of artists's movement. (Drawing by Stephen Houston.)

must have lent prestige to the sculpture itself. It also alluded to a subtle relation of subordination between the two kingdoms.

As for other titles, *'itz'aat* is documented (Itsimte Stelae 7, 8; El Peru Stela 31), along with a title of courtly subordinates, **AJ-K'UH-na** (Bonampak Lintel 4; Museum aan de Stroom Stela). Epithets of skill include a probable reference to the act of polishing or carving, **AJ-yu-lu** (Deletaille Panel; Museum aan de Stroom Stela). Other designations

are less clear in meaning. Texts in the Middle Usumacinta use **xo-ki**, *xook*. It may be related to a term for "shark" but is unlikely to refer to a concept of "counting" in Yukatek Maya—that word is too narrowly diffused to be present in the language of the lowland sites. At Piedras Negras is the equally enigmatic **po-no**, *pon*. Two other titles are linked to carvers: *Sak Ook?*, perhaps connected to a word in colonial Yukatek Maya, *ok*, "head of an ax, adze, or knife" (Barrera Vásquez 1980:585), and *Sak Te'*

a b c d

figure 13.12
"Head-quill," **BAAH-che-bu**: a) La Amelia Panel 1:D4; b) Cancuen Panel 3:H5; c) Uxul Stela 8:glyph 3; and d) Piedras Negras Stela 12:X2. (Drawings by Stephen Houston.)

Ajaw, "lord of the white tree," a label in Ch'ol Maya for a tree, perhaps a pine, used in making the walls of houses (Aulie and Aulie 1978:105).[22] Nonetheless, it is possible, as Simon Martin suggests, that *Sak Ook* was tied specifically to the site of El Palmar, Campeche (personal communication, 2013; see also Tsukamoto and Esparza Olguín 2014), although it might also have been a more general title.[23] At least one sculptor was involved in gathering, storing, and tabulating choice goods, like chocolate. His label, on two stelae at Itsimte, Guatemala, is **Aj-ka-ka-wa**, *Aj kakaw,* "He of the chocolate [beans]" (Tokovinine and Beliaev 2013:fig. 7.9). Not a few signatures also identify the home location of a sculptor. This may have been a foreign place, as in certain sculptors working with a high noble or magnate in the kingdom of Yaxchilan (Kimbell Panel; "Site R" Panel), or a district within a city (see below). One of the principal sculptors of the immense Stela 1 at Bonampak—the sculpture is of uncommon height and width—was known by his home site, "**AJ-ma-ku-'a**," the final element, *'a,* specifying a watery locale. The reference is strangely generic, a specification of place but without any personal name. In this respect, it recalls the **tu-ba-AJAW** calligrapher, who could have been one of many such lords: presumably, many sons of the **tu-ba** king held this title.[24] A curious omission, it is rather like calling Pablo Picasso "the man from Spain" or Vittore Carpaccio "he of Venice," a general epithet standing in for a more specific reference.

Of more expansive interest are the sculptors whose signatures situate them in wider social networks (Figure 13.11). There are six models for conceptualizing such relations. Sculptors could: (1) be employed by their home kingdoms for local, regal commissions; (2) be loaned to subordinate nobles, at sites of considerably smaller size or within the epicenter itself; (3) come from subordinate nobles to serve at their controlling royal courts; (4) pass from one kingdom to another of broadly similar scale; or (5) shift to work at antagonistic kingdoms. A variant sixth pattern, involving work at a politically neutral location, seems only to have concerned painters, as at Naj Tunich Guatemala.[25] The first is almost the default category, the basic presumption in the absence of other evidence. Several sculptors were described as the "head-carving," a pattern in which a person is labeled in connection with a particular object under his or her control or charge: "head-staff," "head-flint," and "head-shield" are also documented (Houston 2014). A sherd excavated at Piedras Negras is quite explicit in saying that such an individual belonged to the last ruler of the site (see below). A comparable expression appears in considerably more sculptures. It involves the expression **BAAH-che-bu**, *baah chehb,* "head-quill" (see Figure 13.12; La Amelia Panel 1, Cancuen Panel 3, and Uxul Stela 8; see also Piedras Negras Stela 12).[26] A particularly intriguing example from Cancuen describes the sculptor as the "head-quill" of the local ruler. Clearly, the sculptor had other, cross-media skills, as did a sculptor at La Amelia. But, more to the point, his role was embedded in courtly service. His marker of salience, "head," employed by sculptors, too, shows something close to a status of primus

'his carving'

u-wi-WINIK-ki

figure 13.13
Block referring to sculptor as *winik*, "servant," Palenque. (Drawing by Stephen Houston, after sketches by Linda Schele and David Stuart.)

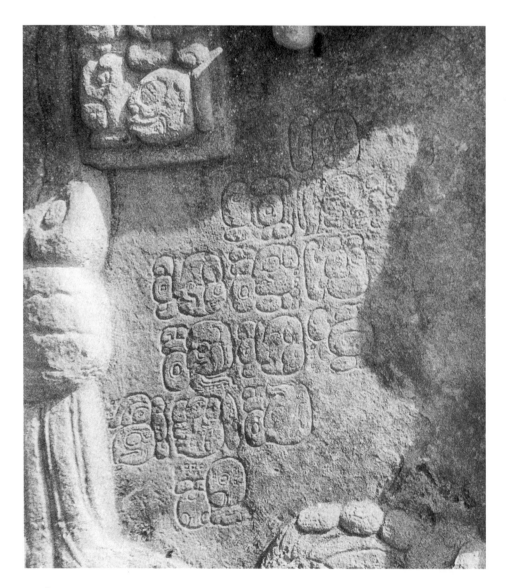

figure 13.14
Sculptors' signatures on Calakmul Stela 51. (Photograph by Ian Graham © President and Fellows of Harvard College, Peabody Museum of Archaeology and Ethnology).

inter pares, "first among equals"—and the status of a master, probably the head of an atelier. Another even more explicit statement was brought to my attention by David Stuart, on a block from the city of Palenque (Figure 13.13). A sculptor, **'i-ka-KAN SAK-TE'-ajaw**, is described as the "servant," or *winik,* of the current ruler, Kan Bahlam.

The second model—sculptors sent to subordinate nobles—will be discussed below, with Piedras Negras. The third, sculptors coming from subordinate sites to governing courts, is suggested by the elaborate set of signatures on Calakmul Stela 51 (Figure 13.14). The titles of the sculptors, *Sak Wayis* and *K'uhul chatahn winik,* correspond to several areas under the control of Calakmul. In this instance, one glyph resembles a place name linked to the site of Uxul, Campeche (Grube 2005:fig. 6). The fourth model, of sculptors loaned to friendly if slightly subordinate kingdoms, can be deduced by a formula that appears on many signatures: the tag for "carving" or a title that reveals a link to carvers, followed by the name of the sculptor, then a possessed expression, *anabil.* It concludes with the name of a foreign patron. The meaning of *anabil* is perplexing; two possibilities make the most sense. A common title of Maya courtiers was **Aj-na-bi**, with close to the same sequence of glyphs. The sculptor would thus be a courtier, although the meaning of the term is not fully explained: a person linked to water-lilies, *nahb*? A text from the Naj Tunich cave would seem to favor some connection to the title, for it follows **AJ-na-bi** with a **ya-na-bi-IL**, the latter a clear possessed form of the former (Stone 1995:fig. 8-29, drawing 29). Yet there is another possibility, with its own attraction. Colonial Tzotzil Maya, which has a particularly rich lexical source, also uses the word *'an* for "hew, carve," and *'anob,* cognate with *anab,* for an instrument used by carvers (Laughlin 1988:1:136). If applicable, this term would characterize the sculptor as an *instrument* of the ruler, who retains his role as the patron and ultimate creator of messages.

The *anab* statements do occasionally occur within kingdoms. A sculptor at *Pomoy,* a site in Tabasco, is said to be the *anab* of an *'itz'aat* and a courtier (Figure 13.15; Museum aan de Stroom Stela; Le Fort 1995). This second figure may have been of

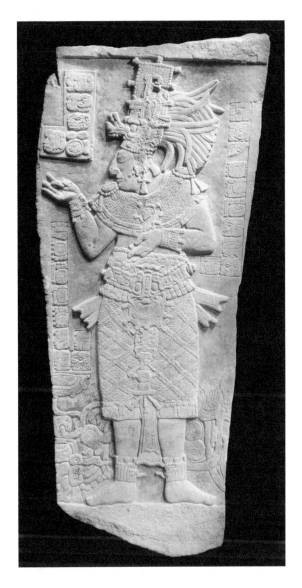

figure 13.15
Anab expressions on Pomoy stela. Signatures flank the standing queen. (Photograph by Roger Asselberghs.)

advanced age—between sixty and eighty years old.[27] On the same stela is the more usual *anab* statement of a sculptor said to belong to the queen depicted on the monument. Naranjo Stela 12 displays another such internal reference to *anab.* More revealing are the statements that show the loan of a sculptor by one ruler to another. Two such examples appear at Bonampak, each belonging to Shield Jaguar IV of Yaxchilan (Figure 13.16; Bonampak Stela 1, Lintel 2). The family of Bonampak had acquired a princess from Yaxchilan, which explains such ties, and felt

ya-na-bi

b

a

figure 13.16
Anab statements: a) Bonampak Stela 1; and b) Bonampak
Lintel 2. (Photographs by Michael Coe, with permission,
and Hans Ritter, courtesy of Mary Miller, Bonampak
Documentation Project.)

figure 13.17
Back of Piedras Negras Throne 1. (University of Pennsylvania Museum Archives © University of Pennsylvania
Museum.)

figure 13.18
Panel made by *Chakjalte'*, from
area of La Pasadita, Guatemala,
The Metropolitan Museum
of Art, 1979.206.1047. (© The
Metropolitan Museum of Art /
Art Resource, New York.)

an apparent need to involve the ruler of Yaxchilan as a witness to certain ceremonies: the Initial Series text in the Murals Building at Bonampak makes this clear. In what must have been an intentional gesture, the sculptor from Yaxchilan is also highlighted on the very lintel at Bonampak that portrays his ruler, Shield Jaguar IV. The remaining *anab* statements underscore a loan to Yaxchilan from an unidentified kingdom (Yaxchilan Lintel 46), and another eroded example appears on Cancuen Stela 1.

Of the fifth model, a sculptor who worked in enemy kingdoms, there is but one clue. A sculptor responsible for two unprovenienced panels from the kingdom of Yaxchilan reveals by his toponymic title, *Aj K'in'a*, that he comes from the highly antagonistic polity of Piedras Negras (Kimbell Panel, "Site R" Panel; Zender 2002). This case is so anomalous as to suggest that the practice was infrequent. At this level of skill, it was the rare sculptor who escaped his ruler's control. One of the sculptures is worth mentioning for another reason. The signature on the Site R Panel peeks out from the eyes

of an emblem for *witz,* or "hill." This may answer a long-standing question about the identity of two, now mutilated, faces that peer out from the *witz* at the back of Piedras Negras Throne 1 (Figure 13.17). The pairing is a puzzle, for they cannot correspond to the name of a single magnate inscribed in a rectangular block above. Conceivably, these were the heads of that magnate, a favorite of the king, in conversation with his lord, the final ruler of Piedras Negras (Houston and Inomata 2009:181–182, fig. 6.12). Alternatively, the heads match the sculptor's tags to either side and thus represent unique formal portraits of two artisans on a public monument.

To write of sculptors is to take account of their oeuvre. Yet the number of different monuments made by the same carvers is limited, at least to judge from overt glyphic evidence. The consistency of style in some carvings with many sculptors, such as Piedras Negras Stela 12, raises daunting odds against discerning these "hands" from style alone; other texts, as at Palenque and Copan, may be more susceptible to study (Van Stone 2005). The examples

a

b

figure 13.19
Sculptor's name on Itsimte Stela 7 (a) and 8 (b). (Photographs by Alexandre Tokovinine [a] and Kenneth Garrett [b].)

from the Kimbell and Site R Panels are one such set of a glyphically identifiable oeuvre—more will be discussed below from Piedras Negras. Yet another is attested by a panel in the Metropolitan Museum of Art (Figure 13.18), to be paired with a looted panel from what was most likely a Guatemalan site. Both date to the reign of Shield Jaguar IV and were carved by someone named **CHAK-ja-la-TE'**, *Chakjalte'*. The same name occurs on the far earlier Yaxchilan Lintel 45, but the gap in time affirms that it could not have been the same sculptor. A final oeuvre is found on Itsimte Stela 7 and 8, separated by ten years. The sculptor was named **ye-'e-MO-'o**—*Ye'mo'*, perhaps "Macaw's Beak"—and seemed to carve in unusually full relief (Figure 13.19). Curiously, he chose to specify a glottal stop in one of his spellings and not in the other—in others words, the sculptor did not fix on one inflexible means of writing his name.

The City of Sculptors

Almost a third of known sculptors come from the site of Piedras Negras, Guatemala (see Table 13.2). At least forty-two sculptors are attested there or at closely related sites, including La Mar, across the Usumacinta River in Mexican territory, and a number of subsidiary centers governed by individuals of noble *sajal* rank (Tables 13.3–13.5; see also Montgomery 1995). The erosion of some carvings makes it likely that there were more such sculptors'

table 13.3
Sculptor's names at Piedras Negras and subsidiary sites

SCULPTOR NUMBER	TRANSCRIPTION	PROVENIENCE	DATE
Sculptor 1	?AJ-?-? ?	St. 34:Fp2–3	October 12, 652
Sculptor 2	? ?-?	St. 34:Fp5–6	October 12, 652
Sculptor 3	?ch'o-ko ?	St. 34:Fp8-9	October 12, 652
Sculptor 4	?-?-?-?	Pan. 4:B'1	October 9, 658
Sculptor 5	?chu-? ?-'BAT'	St. 6:F2–3	April 12, 687
Sculptor 6	?-'MIRROR'-?-? SAK-?lu-?	St. 6:G2–3	April 12, 687
Sculptor 7	AJ-5-?-ni JOY-BAHLAM	St. 6:H2–3	April 12, 687
Sculptor 8	KAN-NAL-'MIRROR' chi-?-? ?-?-NAAH	St. 6:I2–4	April 12, 687
Sculptor 9	K'AWIIL AJ-?-?ba-?	St. 6:J1–3	April 12, 687
Sculptor 10	SAK-pa-chi K'UK' 3-BAAH	St. 6:K2–4	April 12, 687
Sculptor 11	SAK-BAHLAM-ma AJ-?-?	St. 6:L2–3	April 12, 687
Sculptor 12	SIH-ya-KAN-na a-ku-ch'o-ko K'IN-ni-AJAW	CAY Alt. 4:D1–E1	August 19, 731
Sculptor 13	?na-?ma-?nu (?mo)AJAW	DO:K2–3	December 27, 733
Sculptor 14	?-K'AWIIL-TI' ch'o-ko JOM-ma to-?chu	St. 14:E1–I1	March 14, 761
Sculptor 15	WAK-pu KAN-na-K'AWIIL mo-?chu	St. 14:J2–4	March 14, 761
Sculptor 16	?-?si-ya ? ?-mo-K'UK'	St. 14:K2–4	March 14, 761
Sculptor 17	WITE'-NAAH ?-? AJ-?-?	St. 14:L2–4	March 14, 761
Sculptor 18	a-?-la ?-? ?	St. 14:M2–4	March 14, 761
Sculptor 19	ko-to-lo tz'i-ba ?-?	St. 14:O1–2	March 14, 761
	ko-to-lo tz'i-ba po-no	St. 13:E2–4	January 21, 771
Sculptor 20	TE'-la-ja ?	St. 13:F2–4	January 21, 771
	TE'-la-ja ?-K'AWIIL mo-?chu	Thr. 1:Q'2–4	November 3, 785
Sculptor 21	ya-ja-wa KALOOM-TE' ?K'UK-?NAB-TE'	St. 13:G2–4	January 21, 771
	ya-ja-wa KALOOM-TE' ?-? bi-AJ-u-'BAT'-lu	Pan. 3:B'5–C'5	March 25, 782
	ya-ja-wa KALOOM-TE'	St. 12:M2–3	September 12, 795
Sculptor 22	ba-?-ja-? 3-?-? ja-?-?-?	SP:J1–L1	August 4, 780?
Sculptor 23	?-?-? ?-?-?-? ?-?	SP:M2–M4	August 4, 780?
Sculptor 24	?cha-? po-no ? ?-?	Pan. 3:B'2–C'4?	March 25, 782
Sculptor 25	...AJ-bi-?k'i-la	St. 15:?–?E4	November 3, 785
Sculptor 26	KAN-ch'o-ko wa-WAY(bi) xo-ki	St. 15:F2–4	November 3, 785
	KAN-ch'o-ko wa-ya-WAY(bi)	Alt. 4: Support 1	?
	KAN-ch'o-ko wa-ya-WAY(bi) AJ-u-'BAT'(lu) xo-ki	NO:E'1–4	June 19, 792?
Sculptor 27	5-KAN-?NAL cha-ki ?	St. 15:I2–4	November 3, 785
	5-KAN-na-la ?-? xo-ki AJ-u-(lu)?	NO:G'1–J1	June 19, 792
Sculptor 28	a-sa-na wi-WINIK tu-ba AJ-u-'BAT'(lu)	St. 15:H1–5	November 3, 785
Sculptor 29	CH'OK-ko 'EYE'-IL	St. 12:L2–3	September 12, 795

table 13.3—continued

SCULPTOR NUMBER	TRANSCRIPTION	PROVENIENCE	DATE
Sculptor 30	CHAK-?-?-lo U-ko-'o-ma po-no	St. 12:P2–4	September 12, 795
	CHAK-?-?-lo U-ko-'o-ma po-no	Altar 4, Support 1?	
Sculptor 31	?wa-ja-ta na-cha-ki AJ-bi-k'i-la ba-u-'BAT'(lu)	Pan. 3:B'1–C'2	March 25, 782
Sculptor 32	1-na-ta 'o-mo-tzi AJ-bi-k'i AJ-u-'BAT'(lu)	St. 15:F1–5	November 3, 785
	1-na-ta 'o-mo-tzi AJ-bi-k'i-la	St. 12:E2–4	September 12, 795
	1-na-ta-'o mo-tzi AJ-bi-k'i-la	CP:J2–4	September 12, 795
Sculptor 33	AJ-K'AN...	La Mar St. 1:C2–?	November 3, 785
Sculptor 34	ba-?-ma ?-?...	La Mar St. 1:Cp6–? November 3, 785	
Sculptor 35	wa-?-NAL cha-ki AJ-bi-k'i-la	St. 12:G2–4	September 12, 795
Sculptor 36	K'IN-ni-LAKAM-ma cha-ki AJ-bi-k'i	Thr. 1:P'1–4	November 3, 785
	K'IN-ni LAKAM-ma cha-ki AJ-bi-k'i-la	St. 12:I2–4	September 12, 795
	K'IN-ni-LAKAM-ma cha-ki AJ-bi-k'i-la	CP:I2–4	September 12, 795
Sculptor 37	KAN-chi-wo-jo po-no	St. 12:R2–3	September 12, 795
Sculptor 38	?ya-?ja-?-? ?	Altar 4, Support 1	?
Sculptor 39	?-?ya-?-? ?	Altar 4, Support 2	?
Sculptor 40	?-?-? AJ-bi-k'i-la	Altar 4, Support 3	?
Sculptor 41	?-?-? po-no	Altar 4, Support 4	?
Sculptor 42	chi-?-?-? ?-?	St. 12:Q2–3	September 12, 795

CAY = El Cayo; CP = Cleveland Panel; DO = Dumbarton Oaks Panel; NO = New Orleans Panel.

n.b.: All dates are Julian, with "CE" indicating the "Common Era" and employing the Martin-Skidmore variant of the GMT correlation; boldface indicates a syllabic or logographic transcription; and hyphens mark the presence of glyphs within a single glyph block.

tags or, conversely, that some of those listed as distinct artisans were, in fact, one and the same. An approach that splits rather than lumps signatures may be more appropriate given the variable degree of preservation.

The distribution of names presents several anomalies, with the proviso that preservation always affects evidence (see Table 13.4). Some kings seem sparing with signatures, at least in proportion to the number of sculptures they commissioned. Ruler 2 has thirteen sculptures, yet only one with a clear signature. His most massive sculptures, Stelae 38 and 39, have no known name tags to indicate authorship. Succeeding him, Ruler 3 concentrated his sculptural tags on the relatively small Stela 6 and not, according to surviving evidence, on any

other sculptures nearby. The reason for this may have been that Stela 6 was his accession monument. After a vigorous record by his predecessor, the new king may have needed a loud display of important, citable "talent." Was the tacit premise, too, that the sculptors created the other sculptures in front of Structure J-1 at Piedras Negras? The next king, Ruler 4, used no sculptural tags, apart from those at subsidiary sites, and this despite a reign of twenty-eight years. In contrast, Ruler 7 could not have been more prolix: virtually every sculpture from his reign contains the names of carvers.

The placement of signatures is notably patterned (see Table 13.5 for a list of sculptors linked to different carvings). Earlier monuments, from the time of Ruler 2, position sculptors' names away

table 13.4

Number of sculptors at Piedras Negras, by reign or status of patron (fifty-four references)

PROVENIENCE	DATE	NUMBER	PATRON
St. 34	October 12, 652 CE	3?	Ruler 2
Pan. 4	October 9, 658 CE	1?	Ruler 2
St. 6	April 12, 687 CE	7	Ruler 3
CAY Alt. 4	August 18, AD 731	1	*sajal* (time of Ruler 4)
Dumbarton Oaks Panel	December 27, 733 CE	1	*sajal* (time of Ruler 4)
St. 14	March 14, 761 CE	6	Ruler 5
St. 13	January 21, 771 CE	3	Ruler 6
Stavenhagen Panel	August 4, 780 CE?	2	*sajal*
Pan. 3	March 25, 782 CE	3?	Ruler 7
St. 15	November 3, 785 CE	5?	Ruler 7
Throne 1	November 3, 785 CE	2	Ruler 7
La Mar St. 1	November 3, 785 CE	2?	Lord of La Mar
New Orleans Panel	June 19, 792 CE?	2?	*sajal*
Altar 4	?	6	Ruler 7
St. 12	September 12, 795 CE	8	Ruler 7
Cleveland Panel	September 12, 795 CE	2	*sajal*

n.b.: Minimal number of sculptors indicated by ?.

from the visual field, in frames around the central figures, or near the base of panels. With Ruler 3, the signatures infiltrate the background around the royal portrait (e.g., Stela 6), a practice that endured until the end of the dynasty. The lone, later exception, La Mar Stela 1, from 785 CE, returns to the earlier mode of unobtrusive display on an encircling frame. No signatures appear on the carved backs of stelae, suggesting some highlighting of this information. Nonetheless, most signatures, regardless of period, are lightly incised, flush with the surface, and clearly visible only under close inspection. Ruler 7 may have been generous with crediting, but he was stingy in doing so through conspicuous displays. Sculptors' names can be almost hidden, as on Altar 4. The exceptions are panels (Dumbarton Oaks, New Orleans) that do not even come from Piedras Negras but from two currently unidentified subsidiary sites. Both elevate the sculptors' names above the background. The monument in New Orleans borders its first signature, probably that of the principal carver, with a thin band, as though in delicate emphasis.

There is a light, barely visible text on the back of the jade head recovered from the cenote at Chichen Itza (see above; Figure 13.20a). Proskouriakoff (1944, 1974:205) proved long ago that the head came from Piedras Negras, perhaps from the looted chamber known as Burial 10 (Coe 1959:fig. 67) or from tomb reentry in Burial 13, the interment of Ruler 4 (Escobedo 2004:278–279). The head formed part of a standard belt assemblage shown in Maya imagery, and most examples celebrate important ancestors. The very same head may appear on Stela 40, where a comparable object adorns the back of Ruler 4. The Chichen carving refers to various anniversaries of Ruler 3. Capped by a turtle-name, like the jewel on Stela 40, the artifact probably portrays an earlier ruler. Ruler 4 would not have worn a fetish of this sort if it contained his own name—such objects seem always to depict ancestors whose facial portraits are worn as part of royal belt assemblages.

Of relevance here is that a small portion of the text, disposed in vertical band, ends in **xo-ki**. Discussed above, this term is used by two sculptors at Piedras Negras, #26 and #27, although at a

table 13.5

Overlap of sculptors at Piedras Negras by monument, date, patron, and minimal length of activity

SCULPTOR	MONUMENT	DATE	PATRON	MINIMAL LENGTH OF ACTIVITY
Sculptor 19	*Kotol-tz'ihb-pon*			10 years
	St. 14:O1–2	Mar. 14, 761 CE	Ruler 5	
	St. 13:E2–4	Jan. 21, 771 CE	Ruler 6	
Sculptor 20	*Telaj-?-k'awiil-?mohch*			14 years
	St. 13:F2–4	Jan. 21, 771 CE	Ruler 6	
	Thr. 1:Q'2–4	Nov. 3, 785 CE	Ruler 7	
Sculptor 21	*Y-ajaw-te'-kaloom-te'*			24 years
	St. 13:G2–4	Jan. 21, 771 CE	Ruler 6	
	Pan. 3:B'5–C'5	Mar. 25, 782 CE	Ruler 7	
	St. 12:M2–3	Sept. 12, 795 CE	Ruler 7	
Sculptor 26	*Kan-ch'ok-wayib-xook*			7 years
	St. 15:F2–4	Nov. 3, 785 CE	Ruler 7	
	Alt. 4: Support 1	?	Ruler 7?	
	NO:E'1–4	June 19, 792 CE?	*sajal*	
Sculptor 27	*Ho'-kanal-chahk*			7 years
	St. 15:I2–4	Nov. 3, 785 CE	Ruler 7	
	NO:G'1–J1	June 19, 792 CE?	*sajal*	
Sculptor 30	*Chak-?-u-ko'oom-pon*			?
	St. 12:P2–4	Sept. 12, 795 CE	Ruler 7	
	Altar 4, Support 1	?	Ruler 7?	
Sculptor 32	*1-nat-'omootz*			10 years
	St. 15:F1–5	Nov. 3, 785 CE	Ruler 7	
	St. 12:E2–4	Sept. 12, 795 CE	Ruler 7	
	CP:J2–4	Sept. 12, 795 CE	*sajal*	
Sculptor 36	*K'in-lakam-chahk*			10 years
	Thr. 1:P'1–4	Nov. 3, 785 CE	Ruler 7	
	St. 12:I2–4	Sept. 12, 795 CE	Ruler 7	
	CP:I2–4	Sept. 12, 795 CE	*sajal*	

NO = New Orleans Panel; CP = Cleveland Panel

later time, during the reign of Ruler 7. As such, this instance may be, along with a signature mentioned above on a small sculpture (Easby 1966:no. 446), the only known signature in Pre-Columbian America of a lapidary. Unfortunately, the name on the jade is fragmentary and cannot be linked to others at the site. But it does suggest that some carvers worked in multiple media, ranging from relatively soft limestone to obdurate jade: this is consistent, too,

with the **ba-che-bu** title, *baah chehb*, "head-quill" found in several settings.[28] The crediting on the jade remains a subtle message at best. If a signature, the text would have disappeared behind the lashings, threaded through by drill holes, that attached dangling celts to the ancestor's portrait head.

The sequencing of names may reflect a social ordering of the sculptors (Table 13.6). In Maya texts, the rare consecutive listings of names—whether of

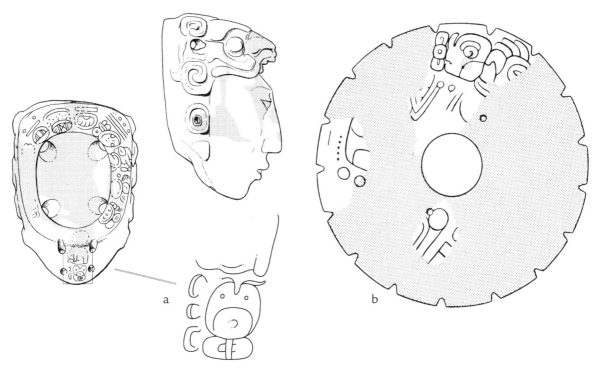

figure 13.20
Signatures of lapidaries: a) "Piedras Negras" jade head from Cenote of Sacrifice, Chichen Itza; and b) jade disk from Cenote of Sacrifice, Chichen Itza (Proskouriakoff 1974:pls. 47e.1 and 60.1). (Drawing by Stephen Houston [inset glyphs in (a)] and © President and Fellows of Harvard College, Peabody Museum of Archaeology and Ethnology.)

historical figures or deities—do not appear to be random. For example, the tabulation of captives on the left side of Piedras Negras Stela 12 accords with visual ordering on the front of the stela: the captive with the most jewelry, positioned closest to the king, appears first in the text. Hypothetically, then, signatures in preferred position—those to the top or left side of a carving—would reflect internal rankings (Figure 13.21). To take one example, Sculptor 21's tag comes toward the bottom or right side of a monument; Sculptor 36 tends to broadcast his name to the top and left. The first person is, perhaps, less important in the overall ranking of sculptors than the second.

A reversal of names may be the exception that proves the rule. On Stela 12, Sculptor 32 comes before Sculptor 6; the Cleveland Panel shows the opposite. A plausible explanation is that this order expressed varying duties. One sculptor focused on Stela 12, the other on the smaller Cleveland Panel. Both carvings were, it seems, due the same day, the

former for a king, the second for a subordinate lord. Sculptural ranking was laid out even more explicitly on the caption for the Piedras Negras Panel 3 (Figure 13.22). The first name belongs to a "head-sculptor," preceding a set of two, perhaps three, other names. The final figure is called "he-of-the-sculpture." At Piedras Negras, this tag is used if there is no overt signature with possessive pronoun at the beginning of a text. Such is the case on Panel 3, but also Stela 15 and the New Orleans Panel.

Another title, **AJ-bi-k'i-la**, is more enigmatic. It marks the signatures of Sculptors #31, #32, #35, #36, and #40—all from Ruler 7's reign—and also describes courtiers on Panels 1 and 3. The first panel has no clear date, and the latter shows a feast in the life of Ruler 4 but in a carving commissioned by Ruler 7. There is no clear reason why the title should be sculptural per se. In the Usumacinta and elsewhere, the **la** sign, positioned much like this glyph, attaches to place names (Houston et al. 2001:51). It may be that these individuals came from

table 13.6
Reading order of multiple sculptors' names at Piedras Negras, by monument

MONUMENT	DATE	PATRON AND READING ORDER
St. 34	October 12, 652 CE	Ruler 2
		Sculptor 1
		Sculptor 2
		Sculptor 3
St. 6	April 12, 687 CE	Ruler 3
		Sculptor 5
		Sculptor 6
		Sculptor 7
		Sculptor 8
		Sculptor 9
		Sculptor 10
		Sculptor 11
St. 14	March 13, 761 CE	Ruler 5
		Sculptor 19
		Sculptor 14
		Sculptor 15
		Sculptor 16
		Sculptor 17
		Sculptor 18
St. 13	January 21, 771 CE	Ruler 6
		Sculptor 19
		Sculptor 20
		Sculptor 21
SP	August 3, 780 CE?	*sajal*
		Sculptor 22
		Sculptor 23
Pan. 3	March 24, 782 CE	Ruler 7
		Sculptor 31 "head sculptor"
		Sculptor 24
		Sculptor 21
Thr. 1	November 2, 785 CE	Ruler 7
		Sculptor 36
		Sculptor 20
La Mar St. 1	November 2, 785 CE	Lord of La Mar
		Sculptor 33
		Sculptor 34

MONUMENT	DATE	PATRON AND READING ORDER
NO	June 18, 792 CE?	*sajal*
		Sculptor 26
		Sculptor 27
St. 12	September 11, 795 CE	Ruler 7
		Sculptor 32
		Sculptor 35
		Sculptor 36
		Sculptor 30
		Sculptor 29
		Sculptor 21
		Sculptor 42
		Sculptor 37
CP	September 11, 795 CE	*Sajal*
		Sculptor 36
		Sculptor 32
Altar 4		?
		Sculptor 30
		Sculptor 26
		Sculptor 38
		Sculptor 39
		Sculptor 40
		Sculptor 41

CP = Cleveland Panel; NO = New Orleans Panel; SP = Stavenhagen Panel

a particular site or even part of Piedras Negras termed *bik'*.

The broader meaning of signatures involves guesswork and a number of imponderables. Presumably, the presence of a signature was a privilege, a sharing of the stage with a monarch, high nobles, and other figures of prominence. The comparative ubiquity of such references at Piedras Negras— close to half come from this one site—triggers the question of why signatures were felt to be necessary. The privilege was, first and foremost, hedged, in that names, not sculptors' images, graced the surfaces of monuments: Throne 1 may be the lone exception (see above). At Piedras Negras, the patterning confirms that the intent to credit sculptors varied by reign and within reigns. Few of the sculptors had overtly high rank, other than the youth at El Cayo, and a number are "youths," *ch'ok*: again, the lordling from El Cayo, also Sculptors #4, #14, #29, and perhaps #26, although the latter may use it as part of a fixed name, not as an age-grade. At some earlier point in their careers, these youths, possibly apprentices, may have crafted the tentative, at times inept, productions reused as building material in the acropolis (Satterthwaite 1965). As at Yaxchilan, several used *Chahk*, the rain god, in their names,

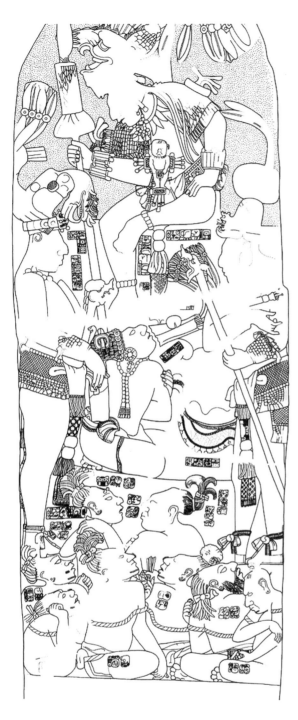

figure 13.21
Piedras Negras Stela 12. (Drawing by David Stuart
© President and Fellows of Harvard College,
Peabody Museum of Archaeology and Ethnology.)

figure 13.22
Sculptors' names on Piedras Negras Panel 3.
Screenshot from the 3D model by Alexandre
Tokovinine. (Photograph courtesy of the Corpus of
Maya Hieroglyphic Inscriptions, Peabody Museum,
the Ministerio de Cultura y Deportes de Guatemala,
and the Museo Nacional de Arqueología e Etnología
de Guatemala.)

again, perhaps, for a deity who wields an ax, a carv-
ing tool (Houston 2000:154). Aside from the youth
at El Cayo, none of the names resemble those used
by rulers. An incised sherd referring to someone—
the text is incomplete—as the "head-sculptor" of
Ruler 7 may or may not link its find-spot, a resi-
dential sector near the Structure R-1 pyramid, to
the residence or workshop of an important artisan
(Figure 13.23). The area was, to be sure, crucial to
lithic production, with triple the quantity of obsid-
ian artifacts as other residences at the site (Hruby
2006:264–265, 272–273).

The evidence is more secure in demonstrat-
ing overlap between reigns. Table 13.5 shows that

figure 13.23
"Head-carver," Ortiz Orange sherd, found in operation PN33E-19-5, Piedras Negras Structure U-16. Transcription: **u-ba u-'BAT'-lu ya-AT?-AHK,** "his head-carving, Ruler 7." (Drawing by Stephen Houston.)

Sculptor #19 worked for Rulers 5 and 6, Sculptors #20 and #21 for both Rulers 6 and 7. Of sculptors working on two or more monuments, most had periods of activity of about ten years, with one standout, Sculptor #21, attested over a twenty-four-year span—all credible given the likelihood that many people at Piedras Negras did not enjoy long lives. A striking feature of sculptors from the reign of Ruler 7 is that they divide roughly into two groups, one set active in the first half of time on the throne, another productive in the second. Only one sculptor, #36, bridges the two periods. It is difficult to know what to make of this: the earlier set of sculptors may have passed away or retired, or Ruler 7 elected to replace it with another group. Sculptors working on sculptures at Piedras Negras and subsidiary sites are always active first at Piedras Negras, and only then are their services loaned out (Sculptors #26, #27, #32, and #36). The panels at such sites are quite small. All are mortuary in intent but post hoc, in relation to fire ceremonies after death: there was no hurried work while a corpse putre-fied. The sculptures could easily have been shipped directly from Piedras Negras and then carried by tumpline or other conveyance to a building site.

The graphic play of texts—their relative back-grounding and foregrounding—characterized most Maya inscriptions of any complexity. The sculptors' tags at Piedras Negras were no exception. Often lightly incised or carved, they demand a close read, although with curious variation in position that affects their comprehension. On Stela 6, the glyphs are both tiny and relatively high up on the carving. Stela 12 places them closer to the ground, for ready review of readers, as do Stela 15 and Throne 1, also commissioned by Ruler 7 (e.g., Stuart and Graham 2003:36–37, 61). Altar 4, the Jaguar Paw-Stone (Stuart 2004), likely dating to the time of Ruler 7, does entirely the opposite: it places signatures low to the plaza, on stone supports—in truth, fully realized *tuun,* or "stone," signs—under the over-hang and top slab of the altar. Readers would need to stoop or drop to their knees, alert to the texts, rather like buyers of silver looking for hallmarks. It is all consultable information, but obliquely and obscurely recorded. The supports were carved sepa-rately, however. Before final setting, the sculptor's tags were in far bolder position on the foreheads of the "stone" signs. Stela 34, a Ruler 2 monument, displays sculptors' signatures in the frame around the central image (Maler 1901:pl. XXVII). In a simi-larly nondescript fashion, Stela 13, from the reign of Ruler 6, presents sculptor's names that float across a neutral background (Maler 1901:pl. XVIII). A cas-cade of sculptor's tags appears on Stela 14, from the time of Ruler 5, running in vertical sequence beside the dark footprints leading up to the ruler's celes-tial scaffold (Maler 1901:pls. XX–2). As for panels at Piedras Negras, most exhibit sculptors' names at the very base, close to the ground-line in which some were probably embedded into floors (Panels 4, 15; Maler 1901:pl. XXXII).

Piedras Negras is probably not surprising in its number of signatures. In striking contrast to that of other kingdoms with comparable records, its inventory of legible texts on pottery and other materials is almost always carved (Figure 13.24). Readable glyphs in paint are quite rare, and the best-documented example was probably found in Mexican territory: a pot from the reign of Ruler 4 that is now on display in Tenosique, Tabasco,

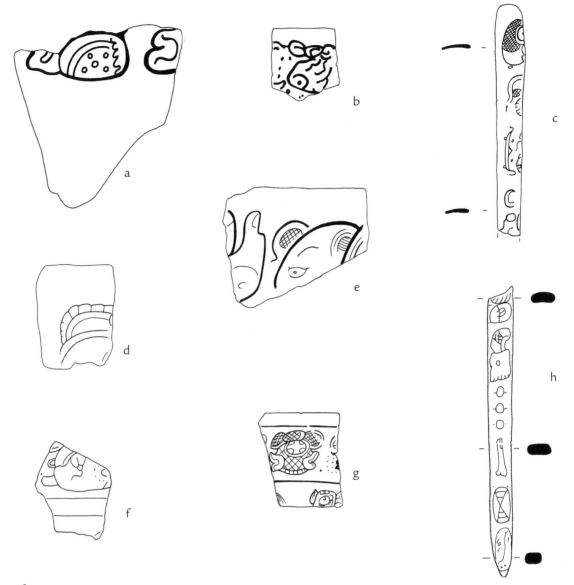

figure 13.24
Incised texts found in excavations at Piedras Negras: a) **yo-ki-bi-*AJAW**, Yaxche Brown Carved, PN15D-12A-2;
b) **'a-chi-hi**, PN24B-3-4-E; c) **?-? ? u-? ?**, bone, PN26A-7-4, Str. F-2; d) **K'UHUL-yo-*ki-*bi-*AJAW**, Pacal Incised;
e) ***ya-AL IX-"Katun"?**, Pacal Incised, PN11F-3-1; f) **'a-ku**, Pacal Incised, PN27A-3-2; g) **ITZAM-[K'AN]AHK**, Yaxche
Orange Incised, PN23E-14-3; and h) **ba-ki ts'u ? 1? nu tzu?**, bone, PN20F-1-2. (Drawings by Stephen Houston.)

pointed out to me by Carlos Pallan. In a word, the artisanal investment in literate carving was comprehensive, an abiding concern of its dynasty throughout the Classic period. This consistent emphasis on carving accounts in some ways for Tatiana Proskouriakoff's ability to discern history in its inscriptions (1960). No other site had quite the concentration of datable monuments, in good preservation, calibrated to five-year spans.

Signed Selves

The placement of a sculptor or painter's signature implies that an artisan laid claim to authorship, or, more accurately, that he was permitted to do so by a patron. What this ability or right to sign might mean is the crux of the matter. In a very different part of the world, theorists of Western literature fall in and out of affection for the concept of "author." Some

find it relatively recent and historically variable, an identity and a role conditioned by law or institutions, the by-blow of "complex procedures" in crediting (Foucault 1977:130–131; Wilson 2004:349). For others, the "author" is, in a related development, a character who arises solely from interpreting the work created by a "writer"—that is, as an entity, the "author" precipitates from the subtleties of reading when others appraise such works and consider their joint features and relative merit (Nehamas 1986:688). In colonial Mayan languages, as in Yukatek, the terms for "author" are unhelpful. Spanish glosses clearly relate to an earlier sense of "author" from "originator" or "founder" (Latin *auctor*, "creator"). In glosses of the early colonial period, an "author" was a promulgator of novelty, originality, even falsity (Acuña 2001:44, 56, 555). But it is likely that the Late Classic Maya had a complex notion of authorship in ways distinctive to them but interpretable by us: there was the *cheheen* statement, an authoritative declaration made permanent, and the *anab* phrase which, by one view, sees the sculptor as a mere vehicle of royal will. The ruler or other patron may not have wielded the chisel but ultimately caused that tool to act.[29]

The way to explain sculptors' signatures is both social and conceptual. A sculptor can be identified on a monument for a variety of reasons. The most basic is that certain sculptors were worth naming—John Beazley's attention to the "temperament" or "mood" of a signing painter would, if grafted to the Maya case, reduce what is essentially a political act to whimsy and to irretrievable or unpredictable states of mind (Beazley 1946:33; Pevnick 2010:225–226). A few sculptors held lordly or *ajaw* status, including the princeling from Piedras Negras at El Cayo; another, featured at El Peru, might have come from the dynasty of La Florida. Their presence exalted the work, showing that certain lords—if the younger sons of royal lines—could bend their knee to others. As Osborne notes for Greece: "[s]ignatures do not so much enhance the person who signs as enhance the pot signed" (2010:244), although, even in that instance, both pot and artist probably rose in general regard.

Then came the question of merit. Leonardo da Vinci labored first for the Duke of Milan, then Francis I at Amboise (Syson 2011:20–21). Hiring his talent burnished a court's reputation for refinement. Leonardo was, at one end, transferring his services—not as a servant of state, but for reasons of lucre and convenience. In contrast, *anab* statements and other contextual clues among the Late Classic Maya show tighter direction. A patron gained advantage by controlling the person and output of artist, both at home and in foreign courts. Most likely, among the Maya, the loaned sculptor remained under the power of a dominant ruler, who thereby influenced the self-presentation of lesser kings. The puzzle is why local rulers would allow this, other than as an advertisement of powerful allies.[30] After all, through *anab* statements the recipient of a sculptor or his skills announced that a pressing need could not be satisfied at home. A relation of dependence was not only conceded but also underscored in permanent form.

The more subtle import of the signatures is a possible shift in how works and their authors were conceived. It is by now widely understood that the dramatis personae of Maya courts achieved an unusual visibility in the Late Classic period (Houston and Inomata 2009:171–172, figs. 6.4–6.5; Jackson 2013). Before, in the Early Classic period, the Uaxactun mural from Structure B-XIII highlighted a varied set of people (Smith 1950:fig. 46). But it remains an anomaly. Early Classic stelae compress this inventory to a ruler, his captives, or perhaps, as on Stela 31 from Tikal, a progenitor in foreign dress. Only later, in the Late Classic period, did other people walk into view. The appearance of signatures corresponds, then, to a more general presence of non-royals in images of the time: others intrude, though whether by invitation or gate-crashing is immaterial. The sculptors occur in more public displays, if always indirectly, by name only. In a sense, the carvers lurk, standing back from the visual field. As for the calligraphers, they materialize in a more rarified form of reading. Their names are spelled out in small texts, legible at close distance, probably by holding the object itself. Unlike a stela, the vases can be passed around, scrutinized, evaluated—the social and physical nature of their reading differs from that of fixed monuments.

Rulers own stelae, panels, or other carvings, but no sculptor or painter possesses an object, other than in a trivial grammatical sense. Signatures' spatial variability—present in certain kingdoms, not at all in sites nearby or massive cities like Tikal—indicates an equally changeable decorum, a decision-making process on the part of patrons. Some allowed signatures, even gloried in them, as at Piedras Negras. Others disdained the practice.

The question is whether the essential nature of the work had changed, opening a window for such comments on the act of making. For the Maya, images and stones in particular clearly had, at all periods, a property of immanent vitality (Houston et al. 2006:72–80; Stuart 2010). More than depictions, they housed energies. Nonetheless, the cultic role of a sculpture—a representation to be engaged, venerated, deactivated—could exist alongside another appreciation: namely, that these were objects made by human hands of uncommon skill. Each region in history has its own conditions in which makers of images were appreciated or recognized, sometimes as a statement made by the artist, but most, presumably, as authorized by a patron (Gilbert 2000:80–81).

In European art, the signature begins, according to some accounts, because of new emphases on markets and sales—an improbability in the dynastic commissions of the Late Classic Maya—the aesthetic concours of royal courts, a set of copied practices conditioned by regional expectation, boastful statements made to peers who could read or parse such statements, and a coalescent notion of the individual (Boffa 2011:204, 207; Bynum 1980; Warnke 1993). The artist had become "self-conscious" (Mathews 1998:616).[31] Yet an autograph is an unstable mark. Michelangelo signed only one of his works, at a young age (Wang 2004:473); Raphael, Bellini, and perhaps Giotto saw their signatures as a kind of "brand name," affixed to works done under their supervision but not by their hands (Goffen 2003:124). To a telling extent, however, Giotto's earlier signatures appeared only on wooden frames, so as not to intrude into the sacred field of a religious image (Goffen 2001:309). By the sixteenth century in Venice, signatures went increasingly out of mode—to the consternation of those wishing to trace artistic careers and attributions (Mathews 1998:641–642).

The argument that local motivations dominate the production and meaning of signatures injects a certain tension into comparisons between the Maya and, say, the first stirrings of the Renaissance or the end of the Middle Ages: what is "local" is, of course, just that, local and potentially idiosyncratic. Yet the exercise serves a purpose. It shows shared process, diverse motives, practices that began variably and then disappeared, the rivalry and attentive patronage of courts, and, in the case of Giotto, a glimpse that, in sacred works, early signatures came into being via small if audacious steps. Notably, for the Late Classic Maya, the painters and sculptors were not the authors of "their" works in any recognizable manner. They did not create the messages; rather, they shaped the means of projecting them. Ultimately, it seems, they were less inventors than the instruments of royal command—carvers but not impresarios.

According to one authority, there are fewer than forty or so named painters of figured Athenian vases, out of a total of some nine hundred painters detectible by the methods of connoisseurship (Boardman 2001:128). A notable fact is that, for all the Maya sculptors known, the preponderance of work has no such tags. Others may even have been a species of *acheiropoieta*, a Greek term for "made without hand," or, more precisely, objects of non-human provenience and association (Kitzinger 1954:112; Nagel and Wood 2010:205–207). These are, to invoke another comparison, Maya fragments of the True Cross, like the "found" stones of Early Classic stelae, lightly shaped and carved (Stuart 2010). One is a stingray spine from Holmul, Guatemala (Figure 13.25; Merwin and Vaillant 1932). In somewhat eroded glyphs, it is claimed to be, if a deity head is correctly identified, the very perforator that passes through the nose of a particular deity. Or there is a celt from Tonina, Chiapas, whose text reveals a link to K'awiil, a deity with such an adze in its forehead (Graham et al. 2006:128). For Maya imagery, the sacred and miraculous are present both in these examples and, one suspects, in most imagery.

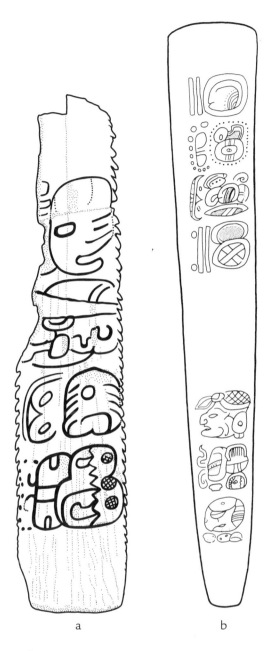

figure 13.25

"Miraculous" objects with texts: a) Holmul stingray spine; and b) Tonina Miscellaneous 6 (Graham et al. 2006:128). (Drawings by Alexandre Tokovinine, with permission, and Lucia Henderson © President and Fellows of Harvard College, Peabody Museum of Archaeology and Ethnology.)

Mention of painters and sculptors must, on final analysis, be seen as a striking irregularity. It was a practice, erratically followed, that went in and out of fashion in less than three hundred years. It asserted the participation of new identities in ways that brushed close to impiety. Doubtless, many sculptures were known at the time to be made by this or that sculptor—this acknowledgment is a repeated lesson from non-Western imagery (LaGamma 1998:24, 26). But a public record of that fact was denied to most carvers and painters. At the twilight of Classic life, they discovered that crafting credit was ultimately out of their hands.

Acknowledgments

My thanks to Cathy Costin for the invitation to Dumbarton Oaks, and to Colin McEwan and Emily Jacobs for all the plush generosity that this place offers. Karen Bassie, Claudia Brittenham, Jorge Pérez de Lara, and Alexandre ("Alex") Tokovinine helped with figures; Bryan Just with a lead to a painter's signature I had not known at the National Gallery of Victoria. David Stuart and Marc Zender provided good discussion, as did Alex on the use of toponyms and the carved expression at Ceibal. Despite jetlag, Simon Martin gave a close and generous read of the manuscript, sparing me from a number of mistakes, as did Colin McEwan. Claudia Brittenham, too, offered useful comments, as did Dmitri Beliaev, Robert Preucel, and David Webster. Keith Moxey was supportive as always. A separate presentation of this paper—for the Columbia University Seminar on the Arts of Africa, Oceania, and the Americas, organized by Francesco Pellizzi—prompted useful observations from Michael Cole. Relevant evidence came from Ian Graham though his field notes and photographs, which he has generously shared over the years. These are accessible, with permission, in the archives of the Corpus of Maya Hieroglyphic Inscriptions project at the Peabody Museum, Harvard University. Ken Garrett provided an image at no cost, as did Justin Kerr and Bryan Just. Juan Antonio Murro helped with a permission at Dumbarton Oaks; Jessica Ganong performed the

same service with cheer and high efficiency at the Peabody Museum. Barbara Fash and Jeffrey Quilter facilitated the study of the jade from Chichen Itza, now in the collection of the Peabody Museum. This paper was written, in part, while a fellow at Dumbarton Oaks, with later support from The Sterling and Francine Clark Art Institute and a MacArthur Fellowship. Readers should note that boldface cues transcriptions of glyphs and italics their transliteration into Maya.

NOTES

1 This essay uses the terms "artist," "artisan," and "craftsman" interchangeably. The target meaning is "a skilled maker motivated by aesthetic guidelines," without any cultural implication beyond that understanding. The one other nuance is that these makers were literate, creating both text and image.

2 The two spellings may render the same word, one with disharmony to emphasize an infixed 'h' (*tz'ihb*), or they may indicate some difference in meaning. Conceivably, the act of "painting" or "writing" (*tz'ihba*) could be cued by a final **ba** syllable, as opposed to *tz'ihb*, which refers to a tangible result of that action (*tz'ihb*; Kaufman and Norman 1984:134). Neither possibility can be confirmed. In ceramic texts, the **ba**, or its "skull" or "cauac" semblant, tends to occur when there is a subfixed **li** or **IL**, suggesting a grammatical nuance to the use of this syllable (e.g., K1092, K1398, K1901, K3026, K4548, K6294).

3 K6612 is unusual for using the term *tz'ihb* to describe carved text. The use of the "bat" sign to describe modeled stucco comes from San Jose, Belize (Thompson 1939:pl. 6e).

4 Curiously, the same expression had been noted by Herbert Spinden seventy years before, but without follow-up: "[t]he head of a bat (Zotz') with a knotted prefix . . . begins most incised inscriptions on this and other monuments at Piedras Negras, and indeed at most Maya sites in the Peten region. This glyph may have some such general meaning as 'here follows a name'" (Spinden 1916:443).

5 A few intriguing examples show levels of representational distance in painting and sculpture. Within the Bonampak murals, for example, brushwork is used to depict a painted text, a *tz'ihb*, on textile, and a similar process obtains on Calakmul Stela 9 (CMHI archives, drawing by Ian Graham; Houston 2012:fig. 12). There, a sculptor hews stone to show a painted text, *tz'ihb*, that runs along the hem of a queen's skirt. The intent is illusionistic, to display an object before the carver and painter: one of the texts refers to the "cloth" (*buhk*) that holds the glyphs.

6 A recent book by Flora Clancy on the monuments of Piedras Negras has little mention of such signatures (Clancy 2009:4, 17, 14), although she supervised the lone thesis on the topic of sculptor's tags, by John Montgomery (1995). She also doubts whether multiple signatures "were in fact the names of actual sculptors"; rather, they indicate "economic support of some kind or . . . support for the rituals and ceremonies that almost certainly surrounded the carving of a monument" (Clancy 2009:179). But there is no evidence for these postulates, and direct contradiction of them from glyphic tags. One suspects an interpretive default set at single-artisan models of production, a norm violated in the West, too, by the busy ateliers of Jeff Koons and Takashi Murakami. In any case, the title for a master sculptor and demonstrable periods of artisanal overlap make such claims unlikely. Megan O'Neil (2012:51, 213, 218) has also authored a fine, recent study of monuments at Piedras Negras.

7 For unknown reasons the **yu** is replaced by a simple **u** in late spellings from Chichen Itza (Krochock 1989:fig. 6, position A1, fig. 7, position B4).

8 Similar words appear in Ch'orti' Maya, which descends from the language of many of the Classic inscriptions: e.g., *uxuri*, "he dices, cuts," in which the *r* corresponds to a more ancient *l* (Pérez Martínez et al. 1996:245; Wisdom 1950:482). Nonetheless, as Dmitri Beliaev points out to me (personal communication, 2014), the root was probably *xur*, "saw" or "cut," prefixed by *u*, an ergative pronoun.

9 There are several clear spellings of **u-yu-lu-li/ IL** in contexts that refer to carving, including

one example that seems to replace the more conventional spelling with the "bat" head (K2292, see also K7146; Robicsek and Hales 1981:fig. 38). Nonetheless, the prefixed ergative pronoun, *u*, makes this an imperfect explanation—no sculptor's signatures use such a glyphic pronoun, and the term on most carvings must have begun with a *u-*. This is shown by rare instances in which the term is stripped of its pronoun (e.g., Stuart 1990:fig. 1). There is also some evidence from a title used by sculptors—**AJ-yu-lu**—that strongly points to *yul* as the relevant root (Deletaille Panel, Mayer 1995:pl. 161; Mermoz Stela, Le Fort 1995:fig. 1).

10 As if to confirm a connection to orality, a sculptor on El Peru Stela 31 appears to be called an *'itz'aat ti'*, "wise words or mouth." This reading would need to be confirmed with a clearer photograph, however.

11 The reading of this site name is still under discussion. Tokovinine and Zender (2012:31, 35) offer good reasons to prefer a reading of *Ik'a'*, "wind-water." The *a'* (or *'a*?) would drop in Emblem Glyph usage and assimilate to *ajaw*, the word that follows. Nonetheless, there are examples of place names—such as *Yax Ha'* or *Yax 'a*, "green-blue water"—in which the final term for "water" continues to appear in Emblem Glyphs (e.g., Naranjo Stela 8:E6).

12 Simon Martin (personal communication, 2013) wonders whether this site is the important palatial center of Nakum, just to the north of Yaxha, Guatemala. The **tu-ba** city is also attested in a number of inscriptions (e.g., Martin and Grube 2000:76).

13 An unsettling possibility that cannot be dismissed out of hand is the example of Greek pottery: signatures may allude less to a person than to an "artistic persona" arising from a "collaboration between an artist, his workshop, vase-painting tradition, and even a patron" (Pevnick 2010:227). Alternatively, as ancient forgeries or homages, works may pilfer or lift the name of an esteemed painter (Pevnick 2010:228, citing Neer 2002 and Robertson 1992). A signature by "Douris" presumably enhanced demand for an object so embellished (Osborne 2010:250). However, it seems just as possible that names such as "Douris" or "Polygnotos," neither endowed with the complex epithets used by some Maya painters, applied to several different individuals.

14 An earlier view that the painter was an offspring of the ruler and his queen was reasonable for the time

but is no longer held by most specialists (cf. Stuart 1987:5, fig. 6). Rather, the order is: owner of the pot (in the rim band), followed in the lower band by the names of his mother, father, and, finally, the scribe.

15 The same person, **yu-ku-la-ja ch'a-ka-ta**, is the owner of a bowl excavated in the Mundo Perdido complex of Tikal (Laporte and Fialko 1995:fig. 68). A graffito from Tikal, incised on the walls of Structure 5C-49, refers to a lord of the same site going into exile (Trik and Kampen 1983:fig. 29c).

16 Simon Martin cautions that this may not be the Emblem of Xultun. One example, Drawing 25 at Naj Tunich, hints that the main glyph is not the expected **WITZ** found at Xultun, but a **TUUN**.

17 By definition, the final date of the monument, which often refers to its emplacement as a stone, is the terminus ad quem for the act of carving. Two stelae from Machaquila, Guatemala, add a further detail: a stela is said to be "wrapped" or consecrated on a certain date and then—two hundred days later in one case (Stela 3), thirty-five days in another (Stela 7)—the sculptures involve a verb "see" (**IL-ja**, Stela 3) or "his image is seen" or "he sees himself" (**IL-u-BAAH**, Stela 5; Graham 1967:figs. 57 and 49; Houston and Stuart 1992). This could be an unveiling or an indication that a stela was erected as an unworked blank, to be carved over a period of days or weeks. In either example, evidently, the sculpture was complete by the final date on the carving. David Stuart first made this observation.

18 There is a proposal for an unusual verbal form, a mediopassive, on a carved bone at Tikal (Beliaev and Davletshin 2002–2003). But this object, suitable for being held in the hand, is probably being described as a **k'a-BAAK**, *k'ab-baak*, a "hand-bone."

19 On both El Cayo Altar 4 and the "San Lucas" stela, the names are separated by the enigmatic **yi-ta-ji** expression that appears to connote tandem participation.

20 Simon Martin and I have had productive conversations about the use of the *ajaw* title. Its range of reference might have varied considerably. At one extreme would be its sole application to the immediate offspring of holy lords, a view I generally favor. At the other would be its use as a more expansive term for lords of high rank. It is possible that both expansive and inclusive patterns could be accommodated within a concept of the

"blood royal"—that is, of lines, including cadets, with acknowledged claims to monarchical succession. The French *prince du sang* exemplifies this arrangement. In 1589, the Bourbon dynasty replaced that of the Valois, but through a lineal connection dating back to 1256. Until reforms instituted after the Second World War, the Japanese imperial house also had several princely lines.

21 The lord on the stela at Arroyo de Piedra has other titles, including **8-PET-AJAW**, "the 8 Island or Province Lord," and a possible if aberrant **'a-K'IN-ni**, "he of the days," a unique reference in the inscriptions to a sculptor as a calendar priest. The text ends with a **che-'e**, *che'*, "it is said" phrase, as though the statement were to be read aloud or treated as a curious kind of hearsay.

22 The term differs from that for "foot" or "leg," which is usually spelled not with **ka** but with a different final syllable, **ki**. *Sak Ook* also occurs in the Naj Tunich cave texts, but in ways that are not clearly related to sculpture (Stone 1995:figs. 8-29c, 8-37, 8-52). Simon Martin makes a convincing case (personal communication, 2013) that this reference includes a title known to occur at El Palmar (**6-PI'T?**, Tsukamoto and Esparza Olguín 2014). Accordingly, the examples at Naj Tunich may cite a connection between the two sites.

23 A clear example of it appears at Cancuen, almost on the border of the Alta Verapaz, Guatemala, and its usage at El Palmar seems to associate exclusively with subordinate nobles. To be sure, Naj Tunich is also a southerly site.

24 I thank Alexandre Tokovinine for his reminder that some signatures are curiously impersonal, referring to more general classes of people, not specific individuals.

25 Painters mentioned in the Naj Tunich cave include one possibly from Xultun, the other from the **ju-t'u** site (note 15). The array of non-local Emblem Glyphs in the cave is notable—Ixtutz and Ixkun to Calakmul, Caracol, and others—but there are no secure references to prominent centers nearby, including, to the north, Tikal, Naranjo, and Yaxha or, to the west, dynasties in the Pasión River drainage.

26 Erik Boot and Nikolai Grube's reading of **che-bu** is discussed in Coe and Kerr (1997:148–150).

27 The glyphs may record an unusual head variant of the number "4," recorded with the head of the Sun God, in addition to a "k'atun" or twenty-year followed by *'itz'aat*.

28 Another lapidary signature may appear on an ear ornament at Chichen Itza (Proskouriakoff 1974:pl. 47e1).

29 The Emiliano Zapata Panel is a difficult case. It may show the ruler as a carver but, to my eyes, there is no internal reason to prove this (Herring 1998; Stuart 1990).

30 This argument is explored in Miller and Brittenham (2013).

31 Compare Claussen 2003, who sees this in social terms, and of far earlier date than some have supposed. "[S]culptors [had] to navigate tensions between the desire for fame and the cultural norms that called for humility and modesty" (Boffa 2011:204).

REFERENCES CITED

Acuña, René (editor)

2001 *Calepino maya de Motul*, by Antonio de Ciudad Real. Plaza y Valdés, Mexico City.

Aulie, H. Wilbur de, and Evelyn W. de Aulie

1978 *Diccionario Ch'ol de Tumbalá, Chiapas, con variaciones dialectales de Tila y Sabanilla*. Instituto Lingüístico de Verano, Mexico City.

Barrera Vásquez, Alfredo

1980 *Diccionario maya cordemex: Maya-español, español-maya*. Ediciones Cordemex, Merida.

Bassie, Karen

2002 The Jolja' Cave Project. Electronic document, http://www.famsi.org/reports/00017/, accessed June 4, 2013.

Beazley, John D.

1946 *Potter and Painter in Ancient Athens.* Cumberlege, London.

Beliaev, Dimitri, and Albert Davletshin

2002–2003 Possible Mediopassive Suffix –**K'-A(J)** in the Maya Script? *The PARI Journal* 3:12.

Boardman, John

2001 *The History of Greek Vases: Potters, Painters, and Pictures.* Thames and Hudson, London.

Boffa, David F.

2011 Artistic Identity Set in Stone: Italian Sculptors' Signatures, c. 1250–1550. PhD dissertation, Department of Art History, Rutgers University, New Brunswick, N.J.

Bynum, Caroline W.

1980 Did the Twelfth Century Discover the Individual? *Journal of Ecclesiastical History* 31:1–17.

Campbell, Lyle

1988 *The Linguistics of Southeast Chiapas, Mexico.* Papers of the New World Archaeological Foundation 50. Brigham Young University, Provo, Utah.

Clancy, Flora S.

2009 *The Monuments of Piedras Negras, an Ancient Maya City.* University of New Mexico Press, Albuquerque.

Claussen, Peter C.

2003 L'anonimato dell'artista gotico: La realtà di un mito. In *L'artista medievale*, edited by Maria Monica Donato, pp. 283–297. Classe di Lettere e Filosofia, Pisa.

Coe, Michael E., and Justin Kerr

1997 *The Art of the Maya Scribe.* Thames and Hudson, London.

Coe, William R.

1959 *Piedras Negras Archaeology: Artifacts, Caches, and Burials.* University Museum, University of Pennsylvania, Philadelphia.

Colas, Pierre R.

2004 *Sinn und Bedeutung klassicher Maya-Personennamen: Typologische Analyse von Anthroponymphrasen in den Hieroglypheninschriften der klassischen Maya-Kultur als Beitrag zur allgemeinen Onomasktik.* Acta Mesoamericana 15. Verlag Anton Saurwein, Markt Schwaben.

Easby, Elizabeth Kennedy

1966 *Ancient Art of Latin America from the Collection of Jay C. Leff.* The Brooklyn Museum, New York.

Escobedo, Héctor L.

2004 Tales from the Crypt: The Burial Place of Ruler 4, Piedras Negras. In *Courtly Art of the Ancient Maya*, edited by Mary Miller and Simon Martin, pp. 277–279. Thames and Hudson, London.

Foucault, Michel

1977 *Language, Counter-Memory, Practice: Selected Essays and Interviews.* Blackwell, Oxford.

Gilbert, Creighton

2000 A Preface to Signatures (with Some Cases in Venice). In *Fashioning Identities in Renaissance Art*, edited by Mary Rogers, pp. 79–89. Ashgate, Aldershot.

Goffen, Rona

2001 Signatures: Inscribing Identity in Italian Renaissance Art. *Viator* 32:303–370.

2003 Raphael's Designer Labels: From the Virgin Mary to La Fornarina. *Artibus et Historiae* 24:123–142.

Graham, Ian

1967 *Archaeological Explorations in El Peten, Guatemala.* Middle American Research Institute Publication 33. Tulane University, New Orleans.

1996 *Corpus of Maya Hieroglyphic Inscriptions*, vol. 7, part 1: *Seibal.* Peabody Museum, Harvard University, Cambridge, Mass.

Graham, Ian, Lucia R. Henderson, Peter Mathews, and David Stuart

2006 *Corpus of Maya Hieroglyphic Inscriptions*, vol. 9, part 2: *Tonina.* Peabody Museum, Harvard University, Cambridge, Mass.

Grube, Nikolai

1998 Speaking through Stones: A Quotative Particle in Maya Hieroglyphic Inscriptions. In *50 años de estudios americanistas en la Universidad de Bonn*, edited by Sabine Dedenbach-Salazar Saénz, Carmen Arellano Hoffmann, Eva König, and Heiko Prümers, pp. 543–558. Bonner Amerikanistische Studien 30. Verlag Anton Saurwein, Markt Schwaben.

2005 Toponyms, Emblem Glyphs, and the Political Geography of Southern Campeche. *Anthropological Notebooks* 11:89–102.

Halperin, Christina T., and Antonia E. Foias

2010 Pottery Politics: Late Classic Maya Pottery Production at Motul de San José, Petén, Guatemala. *Journal of Archaeological Science* 29:392–411.

Hellmuth, Nicholas M.

1987 *Monster und Menschen in der Maya-Kunst: Eine Ikonographie der alten Religionen Mexikos und Guatemalas.* Akademische Druck- u. Verlagsanstalt, Graz.

Herring, Adam

1998 Sculptural Representation and Self-Reference in a Carved Maya Panel from the Region of Tabasco, Mexico. *Res: Anthropology and Aesthetics* 33:102–114.

Houston, Stephen D.

2000 Into the Minds of Ancients: Advances in Maya Glyph Studies. *Journal of World Prehistory* 14(2):121–201.

2008 The Small Deaths of Maya Writing. In *The Disappearance of Writing Systems: Perspectives on Literacy and Communication*, edited by John Baines, John Bennet, and Stephen Houston, pp. 231–252. Equinox Publishing, London.

2012 The Good Prince: Transition, Texting, and Moral Narrative in the Murals of Bonampak, Chiapas, Mexico. *Cambridge Archaeological Journal* 22:153–175.

2014 *The Life Within: Classic Maya and the Matter of Permanence.* Yale University Press, New Haven.

Houston, Stephen D., and Takeshi Inomata

2009 *The Classic Maya.* Cambridge University Press, Cambridge.

Houston, Stephen, John Robertson, and David Stuart

2001 *Quality and Quantity in Glyphic Nouns and Adjectives.* Research Reports on Ancient Maya Writing 47. Center for Maya Research, Washington, D.C.

Houston, Stephen D., and David Stuart

1992 On Maya Hieroglyphic Literacy. *Current Anthropology* 33:589–593.

Houston, Stephen, David Stuart, and Karl Taube

2006 *The Memory of Bones: Body, Being, and Experience among the Classic Maya.* University of Texas Press, Austin.

Hruby, Zachary

2006 The Organization of Chipped-Stone Economies at Piedras Negras, Guatemala. PhD dissertation, Department of Anthropology, University of California, Riverside.

Jackson, Sarah E.

2013 *Politics of the Maya Court: Hierarchy and Change in the Late Classic Period.* University of Oklahoma Press, Norman.

Just, Bryan

2012 *Dancing into Dreams: Maya Vase Painting of the Ik' Kingdom.* Princeton University Art Museum, Princeton.

Kaufman, Terrence S., and William M. Norman

1984 An Outline of Proto-Cholan Phonology, Morphology and Vocabulary. In *Phoneticism in Mayan Hieroglyphic Writing*, edited by John S. Justeson and Lyle Campbell, pp. 77–166. Institute for Mesoamerican Studies 9. State University of New York at Albany.

Keppie, Lawrence

1991 *Understanding Roman Inscriptions.* Johns Hopkins University Press, Baltimore.

Kitzinger, Ernst

1954 The Cult of Images in the Age before Iconoclasm. *Dumbarton Oaks Papers* 8:83–150.

Krochock, Ruth

1989 *Hieroglyphic Inscriptions at Chichén Itzá, Yucatán, México: The Temples of the Initial Series, the One Lintel, the*

Three Lintels, and the Four Lintels. Research Reports on Ancient Maya Writing 23. Center for Maya Research, Washington, D.C.

Lacadena García-Gallo, Alfonso

2004 The Glyphic Corpus from Ek' Balam, Yucatán, México. Reported submitted to the Foundation for Mesoamerican Research, http://www.famsi.org/reports/01057/, accessed July 28, 2015.

LaGamma, Alisa

1998 Beyond Master Hands: The Lives of Artists. *African Arts* 31:24–37, 89–90.

Laporte, Juan Pedro, and Vilma Fialko

1995 Un reencuentro con Mundo Perdido, Tikal. *Ancient Mesoamerica* 6:41–94.

Laughlin, Robert M.

1988 *The Great Tzotzil Dictionary of Santo Domingo Zincacantán, with Grammatical Analysis and Historical Commentary.* 3 vols. Smithsonian Contributions to Anthropology 31. Smithsonian Institution Press, Washington, D.C.

Le Fort, Geneviève

1995 *Lady Alligator Foot Emerges from the Past: Maize God Iconography at Yomop.* Gallerie Mermoz, Paris.

Looper, Matthew G.

1991 *The Name of Copan and of a Dance at Yaxchilan.* Copán Note 95. Copán Mosaics Project, Austin, Tex.

Maler, Teobert

1901 *Researches in the Central Portion of the Usumatsintla Valley.* Memoirs of the Peabody Museum of American Ethnology and Archaeology 2, no. 1. The Peabody Museum, Harvard University, Cambridge, Mass.

Martin, Simon, and Nikolai Grube

2000 *Chronicle of the Maya Kings and Queens: Deciphering the Dynasties of the Ancient Maya.* Thames and Hudson, London.

Mathews, Louisa C.

1998 The Painter's Presence: Signatures in Venetian Renaissance Pictures. *Art Bulletin* 80:616–648.

Mayer, Karl H.

1995 *Maya Monuments: Sculptures of Unknown Provenance, Supplement 4.* Academic Publishers, Graz.

Merwin, Raymond E., and George C. Vaillant

1932 *The Ruins of Holmul.* Memoirs of the Peabody Museum of American Archaeology and Ethnology 3, no. 2. The Peabody Museum, Harvard University, Cambridge, Mass.

Miller, Mary, and Claudia Brittenham

2013 *The Spectacle of the Late Maya Court: Reflections on the Murals of Bonampak.* University of Texas Press, Austin.

Miller, Mary, and Simon Martin

2004 *Courtly Art of the Ancient Maya.* Thames and Hudson, London.

Montgomery, John

1995 Sculptors of the Realm: Classic Maya Artist's Signatures and Sculptural Style during the Reign of Piedras Negras Ruler 7. MA thesis, Department of Art and Art History, University of New Mexico, Albuquerque.

Nagel, Alexander, and Christopher S. Wood

2010 *Anachronic Renaissance.* Zone Books, New York.

Neer, Richard

2002 *Style and Politics in Athenian Vase-Painting: The Craft of Democracy, ca. 530–460 B.C.E.* Cambridge University Press, Cambridge.

Nehamas, Alexander

1986 What an Author Is. *Journal of Philosophy* 83:685–691.

O'Neil, Megan E.

2012 *Engaging Ancient Maya Sculpture at Piedras Negras, Guatemala.* University of Oklahoma Press, Norman.

Osborne, Robin

2010 The Art of Signing in Ancient Greece. *Arethusa* 43:231–251.

Pérez Martínez, Vitalino, Federico García, Jeramías López y López, and Felipe Martínez Alvarez

1996 *Diccionario ch'orti' jocotán, chiquimula: Ch'orti'-español.* Proyecto Lingüístico Francisco Marroquín, Antigua.

Pevnick, Seth D.

2010 ΣΥΡΙΣΚΟΣ ΕΓΡΦΣΕΝ: Loaded Names, Artistic Identity, and Reading an Athenian Vase. *Classical Antiquity* 29:222–253.

Proskouriakoff, Tatiana

1944 *An Inscription on a Jade Probably Carved at Piedras Negras.* Notes on Middle American Archaeology and Ethnology 2, no. 47. Carnegie Institution of Washington, Washington, D.C.

1960 Historical Implications of a Pattern of Dates at Piedras Negras, Guatemala. *American Antiquity* 25:454–475.

1974 *Jades from the Cenote of Sacrifice, Chichen Itza, Yucatan.* Memoirs of the Peabody Museum of Archaeology and Ethnology 10, no. 1. The Peabody Museum, Harvard University, Cambridge, Mass.

Reents-Budet, Dorie, Stanley Guenter, Ronald L. Bishop, and M. James Blackman

2012 Identity and Interaction: Ceramic Styles and Social History of the Ik' Polity, Guatemala. In *Motul de San José: Politics, History, and Economy in a Classic Maya Polity*, edited by Antonia E. Foias and Kitty F. Emery, pp. 67–93. University Press of Florida, Gainesville.

Robertson, Martin

1992 *The Art of Vase-Painting in Classical Athens.* Cambridge University Press, Cambridge.

Robicsek, Francis, and Donald M. Hales

1981 *The Maya Book of the Dead: The Ceramic Codex—The Corpus of Codex Style Ceramics of the Late Classic Period.* University of Virginia Art Museum, Charlottesville.

Satterthwaite, Linton, Jr.

1965 Maya Practice Stone-Carving at Piedras Negras. *Expedition* 7:9–18.

Smith, A. Ledyard

1950 *Uaxactun, Guatemala: Excavations of 1930–1937.* Carnegie Institution of Washington Publication 588. Carnegie Institution of Washington, D.C.

Spinden, Herbert J.

1916 Portraiture in Central American Art. In *Holmes Anniversary Volume: Anthropological Essays Presented to William Henry Holmes in Honor of His Seventieth Birthday, December 1, 1916*, edited by Jesse W. Fewkes, pp. 434–450. J. W. Bryan Press, Washington, D.C.

Steiner, Ann

2007 *Reading Greek Vases.* Cambridge University Press, Cambridge.

Stone, Andrea J.

1995 *Images from the Underworld: Naj Tunich and the Tradition of Maya Cave Painting.* University of Texas Press, Austin.

Stuart, David

1987 *Ten Phonetic Syllables.* Research Reports on Ancient Maya Writing 14. Center for Maya Research, Washington, D.C.

1989a Hieroglyphs on Maya Vessels. In *The Maya Vase Book, A Corpus of Rollout Photographs of Maya Vases*, vol. 1, edited by Justin Kerr, pp. 149–160. Kerr Associates, New York.

1989b The Maya Artist: An Iconographic and Epigraphic Analysis. BA thesis, Department of Art and Archaeology, Princeton University, Princeton, N.J.

1990 *A New Carved Panel from the Palenque Area.* Research Reports on Ancient Maya Writing 32. Center for Maya Research, Washington, D.C.

2004 The Paw Stone: The Place Name of Piedras Negras, Guatemala. *The PARI Journal* 4:1–6.

2010 Shining Stones: Observations on the Ritual Meaning of Early Maya Stelae. In *The Place of Stone Monuments: Context, Use, and Meaning in Mesoamerica's Preclassic Transition*, edited by Julia Guernsey, John E. Clark, and Barbara Arroyo, pp. 283–296. Dumbarton Oaks Research Library and Collection, Washington, D.C.

Stuart, David, and Ian Graham

2003 *Corpus of Maya Hieroglyphic Inscriptions*, vol. 9, part 1: *Piedras Negras*. Peabody Museum, Harvard University, Cambridge, Mass.

Stuart, David, and Stephen Houston

1994 *Classic Maya Place Names.* Studies in
Pre-Columbian Art and Archaeology 33.
Dumbarton Oaks Research Library and
Collection, Washington, D.C.

Svenbro, Jesper

1993 *Phrasikleia: An Anthropology of Reading
in Ancient Greece.* Cornell University
Press, Ithaca, N.Y.

Syson, Luke

2011 The Rewards of Service: Leonardo
da Vinci and the Duke of Milan. In
*Leonardo da Vinci: Painter at the Court
of Milan,* by Luke Syson with Larry
Keith, Arturo Galansino, Antonio
Mazzotta, Minna Moore Ede, Scott
Nethersole, and Per Rumberg, pp. 12–53.
National Gallery of Art, London.

Tate, Carolyn

1994 *Ah Ts'ib*: Scribal Hands and Sculpture
Workshops at Yaxchilán. In *Seventh
Palenque Round Table, 1989,* edited by
Merle Greene Robertson and Victoria
M. Fields, pp. 95–103. Pre-Columbian
Art Research Institute, San Francisco.

Thompson, J. Eric S.

1939 *Excavations at San Jose, British
Honduras.* Carnegie Institution of
Washington Publication 506. Carnegie
Institution of Washington, D.C.

Tokovinine, Alexandre, and Dmitri Beliaev

2013 People of the Road: Traders and
Travelers in Ancient Maya Words and
Images. In *Merchants, Markets, and
Exchange in the Pre-Columbian World,*
edited by Kenneth G. Hirth and Joanne
Pillsbury, pp. 169–200. Dumbarton
Oaks Research Library and Collection,
Washington, D.C.

Tokovinine, Alexandre, and Marc Zender

2012 Lords of Windy Water: The Royal
Court of Motul de San José in Classic
Maya Inscriptions. In *Motul de San
José: Politics, History, and Economy in a
Classic Maya Polity,* edited by Antonia
E. Foias and Kitty F. Emery, pp. 30–66.
University Press of Florida, Gainesville.

Trik, Helen, and Michael E. Kampen

1983 *Tikal Report No. 31: The Graffiti of
Tikal.* University Museum Monograph
57. University Museum, University of
Pennsylvania, Philadelphia.

Tsukamoto, Kenichiro, and Octavio Esparza Olguín

2014 Lakam Officials: The Hieroglyphic
Stairway at the Guzmán Group of El
Palmar, Campeche, Mexico. *Maya
Archaeology* 3.

Van Stone, Marc L.

2005 *Aj-Ts'ib, Aj-Uxul, Itz'aat,* and *Aj-K'uhu'n*:
Classic Maya Schools of Carvers and
Calligraphers in Palenque After the
Reign of Kan-Bahlam. PhD dissertation,
Department of Art and Art History,
University of Texas, Austin.

Wanyerka, Phil

1996 A Fresh Look at a Masterpiece. *Cleveland
Studies in the History of Art* 1:72–97.

Wang, Aileen J.

2004 Michelangelo's Signature. *The Sixteenth
Century Journal* 35:447–473.

Warnke, Martin

1993 *The Court Artist: On the Ancestry of the
Modern Artist.* Cambridge University
Press, Cambridge.

Wilson, Adrian

2004 Foucault on the "Question of the
Author": A Critical Exegesis. *The
Modern Language Review* 99:339–363.

Wisdom, Charles

1950 *Materials on the Chorti Language.*
University of Chicago Microfilm
Collection of Manuscripts of Cultural
Anthropology, Series 5, Item 28.
University of Chicago Library, Chicago.

Zender, Marc

2002 The Toponyms of El Cayo, Piedras
Negras, and La Mar. In *The Heart of
Creation: The Mesoamerican World and
the Legacy of Linda Schele,* edited by
Andrea Stone, pp. 166–184. University of
Alabama Press, Tuscaloosa.

Textile Techné

Classic Maya Translucent Cloth and the Making of Value

CHRISTINA T. HALPERIN

THE MOST NOTED LUXURY CLOTHING OF the Classic-period Maya (ca. 300–850 CE) includes heavy brocaded garments, netted jade skirts and capes, and elaborately embroidered or painted textiles (Bruhns 1988; Johnson 1954; Joyce 2000; Looper and Tolles 2000; Reents-Budet 2006; Taylor 1992). Often excluded from analysis are whisper-thin and slightly translucent examples (Figure 14.1; see Pincemin Deliberos 1998:452–455; Taylor 1992:516). The difficulty in depicting translucent materials in some types of media—for example, ceramic figurines or carved stone—and the poor preservation of textile remnants in semitropical climates leave scant record of these socially and symbolically potent garments. Nevertheless, both painted murals and ceramic vessels indicate that such weaves were not only present among Classic-period populations but also relatively widespread throughout the southern Maya Lowlands, cross-cutting polity divides. This indirect evidence—combined with supporting evidence of textile impressions, spindle whorls, and contemporary

textile production practices—enriches our understanding of this poorly known textile genre.

Classic Maya translucent textiles defy many typical considerations of how crafts accrue value and, thus, provide a useful framework for examining the diversity of ways *techné* was performed in the Pre-Columbian past. The making of an object's value may include many components: an extraordinary amount of labor invested in the production process (Marx 1990); the nature and degree of a producer's skills (Costin 2001); the esoteric knowledge required for its production (Inomata 2001, 2007); the use of exotic or highly valued raw materials (Helms 1993); and the identity and prestige of the producers themselves (Costin and Wright 1998). Importantly, these are relative measures and, as such, must be considered in relation to other crafts as well as to the social events, peoples, and histories surrounding them. In assessing these different value productions, I argue that translucent textiles underscore, above all, the remarkable skills and knowledge required to spin extremely fine

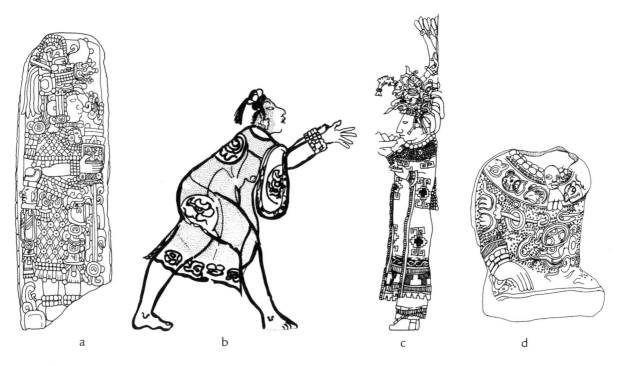

a b c d

figure 14.1

Comparison of different Classic-period Maya costumes: a) netted jade skirt and cape (El Zapote Stela 5, Schele drawing #7316, www.famsi.org); b) open-weave or gauze translucent huipil with embroidery or painted designs (detail of scene SE-S1, drawing by Christina T. Halperin after Martin 2012:fig.4); c) brocaded huipil (detail from Bonampak Stela 2, after Mathews 1980:62); d) elaborately embroidered or painted huipil (Lagatero molded ceramic figurine, drawing by Christina T. Halperin after Schmidt et al. 1988:266).

threads. Such forms of value productions, however, need not end with the production process itself, as techné both informs and is informed by bodily performances surrounding an object long beyond the last step in its manufacture. In the case of Late Classic translucent textiles, it was the youthful female body, in particular, that showcased the skills of such textile producers.

Value as Meaningful Action

David Graeber (2001:49) asks, "What if one did try to create a theory of value starting from the assumption that what is ultimately being evaluated are not things, but actions?" In other words, our understanding of an object's value is not any intrinsic aspect of the object itself (e.g., its standardization, size, raw material properties), but how, by whom, and in what social contexts that object is produced, performed, and entangled. Such a social

constructivist approach appears in many manifestations of value, from Annette Weiner's (1985, 1992) inalienable possessions—in which the value of an object is produced through its history with the people who hold it, keep it, and draw meaning from it—to object biography approaches, which draw on the varied memories and experiences (and, in turn, the forgetting) related to an object over the course of its "lifetime" (Brett-Smith 2001; Bruck 2006; Halperin 2011; Kopytoff 1986; Van Dyke and Alcock 2003).

Likewise, techné, skilled production combining knowledge and mechanical ability, is not fundamentally about a class of objects but rather the acts of making and performing (Parry 2008; Weiner 1995). It is through the acts of making that conceptual models, cultural ideals, understandings of raw materials' properties, and know-how are embodied and realized in material forms (Dobres and Hoffman 1994; Lechtman 1977). The material outcomes, or "finished products," however, are not the end story, since the performative "afterlives" of

crafts arguably help to define how those skills and knowledge—and the artisans themselves—are valued and reproduced. As Marx (1973:91, 93) asserted, "the product only obtains its 'last finish' in consumption. . . . Consumption accomplishes the act of production only in completing the product as product by dissolving it, by consuming its independently material form, by raising the inclination developed in the first act of production, through the need for repetition, to its finished form; it is thus not only the concluding act in which the product becomes product, but also that in which the producer becomes producer."

In some cases, relationships between production and performative use of a craft product are axiomatic or assumed, especially when a product's functions and uses are well known. In the case of translucent textiles, neither their production nor their use has been previously investigated in detail. As such, I first examine the social identities of producers and contexts of textile production; I then discuss the technical parameters of translucent textile production, the possible tools used in their production, and the performative dimensions of translucent textiles as garments to be worn.

Social Identities of Textile Producers

One of the ways in which goods gain their value is in their reciprocal association with the prestige, aura, and identities of the producers who make them (Costin and Wright 1998; Gell 1998; Inomata 2001). For the Late Classic Maya, the acts of spinning and weaving were closely associated with femininity and with elite households (Brumfiel 2006; Clark and Houston 1998; Halperin 2008; Hendon 1995, 1997, 2006). Known iconographic references to spinning and weaving, albeit scanty, place women as the quintessential weavers and spinners (Figure 14.2), and name-tagging on incised bone weaving tools referenced elite females (Dacus 2005; Delgado 1969; Houston and Stuart 2001; Taube 1994).

Although such activities are clearly gendered female, the knowledge and techniques associated with textile production, in actual practice, may not have been held exclusively by women (Hendon 2006). Among contemporary Maya groups, some men and boys spin and weave, but their participation is less common than that of women and girls (Anderson 1978; Schevill 1993; Schevill and Berlo 1991; Sperlich and Sperlich 1980). Brumfiel (2006) argues that the

figure 14.2
Females with textile-production tools:
a) ceramic figurine of elite woman weaving, Jaina, Mexico (after Schmidt et al. 1988:cat. 182); b) old woman or Goddess O with spindle and spun cotton in her headdress (after Taube 1994:fig. 2a). (Drawings by Christina T. Halperin.)

a

b

gendered nature of textile production was dynamic, with class as the most salient identity of textile producers of the Classic Maya, feminine gender identity as the most salient identity among textile producers of the Postclassic Aztec, and ethnicity as the most salient identity among contemporary textile producers. Further, textile production involves multiple stages of labor and implicates productive activities beyond just spinning and weaving, such as plant cultivation, harvest or collection, fiber processing (e.g., cleaning and removing seeds from cotton bolls or scraping, trimming, and drying maguey fibers), plying threads, sizing threads, dyeing, warping, and sometimes embroidering, painting, sewing on decorative elements, and tailoring. Thus, even though spinning and weaving were likely gendered female in the Classic-period past, they probably involved or implicated shared labor between multiple social groups—including adult males and females, the elderly, and children—similar to contemporary practices (Halperin 2011).

Elite Maya households invested considerable energies into textile production, and such activities were likely considered as skilled crafts alongside lapidary work, painting, and stone carving. For example, recent archaeological research on Late Classic–period textile tool distributions reveal that while both elite and commoner households engaged in spinning, weaving, and sewing, these activities were often larger in scale or intensity within royal and lesser elite households than within commoner ones (Chase et al. 2008; Halperin 2008; Hendon 1997; Morehart and Helmke 2008; Widmer 2009:187, 194). In this sense, skilled cloth production may have been intimately associated with elite female identities even though such tasks were not necessarily restricted to either females or the elite class. The productive knowledge, labor, and skills of these textile producers can be understood, in part, through an assessment of the technical parameters of manufacture.

Productive Techniques and Modes of Value

The translucent weaves identified in Late Classic–period imagery may have been produced either by gauze-weaving techniques or by open-spaced plain-weaving techniques (Figure 14.3). Translucent, open-spaced plain weaves are made by interacting single warp and weft elements in a simple over–under fashion, with warp and weft elements spaced far enough apart to create openings in the fabric. Gauze weaves contain in the fabric openings created by warp threads interlaced with each other and held together by weft threads. The latter may come in simple (e.g., plain gauze in which single warp threads interwork with each other) or more complex forms (e.g., pairs of odd-number warps cross over with pairs of even-number warps) (O'Neale and Clark 1956:159–166). Regardless of the type of gauze weave, however, they can be relatively simple to produce, as the principal difference in the weaving process consists of shed roll changes rather than the complicated counting, spacing, and inserting of many, often differently dyed, weft threads, as in the production of heavy brocades (O'Neale 1945:74–75; Pancake and Baizerman 1980-1981:3–9). Contemporary examples from the Maya area as well as well-preserved Pre-Columbian Peruvian examples are sometimes further elaborated with embroidery or supplementary weft designs (O'Neale and Clark 1956; Pancake and Baizerman 1980/1981; Vitale 2010).

Although some have suggested that translucent textiles seen in Late Classic imagery may be an artistic convention rather than a realistic representation of textiles used in the past (Stone 2011:171), evidence of both translucent open-spaced plain weaves and gauze weaves is present in the archaeological record. Gauze weaves were recovered among the Late Classic– to Postclassic-period textiles dredged from the Cenote of Sacrifice at Chichen Itza (Lothrop 1992:66–67, table 3.3), and simple gauze weaves with simple brocaded designs have been found among Postclassic remains from more arid regions of Mesoamerica, such as the Tehuacán Valley, Mexico (King 1979:272). Both translucent open-spaced plain and simple gauze weaving techniques are documented among surviving textiles in Early Classic Burial 19 at Rió Azul, Guatemala (Adams 1986:436, 445; Carlsen 1987). In addition, a single textile impression made on clay

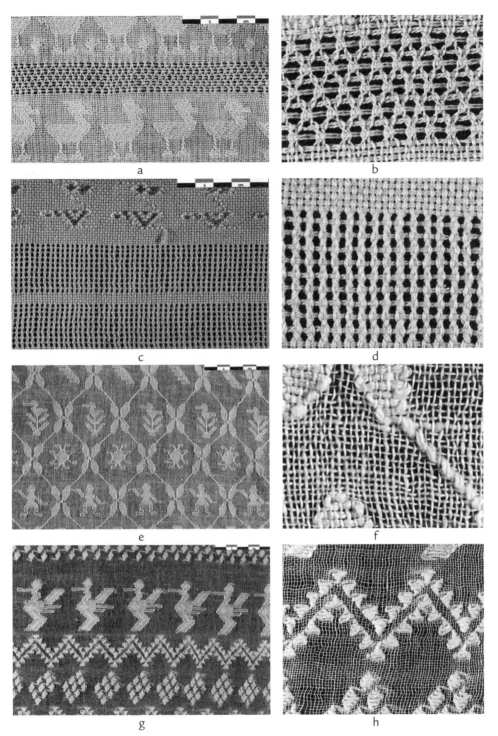

figure 14.3

Contemporary translucent textiles: a) complex gauze weave and plain-weave composite with supplementary weft brocade; San Pedro Carchá, Alta Verapaz, Guatemala; unknown weaver; commercial yarn; b) detail of Figure 14.3a; c) simple gauze (*calada*) and plain-weave composite; San Juan Chamelco, Alta Verapaz, Guatemala; unknown weaver; commercial yarn; d) detail of Figure 14.3c; e) open-spaced weave (*pikb'il*) with supplementary weft brocade; Sanimatacá, Alta Verapaz, Guatemala; María Pub Chub, weaver; unpolished commercial thread size 20/1; f) detail of Figure 14.4e; g) open-spaced weave (*petete*) with supplementary weft brocade; Venustiano Carranza, Chiapas, Mexico; h) detail of Figure 14.3g. (Photographs courtesy of Kathleen Vitale.)

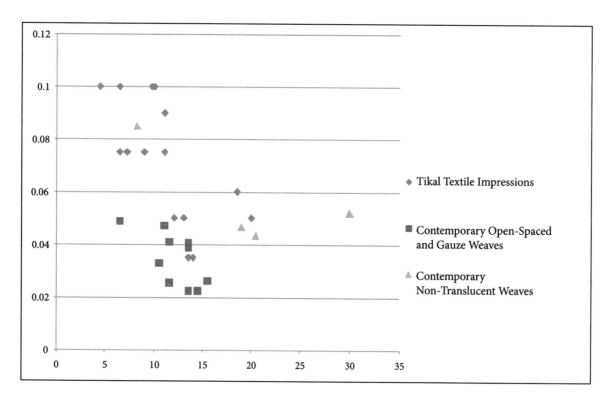

figure 14.4

Comparison of ancient (from Tikal textile impressions; Moholy-Nagy 2003:88–91) and contemporary Maya translucent weaves through a plot of warp and weft count means (per cm; x-axis) by thread thickness (per cm; y-axis). (Note: Contemporary textiles measured four times and averaged; measurements taken using ImageJ software.)

or plaster from the site of Tikal provide a possible example of multiple warp gauze, and several of the impressions can be characterized as open-spaced translucent weaves based on the similarity of their technical dimensions with open-spaced translucent weaves produced today (Moholy-Nagy 2003:88–91; Figure 14.4).

These examples, combined with the Late Classic images of translucent textiles, indicate that the most common forms of translucent textiles were either plain and undecorated, or they boasted simple abstract designs, likely produced through the addition of discontinuous supplementary weft threads (Figure 14.5 and Tables 14.1–14.3). Artistic renderings of some translucent garments use a diagonal cross-hatching design, which may represent either gauze weaves with their characteristic diamond-shaped openings (see Figure 14.3a–b) or open-spaced plain weaves with supplementary weft brocades created in a diamond pattern (see

Figure 14.3e–f). Some of the decorations with geometric or angular patterns (Figure 14.6b) were likely supplementary weft brocades, as in contemporary examples. In rare instances, translucent textiles are depicted with multiple yarn colors, decorative application of glyphs or deity symbols using either painting or embroidery techniques, or the addition of fringe lining. These elaborate versions undoubtedly marked the high status of the women wearing them, although royal women, such as those from the royal court at Bonampak, also wore undecorated translucent garments (Figure 14.6a). Together, these examples suggest that translucent textiles involved some variation in the techniques employed, and, in turn, some variation in the labor, skills, and knowledge required for their production.[1]

Some contemporary Maya weavers produce open-spaced and gauze textiles, although these weavers are few in number and known only from a

a

b

c

figure 14.5
Comparison of different types of Late Classic Maya
translucent weave depictions: a) plain (detail from
polychrome vase © Justin Kerr, K1182); b) cross-hatching
(complex gauze?) (detail from polychrome vase © Justin
Kerr, K1549); c) highly decorated with embroidery or
paint (detail from polychrome vase © Justin Kerr, K5538).

table 14.1

Translucent textiles depicted on Late Classic Maya vessels

DESCRIPTION OF TEXTILE	CLOTHING TYPE	GENDER	POSE/ ACTIVITY	SCENE	REGION*	REFERENCE #
cross-hatching, simple supplementary weft designs	wide scoopneck huipil (only top part of body visible)	F	tending to elderly deity	mythological palace scene	Codex style, northern Peten	K1182
plain	wide scoopneck huipil	F	riding on deer	mythological palace scene	Codex style, northern Peten	K1182
plain	wide scoopneck huipil	F	embracing with deer	mythological palace scene	Codex style, northern Peten	K1182
plain	huipil, wide scoopneck (and broadbrimmed hat)	F	embracing with deer	mythological scene	Codex style, northern Peten	K1559
cross-hatching, simple supplementary weft designs, elaborate fringe	wide scoopneck huipil over corte	F	dancing in front of Tayel Chan K'inich, k'uhul Ik' ajaw	historical palace scene	Tikal	K2573
cross-hatching	wide scoopneck huipil over corte	F?	female or possible female impersonator; dancing with male dancer and musicians	historical scene	Ik' style, western side of Lake Peten Itza; Motul de San José	K1549
cross-hatching, simple supplementary weft designs, elaborate fringe	wide scoopneck huipil over corte	F	dancing with male dancer and musicians	historical scene	Ik' style, western side of Lake Peten Itza; Motul de San José	K3463
painted or embroidered? circular designs and abstract god head?	wide scoopneck huipil over corte	F	seated, paired with male, both of whom face several grotesque and underworld figures	mythological drinking scene	?	K5538
circular supplementary weft designs	wide scoopneck huipil (lower body partly eroded/ poorly visible)	F	seated in palace scene, receiving guests	historical scene?	Codex style, northern Peten	K2603

DESCRIPTION OF TEXTILE	CLOTHING TYPE	GENDER	POSE/ ACTIVITY	SCENE	REGION*	REFERENCE #
supplementary weft designs?	wide scoop-neck huipil; sash at waist; corte difficult to identify if present; wears censer on her back	F	seated facing serpent with elderly figure protruding from serpent mouth	mythological scene	Codex style, northern Peten	K2715
cross-hatching, supplemen-tary weft cloud designs (S scrolls)	wide scoop-neck huipil	F	seated with two other women, facing Hero Twins or other paired mytho-logical figure	mytholocial palace scene	Codex style, northern Peten	K2772
cross-hatching, supplementary weft designs (earth/turtle symbolism)	wide scoop-neck huipil	F	seated with two other women, facing Hero Twins or other paired mytho-logical figure	mytholocial palace scene	Codex style, northern Peten	K2772
cross-hatching	wide scoop-neck huipil with lower body por-tion very translucent	F	standing with hummingbird	mythological	possibly Alta Verapaz?	K7433
plain	corte, wrapped below exposed breasts; trans-lucency at leg area	F	reclined facing a dwarf	mythological	possibly Alta Verapaz?	K8076
plain	wide scoop-neck huipil over corte (corte hem visible under huipil at knees)	F	seated in water sign cartouche with dog on lap; large serpent and elderly Och Chan figure (compare Codex-style versions)	mythological	Chocholá style, northern-western Yucatan	K8685
TENTATIVE IDENTIFICATIONS OF TRANSLUCENT TEXTILES						
plain	huipil, wide scoopneck (and broad-brimmed hat)	F	tending to elderly deity	mythological scene	Codex style, northern Peten	K1559

* identified by vessel style

table 14.2

Translucent textiles from Late Classic Maya painted murals

DESCRIPTION OF TEXTILE	CLOTHING TYPE	GENDER	POSE/ACTIVITY
plain, white	wide scoopneck huipil	F	seated in front of bench/throne
geometric supplementary weft designs, white	huipil over corte	F or M?	seated, central figure on bench/throne, collecting tribute
geometric supplementary weft designs, white	wide scoopneck huipil over corte	F	standing at edge of bench/throne
plain, white	wide scoopneck huipil	F	seated
plain, white	wide scoop neck huipil	F	seated, bloodletting
plain, white	wide scoopneck huipil	F	seated holding child
plain, white	wide scoopneck huipil	F	standing, bloodletting
plain, white	wide scoopneck huipil	F	seated, bloodletting
dyed blue; glyphic symbols painted or embroidered in red, orange, pink, and white; fringe lining	wide scoopneck huipil, slight traces of possible corte	F	central figure in the scene; helping load cargo onto the head of assistant
plain, dyed purple	narrow scoopneck huipil over corte	F	seated wearing broad-brimmed hat, serving tamales
plain, dyed blue	wide scoopneck huipil over corte	F	seated holding dish; cargo and child behind figure

TENTATIVE IDENTIFICATIONS OF TRANSLUCENT TEXTILES

DESCRIPTION OF TEXTILE	CLOTHING TYPE	GENDER	POSE/ACTIVITY
plain, white	wide scoopneck huipil over corte	F	*ix sajal* (noblewoman) standing behind *ix ajaw* (queen) of Yaxchilan
plain, dyed blue	wide scoopneck huipil over corte	F	seated with basket full of ceramic vessels
plain, dyed blue	wide scoopneck huipil over corte	F	seated holding salt wrapped in green leaves?

SCENE	LOCATION	SITE	REFERENCE
historical palace scene, tribute collection	Structure 1, room 1, west wall, throne scene, figure 17	Bonampak, Mexico	Miller 1986:65; Miller and Brittenham 2013:fig.235
historical palace scene, tribute collection	Structure 1, room 1, west wall, throne scene, figure 19	Bonampak, Mexico	Miller 1986:65; Miller and Brittenham 2013:fig.235
historical palace scene, tribute collection	Structure 1, room 1, west wall, throne scene, figure 21	Bonampak, Mexico	Miller 1986:65; Miller and Brittenham 2013:fig.235
historical palace scene, bloodletting	Structure 1, room 3, east wall, figure 1	Bonampak, Mexico	Miller and Brittenham 2013:figs. 100, 261
historical palace scene, bloodletting	Structure 1, room 3, east wall, figure 2	Bonampak, Mexico	Miller and Brittenham 2013:figs. 100, 261
historical palace scene, bloodletting	Structure 1, room 3, east wall, figure 3	Bonampak, Mexico	Miller and Brittenham 2013:figs. 100, 261
historical palace scene, bloodletting	Structure 1, room 3, east wall, figure 4	Bonampak, Mexico	Miller and Brittenham 2013:figs. 100, 261
historical palace scene, bloodletting	Structure 1, room 3, east wall, figure 6	Bonampak, Mexico	Miller and Brittenham 2013:figs. 100, 261
historical public ceremonial/market scene	Chiik Nahb complex; SE-S1	Calakmul, Mexico	Carrasco Vargas 2012:figs. 14, 22
historical public ceremonial/market scene	Chiik Nahb complex; SE-S2	Calakmul, Mexico	Carrasco Vargas and Cordeiro Baqueiro 2012:fig. 19
historical public ceremonial/market scene	Chiik Nahb complex; NE-N2	Calakmul, Mexico	Carrasco Vargas and Cordeiro Baqueiro 2012:fig. 36
historical scene on open steps, receiving of captives	Structure 1, room 2, north wall, figure 98	Bonampak, Mexico	Miller and Brittenham 2013:figs. 161, 303
historical public ceremonial/market scene	Chiik Nahb complex; EsE-LtS2	Calakmul, Mexico	Carrasco Vargas and Cordeiro Baqueiro 2012:fig. 8
historical public ceremonial/market scene	Chiik Nahb complex; NE-E1	Calakmul, Mexico	Martin 2012:fig. 19

table 14.3

Translucent textiles from Late Classic Maya carved stone monuments

DESCRIPTION OF TEXTILE	CLOTHING TYPE	GENDER	POSE/ ACTIVITY	SCENE	MONUMENT #	SITE	REFERENCE
plain	cape/cloak	M	subordinate nobleman seated in front of Bonampak lord	historical accession scene	Panel 1	Bonampak, Mexico	Schele Photo#79054, www.famsi.org
plain	cape/cloak	M	subordinate nobleman seated in front of Bonampak lord	historical accession scene	Panel 1	Bonampak, Mexico	Schele Photo#79054, www.famsi.org
plain	cape/cloak	M	subordinate nobleman seated in front of Bonampak lord	historical accession scene	Panel 1	Bonampak, Mexico	Schele Photo#79054, www.famsi.org

handful of towns in Alta Verapaz, Guatemala (e.g., Coban, San Pedro Carchá, San Juan Chamelco) and Venustiano Carranza, Chiapas, Mexico (O'Neale 1945:75–76; Pancake and Baizerman 1980/1981; Vitale 2010). Q'eqchi'-speaking Maya weavers from Alta Verapaz refer to open-spaced plain weaves as *pikb'il* and refer to gauze weaves as *tejido calado*; Tzotzil-speaking Maya weavers from Venustiano Carranza refer to translucent open-spaced plain weaves as *petete* (see Figure 14.3).

In contrast with the regionalism noted for contemporary Maya translucent textile production, Late Classic–period translucent weaves do not appear to have been tied to local technological styles (Figure 14.7). As such, it is likely that the knowledge required to weave such textiles was not specific to particular Maya polities. For example, translucent textiles appear in imagery from geographically distant zones of the Maya area, such as the Ik' polity located along the western shore of Lake Peten Itza (Motul de San José and environs), Bonampak along the Usumacinta River, northwestern Yucatan, and northern Peten. These weaves are often featured on polychrome vessels whose pottery styles and chemical compositions are specific to competing and often antagonistic political centers, such as Tikal and Calakmul region sites (as

denoted by Codex-style vases; see Table 14.1). In this sense, translucent textiles do not appear to delineate regional identities in the way that artisans from pottery workshops of Late Classic palaces demarcated polity affiliations (Reents-Budet 1994, 1998; see Houston, this volume; see also Brittenham and Magaloni, this volume, for paint recipes). This pattern is not surprising: other ceremonially and socially significant clothing, such as netted jade skirts and capes, also appear in imagery from diverse regions of the Maya area.

Interestingly, the open spacing of translucent weaves seems to go against an ancient valuation system of Mesoamerican textiles in which tightly woven textiles are highly esteemed. For example, the *Florentine Codex* describes a good weaver as one who makes her cloth "tight, [she] compresses it, beats it down" while a bad weaver is "lazy, indolent—a nonchalant, sullen worker; a deceiver" (Sahagún 1961:36). In the indigenous Maya dance drama, Rabinal Achi, the ruler of Rabinal, Lord Five Thunder, emphasizes the quality of the cloth he gives Cawek of the Forest People in describing it as "the soft one, the delicate one, the double warp and tamped weft, the weaving tightly done, the work of my mother, my lady" (Tedlock 2003:107).[2] In the latter case, the value of the cloth appears to

figure 14.6
Bonampak murals showing different types of translucent textiles: a) plain (palace scene of women bloodletting, Room 3 East Wall [top], and detail from Room 3 East Wall [bottom]; and b) decorated with geometric designs (supplementary weft brocade?) and fringes (royal court receiving tribute from Room 1 West Wall [top], and detail from Room 1 West Wall [bottom]. (Photographs by Hans Ritter, courtesy of the Bonampak Documentation Project.)

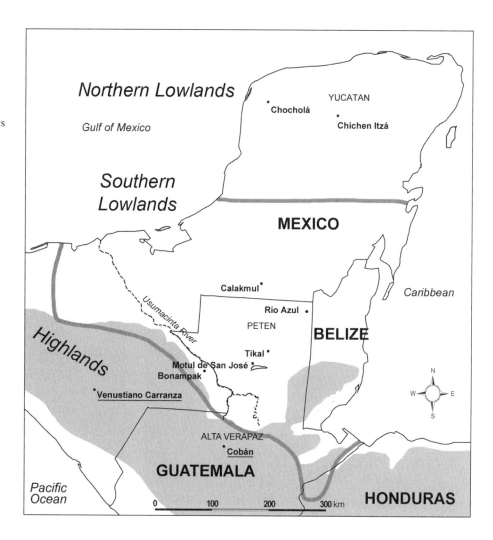

figure 14.7
Map of the Maya area, showing the locations of sites or regions where images or remnants of translucent textiles have been identified (see also Tables 14.1–14.3). Contemporary towns where translucent textile production occurs are underlined. (Note: Several villages around Cobán, such as San Pedro Carchá and San Juan Chamelco, are also sites of contemporary translucent textile production.) (Map by Christina T. Halperin.)

derive not only from its technical attributes alone, such as the tightness of the weave, but also from the artisan herself.

Another factor to consider is the labor involved in weaving and spinning, which was enormous. Cathy Costin (2012:181), for example, estimates that the number of hours devoted to textile production is often more than food production and other crafts production combined. Unlike tightly spaced brocaded weaves, however, most translucent weaves likely required less raw materials and less weaving time. The lightweight, sheer effect of both gauze and translucent plain weaves is accomplished by using: (1) low warp and weft thread counts; and (2) extremely fine thread (Pancake and Baizerman 1980/1981:9). In this sense, they are quicker to weave because there are fewer numbers of warps that need to be placed on the loom during set-up and

fewer numbers of overall motions of passing the bobbin through the shed and tamping the thread down with a batten. For example, Kathleen Vitale records that the weaving of heavy, brocaded *huipiles* in the styles of Chichicastenago, Guatemala, and San Antonio Aguas Calientes, Guatemala (in the latter case, heavy double-faced brocade) took each highly skilled and experienced weaver three months to weave (working full-time and, in many cases, during the night). In comparison, she notes that a *pikb'il huipil* with simple supplementary weft designs may only take three to four weeks to weave (working more intermittently; Vitale, personal communication, 2013). Spinning is also extremely labor intensive. Although fine-quality yarn takes longer to spin than does low-quality yarn (Needham 1988:86–87), tightly spaced, heavily brocaded weaves required more overall yarn than

open-spaced plain or gauze weaves. Vitale recounts Flora Xoc, a master weaver from Tactic, Guatemala, saying that she likes to weave pikb'il (translucent plain weaves with supplemental weft designs) because it lets her rest her hands between more tightly woven styles (Vitale, personal communication, 2013). While the wefts of tightly woven weaves are tamped down harshly with a thud, the wefts of translucent plain weaves are only lightly tamped down in a soft whisper (Vitale, personal communication, 2013). In this sense, they are as light on the ears and fingers during the weaving process as they are on the body when worn.

The value of crafts can also be assessed by the exotic nature of the raw materials used in their production. These values are tied to socially or mythically significant meanings, which are associated with the materials' places of origin and with the journeys and labor involved in retrieval (Helms 1993). Classic-period translucent weaves were probably woven of cotton (likely *Gossypium herbaceum L., Gossypium Schotti,* or *Gossypium religiosum L.*). But in some parts of Mesoamerica—such as in the higher elevation zones of the Basin of Mexico—cotton could not be locally grown; it was both harvested and found growing wild in the warmer climates of the southern Maya Lowlands, among other areas of Mesoamerica (Atran et al. 2004; Lothrop 1992; Mejía de Rodas 1997). As such, translucent weaves contrast with garments that were made from or adorned with imported and elaborately worked materials, such as jade skirts, feather capes made of exotic bird species, and tunics or belts made out of or adorned with *Spondylus* spp. shell plaques or *Olivella* spp. "tinkler" shells taken from the ocean.

Although translucent textiles did not necessarily embody the most labor intensive of all textiles—nor were they made of exotic raw materials—one of their distinguishing features was the extremely fine thread used to produce them. In general, the literature on Maya textile production emphasizes the creativity and skill of weavers, and largely disregards the virtuosity of spinners.[3] Among some crafts, the final production stages might have been more highly valued than the beginning or intermediate stages. For example, the final incising and polishing phases of Classic Maya jade production appear to have been more highly valued, or at least regulated, than the earlier sawing and drilling stages because these final stages were conducted by elite or elite-sponsored artisans; commoner household workshops engaged in the earlier stages (Kovacevich 2007; Taube and Ishihara-Brito 2012; cf. Rochette 2009). Likewise, a small group of Classic Maya painters were celebrated on elaborate polychrome pots. These artists were allowed to leave their signatures on the pots themselves (Reents-Budet 1994, 1998; see also Houston, this volume), but the potters who formed and fired the vessels were not explicitly recognized in this way.

Yet translucent weaves highlight spinners' ability to produce both fine and highly consistent threads. In regard to Pre-Columbian Peruvian textiles, O'Neale and Clark (1956:154) remark that the "[t]ransparency in the lacelike gauzes was achieved by skillful manipulation of yarns; hence much of the responsibility for quality devolved upon the spinners." Finer threads can break more easily, especially when they are spun inconsistently with differing amounts of tension between thin and thick areas of the thread.[4] A spinner must know how to draw out the raw cotton from the spindle and simultaneously spin the whorl at just the right speed so that each section of thread matches the previous one (Johnson 1954:138; Sperlich and Sperlich 1980:5–7). These skills are not acquired overnight—they are developed over the course of a lifetime. Among the Aztec, at least, the development of spinning skills began at age six and continued into adulthood (Berdan and Anawalt 1997:148–149, 57r).

While contemporary Maya weavers from Alta Verapaz buy fine unmercerized commercial cotton, size 20/1, some contemporary Tzotzil-speaking Maya weavers from Venustiano Carranza, Chiapas, were known to spin their own cotton. The fact that the Tzotzil word for such translucent weaves is *petete*, meaning spindle whorl (Laughlin 1975:273), may suggest that there is particular pride in such spinning skills as contributions to the final product. More recently, petete weavers have been noted to unravel commercial thread size 30/2 (the "/2"

signifies double ply) using a ceramic spindle and whorl in order to acquire an even thinner, single-ply thread (Vitale, personal communication, February 11, 2014). Such a practice highlights a desire for ultra-thin thread and the continued use of spindles and spindle whorls; at the same time, the use of commercialized yarn indicates a desire to minimize labor investment. It appears that Classic-period spinning was also highly valued: spindle whorls, in addition to other textile-production tools, were occasionally placed as grave offerings in elite burials (Chase et al. 2008; Moholy-Nagy 2003:46–47; Zralka 2007:fig. 43) and are found in the hair of elderly female deities (Taube 1994).

Late Classic Spindle Whorls and Qualities of Thread

The diversity of spindle whorls present among Late Classic–period archaeological collections may suggest that there was a concern for different intended qualities of the thread, such as thin or thick cotton varieties, in addition to diverse types of fibers (e.g., different types of cotton, agave, feathers, etc.) and spinning techniques (e.g., drop versus support spinning; Figure 14.8; see also Halperin 2008; Moholy-Nagy 2003; Hernández Álvarez and Peniche May 2012; Morehart and Helmke 2008). Most spindle whorls recovered in the archaeological record are made from fired clay. These spindle whorls were likely created in molds, although centrally perforated sherd disks (CPSDs) made from broken fragments of pottery vessels also may have served as spindle whorls (Beaudry-Corbett and McCafferty 2002; Parsons and Parsons 1990:314; Smith and Hirth 1988; Willey 1972:81–82; cf. Chase et al. 2008). Other examples of spindle whorls found in the archaeological record include those made of limestone, shell, wood and other plant materials, and bone—although the latter three are relatively rare (Hernández Álvarez and Peniche May 2012). A whole suite of other materials also may have been used (e.g., unfired clay) to make spindle whorls for which we have no material record.

In a comparison to Late Classic–period (ca. 600–900 CE) spindle whorls from southern Lowland Maya sites (Motul de San José, Nixtun Ch'ich', and Caracol), I found that the hemispherical (bead-shaped) whorls, particularly those made from limestone, corresponded most closely to the sizes and weights of those spindle whorls used by contemporary Mixtec and Maya women for spinning cotton (Figure 14.9 and Table 14.4). In general, small, light whorls with small holes are correlated with the spinning of fine fibers, such as cotton (McCafferty and McCafferty 2000:43–46; O'Neale 1945:fig. 75; Parsons 1972; Parsons and Parsons 1990; Schevill 1993:240–241). Bead-shaped whorls with high height-to-diameter ratios provide a faster, tighter spin than do disk-shaped whorls of the same weight and hole size. A fast, tight spin is particularly useful in spinning short fibers, such as cotton. In addition, tightly spun threads are better than loose ones, as the former provide added strength—a quality necessary when threads are extremely thin (O'Neale and Clark 1956:154). Heavier whorls, however, have higher mass moment of inertia than do lighter ones of the same shape and thus can spin longer and wobble less than lighter whorls (Fauman-Fichman 1999:229–249; McCafferty and McCafferty 2000:43–46; Needham 1988:85–87). The combination of the limestone whorls' hemispherical (bead-like) shape and slightly heavier weight may have provided particularly useful parameters for producing both fine and consistently spun cotton threads, such as those required for the translucent weaves described here.

Alternatively, the technical parameters of limestone whorls may not have been significant compared to those of ceramic whorls, but the specialized labor involved in the carving and polishing of such tools may speak to the role of spinning as a highly valued craft. Limestone spindle whorls are most commonly found in the highest elite tomb and residential contexts (Chase et al. 2008; Hernández Álvarez and Peniche May 2012:448–453; Moholy-Nagy 2003:43–47; Zralka 2007:fig. 43). They date primarily to the Late and Terminal Classic periods (ca. 600–900 CE), overlapping in time with the imagery of translucent textiles.

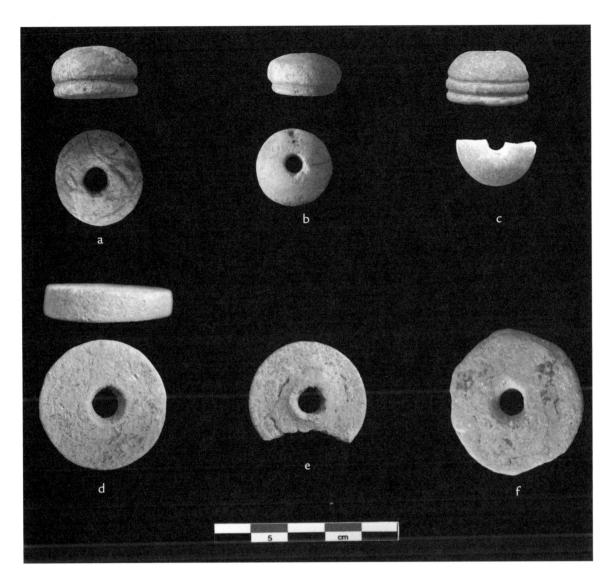

figure 14.8

Classic-period spindle whorls: a) ceramic hemispherical spindle whorl, profile and plan (Motul de San José, MSJ14A-6-1-2); b) limestone hemispherical spindle whorl, profile and plan (Trinidad de Nosotros [satellite site of Motul de San José], TRI21E-1-2-2); c) limestone hemispherical spindle whorl, profile and plan (Tayasal, TY001); d) ceramic centrally perforated sherd disk (CPSD) with polished edges, profile and plan (Nixtun Ch'ich', NC016); e) ceramic disk, plan (Nixtun Ch'ich', NC005); and f) ceramic CPSD, plan (Motul de San José, MSJ15A-35-2-3). (Photographs by Christina T. Halperin.)

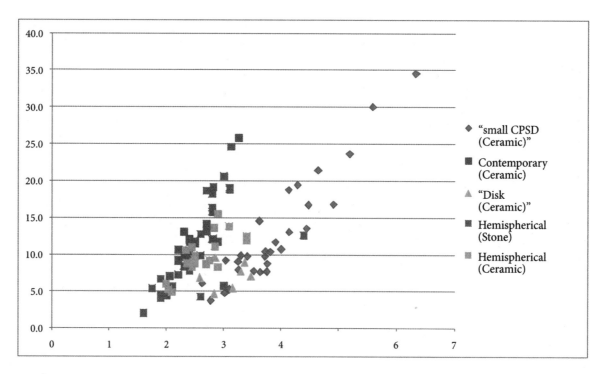

figure 14.9

Spindle-whorl diameter (cm; x-axis) by weight (grams; y-axis), comparing contemporary spindle whorls with Classic-period spindle whorl types (small CPSDs, molded ceramic disc whorls, molded ceramic hemispherical [bead-shaped] whorls, and limestone hemispherical [bead-shaped] whorls from the archaeological sites of Motul de San José, Nixtun Ch'ich', and Caracol; see Table 14.4).

table 14.4

Spindle whorl attributes

SITE	ID #	DIAMETER (CM)	HEIGHT (CM)	WEIGHT (G)	HOLE DIAMETER (CM)	FORM	MATERIAL
Venustiano Carranza, Mexico		2.9	3.25	25.8	0.71	Hemispherical	Ceramic with pitch surface coating
Jamiltepec, Mexico		2.4	2.4	12.0	0.7	Hemispherical	Ceramic
Sololá, Guatemala		2.9	2.3	13.0	NA	Hemispherical	Ceramic
Motul de San José	MSJ15A	3.02	5.5	4.7	8.8	CPSD	Ceramic
Motul de San José	MSJ15A-11-2-3	6.33	7.8	34.5	9.3	CPSD	Ceramic
Motul de San José	MSJ15A-11-3-1	3.91	7.4	11.6	4.9	CPSD	Ceramic
Motul de San José	MSJ15A-12-2-5	3.53	6.4	7.7	5.4	CPSD	Ceramic
Motul de San José	MSJ15A-37-3-1	3.63	10.0	14.5	7.0	CPSD	Ceramic

table 14.4 —continued

SITE	ID #	DIAMETER (CM)	HEIGHT (CM)	WEIGHT (G)	HOLE DIAMETER (CM)	FORM	MATERIAL
Motul de San José	MSJ15A-8-3-1	4.01	7.8	10.7	5.6	CPSD	Ceramic
Motul de San José	MSJ29E-1-3-6	4.14	9.0	18.7	5.9	CPSD	Ceramic
Motul de San José	MSJ2A-24-2-1	3.1	4.6	5.2	7.2	CPSD	Ceramic
Motul de San José	MSJ2A-5-6-17	2.78	3.9	3.7	2.9	CPSD	Ceramic
Motul de San José	MSJ2A-5-6-17	3.65	6.2	7.6	6.2	CPSD	Ceramic
Motul de San José	MSJ2A-8-2-1	3.25	7.6	9.0	6.6	CPSD	Ceramic
Motul de San José	MSJ30A-16-1-2	3.26	6.6	7.8	5.3	CPSD	Ceramic
Motul de San José	MSJ35H-4-1-1	3.76	6.1	7.6	7.3	CPSD	Ceramic
Motul de San José	MSJ35H-4-2-4	3.82	6.4	10.3	7.3	CPSD	Ceramic
Motul de San José	MSJ39C-1-2-2	4.15	6.7	13.0	4.3	CPSD	Ceramic
Motul de San José	MSJ44I-1-3-5	3.04	9.7	9.1	4.8	CPSD	Ceramic
Motul de San José	MSJ7B-1-3-1	4.46	4.7	13.5	7.4	CPSD	Ceramic
Motul de San José	MSJ8D-15-1-2	3.73	4.9	9.6	5.9	CPSD	Ceramic
Nixtun Ch'ich'	NC021	5.6	7.5	30.0	8.6	CPSD	Ceramic
Nixtun Ch'ich'	NC031	4.66	7.6	21.4	6.8	CPSD	Ceramic
Nixtun Ch'ich'	NC038	4.92	5.8	16.7	6.1	CPSD	Ceramic
Nixtun Ch'ich'	NC042	5.2	5.9	23.6	5.9	CPSD	Ceramic
Nixtun Ch'ich'	NC043	3.42	6.6	9.7	4.9	CPSD	Ceramic
Nixtun Ch'ich'	NC010	4.3	8.2	19.4	6.1	CPSD	Ceramic
Nixtun Ch'ich'	NC009	2.63	7.3	6.0	11.8	CPSD	Ceramic
Nixtun Ch'ich'	NC022	3.3	8.2	9.8	24.1	CPSD	Ceramic
Nixtun Ch'ich'	NC029	4.49	7.2	16.7	7.1	CPSD	Ceramic
Nixtun Ch'ich'	NC035	3.77	5.3	8.7	NA	CPSD	Ceramic
Nixtun Ch'ich'	NC036	3.74	7.0	10.3	6.2	CPSD	Ceramic

table 14.4 —continued

SITE	ID #	DIAMETER (CM)	HEIGHT (CM)	WEIGHT (G)	HOLE DIAMETER (CM)	FORM	MATERIAL
Caracol	C001B/3-2A	2.7	NA	13.7	0.6	Hemispherical	Stone
Caracol	C001B/3-2B	2.1	NA	5.6	0.4	Hemispherical	Stone
Caracol	C001B/3-2C	1.9	NA	4.4	0.3	Hemispherical	Stone
Caracol	C001B/3-2D	1.75	NA	5.3	0.3	Hemispherical	Stone
Caracol	C001B/3-2E	2.3	NA	9.6	0.6	Hemispherical	Stone
Caracol	C001B/3-2F	1.9	NA	4.0	0.4	Hemispherical	Stone
Caracol	C001B/4-1A	2.0	NA	4.4	0.6	Hemispherical	Stone
Caracol	C001B/4-1B	2.4	NA	7.7	0.6	Hemispherical	Stone
Caracol	C001H/27-41	2.6	NA	12.7	0.5	Hemispherical	Stone
Caracol	C001H/27-42	2.2	NA	9.2	0.4	Hemispherical	Stone
Caracol	C001H/27-43	2.2	NA	7.2	0.45	Hemispherical	Stone
Caracol	C001H/27-45	2.4	NA	9.9	0.5	Hemispherical	Stone
Caracol	C001H/27-46	2.4	NA	7.9	0.5	Hemispherical	Stone
Caracol	C001H/27-47	2.4	NA	9.7	0.5	Hemispherical	Stone
Caracol	C001H/27-48	2.4	NA	9.7	0.5	Hemispherical	Stone
Caracol	C001H/27-49	2.5	NA	9.7	0.5	Hemispherical	Stone
Caracol	C001H/27-50	1.6	NA	2.0	0.5	Hemispherical	Stone
Caracol	C001H/27-51	2.2	NA	10.6	0.4	Hemispherical	Stone
Caracol	C001H/27-52	2.5	NA	11.5	0.5	Hemispherical	Stone
Caracol	C001H/27-53	2.5	NA	11.7	0.6	Hemispherical	Stone
Caracol	C001H/27-54	2.4	NA	11.7	0.5	Hemispherical	Stone
Caracol	C002D/1-1	2.6	NA	4.2	0.6	Hemispherical	Stone
Caracol	C004H/5-8	2.5	NA	11.4	0.6	Hemispherical	Stone
Caracol	C006B/30-3	2.8	NA	16.3	0.4	Hemispherical	Stone
Caracol	C022E/38-9	2.8	NA	18.2	0.5	Hemispherical	Stone
Caracol	C035A/9-4	2.05	NA	7.0	0.6	Hemispherical	Stone
Caracol	C039B/09-2 (1/2)	2.3	NA	9.8	1.0	Hemispherical	Stone
Caracol	C039B/10-6	2.4	NA	11.8	0.5	Hemispherical	Stone
Caracol	C039E/13-1	2.82	NA	12.1	0.5	Hemispherical	Stone
Caracol	C050C/3-1	1.9	NA	6.6	0.5	Hemispherical	Stone
Caracol	C053B/16-5A	2.7	NA	14.1	0.5	Hemispherical	Stone
Caracol	C053B/16-5B	2.3	NA	8.3	0.4	Hemispherical	Stone
Caracol	C059A/30-8	2.82	NA	19.1	0.5	Hemispherical	Stone
Caracol	C065A/09-1	2.7	NA	13.1	0.5	Hemispherical	Stone
Caracol	C074B/3-6	3.12	NA	24.6	0.7	Hemispherical	Stone
Caracol	C075C/12-4	2.2	NA	9.0	0.6	Hemispherical	Stone
Caracol	C076U/8-15	3.1	NA	19.0	0.6	Hemispherical	Stone
Caracol	C076U/9-14	2.6	NA	9.8	0.6	Hemispherical	Stone
Caracol	C082B/1-1	4.4	NA	12.6	0.8	Hemispherical	Stone

table 14.4 —continued

SITE	ID #	DIAMETER (CM)	HEIGHT (CM)	WEIGHT (G)	HOLE DIAMETER (CM)	FORM	MATERIAL
Caracol	C102B/7-1	2.9	NA	11.7	0.4	Hemispherical	Stone
Caracol	C104C/4-15	2.7	NA	18.6	0.5	Hemispherical	Stone
Caracol	C116D/2-4	2.8	NA	12.0	0.6	Hemispherical	Stone
Caracol	C117B/11-3	2.8	NA	15.7	0.6	Hemispherical	Stone
Caracol	C117D/12-2 (1/2)	2.35	NA	10.0	0.7	Hemispherical	Stone
Caracol	C132D/3-3	3.0	NA	5.7	0.6	Hemispherical	Stone
Caracol	C157C/5-5	2.3	NA	8.3	0.4	Hemispherical	Stone
Caracol	C160H/5-10	3.1	NA	18.8	0.8	Hemispherical	Stone
Caracol	CD4C/1-1	3.0	NA	20.6	0.7	Hemispherical	Stone
Motul de San José	MSJ14A-6-1-2	2.49	13.7	9.4	6.4	Hemispherical	Ceramic
Motul de San José	MSJ15A-12-2-10	1.99	15.2	6.0	7.3	Hemispherical	Ceramic
Motul de San José	MSJ15A-19-2-3	2.47	14.5	9.0	6.5	Hemispherical	Ceramic
Motul de San José	MSJ15A-39-3-1	2.09	11.3	4.9	6.1	Hemispherical	Ceramic
Motul de San José	MSJ29G-8-2-4	2.36	10.3	8.8	5.4	Hemispherical	Ceramic
Nixtun Ch'ich'	NC001	2.5	12.6	8.8	6.5	Hemispherical	Ceramic
Nixtun Ch'ich'	NC002	2.44	14.0	11.0	6.2	Hemispherical	Ceramic
Nixtun Ch'ich'	NC006	2.84	16.3	13.6	7.2	Hemispherical	Ceramic
Nixtun Ch'ich'	NC015	2.34	15.0	10.6	6.4	Hemispherical	Ceramic
Nixtun Ch'ich'	NC027	2.35	15.3	8.8	6.2	Hemispherical	Ceramic
Nixtun Ch'ich'	NC030	2.45	13.6	8.3	5.2	Hemispherical	Ceramic
Nixtun Ch'ich'	NC037	2.03	12.8	5.3	5.1	Hemispherical	Ceramic
Nixtun Ch'ich'	NC014	2.76	12.0	9.2	6.8	Hemispherical, almost conical	Ceramic
Caracol	C002C/5-1	2.9	NA	8.3	0.8	Hemispherical	Ceramic
Caracol	C008M/4-1	3.4	NA	12.5	0.83	Hemispherical	Ceramic
Caracol	C008M/4-2	3.4	NA	11.9	0.84	Hemispherical	Ceramic
Caracol	C090I/4-1 (3/4)	3.1	NA	13.8	0.7	Hemispherical	Ceramic
Caracol	C147B/8-5	2.5	NA	9.8	0.4	Hemispherical	Ceramic
Caracol	C160L/11-8	2.7	NA	8.7	0.7	Hemispherical	Ceramic
Caracol	CD3A/28-1	2.85	NA	11.1	0.6	Hemispherical	Ceramic
Caracol	CD3A/6-1	2.9	NA	15.5	0.45	Hemispherical	Ceramic

table 14.4 —continued

SITE	ID #	DIAMETER (CM)	HEIGHT (CM)	WEIGHT (G)	HOLE DIAMETER (CM)	FORM	MATERIAL
Nixtun Ch'ich'	NC004	2.59	8.0	6.8	10.1	Thick Disk	Ceramic
Motul de San José	MSJ15A-21-1-1	2.86	10.1	9.5	10.2	Thin Disk	Ceramic
Nixtun Ch'ich'	NC005	3.16	6.8	5.4	6.5	Thin Disk	Ceramic
Nixtun Ch'ich'	NC008	2.84	5.4	4.6	5.5	Thin Disk	Ceramic
Nixtun Ch'ich'	NC017	3.3	7.7	7.6	5.6	Thin Disk	Ceramic
Nixtun Ch'ich'	NC023	3.37	5.3	8.9	4.2	Thin Disk	Ceramic
Nixtun Ch'ich'	NC012	3.48	5.6	7.0	6.7	Thin Disk	Ceramic

Note: Data do not represent complete collections of spindle whorls, as fragmentary specimens were excluded; large centrally perforated sherd disks were also excluded, as they were thought to have been used to spin agave and ply threads, or to make cordage; Caracol samples taken from Chase et al. 2008:table 1.

Translucent Textiles as a Component of Performance

In addition to the technical dimensions of translucent textiles, the value of such cloth cannot be completely understood without exploring its role as clothing—to be displayed and animated in conjunction with the body (Figure 14.10a–b). In other words, the skills in producing super-fine threads and weaving them with delicate openings can be more fully appreciated through an analysis of how these garments were put to use as part of bodily performances, whether ritualized or everyday. The translucency of such textiles appears most vividly against the contours of a moving body, a subtle effect that is lost when garments are folded, as in Classic-period images of tribute bundles (Figure 14.10d), or hung against a wall, as in contemporary museum displays (Figure 14.10c).

Based on the iconographic record, it was the moving, youthful female body, in particular, that shaped translucent textiles during the Classic period (Figure 14.11). Although depictions of translucent textiles by no means abound, of the twenty-nine possible examples I have identified (see Tables 14.1–14.3), the majority depict youthful females in their reproductive years. Indeed, such translucent textiles shape the moving female body as much as the body shapes the textiles—and so, they mutually define notions of femininity, beauty, and agency.

The most common construction of the translucent weaves is in the form of a wide scoop neck *huipil* (blouse or tunic) worn by women in conjunction with a *corte* (skirt), which was produced from an opaque, tightly woven weave (see Tables 14.1–14.2). Andrea Stone (2011:170) argues that the scooped neckline not only encoded ideas of youthful feminine beauty but also was associated with women who commanded respect; elderly women, in turn, never wore scooped-neck or translucent weaves. Often the most prominent features revealed through translucent garments are those of the upper body: the breasts, shoulders, and arms. Such exposure is not common for official ceremonial attire; stone monuments and lintels depicting accessions, period-endings, and other formal state ceremonies tend to show royal women wearing heavy, brocaded huipiles, which expose little of the body's contours (see Figures 14.1c and 14.13; see Bruhns 1988; Joyce 2000; Taylor 1992). On the

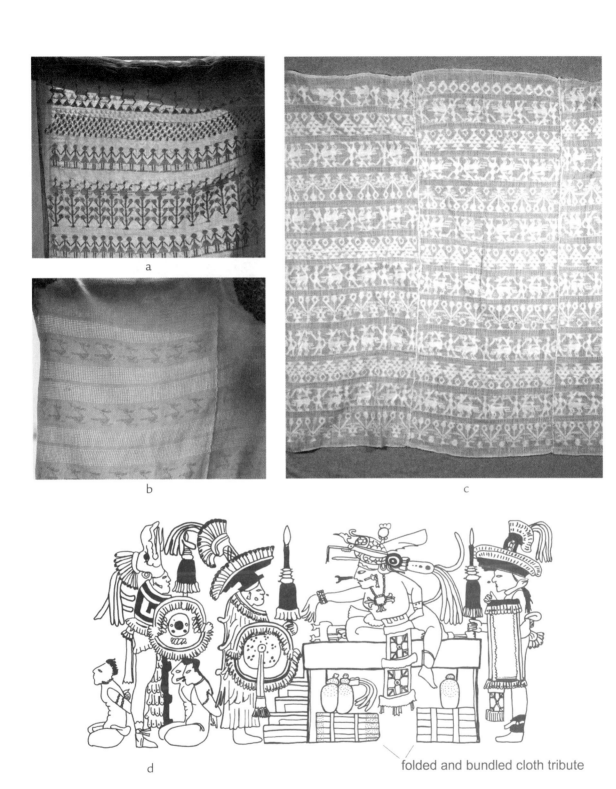

folded and bundled cloth tribute

figure 14.10

Comparison of the visual effects of textiles: a) against extended arm and torso; open-spaced weave (*petete*) with supplementary weft brocade; Venustiano Carranza, Chiapas, Mexico (photograph by Eric White); b) against extended arm and torso; simple gauze (*calada*) and plain weave composite, San Pedro Carchá, Alta Verapaz, Guatemala (photograph by Eric White); c) against wall; open-spaced weave (*pikb'il*), Alta Verapaz, Guatemala (Mossman-Vitale Collection; photograph courtesy of Kathleen Vitale); and d) cloth bundled and stacked (drawing of polychrome vessel K4549 by Christina T. Halperin.)

figure 14.11

Translucent textiles worn by gender:
a) pie graph (see Tables 14.1–14.3)
(*gender designation for "female?"
is ambiguous, although the style of
clothing is feminine); b) female holding
bloodletting instrument and wearing
translucent *huipil* with wide scoopneck
with censer on her back (drawing by
Christina T. Halperin after K2715); and
c) three noblemen wearing translucent
capes (Bonampak Stone Panel 1, Schele
drawing #6006, www.famsi.org).

a

b

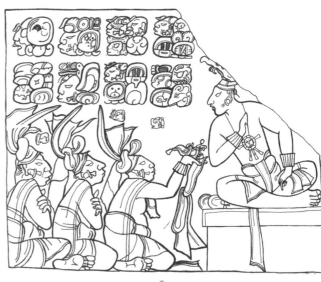

c

other hand, bare-breasted women wearing only cortes were not considered risqué among the Pre-Columbian Maya. This practice of going bare-chested appears among both elderly and youthful females, especially in scenes of domesticity, production, and child-rearing (Houston et al. 2006:42–43; Stone 2011; Taylor 1992:515). Such a practice suggests that the donning of translucent weaves was not just about keeping cool in the tropical heat of the Maya Lowlands; it was structured by particular social and cultural norms.

Nonetheless, translucent weaves were worn in a diverse array of settings that spanned the domains of public performances, public contexts of the marketplace, and more intimate gatherings within the royal court; therefore, it is difficult to associate such attire with a fixed set of activities or social events. In all of these contexts, however, women play critical social roles, exerting a sense of agency through engaged participation and commanding presence.

One motif of women wearing translucent huipiles is the dancing male-female pair seen on polychrome vessels (Figure 14.12; see Looper 2009). The scene places equal pictorial weight on the male and female, with both figures as the central component. Although the female faces her left, a directional position associated with more subordinate

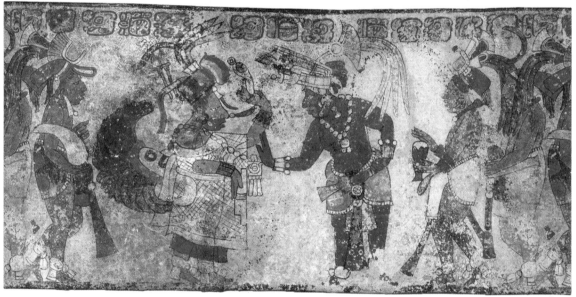

figure 14.12
Dancing male-female pair with female wearing translucent *huipil*: a) rollout photo of Ik'-style vase (© Justin Kerr K1549); and b) rollout photo of Ik'-style vase (© Justin Kerr K3463).

figures (Palka 2002:421), the pair contrasts with many other depictions of male-female pairs on stone monuments, lintels, and polychrome vases, where females are depicted either lower, on the peripheries, on the backside, or on a smaller scale than their prominently portrayed male counterparts (Figure 14.13; see Josserand 2002; Joyce 1996, 2000:59–68). Stephen Houston and colleagues (2006:268–269), and Looper (2009:55), suggest that such paired dancers may signify marriage or courtship. As such, they may have been part of actual marriage or betrothal ceremonies, or allusions to such events in theatrical performances. For example, in the indigenous dance drama Rabinal Achi, two of the main characters, Cawek of the Forest People and Mother of Quetzal Feathers, dance facing each other, but they do not touch; this pose is similar to those depicted on polychrome vessels.

figure 14.13
Male-female pair, with
female at a smaller
scale compared to male
counterpart (Yaxchilán
Lintel 5, Schele drawing
#7642, www.famsi.org).

Although Mother of Quetzal Feathers is an eli-
gible bride, the two are not to be married, since
Cawek will shortly be sacrificed. Nonetheless, their
momentary union through dance recalls the mus-
ings of Mother of Quetzal Feathers's father's ear-
lier desire to have Cawek as a son-in-law (Tedlock
2003:17, 164).[5]

In a series of codex-style vessels recounting
the mythical interactions of a young female and an
elderly deity, clothing in particular appears to cue
differing notions of female agency (Figure 14.14).
The young women wearing translucent weaves
serve as the primary agents in the scene: the one
with a cross-hatched translucent weave tends to the
elderly deity, and the ones with plain translucent
weaves ride on top of, or embrace, a larger-than-life

deer (see Figure 14.14a). These scenes contrast with
other episodes of the elderly deity, in which he
gropes or attempts to grope a young female whose
breasts are exposed and who wears an agave skirt
(the agave skirt was identified by Huckert [1999:219],
who noted its similar pattern to the hieroglyph for
agave *Ki* or logogram, T861a; see Figure 14.14b).
Here the young woman is more passive and receives
the action.

Indeed, many of the women wearing translu-
cent huipiles actively command the visual scene
where they are featured. For instance, a titled noble-
woman from Tikal wears a cross-hatched translucent
huipil over a red corte (Figure 14.15). She is not out-
shined by her male counterpart, the Ik' ruler Tayel
Chan K'ihnich, as is so common elsewhere. Her arm

figure 14.14
Codex-style vessels with mythical scenes: a) women wearing translucent huipiles (© Justin Kerr, K1182); and b) woman in agave skirt (Drawing by Christina T. Halperin, after Justin Kerr, K5164).

positions imply a sweeping movement of dance and her bodily girth combined with her flowing head-dress and garments not only animate but also give her a dominating presence (Just 2012:94–97).

Another example comes from the early Late Classic–period murals at Calakmul. The central figure in the public scene of drinking, eating, and marketing is clearly the woman adorned in jade jewelry and wearing a translucent blue huipil decorated with elaborate lining and red (painted or embroidered?) hieroglyphs (Figure 14.16a). The graceful translucency of her attire (not to mention her pose and compositional positioning) contrasts with the nondescript woman next to her, who wears a plain, gray, opaque garment and who receives a burden of a large olla (jar). Interestingly, however,

this central figure is not the only one to wear a translucent huipil, as at least one of the female vendors or food servers in the murals wears a more modest, translucent purple huipil with a narrow neck over her corte (Figure 14.16b). In this mural, the elaborateness of translucent huipiles appears to mark status, while translucent clothing in general (whether simple or complex) marks femininity.[6]

In addition to clothing, open-spaced textiles may have served a number of other purposes. Open-spaced or gauze weaves may have been used as fish netting, and those with thicker threads may have been used to create laminate masks composed of wet clay applied to open-weave textiles, similar to papier-mâché techniques (Beaubien et al. 2002). The textile fragments from the aforementioned

figure 14.15
Rollout photograph of dancing royal woman from Tikal with seated Ik' ruler (© Justin Kerr K2573).

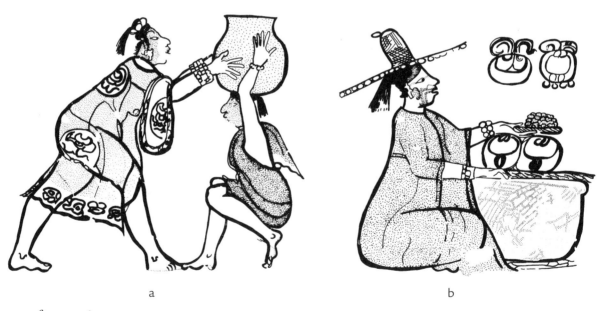

a b

figure 14.16
Calakmul mural scenes with women wearing translucent huipiles: a) scene SE-S1 with central woman wearing a translucent huipil (drawing by Christina T. Halperin, after Martin 2012:fig. 4); and b) scene SE-S2 with woman who wears translucent huipil while serving tamales (drawing by Christina T. Halperin, after Martin 2012:fig. 10).

burial at Rió Azul indicate that translucent textiles may have also served as burial shrouds. Despite the few surviving Maya examples from the Rió Azul burial and the cenote at Chichen Itza, however, such whisper-thin textiles were relatively ephemeral, especially in the tropical heat and humidity of the Maya Lowlands, where they disintegrated quickly. As such, these particular types of textiles were not durable items to be inherited over the generations; rather, they were meant for the immediate moment and for the people who wore, used, or were shrouded in them.

Conclusion

Classic-period Maya translucent textiles point to alternative ways of conceptualizing the making of value. Such reproductions of value do not represent any intrinsic aspect of the craft: they emerge from and are embedded in the social practices, material culture, and histories surrounding them. Unlike other types of textiles and other highly valuable craft objects, they did not embody the most labor intensive of textiles, they were not made from the most exotic of materials, and they were not worn during the most formal of state ceremonies. Nonetheless, Late Classic translucent textiles underscore, in particular, women's techné in spinning—productive tasks often treated in the available literature as secondary or subordinate to those of weaving. These spinners, most likely women belonging to elite households, were well esteemed in Maya society, as spinning tools appear in the headdresses of female deities and were selected as items to be deposited within some of the highest elite tombs. The textile techné involved not only a particular set of skills and knowledge to produce a whisper-thin garment, but it also entailed an understanding of the performative use of such textiles as they subtly highlighted the female body, as they moved with the body, and as they became associated with women's actions in mythic, ritual, and public performances, among other uses. It is these performances (and representations of such performances in clay and stucco), in addition to the actual process of making the pieces, that inform how and why such technical skills and knowledge became so culturally and socially valued.

Acknowledgments

I would like to thank Cathy Costin and Dumbarton Oaks for the invitation to participate in the 2013 Dumbarton Oaks Pre-Columbian Symposium and for her helpful comments on and edits to the paper. I am grateful to Karen Bassie, Chelsea Blackmore, Sarah Brett-Smith, John Millhauser, Tom Patterson, Kathleen Vitale, two anonymous reviewers, as well as many attendees of the symposium for their helpful comments and suggestions. I would also like to thank Prudence Rice and Antonia Foias for allowing me to analyze the Peten Lakes region's spindle whorls, excavated under the purview of their respective archaeological projects. Special thanks are given to Kathleen Vitale, who generously shared with me her textile collection and documentary recordings on contemporary Maya spinners and weavers.

1 Pre-Columbian Andean weavers also exercised a range of skills, knowledge, and labor investments in the weaving of gauze textiles. Unlike the case in Mesoamerica, many more of these Andean textiles and their looms have survived into the present (Gerschultz 2008; d' Harcourt 1962; Kula 1991; O'Neale and Clark 1956; Rowe 1980/1981)

2 See Breton (2007:259) and Van Akkeren (2000:416) for alternative translations.

3 Part of the reason for the lack of such emphases is that most contemporary textile producers have abandoned the spinning process and weave with commercially spun yarn.

4 Some contemporary Maya textile producers strengthen the warp yarns by placing them in a starch bath made from corn boiled with lime (Pancake and Baizerman 1980/1981:2).

5 Likewise, an incised cream-slipped vessel (K7433) depicting a woman with a cross-hatched, translucent huipil may recount a version of the contemporary Mesoamerican myth of male seduction (Chinchilla Mazariegos 2010). As part of the hummingbird myth, a hero attempts to marry a young woman, sometimes portrayed as a moon goddess or weaver, by transforming himself into a hummingbird, enabling him to distract and become physically intimate with the young woman. K1549 may, in fact, represent a performative version of this myth, as the male dancer's nose is elongated like the beak of a hummingbird and his headdress features a small hummingbird suckling on a large flower (cf. Stone 1995:144–145, 2011:179; Taube 1989). Indeed, the young woman on the incised vase is depicted kissing a hummingbird. This vase (K7433), however, is distinct from other depictions of translucent weaves in that the woman's huipil exposes not her upper body but her upper thighs, a portion of the body rarely exposed (see also K8076) and perhaps a sign of social transgression in this particular example.

6 Such expressions of female sexuality may have had multiple connotations, such as seduction as Houston (2014) suggests, or respect, as Stone (2011) suggests. Although such nuances in meaning may have even depended on the eye of the beholder, my point is that women with translucent dress often command the visual scene.

REFERENCES CITED

Adams, Richard E.

 1986 Archaeologists Explore Guatemala's Lost City of the Maya: Río Azul. *National Geographic Magazine* 169:420–451.

Anderson, Marilyn

 1978 *Guatemalan Textiles Today*. Watson Guptill Publications, New York.

Akkeren, Ruud Van

 2000 *Place of the Lord's Dauther: Rab'inal, Its History, Its Dance-Drama*. Leiden University, Research School, CNWS, Leiden.

Atran, S., Ximena Lois, and Edilberto Ucan Ek'

 2004 *Plants of the Petén Itza' Maya*. Museum of Anthropology, University of Michigan, Ann Arbor.

Beaubien, Harriet F., Emily Kaplan, and Emily Shah

 2002 Textile-Clay Laminates: A New-Found Craft Technology from Ancient Mesoamerica. *Materials Research Society Symposium Proceedings* 712 (119):1–11.

Beaudry-Corbett, M., and Sharisse D. McCafferty

 2002 Spindle Whorls: Household Specialization at Ceren. In *Ancient Maya Women*, edited by Traci Ardren, pp. 52–67. Altamira Press, Walnut Creek, Calif.

Berdan, Frances F., and Patricia Reiff Anawalt

 1997 *The Essential Codex Mendoza*. University of California Press, Berkeley.

Breton, Alain

2007 *Rabinal Achi: A Fifteenth-Century Maya Dynastic Drama*. University Press of Colorado, Boulder.

Brett-Smith, Sarah C.

2001 When Is an Object Finished? The Creation of the Invisible among the Bamana of Mali. *Res: Anthropology and Aesthetics* 39:102–136.

Bruck, Joanna

2006 Fragmentation, Personhood, and the Social Construction of Technology in Middle and Late Bronze Age Britain. *Cambridge Archaeological Journal* 16:297–315.

Bruhns, Karen O.

1988 Yesterday the Queen Wore . . . An Analysis of Women and Costume in the Public Art of the Late Classic Period. In *The Role of Gender in Precolumbian Art and Architecture*, edited by Virginia E. Miller, pp. 105–134. University Press of America, Lanham, Md.

Brumfiel, Elizabeth M.

2006 Cloth, Gender, Continuity, and Change: Fabricating Unity in Anthropology. *American Anthropologist* 108(4):862–877.

Carlsen, Robert

1987 Analysis of the Early Classic Period Textile Remains from Tomb 23, Rio Azul, Guatemala. In *Rio Azul Reports, Proyecto Rio Azul*, edited by Richard E. Adams, pp. 152–159. Center for Archaeological Research, University of Texas, San Antonio.

Chase, Arlen F., Diane Z. Chase, E. Zorn, and Wendy Teeter

2008 Textiles and the Maya Archaeological Record: Gender, Power, and Status in Classic Period Caracol, Belize. *Ancient Mesoamerica* 19:127–142.

Chinchilla Mazariegos, Oswaldo

2010 Of Birds and Insects: The Hummingbird Myth in Ancient Mesoamerica. *Ancient Mesoamerica* 21:45–61.

Clark, John E., and Stephen D. Houston

1998 Craft Specialization, Gender, and Personhood among the Post-Conquest Maya of Yucatán, Mexico. In *Craft and Social Identity*, edited by Cathy Lynne Costin and Rita P. Wright, pp. 31–46. American Anthropological Association, Arlington, Va.

Costin, Cathy Lynne

2001 Craft Production Systems. In *Archaeology at the Millennium: A Sourcebook*, edited by Gary M. Feinman and T. Douglas Price, pp. 273–344. Kluwer Academic/Plenum Publishers, New York.

2012 Gender and Textile Production in Prehistory. In *A Companion to Gender Prehistory*, edited by Diane Bolger, pp. 180–202. Wiley-Blackwell, Somerset, N.J.

Costin, Cathy Lynne, and Rita P. Wright

1998 *Craft and Social Identity*. American Anthropological Association, Arlington, Va.

Dacus, Chelsea

2005 Weaving the Past: An Examination of Bones Buried with an Elite Maya Woman. MA thesis, Southern Methodist University, Dallas.

Delgado, Hilda S.

1969 Figurines of Backstrap Loom Weavers from the Maya area. *Verhandlungen des XXXVIII Internationalem Amerikanistenkongresses* 1:139–149.

Dobres, Marcia-Anne, and Christopher R. Hoffman

1994 Social Agency and Dynamics of Prehistoric Technology. *Journal of Archaeological Method and Theory* 1:211–258.

Fauman-Fichman, Ruth

1999 Postclassic Craft Production in Morelos, Mexico: The Cotton Thread Industry in the Provinces. PhD dissertation, University of Pittsburgh, Pittsburgh.

Gell, Alfred

1998 *Art and Agency: An Anthropological Theory*. Clarendon Press, Oxford.

Gerschultz, Jessica

2008 The Serpentine Essence of a Chancay Gauze Headdress. *Textile Society of America Proceedings* 1(1):1–10.

Graeber, David

 2001 *Toward an Anthropological Theory of Value*. Palgrave, New York.

Halperin, Christina T.

 2008 Classic Maya Textile Production: Insights from Motul de San José, Peten, Guatemala. *Ancient Mesoamerica* 19:111–125.

 2011 Late Classic (ca. AD 600–900) Maya Textile Political Economies: An Object History Approach. In *Weaving Across Time and Space: The Political Economy of Textiles*, edited by Walter Little and Patricia A. McAnany, pp. 125–145. AltaMira Press, Walnut Creek, Calif.

d' Harcourt, Raoul

 1962 *Textiles of Ancient Peru and Their Techniques*. University of Washington Press, Seattle.

Helms, Mary W.

 1993 *Craft and the Kingly Ideal: Art, Trade, and Power*. University of Texas Press, Austin.

Hendon, Julia A.

 1996 Hilado y tejido en las tierras bajas Mayas en la época prehispánica: Tecnología y relaciones sociales de la producción textil. *Yaxkin* 13:57–70.

 1997 Women's Work, Space, and Status. In *Women in Prehistory: North American and Mesoamerica*, edited by Cheryl Claassen and Rosemary A. Joyce, pp. 33–46. University of Pennsylvania Press, Philadelphia.

 2006 Textile Production as Craft in Mesoamerica. *Journal of Social Archaeology* 6(3):354–378.

Hernández Álvarez, Héctor, and Nancy Peniche May

 2012 Los malacates arqueológicos de la península de Yucatan. *Ancient Mesoamerica* 23:441–459.

Houston, Stephen D.

 2014 Courtesans and Carnal Commerce. Electronic document, Maya Decipherment: Ideas on Ancient Maya Writing and Iconography, www.decipherment.wordpress.com, accessed June 8, 2014.

Houston, Stephen D., and David Stuart

 2001 Peopling the Classic Maya Court. In *Royal Courts of the Ancient Maya*, vol. 1, *Theory, Comparison, and Synthesis*, edited by Takeshi Inomata, pp. 54–83. Westview Press, Boulder.

Houston, Stephen D., David Stuart, and Karl Taube

 2006 *The Memory of Bones: Body, Being, and Experience among the Classic Maya*. University of Texas Press, Austin.

Huckert, Chantal

 1999 Las figuras textiles en la vestimenta de los mayas de la época precolumbina. *Estudios de cultura maya* 20:205–229.

Inomata, Takeshi

 2001 The Power and Ideology of Artistic Creation. *Current Anthropology* 42(3):321–348.

 2007 Knowledge and Belief in Artistic Production by Classic Maya Elites. In *Rethinking Craft Specialization in Complex Societies: Archaeological Analyses of the Social Meaning of Production*, edited by Z. X. Hruby and R. K. Flad, pp. 129–141. American Anthropological Association, Arlington, Va.

Johnson, Irmgard Weitlaner

 1954 Chiptic Cave Textiles from Chiapas, Mexico. *Société des Américanistes* 43:137–147.

Josserand, J. Kathyrn

 2002 Women in Classic Maya Hieroglyphic Texts. In *Ancient Maya Women*, edited by Traci Ardren, pp. 114–151. AltaMira Press, Walnut Creek, Calif.

Joyce, Rosemary A.

 1996 The Construction of Gender in Classic Maya Monuments. In *Gender in Archaeology*, edited by R. P. Wright, pp. 167–195. University of Pennsylvania Press, Philadelphia.

 2000 *Gender and Power in Prehispanic Mesoamerica*. University of Texas Press, Austin.

Just, Bryan R.

 2012 *Dancing into Dreams: Maya Vases of the Ik' Kingdom*. Princeton University Press, Princeton, N.J.

King, Mary E.

1979 The Prehistoric Textile Industry of Mesoamerica. In *The Junius B. Bird Pre-Columbian Textile Conference*, pp. 265–278. Dumbarton Oaks Research Library and Collection, Washington, D.C.

Kopytoff, Igor

1986 The Cultural Biography of Things: Commoditization as Process. In *The Social Life of Things: Commodities in Cultural Perspective*, edited by A. Appadurai, pp. 64–91. Cambridge University Press, Cambridge.

Kovacevich, Brigitte

2007 Ritual, Crafting, and Agency at the Classic Maya Kingdom of Cancuen. In *Mesoamerican Ritual Economies: Archaeological and Ethnological Perspectives*, edited by E. Christian Wells and Karla L. Davis-Salazar, pp. 67–114. University Press of Colorado, Boulder.

Kula, Gulli

1991 A Study of Surface-Collected Chancay Textiles. In *Estudios sobre la cultura de Chancay, Peru*, edited by Andrzej Krzanowski, pp. 263–284. Jagiellonian University Press, Cracow.

Laughlin, Robert M.

1975 *The Great Tzotzil Dictionary of San Lorenzo Zinacantan*. Smithsonian Institute Press, Washington, D.C.

Lechtman, Heather

1977 Style in Technology—Some Early Thoughts. In *Material Culture: Styles, Organization, and Dynamics of Technology*, edited by Heather Lechtman and R. S. Merrill, pp. 3–20. West Publishing, St. Paul, Minn.

Looper, Matthew G.

2009 *To Be Like Gods: Dance in Ancient Maya Civilization*. University of Texas Press, Austin.

Looper, Matthew G., and T. Tolles

2000 *Gifts of the Moon: Huipil Designs of the Ancient Maya*. Museum of Man, San Diego.

Lothrop, Joy M.

1992 Textiles. In *Artifacts from the Cenote of Sacrifice, Chichen Itza, Yucatan*, edited by Clemency C. Coggins, 10(3):33–90. Harvard University Press, Cambridge, Mass.

Martin, Simon

2012 Hieroglyphs from the Painted Pyramid: The Epigraphy of Chiik Nahb Structure Sub 1–4, Calakmul, Mexico. In *Maya Archaeology*, vol. 2, edited by Charles Golden, Stephen D. Houston, and Joel Skidmore, pp. 60–81. Precolumbian Mesoweb Press, San Francisco.

Marx, Karl

1973 *Grundrisse: Foundations of the Critique of Political Economy*. Translated by Martin Nicholaus. Penguin Books, London.

1990 *Capital*, vol. 1. Penguin Classics, London.

Mathews, Peter

1980 Notes on the Dynastic Sequence of Bonampak, Part 1. In *Third Palenque Round Table, 1978*, edited by Merle Greene Robertson, pp. 60–73. University of Texas Press, Austin.

McCafferty, Sharisse D., and Geoffrey G. McCafferty

2000 Textile Production in Ancient Cholula, Mexico. *Ancient Mesoamerica* 11:39–54.

Mejía de Rodas, I.

1997 El algodón en Guatemala. In *Cuyuscate: El algodón café en la tradición textile de Guatemala*, pp. 1–19. Museo Ixchel del Traje Indígena, Guatemala City.

Moholy-Nagy, Hattua

2003 *Tikal Report No. 27, Part B, The Artifacts of Tikal: Utilitarian Artifacts and Unworked Material*, edited by W. A. Haviland and C. Jones. University of Pennsylvania Museum, Philadelphia.

Morehart, Christopher T., and Christophe G. B. Helmke

2008 Situating Power and Locating Knowledge: A Paleoethnobotanical Perspective on Late Classic Maya Gender and Social Relations. In *Gender, Households, and Society: Unraveling the Threads of the Past and Present*, edited by C. Robin and Elizabeth M. Brumfiel, pp. 60–75. American Anthropological Association, Arlington, Va.

Needham, Joseph

 1988 *Science and Civilisation in China, Part IX, Textile Technology: Spinning and Reeling*, vol. 5. Cambridge University Press, Cambridge.

O'Neale, Lila M.

 1945 *Textiles of Highland Guatemala.* Carnegie Institution of Washington, Washington, D.C.

O'Neale, Lila M., and Bonnie J. Clark

 1956 *Textile Periods in Ancient Peru III: The Gauze Weaves.* University of California Publication in American Archaeology and Ethnology, edited by E. W. Gifford, A. L. Kroeber, R. H. Lowe, T. D. McCown, D. G. Mandelbaum, and R. L. Olson, pp. 143–222. University of California Press, Berkeley.

Palka, Joel W.

 2002 Left/Right Symbolism and the Body in Ancient Maya Iconography and Culture. *Latin American Antiquity* 13(4):419–443.

Pancake, C. M., and S. Baizerman

 1980/1981 Guatemalan Gauze Textiles: A Description and Key to Identification. *Textile Museum Journal* 19–20:1–26.

Parry, Richard

 2008 Episteme and Techne. In *The Stanford Encyclopedia of Philosophy, Stanford.* Electronic document, http://plato.stanford.edu/entries/episteme-techne/, accessed March 4, 2013.

Parsons, Jeffrey R., and Mary H. Parsons

 1990 *Maguey Utilization in Highland Central Mexico: An Archaeological Ethnography.* University of Michigan Press, Ann Arbor.

Parsons, Mary H.

 1972 Spindle Whorls from the Teotihuacan Valley. In *Miscellaneous Studies in Mexican Prehistory*, edited by M. W. Spence, J. R. Parsons, and M. H. Parsons, pp. 45–79. Museum of Anthropology Paper 45. University of Michigan Press, Ann Arbor.

Pincemin Deliberos, Sophia

 1998 Tejidos del poder: Ejemplos de textiles en los murales de Bonampak, Chiapas. *Anuario* 1998:452–470.

Reents-Budet, Dorie

 1994 *Painting the Maya Universe: Royal Ceramics of the Classic Period.* Duke University Press, Durham, N.C.

 1998 Elite Maya Pottery and Artisans as Social Indicators. In *Craft and Social Identity*, edited by Cathy Lynne Costin and Rita P. Wright, pp. 71–89. American Anthropological Association, Washington, D.C.

 2006 Power Material in Ancient Mesoamerica: The Roles of Cloth among the Classic Maya. In *Sacred Bundles: Ritual Acts of Wrapping and Binding in Mesoamerica*, edited by Julia Guernsey and F. Kent Reilly, pp. 105–126. Boundary End Archaeology Research Center, Barnardsville, N.C.

Rochette, Erick T.

 2009 Jade in Full: Prehispanic Domestic Production of Wealth Goods in the Middle Motagua Valley, Guatemala. In *Housework: Craft Production and Domestic Economy in Ancient Mesoamerica*, edited by Kenneth G. Hirth, pp. 205–224. American Anthropological Association, Arlington, Va.

Rowe, Ann Pollard, and Junius B. Bird

 1980/1981 Three Ancient Peruvian Gauze Looms. *Textile Museum Journal* 19/20:27–33.

Sahagún, Bernardino de

 1961 *Florentine Codex: General History of the Things of New Spain,* book 10, *The People.* School of American Research, Santa Fe, N. Mex.

Schevill, Margot Blum

 1993 *Maya Textiles of Guatemala.* University of Texas Press, Austin.

Schevill, Margot Blum, and Catherine Berlo (editors)

 1991 *Textile Traditions of Mesoamerica and the Andes.* Garland, New York.

Schmidt, Peter, Mercedes de la Garza, and Enrique Nalda

 1988 *Maya.* Rizzoli International Publications, New York.

Smith, Michael E., and Kenneth G. Hirth

 1988 The Development of Prehispanic Cotton-Spinning Technology in Western Morelos, Mexico. *Journal of Field Archaeology* 15(3):349–358.

Sperlich, Norbert, and Elizabeth Katz Sperlich

 1980 *Guatemalan Backstrap Weaving.* University of Oklaholma Press, Norman.

Stone, Andrea J.

 1995 *Images from the Underworld: Naj Tunich and the Tradition of Maya Cave Painting.* University of Texas Press, Austin.

 2011 Keeping Abreast of the Maya: A Study of the Female Body in Maya Art. *Ancient Mesoamerica* 22:167–183.

Taube, Karl A.

 1989 Ritual Humor in Classic Maya Religion. In *Word and Image in Maya Culture: Explorations in Language, Writing, and Representation*, edited by William F. Hanks and Don S. Rice, pp. 351–382. University of Utah Press, Salt Lake City.

 1994 The Birth Vase: Natal Imagery in Ancient Maya Myth and Ritual. In *The Maya Vase Database: A Corpus of Rollout Photographs of Maya Vases*, vol. 4, edited by Justin Kerr, pp. 652–675. Kerr Associates, New York.

Taube, Karl A., and Reiko Ishihara-Brito

 2012 From Stone to Jewel: Jade in Ancient Maya Religion and Rulership. In *Ancient Maya Art at Dumbarton Oaks*, edited by Joanne Pillsbury, Miriam Doutriaux, Reiko Ishihara-Brito, and Alexandre Tokovinine, pp. 136–153. Dumbarton Oaks Research Library and Collection, Washington, D.C.

Taylor, Dicey

 1992 Painted Ladies: Costumes for Women on Tepeu Ceramics. In *The Maya Vase Book: A Corpus of Rollout Photographs of Maya Vases*, vol. 3, edited by Justin Kerr, pp. 513–525. Kerr Associates, New York.

Tedlock, Dennis

 2003 *Rabinal Achi: A Mayan Drama of War and Sacrifice.* Oxford University Press, Oxford.

Van Dyke, Ruth M., and Susan E. Alcock

 2003 *Archaeologies of Memory.* Blackwell, Oxford.

Vitale, Kathleen M.

 2010 Documenting the Maya Textile Tradition: Recent Work in Venustiano Carranza and Alta Verapaz. Paper presented at the 109th American Anthropological Association Meetings, New Orleans.

Weiner, Annette B.

 1985 Inalienable Wealth. *American Ethnologist* 12(2):210–227.

 1992 *Inalienable Possessions: The Paradox of Keeping-While-Giving.* University of California Press, Berkeley.

Weiner, James F.

 1995 Technology and Techne in Trobriand and Yolngu Art. *Social Analysis* 38:32–46.

Widmer, Randolph J.

 2009 Elite Household Multicrafting Specialization at 9N8, Patio H, Copan. In *Housework: Craft Production and Domestic Economy in Ancient Mesoamerica*, edited by Kenneth G. Hirth, pp. 174–204. American Anthropological Association, Arlington, Va.

Willey, Gordon R.

 1972 *The Artifacts of Altar de Sacrificios.* Harvard University Press, Cambridge, Mass.

Zralka, Jaroslaw

 2007 The Nakum Archaeological Project: Investigations on the Banks of the Holmul River. Report submitted to Foundation for the Advancement of Mesoamerican Studies, Crystal River, Fla.

CONTRIBUTORS

Claudia Brittenham is associate professor of art history at the University of Chicago. Her research examines the materiality and meaning of Meso-american art, with a particular focus on ancient murals. She is author of *The Murals of Cacaxtla: The Power of Painting in Ancient Central Mexico* (2009) and coauthor of *The Spectacle of the Late Maya Court: Reflections on the Murals of Bonampak* (2013, with Mary Miller) and *Veiled Brightness: A History of Ancient Maya Color* (2009, with Stephen Houston et al.). Her current research project explores problems of visibility and the status of images in Mesoamerica.

Michael G. Callaghan is assistant professor of anthropology at the University of Central Florida. He is an anthropological archaeologist whose research focuses on the emergence of complexity as it relates to community ritual, social inequality, craft specialization, and long distance exchange. He specializes in the study of the ancient Maya with an emphasis on ceramic analysis. His research informs studies of prehistoric complex societies aimed at understanding how technology and pro-duction contribute to changes in social structure. His current research focuses on the development of social inequality as it relates to crafted objects, pub-lic ritual, household activities, and monumental architecture at the site of Holtun, Guatemala. He graduated with his BS (1998) and PhD (2008) from Vanderbilt University. He has published in *Ancient Mesoamerica* and is coeditor of *The Inalienable*

in the Archaeology of Mesoamerica (2013, with Brigitte Kovacevich). Other publications include contributions to volumes that emphasize the study of ancient ceramics and craft production in com-plex societies, including *Ancient Maya Pottery* (2013, edited by James John Aimers) and *Gendered Labor in Specialized Economies* (2016, edited by Sophia E. Kelley and Traci Ardren). His manu-script, *The Ceramic Sequence of the Holmul Region, Guatemala*, is forthcoming with the University of Arizona Press.

Cathy Lynne Costin is professor in the Department of Anthropology at California State University, Northridge. She has a long interest in the organi-zation of craft production, with an emphasis on ceramics and textiles. She works in the Andean region of Peru and has published extensively on Moche, Chimú, and Inka craft production; she has also published more general works on theory and method in the study of the organization of produc-tion. Her work on craft production is at the heart of her wide-ranging interests in political economy, gender relations, and the rise of complex societ-ies. Her recent publications include "Gender and Textile Production in Prehistory" in *A Companion to Gender Prehistory* (2012); "Textiles and Chimú Identity under Inka Hegemony on the North Coast of Peru" in *Textile Economies: Power and Value from the Local to the Transnational* (2011); "The Cost of Conquest: Assessing the Impact of Inka Tribute Demands on the Wanka of Highland

Peru," in *Surplus: The Politics of Production and the Strategies of Everyday Life* (2015); "Who Benefits? Labor Deployment, Relations of Production, and Access to Wealth and Power in the Late Prehispanic Andes," in *Archaeology of the Human Experience* (2016); and "The Study of Craft Production" in *Handbook of Methods in Archaeology* (2005). Her book, *Ceramic Analysis for Archaeologists,* is forthcoming.

Lisa DeLeonardis is the Austen-Stokes Professor in Art of the Ancient Americas in the Department of the History of Art at The Johns Hopkins University. She has conducted a number of projects centering on Paracas and Nasca visual culture and history in the South Coast of Peru. Her research has addressed sacred space and its appropriations, ancestors, the body, settlement landscapes, and mortuary practices. As a 2009 Dumbarton Oaks summer fellow, she investigated questions about Inka occupational specialists and evaluated the *kamayuq* as a construct to more broadly address the social organization of artists and guilds in the prehispanic Andes; her current study of value in Paracas ceramic production and process continues this inquiry. DeLeonardis' work has appeared in *Latin American Antiquity* and *Ethnohistory*, and she is a contributing author to *Andean Archaeology* (2004); *Guide to Documentary Sources for Andean Studies, 1530–1900* (2008); and *The Construction of Value in the Ancient World* (2012). She is currently completing manuscripts on the Paracas of Callango and the architectural and social history of Santa Cruz de Lancha.

Laura Filloy Nadal is a senior conservator at the Museo Nacional de Antropología (MNA-INAH), Mexico City. She received her PhD in archaeology from the Université de Paris I, Panthéon-Sorbonne. She has participated in or directed a series of conservation projects in Mexico, and she has conducted research on the material science and technology of archaeological objects from the MNA collections. Dr. Filloy Nadal was a junior fellow of Pre-Columbian Studies at Dumbarton Oaks in 2006.

Christina T. Halperin is a professor in the Department of Anthropology at the University of Montreal. She received a PhD in anthropology from the University of California, Riverside, in 2007. Since 1997, Halperin has conducted archaeological field research at various settlement and cave sites in Guatemala, Mexico, and Belize. She has published extensively on such topics as Classic Maya textile production, polychrome pottery production, and caves and social understandings of space. She coedited *Mesoamerican Figurines: Small-Scale Indices of Large-Scale Social Phenomena* (2009), which was awarded a CHOICE Outstanding Academic Title. Her book, *State and Household: The Sociality of Maya Figurines* (2014), examines the dynamic relationship between state and households through the perspective of ceramic figurines. Most recently, she has edited the volume, *Vernacular Architecture in the Pre-Columbian Americas* (forthcoming).

Stephen Houston is Dupee Family Professor of Social Science at Brown University. As a recipient of many fellowships, including the MacArthur, and grants from the National Science Foundation and the National Endowment from the Humanities, Houston has authored and edited several books, either singly or with colleagues. These volumes include *The First Writing: Script Invention as History and Process* (2004); *The Memory of Bones: Body, Being, and Experience among the Classic Maya* (2006); *The Disappearance of Writing Systems: Perspectives on Literacy and Communication* (2008); *The Classic Maya* (2009); *Fiery Pool: The Maya and the Mythic Sea* (2010); and *The Shape of Script: How and Why Writing Systems Change* (2012). Houston has directed excavations at Piedras Negras and El Zotz, Guatemala; he is now working on writing up those results and on researching Maya aesthetics, concepts of masculinity, and, as coleader of a Mellon Sawyer Seminar, the role of animals as "con-socials" in extended human society.

John W. Janusek received his PhD from the University of Chicago and is associate professor in the Department of Anthropology at Vanderbilt University. He is an archaeologist interested in

the development of complex societies in the South American Andes. He has worked in the Andean highlands of Bolivia for more than twenty-five years, conducting research mainly focused on Tiwanaku civilization and its precursor formative societies. His current theoretical interests include the origins and particularities of Pre-Columbian urbanism in the Andes, approached from the specific frameworks of human geography and landscape, human agency and identity, monumentality, and ritual practice. He recently directed a large-scale interdisciplinary research project in the Machaca region of Bolivia that was largely focused on the monumental proto-urban center of Khonkho Wankane. He is currently initiating a long-term research project on the role of human mobility and long-distance interaction networks in the emergence of early centers in the eastern Lake Titicaca basin. He is the author of *Identity and Power in the Ancient Andes: Tiwanaku Cities through Time* (2004); *Ancient Tiwanaku* (2008); and *Proto-urbanism in the South-Central Andes: Khonkho Wankane and Its Hinterland* (forthcoming).

Diana Magaloni Kerpel received her MA in art history from Universidad Nacional Autónoma de México and her PhD in restoration and mural painting from Yale University; she holds a bachelor's degree in art conservation. Her research focuses on Mesoamerican pictorial techniques, combining data and methods from archaeology, chemistry, ethnography, and art history to understand how codices and murals were created. Her work on painting and plastering technology has been published extensively in both English and Spanish. She is currently writing a book that focuses on the images and symbolism of the *Florentine Codex*.

Blanca Maldonado is an archaeologist who specializes in the study of ancient metallurgy and production processes. Particular areas of interest include Pre-Columbian copper metallurgy in the New World, pre-industrial nonferrous metallurgy, and the establishment and evolution of technological practices and their relationship to the ancient and pre-industrial societies and cultures. Her

research has focused mainly on Mesoamerica and the south central Andes. She obtained her PhD in anthropology, with a specialization in archaeology, from Pennsylvania State University in 2006. Her doctoral studies included training in archaeometallurgy and archaeological science at the University of Oxford and at University College London from 2003 to 2004. In 2006, she was awarded a CONACyT Research Fellowship to return to her native Mexico and join El Colegio de Michoacán, A.C, where she is currently an associate professor in the Center for Archaeological Studies. Among other academic distinctions, Maldonado has received several research grants and awards, including a DAAD Research Stay for University Academics and Scientists (University of Bonn, Germany, 2008) and a postdoctoral research fellowship from the Alexander von Humboldt Foundation (Curt-Engelhorn-Zentrum Archäometrie, Mannheim, Germany, 2009–2011).

Jerry D. Moore is an anthropological archaeologist and professor of anthropology at California State University, Dominguez Hills. His research focuses on cultural landscapes, the archaeology of architecture, and human adaptations on the North Coast of Peru and northern Baja California. His archaeological fieldwork has been supported by the National Science Foundation, the National Geographic Society, and the Wenner-Gren Foundation for Anthropological Research. He has been a fellow in Pre-Columbian Studies at Dumbarton Oaks (1992–1993), the Sainsbury Centre for the Arts, University of East Anglia (1994), the Getty Research Institute (2001–2002), and the Institute of Advanced Study, Durham University (2013). He is the author of *Architecture and Power in the Prehispanic Andes: The Archaeology of Public Buildings* (1996); *Cultural Landscapes in the Prehispanic Andes: Archaeologies of Place* (2005); *The Prehistory of Home* (2012); *Visions of Culture: An Introduction to Anthropological Theories and Theorists* (2012, 4th ed.); and *A Prehistory of South America: Ancient Cultural Diversity on the Least Known Continent* (2014).

Carlos Rengifo is a specialist in Andean archaeology. He obtained his BA in social sciences from

the Universidad Nacional de Trujillo, Peru, and is currently a PhD candidate at the University of East Anglia. His research interests center on the development of the Pre-Columbian complex societies on the North Coast of Peru. From 2002 to 2008, he actively participated in two of the main long-term projects of the region: the Huaca de la Luna Archaeological Project and the San José de Moro Archaeological Program. As a member of these projects, he conducted several excavations in the Moche and Jequetepeque Valleys, respectively, publishing reports and articles addressing Moche craft specialization and funerary practices in urban and ceremonial centers. He also carried out excavations at the Lima cemetery of Huaca 20 in the Rímac Valley, furthering his interest in the realm of funerary practices and the building of social identity. Since 2010, he has directed the Cerro Castillo Archaeological Project, an initiative that studies the ancient community of Cerro Castillo in the Nepeña Valley, Peru. These investigations focus on social boundaries, settlement dynamics, and cultural identity.

Lisa Trever is an art historian and archaeologist who specializes in the art, architecture, and visual culture of ancient and colonial South America. She is assistant professor of history of art at the University of California, Berkeley. She holds degrees from Harvard, Yale, and the University of Maryland. Her dissertation research included archaeological excavations of mural paintings and adobe architecture in the monumental core of the late Moche site of Pañamarca, Nepeña Valley, Peru. She was a Tyler Fellow in Pre-Columbian Studies at Dumbarton Oaks (2011–2013) and has received grants from the Fulbright-Hays DDRA Program and the Wenner-Gren Foundation for Anthropological Research. She is the author of several articles on Pre-Columbian art and colonial illustration, including "The Uncanny Tombs in Martínez Compañón's *Trujillo del Perú*" in *Past Presented: Archaeological Illustration and the Ancient Americas* (2012) and "Idols, Mountains, and Metaphysics in Guaman Poma's Pictures of Huacas" in *Res: Anthropology and Aesthetics* (2011).

Carolina Maria Vílchez is the director of archaeological investigations at the site of Cabeza de Vaca, the Inka provincial center in the Tumbes Valley of northern Peru. She obtained her *licenciatura* in archaeology at the Universidad Nacional de Trujillo and has extensive experience in heritage management and natural resource preservation in the Department of Tumbes. Vílchez has been actively engaged in a number of archaeological projects in the region, including conducting cultural heritage inventories and planning for the Parque Nacional Cerros de Amotape. Since 2007, she has directed the Proyecto de Investigación Arqueológica y Puesta en Uso Social Cabeza de Vaca, under the auspices of the Proyecto Qhapaq Ñan of Peru's Ministry of Culture. The investigations at Cabeza de Vaca have documented a major Inka presence and imperial infrastructure on the extreme North Coast of Peru.

Patrick Ryan Williams is associate curator of archaeological science and South American anthropology at The Field Museum, where he also serves as chair of anthropology and associate director for research. He studied at the University of Florida (PhD, 1997; MA, 1995) and Northwestern University (BA, 1993). As an anthropological archaeologist, he examines the development of sociopolitical complexity, with a special focus on imperial interactions. Since 1997, he has directed the Cerro Baúl excavations with funding from the National Science Foundation, National Endowment for the Humanities, National Geographic, and Dumbarton Oaks. This work focuses on the nature of ancient Wari imperialism from the Andean Middle Horizon (600–1000 CE) and the nature of its complex relationship with its peer polity, Tiwanaku. He also directs the NSF-sponsored Elemental Analysis Facility at The Field Museum and has published extensively on landscape archaeology and on material sourcing for craft production. His publications include "Wari and Tiwanaku Borderlands" in *Tiwanaku: Papers from the 2005 Mayer Center Symposium at the Denver Art Museum* (2009); "Sighting the Apu: A GIS Analysis of Wari Imperialism and the Worship

of Mountain Peaks" in *World Archaeology* (2006); "A Re-Examination of Disaster Induced Collapse in the Case of the Andean Highland States: Wari and Tiwanaku" in *World Archaeology* (2002); and *Climate Change in Ancient Peru* (forthcoming).

Colleen Zori is an archaeologist and a fellow at the Cotsen Institute of Archaeology at UCLA. Her 2011 dissertation focused on how the organization and technology of metal production in the Tarapacá Valley of mineral-rich northern Chile was transformed under Inka control. She has published on both the technical and social aspects of copper and silver production, including "Late Prehispanic and Early Colonial Silver Production in the Quebrada de Tarapacá, Northern Chile" in *Boletín del Museo Chileno de Arte Precolombino* (2010); "Late Prehispanic Copper Production in Northern Chile" in *Journal of Archaeological Science* (2013); and "Silver Lining: Evidence for Inka Silver Refining in Northern Chile" in *Journal of Archaeological Science* (2013).

INDEX

Page numbers in *italics* indicate illustrations, maps, tables, and charts.

A

Accelerator Mass Spectrometry (AMS), 87n1, 231, *233*

agriculture: at Cerro Castillo, 375; *Spondylus* shell objects used in agricultural or water rituals, 187, 223, 242–243. *See also* maize god

Aguateca Stela 7, 403

Ai Apaec ("Wrinkle Face"), 264, 269

Alcalá, Jerónimo de, *Relación de Michoacán* (1540–1541), *203*, 209, *210*

Alconini Mujica, Sonia, 124n3

Almagro, Diego de, 227

Alonso, Ana María, 321

Alva, Ignacio, 257

Alva, Walter, 257

Amarin, R., 301

AMS (Accelerator Mass Spectrometry), 87n1, 231, 233

anatase, 147

animist worldview and ancient metal production, 167, 170–171

apachetas (piles of stones and offerings), 184–185, *186*

apprentices and apprenticeship, 4, 155, 205, 367, 403, 417

arete (adeptness or excellence), 1

aríbalos, Chimú-Inka, 16, 326–349; anthropomorphic designs, 326, 328–334, *329, 330–334,* 337, 338, *342;* authority claims and conquered local elites, 330–334, *331–334,* 338, *342,* 345–348; face-neck vessels, 326, *327,* 330–332; form, significance of, 328–330, *329;* geometric designs, 326, *327,* 334–338, *336, 339;* hunchback face-neck vessels, *331,* 333; interpreting hybridity in, 345–349; as local design on Inka form, 326, 338, 346, 349; motifs predating Inka occupation, 334, *337;* organization of production in state workshops, 328, 346; plain black-ware, 326, *327;* size, significance of, 330; skeuomorphism, 342–345; stepped pyramids, representations of, *334;* technology of construction, 328; textile motifs used on, 326, *329, 333,* 334–342, *337–341, 343, 344;* zoomorphic designs, 326, *327,* 334–338, *335, 337, 341, 343, 344*

Arnold, Denise Y., and Penelope Dransart, *Textiles, Technical Practice, and Power in the Andes* (2014), 21n1

Arnold, Philip, 300

Arriaga, José de la, 242

Arroyo de Piedra Stela 1, *403,* 426n21

Arte de los metales (Alonso Barba,1640), *202*

artisans, 16–18; burials of Moche artisans, 367–368; at Cerro Castillo, 16, 18, 365–368, 383–384; cross-media skills, 13; defined, 424n1; elites as, 18, 301, 366, 367, 396–397, 402, 403–404, 417–418, 436; hybrid ceramics of Inka empire, 16, 21, 349; Late Preclassic Maya lowland ceramics, 300–302; makers' marks on bricks at Huaca de la Luna, 264; Maya vase depicting maize god as scribe and mask carver, *255;* Moche, 255–257, *256, 257,* 274n4, 366–368, 383–384; models for sociogeographical artists' networks, *404,* 405–409; Paracas post-fired painted and incised ceramics, 18, 135, 154–157, *155;* Paracas textiles, 155; physical injuries and characteristics indicating, 368, 386n1; textile producers, social identities of, *435,* 435–436; translucent cloth production, Classic Maya, *435,* 435–436, 447; unsigned works, identifying hands or workshops by, 22n12. *See also* gender; signed works in the Maya region

atacamite, 151, *153,* 157

attached specialization, 21, 183, 221, 233, 243, 366

aural properties of metal artifacts, 169, 209–211

Aztec: materiality of color for, 85–86, 88n9; spinning skills, 447; textiles and feminine gender identity, 436

azurite, 7, *153,* 183

B

Bakhtin, Mikhail, 321

Barba, Alonso, *Arte de los metales* (1640), *202*

Battle Mural, Cacaxtla, 67–74; blood, material rhetoric of, 74; bloody-bone text in front of Individual E7, 71–72, *72, 73;* 3 Deer Antler, 87n2, 87n4; different pigments used for winners and losers in, 67–71, *68–70,* 72–74, *73;* disk–teeth–bleeding-heart glyph between Individuals E8 and E9, *70,* 71; ground band, *73,* 73–74; iconography, 15–16, 67–74; Individuals E1

475

greenstone regalia of, 9–10, *34*, 40–45, *41–44*, 50–52, *52*; knowledge and technological processes, 12; La Venta Offering 4, 10, *34*, 45–49, *46–49*, 51, 55nn15–18; manufacturing marks, *39, 43*; map, *34*; material properties and associative valuations, 8, 9–10; Mesoamerican popularity of, 31–32; Olmec metamorphic greenstone ceremonial celt, La Venta, *32*; origin and sources of raw materials, *36, 37, 42*; polysemic and symbolic characteristics, 53; re-used objects, 42–44, *43*, 51; technical production sequences, *38*, 40, 45, *50*, 50–51, 53; Templo Mayor, Tenochtitlan, Offering 144, 31, *33*; in west Mexico, 200; written historical sources on, 32–34

grog temper, 296–297

ground blue mineral. *See* challa

Grube, Nikolai, 393

Guadalupito, 378, 386n2

guardapolvo, at Cacaxtla, *73*, 73–74

Guerra collection of *Spondylus* shell figurines, 237, *238*

Guggenheim Museum, *Mastercraftsmen of Ancient Peru* (exhibit, 1968), 254

guilloche or twisted-strand motif, *132, 134*

Gulf Coast: Cacaxtla murals compared to paintings of, 64, 66, 79; material evidence of contact with Cacaxtla, 88n8

Guzman, Don Alonzo Enriquez de, 228

H

Hagstrum, Melissa, 293

hallucinogenic properties of craft materials, 11, 15, 259–260, 269

Halperin, Christina, 6, 7, 13, 18, 19, 81, 433, 470

Hansen, Richard, 289

Hardman, Martha, 147

Helms, Mary W., 385

hematite, greenstone figures coated in, 46; used as pigment, 69, 70, 71, 73, 83, 85, 88n6, 88n11, 160n10, 267

Hendrichs, Pedro, 199

high-performance liquid chromatography (HPCL), 160n4

Hill, Robert M., II, 300

La historia del Mondo Nuevo (Girolamo Benzoni, 1572), *202*

Hocquenghem, Anne Marie, 230, 241

Holmul: Late Preclassic Maya lowland ceramics, *287, 292,* 306

Hosler, Dorothy, 169, 209

Houk, Brett A., 285

Houston, Stephen, 2, 4, 13, 17, 67, 301, 342–345, 391, 457, 462n6, 470

Howe, Ellen, 160n4

HPCL (high-performance liquid chromatography), 160n4

Huaca Cao, 258, 259, *260–262, 263,* 264

Huaca Chotuna, 323, *333, 334,* 347

Huaca de la Luna: makers' marks on bricks at, 264; multiple paint layers, 22n11, *271,* 272; mural technique at, 259; New Temple, 255, 268–269, 274n9; Old Temple,

258, 259, 262, 263, 264, 271, 272, 274n9; prisoners' procession, *262*; research program at, 264; Revolt of the Objects mural, 268, 274n9; spider reliefs, *263*; weavers, mural painting of, *256*

Huaca Partida feline relief, 258, 264

Huaca Rajada, Sipán, 364

huacas: caves and mines as, 170–171, 195–196; Moche-built, 259, 272, 273; *Spondylus* shell found at, 225; Tarapacá Valley metal production and, 170–171, 173, 184, *185,* 187

Huacas de Moche: abandonment of, 20, 385; artisans and workshops, 366, 367, 368; Cerro Castillo compared, 378; as Moche capital, 364; Moche IV phase occupation of, 386n2; Pañamarca mural paintings compared, 258, 259. *See also* Huaca de la Luna

Huancaco, 364

Huantajaya, silver ores at, 10, 169, 172, 173–180, *174*

Huayna Capac, 228

huayra furnaces, 169, *175–177,* 175–178, 179, 202, 203

human sacrifice, 10, 121, 124n4, 171, 173, 187

hummingbird myth, 462n5

Hun Nal Ye. *See* maize god

hybrid ceramics of Inka empire, 319–350; artisans, 16, 21, 349; authority claims and conquered local elites, 330–334, *331–334,* 338, *342,* 345–348; Chimú-Inka style, 323–327, *324*; concept of hybridity, 320–321; differences between Chimú- and Inka-style ceramics, *324, 325*; double-chamber-and-bridge form, 326; form, surface decoration, and iconography, 16, 326, *327,* 328–345, *329–345*; Ica-Inca ceramics, 338, 347; identification and study of, 325–326; Inka designs on local forms, 326, 346; Inka-influenced ceramics, 323, *324*; interpreting, 345–350; knowledge and technological processes, 13, 14, 326–328; Late Horizon material culture and, 323–325, *324*; local designs on Inka forms, 326, 338, 346, 349; map of Andes polities, *322*; organization of production in state workshops, 18, 328, 346; post-production distribution and consumption, 19; social utility and meaning of, 20, 21; *tinquy* and, 320, 348; worldview, identity, and material culture, connection between, 319–320. *See also aríbalos,* Chimú-Inka

hybridity, concept of, 320–21

Hyslop, John, 351n8

I

Ica-Inka ceramics, 338, 347

iconography, 7, 13, 15–16, 19, 20; Cacaxtla murals, 64, 66, 67, 72; Inka ceramics, 330–31; Inka shell ornaments, 230; Maya Preclassic, 285, 297, Moche ceramic, 274n9; Pañamarca murals, 253, 264, 267; Paracas ceramics, 129, 136; representations of artisans, 255

Ik' dynasty, 396, 458

imperial jade, 44, 50, 51, 52, 53

Inka: colonial power, Inka as, 321–323; Cabeza de Vaca, administrative center at, *223, 238,* 238–240, *239*; Chimú, conquest of, 321–323, *322,* 349–350; color hierarchies, 147, 151; Lake Titicaca, Inka-style pottery at, 351n7; Loma Saavedra, 231; *mit'a* labor, 196–198,

The Aztec Templo Mayor, edited by Elizabeth Hill Boone, 1986

The Southeast Classic Maya Zone, edited by Elizabeth Hill Boone and Gordon R. Willey, 1988

The Northern Dynasties: Kingship and Statecraft in Chimor, edited by Michael E. Moseley and Alana Cordy-Collins, 1990

Wealth and Hierarchy in the Intermediate Area, edited by Frederick W. Lange, 1992

Art, Ideology, and the City of Teotihuacan, edited by Janet Catherine Berlo, 1992

Latin American Horizons, edited by Don Stephen Rice, 1993

Lowland Maya Civilization in the Eighth Century AD, edited by Jeremy A. Sabloff and John S. Henderson, 1993

Collecting the Pre-Columbian Past, edited by Elizabeth Hill Boone, 1993

Tombs for the Living: Andean Mortuary Practices, edited by Tom D. Dillehay, 1995

Native Traditions in the Postconquest World, edited by Elizabeth Hill Boone and Tom Cummins, 1998

Function and Meaning in Classic Maya Architecture, edited by Stephen D. Houston, 1998

Social Patterns in Pre-Classic Mesoamerica, edited by David C. Grove and Rosemary A. Joyce, 1999

Gender in Pre-Hispanic America, edited by Cecelia F. Klein, 2001

Archaeology of Formative Ecuador, edited by J. Scott Raymond and Richard L. Burger, 2003

Gold and Power in Ancient Costa Rica, Panama, and Colombia, edited by Jeffrey Quilter and John W. Hoopes, 2003

Palaces of the Ancient New World, edited by Susan Toby Evans and Joanne Pillsbury, 2004

A Pre-Columbian World, edited by Jeffrey Quilter and Mary Ellen Miller, 2006

Twin Tollans: Chichén Itzá, Tula, and the Epiclassic to Early Postclassic Mesoamerican World, edited by Jeff Karl Kowalski and Cynthia Kristan-Graham, 2007

Variations in the Expression of Inka Power, edited by Richard L. Burger, Craig Morris, and Ramiro Matos Mendieta, 2007

El Niño, Catastrophism, and Culture Change in Ancient America, edited by Daniel H. Sandweiss and Jeffrey Quilter, 2008

Classic Period Cultural Currents in Southern and Central Veracruz, edited by Philip J. Arnold III and Christopher A. Pool, 2008

The Art of Urbanism: How Mesoamerican Kingdoms Represented Themselves in Architecture and Imagery, edited by William L. Fash and Leonardo López Luján, 2009

New Perspectives on Moche Political Organization, edited by Jeffrey Quilter and Luis Jaime Castillo B., 2010

Astronomers, Scribes, and Priests: Intellectual Interchange between the Northern Maya Lowlands and Highland Mexico in the Late Postclassic Period, edited by Gabrielle Vail and Christine Hernández, 2010

The Place of Stone Monuments: Context, Use, and Meaning in Mesoamerica's Preclassic Transition, edited by Julia Guernsey, John E. Clark, and Barbara Arroyo, 2010

Their Way of Writing: Scripts, Signs, and Pictographies in Pre-Columbian America, edited by Elizabeth Hill Boone and Gary Urton, 2011

Past Presented: Archaeological Illustration and the Ancient Americas, edited by Joanne Pillsbury, 2012

Merchants, Markets, and Exchange in the Pre-Columbian World, edited by Kenneth G. Hirth and Joanne Pillsbury, 2013

Embattled Bodies, Embattled Places: War in Pre-Columbian Mesoamerica and the Andes, edited by Andrew K. Scherer and John W. Verano, 2014

The Measure and Meaning of Time in Mesoamerica and the Andes, edited by Anthony F. Aveni, 2015

Making Value, Making Meaning: Techné in the Pre-Columbian World, edited by Cathy Lynne Costin, 2016